YALE UNIVERSITY PRESS
PELICAN HISTORY OF ART

FOUNDING EDITOR: NIKOLAUS PEVSNER

WILLIAM WATSON

THE ARTS OF CHINA TO AD 900

William Watson

The Arts of China to AD *900*

Yale University Press
New Haven and London

Set in Ehrhardt by Best-set Typesetters Co., Hong Kong
Printed and bound by C.S. Graphics, Singapore

Designed by Mary Carruthers

Library of Congress Cataloging-in-Publication Data

Watson, William, 1917–
 The arts of China to AD 900 / William Watson.
 p. cm. – (Yale University Press Pelican history of art)
 Includes bibliographical references and index.
 ISBN 0-300-05989-2 (v. 1)
 1. Art, Chinese. I. Title. II. Series.
N7343.W38 1995
709'. 51–dc20
 94-49679
 CIP

TITLE PAGE ILLUSTRATION: Detail of a gilded bronze image of Sākyamuni
and Prabhūtaratna. Musée Guimet, Paris.

Contents

Preface

This book recounts what has now become a classical story in the western world no less than the eastern. It is supported by well known monuments as much as by material recently revealed. Sickman and Soper's volume, published forty years ago by Penguin Books, confined itself to painting, sculpture and architecture. Thus was avoided a problem which, in a general account, presents itself more insistently in Chinese than in European tradition: the relation of decorative art to formally expressive art. Most of the abundant western books on the Chinese arts appearing in recent decades have divided the subject according to technique and material. Painting is the distinguished exception, being given liberal treatment, particularly by the American school of art historians. Through the recorded identity of artists and the better-known history of their works, the account of painting has been brought nearer to our post-Renaissance philosophy of art history than the anonymity of the rest allows. But if the Chinese arts are to be treated globally, as now appears desirable, the European distinction between 'fine' and 'applied' art must be revised or abolished.

For this book we draw illustration from works potentially visible to the student in public and private collections, or readily traceable in eastern or western publication. So long an art history compressed into one volume can suggest perspectives and mutual relations, but must be brief on many themes, and ignore some themes altogether. Technical matters have not been dwelt upon. While the term 'school' is inapplicable here in any of the senses attributed to it in the history of European medieval and later art, we nevertheless retain it sometimes in classifying works. In the case of known artists only a few facts of biography are noted, attention being directed to objects before literature. The break of tradition at nodal points should be clear, though given the stability of things Chinese, 'continuing style' is a title rather often called upon. When Chinese and Japanese writing is cited the reference is not translated or transliterated beyond the author or originating institution, since the content of the source will be apparent from the text, and because a degree of linguistic competence is today indispensable to the study of the subject. Our total indebtedness to scholars east and west will be clear at every turn of text and footnote, and we hope that the volume will be seen as an appreciation of their labours. Our best thanks, for acquiring the illustration, go to Susan Rose-Smith, of unremitting search to east and west; and to Mary Carruthers for arranging pictures and text, always a trying business.

William Watson
Cefn y Maes
February 1995

Chronological Table

SHANG DYNASTY	
In historical tradition	1766–1122 B.C.
Revised dates	1523–1027 B.C.
Zhengzhou occupation	16TH–13TH CENTURY B.C.
Anyang occupation	1300–1027 B.C.
ZHOU DYNASTY	
Western Zhou *Xizhou*	1027–771 B.C.
Eastern Zhou *Dongzhou*	770–221 B.C.
Spring and Autumn Annals *Chunqiu*	772–221 B.C.
Warring States *Zhanguo*	475–221 B.C.
QIN DYNASTY	221–206 B.C.
EASTERN HAN DYNASTY *Xihan*	206B.C.–A.D. 8
WANG MANG INTERREGNUM	9–25
WESTERN HAN DYNASTY *Donghan*	25–220
THREE KINGDOMS *Sanguo*	220–280
Shuhan	221–263
Wei	220–266
*Wu	222–280

WESTERN JIN DYNASTY *Xijin*	265–316
*EASTERN JIN DYNASTY *Dongjin*	317–420
NORTHERN DYNASTIES	
Northern Wei	386–535
Western Wei	535–557
Eastern Wei	534–550
Northern Zhou	557–581
Northern Qi	550–577
SOUTHERN DYNASTIES	
*Liu Song	420–479
*Southern Qi	479–502
*Liang	502–557
*Chen	557–589
SIX DYNASTIES Liuchao (* above, capital at Nanjing)	222–581
SUI DYNASTY	581–618
TANG DYNASTY	618–906
FIVE DYNASTIES	907–960

CHAPTER I
Neolithic Art

In seeking a beginning in China for traditions of technique and art extending characteristically into and through the dynastic period, one is led deep into the neolithic age, and the evidence is furnished almost entirely by pottery. Aspects of the excellence achieved uniquely in China in much later time are already discernible in potteries made seven thousand years ago, in farming communities settled in the Yellow river valley and on the Shandong plains. For a country destined to maintain exceptional political unity and cultural uniformity through millennia, it is remarkable how diverse were the notions of shape and ornament in art which prevailed at the outset.

Before dynastic rule and bronze metallurgy were established in central China in the seventeenth century B.C., three regional and chronological divisions of neolithic culture are defined by ceramic tradition.[1] Red-bodied pottery, the best of it painted, flourished in central China, south Shaanxi, Henan and south Shanxi for about two millennia from 5000 B.C. Followed a phase of wholly divergent black pottery, the best of it burnished and sometimes egg-shell thin, whose origins lay in Shandong but whose eventual extension covered much of central China. A third pottery-based division of neolithic culture was centred on the eastern part of the north-western province of Gansu. Respectively the cultures are named Yangshao (understood to be the tradition of the central plain), Longshan and Gansu Yangshao: the last is well known outside of China through large painted urns of the Banshan type present in many western museums [13].

The central Yangshao tradition, as recorded in its painted pottery, embraces Henan (the north-central zone of ceramic classification) and neighbouring Shaanxi (of the north-west zone), but differences appear which in this neolithic age tell against the view of Henan as the unique cradle of ornamental style to the extent that proves to be the case in the ensuing bronze age [1–3].[2] It is of interest that the initial location of painted pottery at its earliest ascertained date, the fifth millennium B.C., and its subsequent migration beyond Henan, do not correspond closely to the geographic distribution of types of plainer utilitarian ceramics. The art of painting and its associated types of ware thus appear to travel and be accepted in their own terms. With some regional variation, painted ornament favoured linear design, and was abstracted from vegetable or animal form only in certain local manifestations. The abstraction is not dissimilar to the manner which was to recur in bronze ornament some millennia later as accompaniment to animal-like motifs.

The finer pottery due to serve for painting first appears in central Henan ca 5000 B.C., a reddish-brown ware fired at about 900°C in a kiln chamber separated from the fire-pit, an arrangement which anticipates the sophisticated structure of all Henan kilns in the neolithic and bronze periods. The earliest pots are hemispherical bowls and flat-based tall jars, with some scratched ornament but no painting, still betraying no particular interest in the manipu-

1. Yangshao pottery. Fourth–third millennia B.C.: a, c Banpo tradition; b, d Miaodigou tradition.

a

b

c

d

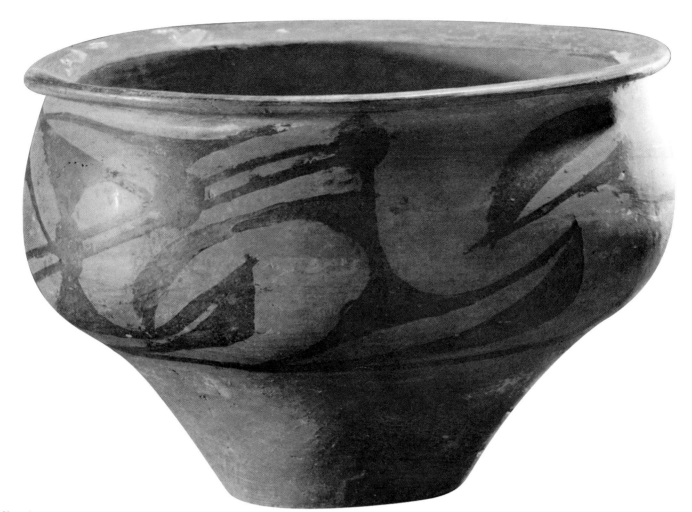

2. Yangshao painted pedestal bowl from Xuanqu, Shanxi. Late third
millennium B.C. Ht 22 cm

3. Yangshao bowl with 'fish face' design, from Banpo, Shaanxi. Late third
millennium B.C. Diam. 44.5 cm

lation of form.[3] These simple shapes are further refined and painting is introduced in the same region in an unbroken tradition occupying the fourth millennium.[4] Manufacture is by the 'paddle and anvil' method of beating out the shape, aided by a turning device but still without knowledge of the potter's wheel. Red and black pigments (based on haematite and manganese-rich earths) were used in painting triangles with in-curving sides set about oblique lines, crescent shapes enclosing a circular area, or a figure resembling a cowrie shell [1]. A practice peculiar to the Yangshao pottery of Henan and significant for all later Chinese ceramics was the application of a clay slip, usually white, derived from primary or redeposited kaolin, more rarely light-red, as the ground for one-colour or two-colour painting; and a haematitic wash may have been added to improve the colour of the normal red body. In the later stages of the tradition, represented by the later phase of pottery of the Dahecun tradition, high-shouldered bowls and varieties of tripod vessels – the début of the perennial *ding* – and a tazza (*dou*) on a high foot achieve some distinction [5]. The geometricizing ornament is multiplied with cross-hatching, meandering lines, stars, rhombs and a characteristic fringed 'eyebrow'. Form is handled more expressively, and the custom of structured shape, as against turned shape, is bequeathed to all succeeding generations of Chinese potters. In the early third millennium the most interesting painted pottery belongs to west Henan, as demonstrated from excavation at Miaodigou (Shaan-xian). Here the curvilinear figures in red and black cultivate unexpected sweeps and turns in concave-sided triangles and crescents, carefully controlled but with the impression of free brushing, anticipating mannerism perpetuated in subsequent bronze-age art.

In Shaanxi ceramic painting along the border with Henan follows the style we have described for that province.[5] Farther west in Shaanxi, however, a stylistic boundary is passed and the painted motifs change, as is demonstrated notably by excavation on the neolithic village site of Banpo near to Sian.[6] This style of central Shaanxi deals with rectilinear triangles in various continuous arrangements, alternating black and red, the effect suggesting inspiration from basketry and textile to a greater degree than appeared in Henan. While the incidence of painted ceramic seems still to be independent of the local manufacture of plain coarser pottery, it also demonstrates that the painting might differ gradually from district to district, and that the vessels which bore it were in every case a local product. Stylized representations of animals are additions to the repertoire unknown from Henan. Tortoise and paired fish are among the simpler items. A bird pecking at a fish is a theme which seems to have acquired symbolic meaning later. But of still greater interest is a manner of stylization. On the interior of a bowl are two mask-like motifs showing a face, possibly meant as human, with fish pecking at the ears and projections resembling fins, all drawn with straight or regularly curved lines. Decorating the exterior of many shallow bowls are geometricized side-views of fish, single, double-headed or twinned. These are drawn with increasingly straight lines, finally dismembered and reassembled into anonymous rectangular figures which may properly be called abstraction [3–4]. This effect seems to be reached in a single trans-

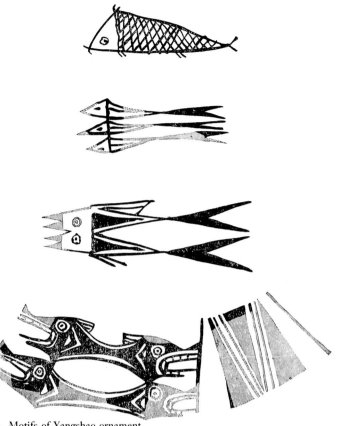

4. Motifs of Yangshao ornament

formation and not through the series of intermediate stages postulated by the excavators.[7] The eye and curved portion of the head is on some specimens enlarged to cover most of the side of a vessel, losing their identity. The Yangshao culture of western Shaanxi with varying painted pottery of the central-China tradition extends along the valley of the Wei across the provincial boundary and far into Gansu, but it is arrested on the line of the watershed which separates the upper Wei from the river Tao, an important boundary when the quite dissimilar styles of the later painted potteries of Gansu are considered.[8]

Excavation has shown that the manufacture of painted red pottery ceased in central China soon after 3000 B.C., its place being taken by grey and black ware made in studied wheel-thrown shapes, the hallmark of the Longshan culture.[9] The upper limit of this phase as demonstrated at Miaodigou in Henan lies in the second or third century of the third millennium. At the lower limit it marches with the introduction of bronze metallurgy and soon with the establishment in the Central Plain of the centralized government recounted in history. The earliest phase of Longshan culture as defined by fine black pottery appears to lie in Shandong, its extension to Henan supervening upon the Yangshao and being in turn followed by grey pottery characteristic of the Shang bronze age. Apart from the burnished deep-black surface of the fine ware and the thin walls of some vessels, the distinguishing feature of Longshan pottery is the preference for shapes whose profiles are ridged sharply at one or two places, as if they copied metal models. The

5. Shandong neolithic pottery: a, b, f Dawenkou tradition; c, d, e Dahecun tradition, Late third millennium B.C.

shapes in some cases anticipate those found later in bronze, although they are reported to have been made in a wholly pre-metal neolithic environment. Handled beakers, the tripod *ding*, *dou* tazzas and various versions of the strange *kui* tripod [6] are the most striking types, all showing an unprecedented care for proportion and balance. The sequence of potteries named after the site of Dawenkou in Zou-xian in south Shandong cover the period from *ca* 4200 B.C. to 2700 B.C., showing a uniform development which culminates in the classical wheel-turned black ware of Longshan [5].[10] At the start some bowls are painted on the shoulder with a large-petalled flower, but thereafter painting is abandoned and the potter concentrates on manipulation of form alone. The *ding* is balanced on three legs spreading from near the centre of the base, and the broad column of a *dou* may be decorated with pierced triangles and circles. Most remarkable are 'pillar beakers' which place a cup about 10 cm wide on a column some 20–25 cm high and only 3 cm in diameter [7]. Variants of this elegant beaker have been found at east-coast sites as far south as Jiangsu, towards the end of their history appearing in thin black pottery.[11] The *kui*, first made a few centuries before 3000 B.C., acquires increasing poise in the first half of the third millennium, and with the pillar beaker was clearly accorded noble status in general use and in groups of funerary vessels. In the final stage of Dawenkou tradition spouted cups, handles imitating rope-twist, and even an impractical and evidently ceremonial cup with spikes projecting around the rim, all reflect growing interest in modelled form, although shortly after 3000 B.C. a fast-turning wheel was in use. The painted ornament present in an early Dawenkou stage may recall the Yangshao type, as on the bowl mentioned above, but even here the circling and interlocking movement of Yangshao design is not attempted. The dots, large triangles, zig-zag, reticulation and whirligigs of Shandong painting are more static, in this respect anticipating the character of the earliest bronze ornament developed in central China. Some painting of red pottery spread southwards along the coast into northern Jiangsu, but here as elsewhere elegant shapes in burnished black ware held the stage in the late third and the early second millennium.[12]

While the Longshan tradition derives from and parallels that of Dawenkou, the name is properly applied to potteries of sites dated after 3000 B.C. typified by specimens excavated at Rizhao on the south Shandong coast and at Lujiakou at the centre of the province, the last stage being represented at the eponymous site of Chengziyai on the Longshan ('Dragon mountain') in west Shandong.[13] Here settlement was on an oblong platform supporting building foundations of rammed earth resembling those excavated at the northern Shang capital. This likeness and that of other cultural material (apart from metal) suggest that the social order was closer to that of the initial bronze age than to neolithic communities. The Longshan assemblages of pottery no longer include pillar beakers; the *ding* assumes a shape nearer to that inherited by Shang, with vertical solid legs, and a new type destined to figure also among the bronze ritual vessels is the *li*, a bowl whose containing space descends into three bulging hollow feet. It is in these vessels, and in single-

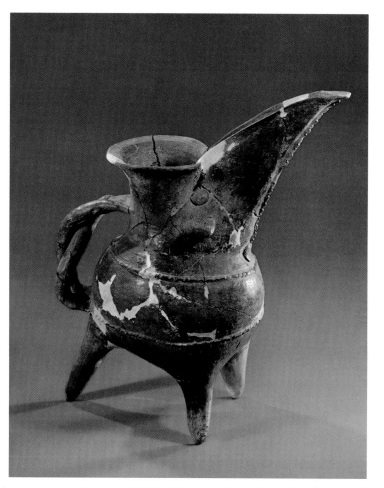

6. Pottery *kui* from Weifang, Shandong. Late third millennium B.C. Ht about 30 cm

handled and double-handled beakers with carinated profile, that rigour of pseudo-metallic design is applied, and a new vision of form is chiefly manifested [8].

It was noticed above that the painted pottery of the Yangshao kind ceases abruptly westwards on the watershed which forms the eastern edge of the Tao river valley. Beyond this line is the region of a very distinct type of painted ceramics whose manufacture begins *ca* 4000 B.C. and continues into the second millennium and sporadically into the Western Zhou period.[14] That the implantation of this group of wares in the Chinese north-western territories of Gansu and Qinghai occurs later than the establishment of Yangshao in central China is demonstrated at a very few sites on the ceramic boundary where deposits of the latter lie beneath those of the former [11]. The north-western painted pottery represents the Chinese branch of a practice of red potteries decorated with black and red pigments which extends across Central Asia and into north India. Though far from resembling these extraneous wares closely, the Chinese equivalents were made of similar well levigated, lightly sanded clay fired by similar means to yield a light red or plum-red surface; and while employing motifs peculiar to China, their ornament is applied in much the spirit that obtained throughout the far-flung tradition.

Three main groups of painted vessels are recognized, all located along the upper Wei river, westwards to the upper Yellow river, and in eastern Qinghai as far as the Longyang gorge. The earliest group, denoted Majiayao, excels in tall vases wrapped around with large curvilinear motifs in black, mostly based on a number of spiral nodes from which extend flails or whirligigs [9, 10]. Oval areas are filled with re-

7. Longshan pillar beaker. *ca* 2000 B.C. Ht 21.8 cm. Shanghai Museum.

8. Longshan pedestal beaker from Weifang, Shandong. Late third millennium B.C. Ht 20 cm (The lip restored)

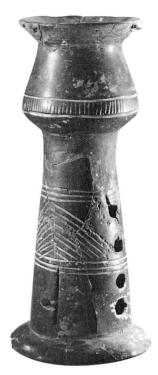

9. Pedestal bowl with wave design, Majia pottery, from Lanzhou, Gansu.
Third millennium B.C. Ht about 22 cm

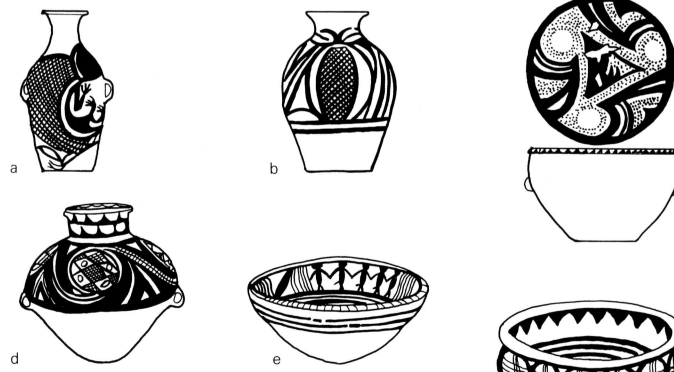

a

b

c

d

e

10. Painted motifs of Yangshao pottery in Gansu and Qinghai. East Gansu:
Xialingxia phase: a: Wushan Fujiamen; b: Qinan Dadiwan. Majia phase:
c: Lanzhou Huazhaizi; d: Lanzhou Shajing. Qinghai: e, f: Datong
Shangsunjia.

f

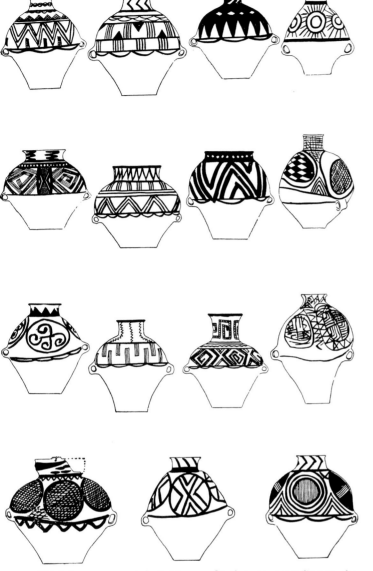

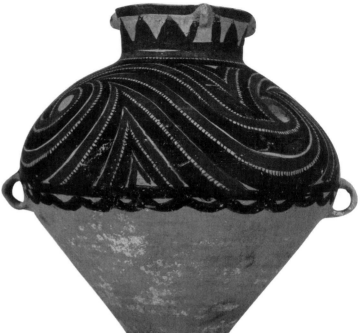

12. Banshan urn. *ca* 2000 B.C. Museum of Far Eastern Antiquities, Stockholm. Ht 42.5 cm

11. Painted urns excavated at Liuwan, Qinghai, corresponding to the Gansu Yangshao phase.

ticulation, and on one celebrated piece the addition of small legs to a serpentine figure turns it into a fantastic lizard. Though a few sketchy birds occur, the use of animal motifs is not much developed, and in a later phase of this group staider designs in bands and circles tend to predominate. One exceptional frieze consists of matchstick men in a row holding hands [10]. Tall vases and bowls, narrow-necked bottles and gourd-shaped flasks display potting skill superior to the Yangshao standard, the much bolder and more varied designs evidently prompted by the enlarged areas offered for decoration.

The specimens best known in the west belong to the succeeding group, designated Banshan after a site somewhere in the region of the middle Tao and upper Wei rivers, the exact place no longer known [12, 13]. Here a vast number of large funerary urns were unearthed clandestinely in the 1930s and found their way to many museums outside China. The typical Banshan urn is nearly spherical, with everted lip at the mouth or a short vertical neck amounting

to about one quarter of the height of the body, the latter averaging 35–40 cm. The profile tapers slightly towards the base, and two small ring-lugs are placed at the middle of the side. In common with the other divisions of the north-west painted pottery the Banshan group has a greater variety of shapes and ornament than is found in any of the painted ware of central China. With the spherical urns went also conical and piriform jars, bottles, double-bulging vases, low sub-spherical beakers with a tall neck, and bowls deep or shallow. Care for shape is no less than the ingenuity displayed in ornament. Circularity in plan and symmetry of the profile are kept accurate without the employment of a fast wheel. In painting, purplish-black and plum-red (manganese-rich and haematitic earths) are the most usual colours, but control of the iron content of the pigment could yield shades of brown and yellow. It is uncertain whether the pigments were applied to the dried but unfired clay, or to the body after firing and fixed by further firing, but the former is more probable. Among the motifs available in the wider Gansu practice, the Banshan potters favoured large rondels, three or four stretching around the whole circumference of the sides and joined by bands of multiple lines spiralling from them. These bands combine the various colours, generally with black lines on the outer edges which are serrated with a succession of small points – the once celebrated 'death pattern' of western writers, now shown not to have been confined to funerary pottery. The painting has been executed with brushes, this more evident in the narrower lines, and with brushes made of hair rather than teased bamboo. Less frequent schemes place circular or hourglass-shaped frames around the middle of the vessel and fill these with cross-hatching ('netting'), chequers or similar small figures.

A group of urns painted in resembling but rougher style are assigned to a Machang stage (Machangyao), succeeding

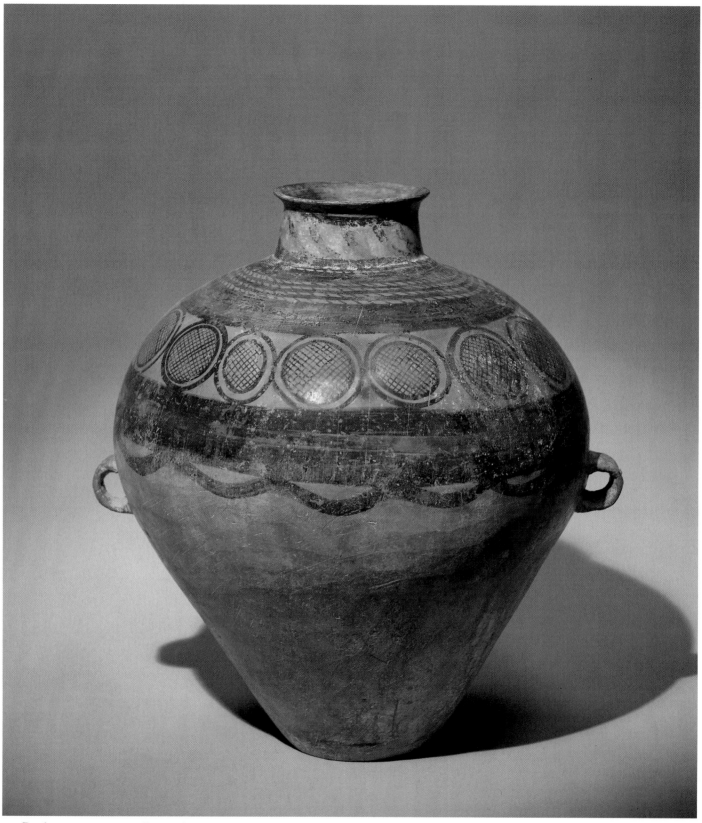

13. Banshan urn. *ca* 2000 B.C. Denver Art Museum. Ht 41.3 cm

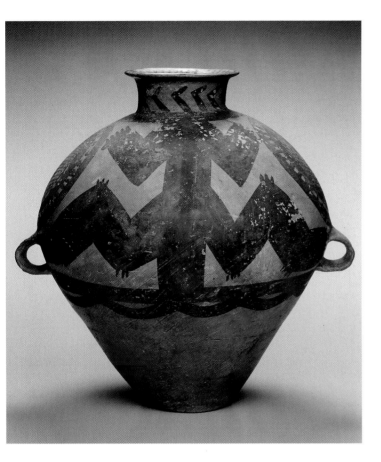

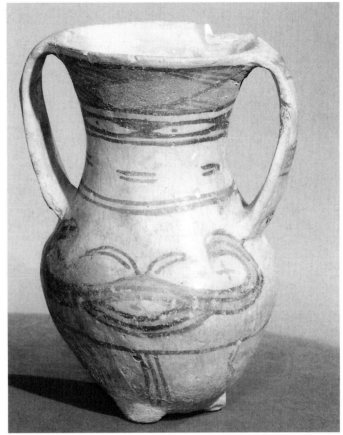

14. Machang urn. Mid–late second millennium B.C. Museum of Asian Art, San Francisco. Ht 35.5 cm. B60P1110

15. Amphora, Qijia pottery. Second millennium B.C. Museum für Ostasiatische Kunst, Cologne. Ht 28.5 cm

16. Urn, Xindian pottery. Second millennium B.C. British Museum. Ht 21 cm

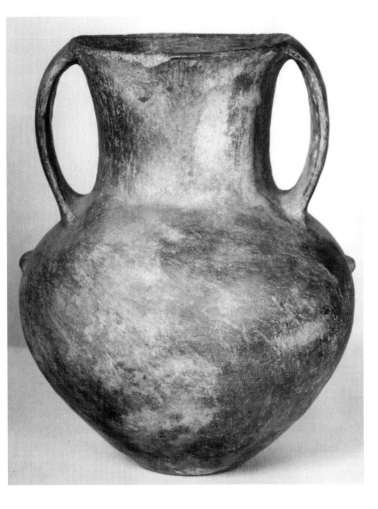

the Banshan stage in the late centuries of the second millennium B.C. [14]. The urns and beakers are taller in proportion to width than the Banshan equivalent, but these shapes and the ornament painted on them clearly represent a mere decline from the former practice. Circles around the upper part of urns contain crosses, chequers or netting, and no longer connect with spirals, combination of colours is rare and broad cavalier brushing is the rule. The bands are single (i.e. not composed of several parallel lines) and the death pattern vanishes. Although animal motifs are not attempted, some broad zig-zag embracing the whole urn adds a little detail to suggest caricature of the human shape. The earlier Majiayao occupied the upper Wei valley and the Banshan group extended this area only to the middle of the Tao valley, but painted pottery of the Machang kind is found not only in these regions but reaching also to the far northwest of Gansu province.

The final stages of painted ceramics in north-west China occupy the first half of the second millennium and so overlap in time with the beginning of bronze-age culture in the centre of the country. The shapes of vase and amphora,

like the impoverished geometric ornament, show decline of artistic sensibility compared with their predecessors. This fag end of a long-enduring tradition comes under the influence of contemporary ceramics made outside of Gansu, from Qinghai to the west and even, in the Qijia[15] stage, from the Longshan culture of Henan to the east [15]. In the succession of ornamental motifs through the whole period of painted ceramics in north-west China variety and competence gradually diminish. On Xindian pottery ornament consists only of modest variations of an 'ox-yoke' motif [16]. Shajing potters were content with a few triangles and vertical striations. In sum:

I Wushan stage (initial Majiayao) 3200–2900 B.C.: schematic lizard, netting.

II Majiayao stage 3100–2700 B.C.: spirals, undulating lines, netting, chequer.

III Banshan stage 2600–2300 B.C.: panels (circular, hour-glass, shield-shaped), spirals, death pattern, swinging bands, zig-zag, netting, chequer, moulded human head on vessel mouth.

IV Machangyao stage 2300–2000 B.C.: schematized human figure, rhombs, leaves, zig-zag, netting, key-fret.

V Qijia stage 2000–1600 B.C.: nested rhombs, chequer, shield-shaped panels, chequer.

VI Xindian stage 1800–1500 B.C.: ox-yoke, striated triangles, broken horizontal lines.

VII Shajing stage 1800–1500 B.C.: bands of vertical lines, triangles, rhombs.

CHAPTER 2

Shang Art

THE ERLITOU PERIOD

Shang art is known entirely from material which lasted below ground, in richly furnished tombs and on and around building foundations. Known from ancient times, the place called Yinxu ('waste of Yin', i.e. of Shang), outside the village of Xiaotun, a short distance north-west of the Anyang in north Henan, was the scene of illicit diggings in the more or less remote past, and especially in the opening decades of the twentieth century. Bronze vessels, weapons and ornaments, pottery and jade objects were removed in large quantity, without any record taken of their context. Systematic excavation began at Yinxu in 1927, and continued until it was interrupted by Japanese invasion in 1936. Traces of the foundations of large ceremonial buildings, deep shaft-tombs with sloping approaches on two or four sides, funeral gifts including fine bronze vessels, burials of human victims and of chariots with their charioteers, all witnessed to Shang civilization as it existed at the centre of the kingdom during the last three centuries of the dynasty's rule, dated in historical sources from approximately 1300 to 1027 B.C. Oracle sentences inscribed on bone and tortoise carapace, in which recipients of sacrifice are denoted by ceremonial names, yielded a list of Shang kings ruling at Yinxu and at earlier capitals, and of their pre-dynastic ancestors. The succession of rulers recorded in the histories was almost wholly confirmed, and the importance of north Henan as a political and cultural centre was proven from contemporary material remains for the first time.[1]

In addition to the more coherent view of Shang art thus afforded, scholars were enabled to evaluate works of similar date already present in many museums and private collections in east and west. Some of this material had reached imperial and other collections in China centuries ago, and around them had grown a vast antiquarian literature.[2] The shapes of ritual vessels, and particularly their supposed names and ceremonial functions, and the inscriptions they bore, had been studied against the historical accounts and in the light of information on ancient ritual codified in the *Liji* and *Zhouli*, texts compiled in the Han period from much earlier sources. Writing from the middle thirties to the early fifties of the twentieth century, scholars in China, Japan and the west brought more contemporary aims to the subject. Their studies laid the foundation of a systematic history of pre-Han art, and may be regarded as a first phase in the modern interpretation. The picture was drawn of a highly characteristic and close-knit artistic style, confined to north Henan as far as knowledge then went, which fascinated by what seemed its extraordinary internal logic of development. A second and continuing phase of the study is guided by the fruits of excavation dating from 1949 and ranging through the whole of China, and by the results of scientific analysis. One purpose of the present narrative must be to modify the earlier view of an isolated and wholly independent artistic tradition established at Yinxu, influencing but uninfluenced. Extraneous contacts both northward and southward can now be demonstrated, and Shang civilization given its place more convincingly in a wider context of East Asian tradition.[3]

The bronze and pottery vessels whose shapes and ornament condition our view combine diverse elements in their style at all the stages of their development. In schemes of ornament undoubtedly governed in part by ritual and political precept were gathered elements of diverse geographical origin. Some basic decorative practice, with motifs of local allegiance, was adopted and developed, and other items were drawn from regions beyond the confines of Henan. A composite official art was created in much the same manner as is seen in bronze-age palace art elsewhere in Asia. In the bronze vessels the ductus and finish of ornament were in part determined by the potentialities of the casting process, and in all the media by a desire to fill the fields of ornament with impressive symmetrical schemes interpreted in tensely sprung line, usually in repeated panels.

The evolution of the art divides into three broad stages. The first is named after the site of Erlitou in Henan, where the occupation (which included a large palace building) is dated by radiocarbon between 2080 and 1580 B.C.[4] Even before this time, during the third millennium, copper and bronze were known across north China at points extending from Gansu to Shandong, a primitive metallurgy evidently practised by neolithic societies, and not attached exclusively to a particular neolithic tradition. Consisting of small blades and the like, such early work has little relevance to the methods peculiar to Shang metallurgists, and the change which is observed at Erlitou in the later two of its four excavated levels, i.e. from about the seventeenth century B.C., is a new departure. The earlier casting method followed at this site, with two-piece stone moulds serving for axes and spearheads, was in keeping with methods extending far across inner Asia, from the Urals to eastern Siberia. From the third phase at Erlitou, however, elaborate multiple-piece moulds came into use, and produced the *jue* goblets which demanded skill of a much higher order [17]. From the implausibility of using stone in this case, and from the absence of any sign of acquaintance with *cire-perdue* casting, we may be sure that the moulds were made of pottery. A basic condition of Shang bronze art was set.

The Erlitou *jue* are plain, but their fanciful treatment anticipates the design of the later vessels on which ornament proliferates. The long projecting spouts and the spidery legs of the goblets suggest a random exploitation of the new technique. The only other shape attempted in bronze in the Erlitou period was the spouted tripod pourer called *hê* in the later ritual tradition [18]. Here the shape also called for a multiple-piece mould with a closely adjusted casting core. The division of the container into three by its pointed hollow legs was to persist as a feature of certain vessels of the later ritual series, notably the *li*. The clearly articulated profile

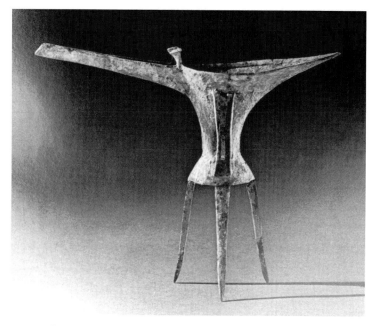

17. Bronze *jue* from Erflitou, Henan. First half of the second millennium B.C. Ht 25.6 cm

18. Bronze *he* of the Zhengzhou phase. Mid-second millennium B.C. Ht 34.6 cm

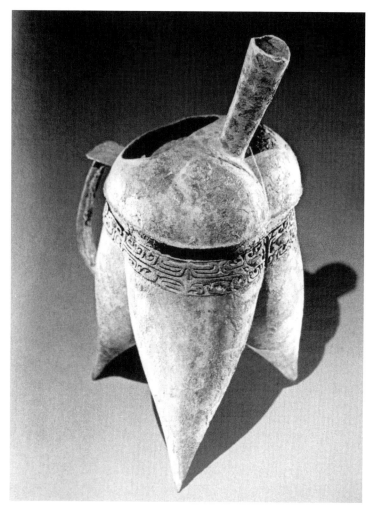

19. Ink impressions of minor motifs impressed on Shang pottery

of these shapes recalls a quality of the best of Longshan pots, particularly those made in the north-east zone, and poses the question of inspiration from local ceramic tradition. In the latter half of the Erlitou occupation some burnished black pots are wholly of the Longshan kind, while at Dengfeng in Henan this late phase of Erlitou is seen to follow directly upon the latest form of Longshan culture. Nevertheless the Erlitou pottery has other associations which underline the independence of the metal-using culture from previous neolithic tradition. Some pottery made of well levigated clay was decorated with wide bands of impressed ornament consisting of repeated small units: continuous boxed and sloping lozenges, squares, zig-zag, curling figures and rosettes. These figures appear on pottery of the suc-

20. Shang monster mask of turquoise mosaic laid on bronze, from Erlitou, Henan. Mid-second millenium B.C. Length 14.2 cm

21. Shang halberd head with jade blade and turquoise-inlaid mount. First half of the second millennium B.C. Minneapolis Institute of Art. Length 23.5 cm

ceeding Erligang period together with the band-like version of the *taotie* mask [19]. Similar small geometric figures occur on pottery of the ninth-eighth centuries B.C. in the south-east zone, where the style is independent of metal ornament and may be presumed to represent ancient tradition. On the other hand, as is recounted below, just such ornament had a rôle in the background and filling of large specific motifs in the schemes of Shang bronze art of the third, Yinxu, period. North-eastern and south-eastern influences are present even in the earliest phase of the Yinxu practice. At Anyang the imitation of metal in pottery is a new art keenly pursued. In the pottery versions of the *jue* and *hê* (these made with greater exactness than was to be observed through the later Shang period) we see the first examples of the interchange of metallic and ceramic shape which dominates in tomb ceramics throughout the pre-Han period.

In this first stage we glimpse also the habit of linear design which formed the basis of all later schemes. Most remarkable is a decorative bronze escutcheon, 14 cm in length, entirely covered with an exact mosaic of small pieces of turquoise [20]. Such work had previously been attributed only to the final decades of the Shang dynasty, when it was executed mainly on parade weapons. The Erlitou example, belonging to the early decades of Shang, depicts a much schematized animal with scrolled jaws and limbs, of which is

noteworthy its lack of resemblance, beyond the linearity, to the *taotie* monster mask so ubiquitous in schemes of the second and third stages; nor does it anticipate the mannerism of the so-called animal style of the Inner Asian steppes whose rôle vis-à-vis the post-Shang bronze style has been so much discussed. A little more suggestive of the *taotie*, however, is the quasi-human face carved on adjacent planes of a jade baton of square section. A stylized face carved similarly around the edge of a jade *zong* is found on a site of Liangzhu culture in Jiangsu, a comparison which strengthens the case for the south-western connexion of Henan culture demonstrated by the occurrence of a distinct kind of high-fired pottery. Meanwhile at Erlitou ritual blades and batons of jade, besides this exotic link, look forward to the corresponding accoutrement of ceremonial in the Yinxu period of north Henan [cf. 21].[5] In the same sense of preseventeenth-century foundations for Yinxu civilization in Henan may be cited also the traces of building foundations uncovered at Erlitou (see p. 11 above). The objects we have cited all come from the eponymous site situated just south of the river in the north of the province. It appears that in general an 'Erlitou culture' spread widely through north-central China in the first half of the second millennium, but there is yet little sign of advanced metallurgy practised beyond Erlitou itself at this time.

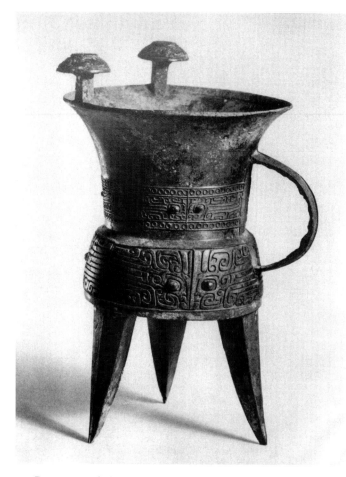

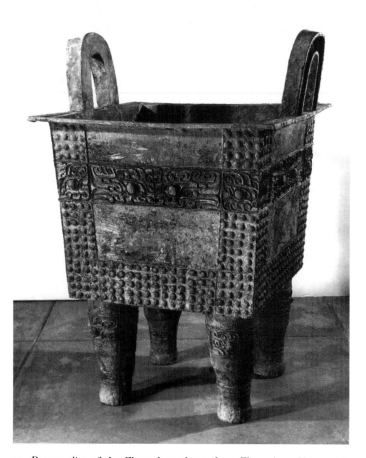

22. Bronze *jia* of the Erligang type. Shanghai Museum. Mid-second millennium B.C. Ht 32.4 cm

23. Bronze *ding* of the Zhengzhou phase, from Zhengzhou, Henan. Ht 1 metre

THE ERLIGANG PERIOD

From the sixteenth century B.C. the Shang dynasty is established historically. Apart from the question of the dynastic correlation of Erlitou culture, whether Xia or early Shang, controversy turns upon the event of *ca* 1300 B.C. when the nineteenth Shang king Pangeng is recorded to have moved northwards to a city called 'Great Shang', now identified with the site at Yinxu. The generally accepted view is that this place became the single Shang 'capital', as the abundant evidence cited above would justify. But in the Erligang period a large city with rectangular walls was built at the site of the modern city of Zhengzhou in central Henan, in and around which many tombs with bronze vessels of new shapes and decoration have been found. It appears improbable that this walled city, provisionally identified with the Shang royal residence of Ao, should be totally abandoned in favour of an unwalled city on the northern side of the Yellow river. The excavators found no clear signs of destruction at Ao, and objects of characteristic late-Shang type have rarely appeared there. An alternative explanation is that the northern city was founded for political and ceremonial reasons which did not preclude a continued occupation of the fortress city at Zhengzhou. Bronze was cast at both places, the ritual purposes of Yinxu demanding a much increased production of bronze funeral vessels, jades and other carvings, and promoting special elaboration of the ornament placed upon

them. The importance of this change in the evolution of Shang art is borne out by the multiplication of vessel shapes no less than the enlargement of the repertoire of motifs.

Before this thirteenth-century expansion took place the art of the Erligang period had assumed characteristic form. Typical of the vessel shapes is the *jia*, apparently developed from the *jue*, which still accompanies it [22]. The tripod bowl-shaped *ding*, owing its shape to a Longshan form (especially as made in west Henan), is next in frequency [23]. The *gu* goblet tends to be paired with the *jue* [25, 30]. Shallow dishes, *pan*, a tall shouldered vase, *zun* [24], and a massive four-legged, rectangular-bodied vessel (also termed *ding*) make rare and isolated appearances. Crisp relief ornament is the innovation, marking both refinement in the casting and a new readiness to convert to bronze the decoration proper to other media. The theme is little varied: the strictly stylized *taotie*, with symmetrical scrolled extensions on either side [26]. It is either depicted in thin raised line, implying narrow grooves cut into the mould, or is formed of flat surfaces from which the background sharply recedes, necessitating exact sculpturing of the mould. The figures are close to those impressed on contemporary pottery, the effect of employing stamps with thread-like relief. The motifs appear to have been reduced from large designs, identical with them and carved in wood, of which an example is cited from a soil impression preserved in excavation at Zhengzhou.

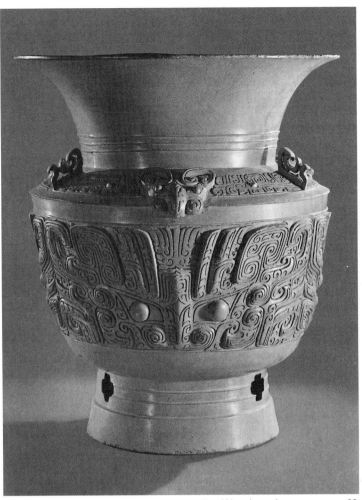

24. Bronze *zun* from Funan, Anhui. Twelfth–eleventh century B.C. Ht 47 cm

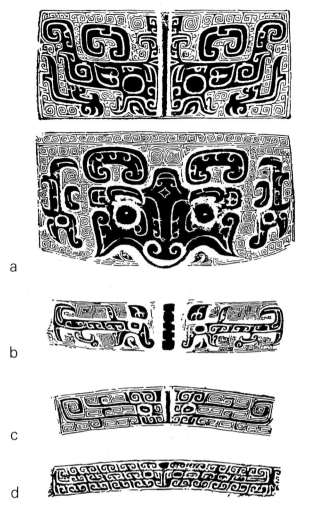

a

b

c

d

26. Ink impressions showing varieties of the *taotie*. a: Varieties of the united motif; b: appendages separated as *kui*; c: comprised of confronted *kui*; d: reduction to continous scrollery.

25. Bronze ritual vessels of the Shang period. a *ding*; b *jia*; c *zun*; d *fang yi*; e *gu*; f *jue*; g *lei*; h *zhi*; i *yu*; j *xian*; k *pan*.

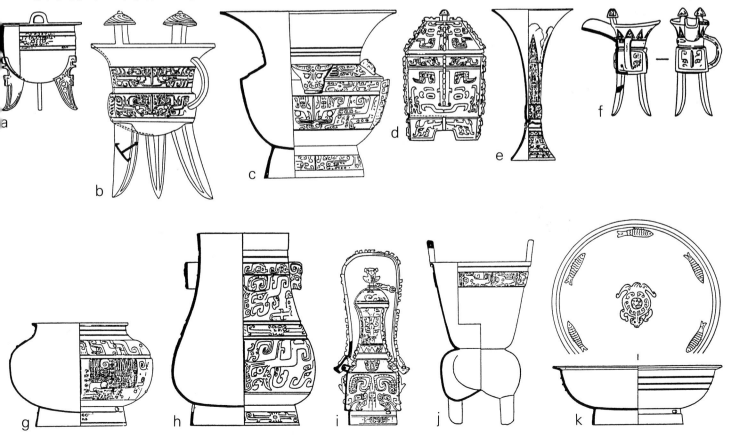

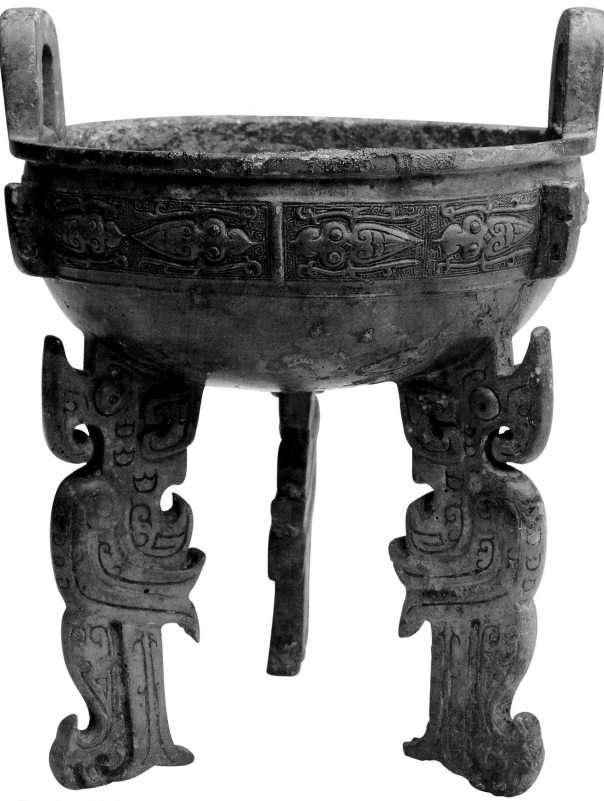

27. Bronze *ding* with bird legs. Twelfth–eleventh century B.C. Shanghai
Museum. Ht 20.8 cm

The small squares, lozenges, squared spirals, a figure resembling a low T with scrolled arms, an 'eye' surrounded by four wings, all used in continuous diaper by the potters, now appear also in bronze. Sometimes the legs of *ding* are shaped into dragons with scrolled head and fleeting body, or into birds with aduncous-beaked birds resting on a long curlicued tail [27]. Commonest of all is the mask with prominent eyes, scrolled almost into anonymity, with the lateral extensions arranged in three horizontal lines. A boucranion in virtual ronde-bosse, perched on the shoulder of a *lei*, is the only other explicit animal motif. The two styles, purely linear design and design in low relief, seem to have co-existed; more rarely the ornament resembles that of contemporary stamped pottery. Attempts to distinguish the Erligang shapes and styles chronologically have thus far met with little success. Typical bronze vessels have been found scattered from north Henan and north Hebei to east Hubei. A wide political sphere is supposed for Erligang culture extending along this north–south axis. At Panlongcheng in Hubei a large group of vessels so exactly reproduce the Zhengzhou shapes and ornament that a question arises whether the manufacture of Erligang-style bronze thus migrated south to the Yangtze region, or the export of Zhengzhou pieces reached so far.[6] When the wider distribution of vessels of the later Yinxu type is considered it must be allowed that a portion of the bronzes found in the south may have travelled from north Henan; but when bronze casting was identified at Panlongcheng the excavators concluded that the excavated bronze vessels were part of the local manufacture [28]. At Panlongcheng was found also a fragment of pottery impressed with a *taotie* in thin raised line, pointing to the exact imitation by the potter of the metal version. It is interesting that in two instances the excavators at Zhengzhou speak of stores of bronze vessels unconnected with tomb gifts. All of the ritual vessels were intended to hold food or wine, mostly the latter; but if the two caches of bronzes indeed represent a secular use, they are remarkable for their large size and decorative style. One group consists of the massive four-legged *ding*, the other includes a shouldered vase whose sides are wholly covered by large *taotie* with close-packed detail, the masks alternately upright and inverted. This scheme shows the Erligang ornament in its fullest development.

The question of continuity between the Erligang culture of central Henan and the Yinxu period of north Henan, these regions being separated by the Yellow river, is an important issue in both artistic and political history. The upper strata of the former and the lower strata of the latter contain similar pottery, which vouches for an unbroken cultural succession at a basic level, but few specimens can be cited to demonstrate a strict continuity of artistic bronze manufacture. *Ding*, *jia* and *gu* found at Hui-xian, a short distance south of Anyang but still north of the river, and at Gaocheng in Hebei represent the initial stage of the Erligang style, while the maturer style appears in vessels excavated at Pinggu near Beijing. Whether local products or imports from south of the river, these vessels do not suggest a transitional stage leading to the Yinxu style, and for the rise of the latter we must suppose industrial impetus and artistic invention occurring from a particular moment at Yinxu itself.

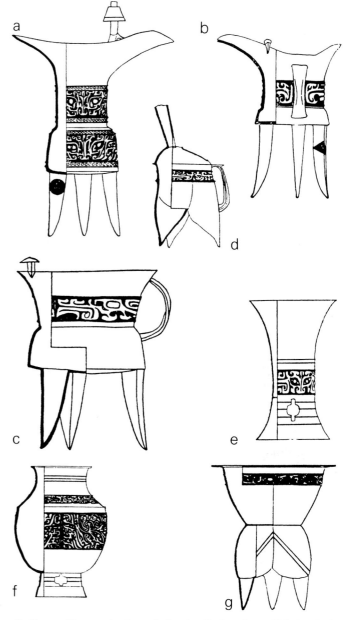

28. Types of bronze ritual vessels found at Panlongcheng, Hubei. a, b: *jue*; c: *jia*; d: *he*; e: *zhi*; f: *lei*; g: *xian*. Twelfth–eleventh century B.C.

THE YINXU PERIOD

Recent interpretations of the styles current between 1300 and 1027 B.C. have been greatly influenced by the excavation in 1976 of an intact tomb situated on the south side of the 'palace site' at Yinxu.[7] Inscriptions on many of the ritual bronze vessels, of which more than 200 were buried, name Fu Hao, identified by many scholars as the consort of king Wu Ding, the fourth and reputedly most innovatory of the Shang rulers at Yinxu. What in this upsets earlier theory is the sudden appearance in the thirteenth century B.C. of a full range of vessel shapes, ornament and iconography, such as many scholars would previously have dated to the late twelfth or the eleventh century B.C. and regarded as the climax of a long process, culminating towards the end of the Shang period. In addition to the round grain-holder *ding* and the

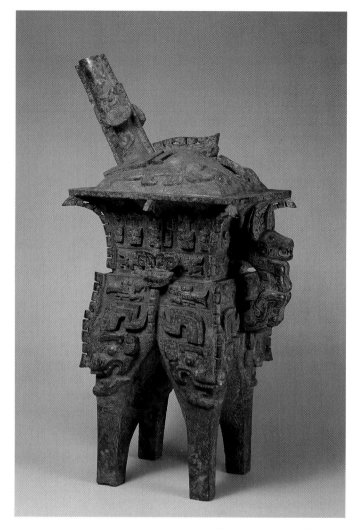

29. Bronze *hê*. Late eleventh century B.C. Nezu Institute of Fine Arts, Tokyo. Ht 73 cm

wine goblets *gu* [30], *jue* and *jia*, already known in the Erligang period, there now appear:

a square-bodied *ding*: *fang ding*.
a tall vase with tripod base, *xian*.
open bowls on a ring foot, *gui* and *yu*.
high-shouldered bowls on a ring foot, *pou* and *lei*.
a square-bodied covered vase [31].
a tall vase with lid and swinging handle, *hu*.
two pourers, *hê* and *guang* [29, 32].
a wider version of the *hu*: *zun*.

The last five of these were probably intended for the wine ceremony; the others mark a more elaborated offering of the grains and meats. In the subsequent history of pre-Han bronze tradition the coherence of shape and ornament displayed in these vessels was hardly to be surpassed, and the variety of their iconography was not repeated. The Fu Hao assemblage is taken to mark a second stage in the development of the Yinxu style; the much simpler vessels made previously, in the comparatively short time of the pre-Wu Ding reigns, employ Erligang shape and decoration. Unfortunately the excavations at Yinxu have not yielded con-

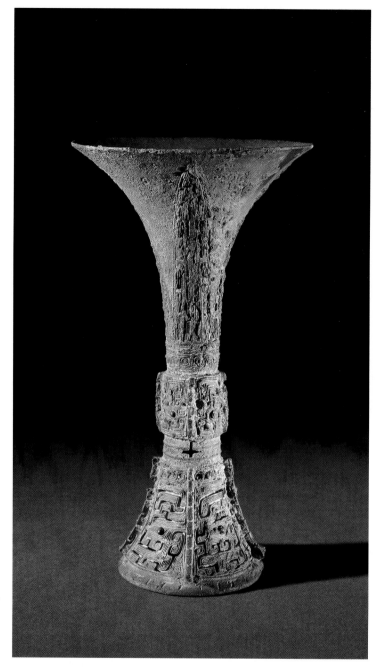

30. Bronze *gu* with openwork foot. Late eleventh century B.C. British Museum. Ht 25.8 cm

secutive dating through stratification. The bulk of superior work belongs to the middle stage denoted by the Fu Hao pieces. As will appear below, the bronzes unearthed at sites to the north and west of Yinxu, across the Huan river, are agreed to represent a final Shang stage. Much of the difficulty of interpreting the stylistic history of this vast material is removed if the idea of a single, slowly evolving and wholly centralized tradition is abandoned.

In the middle Yinxu stage the *taotie* is varied, exploded, reformed, handled in a dozen different ways. Universal are its lack of a lower jaw, a feature relating it to a practice extending in Asia well beyond China. When the lateral extensions are attached, the design is seen either as a complete

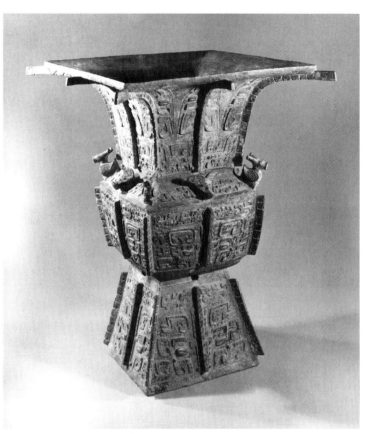

31. Bronze square-bodied *zun* from Changning, Hunan. Late twelfth–eleventh century B.C. Ht 53.8 cm

33. Bronze *zhi* with *kui* and *taotie*. Twelfth–eleventh century B.C. Shanghai Museum. Ht 19.3 cm

frontal mask or as two dragons (now identified as the mythological *kui* dragon) standing nose to nose in side-view [33]. The main elements of the design may be on the same level as the background and be depicted by concave line, or they may be raised from the background in one or two levels of relief (i.e. the eyes projecting above the limbs) [34]. The

34. Bronze *yu* with relief *taotie*. Eleventh century B.C. Museum für Kunst und Gewerbe, Hamburg. Ht 16.7 cm

32. Bronze *guang*. Eleventh century B.C. Harvard University Art Museum. Ht 24.7 cm

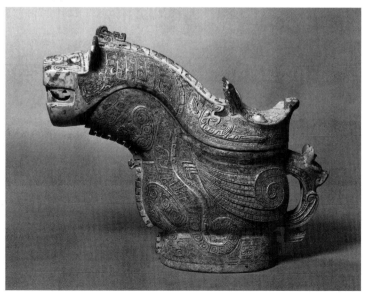

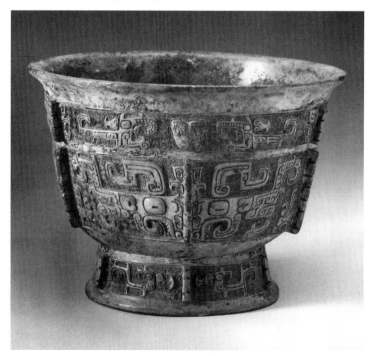

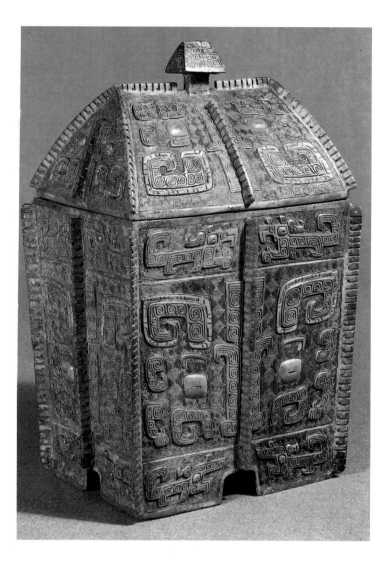

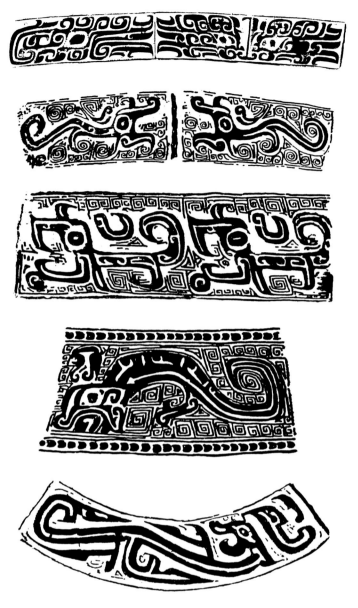

37. Ink impressions of varieties of *kui*

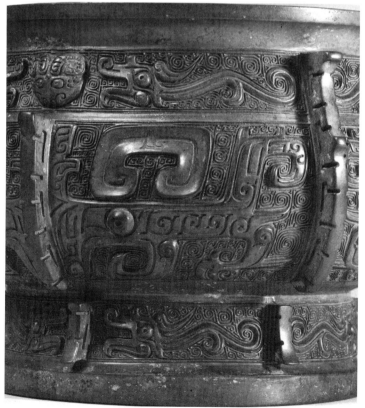

35. Bronze *fang yi* with 'exploded' *taotie*. Eleventh century B.C. Formerly Mayer collection. Ht 25.5 cm

36. Detail of the side of a bronze *yu* showing varieties of *kui* surrounded by leiwen. Museum of Far Eastern Antiquities. Stockholm. Ht 16 cm

constituents of the main design may be split apart, made to float on a ground of round or obliquely squared spiral (*leiwen*, the motif so-called from its chance resemblance to a script character denoting thunder), more rarely on a plain ground [35, 36]. *Taotie* and *kui*, birds, snake, cicada and an animal head in full relief, deer-like but unidentifiable as to species, rings and some other small geometric motifs almost complete the repertoire [27, 37, 38, 40, 42].

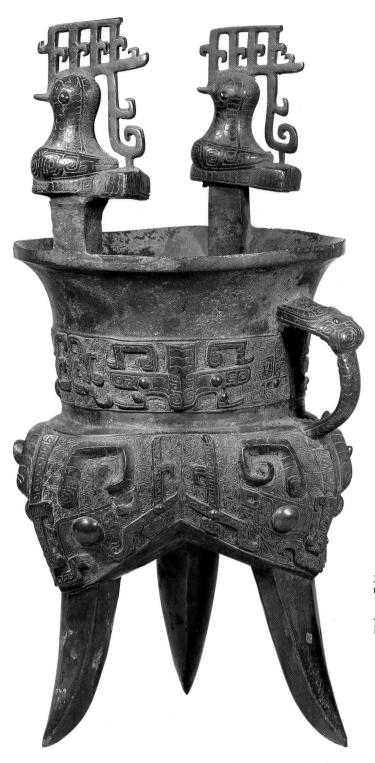

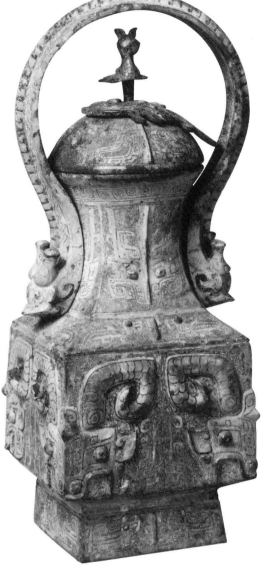

39. Bronze square-bodied *you* with four relief *taotie*. Late eleventh century B.C. Hakkaku Museum, Kobe. Ht 39.5 cm

40. Bronze *lei* with ram-heads. Late eleventh century B.C. Shanghai Museum. Ht 38.8 cm

38. Bronze *jia* with crested birds. Late eleventh century B.C. Sumitomo Museum, Kyoto. Ht 55 cm

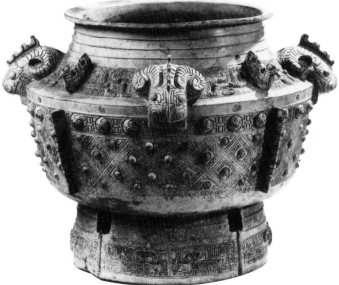

Combination and variation of motifs are made the basis of a 'grammar of style' in Karlgren's studies, and his terminology retains its usefulness.[8] In opposition to the view expressed in its extreme form by Bachhofer, that one style only reigned supreme in China at any one time, Karlgren bequeathed a useful standpoint in his theory of distinct centres or workshops, co-existing and sometimes contributing their product jointly to groups of funeral vessels. The

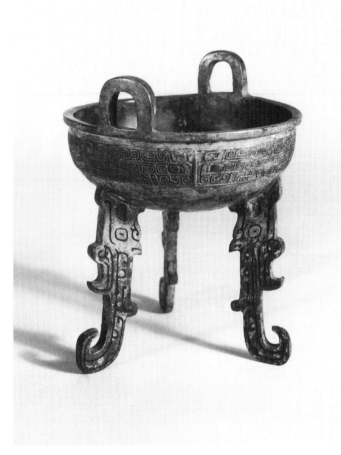

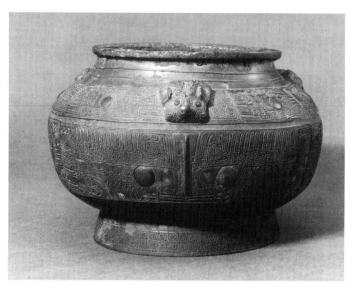

43. Bronze *lei* with dissolved *taotie*. Thirteenth–twelfth century B.C. British Museum. Ht 20.3 cm

41. (*left, top*) Bronze *ding* with dragon legs and *kui* approximating to animal triple band. Thirteenth–twelfth century B.C. Ashmolean Museum, Oxford. Ht 17.7 cm

42. (*left, below*) Bronze rectangular *ding* with *taotie* and double snake. Late eleventh century B.C. Shanghai Museum. Ht 27 cm

44. Bronze *ding* with circle band. Twelfth century B.C. Princeton University Art Museum. Ht 19.3 cm

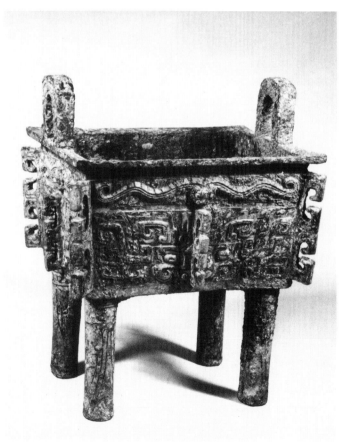

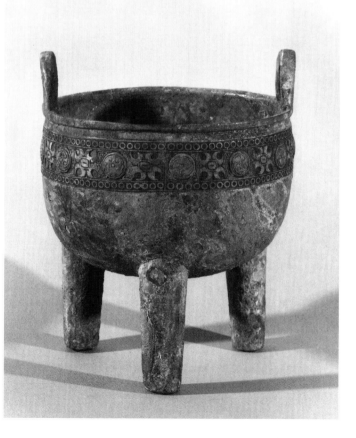

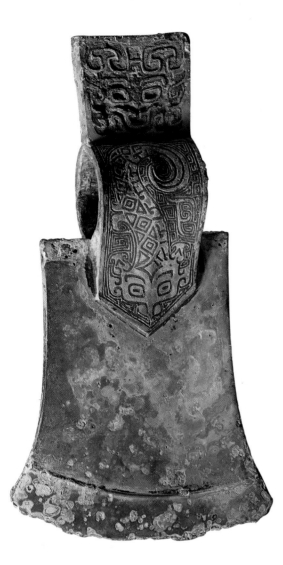

45. Bronze shaft-hole axe showing *kui* and *taotie* enhanced with red mastic. Eleventh century B.C. Museum of Far Eastern Antiquities, Stockholm. Length 20 cm

independent *kui* dragon, whether or not arising from the division of the mask, may be beak-jawed, have feather-like quills along the back, be given a proboscis, a reverted head. It may be placed vertically either side of the *taotie* or, in a band of ornament, twisted into a recumbent S [e.g. 37]. The workshop theory plausibly accounts for regularities observed in combining the motifs, and for the survival of earlier tradition in some form alongside the Wu Ding innovations. Thus geometric or geometricized elements:

dissolved *taotie* [43]
animal triple band [41]

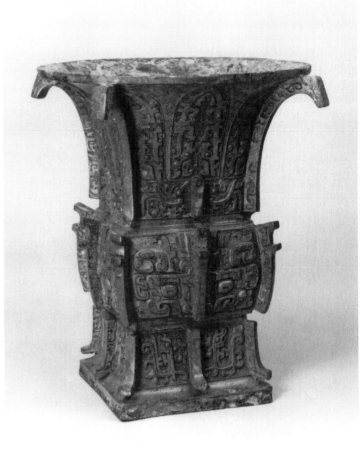

46. Bronze *zun* with 'unidecor'. Late eleventh century B.C. Hakkaku Museum, Kobe. Ht 27.7 cm

eyed spiral band [42]
eyed band with dragons [43]
circle band [44]
boxed lozenges
interlocked Ts

never combine with the coherent and explicit versions of the *taotie* which Karlgren terms mask, bovine, bodied and 'unidecor' [42, 46], but each of these two groups combines readily with the remaining motifs of the repertoire – chiefly the various dragons, blades, *leiwen*. The vessels of the Fu Hao tomb belong mainly to the second group (Karlgren's A style), although examples are included of animal triple band, boxed lozenges and the dissolved *taotie* (i.e. Karlgren's B style). It is not difficult to subdivide further the 'styles' so defined, attributing them variously to surviving Erligang tradition or to new invention, but the exclusiveness which has been noted must result from distinction of local, contemporary traditions.

The descent in technique and style thus leads from Erlitou to Zhengzhou in Henan, both south of the river, thence to Yinxu, north of the river; finds made at other places however show some independence from this main lineage. In a tomb at Funan in Anhui, as at the Panlongcheng site, the vessels are in Erligang style, but mark differing advances on the Zhengzhou equivalent. At Hui-xian, north of the river in Henan, on the other hand, the Erligang style agrees closely

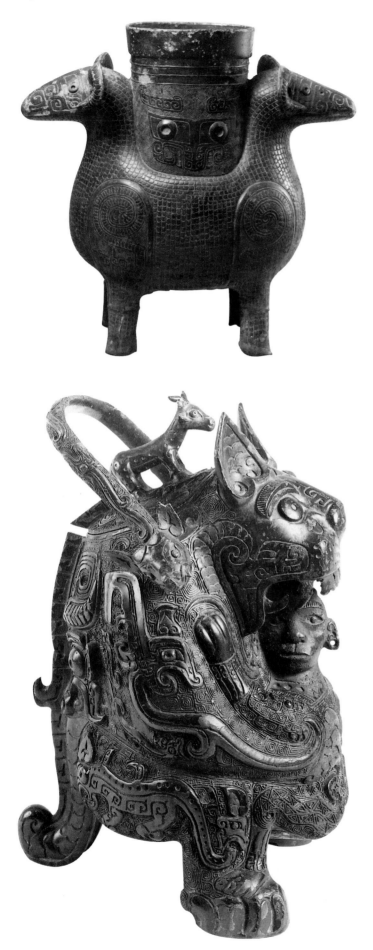

with Zhengzhou and is simpler than the specimens of this style found at Yinxu. Concurrently vessels of virtually certain Yinxu origin have been reported from widely separated places in central and east China: the practice explicitly attested in the Western Zhou period, of giving and transporting bronze vessels beyond normal political boundaries as ritual items with political significance, was probably already instituted towards the end of the Shang period.

Not less important than tracking this diffusion is the recognition of the composite nature of Shang art. It is predictable that motifs and decorative treatments incorporated into the style will show regional distribution distinct from that of any of the fully formed Shang phases. This is the case for the pottery-derived small geometric figures: in purely neolithic contexts they are traced in the South-eastern, Central and Southern zones (Jiangsu, Jiangxi, Fujian, Guangdong), at present thought to date shortly after Shang at the earliest, but assuredly not borrowed from the Henan bronzes. The fullest use made of this resource on bronze is seen on such works as the monster-protector vessels of the Louvre and the Sumitomo collection: linked and independent spirals, all slightly squared, are varied according to the relief which they cover, boxed triangles being reserved as always for the body of the serpent entwined on the man's lower body [48].[9] Also to this geometricizing influence is to be attributed in part the panelled character of much of Shang design, with its broadly rectangular ductus and fondness for sharp corners even in curvilinear figures.

While the conditions of casting, in which some trace of the joins of the mould parts must have had to be removed in finishing, may have suggested the framing of panels with flanges corresponding to the joins, casting technique in itself cannot have given rise to this aspect of design. The flanges, unknown earlier, become the hallmark of superior specimens of the Yinxu product [49]. On the flanges were placed sharply delineated grooves, like cut notches, which generally penetrate only half of the thickness of the flange, shaping a T, occasionally a more complicated figure. Similar flanges occur on stone vessels which do not imitate bronze equivalents. Their meaning is unknown, but they no doubt share in the evil-averting rôle which is the only one – for all the evidence of the oracular inscriptions – which can be assigned to the *taotie* and *kui* themselves.

The *taotie* and *kui* pervade all Shang figurative art. Features of the bronzes and of work in other media support the ready hypothesis that the motifs were invented in carving soft material, and, one may guess, also in embroidery and similar decoration. The *kui* in all its permutations appears to have its independent life, and possibly only the exigencies of metopic and symmetrical design subordinated it so frequently – though by no means universally – to the monster mask. A striking departure in the Yinxu period, fully illustrated by the Fu Hao vessels, is the adoption of zoomorphic shapes for

47. (*top*) Bronze *zun* shaped as double-headed ram. Eleventh century B.C. Nezu Institute of Fine Arts, Tokyo. Ht 45.4 cm

48. (*below*) Bronze *zun* shaped as a devouring monster. Eleventh century B.C. Musée Cernuschi, Paris. Ht 32.5 cm

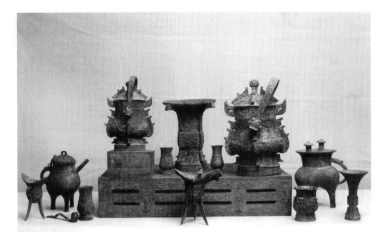

51. Set of bronze ritual vessels from Baoji-xian, Shaanxi. Late eleventh century B.C. Metropolitan Museum of Art, New York. Width of the table 89.9 cm

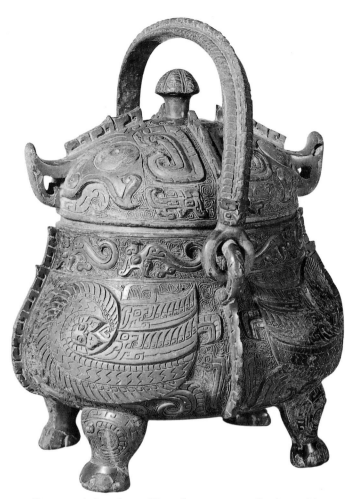

49. Bronze owl-shaped *you*. Eleventh century B.C. Sumitomo Museum, Kyoto. Ht with handle about 30 cm

50. Bronze elephant *zun* from Liling-xian, Hunan. Twelfth–eleventh century B.C. Ht 22.8 cm

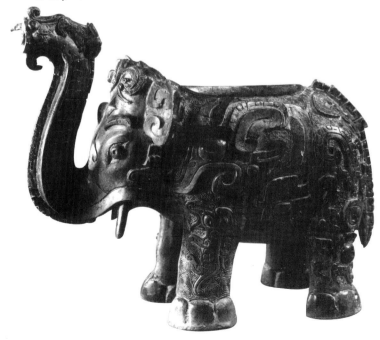

guang and *zun*, such as were unknown at this date beyond the Yinxu foundries, although towards the end of the Shang period they were buried at places far from Anyang [47, 50]. The stereotyped but not schematic naturalism interpreted in entire vessels is matched on later Yinxu bronze by minor decorative motifs of birds, tigers, snakes, cicadas, silk-worms (cited above as joining indifferently with Karlgren's A and B styles), which are not drawn into the linear abstraction characteristic of monster mask and dragon. It is plausibly speculated that animal naturalism is a southern enclave in the Shang style, derived from a tradition of wood sculpture whose presence in the Yangtze region can be demonstrated only centuries later. Tomb 1004 at Xibeigang contained a large rectangular *ding* with a fairly natural deer mask, a rare exception as the central item of the ritual formula. A similar brief naturalism is seen in the horse-head and ibex-head pommels of bronze knives associated with the Yinxu chariot burials, although these items are in a class apart, witnessing to a north-western affinity described more fully below in accounting for the changes which ensued immediately on the fall of the Shang dynasty. The 'humped' *kui* portrayed on Yinxu chariot ornament and harness pieces, and on some vessels, points in the same direction, further indicating geographic eclecticism in late-Shang art. This motif is prominent on the base of the celebrated 'altar set' preserved in the Metropolitan Museum, which together with the heavily flanged you and other vessels it bears were excaved in the Baoji-xian of Shaanxi, old territory of the Zhou rulers [51].

In the ornament two methods were pursued: a linear style with exact *leiwen* as ground, the interstices of the thread-like cast lines being filled frequently, if not regularly, with a black or red substance which is judged to have been a lacquer mastic. The coloured figures will have shown against the brightly polished bronze (of which a small patch has survived unaltered on the Kang Hou *gui* of *ca* 1000 B.C.). The animal band and cicada blades appear frequently in this flat design [33, 41], but so also do versions of *taotie* and *gui* no less elaborate than those interpreted in relief. The latter constitutes the second manner, already fully developed on the Fu Hao bronzes. Usually the relief rises to a flat surface

variegated with running spurred spiral, a variant of the *leiwen*, but some examples of raised animal heads and masks are more fully modelled [39]. Both treatments mirror their origin in carved wood. The relief suggests another atelier tradition when it consists only of a line of rounded section, with or without surrounding *leiwen* (the plain ground marking characteristic of the 'severe style' for which Bachhofer argued a distinct origin and period).[10] The contention that flat ornament and relief were sequential, indicating logical stages and a passage, cannot be supported. The two manners may occur on the same piece.[11]

The question of the latest Shang work in central Henan raises a difficulty. It is not certain how far the comprehensive style of Fu Hao continued through the Yinxu centuries, although many parts of it – for example cicada, whorl circle, bottle-shaped horns – joined the regular repertoire. As is demonstrated from burials in the 'western sector' of Yinxu and at Dasikongcun a short distance beyond the river,[12] both dated to the eleventh century as 'late Shang', there is an evident decline in the quality of both shapes and ornament. Many pieces are plain. *Lei* and handle-less *gui* (these often termed *yu*), round-bodied *ding* with vertical columnar legs, and rectangular *ding* are frequent, together with the indispensable *jue* and *zun*, the *gu* rarer. Zoomorphic shapes have ceased. Flat ornament occurs alongside relief of the 'dissolved' kind. As isolated units of design the circle band, 'square with crescents' and whorl-circle [44], and in continuous design the animal triple band [41], may appear at the mouth of a vessel which is otherwise plain, always conforming to Karlgren's rule of the A and B combinations. Meanwhile one notes jejune versions of Shang design at some sites distant from the Shang metropolis, for example northwards at Shilou in Shanxi and southwards at Ningxiang in Hunan.[13] Bronzes of this character are often classified as 'Shang-Zhou transitional'. They occupy a phase of some duration, probably bridging the last decade or two of Shang and the first of Western Zhou; it is tolerably certain that at this time standards associated with Zhou tradition, already implanted in north-west China, were gradually penetrating into the central plain and Shang metropolitan territory. Some grotesque experimentation is to be seen in the shapes and ornament of the conventional types.

Shang style, or what was deemed such, inspires much of the archaistic ornament of all later Chinese art. Its revival began with Lü Dalin's *Pictures for the study of antiquity* (*Kaogutu*) which appeared in ten volumes in 1092. This work survives in later editions, together with the revised version

of an album illustrating bronzes in the imperial collection (*Chongxiu bogutulu*) whose compilation was ordered in the 1120s. Attention went chiefly to the inscriptions cast on the bronze vessels: the emblematic figures (interpreted as clan symbols) of Shang, and the fully literate texts which begin to appear precisely from the inception of Zhou rule in central China; but the inaccurate linear illustrations included in the book perpetuated both learned and popular notions of the shapes, and through variation arising inevitably in later reprinting may be said to have had an artistic history of their own. The first work just cited referred three vessels to the Xia dynasty, but the second attributed vessels only to Shang and Zhou, and adopted the terms *taotie*, *kui* and *leiwen* from their mention in mid-Zhou literature. By the middle of the thirteenth century a theory gained currency that Xia bronzes were distinguished by their inlay of gold, and to this mistaken belief is to be attributed the decoration inspired by Song and subsequent archaism.[14] In the Shang period ornamental weapons and escutcheons might be richly incrusted with turquoise or malachite in close-set mosaic, and even inlaid with meteoric iron. These means of decoration were not, however, employed on ritual vessels, where the red and black filling of the ground – probably much commoner than the present state of the bronzes suggests – was deemed sufficient. A few small masks are known where insets of stone fill large cells in the design.[15] These, however, date more probably to the early Western Zhou. Under the Shang dynasty no individual creative use was made of inlay in stone or metal, the metal inlay in the later Zhou period appearing as fresh invention (see p. 45 below).

The Shang conventions of shape and ornament established a tradition which may be termed hieratic, regarding its concentration on abstract, symmetrical and heraldic themes as much as its connexion with the sacrifice and symbolic ceremony constituting the religion of the Chinese ruling class. The later pre-Han history of the bronze style shows the hieratic features gradually reduced to pure decoration, while the solemnity of official art is expressed through other elements, mainly astronomical and mythological. At the beginning of the iconographic tradition there is paradox in the virtual deification accorded by the Confucians to the founders of the Zhou line as originators of rite for which the vanquished Shang bequeathed the sacrificial paraphernalia and the apotropaeic iconography. The passage from Shang to Zhou rule in 1027 B.C. remains the most problematic phase in the early period, one to which archaeologist and historian have much to contribute.

Bronze in the Xizhou Period: 1027 – 771 B.C.

The eastward conquest of the Zhou tribes, moving from Shaanxi in 1027 B.C., overthrew Shang rule in Henan, created a new feudal order and established in all central China artistic styles previously nurtured in the north-west. Some of these styles introduce slight but characteristic modification of the Shang equivalent, others depart more emphatically from the Shang standard. Before the Zhou conquest the Shang oracle sentences reflect a close concern with the north-west, particularly in the early thirteenth century, at the time of the *floruit* of bronze art at Yinxu postulated for the Wu Ding period.[1] Although the Zhou are not recorded in the oracles as waging war, their state seems to have been rich and powerful enough to provoke an attack by Shang. The later development of Shang art and the innovations which ensued on the defeat of the Shang dynasts are to be interpreted in a context of political confrontation and cultural interchange extending in territory from Henan to the west limit of Shaanxi, and in time from the thirteenth century onwards. Chariot and harness mounts of bronze and even the bronze armament of the charioteers – animal-head knives and the bow-guard – certainly appear to be intrusive items in the Yinxu equipment, suggesting plausibly that the origins of chariotry and horsemanship lay in Shaanxi and further west. An item of Shang iconography that early points the western connexion is the form of dragon aptly described as the 'humped *kui*' (p. 25) which at Yinxu appears to be confined to chariot ornament. The serpentine back rises to form a hump; the jaws are always agape. Although it is occasionally placed together with hieratic motifs on vessels of late-Yinxu appearance, this *kui* never enters into the rectilinear and metopic permutations of Shang schemes, its curving lines placing it outside the hieratic norm of Henan. It is also associated with the consolidated *taotie* of Karlgren's A style,[2] sometimes given bottle-shaped horns and placed vertically. Most notably it is frequent on vessels and rectangular vessel stands of the late eleventh century recovered in the Baoji district of west Shaanxi (p. 25) [51]. It is repeated around the bowl and rectangular podium of *gui* and *guang*, which with the rectangular *ding* are classic forms at the début of Western Zhou [52, 53].[3]

By the eleventh century bronze vessels approximating to Henan types were known in Hebei and Shandong to the east, in Shaanxi to the west and the Yangtze region to the south. Outside of Henan, Yinxu methods appear to have been further developed chiefly to the west; for probably in the last decades of Shang, and certainly in the opening decades of the Western Zhou period, when political power was exercised from Shaanxi, bronze vessels of Henan quality and elaboration were being made in that province. A *lei* of square section found in Chenggu (Shaanxi) plays with the Yinxu design in a manner suggesting insouciance or incomprehension of the original.[4] The new ruling class was more generally literate. From the late eleventh century some groups of ritual vessels, often of identical or related style,

bear inscriptions containing the dedicator's name or sign, a practice which sometimes allows an affiliation even of pieces otherwise undocumented.[5] Hence arose an old antiquarian convention of specifying vessels by the dedicator or other worthy named on them. The inscriptions may assign nobles or high officials to place, at the main Zhou capital in Shaanxi, at the advanced capital at Loyang in Henan, or in their own provincial feof. It appears that bronzes were now cast under the more varied authority of the feudatories' courts, and at a greater number of scattered foundries than was the case in Shang times. Political diversity gives rise to changed shapes and ornament, and tends to admit local features of iconography which were hitherto excluded. *Ding* round or rectangular, *gui* on a ring foot and *gui* on a square pedestal or with legs, *jue*, *jia*, *guang*, *fang yi*, *yu*, *lei*, *fu*, and *zun* are the main types, with new concentration on the last two [54]. The strange *jue* and its hitherto usual companion *gu*, now often disassociated, continue briefly into the tenth century and then cease. A new feature in the archaeology is the discovery of hoards of vessels, unconnected with tombs, which contain

52. Bronze pedestal *guang* with humped kui dragons. *ca* 1000 B.C. Former Ch'en Jen-tao collection

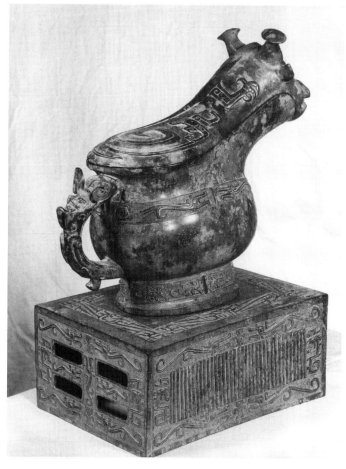

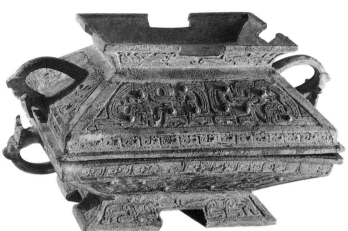

54. Bronze *fu*, found near Luoyang. Inscribed 'Marquis of Chen'. *ca* 900 B.C. Royal Ontario Museum. Ht 21.6 cm

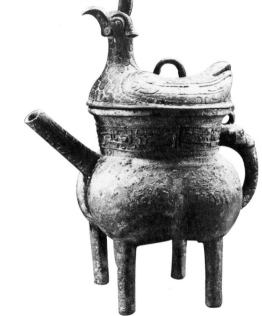

55. Bronze *hê* with bird-lid from Chang'an, Shaanxi. Tenth century B.C. Ht 19 cm

53. Ritual bronze vessels of the Xizhou period excavated at Lintong-xian, Shaanxi. a, b: pedestal *gui*; c: *hu*; d: 'royal' *hê*

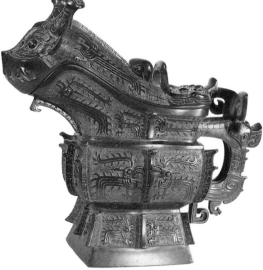

56. Bronze *guang*. Late eleventh–early tenth century B.C. Princeton University Art Museum. Ht 31.4 cm

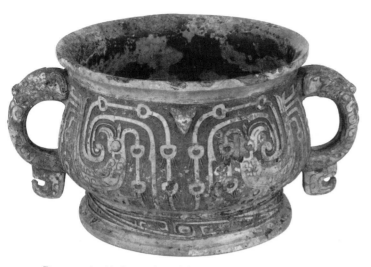

57. Bronze *gui* with large-plumed birds. Early tenth century B.C. Minneapolis Institute of Arts. Ht 15.8 cm

items of different date, at Zhuangbai, Fufengxian (Shaanxi), for example, with vessels of *ca* 1000 B.C. and others of *ca* 900 B.C., and such finds warn against the acceptance of tomb groups as being of about the same age. It becomes clear too that stores of vessels of differing date are likely to have been available to bronze-casters at more than one place.[6] Combinations of ornament eclectic with regard both to earlier tradition and to contemporary practice were readily adopted. In view of this, with little known of stratification at Zhou city sites, and nothing known of Western Zhou foundry sites, any rationalization of stylistic development is still more hazardous than it is for the Shang period. Nevertheless, through all the variety and interchange of the elements, new stylistic trends reflect changing conventions in ritual apparatus, differing concepts of form, and undoubtedly the effect of separate schools of production. At present discussion on these lines is more enlightening than a close structuring of dates inferred for individual pieces.

CONTINUING STYLE

During the reigns of kings Cheng, Kang and Zhao (1027–948 B.C.) styles still somewhat resembling Shang attest the close connexion between Henan and Shaanxi which had existed in the last Shang decades. The *li-gui* from Lintong (Shaanxi), which records in its inscription the conquest of Shang by king Wu, has the mask *taotie* flanked by vertical *kui*, a late-Shang scheme. The addition of the rectangular

58. Bronze *zun* with large-plumed birds. Early tenth century B.C. Princeton University Art Museum. Ht 16.4 cm

59. Bronze rectangular *ding*. Tenth century B.C. Asian Art Museum of San Francisco. Ht 26 cm. B60B954

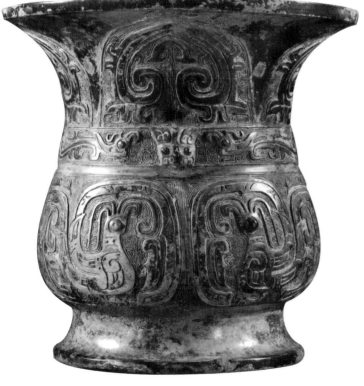

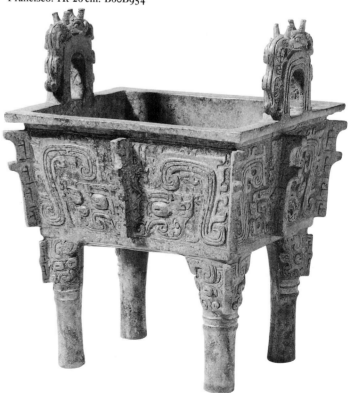

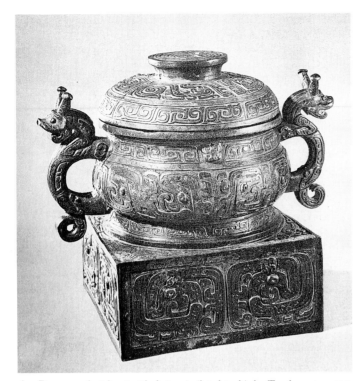

60. Bronze pedestal *gui* with *kui* assimilated to birds. Tenth century B.C. Palace Museum, Beijing. Ht 39.4 cm

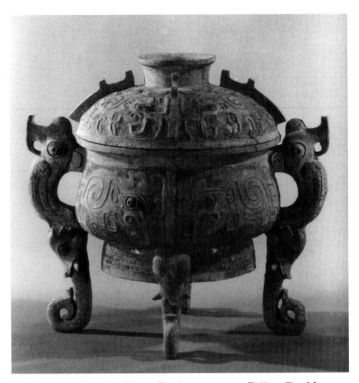

61. Bronze *gui* on animal legs. Tenth century B.C. Beijing City Museum. Ht 27.5 cm

pedestal to the *gui* is also something new [cf. 60].[7] On *gui* of this group the handles are unprecedented: a bovine monster head surmounts bird's wings and claws. Shang concern with taut and light-seeming design gives way to ponderousness and emphatic relief which tends to obscure the profile. The rectangular *ding* with cylindrical legs capped by monster masks, typical of the early Zhou reigns, follow the model of the *Simuwu ding* excavated at the late-Shang site of Wuguancun north of Yinxu – the largest ever, weighing some 700 kg.[8] In an important class of vessels of Western Zhou the rounded lines and edges distinguish the flat relief from that of Shang. The *leiwen* spiral may be circular and not squared, and the spurred meander no longer appears on the raised elements [61, 62]. But the *taotie* with this meander may still be outlined against a ground of the older *leiwen* in flat design, as occurs on *lei* datable to the very opening years of Western Zhou, or somewhat earlier, discovered as far apart as Sichuan, Hebei and Liaoning [62].[9] The use of the head or mask of an ox, or even the whole body, more or less stylized, is frequent in the Cheng reign, the mask a regular convention on the *xian* and sometimes occupying the whole side of other vessels. Accompanying the Sichuan *lei* just mentioned was another whose ornament consists entirely of fully delineated oxen or boucrania, on a plain ground.

The animal band used alone around the upper part of vessels, triple as in Karlgren's B formulation, or altered to contain aberrant versions of *taotie* or *kui* occupying the whole width of the band, is a persistent element in what we have called continuing style. At Beijing, on bronzes attributed to the early Zhou and the territory of the Yan state, the band is reformed to contain rows of *kui* compressed into something like duck-heads, and one band contains the humped *kui*. At

62. Bronze *lei* with confronted dragons, and *kui* on *lid*. Tenth century B.C. Liaoning Provincial Museum. Ht 44.5 cm

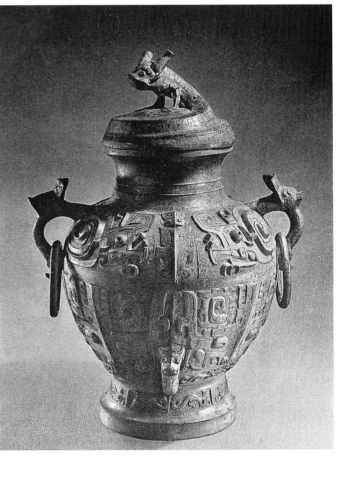

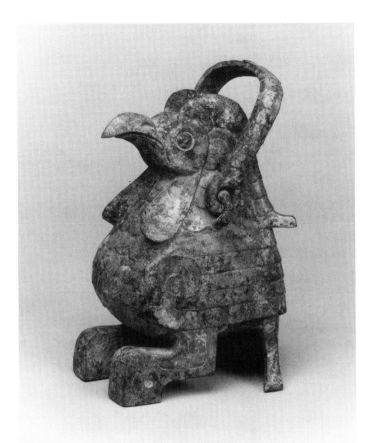

63. Bronze owl *zun*. Tenth century B.C. Hakkaku Museum, Kobe. Ht 23.5 cm

based on a bird motif [64]. The former is prominent in the enlargement and further decorative treatment of the notched flanges whose history and possible technical origin were noticed above for Shang [65]. The combined width of the flanges, now resembling a row of hooks, may amount to as much as a quarter of the width of the body of the vessel, and the hooks may be so large that sides and lids accommodate only three or four of them. At Puducun (Shaanxi Chang'an) even the *jue*, making its last appearance, is subjected to this treatment.[11] The geometricized rhythm of Shang design is lost as the vessel profiles slump into bottom-weighted single curve or cyma. Bird-based schemes assume an importance which warrants separate notice below.

The exaggeration of non-iconic detail may lead to extreme extravaganza, as on two vessels in the Freer Gallery, a *yu* carrying four horn-like projections ending in boucrania, and a *gui* with two zones of long spikes and four large handles, displaying boucrania and birds, which nullify the effect of the vessel itself.[12] Under the head of inflated detail may be brought also a kind of sharp-ridged high relief unknown in earlier styles. This is found notably on *gui*, *yu* and *zun* grouped in a find made at Gaojiabao (Jingyang-xian, Shaanxi), where its occurrence with other motifs well characterizes the truly eclectic diversity of the early Zhou decades.[13] On each vessel the principal motif shows two

64. Bronze *you* with bird decoration, from Tunxi-xian, Anhui. Early tenth century B.C. Ht including handle 23.5 cm

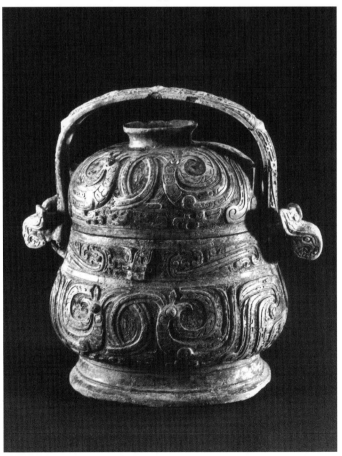

about the same time a band on a *ding* from Fufeng in Shaanxi more resembles the Shang version (as might be expected from the stronger westward influence of Shang) with a top line of quills such as appear in fuller Shang schemes.[10] The history of the animal band, its treatment ever more abstract, may be followed until *ca* 950 B.C., by which time it has acquired features from two post-Shang styles widely prevalent in the first Zhou decades.

EPIGONIC STYLE

One group of successor styles practised in the immediate post-Shang period ('Early Western Zhou', the reigns from Wu Wang to Zhao Wang, 1027–948 B.C.) has been variously termed grotesque, baroque, flamboyant or merely transitional by western writers. The styles are united by an essential character: the relaxation or the exaggeration of detail present in the earlier Henan schemes. The mildest departure from Shang designs is seen on vessels, mostly rectangular *ding*, *yu* and *fang yi*, on which the older motifs are still used, but crowded and especially curlicued and quilled along the borders of dragons and masks, the old logic of connexion between parts of the design lost in the close-packed fields [56]. This treatment usually accompanies one or both of two other characteristic new features: the inflation of non-iconic detail and the introduction of large schemes

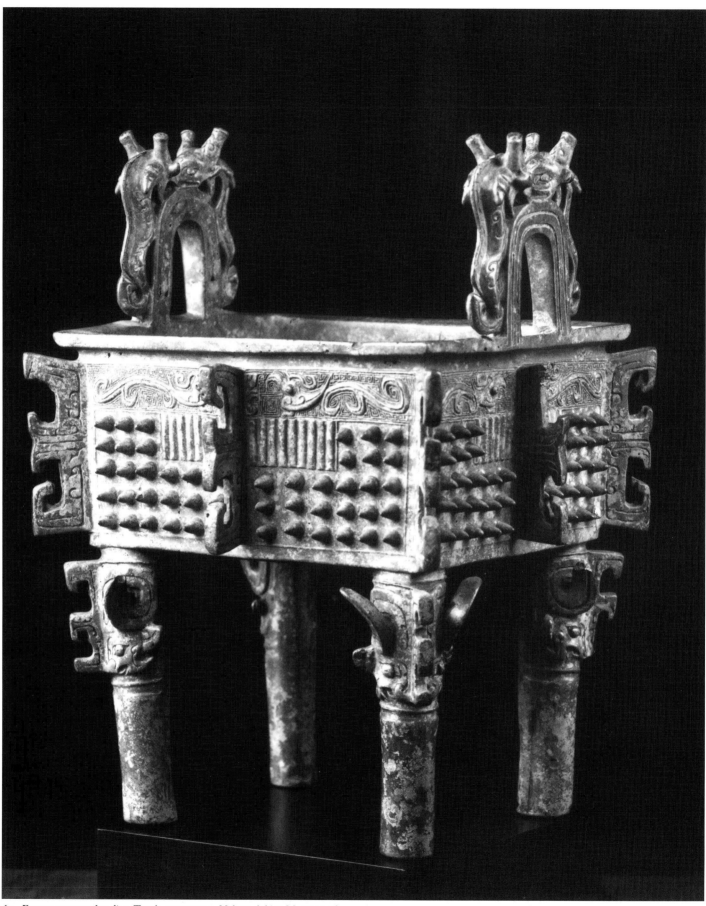

65. Bronze rectangular *ding*. Tenth century B.C. Nelson-Atkins Museum of
Art, Kansas City. Ht 28.5 cm

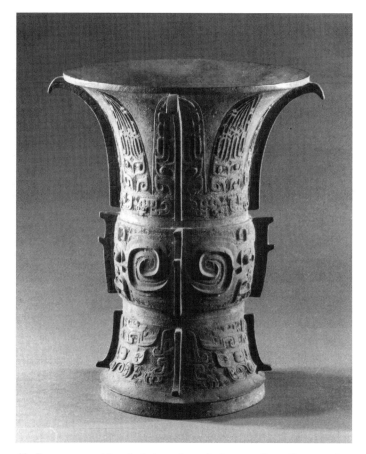

66. Bronze *zun* with spiralled confronted dragons, from Jingyang-xian, Shaanxi. Early tenth century B.C. Ht 31.5 cm

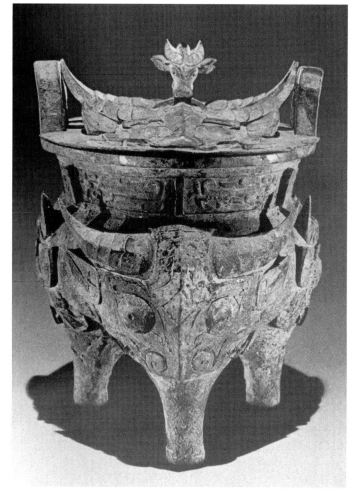

67. Bronze *li* with bull masks, from the Liulihe site, Beijing District. Tenth century B.C. Ht 33 cm

gaping monster heads confronted – a scheme derived from the *kui* by the inflation in this case of an iconic detail of the traditional repertoire – and an accompaniment of humped *kui*, a long undulating tiger (one mask, two bodies), small snakes, cicada blades and a tolerably orthodox *taotie*. All of the latter can be matched on bronzes of the late Shang period. On other vessels the gaping heads may be reinterpreted as confronted elephants, as on the *Xing hou gui* in the British Museum, celebrated for its inscription.[14] Presently tigers might be added to an unprecedented shape, a bell, which was due for much elaboration later [71].

The adoption of animal shape for entire vessels or for important parts of them now also takes a characteristic turn. *Yu, zhi* and *li* might be transformed into over-all bull masks with sharply projecting horns [67]. The *guang* [cf. 56] with its lid-mask varied as tiger, quasi-bull or unreal ruminant becomes comparatively frequent and descends into the tenth century.[15] Reinvented slug-like *kui* confront each other on the handles of rectangular *ding* [59, 65]; similar shapes, or a combination of bird of prey and boar-head, support *gui* which are already supplied with a foot-rim. Among the zoomorphs the most eccentric is surely the *zun* found at Zhangjiapo, Shaanxi: it resembles a ruminant quadruped, is beset with tigers, dragon and bird, has jagged flanges around its belly and is otherwise covered with *leiwen* and incoherent elements derived from the Shang schemes [68].[16] Contrary to earlier attributions of the most imaginative animal-shaped

vessels to the last Shang reigns, it now appears that many of these outstanding sculptural vessels, included in older collections and unprovenanced, are more probably the product of the first Zhou reigns, and the majority of them made in Shaanxi rather than Henan. Among the best-known examples are the monster-protector cited above, known in the two identical vessels in the Cernuschi Museum and the Sumitomo collection [48], elephant in the Freer Gallery and the Fujita Museum of Art [cf. 50], owls in the Victoria and Albert, the Yale University and the Hakkaku and Sumitomo museums [49], ram and double ram in the Fujita Art Museum, the Nezu Art Museum and the British Museum, rhinoceros in the Asian Art Museum of San Francisco. The first named of these vessels are termed *you*, having swinging handles, and the rest *zun*, the usual name given to zoomorphic containers. The celebrated pair of tigers of the Freer Gallery are generally assigned to the ninth century B.C., their relief ornament consisting of confused and disjointed reminiscences of earlier schemes. The magistral *zun* excavated in 1938 in the Ningxiang district of Hunan, standing 58 cm high, carries four large protomes of rams, the horned heads projecting widely and the legs in relief reaching to the base of the vessel [69].

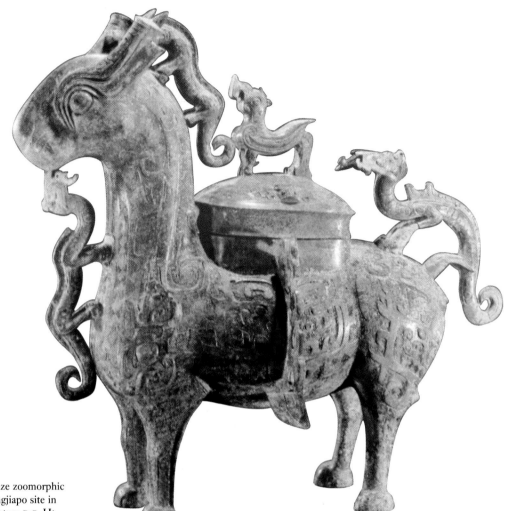

68. Eccentric bronze zoomorphic
zun, from the Zhangjiapo site in
Shaanxi. Tenth century B.C. Ht
38.8 cm

69. Bronze *zun* with four ram-heads, from Ningxiang-xian, Hunan. Tenth
century B.C. Ht 58.3 cm

THE BIRD MOTIF

Motifs based on a bird freely interpreted occur in three forms. The 'small bird' is included in Shang schemes centring on the *taotie*, as one of Karlgren's C elements which combine with all varieties of the décor. Another small bird, elongated and sometimes having the tail separated from the body, listed by Karlgren with his B elements as a 'de-tailed' (!) bird, does not combine with the dominant Yinxu repertoire represented by the A elements.[17] This variety may be safely attributed to a final stage of the Yinxu tradition. But indicative of distinct style and tradition is the large bird, with long drooping crest. This never combines with the *taotie* or its dispersed parts, but is placed alone as the central ornament of a vessel [57, 64]. The birds are usually double-crested, with reverted heads that make them appear addorsed rather than confronted. In a felicitous version of this theme on a *yu* the birds, however, face each other in eight pairs (body and lid of the vessel), triple feathered lines surrounding the heads and falling to the feet.[18] Minor motifs may be added to the bird scheme in bands at the foot and the rim of the vessel, in the shape of *kui* twisted into a recumbent S, or elongated small birds, both items reminiscent of the humped *kui*. The décor moves in sweeping curves which sufficiently distinguish its manner from Yinxu concepts. Sufficient examples have been unearthed in Shaanxi to validate the origin in that province of the design, and probably of the majority of the vessels using it. At Huanyuancun (Haojing, Shaanxi) a *gui* on a square pedestal illustrating the features just described and attributed to the reign of Kang Wang (early tenth century B.C.) came from a tomb neighbouring two elaborate burials of chariots.[19] Included with it was also a tetrapod pourer *hê* whose large lid figures the same bird, singly, in the round. More rarely the elongated bird in a feathery version was made the chief subject, as on a pedestal *gui* and a *ding* reported to come from the Baoji district of Shaanxi.[20] As in the case of the Henan *taotie*, the bird motif for which we infer an origin in Shaanxi was imitated elsewhere, or reached other provinces by way of gift or trade. On the sides and lid of a *yu* of *ca* 1000 B.C. excavated at Tunxi, Anhui, the crests of the birds are crossed over each other, giving the hint of the interlace which was to be one convention of later Western Zhou style [64], while from the province of Liaoning in north-east China comes an unusual *gui* on which large dragons confronted with reverted heads are substituted for the birds.[21] These pieces both retain the ground of *leiwen* which is proper to the central province. The large-bird motif appears to have fallen out of use before the mid-tenth century B.C.; but on vessels found at Fufeng (Shaanxi) and attributed to the Mu or Hong reign (second half of the tenth century B.C.) the elongated bird with detached tail figures in bands, as does also the S-shaped *kui*.[22]

BROAD STYLE

Not all vessels made in the period so far reviewed received elaborate ornament. Many pieces were left plain or decorated only with a narrow band of ornament, so that shape alone determines the general effect. But apart from rejection of opulent pictographic ornament, some classes of vessels

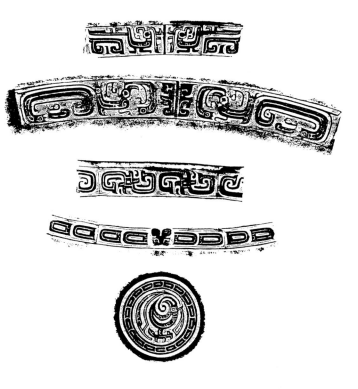

70. Ink impressions of the evolution of the bird motif in continuous ornament. All the examples from the Zhuangbo No 1 tomb in Fufeng-xian, Shaanxi. Tenth century B.C. After *Wenwu*.

71. Bronze bell with projecting tigers. Tenth–ninth century B.C. Shanghai Museum. Ht 42 cm

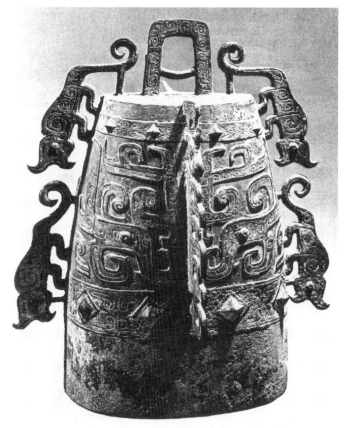

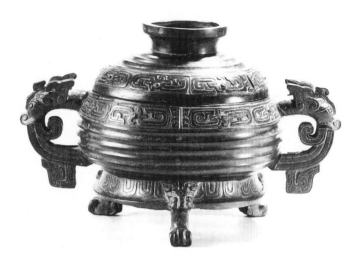

72. Bronze *gui* with grooved sides. Ninth century B.C. Shanghai Museum. Ht 27 cm

reflect a new leaning towards studied simplicity, or towards broad effect. The animal triple band as described above shows a Shang motif long-lived in this process of reduction. In the final decades of the eleventh century, however, the manner seen on a *you* of the Victoria and Albert Museum typifies a more deliberate aspect of restraint referable to an early Zhou reign: a rounded relief line depicts a strongly revised version of *kui* in three bands, with the rest of the elegant shape left plain.[23] Some features of the broad treatment, such as horizontally rilled sides, bands of whirligigs centred on a single *kui* eye, deriving from this a motif often resembling an interlocked double-G, and imbrication or lappets, are associated with inscriptions which allot the donation or manufacture of the vessel to one of the feudal states [70, 72]. It is uncertain how far the casting of ritual vessels remained in the hands of the supreme Zhou state during the Western Zhou period, in the lack of excavated evidence of foundries.[24]

An aspect common to most of the new devices of ornament grouped here as broad style is their clear divorce from the meticulous imitation of carving in wood and bone in which most of the Shang and early-Zhou schemes had their origin. With the simplification of ornament went an increasing naïveté of vessel shapes. The widening of the profile towards the base as if a vessel were sagged by its weight, already evident in the early Zhou decades, becomes more pronounced, a mannerism contrasting with the alertness of Shang profiles. By the beginning of the tenth century a *ding* may be shaped as the segment of a sphere and its legs given leg-of-mutton shape in sympathy. In the ninth and eighth centuries a hemispherical or shallower bowl stands on tall plain legs. The heavy handles of *gui* (monster mask, bird wings on the grip and claws projecting beneath) span the whole of the side. By the mid-tenth century the vessel is regularly made lower in proportion to its width; *ca* 850 B.C. the *gui* is redesigned: the body is cast with wide horizontal grooves, the handle follows the old model but is much simplified, and bands of horizontal lappets on the rim of the container and on the lid provide the only ornament [72].

73. Bronze *hu* with the 'large wave' design, from Fufeng-xian, Shaanxi. Late ninth century B.C. Ht 59.4 cm

The foot-rim is often heightened by the addition of three columnar legs or three stumpy feet.[25] The sharply rectangular *fu*, introduced *ca* 900 B.C., is an unprecedented shape which generally crowds on its sides all the ornament available at this time. About 850 B.C. an established shape is the *xu*, a *gui* on a rounded oblong plan which like the *fu* has

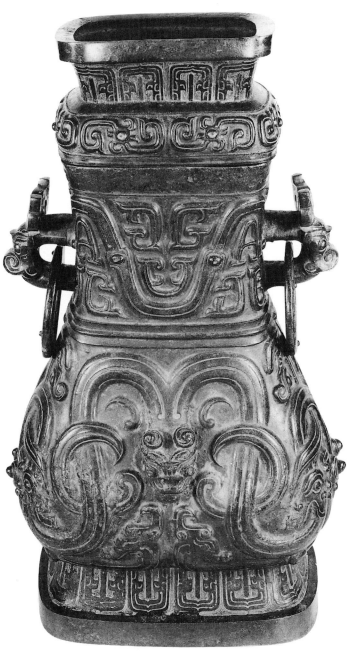

74. Bronze *hu* with entwinning snakes. Ninth century B.C. National Palace Museum, Taipei. Ht 63 cm

the last are often associated rows of similar vertical lappets, along the foot-rim of *gui* or in separated bands on the belly and up the sides of the *hu* vase.

The last-named vessel is a new shape, and one senses a quest after originality in the ornament which clothes its entirety and marks a sharp departure from the ritual tradition even in its devolved ninth-century forms. The large continuous undulations of the design only remotely recall the sweep of the birds' tails, and cannot be derived from the permutations of stylized dragons, although something of these persists in the bands of ornament at the top and the foot-rim [73]. In the troughs of the waves the grooved lines hint at the upper part of a *taotie*, and detail of head-standing *kui* may be worked in. An inscription cast on the *hu* here illustrated vouches for the continuing ceremonial purpose:

> On the auspicious day *geng wu* in the fifth month Tongzhong residing in the Western Palace made gift to Jifu of six . . . , four households of serfs, ten *zhun* weight of gold. Jifu bowed his head to the ground, uttered a prayer for the prosperity of our sovereign, then to commemorate the occasion made this . . . ritual *hu*. Jifu was pious. May his descendants treasure this vessel in use for a myriad years.

Contemporary with the *hu* or a little earlier are many shouldered vases (*lei*) whose sides bear large 'hanging blades' composed not of cicadas in the Shang manner, but of an anonymous figure of complex lines crowned by merest allusion to confronted dragon-heads.[26] In Shandong tombs dated to about the mid-eighth century the undulations appearing on a *ding* are formed of S-shaped snakes with dragon heads at each end. Here the principle of interlacement, adumbrated earlier in the tails of large birds, is applied in high relief to the massive snakes encircling the body of a spherical *hu* [74].[27] The combination of these two ideas, undulations and intertwining snakes, marks the climax of the individual Western Zhou development, achieving once more in very different terms the richness of bronze ornament as it was practised in Shang and the first Zhou decades; but the freshness of the earlier style has departed.[28] A conspectus of the whole development we have surveyed is afforded by a group of vessels excavated at Zhuangbai, cited above as an example of miscellaneous hoarding (p. 29). Here the immediate post-Shang is represented by highly ornate *zun*, *yu*, *fang yi* and *guang*; follow *gui*, *xu* and *hu* in broad style dated to *ca* 900 B.C. To these later vessels belongs also a new type, known in Shang and earlier pottery but not in bronze: a tazza (*dou*) on a wide spreading foot, the sides of which have the undulating motif rendered in openwork. The *dou* was due to have a long subsequent history.

a large lid with a base so that it too serves as a container [54].

Much of the ornament applied to these vessels follows the principle of the long-surviving animal triple band, but adopts new motifs for the *taotie* and its appendages. The themes which play upon one another at the start of the development are S-shaped *kui* and small confronted birds with reverted heads. The detached tails of the latter are abstracted to something resembling a recumbent G-figure; this in turn is taken as main motif, extended and interlocked to produce various figures: a complex whirligig issuing from a nipple which was once the *kui*'s eye; simplification and doubling of this, sometimes resulting in a figure resembling interlocked Gs couched on their side. Simultaneously arises a simpler band consisting of a row of scales, a repetition of Ds. With

Bronze in the Chunqiu and Zhanguo Periods: 771–476, 475–221

In the general run of bronze casting the Chunqiu foundries of central China inherited from their predecessors a limited number of forms – little beyond *ding* and *gui* – and for decorative motifs applied timid variants of *kui* derivatives. Novelty was sought in freer manipulation of these dragon abstracts, in the gradual abandonment of strict hieratic tradition, and the extraction of anonymous linear schemes from the old designs. Among vessels recorded in excavation some bear motifs resembling those of the earlier period, while others are covered with massed repeats of small units which derive from the larger designs. The identity of the ancestral dragon is revealed at most by the retention of a single eye at the centre. The lines are wound irregularly and tightly, without arriving at the interlace to which their movement would seem to lead, the compression never causing distortion. The inference is at hand that such ornament follows only the employment of carved stamps, ever smaller in size, in preparing the casting moulds, an old technique less imaginatively applied. The universality of this reduction in the eighth and seventh centuries shows however that it is not fortuitous in this way, but marks deliberate rejection of hieratic convention and acceptance of the merely decorative as suitable even to solemn items. A hoard of bronze vessels of dates spread over more than a century, found at Liujiadian in Yixian, Shandong, displays all the gradations of the process. At the beginning of the series are the 'double-G' and the S-*kui*, then increasingly compacted versions of these, ending with the miniature diaper used alongside equally close-set imbricated pattern.[1] At Xinyang in Henan the *kui* are worked into a semblance of interlace; in Dadian in Shandong all of these ideas are combined in a free idiom which makes the interlace explicit and spiralizes the now anonymous *kui* diaper into continuous pattern closely anticipating the spiral-and-triangle unit of the Henan 'picturesque' style due to be described below.[2] But the last-named group introduces local divergences typical of the period: tiger-dragons drawn without reference to old convention, long thin snakes, a squaring of the diaper and the superposing on it of a net of straight lines forming squares and triangles. Contemporary with these may be cited numerous examples of local variation into which the elements of hieratic tradition are now freely dissolved: in Anhui an aberrant squared form of the intertwined *kui*[3]; in Jiangsu rows of minute anonymous derivatives combined with projecting openwork[4]; in Hubei close diaper which appears like mere granulation of the surface, and a loose continuous net of snakes[5]; in Shaanxi an expected more conservative adherence to the old Henan tradition, and farther afield also, as in Jiangsu, instances of design archaic for the period.[6] There is no sign in these examples, be it noted, of unified practice which might point to exportation from a single foundry or centre.

REDUCED ORNAMENT

Stages of the reduction of continuous ornament that occurred in Henan are to be seen on a large group of bronze vessels many of which come from tombs in Xinzheng-xian [75].[7] The ornament tends to shrink to an anonymous granulation of the bronze surface in which one still detects an origin in preceding motifs, variations of *kui* and the double-G. Similar filling ornament is found on most of the vessels from the tomb of the marquis of Cai near to Shou-xian in Anhui, a group belonging to the late sixth or early fifth century B.C.[8] But in compensation as it were for the loss of interest in the development of diapered ornament, the Xinzheng bronzes introduce a new content of real and imaginary animals, the latter composed of small scrolled units with projecting *ajouré* elements. The *floruit* of this style in Henan falls in the first half of the sixth century, and the complication of three-dimensional design, with its casting requirement, did not survive the mid-century. The question is then posed of the geographical origin and mode of dispersal of the new designs which supplanted it, and indications are strong that these were still invented at foundries in central Henan and south Shanxi. From the beginning of the fifth century one no longer gains the impression of many foundries scattered under feudal lordships, following their own modifications of hieratic, but rather of the creation of a few standard-setting centres. A first hint of new style appears on vessels from Loyang which the excavators dated to the Chunqiu period, this not, however, in this case implying a time earlier than

75. The reduction of diaper units

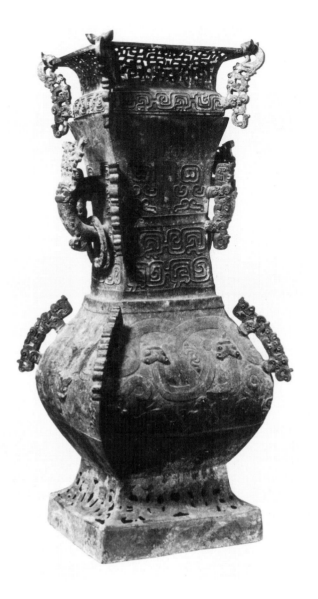

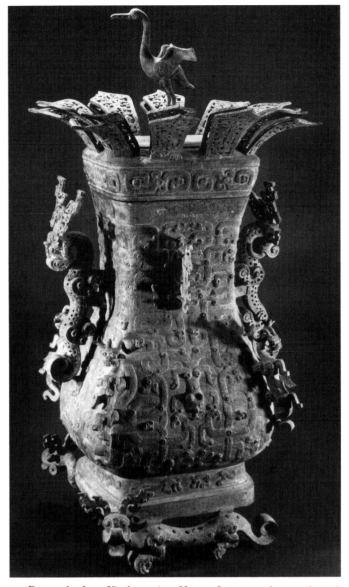

76. Bronze *hu* from Houma, Shanxi. Seventh or early sixth century B.C. Ht 86.6 cm

77. Bronze *hu* from Xinzheng-xian, Henan. Late seventh or early sixth century B.C. Ht 118 cm

the first quarter of the sixth century B.C. On pedestal *gui* of quite aberrant shape *kui*-derived bands are used but spiral-and-triangle filling still does not appear. At Xinyang in the same province the interlocking of the serpentine dragons fuses the hitherto separate units of design into a continuous whole.[9] A *hu* from Houma in south-west Shanxi combines a curious selection of motifs which had been current in the previous century [76]: entwined snakes and a form of the double-G together with tigers composed of an advanced reduction of the dragon diaper.[10] Another fantastic *hu*, from Xinzheng, takes the spiralling elaboration further, mixing interlacing serpents with natural animals and imagined monsters in an easy complex of the real and the unreal, and here the bands are filled with small triangles, though not with the added spirals. The *hu* is set upon two antlered tiger-dragons, with six more spiralled and stylized versions of the same, cast in the round and *ajouré*, crawling up the sides; on the top at the centre of a double circle of shield-shaped *ajouré*

petals stands a faithfully modelled crane poised for flight [77].[11]

LIYU STYLE

These precedents argue an origin in Henan or south Shanxi for a style whose product spread widely in the first half of the fifth century and which was named after numerous vessels found near Liyu in the Hunyuan-xian of north Shanxi, now lodged in the Musée Guimet. As a representative of the style the Liyu group is now matched by the numerous vessels excavated 15 km south of Taiyuan in central Shanxi.[12] The most frequent Liyu pieces are sub-spherical *ding* with a closely fitting lid, on low haunched (cabriole) legs, corresponding vessels on a ring foot and hence termed *gui*, and open hemispherical bowls, *jian* [78]. The somewhat squared interlacing bands are filled with spiral-and-triangle in shallow line, and incorporate tiger-heads, a reinvented *taotie*, and realistic ram masks. The

79. Bronze *pushou* from Yi-xian, Hebei. Fifth century B.C. Length of the mask and hook 45.5 cm

78. Stages in the development of the Liyu motif. 1: bronze mirror back. Stoder collection, late fifth century B.C.; 2: detail of a bronze *jian* bowl. Former Oeder collection, fourth century B.C.

realistic part consists of small relief figures of tiger, sheep, goose, hog and some less identifiable creatures, placed in horizontal bands on a plain ground, and by recumbent animals in high relief on the lid, usually duck, sheep or buffalo. A similar resort to existing objects is the representation of twisted or plaited rope surrounding the vessels, in the case of a *hu* forming a knotted web around plain sides. Liyu treatment of the fantastic is epitomized in a phoenix-shaped vessel: finely imbricated feathers, a kind of granulation, detail spiralled and spurred to the maximum. The head and the tiger-shaped handle define one Chinese response to the

conventions of animal design now spread widely through Inner Asia.

On these bronzes the interlacing ornament is of two kinds, refined, flattened and condensed versions of what is seen on the Xinzheng *hu* [77]. One style makes use of a thin concave line. With this manner co-existed another, based on the same motifs, in which the turnings, crossings, spurs and terminals of the interlacing items are peaked up in tight spirals which grow out of the corresponding part of the spiral-and-triangle of the band filling [78]. The result is a surface of varying relief, conveying a massed writhing movement, and under illumination a coruscation of light and shade. Into these schemes are worked animal heads, claws, wings; the repeats are unnoticed in the impression of endless invention. The unity of design would indicate a single centre of manufacture, and the corresponding clay mould parts excavated at Houma in south-east Shanxi on a foundry site (active from *ca* 500 B.C. to 350 B.C.) suffice to identify this place as the industrial source. Rare are pieces which might suggest imitation of the style at some remove from Houma, such as an egg-shaped *dui* from Tangshan in Hebei, and still feebler imitation of the interlace on bronze bells from the tomb of the marquis of Cai near Shou-xian, Anhui.[13] It is

probably correct to claim for a Shanxi workshop another outstanding work of the early fifth century B.C.: the monster mask and ring, *pushou*, excavated at Yixian in Hebei [79]. The mask is constructed of the parts of snakes and lizards; serpentine dragons curl from the back over the mask crown, at the centre of which figures an item new to the bronze mythology: a peacock construed as a bird of prey with exaggerated claws and beak. Remarkably life-like dragons occupy the ring with their contorted bodies. The theme of broad feathers framing the bird is carried through the whole composition, appearing as a 'feather-and-curl' unit on zones of the mask and dragon bodies where spiral-and-triangle might be expected. On a dragon body also is a row of lappets of the Western-Zhou type, a hint of the archaic which at this stage might still turn up inconspicuously among innovated motifs. Feather-and-curl and volute-and-triangle, although they have been regarded as variations of one motif, should probably be held apart.[14] The evolution of the former may be traced back through hieratic ornament, whereas the latter closely resembles feather decoration applied to textile in the early Han, with the suggestion that this technique has an older history.[15]

HENAN PICTURESQUE STYLE

The style which we here term picturesque is a settled phase of the development initiated by the two variants of Liyu. Its schemes are less individual, despite the often rich detail; the geographic dispersal of the bronzes is greater, enough to suggest widened commerce accompanied by standardized design. A point of departure in considering the picturesque style is provided by a bell and a pair of *hu* in the British Museum whose date of manufacture is argued historically to fall between 482 and 460 B.C. [80, 81].[16] The bell is said to have been excavated at Ji-xian in Henan from a tomb near to the town of Shanbiaozhen. Confronted openwork dragons form the handle, to a design matched almost exactly by a mould part excavated at Houma. Claws, limb joints, snout etc. of the dragons are spiralized with added relief, and there are tiny wings (a dragon had no use for wings in coursing the heavens), all displaying mannerism found in the animal plaques of the Inner Asian steppe. Imbricated pattern, spiral-and-triangle, bands of hachuring cover the dragons' bodies, constituting in sum a final redaction of the *kui* conceived in a new idiom of animal design. The remaining ornament of the bell, on the sides and top, is based on the squared dragon coil whose treatment in Liyu style was described above, with interlace and relief spiralling. The eyes, curled nostrils, brows and claws of the reinvented *taotie* are just legible in the mass of scrolling – one notes that in texts of age comparable to that of the bell the *taotie* is denoted an admonitory symbol. On the sides the lowest zone is the most remarkable, the monster mask complete and explicit, surmounted by grotesque twin dragons. Each of the bosses on the sides represents a monster devouring a goose. The close resemblance of some of this ornament to that of the *hu* (the dragon interlace with spiral-and-triangle filling, the *taotie* with its delicate control of relief) helps to fix the date of the bell,

80. Bronze *hu* in Liyu style (the 'Cull *hu*'). Fifth century B.C. British Museum. Ht 48 cm

following Yetts' argument which interprets the inscription cast on the *hu* with reference to a famous historical event:

> At Huangchi the price of Han was aided by Chaomeng. With the bronze bestowed by the prince of Han this vessel has been cast for sacrificial offerings. Yu.

Evidently ceremonial as well as artistic archaism was cultivated. The Huangchi ('Yellow pond'), near to Kaifeng, had been the scene of a conference at which Fu Chai, king of the south-eastern state of Wu, had demanded the presidency of a treaty already in force which required several states to join forces in resisting the expansion of the south-western state of Chu. The Yu of the inscription was possibly member of a deputation from the state of Qin whose arms were destined to unite the whole of China in the second half of the third century B.C. The political context of these bronzes (the stylistically similar *jian* bowl of the Freer Gallery may be added to them) is significant of the patronage which guided their production towards the middle of the fifth century. Similar high patronage is to be inferred at all times down to Qin, while the growing rôle of the bronzesmith as purveyor of mundane ornament, especially sword and saddlery fittings, was also spreading his custom more widely through society

81. Bronze bell in Liyu style (the 'Stoclet bell'). Fifth century B.C. British
Museum. Ht 54 cm

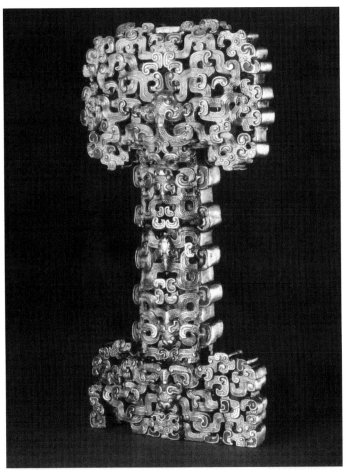

82. Gold *ajouré* dagger-handle. Fourth century B.C. British Museum. Length 9.7 cm

and to more distant provinces. The *hu* of the early fifth century may be made a study of the imitation of Liyu style at foundries other than Houma. An example excavated at Xinzheng has the large in-the-round tigers and dragons while retaining unregenerate continuous ornament of the reduced kind; the *hu* from the Cai tomb at Shou-xian also repeats the large features but makes no attempt to emulate the rich Liyu decoration. These variants had, however, no sequel. A small number of surviving pieces in gold show the application of the picturesque style to precious metal. In some, such as a bronze harness mounted ring with three gold monster masks, there has been no work applied after casting.[17] In the most celebrated example, however, the *ajouré* and hollow gold dagger-handle of the British Museum, it is difficult to believe that some finishing did not take place on the cold metal [82]. The dagger-handle is at once the *ne plus ultra* of the picturesque style and of the refinement of lost-wax casting. The curling 'feather' is made to bridge and connect granulated bands of interlace, with biting masks serving the same purpose down the main line of the design. The resulting surface is as much perforation as solid. In the light of recent excavation any works in gold may be said to be rare indeed, and not only rarefied for us through depredation and melting. For reasons not readily intelligible, work in massive gold appealed less to Chinese taste than the use of gold in gilding and inlay.

MIRRORS

In the full form we have described, the Henan picturesque style hardly survived the fifth century. Its chief legacy to succeeding styles of the Warring States period was its primary components, spiral-and-triangle and feather-and-curl. The latter is found on utilitarian pieces of the fourth century: on bronze axle-caps and other chariot items, a few top blade-guards for swords, and conjugated through a variety of miniature shapes on belt-hooks [90], buckle-plates and saddlery items. On vessels it is rare, appearing somewhat reduced in scale in uniform panels, and on some specimens combined with gilded inlay.[18] This last technique came rapidly to dominate in fine bronzework in both solemn and mundane subjects, making much use of figures deriving from the volute-and-triangle, and is described below under three classes of Henan geometric style. Meanwhile a new custom, the bestowing of finely wrought bronze mirrors in greater and lesser tombs, has provided us with a useful commentary on the decorative art of the fourth and third centuries. Mirrors had been made as early as the Shang period, when some plain bronze discs with loop handles bear no other interpretation. Linear figures of two tigers, a deer and a vulture-like bird appear on a mirror of the eighth century excavated at Shangcunling in Henan; and a few square specimens surviving from the seventh century consist of doubled bronze plates, the plate behind the reflecting surface pierced with ornament related to the *kui* derivatives of Western Zhou, and the openwork in some instances inlaid with turquoise. By the seventh century B.C. the custom was adopted of wearing mirrors slung from the girdle. Unaccountably, attention concentrates on mirrors at the turn of the fifth and fourth centuries. Their ornament lacks the mythological or astronomical reference frequent in the Han period, but a common awe of the reflection persists, if we are to believe third-century philosopher Zhuangzi:

> The ancients believed that that one's shortcomings could be seen in one's appearance, hence they inspected their faces in mirrors.

Later it was held that mirrors reflected evil spirits in their true form and might serve to frighten them away. In some such apotropaeic sense and for lesser expense they assumed the rôle of the ritual vessels in funeral pieties.

Some mirrors dated in the early fifth century, lacking thickening around the edge, have relief or flat ornament like that of contemporary bronze vessels: e.g. a procession of tigers composed in a version of the Liyu convention: a filling of spiral-and-triangle and allied small figures, with larger spirals on shoulders and haunches; or a uniform ground consists of flattened feather-and-curl, an adaptation of this motif to mirrors which was presently developed further. But this flat-rimmed mirror, rare among the surviving specimens, is ousted at the turn of the fifth and fourth centuries by an all but standard type whose hallmarks are a thickened and raised rim backed by a broad rounded groove, a circle at the centre broadly grooved in the same manner and surrounding a small triple-ribbed loop. At this point the mirrors divide into two families as regards ornament and probably their place of manufacture. The group known to western writers as the Shou-xian type (from its supposed most frequent

83. Bronze mirrors of the 'Shou-xian' class. Fourth–early third century B.C. Museum of Far Eastern Antiquities, Stockholm. Diams. 11.5, 15.6, 11.3, 19.2 cm

peculiar 'flails', and, most frequent of all, rhombs and slanting T-shapes copying patterns of twill weave [83, 84].[19] On some rare examples the buds are set with turquoise. The quotations from twill, depicted in wide concave grooves, appear in the first half of the fourth century, a time when textile pattern was being multiplied also in painted (lacquered) ornament. The animals come a little later, and all these motifs continue in use until the middle of the third century B.C. The buds and petals (they must be what Han writers refer to as 'flower pattern') which appear also on fourth-century bronze vessels suggest a sequence from the mid-fourth to the mid-third century, as their number is multiplied and stalks and flails are added. The animals have greater claim to be the invention of the mirror-makers. In addition to the linear animals (some of these abstracted into anonymous design), figures of birds and small unspecific quadrupeds may be superimposed in low relief on the feather-and-curl. Fantasy and animal genre combine in these figures. Their independence from the influence exerted at this time in north China by the Inner Asian animal style lends colour to the theory that the mirror ornament shows a trend of southern taste. The mirrors possess also their own version of the feather-and-curl: a rectangular unit in which an asymmetrical arrangement of several of these items is combined with patches of granulation.

While mirrors of the Shou-xian type have been found in fair numbers in Hunan, Hubei and Shaanxi, those of the second family of Warring States mirrors, named after Loyang, are virtually confined to Henan, being found mainly in tombs near the cities of Loyang itself, Kaifeng and Zhengzhou. They are the later group, belonging to the third century; their choice of the quite flat volute-and-triangle, with a few variants, as the ground diaper of the larger

occurrence in the Shou-xian region) takes repeats of the feather-and-curl as the ground for a variety of large motifs. Depicted in sharp raised line are circles of four leaping creatures intermediate between bear and monkey, holding each others' tails, and more briefly characterized figure-of-eight dragons. Cast in low relief are also four-petalled buds suggesting the water chestnut, some on 'stalks' or projecting

84. Bronze mirror with procession of leaping bears. Formerly Franco Vannotti collection. Late fourth–third century B.C. Diam. 19 cm

85. Bronze mirror of the 'Loyang' class, with four dragons. Fourth–early third century B.C. Art Institute of Chicago. Width 21.3 cm

ornament must be seen as deliberate archaism, an interval of at least a century of disuse intervening between them and the Liyu source. The rims are flat or grooved, the loop sometimes petalled; the ground of some specimens consists of twill lozenge-fret against granulation. An excellence of these mirrors is a design of four dragons in flat low relief, leaping clockwise with unparalleled energy. The graphic manner is unique both in its more explicit form and in an abstraction where the bodies of the dragons are dissolved into quasi-anonymity, the main parts joined by sweeping lines resembling corn stalks and ears. This type of mirror became the model for a much more numerous series made between *ca* 250 and 100 B.C., the 'three dragon scroll' mirror (*sanlongjing*) in which three extremely linearized and barely recognizable dragons are developed into a continuous chain of interlocked curves and spirals, here and there a tiny head or claw betraying the identity [85]. Twill-derived lozenges are interspersed, or the dragon bodies themselves assume this shape, mostly on a ground of spiral-and-triangle. Zones of this motif, or of slanting strokes, lines of rope-twist and the usual wide concave grooves at the edge and centre divide the total field. Through the second century B.C. the formality and symmetry of the design increase; frilled knots bind the lines at their crossings and curly serrations on the erstwhile dragon bodies gradually approach the abstraction of the Han 'cloud scroll'. While there is no certainty as to the unity or dispersal of the workshops responsible for the two mirror families of the Warring States period, it can hardly be doubted that the manufacture was centred in Henan. Where instances of copying are recorded, as in Sichuan, the aberrant treatment rather corroborates this conclusion. The evidence for manufacture beyond Henan belongs to the Han period.

relief of animal shapes, indeed largely govern these shapes, whether entire unreal animals or the heads, cast on shaft terminals and yoke hooks of carriages, and on the miniature sculpture of the belt-hooks and other richly ornamented trifles which increasingly occupied the bronzesmith from the late fourth century onwards.[21] Still looking to the decoration of plain and uniformly rounded surfaces, the two further divisions of geometric style are to be seen as the product of separate workshops, or are at least made in distinct craft traditions which are very seldom manifested on the same piece. *Symmetrical design* about vertical or diagonal axes occurs both as inlay of the kind just described, and as the fixing of turquoise and occasionally of massive gold in precast cells [86]. Of asymmetry the most frequent examples are small cylindrical and rectangular fittings for chariot parts (yoke terminals, hinged joining pieces, various tubes [87]), and belt-hooks, decorated with motifs adapted from asymmetrical design and similarly rendered.[22] Two varieties of this symmetrical manner are represented by pieces in the British Museum: a *dui* with continuous pattern of triangular units filled with broad applications of silver and gold (or gilded copper?) foil issuing from dimples originally holding glass[23]; and a *hu* decorated with similar repeating triangles in which the design is rendered in thin line and small panels of heavier gold. The latter method, dispensing with foil, was continued into the Western Han period.[24]

A characteristic group is formed also by vessels whose sides are covered by two large areas of inlaid design giving only single mirror-images about a vertical axis, asymmetrical units constituting each half of the large symmetry. This fashion is seen on two vessels of the Freer Gallery, a *bian hu* with silver line and foil inlay, and a square-bodied *hu* decorated with copper, silver and malachite laid in precast cells.[25]

HENAN GEOMETRIC STYLE

The geometricized motifs of the Henan bronzesmiths which ensued on the picturesque style were closely associated with metal inlay. Silver foil and gilded copper foil, rarely gold foil, were fixed on the bronze surface by an undercut scoring of the bronze around the contour of the larger areas, or in a fine engraved line for the thread-like parts of the inlay.[20] Massive gold was treated like the turquoise inlay which often accompanies it, and laid in comparatively deep cells. One may distinguish three classes of inlay style followed fairly consistently from the mid-fourth century B.C. The chief manner is that of *asymmetrical design* elaborated from the spiral-and-triangle, although it never combines with this motif used as ground. The very exactly drawn units repeat but avoid symmetrical reflection in any direction, each large or small spiral leading into an area which may be a strict triangle or a comparable trumpet shape, the whole maintaining the taut lateral movement which is the hallmark of the style. The ornament is adapted as readily to small items – belt-hooks, chariot and saddlery fittings – as to the sides of rectangular and rounded vessels. The spirals, spurs and sharp returns of the inlaid figures, with the alternation of fine line and variously shaped panels of inlay, well suit the

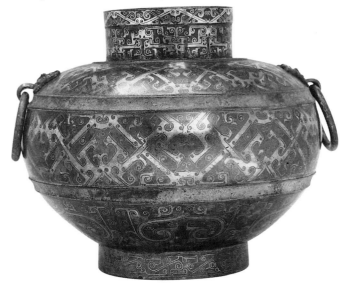

86. Brone *hu* inlaid with silver and gilded copper. Third century B.C. Minneapolis Institute of Art. Ht 24.8 cm

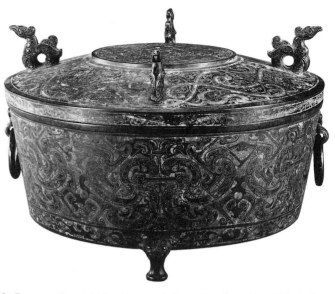

88. Bronze silver-inlaid wine-vessel from Jiangling-xian, Hubei. Late fourth or early third century B.C. Height 17.1 cm

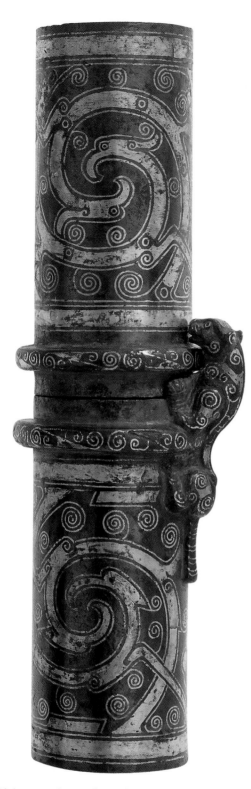

87. Inlaid bronze tube coupler with tiger. Third century B.C. Rietberg Museum, Zürich. Length 20 cm

A more disordered version of comparable widely spaced symmetry occurs on a few ritual vessels which must date early in the series we have examined, notably a *dou* of the mid-third century from which the original inlay of copper wire and turquoise has mostly fallen away,[26] and another *hu*, square-bodied, which may not ever have held inlay in similar diagonally ordered cells.[27] The third class of inlay uses only fine *curving* lines of inlaid silver, as if in horror of a straight edge, the repeats (whether symmetrical or, more interestingly, asymmetrical) tending to crowd the field illegibly and lacking the tense transitions which make the quality of other geometric schemes [88]. It appears that curvilinear inlay was introduced later than the other inlay styles, but it is practised concurrently with them in the mid-third century. It is arguable that the curvilinear manner was peculiar to artists of the Chu state, a southern taste, present also in some minor wood sculpture of the same region,[28] which rejected the more austere and abstracted design inherited in Henan from hieratic tradition. Fine examples of curvilinear inlay are wine-vessels (like shallow cylindrical boxes on three small feet) excavated at Jiangling and Jingmen, cities in Hubei at the heart of the Chu state. Their sides are covered with a complex silver-inlaid interlace of thread-like and wider lines avoiding repeats which would strike the eye [88].[29] The Jingmen piece was accompanied by lacquer painted with equivalent designs made still more minutely elaborate, so that we are left guessing whether painter or bronzesmith was the originator and the more inventive. On a similar vessel in the Freer Gallery the tortuous and crowded curvilinear figures are replete with more detectable symmetries and repetitions.[30] The free-standing dragons on the lids of these vessels approximate to the Henan picturesque convention, suggesting deliberate archaism or provincial retardation. The lid of a similar vessel, lacking inlay, was excavated at Zhijiang near to Jiangling, while a splendid silver-inlaid example of the same work excavated at Zhaoqing in Guangdong belongs to the Jiangling family.[31] The curvilinear geometric is further

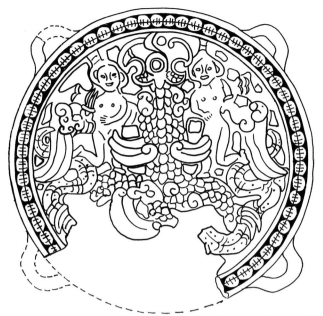

89. *Ajouré* bronze rondel, from Zhongzhoulu, Luoyang, Henan. Fifth century B.C. Diam. 8 cm

90. Bronze belt-hooks in animal shapes, some with jade appliqué. The openwork clutching animals and the coiled jade dragon third–second century B.C.; the pouncing tiger and the bird fantasy first–second century A.D. British Museum. The longest measures 22.8 cm

developed in the Western Han period, when it admits also some mannerisms of the earlier inlay styles of Henan, and may even be the vehicle for fanciful script characters.[32] The indebtedness of Han artists to the Chu studios of Jiangling is a theme we return to in considering lacquer painting.

In the Warring States period the modelling of animals and persons in bronze, more seldom in silver, falls into three well-defined classes. The class of human figurines, in which some plastic effect is attempted, shows the least maturity in its kind; some models of wholly imaginary animals and monsters are developed from the elements of Henan picturesque style; others share the detail of both three-dimensional treatment and superficial ornament with geometric styles. Among the human subjects an exceptional specimen excavated at Luoyang is an openwork rondel with naked kneeling figures of uncertain sex set either side of a scaly bird-beaked monster [89]. The beaker-shaped excrescences on the heads of the human figures and their wings (in this design somewhat disconnected) mark them as the genies entertained in Daoist myth, similar to the dragon-tamer and others portrayed in fourth-century lacquer painting from Xinyang in south Henan. The cowrie-shell border of the rondel resembles that of some early mirrors, and its early-fifth century date is confirmed by an accompanying rondel in full picturesque style. The extant figurines represent menials and dwarf entertainers. Only examples of the latter, in silver and bronze, show any care in the grotesque anatomy, the remainder appearing as lamp-holders or supports for vessels, sometimes as musicians.[33] The former, probably following a metropolitan tradition, are dressed in long stiff robes with at most a little anatomical truth in the faces. Some specimens

of the latter, occurring typically farther south, show a convention widely adopted for the lowest of slaves, a naked crouching figure with nondescript or stereotyped 'barbarian' face. The British Museum's pair of wrestlers in bronze, sometimes cited as a first approach to organic sculpture, goes only a little beyond these.[34] A few of the figurines belong to the fifth century B.C., but the majority rather to the later fourth century.[35]

The second class of miniature sculpture comprises the monsters made up of elements of the picturesque. An ideal example is the dragon of the former Stoclet collection, where the scrolling of mane, wings, limb joints and snout all echoes the movement of spiral-and-triangle, while this motive itself is frequent in the detail.[36] In smaller pieces, particularly belt-hooks, this connexion is less obvious, but the combinations of spirals and contrary curves with feathered parts and granulation shows the work to be in the same tradition, probably in a late-fourth century phase of its development[37]; and surpassing virtuosity appears in some *ajouré* dagger-scabbards composed of intertwining snakes [95]. The finest work in this class includes many examples of turquoise and jade inserted into convolutions of gilded bronze with consummate skill. When the craft takes up these forms, late in the third century B.C., it deals also with variations which suggest the shapes of sprouting bamboo or the loops of a climbing plant, with ever and anon the bite or claw of a dragon [90]. In this work the spell of hieratic tradition appears at last to be exorcized, and the naturalism of Han art adumbrated.[38]

In animal figurines where the inlaid ornament conforms to asymmetrical Henan geometric style, all previously cited examples are eclipsed by those found in the tomb of Wang Xi, ruler in the late fourth-century of the statelet of Zhongshan in Hebei [91, 92].[39] Here in the winged dragon poised to spring, the tiger *passant* devouring a deer (treated as the base for some other object), the ox and the rhinoceros, is recreated the realism of the unnatural which in varying redaction punctuates pre-Han art. The gold-foil inlay employs the lunates, pear-shapes, spirals and sharply angled lines of the tradition with variation which suggests workshop independence from other geometric design we have described. The decoration of the dragon comes nearest to that of the earlier phase of the tradition. Meanwhile decorative addenda might be applied to sculpture which closely represents the real animal.

The most complete rejection of the decorative standards descended from hieratic norms is found on bronzes with pictorial ornament. It is significant that the three groups of work belonging to this class are more restricted in time and space than the species which have been described, while their styles equally reflect provincial character. In technical accomplishment the palm goes to the vessels, chiefly *hu* and *gui*, bearing figures of deer and dragons, and some fanciful abstracts from these, inlaid in the bronze with pure copper.[40] The recorded finds have a southern and western trend (Sichuan and Hubei) which places them in the realm of Chu art even though they cannot be directly connected with the tombs of Chu rulers at Jiangling. The copper of the orna-

91. Screen stand as tiger devouring a deer, in bronze with gold and silver inlay, from Zhongshan, Hebei. Third century B.C. Length 51 cm

92. Table supported by dragons and phoenixes, in bronze inlaid with gold and silver, from Zhongshan, Hebei. Third century B.C. Ht 36.2 cm

93. Bronze *dou* with figural ornament inlaid with copper. Fifth–fourth century B.C. Shanghai Museum. Ht 20.7 cm

ment does not appear to have been hammered home as cold work on the ready-cast bronze, judging from the close suture of copper and bronze, from the fine lines of the copper figures and from the not over-thick sides of the vessels themselves. In some verifiable cases the copper occupies spaces and not cells in these sides, appearing both outside and inside, as inserts rather than normal inlay. So it is likely that the copper was present in the casting process. The figures, cut in copper plate, were placed in the mould between the outer wall and the core, their position fixed by numerous bronze separators ('chaplets' which can be detected on the finished casting) and were thus intimately incorporated in the fill of molten bronze. The melting temperature of copper being a little above that of the tin bronze alloy, there will have been no danger of the copper being distorted or lost into the body of the vessel. The motifs on a *dou* from Liyu are a much varied menagerie: deer, large bird, ox, duck, other quadrupeds, and men wielding spears and bow, some wearing animal masks. The animated style is *sui generis*, neither that of the geometricized animals nor that of the Inner Asian stylization, with untypical spirals and quasi-spiral-and-triangle created on the animal bodies by openwork in the copper inserts which allow the bronze to show [93].[41] The figures are scattered on the ground in no special order, although the purpose is evidently to represent the field of the hunt. A distinct décor executed in the same technique divides the surface of the vessels into rectangles by lines of compressed diabolos, and in each pair of rectangles places stylized dragon, deer and phoenix, confronted or backed symmetrically. Only the curlicue and spiralled appendages are shared with the hunting scene we have just described, but the ductus of the design is so similar that a common workshop origin must be supposed for the two schemes. Of the first manner of copper insert ornament a *dou* was found at Liyu in Shanxi and a *hu* at Tangshan in Hebei; the second manner is represented by a *pou* from the Zenghou tomb in Hubei and a *hu* from the Mianzhu-xian of Sichuan, in all cases the vessel shapes indicating early or middle fifth-century date. The unity of style would imply a common origin of these pieces, and in company with the allied group

of pictorial bronzes described below, we may guess at inspiration from the state of Yan, whose territory comprised Hebei and the forested region to the north-west inhabited by barbarian hunters. A vessel resembling the Tangshan *hu* is inscribed with the record of a sacrifice performed at a place in Hebei. The schemes of ornament are set pieces, as if quoted from prescription as formal as that which governed the schemes of hieratic art.[42]

Another group of vessels is decorated with hunting scenes shown in flat low relief (i.e. without inlay), arranged in horizontal zones of equal formality. A round-bodied and a square-bodied *hu* in the Kunstindustri Museet and the Freer Gallery show identical scenes, from top to bottom [94]:

i snake-swallowing phoenixes confronted
ii hunting birds, hog and deer from a chariot
iii row of archers drawing upon a flock of strange birds
iv above: two men wearing feather head-dress attacking a bull from whose neck hangs a dart; below: flying birds with here and there an arrow attached by a cord (cf. the retrieval)
v a single man confronting a charging bull
vi around the foot rim: repeats of the device formed from the S-shaped *kui*

Other pieces, such as a *hu* in the Brundage collection, show a selection of these scenes separated by zones of spiral ornament which owes little if anything to Henan geometric.[43] These rare compositions suggest a glimpse of the mural painting of palaces of the Warring States period. Still rarer are bronze bowls and vases bearing scenes *engraved* in fine

94. Bronze *hu* with scenes of hunting. Fifth–fourth century B.C. Museum of Decorative Art, Copenhagen. Ht 35 cm

line, taking their subjects from festival performances: mock warfare, feasting in pavilions, the ceremonial music of bells, the hunt and bird shoot (the latter exactly reproducing the scene found in *cast* ornament as already described), the boat race and other ceremony less readily identified. These pictures will be cited later for the light they throw on architecture and conventions of painting: suffice here to note their wide distribution – the bronzes have been excavated in north Henan, Hunan, Hubei (near to Jiangling) and Sichuan – and the similarity of pictorial style. In their case too one surmises the production of a single workshop enjoying wide-spread custom, and the link with the series bearing *cast* pictorial ornament may indicate its location in the north-west. These works belong also to the fifth century B.C.[44]

It remains to chronicle one more technical phase of bronzework: the extreme application of the wax casting method (*cire perdue*) to *ajouré* and other ornament, with what is to our eyes varying artistic success. From the north, the Zhongshan noble tomb already cited for its inlaid bronze, comes the most extravagant work in this class thus far discovered: a stand, 36 cm high, for a square tray, the support of barely credible complexity: four dragons and four pho-

95. Dagger and *ajouré* scabbard in silvered copper. Fourth–third century B.C. Former Mayer collection. Length 34 cm

96. Bronze *hu* clad in openwork and inlaid with gold, from Xuchi-xian, Jiangsu. Third century B.C. Ht 24 cm

enixes in the round, intertwined in a maze of strong curving members; four couched realistic deer support the ring on which the dragons stand, the phoenixes represented as flying up between them on outstretched wings [92]. All the innumerable surfaces are inlaid in gold with imbricated or spiralled pattern answering to the asymmetrical geometric style. The only work to be set alongside this tray-stand is the *pushou* previously mentioned, also found in Hebei, which although lacking inlay is sufficiently matching in detail of relief and openwork to raise the question of common workshop origin. The *pushou* and the tray-stand would then represent successive stages of this tradition of work, one of the early fifth century B.C. and the other of the late fourth, the practice of inlay having arisen in the interim.[45]

A naïve and tasteless exploitation of *cire perdue*, perhaps to be seen as meridional abandon, is instanced in a number of extraordinary castings committed to the tomb of the marquis Yi of the Zeng state in Hubei, who was buried some time in the late fifth century B.C. Here the base of a standard-pole consists of an indecipherable congeries of creatures (bovids or snakes?) with much clear space between, an apparently fortuitous composition following the easy whim of the wax modeller. On bells and vessels the Henan picturesque diaper makes its final descent to something like the eruptions of diseased skin. On the celebrated *pan* from this site the *ajouré* and high tortuous relief display maximum virtuosity, with a total effect that can only embarrass the eye of the viewer [96].[46]

Jade

In the pre-Han period as much as in later times Chinese lapidary art, practised exclusively in nephritic jade, varied in scope and style in response to three factors: the usage of symbolic objects; the imitation, at a characteristic remove, of prevailing decorative styles; and significant changes of working tools and method. The veneration of the material issues from prehistoric times. Its precise sources remain debatable; it has been argued, chiefly from the evidence of place names, that the Shang craft exploited local deposits of the stone, but no nephrite has been reported in this region. The indications are strong that from the earliest time nephrite reached central, north-east and north-west China from a region of Siberia extending westwards from lake Baikal, perhaps already including the Yarungkash (white jade) and Karakash (black jade) rivers of western Turkestan whence the stone was imported in large quantities in the eighteenth century under imperial mandate.[1] The early history comprises three outstanding phases: the late-eolithic period of Jiangsu, the Shang–Western Zhou period of central China, and a phase dating from *ca* 500 B.C. and coinciding with the beginning of the general change of decorative style which spread widely through the centre and the south-east of the country. Between these peaks of production jade continued to be worked, but with less invention than is found in other materials. Similar intermittence was to occur after the Han.

Neolithic jade is an east-coast phenomenon, first appearing at sites dated to the first half of the third millennium B.C. In Shandong, in the Longshan cultural context which favours the theory of a Siberian source of the material, the axes are evidently symbolic.[2] They are made of impractically thin rectangular plaques of nephrite, each with a single perforation of slightly conical section. Here also is seen the earliest manufacture of the *bi*, a ring of thin stone with a central perforation approximating to a third of the diameter. The ritual axes copy approximately the shape of the utilitarian equivalent made in other stone (although these tend to a trapezoidal outline not found in jade); rings in stone other than nephrite are, however, rare, and the ritual character of the *bi* is corroborated by the widespread occurrence of similar (but narrower) rings in South Siberia.[3] Variation on the *bi* theme, with the addition of an inner flange and later of relief ornament, was a prime concern of jade craft throughout its history, the beauty of the material and the precision of its geometry never failing.

Farther south along the eastern seaboard, in the Liangzhu variant of Longshan culture in Jiangsu and towards 2000 B.C., jade carving first assumes artistic purpose and precise iconography.[4] Tombs on the east and south of Taihu lake – the 'jade hoard burials' (*yulianzang*) of the excavators – are found to contain numerous white or light-green bracelets, flat axes, various small ornaments and especially *bi* and *zong* [97]. Of the last, one grave counted respectively 28 and 33. While the *bi* are plain, the *zong* equal or surpass their

bronze-age successors in ornament and fine detail, establishing the classical form of this unexplained ritual object. The *zong* is a slightly tapering tube squared on the outside and circular within [100]. In the larger version, here measuring 20–30 by 5–6 cm, the squared edges are notched on a regular system: triple groups of raised lines going all around are separated by bands left plain but for brief notches at the edges and small circles two to a side. This design, lacking simpler antecedents and defying explanation as much in antiquity as today, established a classical form which was closely followed through the earlier centuries of the bronze age.[5] The sharpness of detail carved on the larger of these neolithic *bi* causes wonder and finds no exact explanation. One must suppose the use of a bamboo drill, cords and stone rubbers armed with an abrasive. The decoration of the smaller *zong* found in the Liangzhu graves (*ca* 7 by 5 cm) is achieved by engraving a narrow line and by removing part of the surface to leave the design proud. Composed of circle eyes, corner nose and fine linear meander, a strange mask is created with deliberation that suggests the importance of this item of the iconography as the remote ancestor of the bronze-age *taotie*. The mask is carved in two or three levels of relief, the double circles of each eye effected with the tubular drill and the detail added in close engraved lines. Most remarkable is openwork rather roughly executed, a technique revived and then surpassed only three millennia later, from the fifth century B.C. The subjects are semi-circular plaques (they do not possess the formality of the later *huang*) with anonymous *ajouré* decoration, one of these vaguely resembling a frog. The graves containing these jades have been dated to the early and middle third millennium.[6]

The Shang practice of jade carving begins with highly finished pieces excavated at the eponymous site of the Erlitou phase in central Henan, already cited for the south-eastern connexion they suggest [98]. New types have pronounced

97. Jade *zong* of the Liangzhu culture found on the Fuquanshan, Jiangsu. *ca* 2000 B.C. Width 15 cm

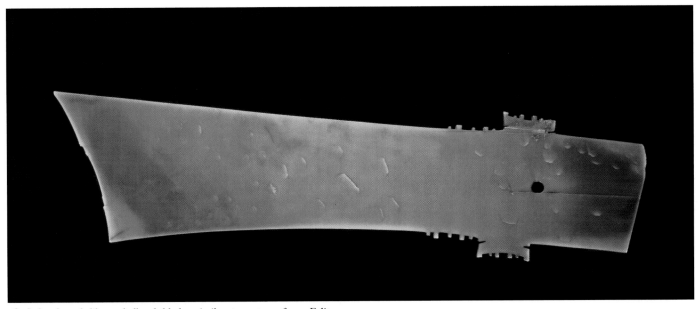

98. Jade shaped like a halberd blade, similar to a type from Erlitou. seventeeth or sixteenth century B.C. Minneapolis Institute of Arts. Length 40 cm

ceremonial character: halberd blade, *bing* sceptre and the notched *bi*. Below a concave grip the sceptre of precise rectangular section is plain, or segmented, the latter form in some specimens suggesting sprouting leaves. A mask resembling the Liangzhu design may be neatly engraved in slender line at either end of the baton. In halberd blades the thin section, regular edge taper and longitudinal curvature, the latter barely perceptible, bespeak the strict control of the work and the aesthetic aim. A modern speculative theory would explain the ordered notches and low projections repeated around the edge of *bi* in two groups as serving to locate stars in view or to symbolize asterisms; but no confirmation of this is found in ancient literature, while the variation of this feature in 'astronomical' *bi* of later Shang date (the *jibi* or *xuanji* of the ritualist writers) gives strongly the impression that the notches had passed into anonymous sanctity or mere decoration, as occurred with other solemn motifs [99]. They occur no less on halberd blades, knives and forms of the *gui* tablet.[7]

It is curious that sites of the Zhengzhou phase (sixteenth to fourteenth century B.C.), succeeding Erlitou, have produced no carved jade of quality. The few inferior halberd blades and *bi* excavated at Zhengzhou are inferior in comparison with what has been described. Simple rings in agate, jade and stone from Erligang stand clearly outside of the Erlitou tradition.[8] So one may reason that the jade carving of the first decades of Shang rule at Yinxu is to be attributed to a revival in palace-fostered craft ensuing on the foundation of the northern dynastic city. Fine jades of this time are found mainly on sites in the vicinity of Anyang. The repertoire has again changed, the *bi* and *zong* retained but joined by a more numerous series of bird and animal plaques and some human and animal figurines in three dimensions. More intricate linear figures, readiness for three-dimensional subjects and a much expanded production may result only from concentration of labour under official control, but one detail suggests an advance of technique. In section the

engraved line of the linear work often shows one side approximately vertical to the surface of the plaque, and the other side sloping. A chisel of hardened bronze chisel may have been used, or even a wheel cutter. Perforations are neater. Most of the shaping was, however, achieved by abrasion as before.[9]

The latter-day ritual interpretations of the jades are wholly erroneous as regards any explicit meanings entertained in the neolithic and Shang periods. The *Zhouli*, a compilation of the fourth–third century B.C., speaks of six

99. Jade 'astronomical' *xuanji*. Tenth–ninth century B.C. Museum of Far Eastern Antiquities, Stockholm. Diam. 14 cm

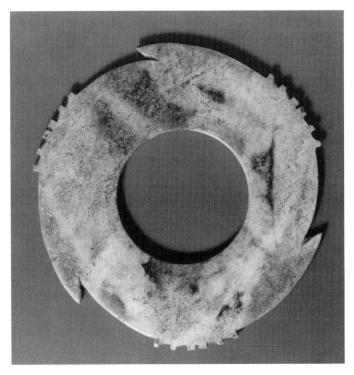

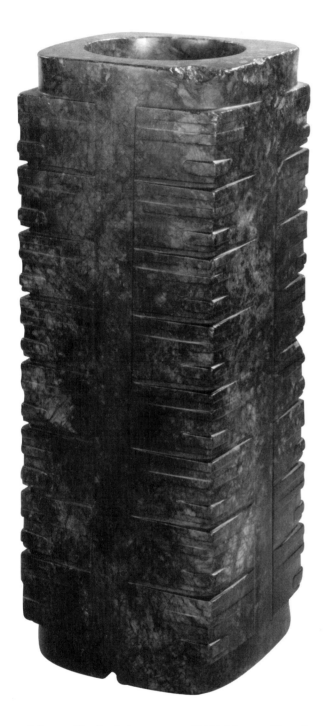

100. Jade *zong*. Tenth–ninth century B.C. British Museum. Ht 21.6 cm

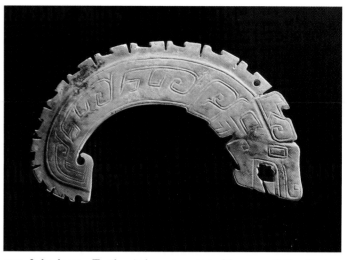

101. Jade *huang*. Tenth–ninth century B.C. Museum of Far Eastern Antiquities, Stockholm. Length 10.8 cm

auspicious jades (*liurui*), attributing them to the Zhou king and to each of the five ranks of feudal nobility. Four of the jades are *gui*, an oblong tablet, and two are *bi*, all with distinguishing words prefixed to these names. The earliest representation of these objects appears to be on a stele of Eastern Han date, in which the vagueness and error of the forms reflect the uncertainty of Confucian scholars as to the true ancient shapes, notions of which had been derived from the *Zhouli* text and its commentators. It happens that one may point to half a dozen jade types of the Shang age with intrinsic symbolic character, to which names used by Han writers (though unknown in pre-*Zhouli* texts) have long been attached: the *zong* and *bi* as described above, a circular segment called *huang*, a *gui* oblong tablet with symmetrical point at one end and a similar *zhang* pointed obliquely, and a couched tiger in side-view [101]. These jades do not occur grouped in Shang tombs, and there are other frequent shapes besides, fish, bird, tortoise etc., which must have auspicious or emblematic meaning in the iconography, particularly towards the end of the Shang reign [103]. Whatever explicit meaning the 'symbolic' jades may have held at their invention is lost to us, as are their original names. It is arguable that the several blade-like *gui* tablets, buried usually near the waist of the dead, and the *bi* itself, buried at the waist or on the breast, are fanciful variations of former stone or bronze weapons, the inherited equivalents of the realistic jade models of the contemporary *gê* halberd on which so much care was expended.[10] The *huang* even when carved as a dragon has been explained as a separated segment of the *bi*, for *bi* consisting of three plain segments perforated for lacing together are attributed to the late Shang. When animals are portrayed we may guess at animism or clan insignia; working tools and toilet items are more intelligible, in tombs these smaller pieces being generally found near the waist of the dead. They almost without exception have one or two small holes at the edge, making clear their purpose of suspension or attachment, most probably to apparel. Some upright owls and parrots have a spigot at the foot indicating a likely use as finial on a wand. Some of the jade fish and *huang* are finished at one end with an oblique point. One

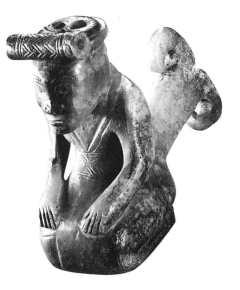

102. Human figure in jade. Twelfth–eleventh century B.C. Ht 7 cm

103. Jade plaque representing a bird. Twelfth–eleventh century B.C. British Museum. Ht 13 cm

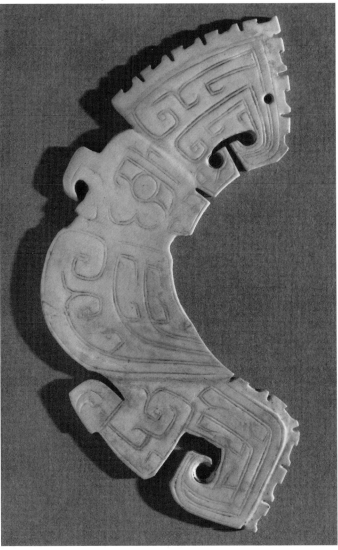

suggestion is what they were used as a scribing instrument to cut the text on oracle bones, although no association of the two in excavation bears this out.

The six hundred jades which were found in the intact Fu Hao tomb afford a view of jade industry superior to any other we gain in the pre-Han period. Their date must lie broadly in the second Yinxu phase (reigns of Wu Ding and his two less prominent successors) and equal that of the Fu Hao bronze vessels whose sculptural pretension was noted above. From the variety of the jades we may best judge the range of subjects treated in the art of the mid-Shang period, both in stylized and in quasi-realistic forms. The humans and quadrupeds are carved solid, among the former numerous kneeling men, a detached head, a horned human standing naked, male on one side and female on the other, a kneeling man with something like a large bird's tail protruding from the middle of his back [102]. The phoenix [cf. 103] is present; the quadrupeds comprise tiger, elephant, buffalo, monkey, dog, tortoise; but tiger, bear and horse occur also as plaques. The birds are made both as plaques bearing linear ornament on one or both sides, and in the round: parrot, swallow, falcon, crane, owl, goose, duck. The instruments are sickles, knives, combs, scoops. The halberd blades are the most elegant so far encountered, one fitted into turquoise-inlaid bronze; axes, *gui* and *zhang* tablets, segmented batons and tubular ornaments, *zong* tall and squat, *huang*, ear-scoops and an adjunct of the toilet-table resembling a small oblique chisel, conceived as a fish-tail or added below a bird plaque, all enter into the extraordinary mix.[11]

There are reasons for recognizing in the jades a dominant part of the style followed in larger sculpture and wood carving, and in the wood-cum-ivory mosaic practised in the mid-Shang period. Many of the three-dimensional items suggest form reached by adapting the faces of rectangular or more or less rounded blocks, giving the effect of two-dimensional design applied to the three-dimensional task, and an assemblage of pre-conceived detail. Such is the character also of the few larger stone carvings which survive, typified by the celebrated tiger and owl excavated from royal tombs at Xibeigang and Houjiazhuang in the vicinity of Yinxu.[12] The larger works, and the majority of smaller pieces in this class, are covered with a network of linear meander, hooked and spiralling, serving to vivify the uncompromising shape and relating the jades to the hieratic style. That the linear motifs were invented on a larger scale is indicated by the use made of them on expanses of carved wood inlaid with ivory or mother-of-pearl, a branch of the art known only briefly from the excavation record of ivory pieces and the earth-trace of wood covered by fragile but nearly inde-structible lacquer paint. Enough survived to show that *taotie* and *kui* dragons were main themes, depicted in black–red–white.[13]

Two further aspects of Shang style are to be recognized in the Fu Hao jades. One is a measured realism which seeks to convey an impression of life without resorting to natural detail, the equivalent *in parvo* of the spirited poses of the zoomorphic vessels. This idiom is seen in the owls and parrots, elephants, buffalos and tigers, even when they adhere to the hieratic convention in other respects. It is less sche-matic in the facial features on some of the human figurines.

105. Jade ornaments from Guangshan-xian, Henan. Eighth–seventh century B.C. Average width 10 cm

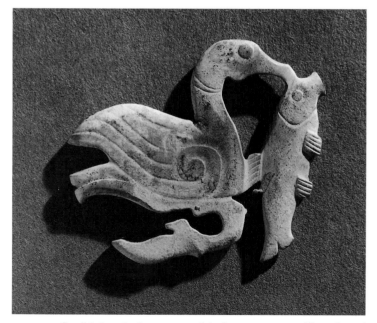

104. Small jade animal ornaments: fish, *huang*, cormorant. Eleventh-tenth century B.C. British Museum. Height of the cormorant 4.5 cm

An independent human mask resembling the face cast on a bronze *ding* found in Hunan evidently follows an established convention depicting a 'barbarian' prisoner or destined victim. In some instances the realistic animals match with items of the ornament of ritual vessels which fall outside of the main hieratic schemes: small birds, cicadas, snakes, silkworms. Another kind of realism gains importance from its anticipating mannerism of the later animal art of north China and the Inner Asian steppes. Examples of this trend are the small animal plaques, chiefly birds, presented in tight formulas of balanced curves. Some pieces in this category are left with plain surface, e.g. duck, hare and horse, but the majority are covered with the normal ornament of spiralling meander [104]. The parrots, hawks and some less identifiable fantasies are particularly varied, elaborately profiled and decorated, befitting their supposed purpose as emblems of the Shang house. The elaborate *huang* and *jue*, chief of the unreal animals, belong to the few types with a post-Shang history. One Fu Hao specimen is furnished with fins, which might associate it with the circle-segment fish, but the latter lack the perforation at each end which is a regular feature of the *huang*. Another specimen has the ends shaped to dragon head and tail, the scaly back represented by a series of notches which observe the peculiar irregularity established on *bi*, blades and axes. The *jue* is basically a ring broken by a radial gap in the circumference, evidently an elaborated descendant of the flat and undecorated penannular jades

first associated with the southeastern neolithic and later made sporadically in central and east China until the middle of the first millennium B.C. In the Fu Hao hoard the *jue* has become a dragon resembling the *huang* but bent in a complete circle, depicted explicitly or allusively.[14] Many pieces, particularly those cut from thicker slabs of jade, match the *kui* dragon of the bronzes in detail, with bottle-shaped horns, curled snout and stumpy legs. These types are of the finest workmanship and mostly perforated for attachment.[15]

Excavation in the north-west sector of Xiaotun shows the late-Shang jades reduced in variety and often in quality. The small animal subjects persist as plaques and in more solid carving, but typical *zong* and *bi* are no longer made. The bull mask is a new subject, in jade as in bronze, while highly finished halberd blades and variously flanged rings may accompany much simplified *huang* and *jue*, these much declined from their classical predecessors.[16] A deer-head, unknown in jade at Yinxu, was found near Jun-xian (a short distance south of Anyang) together with bull masks like those of contemporary bronze, in a tomb whose borderline position between Shang and Zhou is further shown by the mother-of-pearl imitation of the hooked flanges of bronze vessels. Near Lingshi in central Shanxi, in a tomb whose late date in the Yinxu sequence is demonstrated by the humped *kui* on an accompanying *ding*, the more traditional cicada, hare, tiger and *huang* are joined by a deer-head carved in the round, with a mounting spigot at the neck.[17]

Jades of the first half of the Western Zhou period (1027–890 B.C.), best known from excavation in Shaanxi and Hebei, show this impoverishment proceeding. Since the types made (fish, tiger, one shape of bird plaque, plain *bi* and sceptres) are a small selection of the Yinxu range and still reflect Shang style, it is uncertain whether they were manufactured near to the new provincial bronze foundries of the feudal states or represent export from the old Yinxu workshops.[18] Significant innovation did not occur before the mid-eighth century B.C. (Period of the Spring and Autumn Annals, *Chunqiu*) and events then point to the future course of the craft: the echo of motifs used in contemporary bronze, freer carving for plastic effect, fewer animal subjects and the introduction of some iconographically anonymous shapes intended for personal adornment [105]. The Xiasi tomb contained comb, hairpins, bracelets and tiger-tooth pendants as well as plain *bi* and *jue*.[19] A plaque about 7 cm square and a pendant of two mirror-matched tiger-dragons, only remotely reminiscent of *kui*, show the jade carver reproducing, but only approximately and to his own taste and capacity, the compact jigsaw of spiralled units (a version of the reduced style of dragon interlace) which covers some of the bronze vessels contained in the same tomb [105]. No grooved line separates the units of the design, whose low rounded relief is controlled with unprecedented skill, in a manner certainly implying the use of new species of drill, grinding wheel and polisher.

At the site Baoxiangsi in Guangshan, Henan, in the paired tombs of the Huang Junmeng couple, dated to the eighth or the early seventh century B.C., the ornament of bronze vessels is similar, but the modified jade versions are distinct from what is described above. The jade ornament is cut from flat surfaces by some grooving instrument that has allowed small

106. Ornamental jade plaque, from Xichuan-xian, Henan, Sixth century B.C. About 7 cm square

smoothly interlocking hooks and curves to be neatly packed a few millimetres apart [105]. The tendril-like meander moves in easy curves. Tiger-stripes are on *huang* whose feline features are barely noticeable. Tiny bird-heads often terminate the lines. On *bi* and *jue* the close maze resolves imperceptibly into more or less oblong units. Tubular toggles and small tiger-mask plaques abounded in both graves, and in the wife's a small realistic human face, meant for attachment in the usual way. A fragment of silk (a cloth with double warps and single wefts) is embroidered with a sprinkle of hooked and curved items resembling a basic unit of the jade ornament.[20]

The now improved capacity for carving the jade in three dimensions to give at least a rudimentary plastic effect is seen in some miniature human or monster masks. A fairly real human head, 4 cm high, was included with the jades of the female tomb at Baoxiangsi, the large nose intending a foreigner. A similar mask in the Shanghai Museum has a socket in the head. Both are perforated at the ears for attachment. Somewhat related to these pieces are a number of grotesque monster masks, one of which was excavated at Fengxi in Shaanxi, while seven others distributed in western museums are likely to have originated in north-central or north-west China.[21] The face has goggling eyes circular or extended to points, quadruple canine fangs and other detail indicated by stylized raised and curving lines with double perforations for fixing. The masks are plain at the back; a few are flat, but others (particularly a specimen in the British Museum) have some thickness and three-dimensional shaping. The piece from Fengxi allows that the manufacture of the monster masks may have begun as early as 900 B.C., their technique marking innovation of the latter half of Western Zhou.[22]

Changes in status among the decorative arts and in technique distinguish a phase of continuous development which begins *ca* 500 B.C. and embraces the whole of the Period of the Warring States (475–221 B.C.). The residual ritual significance and conventions of dress which deter-

107. Jade *ajouré* rondel of dragons from Pingshan-xian, Zhongshan, Hebei. Third century B.C. Diam. 6.4 cm

mined the range of earlier work are further relaxed, and besides supplying the constant demand for decorated *bi* the jade-carver becomes the purveyor of a variety of secular embellishment and knick-knack. The additions to his tools, which can still only be guessed at, must have included a rotary drill capable of miniature work, and a grinder which facilitated the production of comparatively large areas of flat surface broken by a regular scatter of small projecting elements. In some specimens of *bi* made towards the end of this period it appears that this was achieved by the use of a saw working horizontally, and not by a rotary blade, the cuts being arranged across the surface so as to leave standing rows of regular projections which were then worked to shape individually. For the majority of jades, however, more laborious drilling and small-scale grinding were the rule. In rougher work and for *bi* made of ordinary stone in remoter provinces a tubular drill produced small circles and projections below the general surface of the piece, for example in Shaanxi ca 400 B.C. [cf. 106].[23]

In Shanxi at the beginning of the fifth century can be traced the earliest sign of jade ornament which abstracts a

108. Jade *huang*. Fourth–third century B.C. Museum of Far Eastern Antiquities, Stockholm. Length 6.5 cm

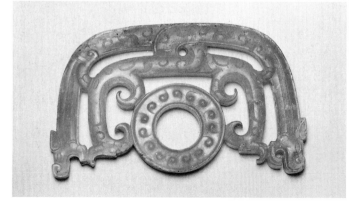

diaper of small curving units from contemporary bronze ornament, repeating the movement of these units in the entire outline of plaques given tiger-heads and dragon-like fins.[24] A little later this idea is taken further with the adoption of a diaper of close-packed short spirals motivated by the more complex hook-and-volute ornament typical of the Henan picturesque style. The total outline of plaques may be made to echo the scrolling movement of the filler motif, a combination of tiger-head with a serpentine body designed in this manner presenting the forerunner of the *chi* dragon frequent in larger and smaller ornament of the late fourth and the third century [108]. As the Han period is approached the impression grows of wide distribution from a limited number of central workshops, although the ready presumption that these were all located in Henan cannot yet be proven. Jades of this description found beyond the confines of Henan may be associated with bronze of an older fashion than the Henan picturesque just instanced.[25]

All the characteristic features of Warring States jade are assembled in the fourth century B.C. The *bi* settles to an ornament oddly termed 'grain pattern' (*guwen*) in antiquarian literature: ideally the projections produced in the manner outlined above are worked to a point, in regular spacing of about a centimetre, each with an engraved line spiralling upwards [111]. The engraving has apparently been added to enhance the cylindrical projections left by a tubular drill, at the same time bringing them near to a jejune version of the bronze hook-and-volute theme whose reduction can be followed through the fourth and third centuries. On some specimens this ornament is simplified to a scatter of short spiral grooves, a provincialism paralleled at a Jiangling site in Hubei by versions of bronze inlay which mark a distinct departure from the Henan standard.[26]

The fourth century burials at Liulige in Henan contained many items of the best metropolitan kind: *chi* dragon plaques in S-shaped contortion with brief limbs curling off, covered with close-packed *guwen* or the equivalent flat spirals; *ajouré* plaques with double tiger-head or interlaced dragons with differing small spiralled ornament; *huang* and various oblong pieces [cf. 110, 112].[27] The position of the jades in the graves suggested that the last-named jades were fixed on a girdle, dragon pieces on the breast and at the shoulders, rings and *bi* at the waist or placed in the burial at some distance from the head; but in one grave some seventy ornamental jades were heaped apart in confusion recalling the neolithic jadehoard tombs of Jiangsu.[28] In the tomb of king Xi of the Zhongshan statelet in Hebei, of the last quarter of the fourth century, the jades in brown, green and white nephrite are exemplary, evidently the product of a single metropolitan workshop.[29] The openwork contortions of *chi* are multiplied and the spiralled units of *guwen* are notably exact. One circular *ajouré* ornament embraces more space than substance: three slender dragons, posturing with reverted heads, scaled of body with spirals at the joints, are posed lightly around a central ring [107]. From the same tomb a large square board made for the *liubo* game affords a rare glimpse of carving in softer stone. The board is crowded with various compositions of interlacing snakes whose general forms and detail of filling ornament can be matched approximately but not exactly in surviving *huang* and related

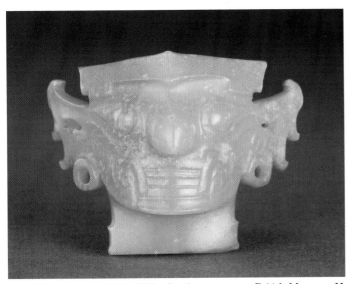

109. Human mask of jade. Fifth–fourth century B.C. British Museum. Ht 4.5 cm

111. Jade *bi* with 'grain' pattern, *guwen*. Third–second century B.C. British Museum. Diam. 7.5 cm

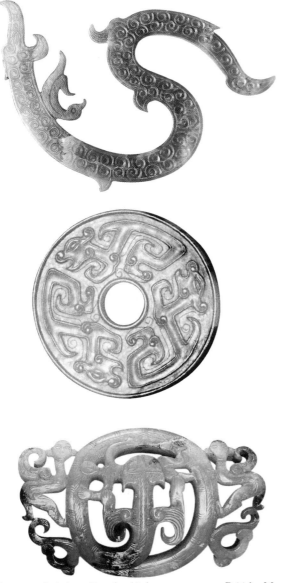

110. Ornamental jades. Fourth–third century B.C. British Museum. Diams. 5–8 cm

linked pendants. Little is known of stone carving of this kind, which in quality far surpasses the stone *bi* frequently excavated in remoter provinces.[30] The contents of tomb 52 at the necropolis of the Lu kingdom in Qufu, Shandong, summarizes the condition of metropolitan jade craft on the eve of the Han period. *Chi* plaques abound and the placing of these *ajouré* dragons as projections on the perimeter of *bi* is a high point of the craft. The *guwen* on other *bi* is exact for the most part, but on some pieces the spiral is lacking. In either case it has become the practice to separate zones around the outer edge or the edge of the central perforation and to fill these with a series of interlacing figures. The execution of this ornament is mostly inferior to traditional standards, evidently exploiting the potential of a new flexibly controlled cutting wheel offering further possibility of rapid manufacture. Within the maze of crossing lines is here and there a detail, mask or wing, suggesting a search for models among older bronze rather than jade. Such motifs probably reflect Confucian archaism, already discernible at the end of the Warring States period and destined to dominate in the ensuing art of Han. One *bi* is made of a purplish-blue nephrite not previously recorded in excavation. A quest after curious materials was to mark the new age. The Qufu jades included small pieces of wholly secular character:

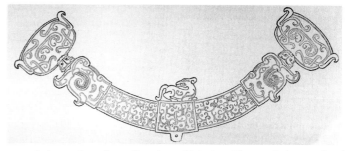

112. Jade pendant from Guweicun, Hui-xian, Henan. A bronze band passes through the five central pieces joining gilded bronze masks which bite the end jades. *ca* 400 B.C. Length 20.2 cm

thumbrings, tubular toggles, multiple tiger masks and *ajouré* plaques forming a necklace. Two belt-hooks outstanding by their delicate carving come from tombs to be dated perhaps a little later than those containing the other jades. The acme of craft as represented by the belt-hooks is, however, to be sought from Guweicun in Hui-xian, north Henan, a pendant in seven parts comprising two tiger masks of gilded bronze, and a silver-gilt belt-hook in which are mounted three small penannular *bi*, the centres of these filled with polychrome glass beads [112].[31]

Lacquer Art

From the mid-fourth century onwards lacquer craft reveals painting style and the evolution of ornament with a fulness lacking in any other branch of pre-Han art; but it has a much earlier history.[1] It is thought that the wood carving which lay behind much of the Shang designs executed in bronze was finished with a coat of lacquer paint, and that from that time onwards all fine wood carving was given this treatment, as much for its preservation as its enhancement. Lacquer has served to the present time as a mere uniform paint, and from this use are to be distinguished phases of work in which its potentialities are exploited as an artistic medium. At neolithic sites some wooden objects appear to have been treated with lacquer, but strictly a question remains. If accepted, the neolithic evidence reaches back to *ca* 5000 B.C. in Zhejiang, and in Liaoning to the seventeenth–fifteenth century B.C. The latter instance, at a level equivalent to the Longshan culture of the Central Plain, is radiologically dated from a curving sliver of wood painted an enduring bright red. The certain history begins at the early-Shang site of Erlitou in Henan, where were found the lacquered boards of coffins, the remains of red-lacquered wooden vessels among which a cylindrical box and a *dou* could be identified, and a fragment carved with a monster mask. The colour of all these is uniform red, and the lacquer seems to have been applied thinly, though for any application several successively dried coats must have been required.[2] At Taixicun (Gaocheng-xian) in Hebei, in context corresponding to the Yinxu period at Anyang, were recovered thin skins of lacquer from wooden dishes and bowls decorated with black and red designs (lamp-black and haematite colouring the pigment) closely resembling some contemporary bronze ornament: *taotie* and *kui* and their customary background scrollery.[3] Some pieces had small studs of turquoise placed on the lacquer. With this work may be compared the traces of red lacquer found in excavations at Xibeigang near to Anyang, belonging to the last decades of the Shang reign, where no black was used and the perished wood had been carved to mirror exactly the ornament of bronze vessels, with some added studs of ivory.[4] In discovering the ready means of colouring, while keeping a crisp painting line, the artistic use of the medium was launched. There is no reason to think that the lacquer tree, *Rhus verniciflua*, differed much in its geographical distribution from that of Han times, when it grew typically in the southwest, Guizhou, Yunnan, possibly Sichuan. The demand from Shang workshops sufficed to bring the expensive sap from a great distance, probably following approximately a route which served the importation of Yunnan tin required for the bronze alloy.

Between the end of Shang and the lacquer *floruit* of the fourth–third centuries B.C. some isolated finds show knowledge of lacquer continuing, but reveal little of its employment in artistic design. It is curious that lacquer is recorded from a number of sites in the form of the pedestal bowl *dou*

of lacquered wood, at a time when this vessel shape has not yet entered the usual bronze repertoire. A resplendent example of this shape from a tomb of the Yan state at Liulihe in Hebei, and other vessels accompanying it, have been described from the reconstruction of the crushed fragments [113]:

> *Dou* in black and red lacquer, the bowl set with mother-of-pearl rondels, the stem covered with large monster masks painted in red and set with many details in mother-of-pearl;
> *Gu* in reddish-brown lacquer with three broad bands of gold leaf, turquoise studs;
> *Lei* of brown-on-red lacquer carved with four monster masks set with mother-of-pearl detail, other painted *taotie*.[5]

These pieces appear to belong to the tenth or ninth century B.C. At Shangcunling in Henan was excavated a *dou* of *ca* 800 B.C., very heavily lacquered and decorated with stone discs; and of about the same date a dish-stand of lacquered wood was found at Panjiagou near Loyang, and a *dou* in the Guangshan-xian of Henan.[6] The loessic soil of Honan might be expected to have preserved more of the lacquer had it been consigned to the grand tombs, but bronze seems to have been the all but exclusive fashion for these funerals, and the cost of lacquer can have been little less. The craft tradition dating from early Shang was almost extinct by the end of the eighth century B.C., and as yet nothing is cited to bridge the space which intervenes before the history of lacquer can be resumed some two centuries later.

From the mid-fifth century to the end of the Western Han period so much of the surviving lacquer ware has been found in tombs near to the capital of the Chu state at Jiangling in Hubei that one may presume this region to contain the main lacquer workshops. The moist soil of this part of China, especially the district of Changsha in Hunan, is favourable to the survival of lacquer, not only the surface lacquer but often also the base of wood or textile escaping destruction. It may be argued that the concentration of finds of lacquer in this region is owed to this circumstance, affording us only a limited view of the craft as a whole, an important question when the relation of metropolitan to provincial standards of art is considered. But apart from the distribution of the finds, the coherence of their painting supports location in Hubei/Hunan, while continuity with the product of Han workshops in Sichuan points also to local industry. The development of the craft may be followed almost continuously from the Period of the Warring States to the end of the first century B.C. Han officials charged with the supervision of a state-supported lacquer industry inherited the Chu situation: the advantage of ready access to the western areas where the sap was collected and probably also the enduring artisan skills present at the heart of the old Chu kingdom.[7] From the fourth to the first century B.C. we may speak of the activity of a Hubei school of lacquer painting.

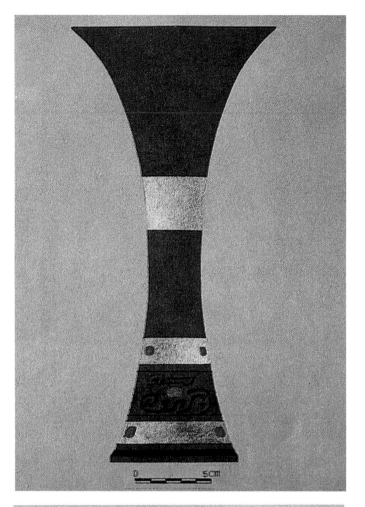

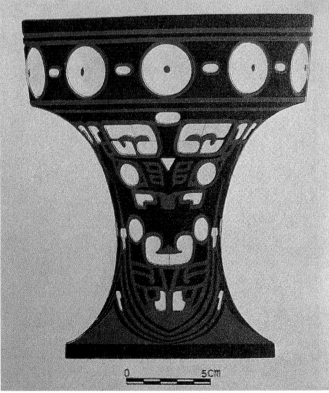

113. Reconstruction of wooden *gu* and *dou*, lacquered and inlaid, from Liulihe site, Hebei. Tenth–ninth century B.C. Hts 20.3 and 28.3 cm

In Chu the hieratic tradition of north China was less potent. Elements of northern style, in vessel shapes and ornament, penetrated to the middle Yangtze region, but these remain distinct from decorative schemes which fed on the local practices of Hubei/Hunan. Here inspiration was found in textile and embroidery. The most striking examples of these recorded thus far were excavated from tombs in Jiangling-xian designated Yutaishan and Mashan No. 1. The twills show almost the farthest that this weave can be taken in representing pictorial subjects [114]. As well as the most varied lozenge pattern the ornament includes confronted monsters, dancers wielding clubs, serpentine dragons, all drawn with a preponderance of straight lines. Designs of this kind, well suited to narrow continuous bands of ornament, were readily imitated by the lacquer painters. Embroidery on the other hand, whether direct stitching (pattern darning or couching) or appliqué work, encouraged curvilinear figures and the multiplication of spiralling detail [115]. The influence of both twill and embroidered pattern can be traced also in bronze, especially in mirror ornament; apart from a somewhat unbridled exploitation of *cire-perdue* casting, textile design lay behind much of the bronze decoration of the Warring States which falls outside of the Henan tradition. Inevitably lacquer painters at large adopted Hubei fashion.

Strict adherence to twill pattern is however comparatively rare in lacquer painting. More often the twill-derived figures are combined with elements of rectilinear geometric style, most often a mannerism of tight spirals placed at sharp angles [116]. Sprung movement with sudden departures and returns was the chief desideratum. Ornament of this kind was painted on coffins and other wooden items of funeral furniture, and in the second century B.C. came to be imitated in Hunan on fabric decorated with applied feather and fur; this last in turn offered new models to the lacquer painter. Sometimes the complexity of the interlace of lozenges exceeds that of the woven motifs [117–20].[8]

A survey of the lacquer so far excavated from tombs, either as intact pieces coming from very damp soil or as reconstructable fragments, allows us to recognize at least provisionally a number of schools of the craft. At the end of the Warring States and particularly upon the nation-wide organization of industry which followed when the empire was unified under Han, uniform shapes of vessels and boxes were in such wide demand that all the lacquer factories participated in the production. For example, oval wine cups with flat projections for handles – 'eared cups' (*erbei*) or 'winged cups' (*yubei*) – are frequent in tombs in the Jiangling district of Hubei and the Changsha district of Hunan before 200 B.C.; thereafter, more widely manufactured, they were in universal use in the empire, occurring not only in China proper but equally in tombs at and beyond the frontiers [cf. 121]. These small objects evidently acquired a social and aesthetic cachet comparable to that of the porcelain tea-bowl of later times. About 400 B.C. in Jiangling the cup is decorated on the general black surface with bands of asymmetric geometry containing a minimum of spirals, in red and yellow; some associated pieces are a *dou* with bird-shaped bowl and a beaker which reproduces the high convoluted and *ajouré* relief of wax-cast extravaganza.[9] In the same region the *erbei* dated a generation or two earlier carry

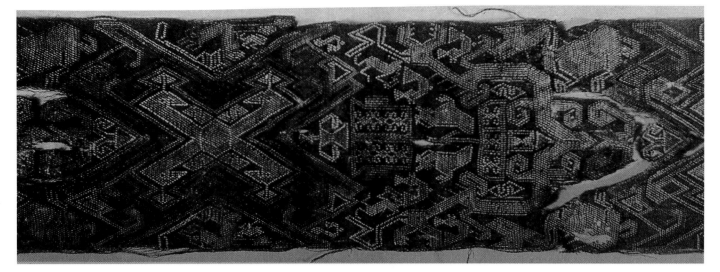

114. Fragment of silk twill, from Jiangling-xian Yutaishan, Hubei. Third century B.C.

116. (*right*) Decoration of lacquered winged bowls, from Jiangling-xian, Hubei. Third century B.C. Width of each bowl about 18 cm

117. (*right, below*) Motifs of lacquer ornament, from Jiangliang-xian, Hubei. Third century B.C.

115. Fragment of silk embroidery, from Jiangling-xian Mashan, Hubei. Third century B.C.

118. Motifs of lacquer ornament, from Changsha, Hunan. Late fourth–third century B.C.

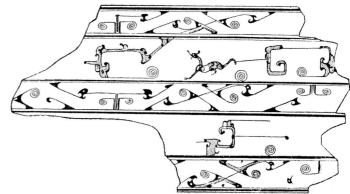

119. Painted lacquer, from Changsha, Hunan. Third century B.C.

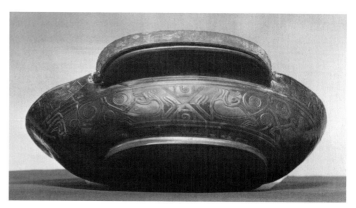

121. Lacquered winged bowl. Third century B.C. British Museum. Length 17.5 cm

120. Carved wooden coffin panels, black, red and green painted lacquer, from Changsha, Hunan. Third century B.C.

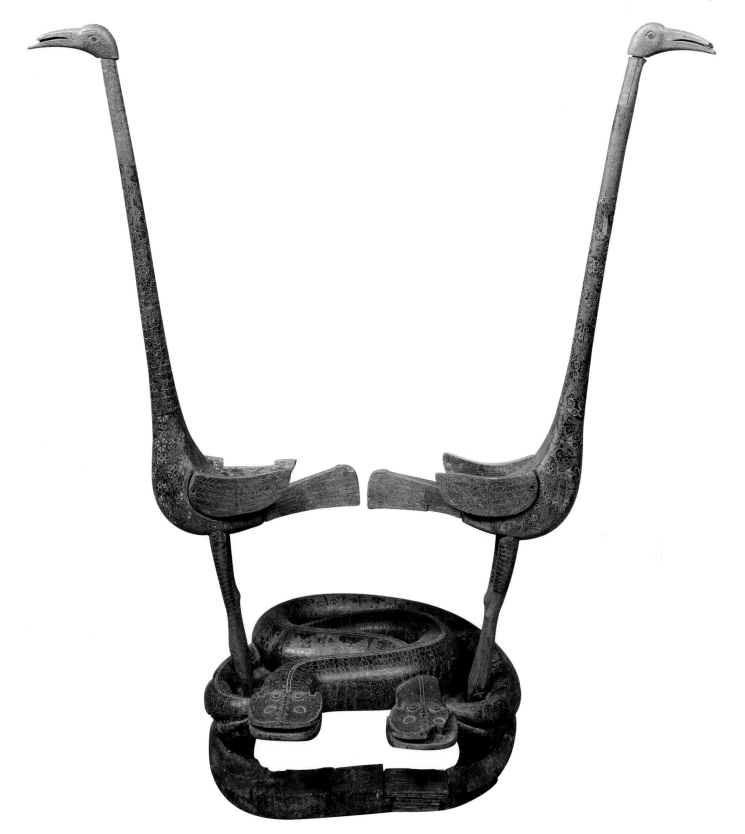

122. Lacquered cranes and serpents. Fourth century B.C. Cleveland
Museum of Art. Ht. 132.1 cm

designs with a twill-derived element, and have uncharacteristic notched and peaked handles. Strict twill pattern is painted on accompanying pottery. The sum of evidence prompts a theory that the shape of the cup itself is a Hubei invention.[10] In the second century B.C. and at the end of the Western Han period the cups more than other lacquer types are largely faithful to geometric ornament, modifying it only a little and sometimes combining it with elements of the by then modish 'cloud scroll'. In them is manifest the archaizing bent of much official art under the earlier Han dynasty. A similar evolution is traced in boxes – round, rectangular and L-shaped – which were multiplied from *ca* 150 B.C. onwards, round boxes and bowls naturally favouring broad circling lines.[11]

Hubei/Hunan was the natural home of a kind of submonumental wooden sculpture, with specimens dated in the earlier and later fourth century B.C., which also called for skilled lacquer painting. One subject, an antlered monster head, remotely human with protruding tongue, represents an underworld spirit attendant on the souls of the dead; in one example the heads are double and the antlers quadruple.[12] A stylized couched deer, or twin peacocks standing on tigers,

act as supports for drums, and twin cranes with exaggerated long necks standing on twin intertwined snakes represent other chthonic powers [122, 123]. Symmetrical geometric pattern of the metropolitan kind painted on all of these subjects has the precision observed on most of the smaller lacquered articles. A much coarser version of the geometric figures appears, however, on some contemporary lacquered boxes, evidently the product of workshops where Hubei standards were less regarded.[13] The sculpture interprets the iconography of myth and superstition peculiar to ancient south-central China, corresponding in part to images appearing on some contemporary painted silks excavated in the Changsha area. Its style does not touch the central tradition at any point, the blocked-out shapes and simplified and rounded animal forms revealing well-established local idiom.

What must be seen as an extension of the Hubei school of lacquer painters is represented by rich finds made in tombs near to Xinyang in south Henan, of the late fourth or early third century B.C.[14] The figural subjects painted in polychrome lacquer are noticed later in this book; the designs corresponding to inlay on bronze reflect both the sym-

123. Detail of base of the cranes-and-serpents sculpture of ill. 122. Width 57.5 cm

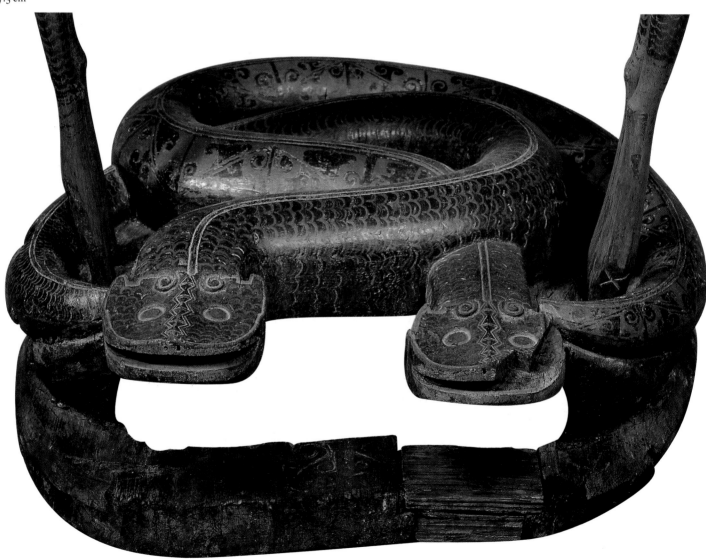

124. Design painted in lacquer on a sarcophagus plank, from Xinyang-xian, Henan. Third century B.C. Width 43 cm

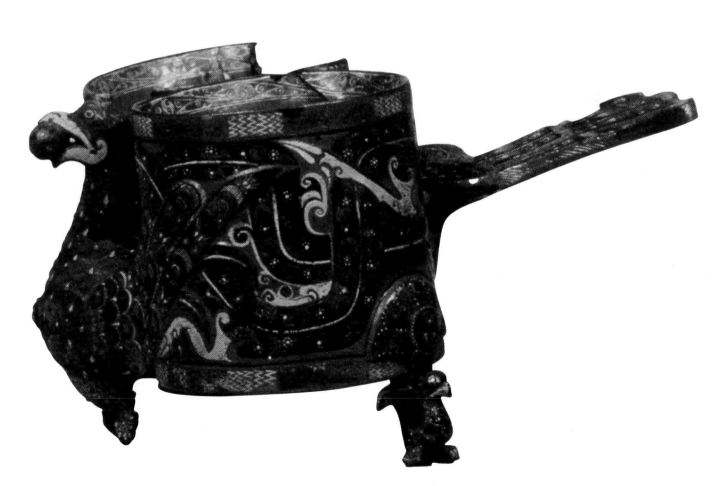

125. Lacquered bird-shaped double cup from Jingmen-xian, Hubei. Third century B.C. Ht 17 cm

126. Fragment of lacquered table showing cosmological items antecedent to the 'TLV' design, from Linzi-xian, Shandong. Early fifth century B.C. Diam. 19 cm

metrical and the asymmetrical varieties [124]. On drums with their bases of addorsed tigers they resemble work from Jiangling and Changsha; on the wooden frame of a *sê* zither geometricized design and pictorial subjects are combined in a style which, while distinct in ductus and combination, still comes nearer to Hubei tradition than to the manner of

contemporary Henan bronze. Similar individuality distinguishes the Xinyang bronzework: the spiralling movement of Henan design (in spiral-and-triangle and winged and spurred detail) is revised, particularly in the *ajouré* of a brazier body.[15] The Hubei tradition in all its aspects contrasts with a confined and less productive lacquer enterprise in the north-east. From Changzi in Shanxi and Linzi in Shandong, both sites of the fifth century B.C., come samples of lacquer ornament unrelated to anything that has been described: at the former rows of zig-zag, diabolo, triangles, entwined snakes, at the latter similar elements more elaborate and crowded, but including also a scheme composed of a circle surrounded by rectangles and enclosed in an outer circle, in which are placed briefly drawn reptilian-looking birds and a repeated scene of two human figures facing each other in ceremonial pose [124].[16] The colours distinguish between red and vermilion, with some white. Possibly the circular composition marks an approach to the cosmological diagrams practised in the later Western Han period, but no monuments have been discovered thus far to bridge the intervening space of three centuries. Lacquers of the second or first century excavated at the Shanxi site make plausible descendants from the fifth-century lacquers found there, and lack celestial symbols.[17] These lacquers of Shanxi tradition could not compete with the work of the Hubei school, which was reinvigorated at the end of the third century and dominated the lacquer market in the Western Han period. The most interesting part of Hubei lacquer painting in this late phase joins the stream of realism which runs through nearly all the art of Han, and belongs to the account of that period. Simultaneously the phantasies of *cire-perdue* casting and zoomorphic invention in bronze were imitated with consummate skill [125].[18]

Inner Asia and the Chinese Borders

The foregoing account has omitted a historical dimension essential in the account of passages of art occurring at intervals through the period covered by this book: the involvement of China with Inner Asia.[1] In Han and later time, Chinese boundaries were moved westwards to include the oases of Central Asia and the surrounding steppe lands extending through East Turkestan to the edge of the Altai mountains, the whole forming China's vast Xinjiang province. Subordinate though it is to the mainstream of Chinese art, the link with 'barbarian' tradition native to this region, at greater or less distance, persisted independently of political control exercised by Chinese states. Before the Tang period this control was intermittent. Two aspects of two-way influence claim attention: the rapidity with which ideas of form and technique were propagated through Inner Asia, westwards and eastwards, from the bronze age onwards, in movement so rapid that virtual contemporaneity may obtain between regions separated by thousands of kilometres; and the selective character of the exchange of items of design and technique between the urbanized population of China proper and the mobile and slender-based inhabitants of the interior steppes.

As reflecting the interplay of civilized and barbarian tradition, stylistic trends at the two ends of the Inner Asian steppe belt had something in common. Events in Western Asia and south Russia find parallels in the art of tribes occupying the plains on the north-western Chinese border. At the beginning of the twentieth century the Inner Asian style which is discussed in this chapter first became known to scholarship as a prominent element in the art of the Scyths of the Don and Dnieper basins, the Crimea and the Kuban valley.[2] From the mid-fifth century B.C. the Ionian Greeks of this region were in commercial and artistic contact with nomad peoples.[3] As knowledge of the material culture of ancient China increased in the west, comparisons made with motifs current in China at the beginning of the period of the Warring States evoked theories of Scythian tribal movement eastwards and consequent influence on pre-Han art of a 'Scythian style'. In the heyday of imperialist archaeology notions of invasion and trade inevitably provided the model for this phase of the Asian past. But no originating centre could be identified, and it was evident that traditions akin to the Scythian existed in the arts of all the settled, non-nomadic, peoples of Western Asia. The famous gold plaques presented to Peter the Great in 1715 and subsequently, though poorly documented, are known to have come from tombs in Siberia. From them it could be argued that an 'animal style' extended far to the east, embracing regions ascribed by Herodotus to the Sauromatians and obscurer easterly tribes, and the region from which the Sarmatians invaded the Dnieper steppes in the second century B.C. But from the 1930s onwards excavation and collecting in China revealed a more evolutionary connexion between the arts of the steppes and of metropolitan pre-Han China.[4]

A classical definition of Inner Asian style[5] speaks in terms applicable to much of the pre-Han art of metropolitan China that was described in the last chapter: a powerful stylization, admitting elements of accurate naturalism, in which the outlines of animals and parts of animals are almost the only motifs, plants and the human figure being eventually added in detail. In the most characteristic work natural form is transmuted into something unreal. The animals represented in the steppe traditions, in styles varying regionally but observing similar principles of design, are few: deer and goats, felines, horse, bear, wolf, and a great bird of prey varying from a recognizable eagle to a griffin of patent Assyrian ancestry.[6] Changes are rung on these figures in characteristic variety. Dismembered parts of animals enter the composition, and one notices in particular the hawk-like bird-heads fixed on antler tines. The chronological limits of this art in south Russia are deduced to lie between 500 B.C. and the beginning of the Christian era, with a stylistic break falling *ca* 200 B.C. which allows division into a Scythian and a Sarmatian period. But this semimillenary phase is the culmination of much earlier processes.

It was noted above that in China a measure of organic animal form was characteristic of the Yangtze valley, in contrast to the more schematic design of the north. As to remote origins of Inner Asian tradition, one may compare a north–south division present also in the ancient Near East. The art of Sumer and Akkad, issuing from the oldest and apparently autochthonous tradition of southern Mesopotamia, worked chiefly in natural form suggestive of modelling rather than carving. Naïve at first, this plastic style developed by the time of Sargon of Akkad (*ca* 2700 B.C.) into the delicate realism seen in the figures of gods, demons, bull-lions and gazelle engraved on cylinder seals. Towards the middle of the second millennium the art takes on a modifying and decorative element leading to the use of hard raised line in the relief of figures. This is combined with the massing of small linear ornament, repeated with geometric precision, in the detail of garments, head-dress and beards. Work in the new style is associated particularly with cities situated on the edge of the ancient oecumene of Sumer-Akkad, a geography suggesting that change took place under northerly influence. Stylization goes farthest in the design of animals, which hover between geometric abstraction and free linear invention. Like the Shang civilization of China, the Mesopotamia of the second millennium assigned some northern elements of design and accoutrement to a subordinate rōle in its widely based tradition. A thousand years later the Mesopotamian mingling of southern and northern is still perceptible in motifs current in the Inner Asian steppes. The closest affinity of Inner Asian art was, however, to be with practices established on the Iranian plateau shortly after 1000 B.C. Meanwhile during the second millennium there were repeated movements of population from Inner Asia to the south and west, the migrations passing on both sides of the

127. Bronze ring belonging to horse harness, from Luristan. Eighth–seventh century B.C. Musée du Louvre, Paris. Ht 13.6 cm

Caspian sea and carrying elements of artistic style with them.

A form of naturalism particularly relevant to subsequent steppe art developed in the second half of the second millennium in the Luristan province of south-western Iran, the region of the Zagros mountains. Here the stylized theme of confronted animals, cervids and felines, often set either side of a branching tree, was interpreted freely and even with some humour in bridle-bits, cheek-pieces and chariot fittings (the so-called 'standards'), the very items most suited to wide dispersal through the horse-riding peoples of the steppes. From the twelfth to the seventh century B.C., with comparatively little change, Luristan art shows the skilled joining of natural detail and imaginative manipulation which are the hallmarks of an enduring tradition [127].[7] Meanwhile the eclectic art of the middle Assyrian period took shape as the city of Asshur established its ascendancy over the Kassite rulers of Babylon. In Middle Assyrian seal designs, dated before 1000 B.C., heroes attack lions with spears, lions and winged griffins fight horses and bulls, winged demons pursue other animals, the naturalism of limbs and muscles recalling the refinement of the earlier Akkadian work. This Assyrian naturalism may connect historically with the Levant rather than the Iranian plateau, being the result of the centripetal flow created by the vast palace-building enterprise of Assyrian kings, a tendency to concentrate art style which is observed no less in Shang China. The Levantine influence introduced a further tendency towards the geometricizing and analysis of animal shapes, for the heraldic compositions demanded by royal emblems and mythological scenes encouraged the artist to reduce animal form to schemata in which the decorative wins over naturalism. The size of the work is limited: seals and such, and the ornaments of bridle and saddlery, were necessarily small. Notably the exigencies of ivory carving compelled the artist to consider how best an elaborate animal might be made to fill a field with a rigidly prescribed contour.

In this also we see a process cognate with the purposes of the bronze-working artist of Shang China.[8]

While the chief elements which went to the composition of Assyrian palace art were thus assembled before 1000 B.C., the most impressive fruits of the amalgam belong to the eighth and seventh centuries. Tiglath-Pileser III extended his control westwards to Syria and the Mediterranean coast, so that influence from these lands was reinforced. Syrian inspiration, or actual workmanship, accounts for highly finished ivory carvings recovered on the site of Assurbanipal's palace at Nimrud.[9] At Nineveh a little farther north (the Khorsabad and Kuyunjik palaces of Sargon and Sennacherib) the ivories display conventional and natural design in perfection, the treatment of their crowded narrative subjects corresponding to a contemporary advance of monumental relief sculpture in stone. The Scythian nomad mercenaries who took part in the siege and capture of Nineveh in 612 B.C. may have become familiar with this work. In the Mongolian steppes are found some large stone versions of the current cervid theme, datable to the eighth–seventh centuries. There can be little doubt, however, that the small works in bronze and gold represent the original invention.[10]

To the east the steppe tradition made contact with Chinese civilization. From middle Zhou time the exchange between nomad and metropolitan themes in bronze can be particularized and closely dated, but in the east as in the west mutual influences between steppe and the riverine cultures of China reach much farther into the past. Animal design as practised at the Shang centres has been described: the combination of anonymous schematic and pseudo-organic form, centred on the *taotie* and its companions, differs in content but in principle resembles much that is found in west-Asiatic design of similar age. But Shang art appears in a naturalistic dress as well as in the prevalent conventions. The zoomorphic vessels make stylized concession to reality, while distinct from these is the closer treatment of natural form seen in some bronze horse-head finials and in the horse-head and ibex-head handle terminals of knives buried with chariots and their charioteers [128].[11] These items have a bearing on the rise of steppe tradition at its easternmost extension, for horses and chariotry connect Shang with territory lying to the north-west beyond its direct political control, the provinces of Shaanxi and Gansu whose northern and western parts continue uninterrupted into the Inner Asian plain.

The earliest contacts of Shang with Inner Asia are shown by bronze socketed axes found scattered in the Baikal region of South Siberia, the result of influence and trade passing along the Amur valley.[12] On the Siberian axes the *taotie* ornament of the equivalent Henan tools is imitated briefly by circles and lines. In the fuller bronze-age culture of the Minusinsk valley knives were decorated with ibex heads virtually identical with those known from Anyang. In some examples the Siberian artist has gone further than the Chinese in reducing real form to formula, matching the Shang practice in principle though not in detail. Soviet archaeologists go so far as to ascribe the introduction of bronze metallurgy into South Siberia to the effect of Shang technique working upon the preceding Andronovo neolithic. It is evident also that communication was established between China and the Ural region through the heart of Siberia some

129. Openwork bronze plaque found in the Crimea, showing a carnivore twisted into a ring. Fifth-fourth century B.C. State Hermitage, St. Petersburg. Diameter 10.2 cm.

became established after *ca* 900 B.C., in parallel to a similar economic shift in the steppes farther west, and in this context a few artistic motifs passed from north China to the steppe repertoire, in addition to the knife ornaments already instanced.

One theme is the animal-in-a-ring, well known in later inner-Asian art [129].[13] In the first strictly formalized version of this motif the elongated dragon descended from the Shang *kui* is used in the design, being cast in ninth-century Shaanxi and Henan on ritual vessels and on chariot parts. A similar motif used later in the nomads' harness ornament must derive from the coiled *kui*, and the principle of the design was adopted for other subjects in both China and Central Asia. In the tenth–ninth centuries a series of imaginative designs current in north China shows the head of a bird of prey adapted to the same circling and spiralling

130. Bronze cheek-piece as bird-in-a-ring. Eighth–seventh century B.C. British Museum. Greatest width 10.8 cm

128. Bronze ibex-pommel knife. Eleventh or tenth century B.C. British Museum. Length 21 cm

centuries before 1000 B.C. If the bronze socketed axe was a westward contribution from Shang China, providing eventually the very hallmark of the late bronze of a temperate Europe, a form of bronze spear-head made in the fourteenth–thirteenth centuries B.C. in Henan and given typical Shang ornament was a type transmitted eastwards from the Ural region. The artistic connexion of Siberia with China survived the end of the Karasuk culture and lasted into the period of the Tagar culture beginning *ca* 700 B.C. Latterly the route of contact was over the plateau of Inner Mongolia. In this region large-scale nomadism dependent on the use of horses

movement as the coiled dragon [130]. A bird with corresponding curve and counter-curve of line and profile is
recorded in steppe bronze some four centuries later. The
use of standing animals as ornaments on knife handles can
be traced in Siberia as far back as the second millennium
B.C. On a famous piece from the Turbino district of the Ural
mountains three sheep are placed in procession.[14] In
Minusinsk it is two lively miniatures of the Przewalski horse
(i.e. the race bred in China under the Shang dynasty); and in
Inner Mongolia and closer parts of north China appears the
so-called grazing animal, with muzzle lowered to the ground.
In a manner now recognizably Chinese this motif becomes a
conflation of horse and tiger. The feet end in crescent claws,
such as are seen for example on a pair of tiger-shaped ritual
vessels of the tenth century B.C. (probably the work of a
foundry in the old Zhou territory of Shaanxi). Claws become
rings and these are multiplied over the animal's body, taking
the place of the muscle-spirals on haunches which were an
ancient convention in Western Asia.[15] Whether these ringed
dimples were intended for inlay, or pre-existed inlay and
themselves suggested this addition, remains a moot point.[16]
Horses resembling the knife miniatures may decorate the
tang of a Chinese gê halbard. As a dagger terminal the
animal more closely approaches the tiger. Corresponding
figurines in the round, crouching and with crescent claws,
have in addition the regular elongated S-shaped or bracket-
shaped marks representing the tiger's stripes that appear on
the ritual vessels just instanced and on the twin tiger-shaped
vessels of the ninth century in the Freer Gallery.[17]

The Karasuk culture of the Minusinsk basin gave way in
the eighth century B.C. to the Tagar culture, which diffused
over a larger area to the south and the south-east. In this
direction the Tagar tradition passed into that of the Chinese
Northern Zone, the steppe belt extending eastwards to the
Taihang range. Horse-heads, the ring-coiled tiger and wolf,
the grazing animal and a fully modelled ibex are stock items
of the Tagar repertoire which now occur sporadically through
north China. In comparison with the designs used by Shang
and early-Zhou artists, the animal designs appear renewed.

In the ninth and especially in the early eighth century B.C.
began the movements of steppe peoples which were to reverse
the flow of artistic ideas through Inner Asia: whereas influence from metropolitan China was traceable earlier to northwest and west, we may now look for the appearance in
Chinese territory of motifs related ultimately to the artistic
events of the Scythian west. The move eastwards of the
capital of the Zhou confederacy in 771 B.C. implied political severance from the nomads of the eastern steppes, but some theory of the relation of the nomad
hordes to the northern Chinese states is necessary
for the understanding of artistic influences present
after ca 600 B.C. One view, that the population of the
steppe was comparatively stable ethnically and geographically
prior to this date, disregards both the effect of the enlarged
nomadism and the statements of Chinese history. The alternative view is of repeated advances by the Di nomads from
an original base lying east of the northward turn of the
Yellow river, under the attraction of the rich upland pasture
of Shaanxi. By ca 700 B.C. a grouping of these nomads, the
Red Di, seems to have settled in Shaanxi, leaving the White

131. Bronze finial, probably a harness ornament, shaped as an elk. First
century B.C. British Museum. Ht 18 cm

Di living farther west.[18] This tribal turbulence hindered the
power of the northern Chinese state of Jin, which was invaded
by Di of both colours in 645 B.C. and suffered their presence
for about half a century. The parallel with the near-
contemporary Scythian hegemony in Media is remarkable,
the motives similar: fresh pasture, plunder and exactions
upon trade. In China the intruders rapidly became sedentary,
recruitable and taxable. Their arrival preluded an epoch in
Chinese art in which animal motifs, in Sinic transformation,
appear alongside others descended directly from Shang and
early Zhou. This phenomenon, with its notable culmination
in the animal realism of the Liyu style, would seem to
require no further historical explanation. Simultaneously the
impulse to geometric stylization present in the steppe tradition
is manifested in bronzes of the sixth and fifth centuries B.C.
found in Inner Mongolia illustrate a tradition still shared
with South Siberia.

Bronzes of the sixth and fifth centuries B.C. found in
Inner Mongolia resemble contemporary pieces from South
Siberia. In addition to the 'standing animal', shapes of ibex,
elk and ram, used to decorate various pole finials and harness
pieces, were treated in curving lines in a manner distinct
from that of Scythian art found west of the Altai [131]. The
effect of wood carving as practised at this time in the Altai is
sometimes imitated in Mongolian bronze. Animal bodies are
divided clearly into segments, each filled with curving parallel
ridges set obliquely to similar ridges in adjacent segments,
spirals on the leg joints generating curves over all the limbs.
Two plaques of tigers standing on fawns sufficiently resemble
the animals carved on wood at Bashadar in the Altai to
warrant a late-sixth century date at the latest [132, 133].
Confronted tigers recall the symmetrical designs of Luristan.
Both in south Siberia and in the Northern Zone of China
the tendency to abstraction supervenes, the animals being
placed back to back, and circular perforations which began
with the feet are repeated elsewhere in the composition. The
energy which was first directed to the analysis of real anatomy
is thus transferred to geometric line and contour in an
uninterrupted evolution [134].

The next phase in Chinese relations with Inner Asia involves recognition of a 'Scythic complex' of culture traits in
art and armament, the formation of which is to be sought in

132. Bronze plaque of a tiger suckling a fawn. Sixth century B.C. Musée Cernuschi, Paris. Length 12 cm

south Russia and the neighbouring territories to the east. In this region the event which marks the time around 400 B.C. as the beginning of a second artistic phase is the explosive rise of Massagetan power and the consequent destruction of Scythian settlements on the lower Dnieper.[19] Supported by armoured cavalry (the *cataphracts* whose fame soon spread to Greece and China) the Massagetae imposed their alliance on the Sauromatians of the Ural region, on the various nomadic populations of Kazakhstan, and even on the Turkic Huns situated on the Chinese borderlands. Such political unity could only encourage the wide circulation of artistic ideas. The axis which joined China to South Siberia in earlier times now swung towards the west, eventually creating contacts through the Turkic population of Mongolia as far as the uplands of Zungaria. More clearly than previously, elements of a cultural continuum are perceptible extending from the Black Sea to the Yellow river. In weapons a short sword, the *akinakes*, and a small bronze arrowhead cast by a characteristic Chinese method, both associated with basic forms of animal design, were current in the steppes between China and south Russia.[20] About 400 B.C. the tribes later denoted Sarmatoi were projected westwards by the Massagetae. In Scythia now appeared their shaft-cum-annex

133. Gold plaque of tiger attacked by griffin and wolf. Sixth–fifth century B.C. State Hermitage, St. Petersburg. Length 20 cm

134. Bronze finial, possibly a harness ornament, combining feline, bird and snake. Early fifth century B.C. Danish National Museum. Ht 13 cm

tombs, comparable in principle to those found contemporaneously in north-west and north-central China of the Warring States period.

The chief artistic pointer in assessing the initial Scythic complex is the Ziwiye treasure of gold, silver and ivory found in 1947 south-east of Lake Urmia and dated to *ca* 600 B.C. Some of the ivory plaques (e.g. depicting charioteers in a lion-hunt) belong to the Assyrian palace style of the early seventh century. On a fragment of repoussé gold plate, Scythian deer and big-horned goats appear with lion masks of the Western Asiatic (Urartian) type, but on other pieces the Scythian motifs are used apart. In particular a circular dish of silver with detail incrusted in gold is decorated wholly in Scythian idiom, with concentric rows of ornament containing crouched tigers, hares and schematic eagle-heads. Since the Scythian work so closely resembles the Asiatic in clarity of design, it is likely to have been produced in the region of the find. The Ziwiye treasure illustrates an initial symbiosis of civilized and nomadic tradition, anticipating the close connexion of Scythian art and Greek art north of the Caucasus in the following four centuries, and paralleling a similar mingling of Scythic and Chinese metropolitan motifs during the same period in north China.[21] The animistic and sacrificial cults to which the animal iconography relates lead

both northwards to the wooded steppe and forest, the home of wolf and bear, and eastwards through Kazakhstan to South Siberia. If magical or totemic significance lies behind eagle, bear, wolf and panther, another order of ideas must attach to deer, mountain goat, horse, antelope and camel. When the deer appears it follows what has become a usual formula, with reverted head and folded legs, and stands pictorially half-way between the schematic design of the predatory cult animals and the realism which is attempted in representing domesticated species.

In Scythic ornament the eagle-head is a common theme from the beginning of the sixth century. It seems not to connect closely with any western tradition, but to take up again the theme of the isolated bird-head which had been in use in north-west China some three centuries earlier, when it was paired to form the handle terminal and guard of bronze daggers. In the Chinese Northern zone the explicit design passed gradually into the anonymous curves and rings of a lingering convention, due to be revived by the eastward reflux of the Scythic version of the motif in the late fifth century.[22]

Aspects of the east–west exchange are demonstrated by the finds made in the frozen tombs (kurgans) in the Pazyryk district of the Gornyi Altai.[23] Here the main motifs of the Scythic complex (eagle, deer or elk, griffin, goat, attack of feline or griffin on a grazing or domestic animal, in realistic or more or less abstracted formulation) were at their most elaborate, while contact with the metropolitan arts of China and Achaemenid Persia is prominent. The eagle-head enters readily into fantastic combinations of animal parts, added to a hoofed quadruped, biting on an antlered deer-head [135]. In a manner suggestive for the origin of much of nomad design, local Pazyryk style was largely determined by the cutting of pattern in felt or leather, to be used as continuous openwork or applied on a surface of similar material, all brightly coloured, and by wood carving, sometimes in kerbschnitt style. Leaves and petals, tulips and rosettes, brief spirals and irregular flame-shapes are multiplied in endless variety. The acceptance of simple symmetry in some of the compositions, so contrary to nomad taste elsewhere, probably arose from the imitation of textile pattern, an influence generally absent in the steppes. The tombs containing these items date from the fourth and third centuries, while material reflecting specific contact with Persia and China comes from the fifth kurgan, dated shortly after 400 B.C. The procession of mounted warriors represented on a knotted woollen carpet must copy a Persian subject. Some of the riders are furnished with felt horse-cloths resembling the specimen preserved in the tomb, on which flame-like figures derived from the outline of a moose-head are repeated in diaper or in imbricated pattern.[24] The realism of the main subjects, eschewing nomad geometry and still differing from the realistic component of nomad art, place the carpet (and its accompanying felt hanging depicting deity and horseman) beyond the pale of the traditional animal design style.[25] The 'jewelled squares' forming borders owe their origin to Western Asiatic embroideries or weaves. In the broadest generic sense they belong with the elements constituting the 'jewelled style' of Buddhist art in the post-Han centuries of China.

The sixth kurgan at Pazyryk contained a fragment of a

135. Design of a fantastic animal tattooed on the left arm of a man buried in a kurgan in the Gornyi Altai. Fourth century B.C. State Hermitage, St. Petersburg. Ht 18 cm

Chinese bronze mirror of the type with a twill-derived T-figure; the fifth kurgan held a piece of silk embroidered with a running bird also akin to a bronze-mirror theme, and a swan made of felt in the round which must copy a Chinese model. Rather than a general context of exchange, such as had existed between China and South Siberia at an earlier period, these objects point rather to a discrete trade reaching the Altai from western China, of a kind with the trade from Persia, but not so frequent or influential.

It is noticeable that the later Pazyryk kurgans no longer held examples of animal polymorphism or of the animal attack. Both of these themes appear however to have been frequent in South Siberia. Excavation recorded there has produced few pieces of the elaborate treatment of these subjects, but it is certain that from this region, and in part possibly from Kazakhstan also, had been buried the bulk of the bronze and gold plaques of the Petrine collection. A few of the plaques, notably a feline-in-a-ring and a group of comparatively archaic animal-attack motifs, belong probably to the sixth–fifth century, coinciding with basic themes in the earlier phase of Pazyryk art; but it is generally agreed that the majority of them date after 400 B.C. and that a part of them belongs to the third century B.C. This last group includes symplegmata of great boldness and originality: a winged lion attacking a horse whose body is twisted through a half-circle, a boar-headed lion attacking a diminutive camel, a griffin and two lions devouring a calf, a lion attacking a griffin which has seized a bull. A pervasive feature is the multiplication of circular and teardrop-shaped dimples inside and outside of the animal contour, contributing eyes, ears, claws etc. to the design. The plaque of griffin and lions preserves inlay of turquoise and coral, confirming the surmise that all the cavities were placed to receive these colourful additions, although those of most surviving plaques remain

136. Bronze plaque: attack on a horse. Second century B.C. Metropolitan Museum, New York. Length 13.2 cm

137. Bronze plaque of twin horses with eagle-head crests, from Inner Mongolia. (Later the motif is turned into an *eagle-headed* horse.) Second century B.C. British Museum. Length 10 cm

empty. Antler tines, small bird-heads and other small animal parts were multiplied in the polymorphs.[26]

The production of the Siberian animal plaques coincides with the rise to power of the Xiongnu khans through the late fourth and the third centuries B.C. By 200 B.C. the khans Tuman and Modeh had succeeded in creating a confederacy of nomad tribes extending from the Chinese frontier to Zungaria, the westernmost steppe occupied by a Turkic population. All the grasslands of the Mongolian steppe were under Xiongnu control, the Chinese recording a Xiongnu garrison even at lake Baikal.[27] The eclectic art of these hegemons might borrow from metropolitan China, but its general context remained that of the later Tagar culture,[28] whose technical tradition and burial customs descended unbroken from those present in South Siberia at an earlier time.

Through their association with Chinese objects two groups of Xiongnu products can be broadly distinguished. The most striking compositions of an earlier phase are oblong bronze plaques (ornaments of the belt and possibly of saddlery) filled with a bewildering medley of animal parts, the longer axis of the rectangle usually being the horizontal. A logic of the design emerges only from close examination. A frequent subject is a lean horse with rilled body, kneeling below the attack of two monsters shown only as frontal biting masks, or as masks accompanied by a pair of talons [136]. The monster hovers between the round-eared bear and the point-eared wolf. The outer parts of the field and the edge of the rectangle are formed of the detail of hooves and claws, and many bird-heads (round eye and head, slightly curving beak) fill other spaces. The whole is executed with multiple sharp ridges in imitation of kerbschnitt. Variants of this theme use openwork, increase the number of tightly packed bird-heads, variegate some important inclined planes of the surface with hachuring etc. Another well-known type is composed of

confronted horses raised on their haunches in a begging posture, with eagle muzzles, and provided each with a couple of small confronted dragon-heads over each horse-head, while the horses' backs are bitten by monster masks [137].

In both these classes of plaques the detail of the animals' bodies is strongly stylized into a system of curving lines supported by many short angular and spiralled strokes, in a manner quite individual in the corpus of animal art. Some of the designs are disposed in revolving symmetry, appearing similar when the plaque is turned through two right-angles. It is noteworthy that the plaques have not been invaded by the comma-shaped and piriform dimples imitating inlay which are frequent afterwards; nor, for all the complexity of the designs, is there any sign of the illegible confusion seen in some later work. One gains the impression that these Xiongnu plaques, like other categories described below, were the product of a single centre, spread by trade through Mongolia. Their like have not been found in South Siberia.

The absence of the Xiongnu type of plaque from the Petrine collection tends to confirm their Mongolian provenance, for Peter's perquisitions could not extend so far. One kind of plaque preserved in the Hermitage Museum does, however, connect with Mongolia: those know as *rho*-plaques from their asymmetrical contour, in which one of the animals rises dome-like over the other at one end of the composition. As a group the *rho*-plaques are thought to date after 200 B.C., although the Siberian specimens may be some decades earlier. The Siberian pieces, all in gold, show a fairly natural tiger seizing a much deformed deer (i.e. reversing the usual award of realism) whose back is lined with small eagle-heads; an eagle tears at a sheep's neck, while a bear (?), hardly noticeable in the flame-line of the kerbschnitt, merely looks on as bears will; eagle and wolf attack a tiger simultaneously; a creature compounded of horse, elk and eagle, whose head is at the centre of radiating antler tines formed of bird-heads on long necks, is under attack from a small feline. The compositions involving eagles have, in the one case, surviving inlay of turquoise applied at roots of wings, eyes, ears, hooves, and, in the other, empty cells prepared for similar inlay. Both may be cited as prototypes for the craze for inlay, often erratically scattered, which spreads to the steppe workshops after 200 B.C.

The last *rho*-plaque instanced above is remarkable, besides its exceptional polymorphism, by its finding in the Verkhne-Udinsk district of Transbaikalia. In addition to the triple character of the main subject, the latter has superimposed on its side ram-head, bird-head and all of a griffin except the legs. Such composition falls out of the context of *rho*-plaques and of the Mongolian style altogether. Since there is no earlier context for it in the eastern region, and nothing similar contemporary with it anywhere, the ornament may be suspected of deliberate archaism. Such archaism is encountered again later in Xiongnu practice, and it is tempting to follow an argument which connects this piece with the presence of Xiongnu persons in the camp at lake Baikal.

Other groups of the earlier Mongolian work can be singled out. Some ronde-bosse figures of deer, running at speed, couched or standing, are intended as free-standing figures or as pole-tops. In the east these have an archaic air, inasmuch as they neither reflect the style of the contemporary plaques nor resemble the couched deer in the 'emblematic' form which became common in South Siberia before 200 B.C.[29] As a pendant to this supposed western influence some openwork bronze ornaments may be taken to show indepen-

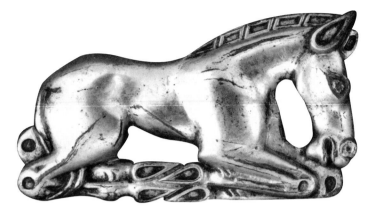

138. Gilded bronze hollow-cast plaque of a steppe horse. Second–first century B.C. Museum für Ostasiatische Kunst, Berlin. Length 13.9 cm

dent eastern invention. These combine snakes with other sketchily portrayed animals; and since the snake is ubiquitous in the art of the southern Chinese state of Chu at this time, one may suspect here an idea transmitted to the steppe along the western highlands of China. The compositions in which the snake figures are eccentric by normal Mongolian standards: paired intertwining snakes between camel-heads, a bird-headed couched deer set over a snake meander bearing a head at either end. Some plaques of single, more or less specific animals (wolf, tiger, monster), executed in fairly high relief, may briefly antedate 200 B.C., while two elegant silver belt-buckles in the shape of couched horses may join the naturalistic or pseudo-naturalistic work of the second–first centuries B.C. [138]. The latter remain, however, mysterious, being thus far the only silver pieces of this period known from Mongolia, and displaying elegantly rounded anatomy foreign to the usual Mongolian style.

In the second century B.C. the culture of metropolitan China is brought more closely, and as it were officially, into contact with elements of the art of Inner Asia. Political events reinforced the mutual influences across northern and western frontiers whose history we have sketched through earlier centuries. In spite of the defeat inflicted on the nomads in 214 B.C. by the Chinese north-western state of Qin (with the object of discouraging the nomads from making common cause with Qin's eastern Chinese neighbours) the Xiongnu confederacy went from strength to strength. The Dong-hu of the east, the Jiang in eastern Tibet, the Wusun tribes of outer Gansu and the inhabitants of the Sasyan-Altai uplands all acknowledged the rule of the Xiongnu khan. Until the beginning of the first century B.C. the latter was able to resist the attacks of the emperor Wu-di, who brought the full resources of a recently united China against the nomads; but in 50 B.C. the Xiongnu command collapsed, their forces being divided into northern and southern groups, and the Chinese had nothing more to fear from them. Already in the third century B.C. the Xiongnu had established large numbers of their tribesmen in the Ordos (the territory contained by the northern loop of the Yellow river and adjacent to the Great Wall), and the nomads continued to occupy this land after an accommodation was reached with the Chinese in the first century B.C. Meanwhile Xiongnu rulers and nobles had retired to the southern foothills of the

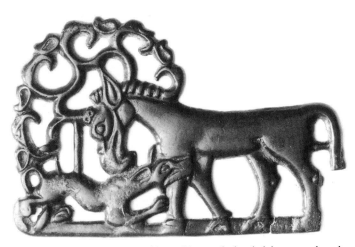
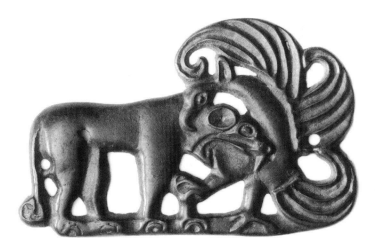

139. Two bronze plaques, wolf attacking eagle-headed horse, and eagle attacking tiger. First century B.C. British Museum. Length of both 12.1 cm

Kentel mountains on the border between Mongolia and Transbaikalia. The graves at Derestui on the Kyakhta river (a tributary of the Orkhov flowing into lake Baikal) contained bronze plaques of the full steppe character, while timber-built shaft-graves at Noin-Ula on the upper course of the Kiron (some hundred kilometres north of Ulan Bator) have yielded abundant material to illustrate a luxurious art in which Chinese design and Chinese-influenced design are included with steppe motifs.[30] The surrounding population was now largely settled and agricultural. These developments in the east coincide broadly with the expansion of Sarmatian tribes in the far west and the Sarmatian occupation of south Russia. East and west, a third phase of steppe art may be defined as beginning around 200 B.C.

Chinese plaques with animal design of the third phase, unaffected by civilized contacts, are numerous in museum collections, where they have usually been designated merely

'Ordos bronzes'. They are almost without exception undocumented finds, and while it is certain that the majority come from the Ordos or from the adjacent parts of Inner Mongolia, they represent a style extending to eastern and central Mongolia and to South Siberia [139]. Continuity with the earlier Mongolian phase is made clear by the *rho*-plaques, this outline being retained even when the content is different, e.g. a horse with griffin-like muzzle, attacked by a wolf, the head surmounted by a fan of pseudo-antler tines composed of bird-heads on long necks. But a more normal subject is the attack by a predatory on a pacific animal, the conflict placid enough to suggest that the reality of the theme was at a further remove from the artist's experience than it had been in ealier times. Horses are shown grazing or fighting [140], yaks (*Bos grunniens*, and hardly the wild variety) paired peaceably, eagle and wolf attack a horse simultaneously, tiger masks bite at a horse's back. It is likely

140. Bronze plaque of fighting horses. First century B.C. British Museum. Length 12 cm

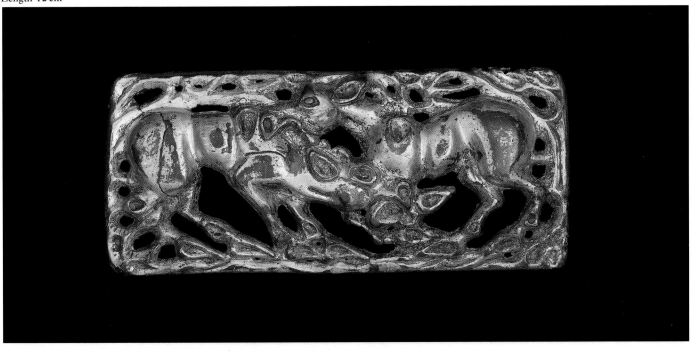

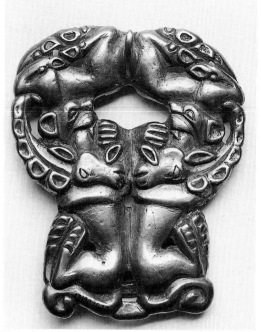

141. Gold buckle plaque: two felines attacking ibex. Third century B.C. Metropolitan Museum, New York. Ht 6.7 cm

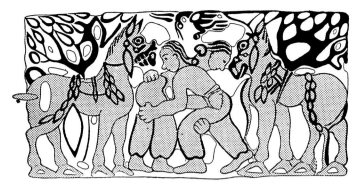

142. Rendering of design on a bronze saddlery ornament: bronze plaque of horsemen wrestling between their steeds, from Keshengzhuang, Shaanxi. Late third or early second century B.C. Ht 7.3 cm

that these subjects were treated in regions of more or less settled farming along the foothills of the northern Mongolian boundary, and simpler versions of the animal themes were still in fashion in the traditional nomad haunts of north Shanxi and Hebei.[31] Elsewhere the subjects and style of the third or early second century B.C. may show a more traditional trend, as at Jungar Qi in the Ordos, where couched deer, griffin-headed quadrupeds and extremely formalized animal-attack subjects, as well as horses, were depicted in repoussé gold leaf, and in-the-round figurines of goat and deer were cast in bronze.[32] Plaques worked in kerbschnitt flame-line can be separated from a more numerous group with smoothly rounded relief, but both classes have the hallmark of third-phase style in the comma-shaped and piriform dimples scattered over the design. Openwork multiplies the contours, but the line is now relaxed and elegant, the old fire departed.

A host of small animal figures accompany the plaques. Deer, rams and horse appear in profile without a frame, felids and bears are conventionalized to join the minor ornament of florets and serpentine lines. Even within the Chinese border none of this appears to be under influence from metropolitan China, for this might be expected to have induced an avoidance of symmetry. Extreme reduction of form, peculiar to the eastern steppes, may produce a barely legible structure of unrelated heads and limbs. An outstanding piece of this class is cast in gold, made symmetrical to serve as a buckle-plate, with compact folded bodies of horses and tigers surrounded by a halo of hoof-shaped dimples [141]. The interest in naturalistic portraiture finds its fullest expression in some plaques representing scenes from story or legend of which there is no other record. Among the best-known is a gold openwork plaque in the Russian imperial collection which depicts a warrior lying on his side beneath a tree with drooping leaves. The warrior's head reposes on the lap of a Mongol lady whose head is

drawn in profile, surmounted by a tall cylindrical cap. She is looking across at a seated broad-faced retainer who holds two horses by the bridle, on the foremost of which the saddle and head-straps are clearly modelled. The warrior's quiver-cum-bowcase hangs on the tree behind him. Such pictorial art of ancient Mongolia, known now from only a handful of pieces, maximizes the increasingly realistic style which spread through the eastern steppes in the third phase. A date is suggested by one specimen in which two men are shown wrestling while their horses stand facing from either side, the space above filled with tree-branches. The composition bears the tell-tale scatter of piriform dimples (apparently indicating leaves festooned illogically over the horses' bodies) whose second-century date is corroborated at the find-point: a tomb at Keshengzhuang in Shaanxi which intruded on a fourth–third century stratum [142].[33]

Although the bronzes we have described record the styles and subjects of the steppe art, its abundance and colour can be glimpsed only at a few places where soil and climate have combined to preserve examples of work executed in softer materials. The contents of the Pazyryk kurgans show dyed felt as the medium for highly wrought treatment of the prevailing themes. Noin-Ula tombs are comparable in their fortuitous preservation of perishable materials and the range of artistic subjects represented, with corresponding signs of contact with metropolitan China and with Achaemenid and Parthian Persia. Silk and wool textile, wood, lacquer, fur and felt were preserved together with bronzes and pottery. The tent hangings from the sixth kurgan depict in brilliant coloured embroidery (red, green, yellow, brown) such motifs as a griffin assaulting an elk, a quadruped monster assaulting a yak, a dragon with griffin traits, all these sufficiently resembling the Pazyryk felts to indicate a tradition carefully maintained. A silk from the twenty-fourth kurgan, embroidered with a Chinese-looking dragon adapted to steppe taste, is claimed to be an import from China, while a silk with tiger and deer scattered through a tight cloud-pattern, in the Kondrat'ev kurgan, is certainly a metropolitan Chinese weave. Other wool embroidery, mainly accompanying the embroidered attack scenes in the sixth kurgan, appears to be local work inspired by Chinese flowered and embroidered weaves, figuring fish and tortoise among water-weeds, quatrefoils and stylized fronds. Tiger masks repeated on a ground of tiger stripes make a most original design [143, 144].

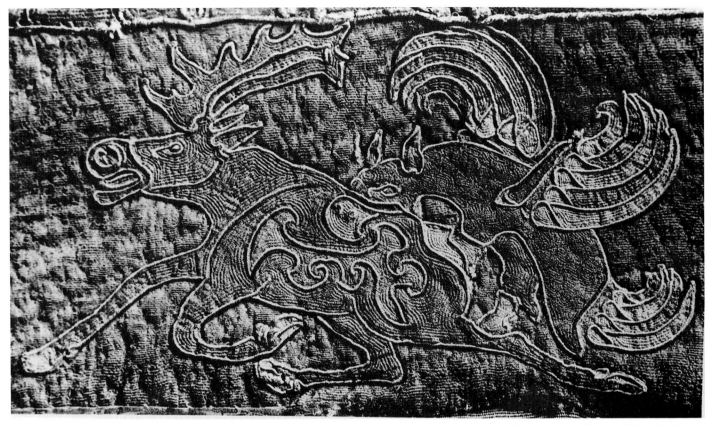

143. Symplegma of griffin and elk embroidered on felt, from kurgan No. 6 at Noin-Ula, Inner Mongolia. Fourth–third century B.C. State Hermitage, St Petersburg

144. Dragon embroidered on silk, from kurgan No. 24 at Noin-Ula, Inner Mongolia. Fourth–third century B.C. State Hermitage, St Petersburg

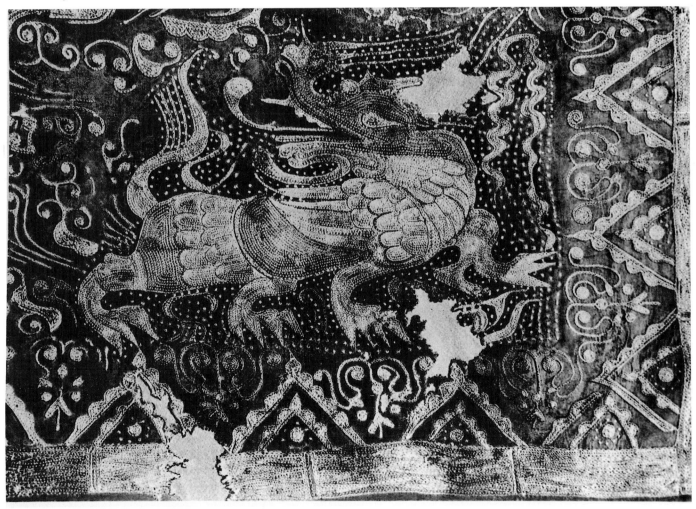

The contents of these tombs span the duration of the Western and Eastern Han dynasties. The approximate date of the sixth kurgan in the early first century A.D. is assured by its inclusion of a lacquered wing-cup of the type distributed by the Chinese government as diplomatic gifts, here dated to A.D. 13. The embroideries with attack scenes, steppe motifs *par excellence*, are more likely to be later reproductions, more or less contemporary with the kurgan, than the work of fourth-century date which they appear to imitate. Only the first kurgan, holding a composite jade *bi*, may precede the sixth by a century or more. Still in the sixth kurgan, embroideries depicting soldiers standing by their horses, and portraits of warriors' heads in three-quarters view, certainly copy the realistic style of contemporary mural painting in Parthian Iran. Smaller items point in the same direction: flying birds, formal 'jewelled' borders, a winged griffin *passant*, recall the like in the Hellenistic–Iranian repertoire of the last centuries B.C. A boy holding a shield stands in a corolla of petals—a theme to be matched in surviving Central Asian painting of the third–fourth century A.D.; a similar connexion can be made with the floral weaves from the Kondrat'ev kurgan, of *ca* 200 A.D. Granulated gold jewellery from the twenty-third kurgan (a small hemisphere set with garnets, a bull-head and a cylindrical pendant) must be seen as imports from the Bosporan kingdom, specialist in such items, in a trade which also reached Han China. They determine a date in the second century A.D.

The artistic events of the third phase of the steppe tradition accompany the *pax Sinica* achieved from the mid-second century B.C. The Xiongnu kept in touch with the Yuezhi after their sudden westward retreat, with the Wusun, and with the Sogdians who mediated between them and the Parthians. In contacts between the Xiongnu magnates and the rulers of these peoples diplomacy and gifts came to replace armed conflict. All parties reacted to the Chinese

145. Parcel-gilt bronze leopards inlaid with silver and garnets, from the tomb of princess Douwan in Mancheng-xian, Hebei. Late second century B.C. Ht 3.5 cm

advance and had an interest in profiting from the traffic which took Chinese silk as well as Chinese armies as far as Sogdia. Sogdian merchants hung on to the east–west luxury trade from this time until the eighth century. Some exceptionally finished animal figurines of the early Han period inherit from Mongolia a vigour and immediacy which mark them off from earlier, more static metropolitan styles.

Cultural Unity. The Han Empire

The effect of the unification of China achieved by Shihuangdi ('First Emperor') of Qin in 221 B.C. can be followed in art as in other branches of intellectual life. From the founding of the Han dynasty in 206 B.C. China enjoyed four centuries of comparative peace. Short interruptions by civil war did not alter the extent or method of central control. In the seven years of the initial Han rivalry with a reviving Chu state (earlier crushed by Qin), power emanating from Hubei and Hunan on the upper Yangtze was eliminated. Nevertheless under the Western Han the craft already long established in this area continued to set standards of decorative style farther east and north-east in the metropolitan region of the empire.[1] Five years of war preceded the establishment of the house of Xin under Wang Mang, whose reign from A.D. 8 to 23, despite the ruler's obsession with magical practices, saw a further entrenchment of Confucian ideology in the official class. Previously this philosophy had aimed at adjusting government to the very precepts of the master. Under the Eastern Han it was recognized however that the Confucian tradition, preserved in writings now avidly sought and edited, described only a utopia against which reality might be judged. Parallel to conventional Confucianism, and overlapping with it in the minds of the intelligentsia, were Daoist-orientated theories of a physico-spiritual cosmos, based upon the duality of *yin* and *yang*, or the cyclic functions of the five elements, *wu xing*, or the influence of astronomical space-powers. All of these branches of thought carried with them a pictorial component which might influence art at all levels. The decline of Han government began in A.D. 184 with the rebellion of the Yellow Turbans. At the fall of the dynasty in A.D. 220 the political and ideological unity which characterizes the Han epoch was lost. The empire was divided and art began to respond to new frontiers and new philosophies.

In earlier periods the restriction of the surviving evidence to funeral gifts controlled by stringent custom, and the logic of the art forms themselves, made it convenient to separate the discussion according to the craft materials. In the Han period however analogous trends of style are more readily traced through various media. Pictorial subjects increase and more clearly reflect social and political contexts. One may broadly divide between design which is, to varying degrees, realistic and based upon observation and design which is either non-figural and ornamental, or subordinates real form wholly to ornamental concepts. Neither manner is wholly exclusive of the other, and the two may figure jointly in compositions, but the origins and the development of each are somewhat distinct. The applications of the two styles, separately or in combination, appear already largely defined at the beginning of Western Han, and there is little change of principle through the following three centuries. In Eastern Han, particularly in the latter half of the second century A.D., forms of a stylized realism are very fully documented. Throughout the Han period, realism in human and animal

portraiture meant the instantaneous impression of life given by captured movement and tense posture, usually a single forceful movement and a stance of unmistakable meaning. The designs so based were often simplified to a degree bordering on the abstract. Conversely, facsimile naturalism was seldom attempted by the artists of the metropolitan region, and when it occurs stands in marked contrast to general trends.

DRAUGHTSMANSHIP BEFORE HAN

Styles of drawing and painting of the pre-Han period are to be inferred indirectly from their imitation and reflection in craftwork; while the originality of craft design, particularly in lacquer, undoubtedly exercised influence beyond its own limits. In portraiture, where the demand for realism was greatest, three manners appear. One composes with the deliberate uniform line which is the hallmark of Chinese draughtsmanship in all periods. Another divides the subject into areas sharply defined but less linear in rendering; and a third depends on the employment of a soft brush which allows variation in the breadth and emphasis of the line. The *areal* type of composition is best documented in the second century A.D., when as practised in Shandong it affords a glimpse of contemporary mural painting, but its ancestry must reach far into the pre-Han period. Winged immortals and a dragon master painted in red, yellow, black and silver lacquer, from a tomb at Xinyang (south Henan) of the late fourth or early third century B.C., adopt this style, and may preserve the record of large-scale murals [146].[2] A purely linear style is seen in two paintings on silk, from tombs at Changsha (Hunan) of the same date. Slender lines, straight or broadly curving, depict long-robed persons in side-view in the company respectively of phoenix and dragon. A well-practised hand is implied, but since there is no variation in the weight of the line the instrument is likely to have been a reed-pen rather than the writing brush.[3]

DRAUGHTSMANSHIP AND PAINTING UNDER THE WESTERN HAN: HUMAN AND ANIMAL FIGURES

Scenes painted on the so-called silk banner from the Mawangdui, tomb of the Lady Dai at Changsha (Hunan), of the mid-second century B.C., show a full painting style, with detailed accuracy in human figures and objects, and for the first time with attention to the illusion of space [147]. The lady and her attendants are depicted standing in strict side-view, drawn in the delicate uniform line described above from the earlier Changsha painting, but with smoother and more varied curves. Within the outline only the eyes are indicated. A broad brush has then been used to colour the areas so defined, and a finer brush to give the scrolling

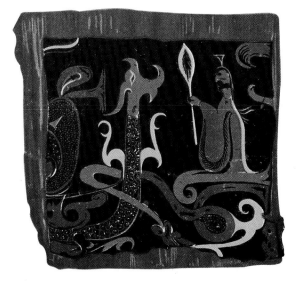

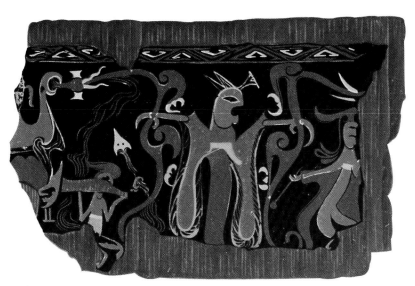

146 a and b. Mythological figures painted in coloured lacquers on a *sê* lyre, from Xinyang-xian, Henan. Third century B.C. Width about 10 cm

147. Detail from the silk banner from the Mawangdui at Changsha, tomb of the Lady Dai, who appears with her servants over a scheme of knotted snakes and human-headed birds. Mid-second century B.C. Ht of the detail about 50 cm

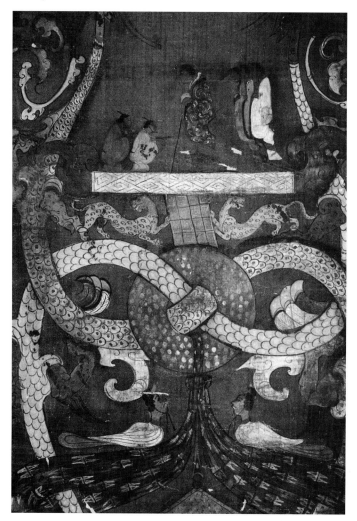

and tapering lines of the ornament on the lady's robe. In particular the ductus of the latter suggests the calligraphic control of the brush which appears afterwards in most draughtsmanship, establishing the link between writing and painting which is recognized in all later tradition. In only one face is any attempt made to render the three-quarters view. The kneeling figures are échelonned one behind the other in the altar scene, and the standing figures of the main scene also imply the perennial principle of later Chinese composition, the lower-placed being nearer to the viewer. The small animals and monsters scattered on the banner and decorating the sides of the wooden coffin show aspects of animal portraiture which were to endure: the figure reduced as far as possible to continuous curving line, with more or less violent movement, hence life, indicated by tension or contortion of trunk and limbs.[4]

Fragments of a lacquered *lian* of the first century B.C. found in Jiangsu show the human figure treated in the linear style just described: a long even line, a minimum of detail, emphatic gesture and movement.[5] This lacquer is likely to have originated in Hubei and to reflect a tradition already long practised there. In contrast to this, the medley of animal and human figures painted on plastered brick in a tomb of the late first century B.C. near to Luoyang in Henan, most likely represents a style localized in that province [161].[6] The tomb is the largest and best-preserved monument of Han polychrome painting so far discovered. In the upper panels of a false gable located in the middle of the tomb chamber, figures of deer, monkeys, snakes, tigers and bears show the characterisitc curvilinear distortion and the *areal* analysis of shape at their full expression. Within the outlines detail renders animal fur, scales, men's whiskers, peacock's eye feathers. On a pair of winged horses muscle marks on the haunches repeat a convention of Inner Asian nomad art, here converted to fragments resembling the cloud motif described below. In an oblong panel below this farrago is a horizontal row of thirteen male figures whose style resembles that of the Jiangsu lacquer. The sweep of the brush, rather than the weight of line the detail of the subjects might demand, takes charge of the variously curving lines. Faces are in three-quarters view, two figures are confronted in

histrionic pose, others make emphatic hand gestures. The scene is tentatively interpreted as the story of three warriors who fought to mutual extinction over the gift of two peaches offered to them at a feast by Jing duke of Qi. There is much in these compositions which anticipates the work of the Shandong school of the second century A.D. as described later (p. 96 ff).

THE INHABITED SCROLL

In the Qin period and during the first two or three decades of Western Han, design stemming from the pre-Han geometricizing art is transformed. The schemes are invaded by frilled (wavy or fluted) additions which finally eliminate the rectilinear element. The result is the combination of contrary curves, repeated in clumps at intervals, which constitute the 'cloud pattern' of early Han art, seen at its most accomplished on lacquer. Stages may be defined in the process. At the end of the third century the geometric element is slight on some pieces but complete on others.[7] At about the same time was adopted ornament inhabited by small realistic figures of men, animals and their transmogrified equivalents. At first a few hunting dogs are attached to geometric schemes.[8] In the last decades of the second century B.C. the new formula is established in its fullest expression, as it appears in parcel gilding on a *hu* from the Mancheng tomb instanced below. In painting it is seen on a *lian* from a Jiangsu tomb [148], and on black-red painted *hu*, bowl and cylindrical box, from a tomb in Fuyang-xian, Anhui, works which must represent the industrial norm of the new style. As well as visual pattern is able, the massed swirling movement, punctuated seemingly at random by precise vaporous knots, interprets a notion ubiquitous in later Han poetry: a soaring through space to the empyrean, conveyed in a maze of words rivalling the complexity of the painted designs.[9] A staider treatment of this ornament is also found, still of Hubei origin, but the rapturous manner, with its free brushwork and calligraphic elegance, established the fashion for the bowls and boxes whose possession now advertised official favour and social distinction. The schematic ornament used on the lacquered platters of the Mancheng tomb in Hebei shows the frilled and spiralling shapes of the Han cloud motif at an early stage of its development.[10] The herons in procession with fish are in the Hubei realistic idiom. Small human and animal motifs – crane, phoenix, bull, deer, dog, bowman, spearman – are found on a Changsha *lian* combined with geometric ornament of a pre-Han kind. The true Han manner is established, however, when living motifs are fitted into cloud scrolls, as instanced above from the Mawangdui coffin-board. The scrolling may be enlarged into an eye-cheating maze that fills a wide field, or treated briefly and allusively as a small adjunct to the lively inhabitants of the design. Another style of Hubei lacquer extending through the Qin period into Western Han is demonstrated from tombs in Yunmeng-xian to the east of Jiangling. Here the animal drawings – galloping horse, romping felines and an eccentric *feng* – are enlarged to fill the sides of *pianhu* flasks. Touches of strange fantasy decorate flasks and cylindrical boxes, spiralled motifs on bowls and *erbei* turn into plant tendrils or join with cloud clusters [150]. An outstanding example which escapes from industrial routine by

148. Lacquered box, *lian*, decorated with inhabited scrollery, from Yangzhou, Jiangsu. *ca* 100 B.C. Ht 21.5 cm

149. Gilded bronze double cup with turquoise inlay, surmounted by a fabulous bird, from Mancheng-xian, Hebei. Late second century B.C. Ht 11.1 cm

its spontaneous brushwork is painted on an end-board of the coffin placed in the Mawangdui tomb. Here the tighter cloud scrolling of the frame overflows into the much freer scrolling of the main field. The minutely painted inhabitants of the scrolls are animal-headed human huntsmen, phoenix and various monsters approximating to deer, perched on the lines of the scrolls or careering through space.[11] After the profusion of this work in the earlier second century B.C. came apparently a period of neglect, and when scrolled ornament was revived in official workshops towards the end of the first century B.C. it wears an archaistic air. The character of this repetitive ornament even in the earlier period implies the creation of pattern books, with the diffusion of sets of motifs from particular workshops.

Apart from the inhabited scroll, animals in side-view – tiger, dragon, phoenix, in sinuous line or in equivalent silhouettes – became a widespread stock-in-trade in the two-dimensional decoration of pottery and bronze after the mid-second century B.C., and corresponding models were created for three-dimensional ornament [145]. Impressed on the hollow bricks used in tomb building tigers and dragons are confronted stiffly in a narrow horizontal frame, usually either side of a *bi* ring; but this stereotype may be broken, as in a pair of silhouetted tigers which prowl or spring asymmetrically.[12] In bronzework the older and the newer traditions seem to intermingle. The princely tombs at Mancheng in Hebei contained bronzes of pre-Han style (inlaid vessels, zoomorphic harness pieces etc.) laid alongside others with animal realism comparable to that of the Mawangdui drawings [149]. There can be little doubt that the Mancheng bronze ornaments are the product of Hebei or Henan, but the lacquerware is likely to represent export from Hubei workshops.

The history of the inhabited scroll runs parallel to that of the inhabited landscape. Cloud scrolls might reach chaotic dispersal.[13] When they are more disciplined and subordinated to the men and animals they all but coincide with a convention of fantastic mountains.[14] Stylized curvilinear crags frame wholly realistic items (bear, tiger, wood-gatherer's cart etc.) on the bronze *boshanlu* censers; and by *ca* 100 B.C. the lacquer painter too succumbs to the general interest in mountain landscape as a theme of ornament. In the landscape the painter and the bronze engraver scatter elephant, deer, peacock, tiger, men in the bull-leaping performance or the hunt conducted from a chariot. These subjects are separated by brief passages of cloud pattern and by craggy hills similarly drawn, the whole approximating to the scenic convention of the contemporary *boshanlu* made in both bronze and pottery [156]. On a gilded bronze wine warmer of 26 B.C. deer, camel, tiger, birds and Chiyou figure in relief amid the briefest suggestion of clouds and crags.[15] The Hubei lacquer school may indeed have borrowed the principle of inhabited ornament from such Hebei bronzework. After 100 B.C. similar ornament appears on pottery 'hill jars' and ornamental bricks displaying mountains and pacing felines.[16] A Shaanxi lacquer *lian* of the last quarter of the first century B.C. sets among crags and cloud tiger, peacock, elephant, bull-leaping braves, hare, goose, carriage-borne bowman, all depicted in what is now a well-established realistic idiom.[17] The figures are virtual

150. Ornament in red, brown and black of lacquered flasks, from Yunmeng-xian, Hubei. Late third–second century B.C. Heights: upper 24 cm; lower 32 cm

silhouettes, with minimal linear detail. At this time linear draughtsmanship is combined with the *areal* manner and transferred to stone. Due for great elaboration in Shandong in the Eastern Han period, this stone engraving may be said to retain a link to lacquer craft. After *ca* 50 B.C. the clouds might surround a large bird in flight, variously elaborated to represent the sacred *feng*.[18]

In the early first century A.D., at workshops continued or founded under the Eastern Han dynasty, the theme of the inhabited landscape has spent its force; the line becomes less assured and the detail less legible. On some pieces its place is taken by a relaxed design of larger tiger and dragon *passant* against an insignificant background.[19] Exceptional among the lacquer designs of this time are examples of a free fantasy which takes small parts of the usual geometric motifs and cloud pattern, disconnects them and rearranges them sparsely on a clear ground, with Klee-like effect. This decoration seldom appears on pieces other than *erbei* wine cups, where its confident use confirms it as an established style, infrequent though it is in comparison with the other schemes.[20] Even rarer among the excavated lacquers is the inclusion of real-life human figures. An example comes from a tomb in Jingmen-xian, near to Jiangling, where a cylindrical *lian* has around its sides scenes of fine ladies and gentlemen in side-view and back-view, and two-horse and three-horse carriages (some preceded by runners), much-stylized willow-like trees separating the groups. A richer palette is used: red, yellow and blue, and it is probable that different hands worked on this combination of figural decoration on the side of the lid and elaborate symmetrical geometric on the rest of the side and the lid of the box. The *lian* was accompanied by other lacquered pieces, already instanced (p. 83), which mark the acme of achievement at the Jiangling workshops: a double beaker arranged around a phoenix (a jewel in its beak, the tail a projecting handle) whose sides are decorated in low relief with unique geometric interlace painted in red, yellow and blue; a cosmetics box allusively zoomorphic, and a horn-like object of intertwined serpents spaced in openwork.[21]

What is said above of regions of production and schools of style is based upon the geographical distribution of the recorded finds of lacquer. From about the mid-first century B.C., however, a light of written history is thrown upon the subject. The notice of lacquerwork contained in the *Hanshu* (the history of the Western Han dynasty compiled in the first century A.D.) combines with information given in inscriptions engraved on the lacquer to provide some exact points of locality and age.[22] In central Sichuan was situated a 'Western Factory of Shu Commandery' whose surviving products range from 85 B.C. to A.D. 71. The activity of another factory at Guanghan in Sichuan is recorded by inscription from 43 B.C. to A.D. 54; and a commentary on the *Hanshu* text mentions three state-owned factories under the control of a prefectural governor: Inspection Factory, Right Factory Hall and Eastern Garden Craft. The decoration of the cups is similar at the Western Factory and the Guanghan factory, both placing stylized confronted birds in simple symmetrical geometry, but the former paints with a thick line to produce a rich effect of crimson, brown and yellow, whereas the latter's delicate line more resembles the old Hubei style.

Evidently the makers were charged with reviving former styles as part of an official archaism. The cups had their part in Han cultural propaganda, being sent as gifts to Chinese representatives on the frontiers and in the Lolang colony in north Korea, and to Xiongnu chieftains ruling in the north-western steppes. The inscription on the cup in the British Museum (cited above in Chapter 6 [121]) records the division of labour in the workshop and something of the bureaucratic control of production[23]:

> 4th year of Yuanshi [A.D. 4]. Shu commandery, West Factory. Imperial cup of wood, lacquered engraved and painted, with gilded handles. Capacity 1 *sheng*, 16 *yue*.
>
> Initial work, *Yi*. Application of lacquer, *Li*. Top work, *Tang*. Gilding of bronze handles, *Gu*. Painting, *Ding*. Engraving, *Feng*. Finishing, *Ping*. Production, *Zong Zao* [?]. Official in charge of the soldiers of the factory guard, *Zhang*. Manager, *Liang*. Deputy, *Feng*. Assistant, *Long*. Head Clerk, *Baozhu*.

The titles in the inscriptions read like inventory headings, and do not always correspond exactly to the features of the cup on which they are engraved. The material of the base is wood, as in the British Museum specimen, and, as far as can be ascertained, in all the lacquerwork of earlier date. But the wood might be combined with textile, or in some cups wholly replaced by it, as inscriptions indicate: 'lined with hempen cloth', this proving in analysed fragments to be hemp or ramie. The archaism of official lacquers was abandoned towards the middle of the first century A.D.: it is absent from a circular tray made at the West Factory in A.D. 69, on which a small part of the otherwise plain field contains realistic vignettes of deer and celestial beings.

The glimpses which lacquers afford of change in conventions of the human figure are enlarged by two more expressive works which also bracket the last decades of Western Han with the opening decades of the first century A.D. The celebrated 'painted basket' excavated at the Chinese commandery of Lolang near to P'yongyang in Northern Korea is decorated with rows of seated men whose style epitomizes an old manner: heavy curving lines and large areas of colour for the robes, fine lines for faces and hands [151]. Retrospective in technique, the pictorial purpose is new. The men are in animated conversation and so necessarily occupy space, this emphasized by the obliquity of arms and legs thrust forward and of a screen placed behind one of the figures. A differing draughtsmanship is seen on paintings of men equally engaged in mutual talk and gesture which decorate bricks forming a gable and lintel preserved in the Boston Museum.[24] Here the brush style resembles that described above from the Luoyang tomb, with which it is nearly contemporary in the later first century B.C., but is put to better effect. Variation in the width and ductus of the line interprets the weight of the robes and the poise of heads and bodies. Some of the men are caught in dramatic movement, all wear court robes and headgear and carry tasselled wands of unknown ceremonial meaning. The line of the painting is black, the outlines are filled with uniform red, purple and grey, all on a white ground. While the basket figures fill a capsule of space strongly indicated, the positions of those on the bricks imply a base plane and some recession not

151. Detail of the celebrated 'painted basket', coloured in red, green, brown and yellow on a black ground, from Lolang, North Korea. First century A.D. Length of the basket 29 cm; length of the portions shown about 18 cm

otherwise brought out in the design. Location in space, on principles recognizably ancestral to later painting style, particularly with the adjustment to this end of an inflected brush line of varied width, is another feature of the realistic style.

NATURALISTIC MODELLING

Before following the modified realism of the draughtsmen into the Eastern Han period two remarkable phases of realistic *modelling* claim attention: one in west China at the tomb of the first Qin emperor, and the other, remote geographically and culturally, in the Dian kingdom of Yunnan. The former deals with monumental statues, full-

size soldiers and horses, and the latter with small bronze models of persons and animals. Utterly disparate as these practices are, they share a status outside of the mainstream of Chinese art, inasmuch as they make their aim the exact imitation of living forms, a verisimilitude free from the graphic decorative bias of the metropolitan styles. Shihuangdi of Qin was buried in 210 B.C. under a mound that remains the most imposing of the Chinese inperial tombs. It is shaped like a four-sided, three-stepped pyramid, reaches a height of 141 feet and is surrounded by a double-walled precinct measuring $1\frac{1}{4}$ miles north to south and half a mile in breadth. Sima Qian tells us that the tomb contains a stone map of the empire on which flowing mercury represents the 'hundred rivers'. He makes no mention of the

152. Head and shoulders of a pottery soldier from buried gate guards of the tomb of the first Qin emperor. Late third century B.C. Life-size

153. Bronze plaque: attack by wolves (?) on a caprid, from Shizhaishan, Yunnan. First century B.C. Width 15 cm

pottery effigies of soldiers and their mounts which were buried in huge timber-framed pits at entrances to the precinct. Recent excavation has shown three of these pits to contain a total of more than 15,000 of such statues, together with bronze weapons and the remains of wooden chariots [152]. In the best restored specimens the life-like faces and the imposing soldierly stance are impressive, but the size of the performance and the accuracy in dress and armour engage the viewer more than sculptural quality. The statues are composed of separate heads, trunks, hands and legs. The success in firing these pottery parts with so little fault, the implied dimensions of kilns, the vast requirement of clay and fuel, say much for the efficiency of the ceramic industry of the late third century B.C. Inexplicably there appears to have been no sequel to this enterprise, the tomb figurines of soldiers and servitors consigned to Han graves bearing no artistic or technical relation to their life-size predecessors.[25]

The art of the Yunnan kingdom of Dian, so fully known from the bronzes excavated on a royal necropolis at Shizhaishan near to Kunming, receives mention here as the outstanding instance of a wholly independent tradition established on the very border of the characteristic Chinese sphere. A dynastic fiction was propounded already in the Han period to account for the presence of cultural achievement among the tribes inhabiting Yunnan. The submission of Dian to Chinese arms came only in 109 B.C., whereupon the Dian king was given court rank under a Han practice of

ensuring the adherence of frontier peoples whose territory was not yet controlled in the regular manner. A technical difference is significant: in casting by the *cire-perdue* method, Dian bronze art exploited the freedom of wax modelling more fully than the contemporary craft of metropolitan China. The distinctive feature of the culture is the ubiquitous decoration of both ritual and utilitarian pieces with animal and human figures modelled with extraordinary naturalism [153, 154]. On drums (or 'cowrie holders', for such was their purpose in the burials) and house models are composed crowded scenes of persons assembled on ceremonial occasions. At their best the figures so closely copy reality, facial features and accoutrement, that anthropologists have had their field day in identifying the various types with the diverse tribes recorded in Sima Qian's history. The animal figures are executed in the round or as plaques in high relief, and the observation behind them is still more impressive, the equal or superior of any animal portraiture known from the ancient world. The tigers, bulls, boars are

154. Bronze plaque: leading the sacrificial ox, from Shizhaishan, Yunnan. First century B.C. Width 15.5 cm

155. Detail of a bronze chariot fitting inlaid with gold and silver, depicting real and fantastic animals among hills. Second–first century B.C. Formerly in the possession of Messrs Eskenazi. Total length of the tube 26.5 cm

shown in their natural movement and aggression, tension of muscle and strain of effort made manifest. Through all the art runs an interest in the genre scene: crowds at a sacrifice, soldiers in battle, dancers and singers in ordered bands; the animals may be treated playfully: monkeys or foxes joined by their tails around circular ornaments, snakes involved as the ground line in animal-attack subjects and in the ritual procession with a bull. The nature of the ceremony and animism which inform this art – apart from the general theme of offering and sacrifice – can only be guessed at. Chinese imports included in some burials indicate that the earliest Dian tombs must belong to about the mid-second century B.C. The origins of the accomplished form in which the art emerges are unknown; when full Han rule was imposed in the early first century B.C. and the import of Han goods increased, Dian culture vanished.[26]

Iconography under the Western Han

As it appears towards the middle of the period Han iconography leads in many directions. Some of the stock figures have roots in ancient superstition, and their revived use symbolizes some ritual observance, or is associated with actual performance.[1] Other motifs appear for the first time. A studied elaboration of the icons in various artistic media occurred from the middle of the second century B.C. to the end of the second century A.D. Ancient motifs which had survived in artistic use until the end of the Warring States retained their force and were variously adapted, and explicit meanings previously lacking literary expression were attributed to both ancient and newer motifs. The new group included real human and animal figures, imaginary animals and fairy beings, landscape (or at least a mountain shape), constellations, the heavenly mansions, the courses of planets, scenes of entertainment, subjects from established ancient or recent moralizing literature. Some items were depicted realistically, others in the abstraction characteristic of the schematic tradition. The diverse interests presiding over this process are readily identified, in collaboration or in rivalry: the Confucian moralist, the Daoist theorist inseparable from the astronomer, the governor and official. The silk manuscript of the fourth century B.C. recovered at Changsha, with its crude illustrations of grotesque spirits, certainly indicates the pre-Han existence of an iconography of the soul's journey after death, against whose dangers the text gives warning.[2] There is no sign however of any similar coherent body of beliefs in the representations of the Han period, although all the cautionary bogles of tradition are likely to have been included in the *Shanhaijing* anthology cited below.

Important for the genesis of art is the sign of Han innovation of important themes, of which a telling example occurs on the *boshan* censer cited above from the tomb of Douwan (p. 84), dated shortly after 113 B.C. [156].[3] Three of the animals encircling the censer are recognizable legacies from the past: bird, tiger, dragon; but the fourth is most unusual, a camel, badly drawn. The sequence of the animals, as one looks down on them from the top, taking the bird to mark the south as it has done in pre-Han times and continues to do in Han later schemes, places the tiger – biting the bird's tail – in the east, and the dragon, primordial symbol of the east, in the west. Literary reference to the four sacred animals confirms an uncertainty about the symbol of the north which was to persist through the whole period. *Xuanwu* (dark warrior) was a term for the seven starry mansions of the northern heaven, the origin of the name unexplained, and its date of adoption probably not earlier than the second century B.C. It ran parallel with another idea, that the north was aptly represented by a tortoise. The tortoise, anciently sacred through its connexion with divination, and now favoured by some Daoists 'because it could hold its breath so long', and for a sexual connotation, was given a prime place by early Han theorists in doctrines of *shen* and *xian*, sacred animals and immortal persons.[4] Typical of Han rationalization was the theory that *xuanwu* must mean a northern (*xuan* = dark = northern hemisphere) warrior and therefore a Mongolian type, wearing scale-armour: hence the scaly snake which was presently wrapped around the tortoise to produce a lasting version of this symbol; and in later versions the whole warrior is sometimes portrayed. It is possible also to interpret the *xuanwu* as a single entity, a snake-like tortoise rather than two animals.[5] The Mancheng censer makes a capricious choice. A different set of motifs, not all explained, furnishes the ornament of a *boshan* censer in the Freer Gallery: above an animal attack a man leads his horse and cart through the mountains [158]; a spearman defies a raging bear; a bowman aims at an animal standing below a stylized tree [157]. On a *lian* in the same museum numerous animals course over the hills. There is only proximate reality in the outlines, and the distribution of the animals and the brief horns and wings

156. Bronze censer, *boshanlu*, from the tomb of princess Douwan in Mancheng-xian, Hebei. Late second century B.C. Ht 32.4 cm

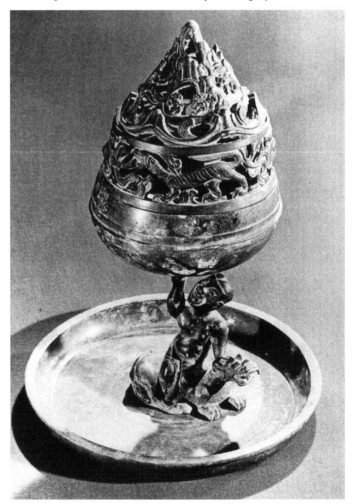

157. Detail of a bronze *boshanlu*: man defies bear. Second century B.C. Freer Gallery of Art, Washington. Height of detail about 4 cm

added to some fail to suggest a particular iconographic prescription.

Many of the figures of the iconography suggest stylistic comparison with the animal art of the northern and north-western nomads, and influence from the barbarian tradition has often been sought in them. Neither the character of the animals nor their shapes are however paralleled in steppe art. The smooth line of the tiger on the Mancheng censer can be matched in Henan bronze of an earlier period, and appears on other bronzes of the Mancheng tombs. It is to be presumed that all of them are the product of a nearby workshop, in Hebei itself or in neighbouring Henan, under Zhongshan state patronage, where an individual style was well established during the second century B.C. At this time

158. Detail of the *boshanlu* in ill. 157: woodman's cart and an animal fight

the true nomad tradition was already entrenched in north-eastern China, and it is possible that the same workshops serviced both nomad and metropolitan Chinese custom.

Older motifs were altered in style and function. The dragon and bird had to be shown from the side, in procession, and the bird was now associated with a monster mask descended from the *taotie*. In the early period *taotie* was chiefly characteristic of Henan and the Shang dynasty, while a main bird-motif belonged originally to the north-west and the Zhou polity. In the north-west the body of a bird might be combined with a head fancifully derived from a tiger. On the handles of the sacrificial *gui*, where this motif is most frequent, there is nothing to indicate the peacock; but worked out more fully on a bronze *guang* of *ca* 1000 B.C., this idea yields a composite animal with lavish tail starred in imitation of the peacock.[6] Early Han literature abounds with reference to the *feng* (a 'phoenix' with no relation to the western bird) and theories were rife as to its rôle in the schemes of celestial geography and spiritual hierarchies that were being elaborated. An old name had been *feng-huang*, in use throughout the Zhou period, from the time of the *Shijing* and the sixth-century philosopher Guanzi to that of the *Shanhaijing* (Classic of Mountains and Lakes), the late-Zhou compilation which inspired Han with a host of names and shapes of spirits and monsters. In all these works the two-syllable name denotes a single bird. If the *huang* of the name is an epithet, as is argued,[7] there is here a hint of south-China allegiance, for language widespread in Chu territory is said to have placed epithets after substantives. Han theorists came however to envisage two birds, male and female; or under the influence of *wuxing* philosophy (philosophy of the five elements of the physical world), even five phoenixes were supposed, differentiated by colour. According to the *Lun heng* (Arguments and Judgements, by Wang Chong of the first century A.D.) these five 'in size and colour of plumage resemble a phoenix, but they are very difficult to describe.' In the same writing appears the by now inescapable attribution of nearly all such phenomena to the heavenly bodies: there is mention of 'Jupiter injuring the Bird and Tail stars', the Bird Star being *Cor Hydrae* (alpha Hydrae, Alfard), a star named anciently in the Shujing, the brightest star of the serpent constellation.[8]

Illustrations of the iconography that now survive show nothing of this; but in the fifth century B.C., when the Shang and Western Zhou iconographies had perished, we first perceive a meddling with ancient themes: the combination of the *peacock-phoenix* with the *taotie*. The outstanding example of this device is the mask-and-ring already instanced [79]. Some detail of the mask can be traced to the foundries at Houma in Shanxi, but no combination with the bird appears there. The size of the Yixian specimen suggests that it was fastened to a tomb door, and this theme, apparently peculiar to Hebei and Henan, is taken up and varied in the Western Han, carved on the façade of subterranean stone-built tombs, on slabs of stone representing doors or on the flanking panels, and made smaller to be attached to coffins. It is tempting to see the bird as representing the *hun*, the departing soul (the *po* remaining to haunt the tomb), but no ancient text makes this explicit. The *taotie* survived as an apotropaeic symbol whose meaning was not further elab-

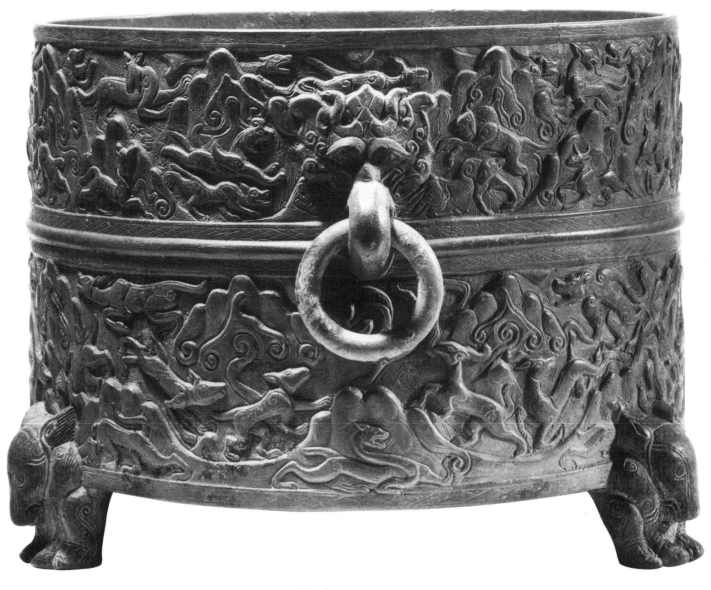

159. Bronze *lian* with relief ornament of animals among hills. Late second–first century B.C. Freer Gallery of Art, Washington. Width 25.4 cm

orated. The peacock was adopted into other schemes of the Western Han, figuring in profile among the animals of the magic mountain, the *tierwanderung*, or spread in heraldic fashion, but is not found after the first century B.C.

The human figure of any natural appearance had been excluded from the pre-Han icons of ceremonial bronze. The schemes of group ceremonial cast on bronze vessels of the Yan state of north-east China in the sixth–fifth centuries B.C. suggest miniature renderings of extensive murals, the matchstick-like participants giving no hint of the later naturalism. But items on lacquer and bronze from Shanxi and south Henan show less stylized figure drawing, still of persons engaged in ritual performance, in linear style which prefigures the lively movement of the Han style. In Hunan a medley of animals, real and unreal, and some magician-like persons are depicted in a style of rapid and allusive realism which departs wholly from the patrician metropolitan manner, as seen on sketches at the Mawangdui tomb and on some Changsha lacquer *lian*. In the second century B.C. the

boshanlu censers introduce for the first time into the officially countenanced art an element of genre, human figures and objects taken from mundane life, stylized but still answering to the new realism. Landscape was a new concern, presenting on the majority of *boshan* censers a row of regular sugar-loaves, a convention which proved long-lived later in Buddhist painting. On a bronze *boshanlu* inlaid with silver and gilded copper the crags repeat the rhythms used in the ornamental figures developed in metal and lacquer painting shortly before the beginning of Han, evidently further proof of influence reaching even north-east China from the workshops of Jiangling on the middle Yangtze [156]. Not Han writers themselves, but many recent writers east and west have speculated on the meaning of the mountain as it appears in the censers. A favourite theory is that in some way it refers to the shamanistic notion of a central spirit-haunted pillar separating heaven and earth, by which the shaman in his trance – a state no doubt achieved by burning narcotic substances in a censer – might visit the upper world

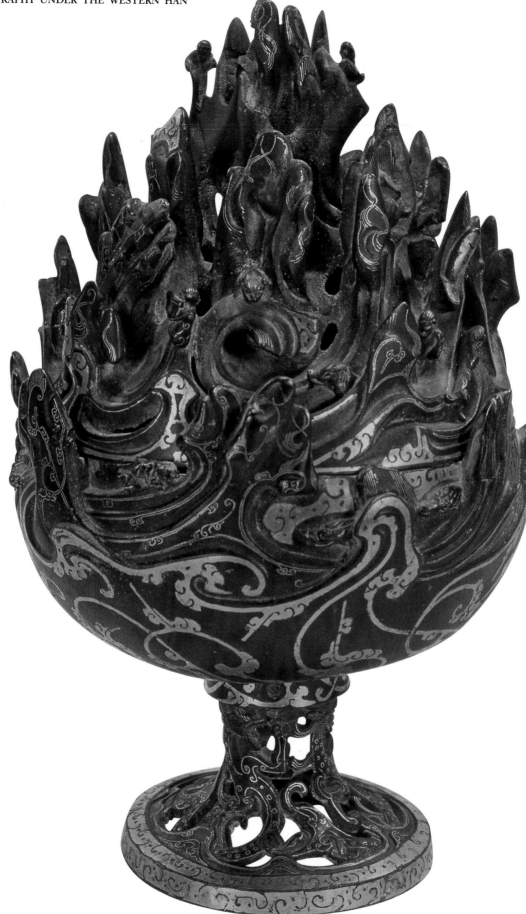

160. Gold-inlaid bronze *boshanlu*, from the tomb of princess Douwan in Mancheng-xian, Hebei. Ht 25.4 cm

of spirits; and the *boshan* anticipates something of the towering mountain of later classical painting, from which symbolic and subjective meaning was never absent. It was perhaps the habit of northern chieftains, visitors to the Zhongshan court, to bring their personal censers with them (it is even suggested that there was concern with the *Pediculus vestimenti*), as later Wuhuan chiefs are said to have travelled with their personal spittoons.

The scenes depicted on the censers are standard in form and content:

man driving a laden mule cart along a steep road;
man defying a bear near a large tree;
tiger attacking a goat;
man defying a tiger;
archer drawing an arrow at something in a tree.

No literary descriptions survive of this romance of mountain solitude and heroic hunting. Gestures of fortitude and hunting prowess (e.g. retainers defending their masters from wild beasts) were to became stock subjects in tomb decoration of the later Han period. The tiger-and-goat scene recalls the animal symplegma so popular in the Inner Asian steppes, but there is no hint here of the nomad style.

In the Hebei/Henan region of north-central China the school of ornamental metal represented at Mancheng is succeeded by what may be called an early Henan school, whose work of the second half of the first century B.C. is preserved in stonework and painting. Between these two schools occurs the compilation or recompilation of the *Shanhaijing*, which survives today in eighteen chapters. The legion of strange monsters it describes are not ordered in any hierarchy, in particular are not attached to the culture heroes of Confucian legend.[9] Its placing has embarrassed the cataloguers: it appears at the earliest as belonging to the *xingfajia*, which seems to mean 'describers of shapes'; later it is put with geographical works, and now in the recent catalogue of the imperial library is classed with fiction. The painted silk banner from the Mawangdui tomb in Hunan, cited above in the description of figure painting, takes its mythological subjects from the lore which the *Shanhaijing* sets out to record. The banner appears to preserve the work of well-supported artists drawing on a body of iconography related to the repertoire of the Jiangling lacquer painters. The style could hardly be farther from the scenes of the Hebei censers in its command of perspective and the employment of elaborate conventions.

Some of the subjects appearing in the banner for the first time were due to become familiar in later Han iconography. Three divisions of a Daoist cosmography are depicted. The upper part of the banner shows the sun inhabited by its crow and the moon with its toad and hare: the hare pounding the simples of immortality had a special meaning for the cult of longevity which was receiving growing attention among the conoscenti. Below the sun are eight supernumerary luminaries, which the Divine Archer Yi was obliged to shoot down for the salvation of mankind. Between the sun and the moon is a human figure, ending in a long snake body, whose identity is unknown. Below come large flying dragons and leaping deer mounted by human riders, and two rat-like creatures, unexplained. A question remains whether the topmost human figure is to be identified with *Xiwangmu*, Queen Mother of the West, a deity much illustrated in the later Han, whose pre-eminence on the banner may have dictated the whole composition. Between and slightly below these motifs are two squatting figures, facing each other and wearing the mortarboard caps of Confucian court dress. These are likely to stand for Masters of Heaven, no doubt in the guise of the Daoist adepts themselves, who seem to guard entry into the celestial sphere. Lower still, framed by interlaced and extremely serpentine dragons, are two terrestrial scenes. First is shown the deceased occupant of the tomb with kneeling servants and attendant ladies, and farther down a banquet, which can only be a funeral rite, since a painted coffin appears in the background behind two rows of seated men wearing ceremonial dress. The lowest section is the least explicable in the light of transmitted mythology. The dragon tails reach to the bottom, and above them a dwarf appears, supporting the banquet scene immediately above him. Many creatures inserted in this composition, often doubled for the sake of symmetry, are readily accounted for by the animistic lore recorded in the *Shanhaijing*: human-headed peacocks, tigers, turtles, a bat spreading its wings over the portrait of the deceased lady, and a lively monster, familiar but unspecifiable. The jade *bi* ring and the arched *huang* hung over the banquet scene fill their ancient rôle as symbols of the other world to which the migratory soul *hun* was deemed to depart, leaving behind the perishable *po*. The total collection combines the snake-obsession of south-China superstition with the flying dragons of the north, as well as incorporating much from the south-central tradition which appears to have furnished the chief matter of the *Shanhaijing*. It is significant that polite society is now shown in contact with these ideas, an anticipation of the syncretism of Confucian and Daoist theory which was to govern the iconography of the Eastern Han period. The banner shows a provincial noble lady set in a web of superstition fulsomely depicted, in contrast to the more classical restraint of the paraphernalia of the Mancheng couple. The fully drawn polychrome of the banner selects from the many motifs used in Hubei lacquer painting. In lacquer, on a smaller scale, the manner is briefer, flimsier, more linear and lively. The later discovery of a similar banner in the Changsha district shows that the iconography was well established.

Probably the *Shanhaijing* was quarried more widely for funeral iconography than the surviving material demonstrates. In the second century A.D. it was much drawn on for tomb decoration in the metropolitan areas of Shandong and Jiangsu; but already a century earlier material akin to its contents was used in the elaboration of a new astronomical-spiritual figuration, as it appears in the Luoyang tomb mural described below for its painting (p. 94). One surmises that by this time the Daoists had gone far in building a cosmology in which stars and celestial mansions were identified with spiritual entities, some *Shanhaijing* subjects being given specific astronomical reference. The influence of this philosophy in art increases through the first century B.C., especially at the approach to the Xin interregnum between the Western and Eastern Han dynasties. In the iconic architecture of the heavens a Jade Emperor was eventually

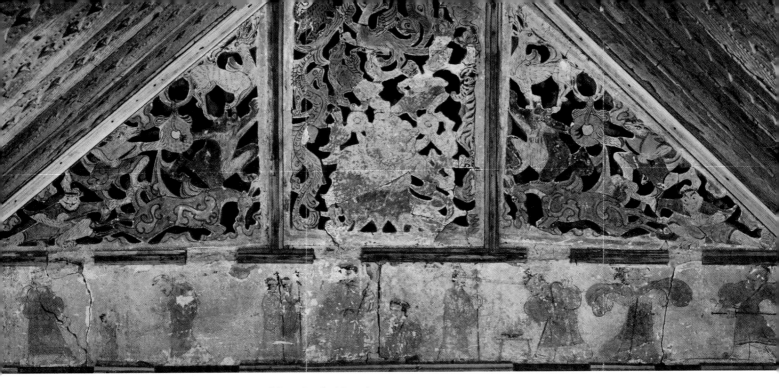

161. Subterranean tomb 'gable' *ajouré* on stone slabs, painted with mythological animals, human genies and parading officials, in blue, green, red, black on yellowish ground, in Luoyang-xian, Henan. Late first century B.C. Height of the ornament about 75 cm

placed at the celestial north pole to reign over all the other entities. This personage does not achieve an icon in the Han period, and did not become prominent before the Daoists were consciously competing with Buddhists in creating a spiritual hierarchy in space.

The Luoyang tomb best cited for mural style assembles items from various sources [161].[10] Astronomical devices decorate the burial chamber entrance; images suggested by the descriptions of the *Shanhaijing* are adopted to give asterisms more expressive form, while other entities are represented by men in official dress. Along the ridge of the ceiling are twelve panels painted with cloud figures in which are dotted ten constellations, the sun and the moon. The constellations vary greatly in their distance from the line of the ecliptic, making a rather erratic pattern if the purpose was only to trace the sun's course against the stars, as the total of twelve and the presence of sun and moon may suggest; so probably some mystic association of the star names guided the choice. Over the entrance door is a sheep's head in full relief (an ideographic pun, *yang* 'sheep' for *xiang* 'auspicious') and below this a naked woman stretched on the ground being devoured by a tiger. This scene, with a further three black birds, is interpreted as the vanquishing and devouring of *ba*, the drought demon. Many of the *Shanhaijing* creatures are given the task of devouring specific evil monsters and spirits. On the lintel of the pierced hanging wall which divides the tomb chamber are painted twelve men, standing with ceremonial wands or gesticulating. Many theories are advanced on their identities, but none is final or seems particularly significant. The presentation of the figures, with three-quarter views, throwing out of arms and legs and suggestion of specific activity, gives the illusion of movement essential to current concepts of realism. At the top of the middle panel is the peacock flying with reverted

head. Clockwise from the peacock are the green toad of the moon, the white tiger of the west, the green dragon of the east, and a red tiger whose celestial residence was never subsequently defined. Thus three animals of the cardinal points, as presently made standard, are in their correct positions. The bird dominates the south as the most important direction, towards which face the enthroned emperor and apparently other important officials when elevated to the heavens (the main axis of the tomb is however east–west). So the lower figure in this panel must represent the north, and here the same dubiety reigns as appeared at Mancheng. The north point is occupied by a red monster with long hair, four legs and a tiger's face. It is uncertain whether a bear is chosen as appropriate to the Great Dipper (whose *tianzuo*, 'constellation site', is the Great Bear, *daxiong*), or is meant for Chiyou. The latter fierce genie figures frequently in the following century, when he was made a tutelary deity of warriors and was shown dancing furiously with weapons in all four paws. With typical euhemerism Chiyou was also imagined fighting together with his brothers against the Yellow Emperor, a favourite of the Daoists among the ancient culture heroes. Or, again, Chiyou might be conceived merely as one of the numerous *fangxiang*, the adepts in magic whose rôle was to counter evil spirits. It is strange that in the inner field of this panel is placed another bear, now black, opposite to a man in the warrior's on-guard posture; and that the traditional *bi* rings are included, held by human-headed birds resembling those of the Mawangdui banner. *Bi* are also important items in the triangular panels either side of the rectangular panel. The schemes in the triangles are arranged as mirror images, white deer, black bears, winged horses, hairy strong men (or are these monkeys?) and a wolf dressed in green and red, all speeding around the suspended jade rings. None of these iconographic

schemes contains the portrait of Xiwangmu, who is suspected in Hunan on the Mawangdui banner. The concept of a heavenly ruler in the west apparently made yet no appeal in Henan, at the centre of the Han state, and was not given an astronomical rôle. On the other hand the reverse side of the triangular panels of the hanging wall show symmetrical confronted dragons, each with a hind foot on a mountain peak and each ridden by a little winged man wearing the southern peasant's conical hat. This exceptionally ornate tomb was built and decorated probably in the reign of the emperor Yuan or the emperor Cheng, between 48 and 7 B.C.[11]

The funeral iconographies of the Eastern Han are chiefly known for the metropolitan regions of Shandong and Jiangsu. They combine much that has been described from the Luoyang tomb, promoted to official respectability, with illustration of the culture heroes of Confucian lore, and of many carnival performances which now joined the funeral pomp of the rich. The pictorial stones of Shandong on which these subjects figure are the most important record of Han art in the second century A.D.

Draughtsmanship and Painting under the Eastern Han

Less is known of figure style through the first century and the earlier second century A.D. than in the previous two centuries. The rôle of lacquer painting in the development ceases; the new fashion of stone-built tombs invited decoration on a large scale in styles which combined painting with carving. The main interest moves decisively from Henan to Shandong, although it is possible that the origins of what may now be called a Shandong school are to be sought farther west. In the region around Nanyang in south Henan have been found many tomb bricks of the mid–late first century A.D. bearing impressed ornament of standing armed guards and servitors, more rarely prancing horses, phoenices and other animals, sometimes framed by small floral or geometric motifs. The figures are set in side-view, drawn in fine uniform line when linear, without the suggestion of brush inflexion.[1] Their style was transferred to stone at first without change, as seen on the walls of a stone-built tomb at Xiaotang-shan in Shandong, with huntsmen, hare and dogs, battle of horsemen, prostrate servant reporting to his master,[2] and on stones from a shrine in Feicheng-xian in the same province [162].[3] At the Yangguan-si stone tomb in Nanyang frontal figures and buildings are placed in more ambitious compositions, the drawing similar but inferior.[4]

From *ca* A.D. 100 stone engraving was developed in three directions. As bas-relief in the proper sense, i.e. with shallow modelling of the raised parts, it was practised for a short time in Shandong, with dragons and tigers, symmetrical schemes of carnival performances, and even genre scenes: carriages, kitchen, carnival, bird-shoot with the bow, carpentry or mensuration.[5] A second manner adopted in the later second century shows similar motifs engraved lightly on a smooth polished surface, and must derive from the most skilled draughtsmanship of the time. Crowded scenes of domestics and entertainers are executed in rapid economic line. The style is seen on stone-built tombs at Zhucheng in east-central Shandong and at Pengcheng just across the Shandong border in Jiangsu. The latter tomb, with its mountain hunt, official cortège, kitchens, acrobats and musicians, is dated to A.D. 88, and so is the earlier by some decades [163].[6] Among recent discoveries the acme of the purely linear method is to be seen at the Yinan tomb in Shandong (p. 109). It remains a question however whether the originating centre of this style was in Shandong or Jiangsu. The style is distinct from the third manner we are about to describe, and so may not have the special Shandong allegiance which this third style possesses.

The third stone-engraving style is often wrongly termed relief carving. The technique differs from the two other techniques in chiselling back the ground a few millimetres in order to leave the flat-surfaced design standing proud; and it is reliably inferred that painting was substituted for linear-engraved detail. What now remains on these monuments is figures in smooth silhouette against a slightly roughened

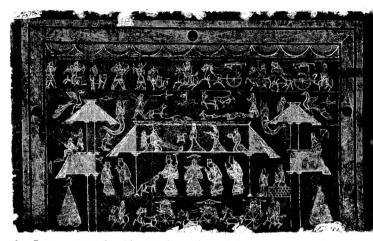

162. Stone engraved with people and mythological animals, from Feicheng-xian, Shandong. First century A.D. Ht 70 cm

163. Butchering and cooking, figures engraved on stone slab of a tomb in Zhucheng-xian, Shandong. First–second century A.D.

164. False stone gateway of a tomb. carved in low relief with real and mythological items, from Mizhi-xian, Shaanxi. Late first–early second century A.D. Ht 1.2 metres

background. It is argued[7] that the ground was originally covered by a lacquer mastic in a contrasting colour, making a total smooth surface, although every trace of such a ground has now disappeared. Traces of colour are said to have been visible on Shandong storied stone slabs of the first century.[8] Painting on the raised surfaces together with ground filling in a contrasting colour would combine plausibly, making good sense of the engraved pictures as they now appear. But the main effect of the compositions by no means depended on the rendering of detail. The silhouette manner was developed on its own account for presenting dramatic and moralizing subjects drawn from history, legend and the insignia of official life. Although the surviving monuments place the most diversifying centre of this 'silhouette style' unambiguously in Shandong, there is evidence that the style was practised to some extent also in Shaanxi and Jiangsu, where early examples are recorded. A tomb in Mizhi-xian of Shaanxi dated to A.D. *ca* 100 displays the official carriage cortège, *taotie* and phoenix, charging bull, animals of the hunt, dragons and fairy men. Horse and manger with magic tree, linked *bi*, a late version of cloud scrolling, the *boshan* censer, halberd-bearing guards and some simple collocations of human figures evidently depicted from ceremonial occasions, also all come from a first-century repertoire [164]. In the same province a comparable scheme explicitly dated to A.D. 104 gives prominence to the shamanistic 'pillar of heaven' on whose branches are perched humans and fairies, surmounted at the apex evidently by deities, one at least of whom resembles the Xiwangmu of the second-century Shandong schemes. The storied pillars and lintels from the Wang Deyuan tomb of A.D. 100 in the Suide-xian of north Shaanxi belong to the same class, and corresponding ornament and technique occur in a Nanyang tomb of about the same date.[9]

Allowing for these hints of artistic kinship farther afield, we may still speak of a coherent Shandong school composing in 'silhouette style', active at the latest from the middle of the second century. Tombs with pillars, lintels and wall stones decorated in the typical manner have been recently excavated in Jiaxiang-xian in south-west Shandong,[10] but the draughtsmanship and subjects at these places, all referable to the third quarter of the second century, have not added appreciably to what has been long known from the stones of the so-called 'Wu family funeral chapels' (*Wu-shi citang*) at tombs situated in the same district. The storied stone slabs of these shrines were moved in the Song period from their original sites, and have troubled antiquarians ever since with the problem of their exact reconstruction into the several chambers of the funeral chapel.[11] Many of the stones survive, while dispersal of thousands of ink-impressions made from them has placed their engraved scenes among the best-known monuments of Han art world-wide. One chamber relates to Wu Liang, who died in retirement in A.D. 151. The high offices of other Wu, dying between A.D. 147 and 167, comprise governorship of Dunhuang, command of the military in Suzhou, adjutant to the commander of the guard of the interior palace. The patrician status of this group supports the theory that these men were personally responsible for innovations in the subject matter of tomb ornament and for seeing to finer execution than had been customary. One notes that the stones of a brick tomb in central Henan dated as closely to the Wu chapels as A.D. 132 are carved in the older manner, with comparatively coarse rendering of only tigers, dragons and feathered men.[12]

The engraved stones display some fifty recognizable individuals or events, besides many crowded celestial concourses of supernatural beings, covering lintels or forming horizontal bands filling large stone panels. Many of the subjects illustrated are not identified; those now recognizable form five groups:

i. Legendary emperors, culture heroes, various celestial and real courtiers, shown as single figures.[13]
ii. Assemblages representing the enthroned deity Xiwangmu, and the culture-founders Fuxi and Nüwa, the former set at the top of multi-scene panels, the latter as one incident of many among the scenes.[14]
iii. A long series of more or less dramatic scenes, depicting personages famous for virtue or evil, exemplars of loyalty and filial piety, and historical events (the latter including the mysterious battle at a bridge).[15]
iv. Some items of less euhemerized myth, such as the exploit of the archer Yi, and many scenes of warriors, winged men, dragon-drawn carriages coursing through clouds.[16]
v. The procession of high officers seated in pairs in umbrella'd carriages drawn by magnificent horses.[17]

There is evident effort in nearly all the compositions to amplify reality by depicting or implying movement, in course or imminent: and if not positive movement, at least gesture and pose implying tension of limb and mind. Much skill goes to achieving this under the limitation of strongly silhouetted side-views (and, for some heads, the three-

165. Scenes engraved on a wall of one of the Wu funeral chapels in
Jiaxiang-xian, Shandong. Top scene unidentified; middle, the attempt of
Jing kê to assassinate the future Qin emperor; lowest, Fuxi and Nüwa with
their messengers. Mid-second century A.D. Height of the slab 80 cm

quarters view). In crowded scenes of supernatural beings rushing movement is the main theme. The figures in all the compositions are represented on a flat plane, only some angular arrangements of the main elements or variation in the scale of human figures suggesting recession in space. In comparison with the growing spatial freedom of figure draughtsmanship in the Western Han, the Wu Shrine style indicates a closely disciplined archaism. The compositions must also have been executed on a larger scale than that of the engraved stones if they were to take full effect, and their origin in palace wall painting appears very probable.

Among the single figures Fuxi and Nüwa, male and female genies put together with the legendary rulers, are shown with entwined snake tails, brandishing respectively compasses and a set-square, their retinue among scrolled clouds being the feathered men (*yuren*) of ancient myth, now given crowns or two-spiked hats. Fuxi and Nüwa regard each other earnestly or lean apart as if about to take flight [165, lowest register]. The emperors and rulers have each his activity: Shennong ('farmer deity') digs, the Yellow Emperor turns his head and points forward urgently with both hands; Yu, famous for flood control, holds a miniature sluice-gate; Yao, the emperor supposedly ruling from 2357 B.C., who chose the outsider Shun to succeed him, is shown supplicating with joined hands. These few examples taken from an unprecedented wealth of icons are characteristic of the syncretic ideology of second-century Confucianism.[18] The scholar's extraction of an ancient king-list from written sources (there are many variants of the list[19]) combines with notions taken from an un-Confucian body of myth, the marriage of philosophies symbolized by the scene of Confucius on a visit to Laozi. Moral and political admonition in pictorial form, even on tomb walls, was increased at a time when Han government felt increasingly the rivalry of the great land-owners. The enthronement of the young king Cheng of Zhou recalls ancient legitimacy and unity[20]; the extremely vigorous portrayal of Jing Kê's attempt on the life of the Qin emperor in 227 B.C. puts loyal officers on their guard [165, middle register][21]; the Han claim to rule is underlined by showing the laborious recovery from the river of the nine bronze tripods betokening the command of heaven.[22] In the scene of attempted assassination space is skilfully handled to enhance the violence of contrary movements: the outline of the assassin almost wholly covers an assistant who turns to flee, the retreating emperor is placed higher in the field, below him a soldier who has fallen flat on his back, and only rests quiet in its box the head of the rebel general which had been offered as a pretext for the interview. The event had been minutely described by the historian Sima Qian, with an abundance of detail from which the artist has made a limited selection. Many scenes remain unexplained [cf. 165, top register].

Among the illustrations of family piety the picture of Zengzi's mother at her loom is one of the most striking: she turns sharply to rebuff the first reporter of her son's alleged crime (later she was forced to believe, and then leapt the wall and fled).[23] Instead of taking a single characteristic moment, the narrative method may be that which recurs later in Buddhist painting, successive events appearing alongside each other. Such is the portrayal of Dong Yong's old father with his hand cart, then Dong himself gathering his goods for sale to cover the father's funeral expenses, and above him the astral goddess Weaving Maiden who in human guise married Dong and restored his fortunes with her wealth.[24] Yu Rang, who failed in a murder intended to avenge his master, falls in a heap beneath the feet of a rearing carriage horse.[25] Min Sun defends his harsh stepmother.[26] Lao Laizi at seventy still attends on his parents.[27] Assassins, approved or not, made attractive subjects of dramatic action. Many large scenes now defy explanation. Such is the dignitary receiving kowtowing inferiors in a pavilion over which, in an upper storey unexplained architecturally, Xiwangmu presides with many retainers, these including her regular *yuren* attendants. Under a tree to one side stand a carriage and its unharnessed horse. Upon the latter perch some of the birds representing supernumerary suns which Yi, standing apparently on the carriage roof, is engaged in shooting down [166].[28] Some densely confused scenes depict a form of earthly life below an upper realm of dragon-drawn chariots and feathered men directed by an anthropomorphic being.[29] Chiyou, the soldiers' mascot, serves repeatedly as space-filler in the wilder compositions.

The purely linear drawing style which we have followed through the first century is found in ideal development at the celebrated stone tomb near to the town of Yinan, also in Shandong, some 200 km east of the site of the Wu chapels, constructed most probably between A.D. 170 and 190 (cited below for its architecture).[30] Now no hint of archaism appears in the engraved scenes. Space conveyed by obliquity of lines and by the high view-point, and the frequent confronted poses of the personages, are tomb decorators' stereotypes, but stereotypes which must have had their origin in contemporary painting. In a building consisting entirely of stone, the pictures cover lintels, pillars, even the risers and imposts of eaves brackets. A freedom of touch in the engraved line, even some imprecision, marks off the Yinan style from other linear styles we have considered. Garments are softer than those seen at the Wu chapels, with attention to textile folds disposed around limbs [167]. The usual mythological motifs, with special elaboration of Chiyou and explicit detail of the feathered men, occupy the smaller fields, often vertically, and in these there is an occasional brief reference to the bronze-inlay pattern and cloud scrolls of earlier centuries. Special ogres, e.g. a bodiless raging head, recall the use made of *Shihaijing* material in Western Han. The drawings of carriages and buildings aim at exactness: the former mark recession in space by overlap without reduction in scale, and the latter tend to a raised near-isometric view. Enough error and hesitation appears to reveal the borrowing of the designs from serious models. Agile drummers, bell-strikers and acrobats appear with their apparatus; musicians sit in oblique rows which are meant to be retreating from the viewer's standpoint [168]. Even when no lines guide the eye objects may occupy a supposed intervening space. But the greatest interest attaches to scenes placing together two or three male figures. Some of these are worthies of Confucian history, two are philosophers seated and conversing below the much stylized fronds of slender trees. Least explicable are a number of paired males,

166. Mythological scene on a wall of one of the Wu funeral chapels in Jiaxiang-xian, Shandong. The figures include the archer Yi, Xiwangmu and her attendants and an unidentified worthy receiving gifts. Mid-second century A.D. Height of the slab 69 cm

strangely garbed and whiskered, who confront each other, turn from each other, even stand back to back, in postures of furious movement. Presented in strict side-view or three-quarters view, they hold swords or staffs, as if sword-play or such were the theme, with reference to a school of fencing known to have existed at this time.[31] One man is caught as he unsheaths his sword. Unconventional hand gestures identify extreme passion. The gestures vary more than those

of the Wu chapel pictures but are still confined to a few studied variants, as are also the shapes of thrusting leg and twisted waist. Human and animal grotesques, sober gentry and officers who may still be mummers, the totality of the Yinan decoration savours of festive events, and histrionic emotions.

The individuality of the Shandong schools we have described is made clear when their work is compared with

167. Stone-engraved scenes in a subterranean tomb in Yinan-xian, Shandong, displaying a fantasy of carnival and feasting. Second century A.D. Height of the decorated band about 48 cm

near-contemporary tomb decoration in other provinces. In Henan wall painting continued into the Eastern Han. Well-preserved specimens were found in a tomb in Yanshi-xian: riders and carriages painted in brown, blue and red on a light-greenish ground, display impressive brush skill applied to a few variants of equine and human posture.[32] The Shandong linearity on stone does not however imitate this brush manner. To the south-east, in Jiangsu, is an example of inferior work which may be a remote imitation of the Yinan style,[33] and in Zhejiang at a date which can only be a decade or two later a skilfully drawn but disordered profusion of genre and mythological items which echoes the idea but not the engraving style of Yinan.[34]

Beyond the eastern region where stone engraving was practised the evidence for drawing style in the Han period is very slight. West China may have followed its own graphic tradition. In Shaanxi some rare wooden tablets preserve examples of artless painting datable in the first century B.C. and the first–second centuries A.D.[35] The earlier specimens, rapid sketches of horses and carriages, reflect no particular discipline, while the later specimens are executed with the

168. Stone-engraved scenes in the Yinan tomb: officers in converse, officer confronted by a demon. Second century A.D. Each scene about 40 cm square

169. Tomb brick impressed with scene of a farmstead. from Chengdu-xian Yangzishan, Sichuan. Second century A.D. Ht 40 cm

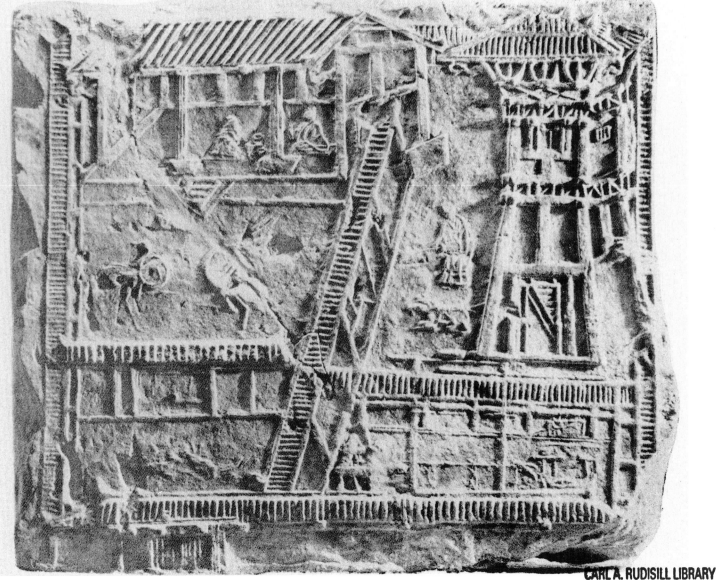

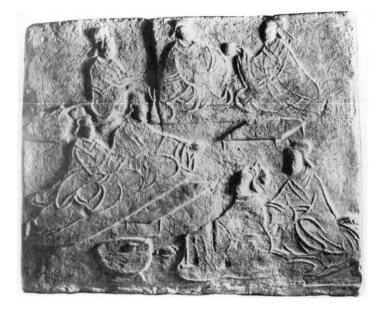

170. Tomb brick impressed with scene of a feast, from the vicinity of Chengdu, Sichuan. Second century A.D. Ht 39 cm

circling brush which in central and eastern China is as-sociated with lacquer painting. For Sichuan the indications of an individual style are stronger, present in rough stone engraving and in scenes impressed on bricks, both falling in the later second century A.D. The draughtsmanship lying behind the brick pictures from Yangzishan near to Chengdu adopts a method of perspective hardly to be found elsewhere at this time. The view-point is level with or a little elevated above the objects, and dimensions of width and height increase rather than diminish as they retreat in depth. Dashing carriages and horses are inevitable favourites, sometimes in abstract space but in one revealing composition set in oblique perspective as the carriage crosses a bridge. Here carriage, passengers and bridge pilons are échelonned to the right following the movement, and sloped a little upwards, but there is no backward diminution of scale.[36] Left-to-right rising obliquity is standard in all the grouped compositions, particularly suiting scenes of persons seated drinking as they watch dancers and jugglers or listen to music. Some stereotyped scenes of industry, farming, hunting, suffice to contrast the subject interest with that of the Shandong and Henan pictures, as if bourgeois and bucolic tastes have supplanted the emblems of officialdom and the court. Landscape settings are called for:

conventional hills with stag, tiger, bear and ostrich backing the derrick and evaporation pans of a salt mine;
a walled villa with guest room and watch-tower showing details of architecture [169];
rice reaped while archers shoot birds besides a fishy pond;
man gathering lotus from a boat in the lily pond;
cockerel, duck and parrot, weaving and the grain store, shopping and cooking.

On the bricks the relief of persons and animals is realistically and delicately rounded. How far this aspect of the work may be taken to reflect the devices of contemporary painting or linear draughtsmanship is strictly uncertain, but it is difficult

to see what other than flat design can have been imitated. A few pottery figurines of dancers are modelled in a style corresponding to the brick reliefs, but these hardly warrant an origin of the style in minor sculpture.[37] The natural fall of folds in the garments of the human figures points to greater sophistication in this aspect of drawing than was to be found in the east [170]. In Xinjin-xian a short distance south-west of Chengdu were found the slabs of a tomb cist carved in low flat relief with a series of human figures. Here an accomplished linear rendering of the figures, in odd contrast with the general crudity of the work, attests a thoroughly sophisticated tradition. Aided by the convincing flow of drapery, greater freedom is achieved in stance and gesture than is seen in the Shandong work, the proportionally small heads giving an impression of height. The subjects appear to be taken from drama, with sword-play and well-staged scenes of remonstrance. One couple shows Qiu Hu, a worthy of the state of Lu (Shandong), chatting with his wife as she picks mulberry.[38]

SCHEMATIC DESIGN

The description of the earlier bronze mirrors (p. 43 ff) brought this subject into the second century B.C., when the ornament cast on the mirror back made use of motifs of the previous century – changes rung on dragons, the lozenge motif derived from twill weaving – together with cloud scrolling. In the later Western Han and in the Eastern Han the mirrors adhered still largely to geometricizing design, in a last flicker of old style before figural and vegetable motifs excluded all else.[39] On the so-called TLV mirrors the marks, not precisely explainable, which give them their name cor-respond in part to the board used in the *liu bo or boju* game [171]. The latter, known from stone engravings and pottery models of the period, was evidently based on a cosmological

171. Bronze mirror with the 'TLV' cosmological design. *ca* 100 B.C. Sumitomo Museum, Kyoto. Diam. about 19.9 cm

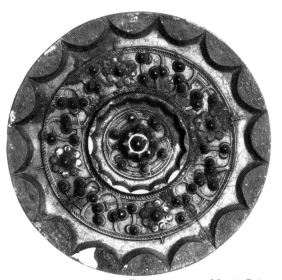

172. 'Star-cluster' bronze mirror. First century B.C. Musée Guimet, Paris. Diam. 10.2 cm

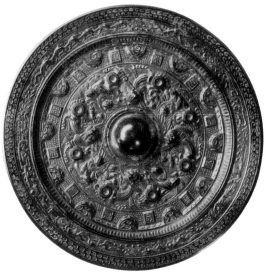

173. Bronze 'spirits and monsters' mirror. Second–third century A.D. Museum of Far Eastern Antiquities, Stockholm. Diam. 14 cm

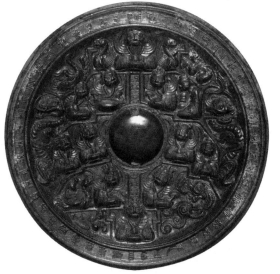

174. Bronze 'five emperors' mirror. Second–third century A.D. Asian Art Museum, San Francisco. Diam. 13.6 cm. B60B1064

diagram with a square at the centre representing the earth.[40] The TLVs are first adopted in the first century B.C., displaying square and circle (the carrying boss) surrounded by a scatter of cloud-scroll units. The most elaborate version of the type belongs to the Xin interregnum (A.D. 8–22) or to the opening of Western Han, when the design is standard: TLV units, inner set of twelve and outer set of eight nipples. A dragon-derived frieze forms the outer band of ornament, then dog-tooth, a plain zone and an inscription zone,[41] and the main field. In the field, at its fullest, appear the animals of the southern, western and eastern quarters – not necessarily in their exact relative positions – the three-legged toad of the moon, sometimes other strange quadrupeds, and *yuren*. The general reference of the ornament is thus intelligible, although the significance of the TLVs themselves eludes us. The animals show the rapid brush drawing of central China, and the varieties of dog-tooth are akin to the simplest ornament of the impressed bricks of the later Western Han.[42]

Through the first century A.D., as the full scheme is abandoned, the TLV units occasionally combine with ornament normally found alone on independent mirror types, particularly with the scheme called *caoye* ('grass and leaves': late first century A.D.).[43] In the latter, symmetry and geometry assert themselves, as is true also of the types designated dragon band, animal mask (second century A.D.), which copy old conventions.[44] Mere geometry adorns the 'astronomical' or 'star' mirrors of the late first and the second centuries A.D. These elaborate and add bands of luck-wishing inscriptions to the convention of the eight-pointed star enclosing a circle, as heralded two centuries earlier on a Loyang-type. The design 'conforms precisely with the contemporary philosophies, which were greatly preoccupied with the concept of the centre of the world, the universal axis, the motionless turning point around which the universe revolved, the point of origin'.[45] The minor additions to the cosmological diagram are subtle: sloping lines, small hemispheres, triple lines within the star etc. [172].[46]

The mirrors thus far described have been found dispersed through all the metropolitan provinces. The TLV type often declare themselves made in the *shang fang*, a factory established by government in the Guanghan-xian of Sichuan, and it is probable that the subsequent geometricizing types had a similar official origin, their archaism and astronomical concerns arising from this patronage. The schematic ornament of mirrors was finally dismissed in perpetuity with the appearance of a group made in Jiangsu, the *shenshou* ('spirits and monsters') mirrors [173, 174]. These display human figures and animated scenes in high relief, with carriages, engagements of soldiers, Xiwangmu holding court with her attendants, rows of seated figures evidently representing Daoist deities which we fail to identify individually. These mirrors belong to the end of the second century A.D. and the turn of the third century.[47] The art they represent, unaffected by the northern geometricizing, looks forward to post-Han tradition. In particular it anticipates an interest in plastic form which was presently to find scope in Buddhist image-making.

Architecture in Retrospect from the Second Century A.D.

The only traces of pre-Han buildings now remaining above ground are much weathered sections of town walls, notably that of early Zhou date at Zhengzhou, and a few high building cores (terreplein) of the later Zhou. Something of the early history of architecture can however be inferred from the foundation platforms of early buildings which are revealed in excavation. In the late Zhou period and in the Han period designs on bronze and pottery models supply further architectural detail; and the subterranean stone-built tombs of the later Han inform us on the chief decorative elements of the contemporary wooden buildings. The pillar-and-beam principle was developed continuously. Comparatively large timber-framed buildings were raised in the later Shang, and the only important structural change thereafter was the adoption *ca* 400 B.C. of a pyramidal terreplein as a means of elevating grand buildings: a solid core of earth was clad with galleries rising one above the other so as to give the impression of many storeys. Excepting some ceremonial halls, Han trabeate architecture made no use of the terreplein, and pillar-and-beam buildings therefore seldom exceeded one storey; but means were found of raising high towers in which were solved the main problems posed by expansive timber framing and by the need to support heavy tiled roofs. The creation of a stone architecture based on wooden forms, as seen in buried tombs, was an original conception. In wooden buildings elaboration of the pillar-head bracketing became the almost exclusive decoration. Under the Han this quintessential Chinese architecture came to a term in its development which determined the course it was to follow until the present day.

At the start, in neolithic villages, three traditions are present. In the Amur valley on the far northern boundary, habitations were built almost wholly underground, the deeper the floor the more dignified, and the earth-covered roofing gave no incentive to complex timber framing. Over all central China the floors of neolithic houses were sunk a little below the general surface. Probably already at this early time the southerners raised houses on stilts above wet or flooding ground, as demonstrated by bronze and pottery models of Han date, in the tradition which persists to the present day in Southeast Asia. The roots of the historic trabeate architecture, rising above ground by pillar and beam, lie in the central region. A first hint of the method is at the neolithic village of Banpo in Shaanxi. Here the floors, mostly circular, were sunk 60–70 cm below the general ground level. Some heavy wooden pillars surrounded a fireplace at the centre and rose to the apex of a conical roof made of perishable materials, this shape indicated by the trace of small upright timbers set around the edge of the sunken plan. For the smaller round and square houses only light timber framing will have been necessary, but for a larger rectangular building in the middle of the village the span of roof over a plan some ten metres square and the stoutness of the sustaining pillars at their foot certainly mark the beginning of regular pillar-and-beam.[1]

From the middle Shang period, some eleven centuries later, is deduced a larger architecture on similar lines. Palace and temple halls were still rustic in appearance, if we may judge from the lack in excavation of any ornament or roofing in lasting material. Two new principles are established. Upright timbers no longer sank their base in the soil but stood on stone or bronze footings, a feature bespeaking the stability of the timber frame; and the buildings were raised a metre or two above the ground on conforming earthen podia of rammed earth. *Hangtu*, the loessic soil consolidated by ramming numerous thin layers with a post measuring three or four centimetres across, formed the foundations of all Shang buildings. Sometimes the walls between the exterior pillars of major buildings, or their lower part, were made in the same way (i.e. in the manner still to be seen in the Chinese countryside), while in other cases the lack of any trace of such walls suggests that the inter-pillar spaces were filled with lighter material, such as the lacquer-painted, carved and inlaid wood of which traces survived at Xiaotun.

Reconstructions proposed for these major buildings rely on two factors: the disposition in the plan of vertical timbers of varying weight, shown in excavation either by soil marks or by surviving stone cushions, and the implication of a few ideographs denoting buildings or height. The most significant of the latter, a building in elevation, is composed of a smaller squarish rectangle above a larger, crowned by a steeply sloping ridge-roof. There being no sign of terreplein suggested in the ideograph, or found in excavation, this arrangement is interpreted as the section across a hall with a stepped roof. An ideal example is a small pavilion set over the Fu Hao tomb at Anyang [175]. It stood on a rectangular podium of *hangtu*; ten major timbers were embedded in the podium, and ten corresponding minor supports came down

175. Reconstruction of a Shang pavilion set over the Fu Hao tomb at Anyang

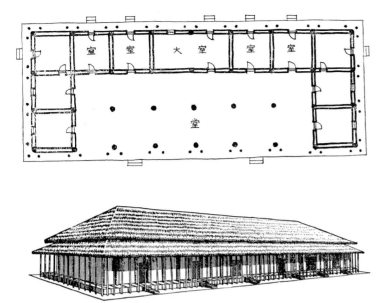

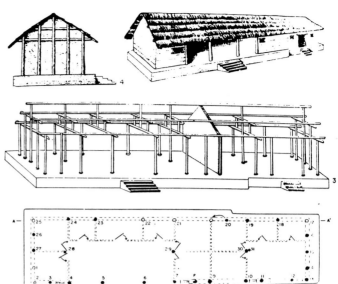

176. Shang halls as reconstructed from the Panlongcheng and Erlitou sites

177. Reconstruction of features on Alpha-4 at Xiaotun

to the ground surface below the podium.[2] Like the far-projecting eaves of later buildings, the outer part of this double roof is considered to have its origin in the need to protect the main pillar footing from rain. It bears the germ of the surrounding gallery, *huilang*, which became an all but indispensable feature of large trabeate buildings in the sequel.

At the Erlitou site one foundation measuring 58 by 73 metres had close-set pillars and a surrounding *hangtu* wall around the edge, but showed no sign of interior pillars to support the wide span.[3] Another oblong foundation of comparable size is thought to have held a series of small rooms around three sides, leaving a large space in the middle and to one side. Ten pillars stouter than the rest were sited down the middle and along the fourth side, raising a roof over the whole podium.[4] At Zhengzhou and Panlongcheng, sites roughly contemporary, similar shapes are deduced for two large buildings. At Zhengzhou the hall stood within the rectangular city wall (orientated north–south) in approximately the position assigned to a dominant structure in later city plans, about one quarter of the way down the median line from the north.[5] At the Panlongcheng hall, measuring 28 by 12 metres, the *huilang* is very evident, for the four rooms into which the building is divided longitudinally are only a little over six metres wide [176]. The rooms were enclosed by *hangtu* walling around the whole and transversally at three places. By ingenious comparison with modern village practice, it is argued that the lower roof constituting the eaves projected about three metres beyond the room walls, being supported by stouter pillars engaged in the edge of the podium and slender pillars rising from ground level just beyond the edge of the podium. Gaps in the walls show doors leading into each room from both sides, and at ten places around the podium were traces of steps.[6]

At these sites and at the numerous *hangtu* foundations excavated at Xiaotun the absence of tile fragments is sufficient proof that thatched roofing of some kind was the rule,

and the system of framing below the thatch and across the comparatively great width of the buildings can only be guessed at. Where walls filled the bays between pillars long timbers must have reached from wall top to roof ridge, supporting rafters. But where signs of earth walls are absent, as on some important foundations at Xiaotun, the system is more problematic. Only at this site is the use of stone pillar footings made clear, the flattish boulders, about 20 cm in diameter, which served this purpose appearing aligned in excavation.[7] A speculative reconstruction of a building in area Alpha-4 of Zone A at Xiaotun allows for interior pillars rising to the ridge, with transverse beams and vertical props rising from these [177]. A large complex of *hangtu* in Zone C at Xiaotun, whose ceremonial purpose was made manifest by the numerous human and animal sacrifice pits engaged in them, proved to consist of various foundation podia obtruding on one another, and much of the east side of the whole had been eroded by the river. A foundation in the Beta-21 area of Zone C lends itself however to a somewhat imaginative reconstruction: a plain oblong platform lying east–west, on which at two places at thirds of the length rose a small pavilion with double roof; railings are surmised to explain the small post-holes along the edges of the podium, and seven sets of steps are thought to have led up to the platform on its south side [178].[8]

178. Reconstruction of features on Beta-21 at Xiaotun

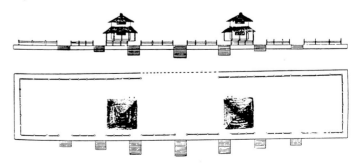

179. View of the Great Wall north of Beijing (photograph by A. Brankston, 1939)

180. Foundations of a courtyard mansion in Qishan-xian, Shaanxi. Ninth–eighth century B.C.

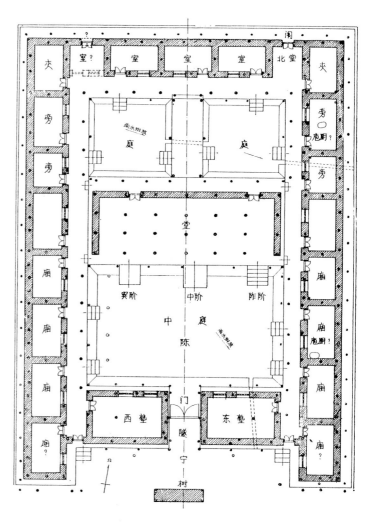

Little is yet known of smaller dwellings at any stage of the pre-Han period. One Shang house at Anyang however seemed to answer this description, having a floor sunk three metres below the ground level, a sacrificial pit at the centre, and around the sides a furnishing ledge raised one metre[9]; and another, at the earlier site of Zhengzhou, appears on a more varied ground-plan, without sinking, and possibly with roofs of two heights.[10]

A major development which took place at the turn of the eleventh and tenth centuries B.C. was the courtyard mansion. In the plan now adopted for a single extended building, or a nucleus of buildings logically arranged, the excavators identify a scheme which furnished the basic design of later palaces. *Hangtu* foundations of a courtyard mansion were excavated in detail at Fengchu in Qishan-xian, Shaanxi [180].[11] An oblong rectangle, orientated by its longer sides almost exactly north–south and measuring 45 by 33 metres, enclosed two courtyards separated by a great hall. The whole perimeter was occupied by small uniform rooms giving on to the courtyards, the foundations and wall footings of some of these surviving intact and others being readily assumed from the symmetry of the general design. Two small entrances were pierced in the north wall, and the comparatively narrow main entrance on a recessed portion of the south side was flanked by large rooms and sheltered by a short screen wall placed just beyond the outline of the precinct. Outer shape

and orientation, courtyards with surrounding rooms backing on to the outer wall, arrangement of the south entrance, all foreshadow features of the the enduring tradition of later times.

For the first time there is evidence of ceramic tiles used in the roofing, although the greater part of the cover consisted of a layer of straw-tempered clay laid on close-set purlins made of bundled reeds. The tiles appear to have lain on the top ridge and sloping ridges, the roof being sloped (as is argued) also at the gable ends. Some at least of the rectangular curved tiles appear to have been laid in pan-tile fashion, their fixing aided by perforations, knobs and ring-lugs. While impressions in excavated clay fragments testified to the purlins, the nature of the rafters and other timbering of the roof could only be guessed. It is clear however that the *ang*, the rafter with cantilevered projection far beyond the pillar line, had not yet been devised, for eaves support must be the purpose of the smaller peripheral pillars. Many suggestions have been made on the elevation of the roof, all consistent with the location of the excavated pillar footings, but since there is no way of guessing how the pillar tops engaged in the beams, it remains uncertain whether the roof rested on triangular frames or on kingposts rising from the tie-beams. Later practice points rather to the latter. The main pillars rested each on a large boulder lying a little below the floor level and over a narrow pit filled with smaller stones. The foundations excavated at Zhaochen in Fengfu-xian, Shaanxi, belonged to a number of unconnected buildings, three main halls and a number of small structures between and alongside them.[12] One of the halls is notable for its massive pillars, which certainly imply a roof more elaborate than others at this site or at Fengchu, possibly a form of lantern roof, which on one interpretation was round.[13] The disposal of important halls within a precinct and with an accompaniment of smaller buildings resembles the plans of some of the first Buddhist temples raised later in China.

Little more can be said in general about the architecture before the fifth century B.C., the period of the Warring States. It is to be supposed that the courtyard mansion continued; but as old settlements grew into cities which survived into modern times, the archaeological evidence for them has been destroyed or is inaccessible. What now claims our attention is the tower-shrine, the *taixie* (platform terraces) or *lingtai* (spirit platforms) of Han writing. They are found particularly on the abandoned sites of the capitals of the north-eastern feudal states,[14] situated either in the main precinct or in an adjoining precinct devoted to burial and ceremony. The remains of these buildings present an amorphous mound of earth, or a mound whose sides are shaped into broad steps. The origin of the form appears to be the square-based mound raised over a partly subterranean tomb chamber, bearing roofed lateral galleries accessed by wide stairways.[15] At Yanxiadu ('lower capital' of the Yan state in Hebei-Liaonong) is a group of nine such mounds, one of which has four gradations.[16] At Handan, capital of the Zhao state in lower Hebei, sixteen mounds are scattered in the twin precincts (rectangular, together about 2.3 by 1.4 km). The largest of them, now called Longtai (Dragon terrace), orientated north–south, was heaped in *hangtu* on

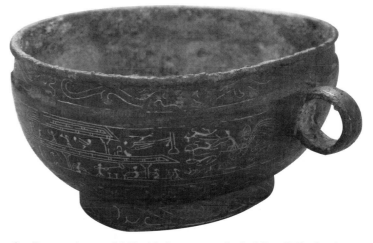

181. Bronze wine-cup inlaid with figures around a building. Fifth–fourth century B.C. Boston Museum of Fine Arts. Ht 6 cm

an oblong base measuring 210 by 288 metres. Four terraces rise to the flat top of 130 by 105 metres. Bricks and tile fragments are scattered on the smaller mounds at Handan, and although the Longtai has less of this material, there can be no doubt that like the lesser mounds it was surrounded by galleries with pillared roofs, and on it must have stood the building in which the king of Zhao gave audience. Boldly detailed reconstructions of this type of building as proposed in recent literature depend less however on the direct evidence of excavation than on the indications given by a few designs engraved on contemporary bronze vessels and in one instance on a bronze plate.

The most interesting feature attested in these designs is the detail of pillar support, shown clearly on a bowl excavated at Hui-xian in north Henan [181].[17] The pillars vary in size, the longer carrying the main eaves beams on the two upper layers of the structure, the shorter supporting the outer edge of the eaves themselves. The gallery at ground level has lower pillars and apparently no projecting eaves over it. Intervening between the pillar heads and the supported timbers are simple capitals expanding to about twice the pillar diameter. At the centre of the middle gallery are three close-set pillars which lack capitals and are stouter than the rest. These are interpreted by Fu Xinian as supporting the floor of the top layer of the building (i.e. the floor resting on top of the terreplein), but their relation to the wall of the terreplein at the second level is not explained.[18] It is reasonable to make the top eaves roof separate from the main roof and less steeply inclined, the lower eaves adopting the same slope; and consequently the main roof will have appeared stepped in the manner argued already for hall roofs of Shang date. It is noticeable that thus far no attempt appears to be made to spread the pillar-head thrust by means of horizontal brackets, the quintessential feature of all later development of the trabeate style. The tomb of a Zhongshan king of the last quarter of the fourth century B.C. contained a bronze plate cast in low relief with the plan of the sepulchral precinct, the *zhaoyu*. Five squares, evidently the plans of burial shrines, are placed in a row and enclosed by double walls.[19] The main gateways, presumably intended

for the south side, are opposite the central building. Behind the main five foundations are four smaller ones, accessed by gates in the inner perimeter wall opposite the spaces between the five. Of the latter, the two at each end are somewhat smaller and set back a little from the rest. It is likely that the project, if ever carried out, presented three major and two minor *taixie* of several gallery-storeys, in line facing south.

The former Han dynasty, ruling in the last two centuries B.C., disappoints the historian of architecture. This period must have seen the introduction of building types and structural devices which do not appear in the archaeological record before the first century A.D. and are most fully attested in the second century A.D. The evidence is then provided by pottery models buried as grave-gifts, and designs engraved on tomb walls, making us beholden to a social fashion which barely survived the end of Han rule. Palaces and shrines adhered to the trabeate style in wood, but we may now take cognizance of the stone, brick and plaster used in less pretentious edifices. Towards the end of the second century B.C. the old shaft-tombs with log-built coffin chambers were replaced by a new type, apparently first under the Yan and Zhongshan rulers of the north-east. This provided for the coffin chamber (*mingtang*, 'hall of light'), a room behind this (*qinshi*, 'sleeping chamber'), a surrounding passage, an approach passage (*gongdao*, 'palace walk') flanked by rooms supposed to cater for carriage, horses, provision of meals etc.[20] In Henan in the following two centuries box-like tombs on approximately this plan (with flat or slightly ridged covers over each space) were built of large hollow bricks made of a characteristic grey pottery,[21] this ceramic allowing impressed or engraved decoration which affords an insight into the graphic art of the period.

Large vaulted tombs in solid brick came into fashion in the second quarter of the first century A.D. A tomb in the Cixing-xian of Hunan is dated to *ca* A.D. 33 by an inscribed brick found in another tomb of the group. The main chamber is a transverse barrel-vault three metres high approached through a lower vaulted antechamber.[22] Next a *qinshi* added behind the main chamber produced a cruciform plan which was followed by the majority of brick tombs during the remainder of the dynasty, as seen especially in Henan and the vicinity of Luoyang. The arms of the cross, open to the main chamber, gave ever more room for stowing pottery and other grave-gifts.[23] Even when the main chamber at the crossing seems to call for domed roofing (as in a tomb of *ca* A.D. 100 where the profile of the vaulting is somewhat pointed towards the top), the dome appears not to have been attempted.[24]

Since the walls of these structures were held by the sides of the earthern pit in which they were built, there was no need to devise buttress systems for their support. Adherence to timber pillar-and-beam for patrician edifices domestic and official gave no encouragement to over-ground brick building of any size. The use of brick in large structures had been established through the Qin emperor's repair and extension of the Great Wall, a task completed by 210 B.C. Since the brick technique of the Great Wall was continued in city walls and forts through all later history, it is strange that it should appear in tomb building only after an interval of three centuries. In the second century A.D. grandiose

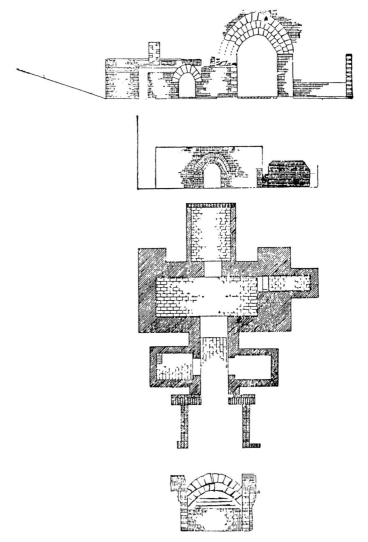

182. Structure of the subterranean stone tombs in Xiangcheng-xian, Henan, and Wangdu-xian, Hebei. Second century A.D.

brick tombs added side chambers opening from the antechamber through round-headed doorways, sometimes communicating with the transept arms of the main chamber; and concurrently the height of the main vaults was increased and the arch became a little pointed. Elaborate examples of these tombs were excavated at Cigou in Xiangcheng-xian, Henan, and in Wangdu-xian, Hebei.[25] The eight-roomed Wangdu tomb measures 17.6 metres from stone two-valve door to the back of the *qinshi* and rises almost five metres at the highest vault [182]. The painted figures of officials covering the antechamber walls document Han mural style in its maturity. The brickwork offers no ornament other than horizontal courses of alternating horizontal and vertical settings. Only at a multichambered tomb of *ca* 150 A.D. in the Wuwei-xian of Gansu, the source of many exceptional figurines of horses and carriages, is there record of brickwork patterned in contrasting colours.[26]

Dated by inscription to A.D. 132, one of the Cigou tombs adopts for its ornament a type of stone relief developed towards the end of the previous century. By chiselling down the background, leaving the subjects in smooth relief on

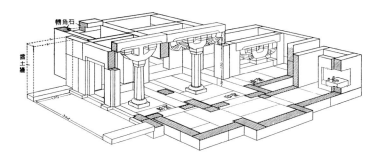

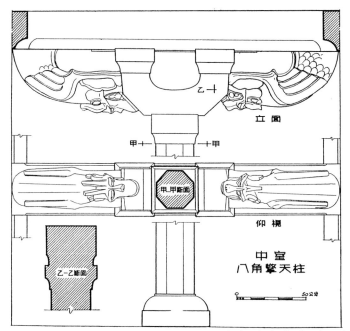

183. Stone subterranean tomb in Yinan-xian, with detail of pillar heads and brackets. Shandong. Late second century A.D.

They complement the history of these items as deduced from the many models made through the second century A.D., in response to the demand for detailed social representation in the grave-goods. As a central artistic element as well as a technical device, the development of bracketing is a leading theme in the architectural history.

The earliest representation of the pillar head appears also in the bronze-engraved scenes of the fifth century. Capitals expand upwards in two steps to a width three or four times that of the pillar [184]. They consist of a complex of several items, some being apparently timbers shown end-on. The pillar is seen to spread its thrust along the eaves beam and some transverse beams. There is no suggestion however of brackets springing from the pillar head.[29] It is not known just when brackets were introduced, but their use is evidently well advanced when they are documented in pictures and models of the later first century and the second century A.D.

Wide eaves were ever the desideratum, and in particular their need of support at the corners of the buildings recurrently prompted new devices. An early method is indicated by an ornamental bronze table found in the royal tomb at Zhongshan (second half of the fourth century B.C.). This adopts an architectural feature at its angles, with a straight corner bracket holding a beam-bearing post in each of the two planes.[30] By the mid-first century A.D. at the latest the standard bracket has become a high-rising U-shaped member standing on the pillar impost and supporting the beam on its own two imposts; or a third vertical support is added between the outer arms. This also might branch in one plane across the corner, at 45° to the façade, a treatment implied on house fronts shown in the tomb reliefs, though obscured here by the limitation of the current perspective

184. Engraving on bronze: ceremonial building and attendants, showing pillar capitals and roof framing. Excavated at Changzhi, Shanxi. 5th century B.C. width of the fragment 19 cm.

which detail is incised, the door jambs and lintels of the antechamber and the main chamber display dragons, tiger, deer, horse, dog, elephant (?), and a supernatural huntsman. In this tomb and many similar, stone is combined with brick; but already a generation earlier a tomb of *ca* A.D. 100 in Nanyang-xian, Henan, is built entirely of stone, the doorways decorated in similar fashion but with naïver figures.[27] At first, as this tomb shows, stone was placed in slabs and lengths of rectangular section, the cutting of the simplest. The employment of stone in large regular units challenged a closer imitation of the forms of wooden architecture. In the small stone tomb near Yinan in south-east Shandong one may see how far this idea was taken in the last decades of the second century [183].[28]

With unaccustomed disregard of symmetry in the plan, the six forward bays of the Yinan tomb are roofed by square-based corbelled vaults of three to five steps. The three bracketed pillars down the centre line from the entrance on the south side carry stone beams which underpin the inner edges of the four middle vaults, and the whole of the remainder is made up of slabs and square-section beams of what appear to be a few standard sizes. Apart from the ubiquitous engraved decoration of the stone surfaces, the imitated stone pillars and brackets hold the chief interest.

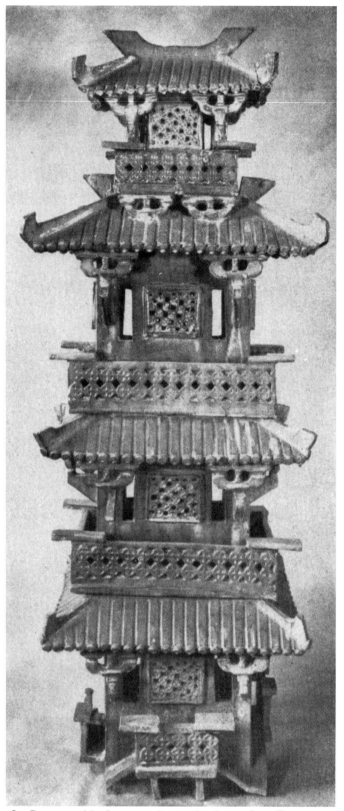

185. Pottery model of a tower showing bracketing, from Gaotang-xian, Shandong. First–second century A.D. Ht 130 cm

drawing.[31] But brackets in a single plane across corners are seen on some of the tower models of the second century, while on others the eaves or balconies are held up by a pair of single-plane brackets set close together on either side of the corner [184]. The pillars of the stone tomb at Yinan have plinths of a square below a ring, square imposts with the lower edge channelled, branching single-plane brackets holding similar imposts. The octagonal section of the pillars was probably a necessity of the stone working, there being no evidence that wooden pillars were anything but round. The dragon heads biting the brackets of the inner pillar are a fanciful addition, though not unlike other non-functional ornament which appears on the pottery models.

The most instructive of these are the towers composed of three to five storeys. Some are part of an assembly of buildings enclosed by a wall, a plausible version of the kind of defended homestead with a watch-tower which seems to have become increasingly necessary in the late Han. Others stand free, are painted (usually with lozenge pattern in red, green, white) or have balustrades decorated in openwork. The originals of the latter are likely to have been of wood, like the brackets supporting the wide tiled eaves sheltering the balconies at each storey [185]. A question remains on the nature of the main internal structure, whether this was framed wholly in timber or consisted of brick as represented by the solid parts of the walls at each level. The brackets, of the tripartite single-plane type, bear on short posts which rise from beam ends projecting from the walls. They are situated either across the corners or in pairs at each corner parallel to the eaves. Stout transverse beams are implied, and the entire tower was presumably framed in timber continuously through the storeys. When a tower model shows no sign of wooden parts, as is sometimes the case with the homestead watch-towers, it might be supposed that only brick was used. Yet the equally wide eaves on these towers suggest that the necessary brackets were merely omitted by the potter. Eaves tiles have circular ends, the *wadang*. The many surviving examples of these, decorated with geometric figures, more rarely with dragon mask or phoenix, have engaged the attention of antiquarians since medieval times.[32] The pottery towers have been found only in Shandong and Hebei, where they are accompanied by many models of dwellings and their adjuncts: cattle pens, granaries, chicken coops and dog kennels, which certainly represent brick and plaster, possibly with some timber strengthening. House models of this class have been found also west in Shaanxi and south in Guangdong (where they are raised on stilts), showing three forms[33]:

 i. houses on a rectangular plan, divided into rooms around a small central yard, with separate tiled roof over each main bay;
 ii. houses consisting of a cluster of separately roofed rooms around a central bay of two or three storeys, the upper part giving the impression of a lantern roof;
 iii. homesteads set within high defensive walls, sometimes turreted at the corners, with a central courtyard and a single entrance.

Oblique interior views of walled homesteads are impressed on tomb tiles in Sichuan and carved on the stone of the

186. Ink impression of an impressed tile portraying a small house, from Chengdu Yangzishan, Sichuan. Second–third century A.D. Diam. about 40 cm

Yinan tomb in Shandong [186]. These pictures include a watch-tower whose timber structure is put beyond doubt and houses of one or two storeys wholly timber-framed.[34] The roofs of these buildings are supported on triangular trusses, with narrow eaves lacking support by pillars or brackets, this in contradistinction to the trabeate structure of grand build-

187. Representation of a ceremonial gate and the entrance to an estate, from a tomb in Deyangxian, Sichuan. Second–third century A.D. (The oblique view is one-tenth size, the smaller elevation three-sixteenths)

ings whose untrussed rafters balanced on bracketed pillar heads by the weight of their projecting part. A tile picture shows also a gateway in a wall, with engaged turrets acting as buttresses, at the top of which eaves beams are supported by short close-set, fanning stilts, without resort to bracketing. Along the wall top are laid longitudinal and transverse beams. Over one turret top rises a smaller replica of itself. These features of a defensive city wall had a long history, and resemble the guarded gateway of the early Tang period in western China. Not all gateways were so massive. In a tomb at Deyang in Sichuan are depicted two elegant bracketed towers of four storeys situated behind a double gateway, crowned by male and female phoenixes and in the accompanying inscription described as the eastern gate of a customs post. Another drawing shows what must be the entrance to a civil estate, with open roofed space either side of the gate, simple imposts and trees visible beyond [187].

Grave-side ceremonial chambers (sitang), built of wood from the mid-first century A.D., were multiplied in stone from the sixties of the following century. The fashion of sitang spread rapidly in the later second century from the metropolitan area of Shandong, Hebei and Henan west to Shaanxi and south to Jiangsu, furnishing proof of the centralizing patronage of imperial government and the growing fortunes of the nobility and high officials. These monuments contributed to the unification of art style so characteristic of the Han period, for they took with them styles of painting no less than of stonework. The mural painting which was transferred to stone was already an ancient tradition: the Lingguang palace built in the middle of the second century B.C. by a son of the emperor Jing had 'exuberant' painting on walls and ceilings.[35] Near the end of the second century the placing of inscribed funerary stelae was forbidden by edict – a prohibition maintained by the Wei successors of Han – and the use of stone for tomb chambers ceased.

An uncertain question is the extent to which major architecture of earlier times survived unchanged under the Han dynasties. During his regency at the end of the Western Han period the superstitious revivalist Wang Mang saw to the building of piyong, mingtang and lingtai ('imperial ceremonial hall, hall of light and spirit terrace') on traditional lines at Chang'an, and after he secured the throne he added his jiu miao (nine temples). Of these the first and last appear to be referable to foundations now excavated. The jiu miao are marked by three rows of square foundation podia (actually eleven of them) enclosed by a rectangular wall, situated just south of the Han city wall.[36] The foundation identified as a piyong consists of the weathered remains of a rectangular terreplein of the kind frequent in the fourth century B.C. Settings of square floor tiles around the sides of the terreplein, the position of post-holes and pillar bases, and traces of an inner rectangular enclosure with gateways and an outer circular enclosure have prompted an impressive paper restoration which takes advantage of the other evidence for pillar brackets and roofing [188].[37] On the evidence of a well-preserved ground-plan a paper reconstruction of the Qin emperor's Xianyang palace near Chang'an shows two symmetrical main halls raised on terreplein, with a long gallery joining them.[38] There is record of the surpassing

188. Plan and reconstruction of a ceremonial precinct at Xi'an, Shaanxi. Early first century A.D.

189. Reconstruction of part of the plan of the Yanggong palace in Xi'an, Shaanxi. First century B.C. or early first century A.D.

the end of Wang Mang's reign. The site of one building of the palace has thus far been excavated. The plan of the former courtyard mansion is approximately repeated: two adjacent precincts, oblong in plan with the longer axis lying east–west, measuring together 134.7 by 65.5 metres [189]. Two open courts in the west precinct and one in the east precinct were surrounded by walled apartments. Two covered open areas fronted on the south façade, where was located the main gateway untraced by the excavators. Elaborate roofing, an aspect of architecture eulogized in early descriptions, is indicated by the many rows of pillar footings, but has not been elucidated in any detail.[39]

splendour of the Yanggong palace, situated within the perimeter of modern Xi'an, which was destroyed in war at

The Period of the Six Dynasties

A glance at the Chronological Table (p. x) will show the complication of the dynastic history from A.D. 220 to 581, the time intervening between the Han and Sui unifications. Of the many states which successively divided the country those denoted *Six Dynasties* (Liuchao) all had their capital at or near Jiankang in Jiangsu (in the modern Jiangning-xian). The earliest of them, Wu (A.D. 220–280), shared the territory of the empire with Shu in the west and Wei in the north – the period of the Three Kingdoms. The remainder, Eastern Jin, Liu Song, Southern Qi, Liang and Chen, ruled the south-east and the Yangtze valley from 317 to 589. But these groupings leave out of account the great northern states, of which the Northern Wei (386–535) line of Turkic rulers, with their capital at Pingcheng near to modern Datong in Shanxi, had an all-important part in the creation and communication of art. From the fifth century the main political and cultural boundary is recognized in the term *Period of the Southern and Northern Dynasties* (Nanbeichao, 420–581). The northern states of Western and Eastern Wei (successor states to Northern Wei), with Northern Zhou and Northern Qi, are then placed in contrast to their south-eastern contemporaries. In the decade up to 581 Yang Jian, the future emperor Wen of the Sui dynasty, succeeded in uniting the country. His reign achieved the internal control and the foreign contact westward which ensured a characteristic cultural poise and receptivity under the following Tang dynasty.

BUDDHIST AND SECULAR

In the preceding chapter of this book graphic styles were described from monuments separated by considerable stretches of time in which the surviving evidence is meagre or absent, so that artistic events of the later first century B.C. and the second half of the second century A.D. appear in unreal isolation. The evidence of the Six Dynasties is also episodic. Sculpture, and painting also if we confine ourselves strictly to contemporary evidence, are known almost exclusively from Buddhist contexts. The first knowledge of Buddhism in China is usually assigned to the reign of the Han emperor Mingdi (A.D. 58–75), while surviving material evidence of the religion dates about two centuries later.[1] To be reckoned with through the earlier history of Chinese Buddhist art are intermittent imports from the Buddhist west, remotely north-west India itself, more immediately the Buddhist centres of Central Asia. These imports were models for image types and narrative themes sculptured and painted, and brought with them iconographic and symbolic detail which are judged to have been more or less well established in the places of origin. But evidence for close comparison rarely survives in these places. In China the Buddhist artists inevitably drew on secular practice, both as to style and iconic detail, just as the theology gradually took advantage of the ancient Chinese attachment to a cosmological spatial scheme of spiritual forces. The development of style in China does not follow even remotely the succession found in India itself. The Indian iconography, with its concentration from the first century A.D. on the human form, had been transformed in the later second century A.D. In the earlier period the leading subject of the iconography is the terrestrial history of Sākyamuni Buddha as founder of the religion, in his latest and his earlier lives. The Bodhisattva[2] Maitreya is portrayed as his successor in an age to come. In the second period other images are added, eventually in considerable numbers, to represent multiple spiritual functions of Buddha and Bodhisattva, and room is made even for cults springing from local pre-Buddhist tradition. In Chinese iconography the division of the two phases, *hīnayāna* (lesser vehicle) and *mahāyāna* (greater vehicle), is less clear; the historical themes of painting and sculpture persist through the Period of the Six Dynasties alongside images representing aspects of *mahāyāna*, while the portrayal of Sākyamuni Buddha and his accompanying Bodhisattvas and disciples takes chief place among images of all types. The scriptures of western Buddhism were translated in vast numbers by ecclesiastics avid to extend the religion, and the influence of texts such as the *Lotus sūtra* and the *Nirvāna sūtra* is prominent in the imagery.

It must be supposed that draughtsmanship resembling that of the Han period as described above continued into the Six Dynasties, but on the present evidence its trace is not recovered before the early fifth century. It is then found under the south-eastern dynasties, still recorded as engraving on stone, at dates reaching to the 580s. Some of the themes adopted are of Buddhist character, but their style seems to owe nothing to the murals first painted a little earlier, or continued contemporaneously, in the Buddhist cave-temples of Dunhuang (Gansu) at the western extremity of China proper. Conversely, these murals retain elements which connect more clearly with Han non-Buddhist art than do the subjects engraved in the south-east. The surest continuity of an expressive art through the Six Dynasties is to be seen in Buddhist sculpture, recorded by isolated examples from the third century and more closely by extant monuments from the mid-fifth century onwards. Secular sculpture of note is confined to the south-east, in tomb-guard animals executed from the second quarter of the fifth century to the mid-sixth century under the Song, Qi and Liang dynasties.

The Age of Division: Sculpture of the Northern Wei First Phase

Little survives before the Han period to show the existence in China of developed stone-mason's craft or the practice of monumental sculpture.[1] The stone carving of architectural elements seen in the Han tombs of the second century failed to found a lasting tradition, so that the monumental sculpture launched under the impulse of Buddhism appears to make an independent start.[2] The first surviving images, of the fourth century, are all in bronze, gilded and of small size; traces of image-making reflected in some secular ornament of the previous century suggest similar types. The images imitate forms introduced into China from the west as figurines or paintings. After a time of direct copying, with alteration imposed by local taste and a readiness to simplify, or by incompetence or artistic indifference, begins a more creative phase, when the small figures are more fully worked. They were taken also as models for larger images carved in stone, free-standing, or in high, virtually detached, relief on the walls of the cave-shrines such as those created in north China under the Northern Wei. Style was exchanged between large-scale sculpture and its miniature equivalent. The support offered to temporal power by their deities was a prime topic in the missionaries' propaganda, and image-making became a matter of governmental and patrician patronage. A difference of northern and southern practice is already discernible in the styles of the few surviving works antedating the cave-shrines. In the light of work subsequent to the initial phases of the cave sculpture one may speak with more assurance of ruggedness and experimentation under the Northern Wei and its Eastern and Western Wei successors, in contrast to more assured design and smoother finish in the Liu Song and Qi states: Mizuno's 'powerful naïveté' against an 'air of nobility and elegance'.

Embassies from the west reached both the northern and the southern courts, often bringing priests and images. Monks came to the Wei capital in the 450s. Of three images presented in 455 one was a replica of the 'shadow of Sākyamuni' said to be seen in a cave near to the modern Hadda in Afghanistan. At this time the Wei kingdom seems to have had little official contact with the southern rulers; an envoy coming from the Song state found little of Chinese civilization there. Wei expansion was to the west, and a decisive event for the progress of Buddhism and its art was the Wei capture in 439 of Liangzhou, capital of the small Gansu state of Hou Liang. Since 386 Hou Liang had been in possession of the Dunhuang territory. Here the first of the Mogao cave-shrines had been excavated in a sandstone ridge some decades earlier. The Wei ruler is said to have moved thirty thousand families from Dunhuang to the vicinity of Pingcheng, and these are likely to have included some of the sculptors and painters who were presently to be engaged on the Wei rulers' own cave-shrines, begun in the early 450s at Yungang near to their capital and close to modern Datong in Shanxi.[3] In the Dunhuang caves the types of the Buddha seated with pendent or crossed legs,

and the Bodhisattva standing, or seated cross-legged, were already well established.[4] Modelled in clay and painted, these images are a local redaction of the Gandharan tradition of north-west India as it had penetrated though Central Asia, with concentration on a cross-legged version unknown in Gandhara itself. The latter, in view of its later history, may be intended to represent Maitreya, although the simplicity of the image suggests rather Sākyamuni [190].[5] When they are shown at all, the folds of drapery are represented by a uniform raised line which appproximates to one of the Gandharan conventions, but the slack modelling of the figures departs essentially from the remote stone models. Inheriting this Dunhuang tradition in some form, the sculptors of the Wei metropolis in the east were required to work in stone, and in doing so created new styles.

The over-lifesize images of Buddhas and Bodhisattvas[6] carved in the stone of the Wei cave-shrines at Yungang and Longmen (respectively near Datong in Shanxi and Luoyang in Henan) are matched in the south by similar large statues in bronze, as when the monk Seng Yu was entrusted by the Liang ruler with the casting of a colossal Buddha for a cave-shrine, none of this work now surviving. Although suitable

190. Clay image of Sākyamuni, seated with crossed legs, in Dunhuang Cave 268. Early fifth century A.D. Ht 79 cm

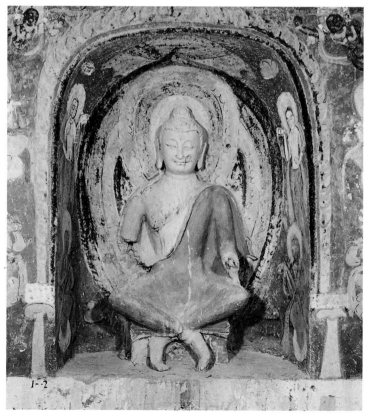

material was rarer, stone also was carved in the south-east, as in the first decades of the fifth century by Dai Kui and his son Dai Yong. This mention of named sculptors, exceptional in the literary record, attests a practice of large-scale carving comparable to that of the northern cave-shrines. While inspiration for the northern images came at its remotest source from Gandhara, models reaching the southern states appear to have originated from other schools, situated, it is surmised, in central and south India. Foreign monk-artists worked at the Liang court, whose ruler accepted Indian religious authority. Iconographic cartoons by one Sanghabuddha living at this time were extant in the imperial collection at the beginning of the Tang dynasty. Pengcheng, at the north-western tip of Jiangsu, was disputed territory: while it was in Song hands an 118-foot gilded bronze statue was made there for the Songwang-si temple; and when the town fell to the Northern Wei in 467 following the annexation of parts of Shandong, Jiangsu and Anhui, population was again transferred to the vicinity of the Wei capital. On this evidence and more we may suppose a ready exchange of sculptural ideas between north and south-east, leading to a blending of influences emanating from two regions of India. The intermittent hostility between the Wei and Song states seems to have favoured certain personal and cultural contacts rather than inhibit them. Northern Wei sculpture divides readily into the three successive phases: pre-Yungang, Yungang and Longmen.

PRE-YUNGANG SCULPTURE:
NORTHERN WEI FIRST PHASE

Bronze mirrors of A.D. 240–260 found in Zhejiang and Hubei (Wu state) and as export to Nara, Japan, include seated and standing figures in silhouette, aureoled, which must copy Buddhist images [191]. They are multiplied in the ornament and combined with phoenixes and other non-Buddhist devices.[7] Thereafter small images in gilded bronze supply the greater part of the record for the fourth and the early fifth centuries, the earliest inscribed example at present known being dated to A.D. 338 with a reign title of the north-western Houzhou state [192]. The folds of the gar-

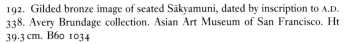

192. Gilded bronze image of seated Sākyamuni, dated by inscription to A.D. 338. Avery Brundage collection. Asian Art Museum of San Francisco. Ht 39.3 cm. B60 1034

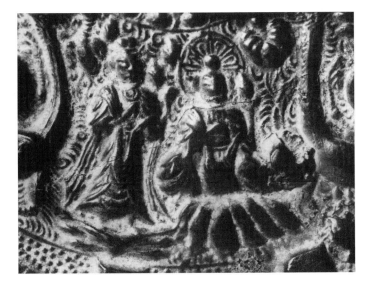

191. Image of the Buddha used in the ornament of a bronze mirror. Found in a *kofun* tomb in Nagano-Ken, Japan. Third century A.D.

ment are formalized from the Gandharan model into stepped bands almost wholly symmetrical. Rather than adopting a posture proper to Sākyamuni in the Indian tradition, the hands are placed together on the lap approximately in the *mudrā* of meditation; the hair is neat over the head with *ushnisha*, instead of displaying the irregular locks of the Buddha's sword-cut tonsure. Apart from the simplification one suspects uncertainty in some iconic features, as when the number of Buddhas of the past displayed on the mandorla varies from a multitude – signified by a dozen or a score – to a mere three, the latter anticipating the canonical seven which becomes the rule in the latter part of the century. In contrast to the austere model and as an exemplar of the finest work of a somewhat earlier time, probably the end of the fourth century, the celebrated Bodhisattva of the Fujii Yūrinkan intends a faithful copy of a Gandharan model: the dress is the princely finery of the Bodhisattva Maitreya[8]; the hand is enlarged as one of the marks of greatness (*lakshana*), the drapé attempts to represent the free fall of folds [193].[9]

The early fifth-century images follow one or other of these styles: to the austere type may be added the lions of the Buddha's royal throne [194],[10] or a flame-edged man-

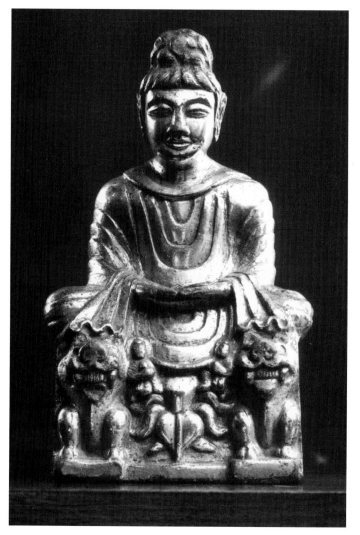

194. Gilded bronze image of Sākyamuni seated. Early fifth century. Nelson-Atkins Museum of Art, Kansas City. Ht 11.3 cm

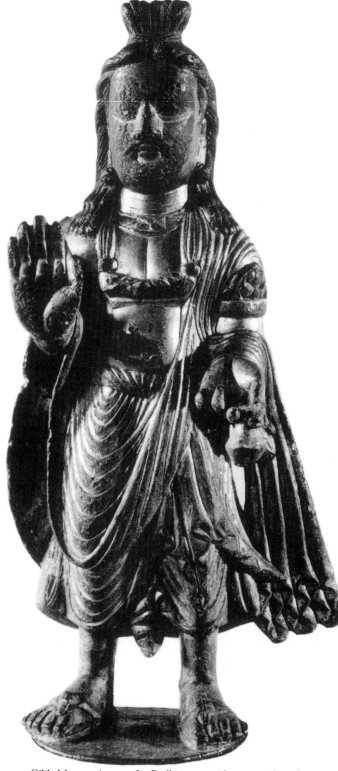

193. Gilded bronze image of a Bodhisattva, said to come from Sanyuan-xian, Shaanxi. Fujii Yūrinkan, Kyoto. 4th century A.D. Ht 33.3 cm

dorla[11] surrounding a seated figure dated to 437 [195][12]; while a seated Śākyamuni with the suggestion of flames issuing from his body (as allusion to the miracle of Śrāvastī) is of the sculptural Gandharan type, with sensitively moulded body and flowing drapery.[13] Similar in this respect is a standing Śākyamuni of 443, whose outer garment spreads wide.[14] Manufacture in the south is vouched for only in the case of the Buddha of 437 with flame mandorla, the regnal period here belonging to the Liu Song state: its drapery is as stiffly geometric as that of the like northern pieces, giving no support to the theory of distinct southern style at this time. But most remarkable of all is the standing Śākyamuni of gilded bronze now in the Metropolitan Museum, said to have come from Wutai-shan in Shanxi [196].[15] Measuring 1.4 metres in height, it is the only surviving piece which conveys the quality of the monumental bronzes of the fifth

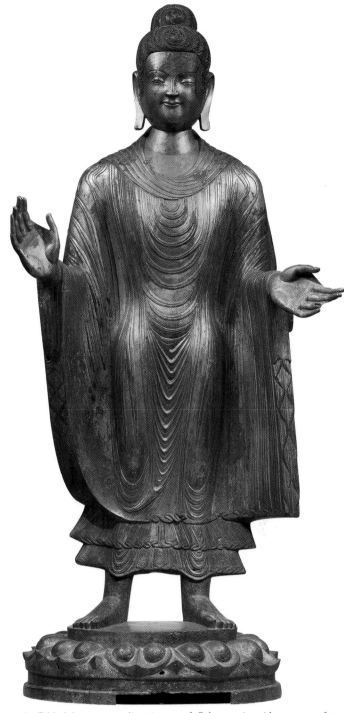

196. Gilded bronze standing image of Śākyamuni, said to come from Wutai-shan, Shanxi. Dated by inscription to A.D. 477. Metropolitan Museum, New York. Ht 1.3 metres

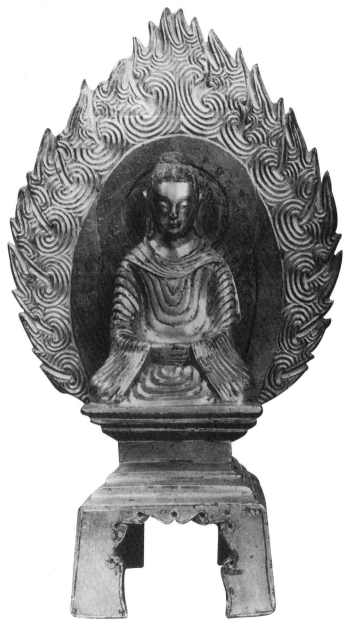

195. Gilded bronze image of Śākyamuni seated. Eisei Bunko, Tokyo. Dated by inscription to A.D. 437. Ht 29.4 cm

century. Posture and drapé are what the above image of 443 copies at half the size. The folds of the garment are represented by flattish raised bands divided by grooves into two or three ridges, an imitation of the Gandharan convention of alternating high and low waves of cloth (as seen in section). The forking of the folds over the upper arm is a Chinese convention, the suave curves and symmetries an ideal rendering of Chinese geometricizing pattern; the pleasing effect achieved by regard for the trunk and limbs beneath

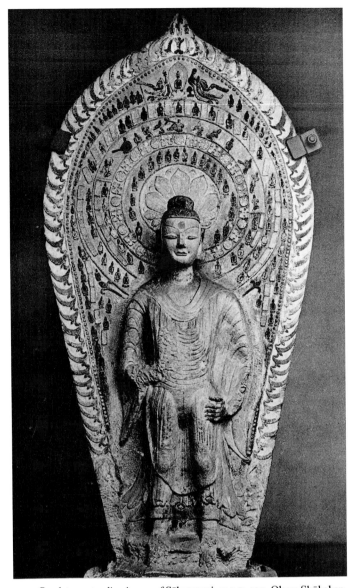

197. Sandstone standing image of Sākyamuni. *ca* A.D. 400, Okura Shūkokan, Tokyo. Ht 2.4 metres

the garments is a quality absent from other work of the fifth and sixth centuries. The inscribed Northern Wei date equivalent to A.D. 477 recently discovered on this image places it within the Yungang period, but the style it represents is anterior.

Mainly from these bronze figures must be judged the character of stone sculpture as it was before the unifying and widely spreading effect of the concerted enterprise at the cave-shrines. Some small stone sculptures of pre-Yungang date preserved in Japan do however confirm the close connexion of work in the two media. A seated Sākyamuni of 455 has the hands in proper meditating attitude, with a score or so of the Buddhas of past aeons aligned around the mandorla. The garment folds resemble those of the Metropolitan bronze, but, unusual for China and never seen later, the right shoulder is left bare. On either side of the Buddha is a seated Bodhisattva, each with the ankle of the inner leg resting on the knee of the outer leg and the inner arm raised to the face. There is precedent for such a pair in Gandharan sculpture, but not for the special cult accorded later in north-east China to single figures of this form as 'meditating Bodhisattva'.[16] A stone version of this last type has a Northern Wei date equivalent to 442, and is the earliest indication of this cult.[17] A Northern Wei Sākyamuni of 457 is flanked by small standing Bodhisattvas, and here we see the germ of the trinity array which was to dominate in the cave-shrines and in free-standing sculpture thereafter.[18] The style of the bronze seated images of early Northern Wei type is seen also in a standing Buddha of sandstone, 1.97 metres high, with flame-edged mandorla backing the whole figure and incorporating lotus aureole and circles of multiple Buddhas around the head [197]. This unique work is said to have come from Yongluo-cun in Hebei, the only standing stone image of monumental size surviving from the first phase of Northern Wei. The block-like head, almost square in horizontal section, and the high smooth neck (i.e. lacking the triple grooves which became universal later) are typical early features.[19]

Yungang Cave-shrines: Northern Wei Second Phase

Between 460 and 465 began the hewing of five cave-temples in a south-facing sandstone cliff, the Cloud Ridge, *Yungang*, a short distance from the Northern Wei capital at Datong in Shanxi.[1] In 452 the ruler Wen Cheng had restored the Buddhist religion after a proscription in 446, and now upon the advice of the monk Tan Yao five caves were to be carved as a start, in expiation and as commemoration of earlier Wei kings. A headquarters of the grand operation was established as the Temple of the Miracle Cliff, *Lingyan-si*. More than forty caves were excavated, but of these the latter half degenerate to mere niches. Those numbered one to twenty record the major dealings of Wei kings with Buddhism, their dating and contents as follows:[2]

Period 1 = A.D. 460–475
Period 2 = A.D. 475–490
Period 3 = A.D. 490–505

Eastern sector:

I, II, period 1. Opened by Liu Chang, refugee in Wei in 465, to commemorate the emperor Wen Di of Song. Carved pagoda pillars reach to the ceilings of square-plan chambers.

III, IV, period 3. In III, the largest cave, twelve holes suggest an original wooden structure now perished. There are traces of Sui or Tang sculpture. IV has a central square pillar carrying niches with only one cross-legged Maitreya tolerably preserved.

Central sector:

V, VI, period 2. Paired caves measuring 23.8 by 17.7 metres were opened probably by the dowager empress Wenming. V has a seated Buddha 17 metres high. VI is on plan 14 metres square, with Buddha images on all sides of a two-storied square central block 15 metres high, the walls covered with rows of image niches framing Buddhas, arhats and apsarases [198, 199].[3]

VII, VIII, period 1. Paired caves were dedicated by the emperor Wen Xian to his predecessor Wen Cheng and consort, soon after 465. The caves have front and back chambers. On the main wall of the back chamber of VII a Bodhisattva sits on a lion throne. Niches and images cover the walls. VIII chiefly preserves exotic reliefs, in particular Vishnu (Mahesvara) and Shiva (Kumārakadeva), on the reveals of the entrance.

IX, X, period 1. Paired caves, with front and back chambers, were dedicated by emperor Xiao Wen to his predecessor Xian Wen and the latter's consort, after 476. IX has octagonal doorway pillars. The upper east and west walls are carved to resemble wooden houses; the rest of the walls is filled with niches holding images of the Buddha, heavenly musicians and dancers. In X the images include a cross-legged Maitreya flanked by Meditating Bodhisattvas, surrounded by crowded galleries of heavenly musicians and apsarases.

XI, XII, period 2 (an inscription gives the year 483). Paired caves were dedicated possibly by the reigning boy emperor Xiao Wen. A square pagoda pillar at the centre reaches to the roof, all its sides carved with Buddha images. Multiple identical niches and Buddha images cover the walls. The front chamber of XII is carved with house façades on the east and west walls.

XIII, period 2. At the centre is a seated cross-legged Maitreya almost 13 metres high.

XIV. Little remains besides a square pagoda pillar on the east side.

XV. The 'Cave of the Myriad Buddhas', these occupying uniform small niches over the side walls. Some larger niches and images occupy the front wall.

XVI–XX: the initial imperial commemoration caves, all of period 1.

XVI. Although excavated in period 1 the only image occupying the cave is a high standing Buddha which was completed in period 3.

XVII. On oval plan; the chief image is a cross-legged Maitreya seated on a Sumeru (i.e. nine-échelonned) throne.

198. Scheme of sculpture on south wall of Cave VI, Yungang. After Nagahiro and Mizuno. Scale one-seventieth.

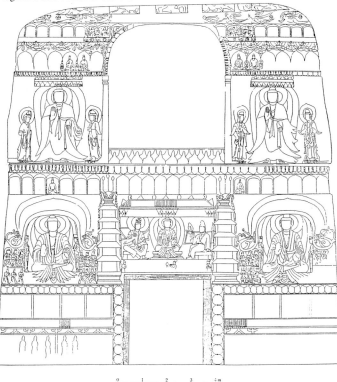

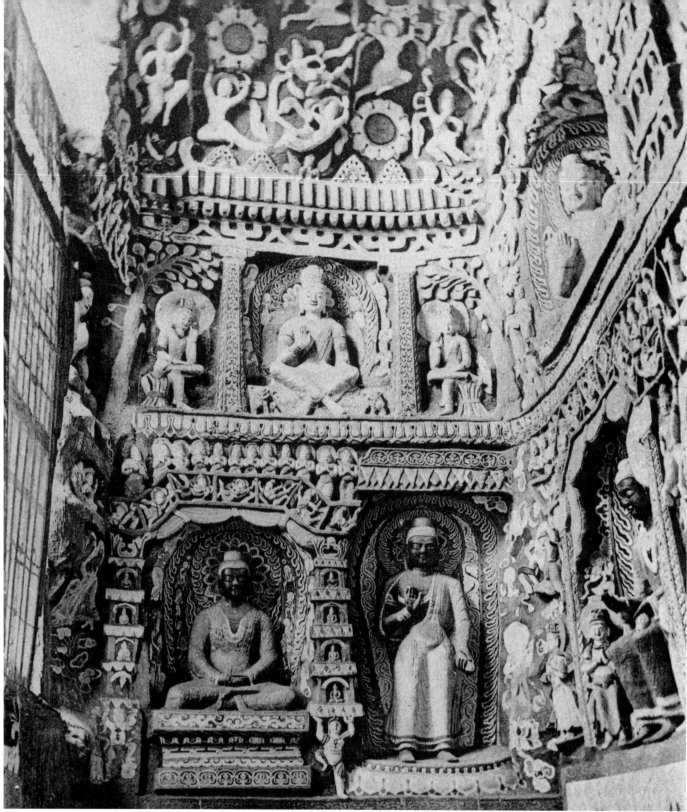

199. The west wall of Cave VI, Yungang

XVIII. On oval plan, with a standing Buddha 15.25 metres high on the north wall. The robe, covered with multiple small seated Buddhas in meditative pose, leaves the right shoulder bare. On the north-east wall a crowned Buddha with accompanying Bodhisattva carrying a kundika vase of pure water, and several arhats.

XIX. A colossal seated Buddha at the centre of the cave.

XX. The largest of the colossal seated images, a cosmic Buddha presumed to represent Vairocana, although he was flanked by standing images of the Buddha. The surviving eastern one of these raises the right hand in *abhaya mudrā*.[4] This combination of images is a measure of the iconographic eclecticism of the time.

The Yungang cave-shrines and their successors at Longmen are distinguished from all others by architectural detail used in ordering extensive storied schemes of image niches. One surmises a coherent body of motifs mediated from the west through Gandharan sculture, whose ultimate source was the

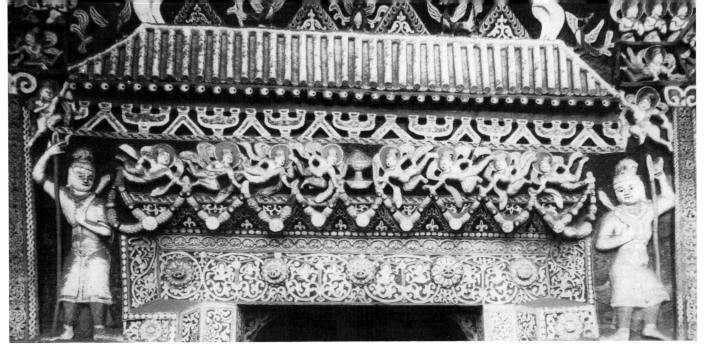

200. Architectural ornament in Cave V, Yungang, showing aeroteria on the gables, brackets and 'frog's legs' under the eaves.

202. (right) Representation of *jātaka*: the Great Departure. Cave VI, Yungang

201. Representation of *jātaka*: the elephant ride of the Bodhisattva Sākyamuni. Cave VI, Yungang

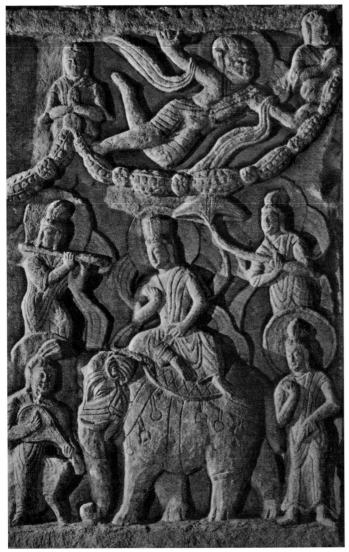

architectural ornament of the Roman Levant in the second and third centuries: the palmettes, half-palmettes, tongue-and-dart, vine-scroll and honeysuckle-spray of this repertoire all have their Northern Wei equivalents, albeit more stiffly geometricized or reinterpreted with additional Buddhist elements [199]. Borders of palmette and leaf-scroll separate the galleries of niches. Vigorous versions of Roman erotes are incorporated into scrolling or figure with apsarases,[5] while tongue-and-dart is transformed into imitation of cloth lappets with much the same effect. These Gandharan elements increase through period 1, XVI–XX to VII/VIII and IX/X, reaching period 2 in V/VI; but the latter paired caves belong with I and II to a group distinguished by sinicizing features.[6] As regards architectural detail this meant niche-framing with curving dragon-bodies instead of vertical pillars, or with pagoda-columns (i.e. piled small image niches); and instead of straight-lined lintels, more frequent representations of Chinese roofs complete with tiles, acroteria, triple and 'frog-leg' brackets under the eaves [200]. Entire realistic buildings are carved in *jātaka*[7] scenes. The columns may, however, be filled with exotic palmette-based motifs. A canopy sometimes replaces the niche recess (VI upper east wall), and animals, birds and schematic landscape introduce an exclusive Chinese interest: in VI, the

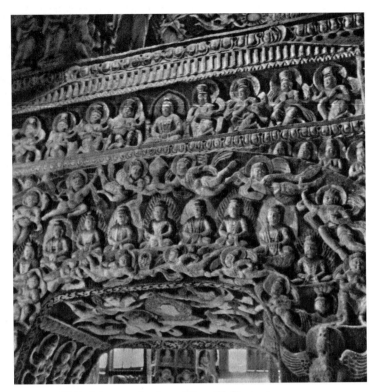

203. Wall of the rear chamber of Cave IX, Yungang

sāla trees placed in the Sākyamuni birth scene and over Meditating Bodhisattvas; in II the relief-carved perspective scenes of Sākyamuni's previous luxurious life, his ride on an elephant, his encounters with an old man and with a funeral, retreat to the wilderness, the Great Departure from the palace, and the death [201, 202]. The niches given a beam roof, straight but for the down-angled ends, are invariably framed with imitation of swagged cloth. The ornament of VII/VIII and IX/X attains a climax of variety and splendour that defies description. Minor Buddhas and Bodhisattvas, apsarases, erotes and heavenly musicians are lightly framed in architecture, joined by garlands, sit in solid rows or fly freely on ceilings, closely packed in true *horror vacui*, with ubiquitous lotus stems and blossoms. The rear chamber of IX is an ideal sample [203].[8] All that lacks to the modern viewer is the brilliant colours which covered the total work, leaving now only the minutest traces.

The main images of the caves allow definition of three manners, distinct but not wholly sequential. The first manner, of period 1, is at its fullest expression in VII/VIII, and gives the impression of the rendering in stone of forms first modelled in clay and stucco. No hint occurs of the inner mass and articulation of the human body, and no advantage is taken of contrasting planes of surface brought to meet along significant lines (i.e. a leading principle of work immediately following that of the Yungang shrines) [204]. The unchallenging plasticity of this manner, readily legible and flattering to the eye, flows smoothly from main image to surrounding frame and beyond to the mass of other figures and decorative items. The architectural frame appears essential to it. The loss in presentation which arose when architectural discipline was relaxed makes itself felt already in IX/X; then the total design could no longer develop along

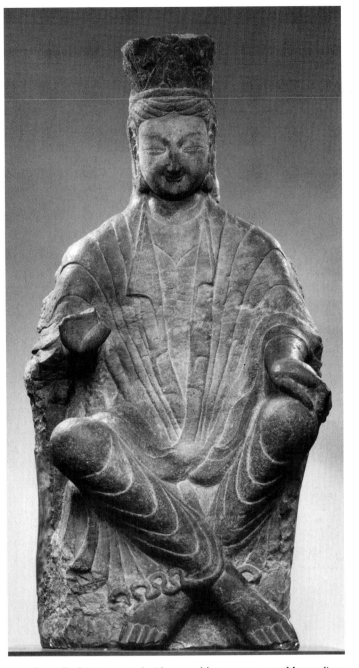

204. Stone Bodhisattva seated with crossed legs. *ca* A.D. 470. Metropolitan Museum, New York. Ht 1.30 metres

the same lines, and some later caves are content with mere repeated small niches lacking noticeable order. The Hindu deities on the reveals of the entrance to VIII, their treatment particularly complete in the first manner, are repeated with the general ornament high on a wall of VI. These icons mark a first flush of exotic influence, and do not recur in Chinese Buddhist sculpture [205, 206]. In the lower zone of each reveal in VIII stands Indra holding his thunderbolt. On the left a bull carries three-headed and eight-armed Mahesvara, lord of the present universe of worlds.[9] The five-faced six-armed Kumārakadeva on the right, with his symbols of chicken and bell, has exchanged his proper peacock for a dragon-headed bird. The folds of garments on sculpture in

205. Kumārakadeva in Cave VIII, Yungang

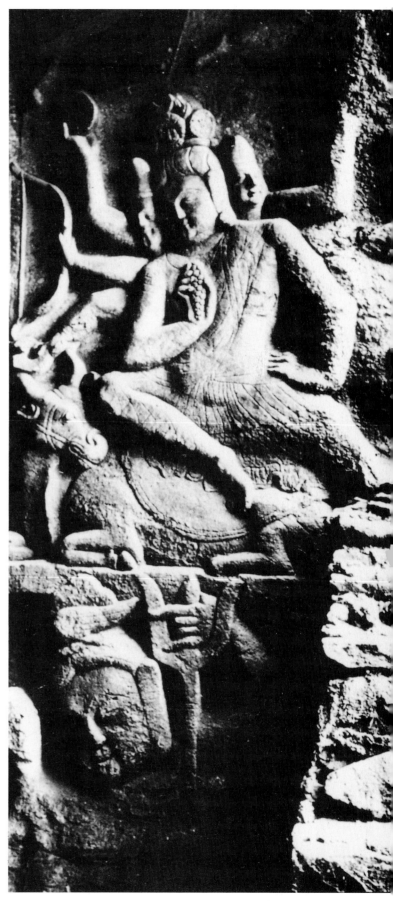

206. (*right*) Mahesvara in Cave VIII, Yungang

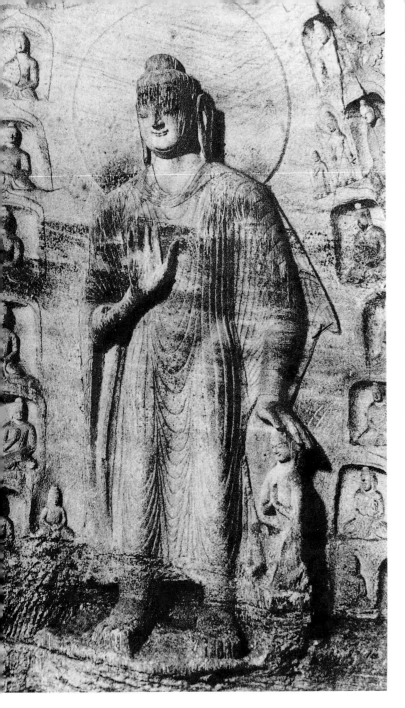

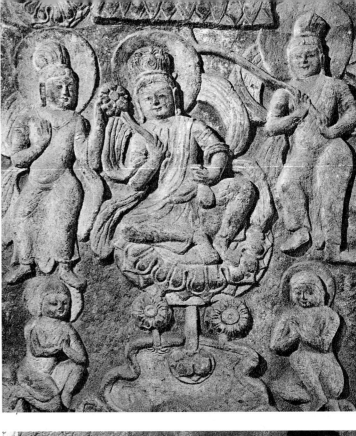

207. Colossal standing image of Śākyamuni in Cave XIX, Yungang

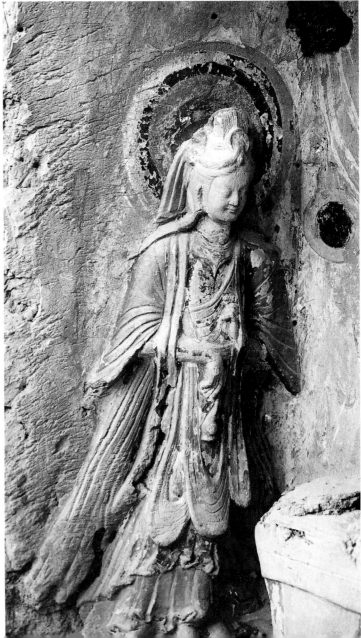

208. (*top, right*) Crowned seated Bodhisattva in back chamber of Cave VII, Yungang. A little over lifesize

209. (*right*) Clay image of a Bodhisattva at the Maijishan cave-temples. Late fifth century A.D. About lifesize (the face remodelled)

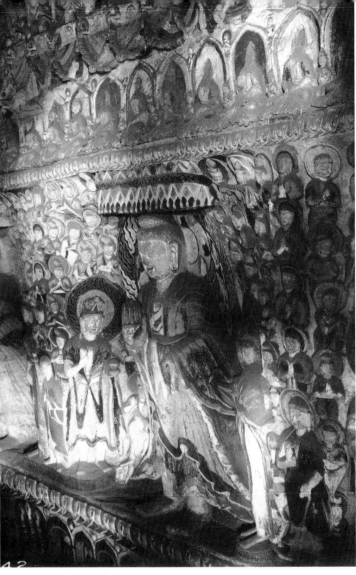

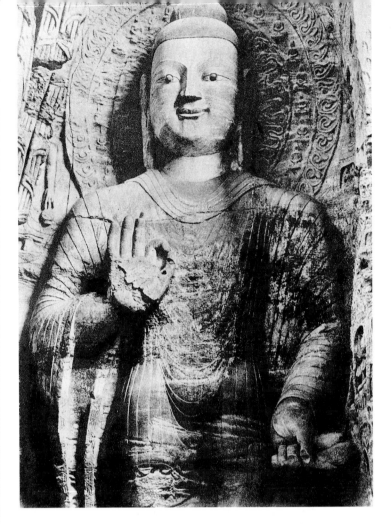

211. Colossal standing Buddha in Cave XVIII, Yungang

210. Trinity on the upper east wall of Cave VI, Yungang

the first manner are mostly reproduced as simple grooved lines on otherwise even surfaces, as for example on a standing Sākyamuni in XIX [207]. A crowned cross-legged Bodhisattva in VII (main room, south wall, fourth storey) and another in IX seated on a lotus throne and holding a lotus bloom (rear chamber east of window) show a more considered handling of the grooves [208].[10] The stucco sculpture of late Northern Wei date at the Maijishan and Bingling-si caves presents the same appearance, and similar grooving is the rule on some small clay images of the time, which are likely to represent a commoner practice than the rare surviving examples might suggest [209].[11]

The second Yungang manner, of period 2, raises the surface of the garments in wide stepped bands, somewhat resembling the 'plate drapery' of Gothic sculpture [210]. It is a manner already apparent in lesser degree in period 1, as on the great standing Buddha of XVIII [211]. It becomes characteristic in period 2 in V and VI, being ideally represented by the Sākyamuni trinity on the upper east wall of VI. In this last array the garment skirt of the central image flares to the sides in the shape called 'fish-tail' by Japanese scholars. The accompanying standing Bodhisattvas introduce the loops of cloth crossing on the front of the figure, a device due to set a long-enduring fashion. This arrangement is particularly effective on the seated crowned Bodhisattva with

crossed legs, the Meditating Bodhisattva, an image now accorded an individual cult. The second manner belongs to the 'sinicizing' period of Yungang sculpture, and is plausibly explained as a response to influence reaching the Wei capital from the southern Liu Song state. In XI and XII of period 2 the manner is seen in Buddhas and Bodhisattvas, in main and subsidiary images. It is used on the principal image of XVI, which was not completed until period 3. Many fine examples of the second style are to be found in the images of the small caves and niches at the western end of the Yungang cliff, all of which are of period 3 or later.

The third manner, contemporary in period 1 Caves VII/ VIII and IX/X with the manner of plastic relief and grooved drapery, attempts closer imitation of the Gandharan idiom as this appears in Bodhisattva images. It results in somewhat irregular and heavy folds, more or less realistic but tending to lack the sculptural unity of the other Yungang manners. This treatment is seen ideally in the great cross-legged Bodhisattva with flanking seated Buddhas on the upper north wall of the main chamber of VII [212]. All three figures of this exceptionally well-wrought trinity raise the right hand in *abhaya* – an eccentric combination on all accounts. The treatment of the garment folds on the colossal Vairocana of XX stands outside of the trends indicated by the three manners we have defined. With the other imperial caves, work on XX appears to have been wholly, or at least mainly, completed in period 1 (Mizuno's chronological table

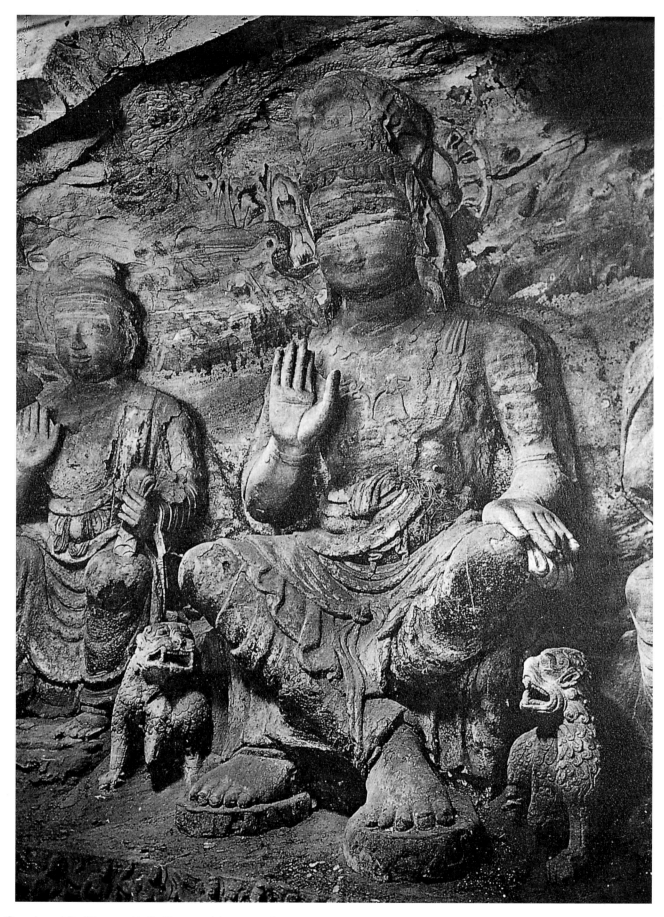

212. Cross-legged Bodhisattva with flanking seated images on the upper
north wall of the main chamber of Cave VII, Yungang. About two-thirds life
size

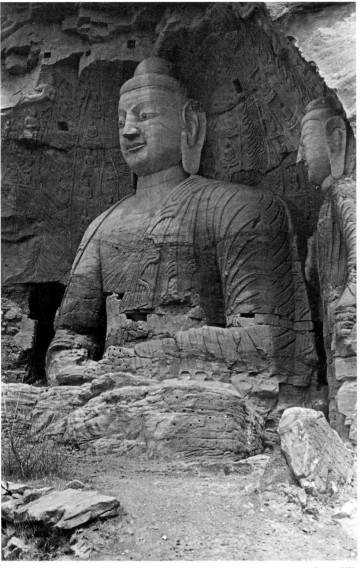

213. The colossal Vairocana, with flanking Bodhisattvas, in Cave XX, Yungang. Height of image 13.75 metres, (before recent restoration)

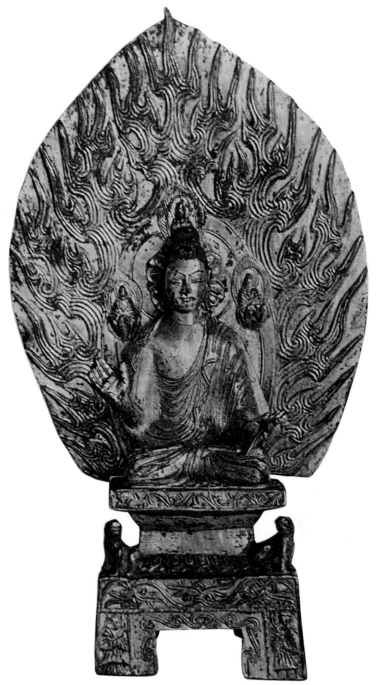

214. Gilded bronze seated Sākyamuni. A.D. 480–500. Collection of Ogihara Yasunosuke, Kanda, Tokyo. Ht 28 cm

allows a short extension after 475), and this date is corroborated by the first-manner grooved robes of the standing Buddha images which flank the colossus [213]. The drapé of the Vairocana may be regarded as an anticipation or variation of the second manner, distinct in raising the folds in separate relief bands and in giving greater prominence to the forked folds on the arm, while adopting a particular convention in the design of the lappet which hangs over the left shoulder. In all these features the Vairocana recalls a small gilt-bronze Sākyamuni (28 cm high) of early-Yungang date and of an elegance suggesting origin in the southern Liu Song region [214].[12] Here the resemblance aptly illustrates what has been suspected: the pointing of large images from smaller portable equivalents. It is remarkable that the cave-shrine artists did not fully reproduce the quality of the mature version of the first style presented by such small

images and by the bronze Buddha of 477 from Wutai-shan [196]. The *jātaka* scenes I, II and VII mark a pictorial interest of a home-bred kind which may also reflect the southern connexion. Realistic work in the spirit of the third manner at Yungang vanishes from monumental sculpture before the end of the fifth century, to reappear only some three decades later in the sculpture of the Northern Qi state.

Northern Wei Third Phase: A.D. 495–535

GILDED BRONZE IMAGES

A few of the gilded bronze images that survive from the second phase of Northern Wei attain or surpass the quality of the best of contemporary stone sculpture. The seated Sākyamuni received special attention: the right hand in *abhaya*, the left holding an end of the robe of which a small portion falls over the bare right shoulder. In the exceptional example instanced above (p. 117) the drapery resembles that of the Vairocana of Cave XX at Yungang, but the first Yungang manner is the rule. The images are backed by elaborate flame mandorlas on which often perch three or seven of the Buddhas of the Past. Apart from sculptural style, the northern manufacture of the majority of these images is guaranteed by the run of the ribbon swags and floral motifs ornamenting the throne, and often by engravings of donors and worshippers placed on the front legs of the throne and on the back of the mandorla. These representations furnish an album of Northern Wei draughtsmanship, displaying a settled naïveté which contrasts ludicrously with the delicate finish of the better images [214, 215]. In a standing Buddha of this class a slight inflexion of the body faintly echoes the triple-bend *tribhanga* pose of some near-contemporary Indian sculpture.[1] Versions of the twin Buddhas – Sākyamuni conversing with Prabhūtaratna, Buddha of a former age – were cast from the mid-fifth almost until the end of the sixth century [216, 217]. Like the contemporary seated and standing Buddhas of the second phase, their finish varies from delicate accuracy to a degree of crudity. When the single figure is a Bodhisattva it is likely to represent Avalokitesvara, *Guanshiyin* or *Guanyin*, although there is little sign of this cult (properly involving recognition of Amitābha, *Mituofo*) in the cave-shrines of the second phase. One form of the Guanyin is given a cloth crown with bands extending wide at the sides, apparently in imitation of the head-dress of Sasanian kings.[2] The lotus, figuring as petals on haloes and thrones, appears also as a complete bud, sometimes in the hands of donors, but notably in a cult figure made as a small image in all the phases of Northern Wei Buddhist art, though absent from the cave sculpture: Padmapāni, the standing Bodhisattva holding a lotus bud in his right hand. Lacking a western prototype, this icon takes two forms: a quieter version sometimes with inflected body, and another with flying scarves and parted legs, in a warrior-like stance which perhaps appealed to Toba patrons [218].[3]

As a foil and necessary supplement to stone carving, the Northern Wei third phase is best introduced through the bronze images. During a large part of the fifth century controversy had continued over the proper interpretation of the Nirvāna sutra, this involving opposing doctrines of sudden enlightenment and gradual enlightenment, and eventually leading to a reconciliation whereby the two doctrines might be held by the same person. At the heart of the puzzle was the question whether the Buddha on reaching *nirvāna* was totally extinct or might still be manifested in a vision. It was concluded that the latter is possible. From bronze images of Sākyamuni made in the third phase, after 500, one gains the impression that the sculptor was now set the task of inventing an image which would symbolize the moment of the Buddha's manifestation. His solution was probably that seen in the type represented by images in the Metropolitan and Philadelphia museums [219][4]: Sākyamuni presented gliding into our cognition to the accompaniment of Bodhisattvas and a flight of apsarases.[5] In these images of an *emergent* Buddha advantage is taken of the 'fish-tail' arrangement of Sākyamuni's drapery, already adopted in the second phase, to create the sense of movement, this agreeing with a chief aspect of pictorial verisimilitude as conceived since Han time. The bronzes are at the acme of such work: the Philadelphia

215. Gilded bronze image of Sākyamuni in the form of a relief plaque. Dated by inscription to A.D. 460. Asian Art Museum of San Francisco. Ht 16.8 cm. B60 643

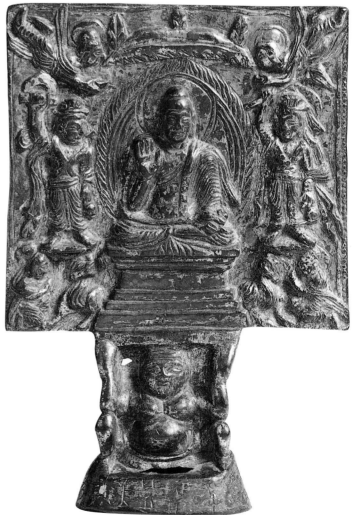

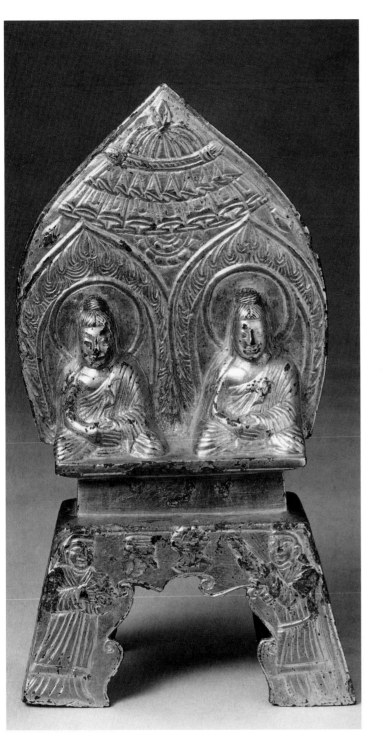

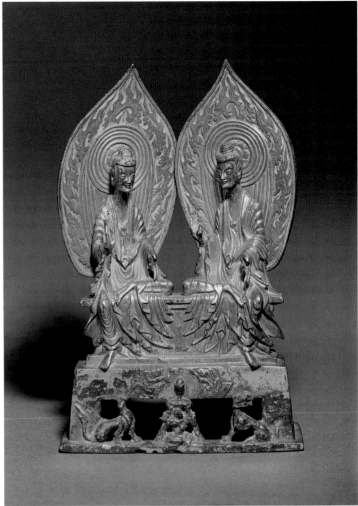

217. Gilded bronze image of Sākyamuni and Prabhūtaratna. Dated by inscription to A.D. 518. Musée Guimet, Paris. Ht 26 cm

216. Gilded bronze image of Sākyamuni and Prabhūtaratna. Dated by inscription to A.D. 472. Asian Art Museum of San Francisco. Ht 15.9 cm. B60B1035

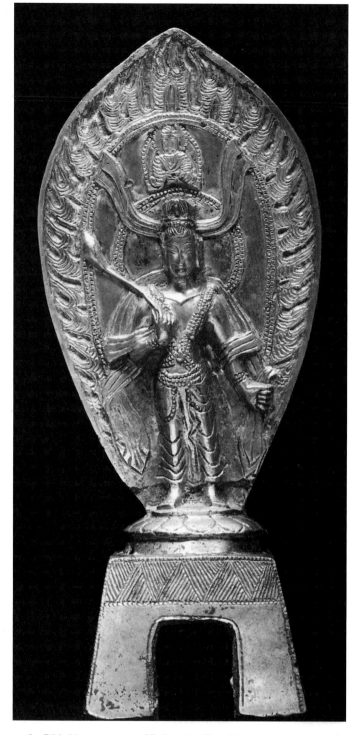

218. Gilded bronze image of Padmapāni. Dated by inscription to A.D. 485. Seattle Art Museum. Ht 21.6 cm

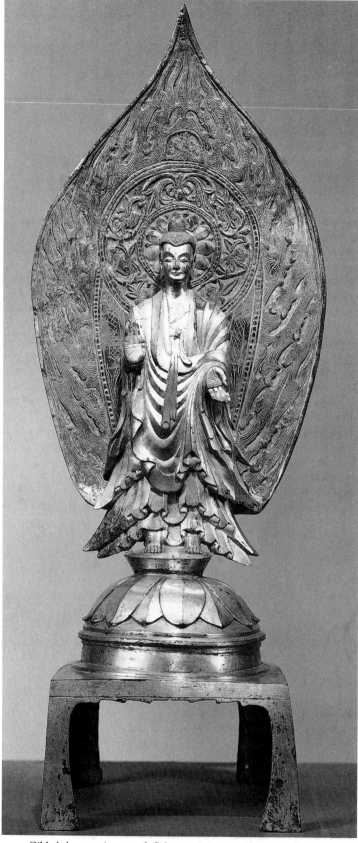

219. Gilded bronze image of Sākyamuni in manifestation. Dated by inscription to A.D. 536. Philadelphia University Museum. Ht 61.7 cm

220. Tiers of images, seated Buddhas and cross-legged Bodhisattvas, set on the left hand of a Sākyamuni trinity in the Guyang Cave at Longmen. Early sixth century.

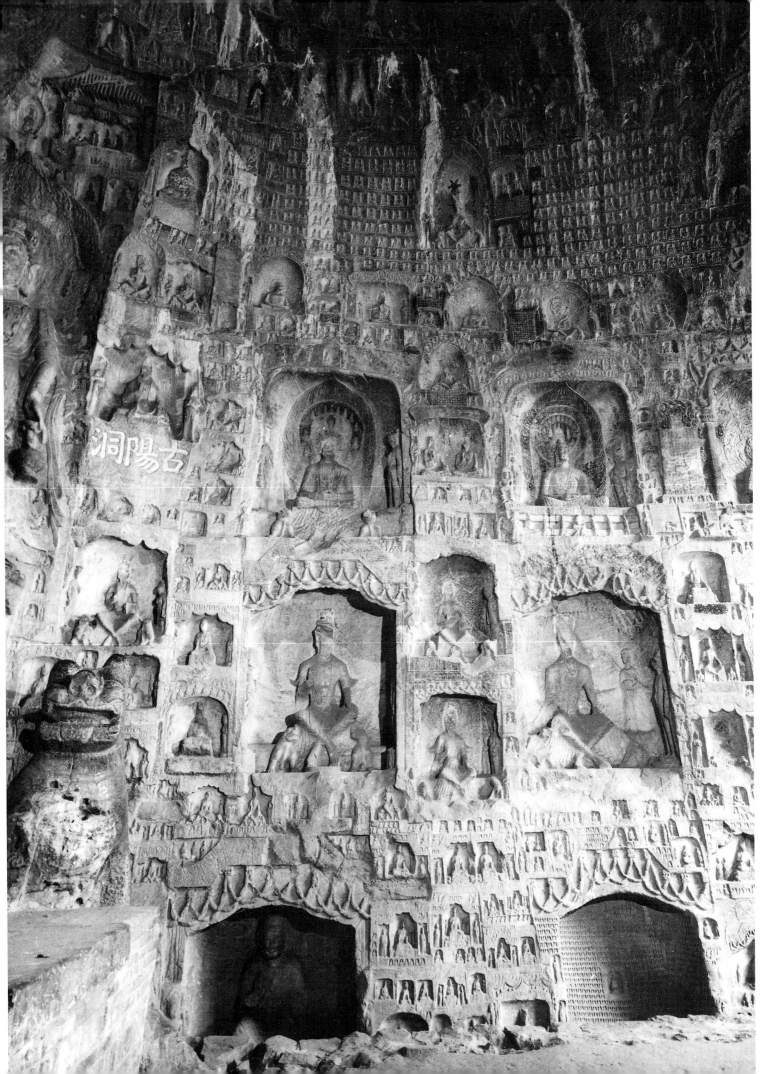

image with serene finality, the others stirring the imagination by all that is implied in the elaborate structures surrounding the main figure. The dates of the inscriptions are respectively 536 and 525.

LONGMEN CAVE-SHRINES

These caves were hollowed out during the last four decades of Northern Wei rule, starting shortly after 494 when the capital was transferred to Luoyang in central Henan.[6] The site is a south-facing limestone cliff about 12 km south of the modern city, Dragon Gates of the Yi Peaks, *Yique Longmen*. Most of the caves, and all the early ones, are on the north bank of a river which flows through a pleasantly wooded valley, such a place as Buddhists have generally sought: watered, shaded, verdant. Sculpture continued until the mid-eighth century at one or other of twelve main caves, of which the first five contain work of the Northern Wei third phase.[7] The sculpture of the two oldest caves, Guyang and Binyang, shows the Northern Wei second style at its extreme development. Flat bands of drapery are offset against each other by sharply chiselled parallel steps. Thick bundles of stiff and rigidly ordered cloth appear to enfold the body, nothing of anatomy penetrating the emphatic linear scheme. The garment skirt of both standing and seated figures is spread unrealistically to provide a field for a geometry of fictitious folds. The Guyang cave has a single scheme of smaller images around a main trinity of standing Sākyamuni and Bodhisattvas. The trinity is raised on a two-tiered throne with flanking Bodhisattvas set a little lower [220]. Two zones of niches extend on either side, the upper with eight seated Buddhas, each with hands folded in the meditading posture. In the second zone, the third niche from the left holds the twinned images of Sākyamuni and Prabhūtaratna and the remaining seven niches images of the cross-legged Bodhisattva similar to those carved in the first and second styles at Yungang. Evidently the somewhat irregular disposition of images followed the whims of patronage, now wider – as the increasing number of dedicatory inscriptions corroborates – than the governmental and patrician patronage of the main caves at Yungang. Of the images of the third and lowest, only two of the Buddha were completed, and two of the cross-legged Bodhisattva left unfinished. Most of the narrow surfaces separating zones and large niches are occupied by small niches with images. Such multiplication of the Bodhisattvas, many explicitly intended for Maitreya, is characteristic of the opening decades of the sixth century, when the Lotus Sutra served as basic teaching in the most popular theology.[8]

The emperor Xuanwu began the Binyang cave in 505. Geometric stylization has gone farther in some image types, and on the walls flat-surfaced relief ornament is more varied. The principal images now constitute pentads [221]: in each division of this triple cave a colossal Sākyamuni is seated between the standing figures of his oldest and youngest disciples, Kāsyapa and Ananda, and two Bodhisattvas; the side walls are occupied by standing trinities of Buddha and Bodhisattvas. Masses of flying musicians, apsarases and flowers crowd the ceilings [222]. From this time through the

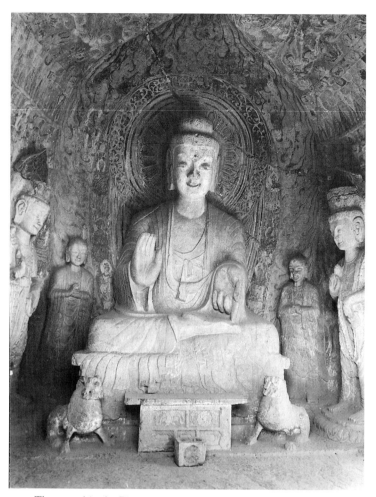

221. The pentad in the Binyang cave at Longmen. Early sixth century

222. Ceiling of the Binyang cave at Longmen. Early sixth century

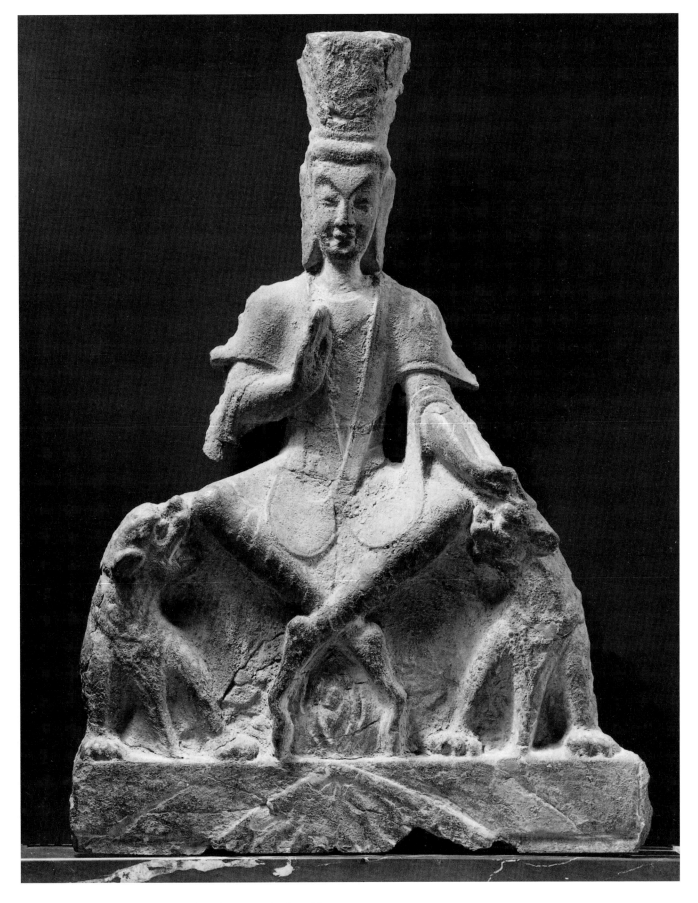

223. Bodhisattva in analytic style. Early sixth century. Rietberg Museum,
Zürich. Ht 54 cm

following five decades of the northern sculpture a rivalry is perceptible between the increase of rounded relief, both in the whole bulk of figures and in the detail of their drapery, and the further development of more linear-analytic design in figures and in subordinate relief carving. Place is found in the bas-reliefs for borrowing from a secular style of figure and scenic design. There is a marked difference in sculptural style between standing and seated figures. In other than main images the seated figures are either reduced versions of the colossus of Cave XX at Yungang or, with more elongated body, are treated in characteristic linear-analytic style, the sculpture tending to a frontal display of rhythmic figures composed of narrowly defined and sharply offset flat surfaces passing into pure geometricized ornament on the hem of the garment, or spread independently of the garment over the front of the throne [223, 224]. Patterning of the drapé out of relation to its natural fall, already announced in the treatment of the 'manifestation' images, now takes leave of all reality. In sculpture of this class the so-called 'archaic smile' becomes more pronounced, lips curving inwards from small drill holes at each extremity of the mouth.[9]

In contrast with these well-integrated designs in flowing lines, many principal images are heavily static, their shapes composed of large three-dimensional rectangular sections: head, trunk, the horizontal base formed by legs and knees, the draped but clearly separated throne beneath [225]. The austerity of the assemblage of block and column is unified, often most beautifully, by decorative detail in the garment folds. In the artistic contrast between main images of this kind and the type described above as the Buddha manifested, a doctrinal change is also discernible: the purpose was now the presentation of a stable and permanent Buddha presiding with his coadjutants over an imaginable realm.[10] The sequel to such architectonic treatment of main images, soon communicated to subordinate images also, is the 'columnar' style of 540–550. The Sākyamuni with four companions which is the chief image of the Lianhua-dong shows a pleasing combination, in a standing image, of the linear manner with the rotundity of the architectonic style, providing a model for much that was to follow.

In all the Longmen caves there is a determination to multiply ornament, some of it making continuous pattern of apsarases and heavenly musicians who had previously received more individual treatment. As the initial echoes of Gandhara are replaced, ornament increasingly resorts to Chinese secular tradition, introducing dragons, monsters, scattered flowers, rows of donors and procession of courtiers [226][11]; and the lotus becomes ubiquitous, its use in large size at the centre making a more methodic display of the ceiling ornament. Two influences from beyond the Wei territories are detectable: a further elaboration of flame haloes as foil to statuary again points the debt to Liu Song practice in Zhejiang and Jiangsu; and wide use of floral chains around the niches suggests an element of 'indianization' which antedates the development in the later sixth century to which this term will be applied.[12]

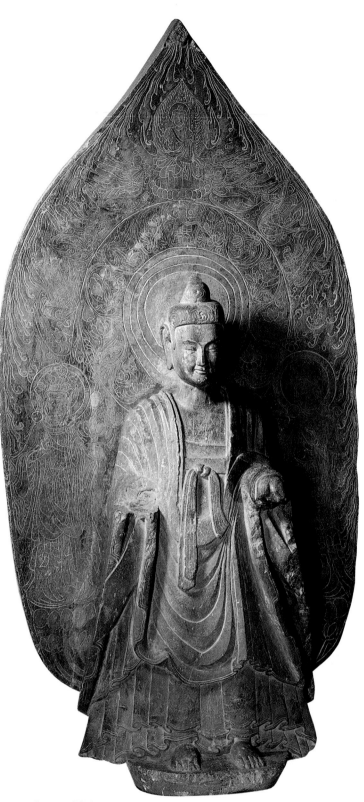

224. Image of Sākyamuni in analytic style. Mid-sixth century. Museum für Kunsthandwerk, Frankfurt am Main. Ht 1.64 metres

225. Buddha in columnar style, Binyang cave, Longmen. Early sixth century

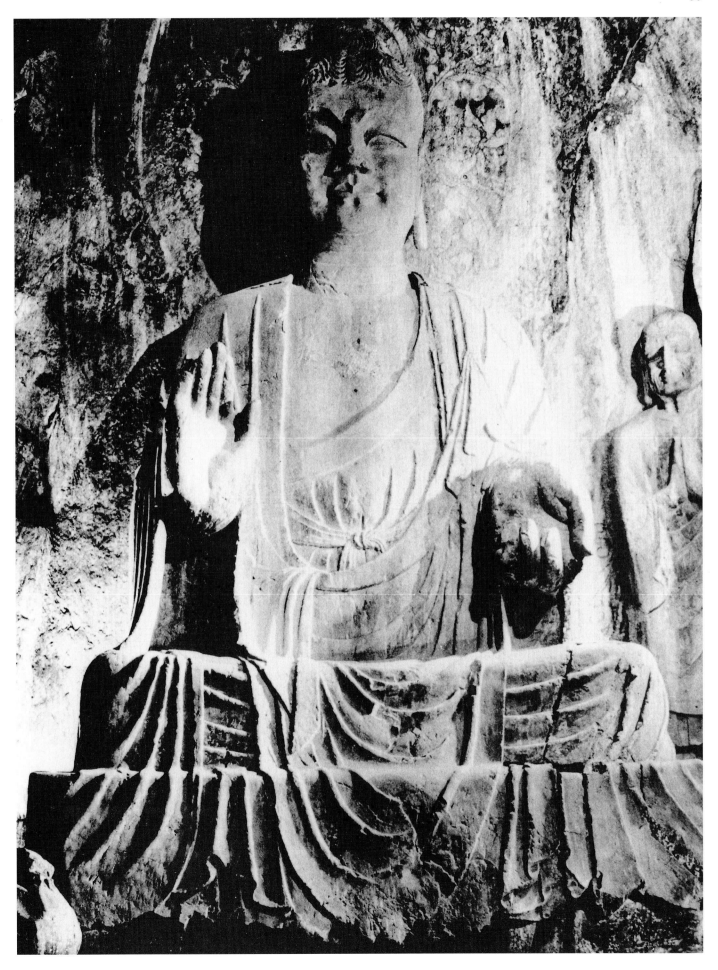

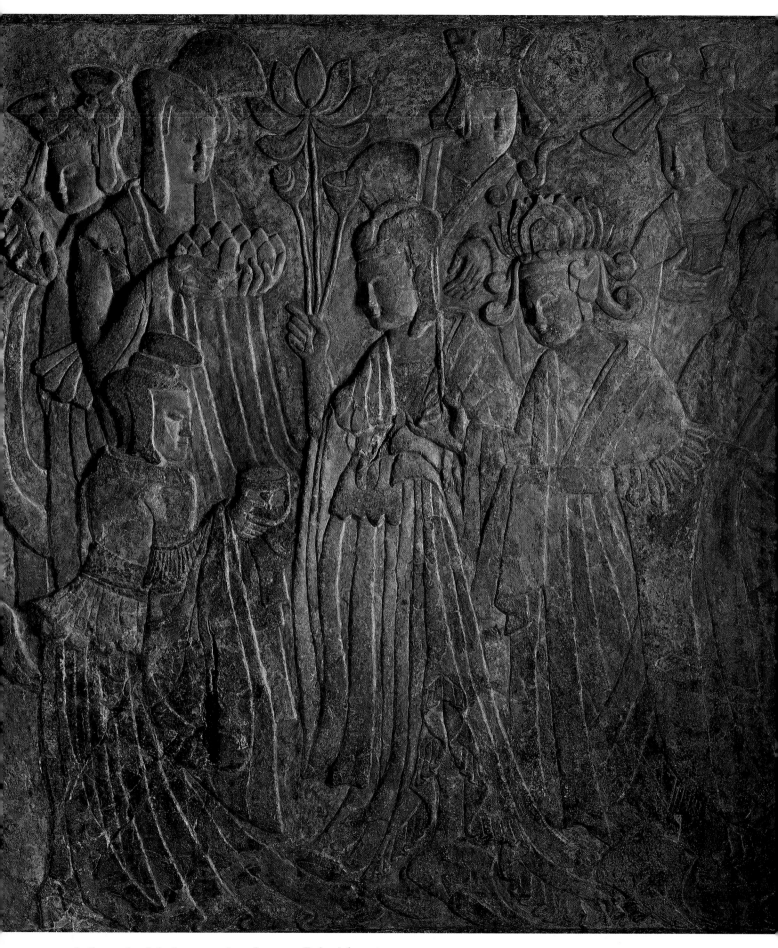

226. Cave-wall relief of a procession of patrons. Early sixth century.
Nelson-Atkins Museum of Art, Kansas City

CAVE-SHRINES OF NORTHERN WEI DATE
AT MAIJISHAN, GONG-XIAN

In north-west China as throughout Central Asia the sculptural medium is clay. At Maijishan on the eastern boundary of Gansu the surviving sculpture is modelled, apart from some free-standing stelae of post-Northern Wei date.[13] Work began on the caves *ca* 500, rows of small cave-shrines being excavated at some ten different levels on both faces of the mountain.[14] Cave 4 (the 'Hall of Scattering Flowers', *Sanhualou*) comprises a row of seven small chambers, each holding a Buddha with two Bodhisattvas and two disciples on either side, opening on to a forecourt framed by round engaged pillars carved in the rock. Cave 30, forming three chambers, each with a seated Buddha and six companions, opens on to a forecourt defined by two free and two engaged pillars octagonal in section and tapered to rectangular imposts. A plain eaves beam supports a tiled roof. The façades of these caves approximate to Indian style, although no corresponding indianization of the sculpture is perceptible.[15] Other cave-fronts are of simple Chinese design, some with imitated bracketing, the roofs of the interiors rising to an imagined ridge, or arched, or imitating a corbelled lantern roof.

The works attributable to the Northern Wei period and free from later restoration echo at a lower level of skill all three phases of the Northern Wei succession in Shanxi/Henan.[16] On most of the images the folds of the garment are mere incised lines; when they form flat bands the rhythms of the design are poorly felt. With a few exceptions in subordinate statues, where a gentle smile and natural glance emulate reality (acolytes of Caves 59, 60), the faces are carved to a rigid formula comprising a hint of the archaic smile; the swags of crossed scarves are exceptionally weighty (Caves 69, 127); geometricized folds diversifying the garment hanging over the throne of seated Buddhas are merely symmetrical (Cave 133) [227]. A standing scarved Bodhisattva sways towards a seated Buddha, placing his weight chiefly on one foot in what seems a misunderstood version of the Indian three-bend posture (Cave 72a). Iconographic peculiarities mark off the statuary from the eastern groups: a standing Bodhisattva has the right hand in *abhaya* and in the left holds a jewel (the pearl in a peach-shaped halo); a seated Buddha has the single right hand in the *vitarka* position, the finger bent as a teaching point is made.[17]

After the comparison we have drawn between the metropolitan and the provincial versions of Northern Wei sculpture, we may contemplate the culminating achievement of the tradition at another metropolitan site. Caves carved in an isolated outcrop of limestone at Gong-xian in Henan constitute the most coherent, and concurrently the most secularized, monument of the third phase.[18] The unity of period, themes and style which obtains here is owed to the close patronage of two successive emperors. Work was completed in the four principal caves between 517 and 528, and the first inscribed dedication is dated to 531. Each cave consists of a square chamber with square central pillar filling a quarter of the floor-plan, the entrance facing south.[19] Seated Buddhas are universal, with twin Bodhisattvas in the niches of Cave 1, and pentads of Buddha, Bodhisattvas and disciples

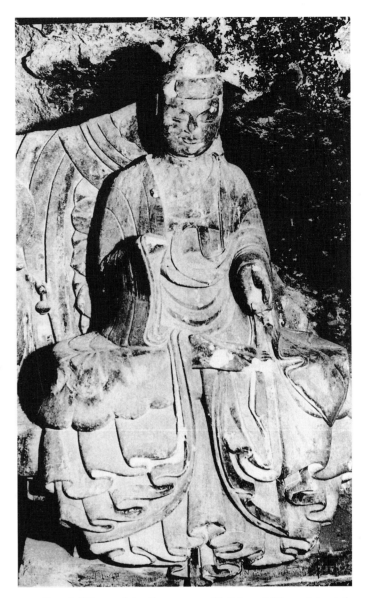

227. Seated Sākyamuni in Cave 117 at Maijishan. Mid- or late sixth century. About lifesize

on the sides of the central pillars. There is a significant stylistic difference between the images on the cave walls and those on the central pillars. The former proceed from the second manner described above from Yungang. Now endowed with greater rotundity, the figure is wrapped in broad stepped bands of drapery. A net of lines formed by the edges of the offsets suggests movement of detail within a total design of reassuring repose. The single example of this style applied to a standing image is a Sākyamuni measuring 5.4 metres in height set against the outer wall of Cave 1 [228]. Within the caves, similar grace and dignity are intended in the pillar images, which average two metres in height; but here the style builds upon the third manner of Yungang: the folds and loops of cloth are deeper and have more their natural weight and fall, creases are made more casual [229]. In the Gong-xian caves the adoption of Yungang style in its second and third manners mark a retardation of two or three decades.

228. (*following page*) Colossal Sākyamuni statue at the entrance to Cave 1 at the Gong-xian cave-shrines. Ht 5.4 metres

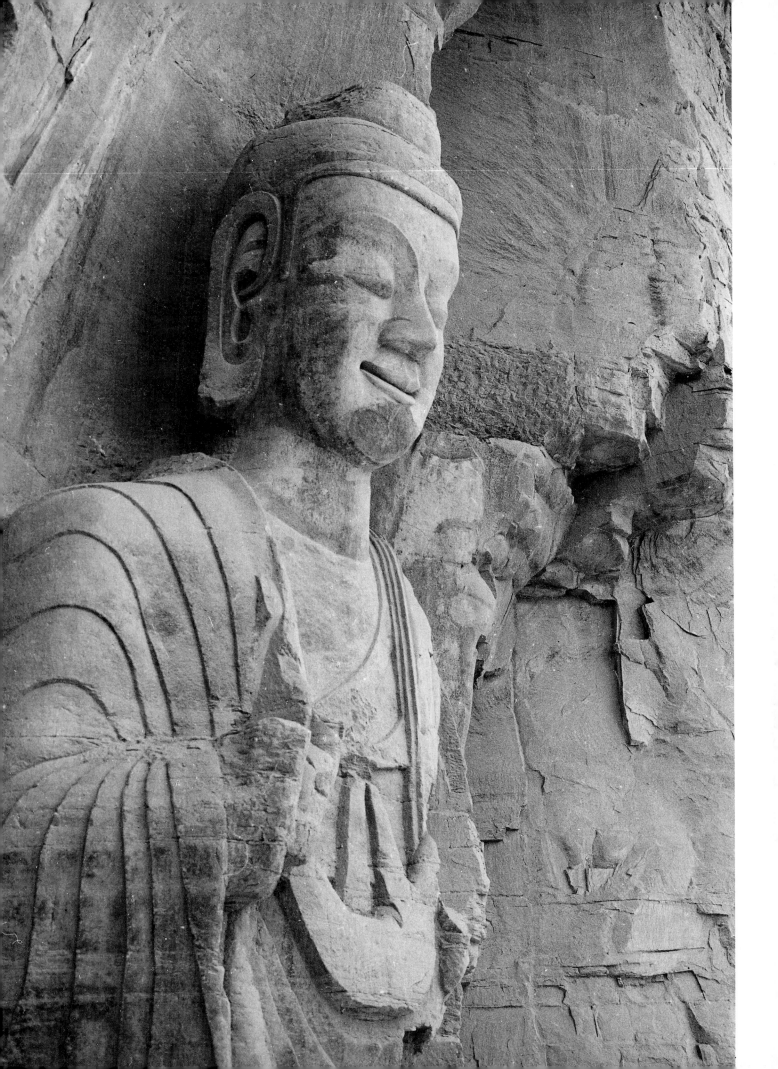

230. Detail of the ceiling of Cave 1 at the Gong-xian cave-shrines

229. (*preceding page*) Sākamuni and Prabhūtaratna in Cave 1 at Gong-xian, in the third Yungang manner. First half of the sixth century. Two-thirds lifesize

231. Demons in bas-relief at Gong-xian. Ht about 60 cm

232. Spirit kings in bas-relief at Gong-xian

The bas-reliefs of the coffered ceiling of Cave 1 present the most innovative floral ornament employed at Gong-xian: a lotus bud bearing a worshipper, leafy sprays, rondels and whirligigs developed freely from the lotus, with palmette and half-palmette; and flying figures fitted skilfully into the rectangular frames [230]. A precise western source with a Buddhist connexion must be supposed for this display, whether painting or embroidery, and a pattern-book distinct from those which supplied other categories of non-Buddhist subjects taken from Chinese tradition. Among the latter the various demons are the most readily explicable, being excerpted from *Shanhaijing* lore and presented in original versions as defeated atlantes beneath the images [231]. Dwarfs fulfil the same function, some naked with raised hands and dejected look. Touches of reality foreign to the cult images enliven these figures, the pose of straining bodies and the rendering of hands employed in tasks, as those of musicians upon their instruments, having demanded unprecedented invention. The ten 'spirit kings' (*shenwang*), placed also in the lowest zone of sculpture, are depicted with the customary variation of their fantastic rôles: carrying giant fish, tongs, thunderbolt, projecting a long tongue, spitting jewels, *taotie*-crowned and elephant-headed, allied to winds, trees and mountains [232].[20]

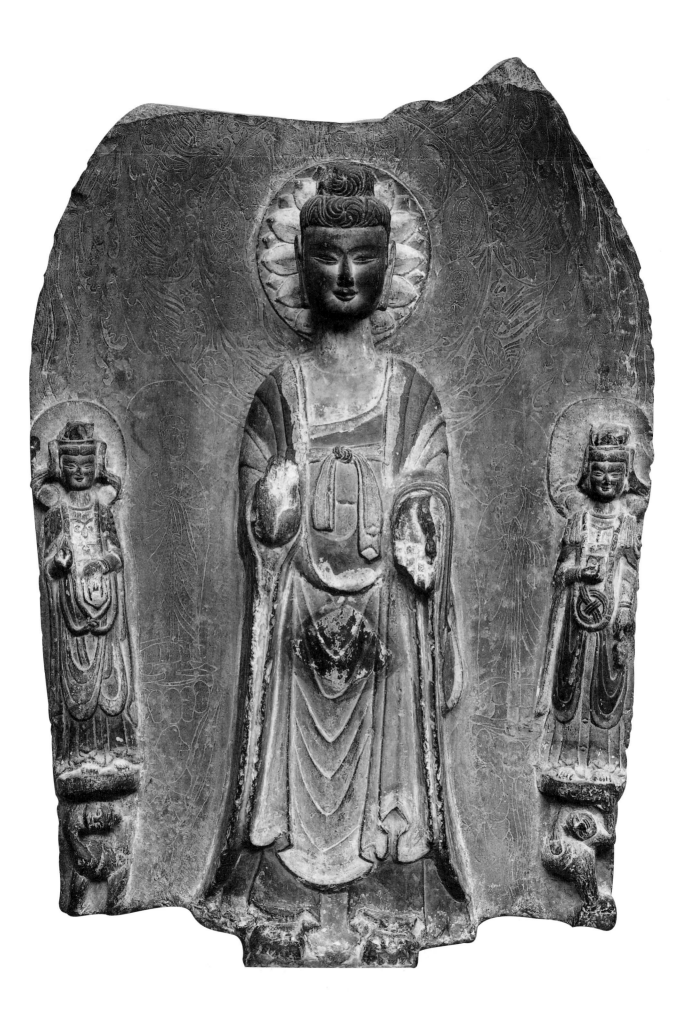

Monumental Sculpture of the Mid-Sixth Century

SCHOOLS OF SCULPTURE

The experience afforded by Wei patronage at the Longmen caves is reflected through the northern territories by free-standing images, contemporary with the third phase of Northern Wei sculpture or produced in the two succeeding decades.[1] These are mostly in analytic or columnar style and of dimensions varying from less than one metre to lifesize or more. When a statue bears a dated inscription, the regnal title of the date will usually indicate the state in whose territory the work was executed. More rarely a record of finds of sculpture is evidence of a local school. Numerous images excavated on the site of the Xiude temple in the Quyang-xian of Hebei attest such a centre, where images averaging half a metre in height, carved in a local crystalline limestone, record stylistic change in the north from the early sixth to the mid-eighth century.[2] In Henan, as seen in a trinity of the Metropolitan Museum, the figure of the standing 'emergent' Buddha may assume a strangely elongated form, with a single Buddha (presumably intended as Maitreya) or the Seven Buddhas of past ages, apsarases and the flame fringe carved in low flat relief on the mandorla. Here and in comparable statues the analytic formula has sunk to flaccid symmetries [234].[3] Among the surviving works dated to the very last years of Northern Wei and the opening two decades of Eastern Wei, many were demonstrably produced in Henan and the adjacent areas of Shanxi, Hebei and Shandong. In them 'fish-tail' spread of the garment skirt rarely appears. The asperity of the analytic style is now dissolved in smoother detail on bodies of rounded horizontal segment, yielding a characteristic Eastern Wei style as ideally represented by a trinity in the Freer Gallery, where an unchallenging Sākyamuni and companions stand against multiple ornament engraved on the mandorla [233]. The sense of imminent movement which appears in the prime examples of the type is abated.

A more sculptural treatment of the ornament distinguishes a group associated through one of its members with Huayin-xian in east Shaanxi near to the Henan border. The subjects, carved also on mandorla-shaped stelae, are Buddha trinities, Sākyamuni with Prabhūtaratna, or a manifested Buddha (represented by a small seated image) placed over main figures of Bodhisattvas and disciples. In all cases much is made of the flight of apsarases occupying the upper edge of the mandorla, bearing a small seated Sākyamuni or a casket holding the pearl which represents him: the relief is so emphatic, in part undercut, that the apsarases appear detached from the mandorla, the curving bodies and flying scarves an exercise in rendering effortless passage through space. The play of light on rapidly changing relief is em-

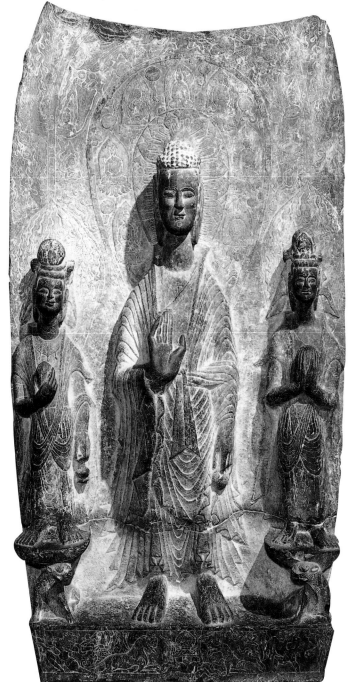

234. Sākyamuni with attendant Bodhisattvas, in elongated style. Dated by inscription to A.D. 505. St Louis Art Museum. Ht 1.88 metres

233. Sākyamuni trinity. Sixth century. Freer Gallery of Art Washington. Ht 1.17 metres

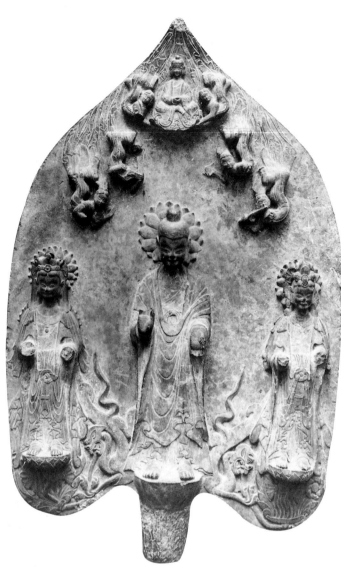

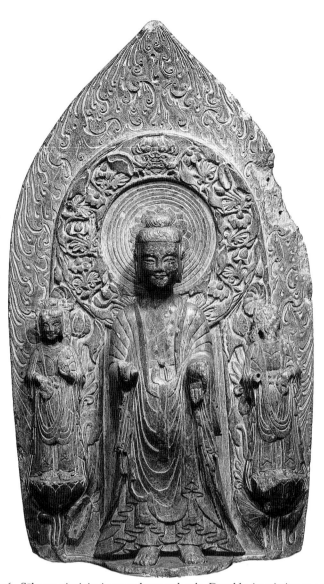

235. Sākyamuni trinity in Huayin style. Musée Guimet, Paris. Ht 78 cm

236. Sākyamuni trinity in over-decorated style. Dated by inscription to A.D. 537. Cleveland Museum of Art. Ht 77.5 cm

ployed more effectively than in earlier sculpture. In other particulars, trinities in the Guimet and Metropolitan museums (the latter dated to 534) present the quintessential third-phase style of Northern Wei [235]. A simpler use made of high relief is seen on a comparable trinity of 535 in the Fujii Yūrinkan, Kyoto. To a Henan school broadly defined, and a more coherent Huayin school, is to be added another, probably located in Shandong, whose works date between 518 and 537. A Buddha of the third-phase type, executed with the hint of archaism, is surrounded by such busy relief ornament of lotus and flying figures that its individuality all but vanishes, as in the stele of 537 in the Cleveland Museum [236]. In Henan tradition, complementary ornament had been typically inscribed in line on the flat surface of the mandorla. In contrast, the rich effect of quasi-naturalistic floral ornament in deep relief is sufficient to place this Shandong work in a class apart, with the suggestion of influence from the south-east.

Thus far the Chinese sculptor has confined his view to the external pattern of his subject. From the mid-sixth century his aims increasingly embrace the reality of the body beneath the garment and the plausibility of poise and stance. Realism

of this order comes to pervade all the branches of the art: main image and subordinate figures, the plainly clad Buddha and the jewel-bedizened figure of the Bodhisattva Guanyin whose cult now dominates. As to the date of this change, the new features are in general earlier in sculpture recovered from the site of the Wanfo temple at Chengdu, Sichuan, than in comparable pieces found in the north, where old habits persist in modified forms.[4] In Sichuan an exotic character distinguishes much of the sculpture, as distantly reminiscent of central and south India as the earlier northern style is of Gandhara. But at first there is a connexion with the north and east. From Mou-xian, also in Sichuan, came a seated and a standing Buddha in analytic style close to that of the Northern Wei third phase: their inscribed date of 483 even raises the question of a Sichuan influence in the genesis of this style. Work with a Northern Wei affinity continued at the Wanfo-si at least until 537, the date of a seated Buddha in quasi-columnar style.[5] But overlapping with these is a theme unknown in the north under Northern Wei: compositions with Liang state dates of 522, 533 and 548, which combine four Bodhisattvas, two disciples and two guardian *lishi* (strong men) about a standing Buddha, this

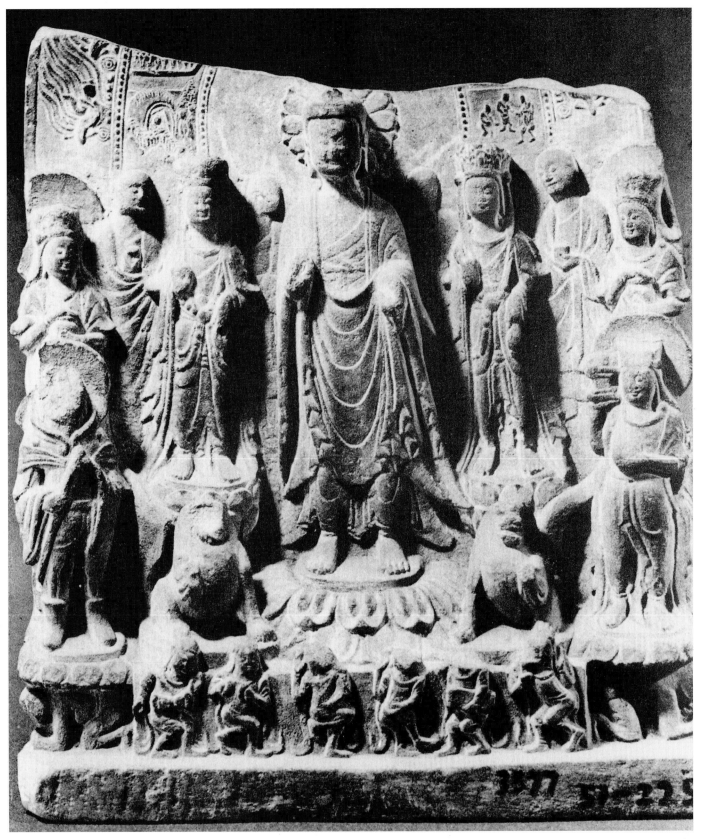

237. Sākyamuni group in the Wanfo-si, Sichuan. Mid-sixth century

last in analytic style. These works reveal new skill in the natural poses of the figures and in the handling of the much-varied relief [237]. Comparable but inferior free-standing sculpture of multiple figures does not appear farther north until the period of the Northern Zhou (557–581), when this state had added Sichuan to its domain, and is developed

particularly in the north-east under the Northern Qi.[6] A typical composition in white marble presents a seated Sākyamuni between pairs of Bodhisattvas, Arhats and disciples, framed by the trunks and foliage of the sāla tree. Below this array a flaming jewel supported by dwarfs is central between a pair of lions and gesticulating lishi. As

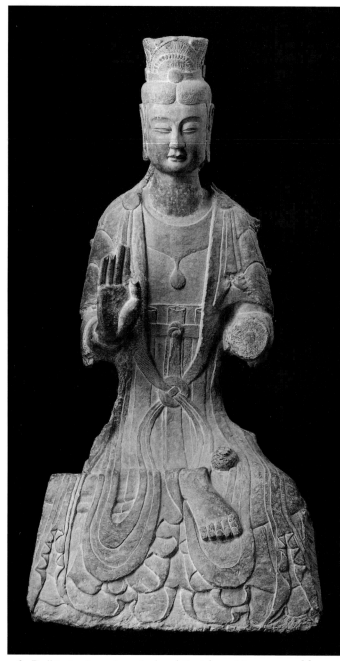

238. Bodhisattva image in revised analytic style. *ca* A.D. 530–540. Museum of Fine Arts, Boston. Ht 1.96 metres

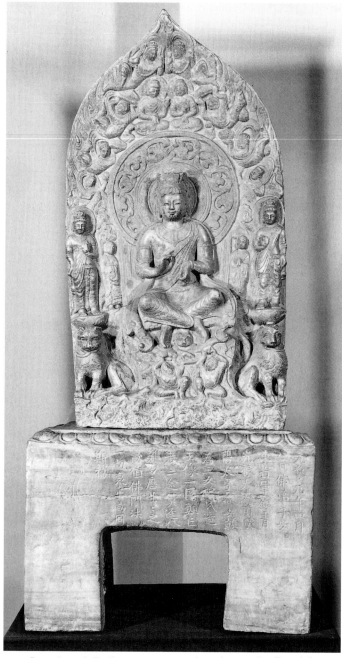

239. Cross-legged Bodhisattva in revised analytic style. Dated by inscription to A.D. 538. Fujii Yūrinkan, Kyoto. Height (of central image only) 20 cm

represented by an image excavated at Linzhang in Hebei, this type is allied to the work of the Huayin school described above: the array of images and the tree-branches, as well the flight of garland-bearing apsarases and the dragon and jewel which constitute the upper half of the stele, are worked in high-relief openwork.[7] In contrast to these grouped subjects with their varied relief and indianizing additions, and in more direct continuance of Northern Wei tradition, comparatively numerous trinities consist of a seated Buddha flanked by Bodhisattvas, inscribed with both Western and Eastern Wei dates. The majority of these works are markedly eccentric in the drapé, the proportion of the figures, the faces and the ornamental additions.[8] Work of this class has given Western Wei sculpture its reputation for provinciality vis-à-vis Eastern Wei, a division which the inscribed regnal years do not warrant in every case.

The most original of Eastern Wei sculpture is seen in a small number of images singled out for singular technical finish and mature handling of the pose. It is significant that the majority of these appertain to growing individual cults of the period. The Meditating Bodhisattva is ideally represented by the statues of the Hosokawa collection and the Shodō Museum of Tokyo, the former dated to 544, the latter notable for its sweet countenance and the convincing inclined posture.[9] A seated Maitreya measuring 1.96 metres in height, now in the Boston Museum, attempts a revision of the analytic formula out of keeping with the prevalent Eastern Wei style [238].[10] The Guanyin of the Wannieck collection of the Guimet museum perfects the formula of the Bodhisattva as Buddha-companion, making clear the identity as Guanyin by the flask and jewel.[11] Strangest of this group is the complex image preserved in the Fujii Yūrinkan which

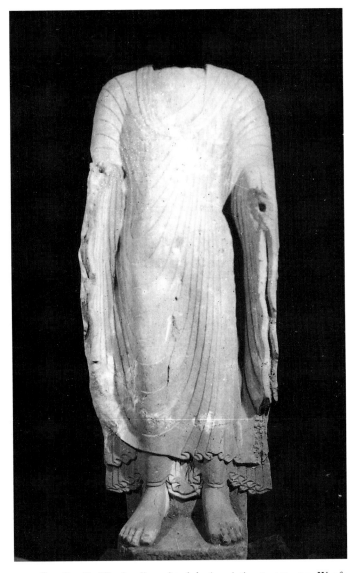

240. Standing Buddha headless, dated, by inscription to A.D. 529. Wanfo-si, Sichuan. Lifesize.

241. Torso of a bejewelled Bodhisattva. Dated by inscription to A.D. 567. Wanfo-si, Sichuan. Lifesize

sets a cross-legged Bodhisattva between disciples and Bodhisattvas. Here all is unusual: the choice of the main figure, the deeply carved twin Buddhas and apsarases of the mandorla, the peculiar management of the throne with its lions, the heavy adaptation of a Yungang palmette scroll used on the aureol [239].[12] An air of archaistic revival surrounds these statues; the evidence is hardly complete for postulating a single school, but it is tempting to do so.

But a new order of historical interest attaches to wholly unprecedented types found at the Wanfo-si in Sichuan. Of these two standing images of the Buddha Sākyamuni, one dated by inscription to 529, recall the Amarāvati style of south India: the garment abandons symmetry for folds falling loosely in rhythmic loops [240].[13] Trunk and thighs swell gently under cloth which attempts the 'wet drapé' of Gupta sculpture. These features are still more pronounced in a standing image whose inscription dated to Northern Zhou 562–565 declares it to be the image made for king Ashoka, apparently implying a direct Indian model.[14] In the department of Bodhisattvas a headless figure of 567 displays the

new formula: a more realistic pattern of folds, pendants and jewel-chains [241]. This resembles that in contemporary use on the Guanyin image standardized by the sculptors of Northern Qi (550–577), but is richer in natural detail and unaffected by the perennial columnar bias of the north.[15] The independence of a Wanfo-si school appears well established. Its link from the 520s with western Buddhism was unique, and its influence through Northern Zhou patronage refreshed the northern tradition.

MONUMENTAL SCULPTURE UNDER NORTHERN QI, NORTHERN ZHOU AND SUI (A.D. 550–618)

Sculptural tasks changed from the middle of the sixth century as the Amitābha cult became established in the statuary. Not the impression of instantaneous manifestation to the meditant was now the aim, but an interpretation of the Buddha's transcendental permanence and detachment.[16] The northern sculptors, whose work the surviving images chiefly record, responded with a formula deriving from the tradition we have termed columnar: a seated image of which head, neck, trunk and folded legs are made discrete and virtually rectilinear components related in terms of simple volumes, with little or no concern for organic reality, while

242. Seated Buddha in columnar style, in the Yaofang cave, Longmen. Late sixth century. Twice lifesize

243. Arhat of the Yaofang cave, Longmen. Late sixth century. Ht about 1.3 metres

sculptural import hardly attaches to the garment. The Yaofang-dong at Longmen (excavated from 570) and Cave 8 in the Tianlong-shan of Shanxi (excavated from *ca* 584) are the chief sites from which the style is demonstrated [242]. The block-like treatment at the former exaggerates a tendency already present in the sculpture of the Binyang south cave, and is now combined with a new large-featured face. Characteristically the upper garment falls over the right shoulder and is suspended over the left shoulder by a narrow band or cord. A knotted band at the front holds the inner garment which hangs from the left shoulder. The Tianlong-shan arrays follow the theory of the spatial distribution of the deities, the identities probably intended as Sākyamuni on the north wall, Amitābha on the west and Maitreya on the east, each with flanking Bodhisattvas and arhats. In the centre of the cave is a pillar with a seated Buddha on each of its four faces. The folds of the robe are shown as double lines, in the manner introduced some decades earlier by the Northern Qi sculptors. In contrast to Northern Wei style, all the figures are wide-shouldered, with heavy cylindrical necks, the trunk nearly cylindrical, and on the standing images block-like

feet. While the Bodhisattva and arhats are columnar, with symmetrical rounded shoulders, the latter attempt an individuality in the faces, evidently in an effort to reproduce Indian features [243]. Outside on either side of the door are guardians (*lishi*) in high relief, whose twisted bodies, turning necks and realistic armour anticipate the convincing portraiture presently to be attempted in this type; but here too the image sculpture remains columnar.[17] Only in the type of the seated Tathāgata was columnar style destined for refinement into an enduring type, predominantly representing Amitābha, which resisted later decorative trends. In such a work as the bronze altar group of the Boston Museum, dated to 593, the plain lines of the seated Buddha are set against a rich surround of Boddhisattvas and other figures, dwarfs, animals and a leafy canopy which here denote Sākyamuni [244].[18] Later carried throughout East Asia in the diffusion of Tang standards, the seated figure, as Amitābha or Sākyamuni, was the model for some of the most effective icons in the whole range of Buddhist sculpture.[19] During the last decades of the sixth century equally austere standing or seated figures of Sākyamuni were carved free-standing in the white limestone of Hebei, at half or full human size, or even as large as the 5.8-metre high image of 583 in the British Museum. To the modern eye the effect of the seated figure is superior, as if the iconic purpose is better achieved. Meanwhile central seated images of uncompromising

244. Gilded bronze altar group with Sākyamuni and attendants. Dated by inscription to A.D. 593. Museum of Fine Arts, Boston. Ht 78 cm

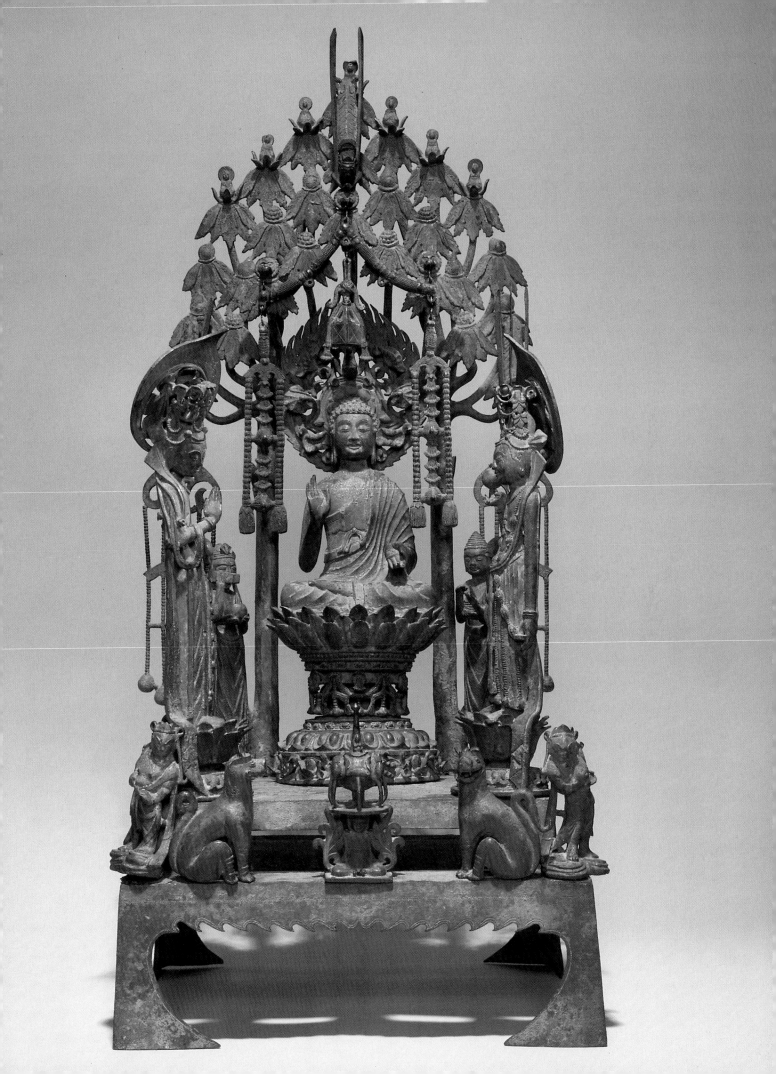

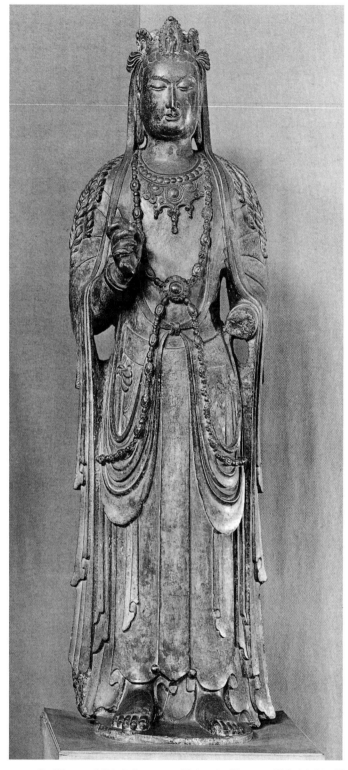

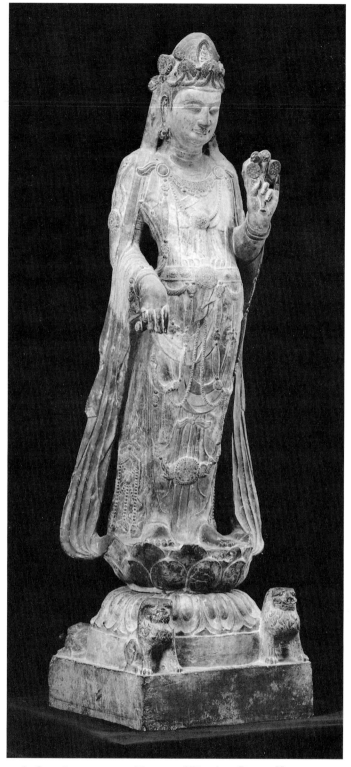

245. Bodhisattva. Mid-sixth century. University Museum, Philadelphia. Ht 1.7 metres

246. Guanyin. *ca* A.D. 570. Museum of Fine Arts, Boston. Ht 2.49 metres

columnar remoteness were still carved under the Sui at the cave-temples of Yuhan-shan, Yunmen-shan and Tuo-shan in Shandong, attaining extreme forms which could have no fruitful sequel.[20]

A contrast in the handling of Amitābha's flanking Bodhisattvas Avalokitesvara (Guanyin) and Mahāsthāmaprāpta (Dashizhi) during the Northern Qi period is well recorded in the cave sculpture. In the Yaofang-dong of Longmen and the cave-shrines at Xiangtang-shan[21] on the Henan–Hebei border the figure is wholly columnar, but at Tianlong-shan Cave 8 the body is triple-inflected, with one lighter-placed leg (*tribhanga*) and inclined head, features heralding the natural stance proper to this type in the Tang period. The free-standing versions of the Guanyin large and small, made in the Northern Qi and the opening decade of Sui periods, seldom adopt an inflexion of the body, no more than a slight narrowing of the waist, or relaxation of the earlier stiffness of garment folds and jewelled chains.[22] But in statues measuring six to eight feet in height appears a new concern for the communication achieved through stance and equilibrium. The earlier dated works in this class belong to the Northern Zhou, and there can be little doubt that they owe their innovation directly to the example set by the sculptors of the Wanfo-si school of Sichuan. Three variations of

the stance can be distinguished. The Bodhisattvas of the Philadelphia University Museum are exceptional by their broad shoulders, the backwards-tilted and correctly proportioned head and the refinement of the ornament, all of this combining to create an unprecedented air of authority [245]. Some examples of this class of Sui date present an unusual frontal outline: a narrow high waist and a greatest breadth near to the knees. This shape and the detail of folds and jewels compare closely with an incomplete Bodhisattva image at the Wanfo-si, the breadth at the knees an effect of Iranian costume.[23]

In the Northern Zhou and Sui periods the more typical Guanyin type, as would seem, of Shaanxi and the western region of China is upright but gently flexed in outline, relaxed and natural in stance, abundantly decorated, with head-ribbons and body-scarves spreading to the side – an aerial effect hitherto not attempted – and clearly in the lineage of the Wanfo-si stelae dated from the 520s [246].[24] The conservatism of Shandong images of the humbler sort through the late fifth and the sixth century is well illustrated by the bronzes excavated in Boxing-xian, Northern Wei types surviving there until the Sui, with no concessions made to the inflected and aerial outlines introduced elsewhere under Northern Zhou influence.[25]

Draughtsmanship and Painting of the Six Dynasties in Henan, Hebei and Jiangsu

Much writing on the theory of art is attributed to authors of the Six Dynasties, but the texts are preserved only from the ninth century, when they are to be considered in the light of ideas then prevailing. No original works of the recorded artists of the Six Dynasties survive. One may however judge the draughtsmanship of this time, as used for narrative and pictorial subjects, from mural painting and from line engraving and relief carving on stone. The context of many of these compositions is Buddhist, but even in Buddhist work the style belongs largely to secular tradition. Parades of persons, scenes of religious ceremony, exemplars of piety and the *jātaka* of the Buddha appear accompanying the sculpted icon, or on the back of free-standing statues, on funeral biers; and on Buddhist stelae, whose miniature carving of images may be surrounded by multiple pictures of such lay themes as officers' carriages and horses as well as religious story. The names of benefactors of the temple or shrine may be recorded among the inscriptions.

SECULAR SUBJECTS: THE FRIEZE OF PERSONS

The earliest examples of Six Dynasties drawing style traced thus far, Buddhist and secular, appear not to date before the second or third quarter of the fifth century, leaving some two centuries unrecorded since the end of Han. The secular art of the mid-fifth century is represented in the Zhejiang-Jiangsu region of the Liu Song territory by a series of portraits executed in fine raised line across bricks in the walls of brick-built tombs of local nobles.[1] The subject repeated in the Jinjia-cun and Wujia-cun tombs is the Seven Sages of the Bamboo Grove, whose biographies are included in the *Jin shu* of the preceding century. The figures are mutually arranged, facing pairs of sages resting or conversing, some appearing to listen to music that is being played on the opposite wall [247]. The figures are drawn in narrow regular lines (the *iron-wire* line, as it was later to be called), relaxed but still set in studied poses with fluent drapery. The designs appear to reflect established portraiture, no less than the patterned tree-branches and leaves follow strict convention. In three-quarters view and competently rounded, each labelled with his name, the sages occupy intelligible space between and forward of the tree-trunks. The poise of heads and the bearing of hands and fingers are made important, as giving an impression of the character of the sages portrayed in literature. The suggestion is ready to hand that so settled a style may be a legacy of the celebrated painter Dai Kui of the previous century, whose interest in music is recalled by the lute and

247. Part of the tile representation of the Seven Sages of the Bamboo Grove, from a tomb in Danyang-xian, Jiangsu. Height of the figured wall 80 cm

qin shown in the hands of a number of the sages. In common with other pictorial styles that were to follow, the balanced and rhythmic patterning of all the elements is essential to the composition, well illustrating the union of veracity and decoration which is the very hallmark of the metropolitan style. Foliage of pine, locust, willow, gingko, pawlonia is distinguished in uniformly repeated units drawn in one plane with the utmost clarity, as if painted on a screen. Other items depicted on the bricks include horsemen and a heraldic lion, but nowhere appear the dramatic confrontations of persons which were frequent in the late-Han style of Shandong. The tombs containing these murals were guarded along the 'spirit path' of the approach by pairs of heraldic lions carved in the exotic style of contemporary secular sculpture (p. 228 below).[2]

Mural pictures in a different tradition but approximately contemporary with what is described above are known from the tomb of the noble Lou Rui (died *ca* 570) near to Taiyuan in Shanxi.[3] Horsemen in overlapping clumps and persons grouped at an ox-cart are painted in fine line (i.e. showing no use of a brush making an inflected line), coloured in brown and yellow whose tones impart some modelling to the figures [248]. The uniformly repeated postures are limited to profile and the three-quarters view, in obvious strict adherence to a pattern-book. Half a century or more later similar conventions governed the relief carving of noble persons attending ceremony at the cave-shrines of Longmen and Gong-xian. Here detail of parasols, sashes, purses and headgear vary the picture, some large-leaved trees recalling those of the Jiangsu designs. Scenes carved in the Binyang-dong of Longmen achieve a degree of natural realism; while more formally at Gong-xian there is a courtly affectation in the stance, a forward-bulging curve of the bodies which is most pronounced in the figures of the emperor himself and his consort [249]. This lends itself well to the relief, while suggesting the leisurely progress of the official party.[4]

THE DEMON FRIEZE AND THE LANDSCAPE FRIEZE

Pictorial decoration of stone monuments by linear engraving and low-relief carving flourished in the earlier decades of the sixth century, on both Buddhist and non-Buddhist monuments. The demonic subjects ('terrifying monsters', *weishou*) point to survival or revival of the style and repertoire initiated by Han artists, the *Shanhaijing* still drawn upon and added to, after a lapse of three centuries from which no similar work can be cited.[5] None of these subjects was executed in the earlier Northern Wei cave-shrines. Later, in the Gong-xian Caves 2 and 5, they appear suddenly in stone, well assimilated sculpturally among the symbolically oppressed creatures placed low as supports of pillars and

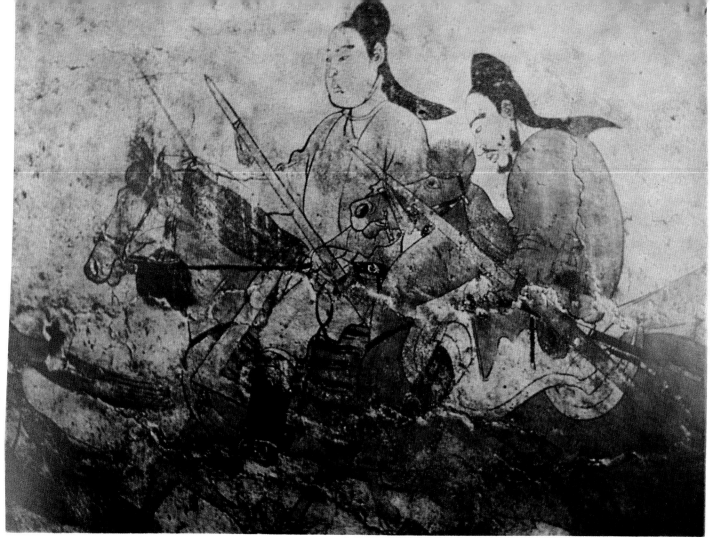

248. Mural of horsemen in the tomb of Lou Rui, Taiyuan-xian, Shanxi. Late sixth century. Height of part shown about 1 metre

249. Bas-relief of royal procession in Cave 4 of the Gong-xian cave-shrines. Early sixth century (after A.D. 517). Height of the band of figures about 50 cm

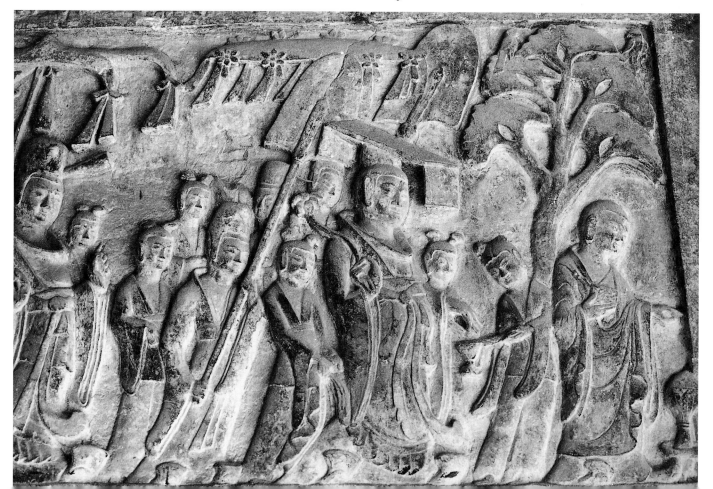

image-stands and thrones. Their style of broad high-relief is shared with the musicians and spirit kings assigned to the same lowly status [250]. In a cave of the Bei-Xiangtang-shan group a symmetric facing demon squats under a pillar. In this class of sculpture, especially at Gong-xian, a certain tentative character of the work sustains the argument that graphic and not sculptural models were at the origin of the designs, with a presumption that influence from the Zhejiang-Jiangsu region was formative.

One style shows the forms of the demons and animals as smooth low relief in silhouette with engraved linear detail. On a stone coffin from a tomb near Luoyang, Hénan, compositions of extraordinary vigour are isolated in rectangular frames, each figure dashing along with flying spiralled appendages, petals and cloud scrolls filling the ground: demon, tiger, phoenix and some goblins less identifiable. The sides of the coffin are covered with still more complex scenes in somewhat similar style of relief and line, against a ground of formal trees and scrolling, depicting dragons and persons in landscape [251]. The composition may be compared with the landscape friezes described below, but suggests an earlier date than these, probably in the last decade of Northern Wei.[6] Comparable engravings from the tomb of the Yuan clan, *Yuan shi*, are dated by inscription to 522.[7] Here the frieze is continuous, the demons' great leaps and whirlwind career still wilder. Engraved detail within the silhouettes shows how well the iron-wire line could convey the rotundity of the form. The drawing is more sprightly, the grotesque exaggeration of the furious demons still greater than on the Henan stones, and yet the sense of stylized form is more marked, these characteristics alone endorsing the

250. Demon from the base of a Buddhist sculpture. Mid-sixth century. Cleveland Museum of Art. Ht 75 cm

251. Ink impression of immortals and dragon engraved on the side of a stone sarcophagus in a tomb in Luoyang-xian, Henan. Early sixth century. Height of the figured band about 44 cm

252. Ink impression of engraved pictorial ornament of a stone sarcophagus. *ca* A.D. 530. Nelson-Atkins Museum of Art, Kansas City. The whole panel 61 cm by 2.24 metres

theory of southern origin for this work. Stones preserved in Nanjing from the tomb of a prince of Liang who died in 526 more resemble the Henan example cited above, with similar subjects in square plant-scrolled frames.[8]

The alternative manner, drawing wholly in engraved line, is to be seen on stone slabs of a coffin-bed in the Kansas museum, where the demonic theme is used for continuous pattern, with equal vigour if less clarity of the individual items.[9] On the reverse of these slabs, also in engraved line, are six scenes illustrating stories of filial piety [252]. These scenes belong to a larger group of surviving works in which sixth-century draughtsmanship as applied to persons, architecture and vegetation is more fully recorded. The compositions consist mostly of two or three persons set before houses, or among fancy rocks backed by a variety of formalized trees, all executed with an assurance that bespeaks mature practice and an established routine of copying from original drawings on paper or silk. Each subject embraces a maximum of narrative fact, blending the man-made objects into a maze of vegetation by which the viewer's eye is restlessly entertained. The beginning of this tradition of narrative illustration is shown by two tomb slabs preserved in the Boston Museum, each with three framed scenes, which must belong to the last decades of the Northern Wei period. Elegantly posed ladies and gentlemen stand under trees with large stylized leaves, or among boxed conical rocks which evidently symbolize a wider landscape sheltering animals. Wine is being drunk in one scene; another portrays a bedizened horse below umbrellas and

fans. In spirit the composition answers to the courtly procession of the Gong-xian caves.[10] The Luoyang stones already instanced, also early in the narrative series, are distinguished by archaistic elements in the compositions, with some subjects apparently taken from *fu* composed in Han time: two young men carrying an emaciated old man on a stretcher (possibly an unidentified story of filial piety), dragon-masters, fairies in celestial chariots and musicians, all in compact and marvellously diversified progress from right to left. A passage of mountain and trees links this design with other coffin schemes, but the whole remains distinct, arguably representing a northern pictorial tradition.

During the next half-century the stone-engraved scenes further develop the narrative technique. Separated in adjacent frames the scenes are still continuous, trees and tall rocks parting the scenes without breaking the landscape. The secular subjects are exclusively moralities, exemplars of filial piety, some of these labelled with names which mostly recur in the later conventional list, or other persons recorded in Confucian tradition for their noble behaviour.[11] On the other hand the stones of the Tenri museum[12] introduce a variant of the style which it is agreed to refer to a Zhejiang-Jiangsu tradition: a delicate arrangement of slender persons in the stance described above from Northern Wei courtiers, a couple in an ornate kiosk, four kinds of largeleaved trees strictly stylized, and overlapping mountain peaks. This setting Nagahiro terms the 'noble garden', symbol of leisurely stroll and cultivated converse. The creation of pattern guides the whole and no effort is made to apply even principles of

253. Dragons and phoenix engraved on the cover of a memorial tablet. Mid-sixth century. Minneapolis Institute of Art

254. The Widow of Liang, moralising scene engraved on a stone sarcophagus. Mid-sixth century. Nelson-Atkins Museum of Art, Kansas City

recession which were practised elsewhere. The clarity of the best of these designs is lacking in the stones of the Minneapolis Institute of Art, where phoenix, dragon and *taotie* are set over continuous scenes of ten of the exemplars of filial piety [253].[13] The crowded conjunction of the two themes in this case might imply that separate draughtsman's models were combined in the copying, as if a Northern Wei artist were bent on appropriating the southern subjects and style.[14]

This branch of art is represented at its best on stones in the Kansas and the Tenri museums. One series of pictures set in upright oblong frames is on the reverse of the Kansas slabs already mentioned for their demonic ornament. Some features are likely to reflect the normal painting style of the period: empty space is not tolerated, tree-branches and leaves fill every piece of background. The point of view offered to the observer varies: he sees much of the scene from a certain height, but the main figures are presented standing on a level with him, or the scenes are depicted close-up, so that figures and vegetation form almost continuous pattern. The three-quarters view prevails, even when heads are in profile. Much realistic detail is included, and while the patterned surface makes a pleasing total impression, rhythmic decorative effect does not dominate. There is a tendency to arrange the composition obliquely from the lower left corner, at the same time emphasizing the lower right corner. The crowd of suitors attending on the Widow of Liang is posed in natural variety; the widow appears a second time indoors on the left – implying a reading of the narrative from right to left – looking into a mirror and about to cut off her nose in order to escape the king's summons [254]. The stories extend in date from Zhou to Han and later, but the costumes are those of contemporary fashion. The moment of action governs the design. Guo Ju plies his spade to bury the baby for the relief of his mother's poverty, his wife holding the unfortunate

infant and apparently weeping, while her suitably impassive attendant stands by. We are shown the seventy-year-old Lao Laizi from above, as he capers childishly on the floor to entertain his father, but the view of the ancient himself and his attendant is horizontal. Cai Shun sets about rescuing the long-preserved coffin of his mother when fire is reported in the house; the straight lines of the façade and tiled roof of the building frame the men hauling at the coffin with rolled-up sleeves, while a woman wrings her hands and urges them on [255]. Dong Yong sets off to borrow money for his father's funeral; the old man, still alive, squats on his carefully depicted three-wheeled chair; and in the following scene a woman at a loom indoors is the weaver-goddess Zhi Nü who came to his rescue.[15] Narrative subjects had been painted in the later Han, and had monuments survived from the intervening time we should no doubt have witnessed an unbroken tradition of this art. The variation of perspective in different parts of the composition is a feature which persists in landscape painting as it is known later. In the second half of the sixth century figural narrative is endowed with a degree of psychological interpretation, realism achieved by rich material detail and by the grouping of participants as well as by their vigorous movement. One surmises that the architectural and botanical items take their style from distinct disciplines which probably reflect the practice of the southern provinces under the Liang and Chen dynasties.

The engravings on the two long sides of the Kansas stone coffin present a form of continuous landscape elaborated for its own sake.[16] Figures are placed among a serried rank of

255. Cai Shun at his mother's sarcophagus, top middle detail of ill. 252

256. Dong Yong's piety, top right detail of ill. 252

trees and rocks, in hollows on a gently rising ground-plane. The waving fronds of willow, pine and pawlonia cover the sky, their patterns very like those of the figural tiles described above, their stems alternating with the rocks or even set in front of them [256]. The rocks, nearly all narrow vertical pillars, are straight-cut obliquely at the top, the majority sloping upwards to the right and so contributing to the general left-to-right rising trend of design intended to create a sense of receding space. In the Cai Shun scene wisps of scrolled cloud suggest the suspected fire – an archaic touch. The perspective of the figures is bolder than ever: the back view of the mounted officer and his attendants in the 'officer' scene, Cai Shun prostrate over the coffin, his dog waiting outside of the pavilion. In this work is seen the acme of narrative–decorative draughtsmanship towards the end of the Six Dynasties. What survives on stone plainly represents fine copy craft, and we are left to imagine the quality of sophisticated draughtsmanship which must have lain behind it. But the whole style is not to be dismissed as mere artisans' convention because of the lack of calligraphic mannerism, for that view would savour too much of the retrospective critism of the eighth century, as will appear in a later chapter.

Independent traditions of draughtsmanship are recorded on Buddhist monuments, particularly on the stelae bearing miniature image sculpture which become numerous in the Eastern and Western Wei periods. In his translation of the Lotus Sūtra, Kumārajīva had replaced the Sanskrit 'mountain cave' as the place of meditation with 'forest and mountains'. The latter themes, in addition to grouped figures of disciples and donors, are frequent in the decoration of stelae and on the back of the mandorla of free-standing images. A rubbing survives of a fragment dated to 425 in which a landscape with successive rows of low hills is shown rising almost vertically. Between the hills are rows of stylized banana and other trees, images on lotus thrones fronting various activities, a pavilion, and a lake bearing a sailing ship. Excerpts from this composition are still carved in 522 and 533 on the back of image groups of the Wanfo-si in Sichuan. On another image is the representation of a temple precinct, shown from a raised view-point with the lines of kneeling monks, trees and buildings conforming to a single retreating perspective.[17] On the sides of a stele of 551 in the Philadelphia University Museum six compact scenes of forest and hills are ideal examples of the Buddhist narrative style used in portraying the events of Sākyamuni's life before the Enlightenment [257].

In the Wei territory of east China the stele illustration begins with engraved figures similar to those carved in relief for the courtly processions depicted in the Gong-xian cave-temples.[18] The effect is not dissimilar from the crowded figures portrayed on such a secular work as a model gateway.[19] On a stele of 529, donors mounted on prancing horses and shaded by large umbrellas recall the Han tomb pictures, in the spirit of Northern Wei archaism; and this type of ornament lasts into the Western Wei period in the more conservative tradition of Shaanxi and Gansu.[20] In the 520s a usual decoration appears to be that so admirably represented on the stele of 528 in the Sackler collection of the Metropolitan Museum: lotus blooms and half-palmettes

257. Forest and hills depicted on the side of a Buddhist stele dated to A.D. 551. University Museum, Philadelphia

258. Detail of lotus and palmettes, sacrifice at an altar and tumblers decorating a Buddhist stele (the 'Sackler stele'). Metropolitan Museum, New York. Mid-sixth century

259. Detail of incidental themes depicted on a Buddhist stele (the 'Trübner stele'). Mid-sixth century. Metropolitan Museum, New York. Height of the stele in its present condition (part of top missing), with the base: about 3.6 metres

260. Manjusrī and Vimalakīrti, detail of the stele of ill. 259

caught in delicate scrolling, a step on from the like motif used in the Yungang cave-temples [258]. On one side of a stele in the Boston Museum a Bodhisattva with four companions is framed in large-leaved *sāla* trees, these owing nothing to the secular convention of the time; and on the other side Sākyamuni as Bodhisattva instructs a row of five monks in the Deer Park, the whole surrounded by elements of the forest scene, hills and trees with added deer. On the edges of one stele the formality of lotus blooms and figures approaches that of the contemporary secular convention, but the échelonned rounded hills sheltering monkey and wolf depart sharply from the rocks of the secular funeral friezes; on an Eastern Wei mandorla of 546 the engraved groups of figures and elements of landscape more resemble what has been described from the Wanfo-si.[21]

The greatest variety of design and the most spectacular grouping of divine and lay figures is achieved in the 'Trübner stele' of the Metropolitan Museum, its suave crowded relief the very acme of late Northern Wei sculpture [259–61]. The inscription states that work began on it in 533 and ended in 543 of Eastern Wei rule.[22] The broken upper register is occupied by Sākyamuni flanked by the disciples Ananda and Mahākāsyapa and two Bodhisattvas. A canopy now missing is supported by two fat and exotic genii, and other exotic items crowd the zone below the images: two contorted fakir-like ancients, one of whom holds a skull (the significance of this detail is not explained); lions confronted about three ornate vessels of strikingly un-Chinese appearance, these supported by two men bare to the waist and wearing baggy trousers [259]. On either side of this pair a monk makes an offering[23]; and at either extremity stand two guardian strong men, *lishi*, of decided Indian aspect, the right-hand one an ostensible Indra. Next comes the scene which most nearly represents a painted version of the event: the debate between the virtuous citizen Vimalakīrti and the Bodhisattva Manjusrī, as recounted in the Vimalakīrti sūtra [260]. The pavilions housing the two principals, separated by a tall tree, are presented in an oblique perspective distinct from lay composition as it appears in tomb pictures of about this time. The heads of the monks and Bodhisattvas seated around turn in various directions as if they comment on the proceedings; and at the centre but separated by

261. Detail of the stele of ill. 258. *Right*, the Mountain Spirit King; *left*, the Tree Spirit King

the tree-trunk are the elegant figures of the Bodhisattva Sāriputra and a lady who appear to conduct a conversation of their own.[24] Below are the rows of donors with umbrella-bearing attendants, and along the front of the stele base the strange images of spirit kings.[25] Here only eight of the ten appear (as at Gong-xian): kings of Wind, Pearl, Tiger, Dragon, Lion, Fish, Mountain, Tree, representing, it is supposed, the ten Buddhist kings of India [261]. Much of the exotic content of this iconography repeats items found at the Wanfo-si of Sichuan, and is to be taken as betokening an indianizing interest, an equivalent of more directly westward-pointing features in sixth-century monumental sculpture. The connexion appears to be with some central-Indian sphere, superseding the earlier universal authority of Gandharan models mediated through Central Asia, and is unique in sculpture executed in east China.

Pre-Tang Mural Painting in West China

The existence in Northern Wei territory of figural murals of the 570s was noticed above. These compare closely with the draughtsmanship of the southern provinces, and anticipate the style of Tang murals. In the north there persisted also until the opening of the sixth century a mural style in which dragons and phoenixes, and sages mounted on them, mix with flowers and trees and fly through the heavens, all recalling Han painting of the first century B.C.[1] A similar spirit animates the ceiling painting of the Dunhuang Caves 249 and 285 in western Gansu.[2] On the pyramidal ceiling of the former, on a light ochreous ground and in malachite light green, red ochre, ferric browns and yellows, are depicted a spacious medley of air-borne creatures: *Fengbo* lord of the wind, the 'tamed savages' *kaiming*, feathered men, the gods of thunder and water, *Wuhuo* the strong man of the Warring States, Xiwangmu drawn on a carriage harnessed to four peacocks, less conspicuously her consort Dongwanggong, a deer hunt [263]. On the western slope of the ceiling a brown giant stands on nine mountains and eight seas, ostensibly an Asura who warred with Indra, now raised on Mount Sumeru and holding up sun and moon; on either side the thunder god with his garland of drums and the wind god with whirling scarf [264]. The ceiling of Cave 285, occupied by flying creatures and scattered blossoms, rises over a row of Bodhisattvas seated each in a separate craggy retreat [262].

The iconography of these ceilings, exceptional in the Buddhist context and marking an incursion of eastern style, falls in the period 525–545, when Dunhuang was under local rule by the Yuan Rong house, the third period of the artistic history.[3] But from the opening of the caves in the fourth century until the late seventh century, even during the Yuan Rong episode, the styles of Dunhuang murals look chiefly westwards to Buddhist foundations in Central Asia. At these places no east-China influence was felt before the late sixth century at the earliest.[4] The degree of adaptation and development the western models received at the outset from Dunhuang artists is variously estimated, but a characteristic local style was achieved from the late fifth century. The first cave-temples were dedicated under the emperor Mingdi Jian in the period Yonghê (345–356) of the small Qian-Qin state (351–394); and in 366 is recorded Lo Zun's vision of a thousand Buddhas on three peaks. No sculpture or cave murals are attributed to this early time, the surviving work beginning with the murals of Caves 268, 272, 275 being inaugurated under Bei Liang in the second quarter of the fifth century, Period I.

The images of the first period are in recesses framed by pillars with painted bracketing and imitation of projecting tiled eaves, in the Chinese manner. In Cave 249 an over-lifesize Sākyamuni is seated with legs lowered, only a brief lappet falling over the bare (proper) right shoulder, the folds of the garment shown as well-separated symmetrical loops of narrow raised line [265]. Numerous other images portray the cross-legged Maitreya. All the intervening spaces of wall are covered with figures painted on a uniform plum-red ground relieved with a scatter of white leaves and fleurettes, or some branches vaguely indicated in subdued colour. As they appear at present, with some possible loss of surface colour, the main forms of the figures are based on approximate circles at head, eyes, breast and belly, drawn in a wide uniform line of black [266].[5] Detail is added in white on the bodies, and the scarves and skirts of flying apsarases are in white or light blue. The attempt at foreshortening the apsarases implies a concept of pictorial space, but the multiplied minor figures are not arranged in any intelligible relation to each other. Many of them are musicians, dancers and bringers of gifts, all haloed. Bodhisattvas flanking main images have the triple inflexion in the body, part of indianizing tradition which reached metropolitan China a century later. Other bodily attitudes are crude enough, the most ambitious of them, in Cave 275, a king *Bilengjieli* who as the cost of receiving instruction on the Law from a Brāhman allows a nail to be driven into his body, writhing a little [267]. On the wall of the same cave Sākyamuni is shown in his incarnation as prince Chandraprabha, when he gave his blood and the marrow of a bone to anoint a leper – with little drama, the leper merely kneeling. Close to the main Maitreya a confused picture, with Chinese architecture, assembles without spatial connexion the events of Sākyamuni's walk outside of the palace, when for the first time he witnessed suffering, old age, death [268].

The naïveté of these compositions is to be contrasted with the work of Period II, corresponding to the second phase of Northern Wei art and the carving of the Yungang cave-

262. Dunhuang. Detail of ceiling of Cave 285, with Bodhisattva in a cave

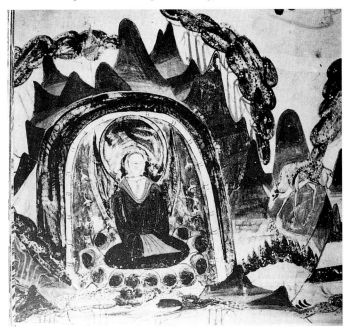

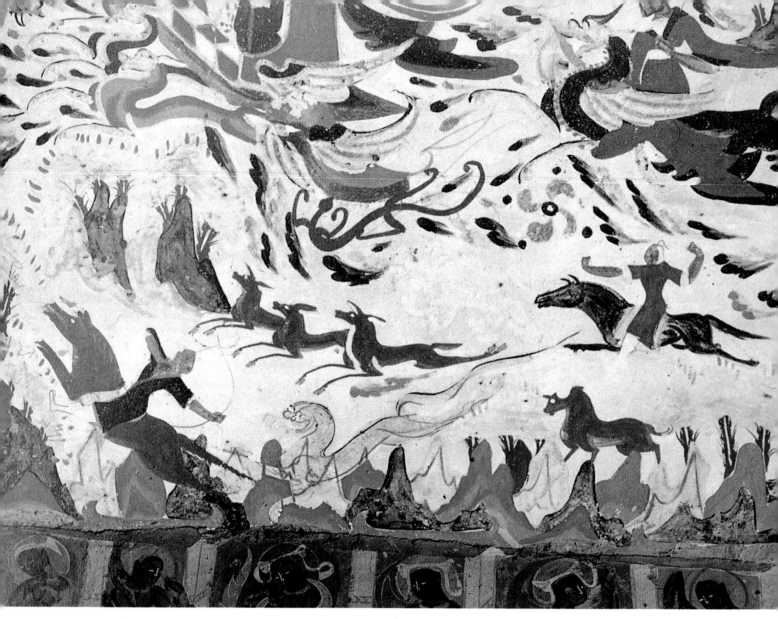

263. Dunhuang. Detail of ceiling of Cave 249

264. Dunhuang Cave 249. Asura appearing over the image shown in pl. 265

266. (*facing page*) Dunhuang Cave 272. Figures painted with the circling movement

265. Dunhuang. Śākyamuni in Cave 249

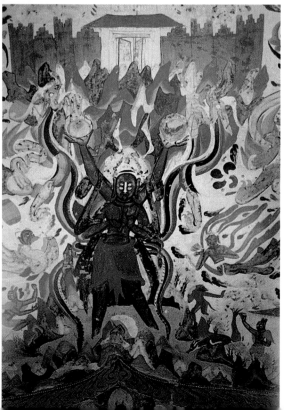

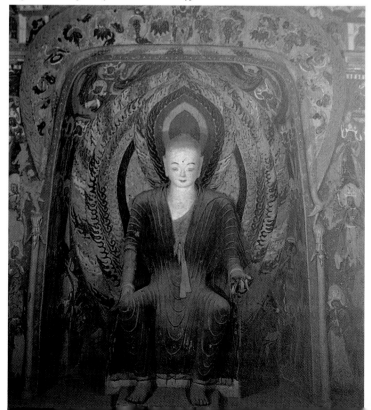

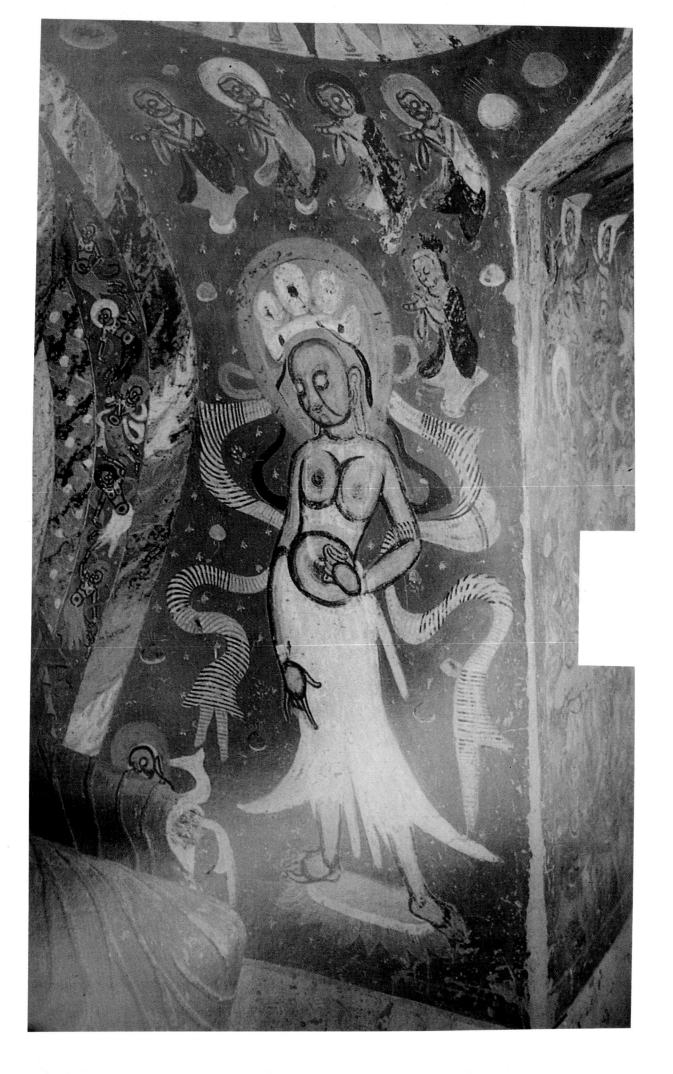

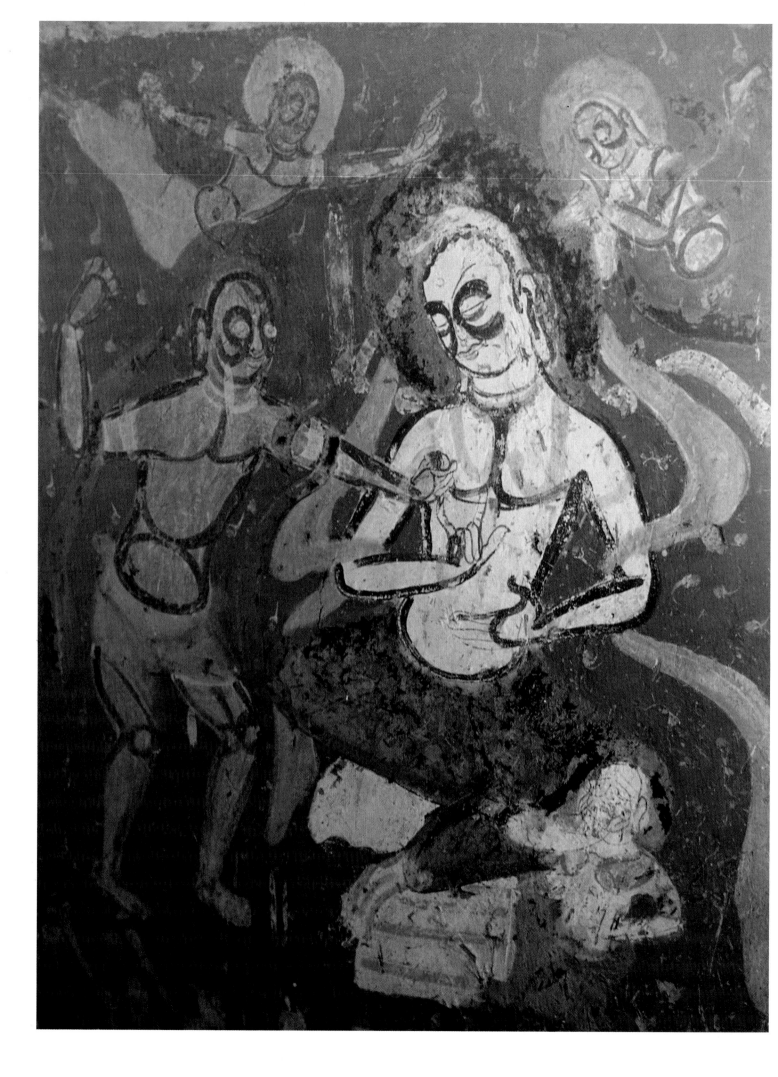

temples. The new style is prominent in Caves 254 and 259. The image niches are altered, now resembling those of Yungang, with ogival top and dragon-head terminals to the arch; the close accord of this shape with the painted figures contained in it and disposed around it certainly suggests that here is the origin of a form which was carried to Yungang with the enforced transfer of craftsmen that occurred after the Northern Wei conquest of the region in 439. A transformation of colouring and design seen in Cave 254 is the most striking innovation. Dark grey, brown and black, and subdued tones of the blue and acid green, all on a dark ground, give a sombre effect not found in the earlier or later painting. The scene of the Shivi king at the centre of the north wall of the cave marks an emphatic change of style [269]. In this incarnation Sākyamuni tries to save the life of a dove which is pursued by a famished eagle, the latter a disguise of Indra who has set the test. The birds are minor features at the top of the picture. Well rendered is the tension of the king's body as he stoically watches flesh cut from his leg to feed the eagle. A friend grasps his knee begging him to forbear; a man dressed in local style stands indifferent at the side holding scales to weigh the flesh. Such an attempt to summarize all the elements of a dramatic event in a single picture is a new departure. Other individual

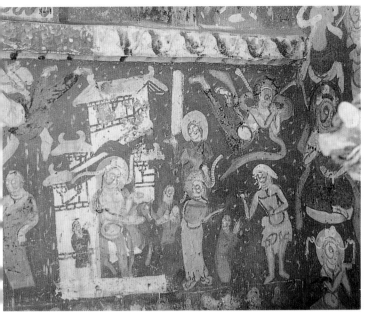

268. Dunhuang Cave 275. Sākyamuni's walk outside the palace

267. (*facing page*) Dunhuang Cave 275. King Bilengjieli

269. Dunhuang Cave 254. The Shivi king

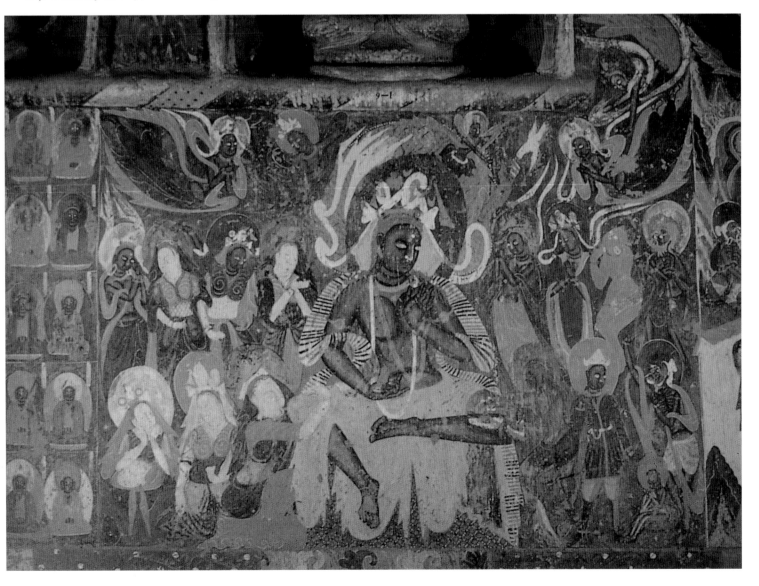

270. Dunhuang Cave 254. The king of Magadha

pictures in the cave, similarly coloured and with corresponding bold treatment of tortured bodies, are evidently also the work of the Master of the Shivi King. The king of Kosala cowers after his defeat in miracle-working at Srāvastī; the king of Magadha, become a hermit, agonizes as the earth swallows him alive for killing an animal [270]. On a larger scale, one surmises the same hand in the much-varied figures and the riot of demons on the south wall of the antechamber of the cave, where the birth, temptation, predication and nirvāna of Sākyamuni are all worked into one scene. The taste for violent action and boldly experimented human anatomy is seen again on the south wall of the main chamber: the story of prince Sattva who to save a starving tigress sacrificed his life by jumping from a cliff, the event represented here only by the climax, with prostrate prince and feeding tigress [271].

What has been described from Periods I and II at Dunhuang suggests excerpts from the practice of mural painting at Kizil, near to Kutcha about a thousand kilometres to the west. Here some figure drawing was based on a scheme in thick black line; uniform black forms the ground of many scenes, and among the minor figures occur incidents of vigorous action. Some of the Kizil painting may be contemporary with that of the first two periods at Dunhuang, but the greater part of it is probably older by half a century or more. The work of the Master of the Shivi King in which the Kizil tradition is reflected may therefore be to some extent archaistic. It notably eschews the Iranian characteristics of Kutcha painting which are present in nearly all the Kizil murals, from the mid-fourth to the late sixth century. In the same Period II however the principle of the frieze composed of consecutive scenes of the story is introduced, and in these paintings elements of Iranian and Chinese origin are combined. The tales of the rich man's novice son who killed himself to escape the temptation offered by a beautiful maiden, and of the stag of nine colours whose generosity was betrayed,[6] are recounted in narrow bands, read from right to left. The ground of brick-red with scatter of fleurettes follows Iranian practice, and the open-sided buildings framing the main protagonists copy Chinese architecture, albeit with little understanding. None of the characteristics of the Master of the Shivi King survives in these pictures, and one may see them more confidently as the special creation of the Dunhuang school. Drama is made unambiguous by gesture and posture delicately drawn: in the first frieze the bhiksu who admits the novice's vows, the desperate moment when the maiden is shut in a room to which the novice has enticed her; in the second frieze the royal figures listening to the rescued man, the diseased man leading the king's carriage, the king confronted by the deer [272]. In this frieze space is implied by landscape sloping up steeply to the left, with identical mountain peaks in different colours on an ascending line. When it appears at Dunhuang the narrative frieze antedates the east-China secular illustration in the frieze format by at least several decades, although it may be contemporaneous with some of the Sichuan and east-China Buddhist illustration, not in frieze

271. Dunhuang Cave 428. Detail of the Sattva jātaka

272. Dunhuang Cave 257. The deer *jātaka*

273. Dunhuang Cave 254. Seated Buddha

format, which precedes the secular subjects. No direct contact can yet be demonstrated.

A striking feature of the comparatively brief Period III (525–545) is the episode of east-China archaism which extended from Period II. But the greater part of the painting executed at this time shows continuous progress from what had preceded. In many subjects the style of figure painting is unaltered, with the broad line and much use of black, but the bodies of Bodhisattvas more often given the triple bend. In depicting swinging drapery and folds in the garment the broad line may be varied in width so as to suggest movement and the real fall of cloth. On a Buddha in Cave 254 is an alternation of wide and narrow lines which aims at reproducing the effect of sculpted Gandharan drapé [273]. Here is implied also the use of a flexible brush capable of holding sufficient pigment for tracing long unbroken lines, evidently one similar to the normal Chinese type. On the whole the development of figure painting is the hallmark of this period. The finest possible line in white may trace the outline of long scarves painted in azurine blue, and eyes, noses and ears are mostly highlighted in white.

Outstanding in this period and detached from the predominant tradition is the main (east) wall of the great Cave 285, unique for the design and the quality of its painting. In the central niche sits a Sākyamuni with pendent legs, clothed in red and surrounded by a triple multicoloured flame mandorla of unprecedented magnificence [275]. In the lateral niches are Buddhas seated with folded legs. In the niches and on the remainder of the wall are compact schemes of figures which call for recognition of a new hand in the mural painting, and introduce items from the Hindu

274. Dunhuang Cave 285. Vishnu

pantheon which now occasionally appear in the Mahāyāna iconography. On the (proper) right of the central image a three-headed eight-armed Vishnu is portrayed in ecstatic pose [274]. The outline is traced in fine black line, the pinkish flesh shaded to suggest relief, the sharp clarity of the facial detail recalling the importance given to the eyes in later Chinese theory of portraiture. Below are two celestial deities and two armoured guardians in the same idiom. On the image left is Shiva, with a Ganesha and guardians. The surrounding multiple Bodhisattvas and adorers reveal similar concern for fineness of line, relief of surfaces and expressive faces. The work of this Master of the Vishnu Icon appears to be confined to Cave 285.

A new theme, the Conversion of the Five Hundred Bandits, calls for wide landscape not hitherto attempted in the murals, as portrayed on the south wall of Cave 385 [276]. The viewer is imagined well above the ground plane, tight rows of small hillocks ascend obliquely from left to right, pavilion roofs are drawn in discordant perspectives. Human figures, nearly all in three-quarters aspect, are scattered

275. Dunhuang Cave 285. Buddha on east wall

276. Dunhuang Cave 285. Conversion of the Five Hundred Bandits

277. Dunhuang. Detail of ceiling ornament of Cave 285

freely through the scene. Incident is of the most varied kind: mounted warriors in scale armour, men fighting with sword and shield, groups of prisoners, rows of monks before the Buddha. In Period III the perfection of ornamented ceilings which imitate a roof-well is more noticeable than it has been hitherto [277]. The design was to be followed for long afterwards: successive square openings are fancied, each turned 45° from its predecessor. The many bands and triangles so produced are filled with floral ornament based on a half-palmette drawn to great accuracy, in brilliant contrasting colour and shadowed in lighter tones, with perhaps apsarases in the larger triangles. The fringe of tassels and other pendants around the 'well', imitating the edges of a canopy, is a feature due for great elaboration in the sequel. It first appears also in Cave 285. Where the cave roof is shaped in two slopes each of these is divided into vertical panels filled with a fantastic lotus bloom. As an alternative to the floral ornament, ceilings may be covered with small rondels or squares in rich colours. Like the abstract geometry on the front of imitated balconies holding adorers, this diapered embellishment prefigures the ornament which we shall later term the jewelled style of Tang painting [278].[7]

Period IV, under Western Wei and Northern Zhou from 545 to 580, shows a decline in the quality of both sculpture and mural painting. The types and grouping of statuary repeat approximately what has been described from the contemporary stone sculpture of metropolitan China, as if this sculpture rather than that of more western tradition now set a standard. The five-figure groups in Caves 296 and 297 follow the Chinese scheme, without however adopting the columnar simplification of contemporary east-China sculpture, and resembling rather the Sichuan practice recorded from the Wanfo-si.[8] If it does not only mark a falling off in local skill, the insensitive surface of the clay

modelling may result from the imitation of designs based on the eastern stone sculpture, although the present appearance may also owe something to more drastic restoration than some of the earlier work has suffered. In icon painting the distinction is still more marked between the basic heavy line in black and the flexible line which the Chinese brush permitted. The latter occurs in minor items rather than the icons themselves, some portraits of donors differing little from what would be found at this time in east China. Drawn freely in heavy line are apsarases, strong men at the foot of the image throne, as well as icon groups. Some groups (e.g. on the north wall of Cave 428) may acquire a rigidity in the execution which argues routine copying of the old style. As to draughtsmanship, the main change is found in the jātaka recounted in continuous narrow ribbon-like format, with much vigorous action. In these and in some detail filling interstices in the principal compositions one is tempted to see a direct influence of a genre style equally current in the metropolitan region, which anticipates the frequent recourse to genre subjects in murals of the Tang period. A prancing horse with its startled groom, a small picture in Cave 290, is a case in point.

The account of Sudāna in a long triple frieze in Cave 428 is crowded with mountain peaks through which the prince wends his way, banished for too readily presenting a white fighting elephant to a neighbouring hostile country [279]. One by one he yields up his possessions, even his wife and son. Leaping horsemen, monkeys, tigers devouring human prey, the elephant ridden by six men, carriages, sober citizens, sages and Buddhas, wildly gesticulating savages – the artist's fancy ranges farther than ever before at Dunhuang. Fir-like and bushy-topped trees are less stereotyped than their equivalent in the east-China friezes, yet the motivation to realism and the action picture is surely inspired to some

279. (facing page, below) Dunhuang Cave 428. Detail of the Sudāna jātaka

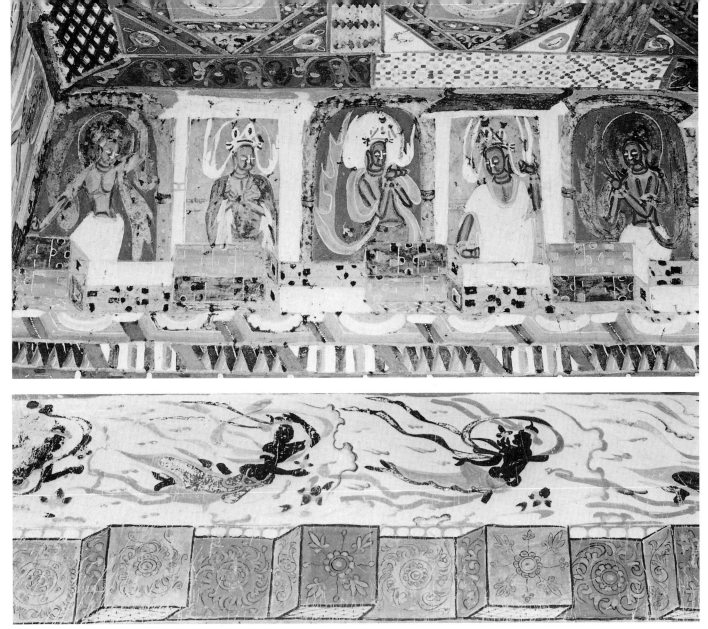

278. Geometric and floral ornament: 1: Dunhuang Cave 435; 2: Dunhuang Cave 390

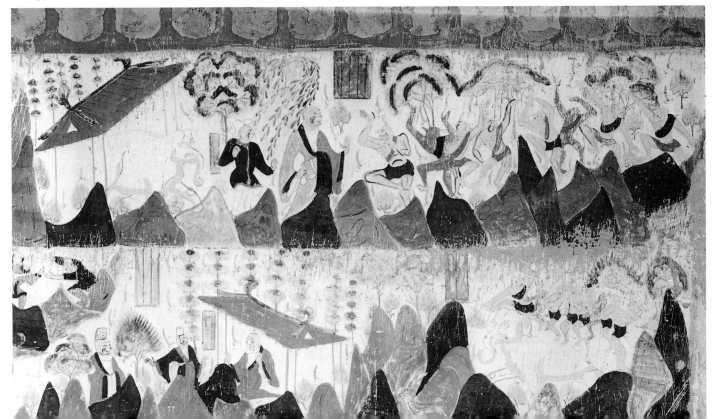

extent from that quarter. A light brush, apparently now adopted for the first time, creates foliage and branches, limbs of horses and men. The figures are outlined in fine black line and filled with uniform wash of black, grey and shades of brown. Alternating colour distinguishes the dentation of hills.

Inculcation of extravagant alms-giving and self-sacrifice governs much of the iconography of the late phase of Northern Wei and the succeeding reigns, and the *jātaka* were particularly appropriate to this purpose. Although no painting on paper or silk of these subjects has survived from this time, one surmises that work on these materials inspires the *jātaka* painting at Dunhuang, as it must also have provided the models for the stone-engraved friezes of east China. A triple frieze of Cave 296 recounts the tribulations of the prince 'Good Works', *Shanshi*, son of king Ratnavarmin, who resists the machinations of his evil brothers. It is evidently by a different hand from the one just described, showing complex buildings in bird's-eye view, and introducing oxen ploughing and an archer shooting at deer; but the action is less vivid and the figures more stereotyped. In the same cave the Five Hundred Bandits appear again, before a fortified gate in eccentric perspective, the interest in wide landscape yielding to a patterned repetition of colours amid which reality recedes. Also in Cave 296 an inconsequential and repetitive series of pavilions frames the sorry events in the life of the *bikshunī* Weimiao as she expiates the murder, during a former existence, of a concubine's child by driving a nail into it. A walled orchard, laden ass and camel, horses at a manger, rice being planted, and an infant thrust into an oven, are bits from the contemporary scene which the new realism favours.

The division of Sui rule at Dunhuang serves only to distinguish a brief beginning when previous styles still hold, Period V, and a final phase which runs unbroken into the opening decades of Tang, Period VII; in the intervening Period VI (589–613) we may look for features more particular to the Sui reign. From the mid-sixth century the abundance of lotus ornament and the multiplication of adorers and Bodhisattvas are prompted by the Lotus Sūtra, *Miaofa lianhua jing*, with its account of the myriad listeners to Sākyamuni's words and the showers of flowers and jewels. This influence becomes still more prominent in the Sui murals. Miraculous events recounted in the sūtra form the subject of two-tiered friezes in Cave 305. The part of genre and the action scene is greatly reduced, the content becoming an almost unbroken series of small open pavilions housing images and priests, all set oblique and facing right, presented from an elevated view-point. The people are nearly all attentive monks; only an occasional sinner burns in flames or is launched on water by demons. Trees retain the realism that was noticed earlier, but rocks are as fantastic in their jagged unreality as those of the East China friezes. The Sudāna and the Sattva stories combined on the east ceiling slope of Cave 419 can have been little legible to the visitor, filled as they are with the now too facile trick of pavilion roofs with a background of foliage, the all but eclipsed human figures stereotyped from earlier versions. On the roof of Cave 301 landscape has degenerated to an illegible spatter of forms. In Cave 305 zest in the composition is reserved for the ceiling, where Xiwangmu and her consort are depicted with fresh abandon, apsarases taking the place of the old Han genii of the air. The five-figure array, a seated Buddha with pairs of Bodhisattvas and disciples, remains the chief

280. Dunhuang Cave 295. *Mahāparinirvāna*

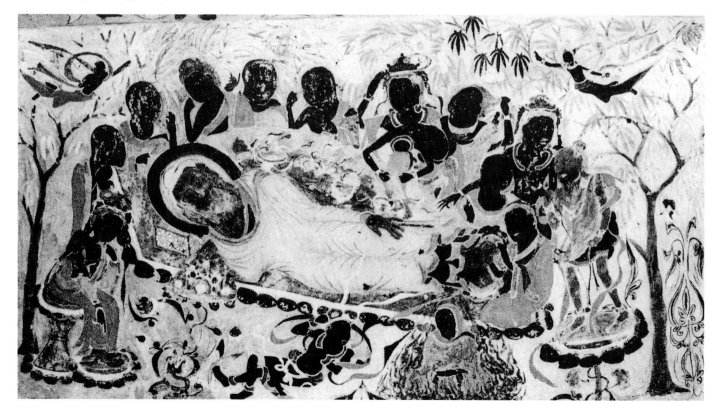

281. Dunhuang Cave 420. Bodhisattva

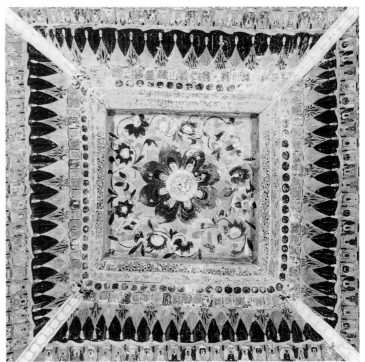

282. Dunhuang Cave 397. Representation of inlaid jewels in ceiling ornament

sculptural task. When the icon is painted the accompanying figures are multipled in dull repetition, packed unintelligibly into the pavilions holding Manjusrī and Vimalakīrti (Cave 420). Some walls and ceilings are covered entirely with small identical pictures of a seated Buddha, as if inspiration gives out. Such finesse as is found is reserved for isolated subjects. One of these is the death of Sākyamuni, *Mahāparinirvāna*, in Cave 295, the first appearance of a composition which in the Tang period was to be the occasion of an unprecedented attempt to portray extreme emotion in the countenances, as the attenders at the death yield to paroxysms of grief [280]. Others are a few exercises in the old broad-line manner in black and grey, such as the much-cited Bodhisattva head in Cave 420, which is given a halo and other detail in green, pink and white, and a studied misericordious expression in keeping with the religious sentiment of the time [281].

But if many of the main subjects of the Sui murals wear an air of tired recourse to past models, the same cannot be said of much of the accompanying decoration, whose motifs foreshadow the rejuvenation of Dunhuang style achieved under the Tang. The use of colour is more temperate, a tonality maintained through all the polychrome. A Vimalakīrti in Cave 276 may be drawn in fine brush-line with a realism in the features which we suspect of echoing contemporary secular portraiture. A new delicacy in the poise and expression of both main image and flanking Bodhisattvas may be matched with a lighter touch in the flowers of the ground, the ornaments of the baldaquin and the apsarases added unemphatically to the décor. The mural of a seated crowned Buddha in Cave 390, on the border between Sui and Tang, is set in a rectangular frame of small plain circles. Abounding around the cave, these circles resemble others that are in addition beaded around the edge,

making a figure found on Tang textiles with design of Iranian inspiration – the influence of Sasanian Persia is detectable before the expansion of the Tang state had further opened access to the west. Equally significant are the antecedents of the Tang jewelled style: the spiralled blossoms on the jutting rectangular fronts of painted balconies in Cave 390 [283], the imitation of inlaid jewels and of semi-precious stones set in filigree on the ceilings of Caves 397 and 392–394, all of Sui date [282]. A beautiful revival of the flower scroll, now inhabited by images and lutenists, is refreshed with a realistic touch which also points westwards. A decade or so later we hear of the painter Weichi Yiseng at the Chinese court in Chang'an. He was said to come from Khotan, and was famed for floral verisimilitude.

283. Dunhuang Cave 393. Inhabited scrollery in ceiling ornament

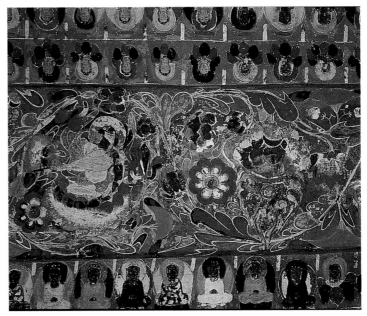

Architecture from Han to Tang

Although the material evidence for architecture in the post-Han centuries is sparse, even in the Tang period, when the most pronounced development took place, literary description leaves no doubt as to the large size and abundant ornament of buildings both secular and religious. Painting, gilding and sculpture still covered the walls of palaces, and post-Han monarchs are likely to have emulated the lofty towers and huge audience halls of their immediate predecessors.[1] In timber-framed architecture the technical tradition is to be surmised unbroken, and masonry architecture above ground can only have continued and developed the methods which the excavation of tombs has revealed for the Han period. As appears in monuments dated from the sixth century, it was chiefly Buddhists who sought grand effect in brick, probably covering it in most instances with white plaster to resemble the Indian stone architecture which remotely influenced the design. But in keeping with tradition it was accepted that noble temple and secular hall alike should be framed entirely in wood, the more expensive material. Carpenter's skill determined the progress of structure and ornament. Brick and stone alternated with wood only in the Buddhist towers and memorial pagodas,[2] whose decoration inevitably imitated the detail of timber buildings.[3]

THE BUDDHIST PRECINCT

In disposing the various buildings of a Buddhist temple the axial plan became the norm before the beginning of the Tang period, although the initial scheme, based upon a tower-pagoda, seems not to have observed strict axiality.[4] The placing of each structure on a podium about one metre at least in height followed the ancient rule. In timber-framed architecture the task confronting architects continued the same as had determined the outer design already in the Shang period: the achievement of height in the façade and the support of far-projecting eaves covering the pillar footings, the margins of the podia and the surrounding ambulatory *lang* when this existed. To supplement the account of Chinese building one may look to Japan, where plans and in some cases even the elevations and bracket systems date from the seventh and especially the first half of the eighth centuries. The Japanese buildings must copy in detail the contemporary Chinese practice, brought to Japan at this time by migrating architects and other craftsmen. The models so introduced into the Yamato kingdom are thought to represent in particular the practice of Zhejiang and Jiangsu, whence the migration most probably came.

The first accounts of Buddhist temples which furnish any detail are those contained in Wei Shou's *Treatise on Buddhism and Daoism*, which describes the Yongning-si of 467 in Datong, the first Wei capital; and in the Wei History, where a temple of the same name erected in 516 at the new Wei capital near Loyang is given fuller treatment. The tower of the former is said to be seven-storied and 'more than three hundred feet in height. Its base and frame were vast, and it was the first in the Empire'.[5] Four years later was 'also built a three-storied reliquary. The beams, the chevrons, the lintels, and the pillars, joined together from top to bottom, were all, whether larger or small, of stone. The height was ten rods. Firm, solid, cunning, and compact, it was the grand sight of the capital.' All of which, with the height of about four hundred English feet, makes this temple exceptional by its height, however exaggerated the recorded figure in comparison with the surviving stone structures to be noticed below.[6]

Excavation on the site of the Yongning-si in the Han-Wei city of Luoyang revealed a centralized square plan for the main structure which recalls Han ceremonial building and the principle of the *mingtang* [284].[7] The general plan is rectangular, orientated to the south, where the main entrance appears to have been situated, but is not axial in detail (and, it may be added, axiality is no more observed within the oblong precinct of the city palace or in other foundations). The main building of the Yongning-si was a tower raised on the square foundation. The latter consisted of a basic layer of *hangtu* 2–3 metres thick, beginning a little below the original earth surface, then overlaid by further *hangtu*, this

284. Foundation of the Yongning-si, built in A.D. 516. Luoyang City, Henan

upper layer accurately 2.2 metres deep, orientated to 185°
and adjusted to the square base of a tower of side 38.2
metres. On the base were traced the footings of 124 pillars,
arranged in five concentric squares numbering from the
centre 16, 12, 20, 28 and 48 pillars.[8] The outermost setting
was of slenderer timber, evidently serving to hold the roof of
the surrounding *lang*. Corners were strengthened by crossing
the converging pillar lines. On this base was raised the tower
which was once described as seven-storied (see above) and
again as nine-storied, with each of the four façades pierced
by three doors and six windows.[9] The base of a brick struc-
ture occupying the centre of the tower foundation is thought
to be part of the internal staircase giving access to the upper
storeys. Clearly the temple functioned around the tower,
which had the status of relic repository in the manner of the
Indian stupa on which the cult was centred.[10]

So a question arises as to when, in imitation of palace or
other secular complex, north–south axiality was first adopted
in siting buildings within a temple precinct. At a mountain
site at Longmen the various halls of a Tang temple are
scattered irregularly as the terrain required[11]; at the Changle-
si in Hebei, of Northern Qi date, the tower is placed to the
left at the South Gate, and the remaining buildings and
subdivisions of the precinct are about a central line.[12] In the
Xinjiang province a temple was designed *ca* A.D. 900 with
utter symmetry of smaller buildings either side of a central
court forming the approach to a square podium which may
have supported a tower in the manner of the Yongning-si
[285].[13] For the development of temple plans between the

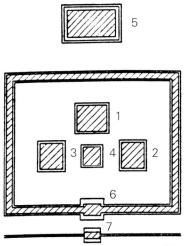

286. Plan of the Asukadera, Nara-ken, Japan. 1: middle main hall; 2, 3:
east and west main halls; 4: pagoda tower; 5: teaching hall; 6: inner main
gateway; 7: front main gateway. Founded in A.D. 588

dates of these two buildings, which embrace the whole Tang
period, one may only look to the extension into Japan of
Chinese architecture, where temples of the Nara region
dating between the late seventh and the first half of the ninth
centuries preserve their original schemes. The most impor-
tant of these, with one exception, adopt the symmetrical plan
on a north–south axis. The Asukadera (founded in 588) has
a rectangular precinct of somewhat greater width than depth,
in which the pagoda is central opposite the south gate, and is
flanked by two identical halls [286]. The main image hall
stands behind the pagoda. Beyond the back wall of the inner
precinct is the *jiangtang* (Jap. *kōdō*), the teaching hall. Ques-
tions hereafter were the placing of the pagoda and the
relation of the *kōdō* to the inner precinct wall. The Yakushiji
(founded in 680) has two pagodas set inside the precinct wall
either side of the gateway, the main image hall – Golden

285. Plan of the foundation of a Buddhist temple at Kirinsar, Xinjiang.
1: main hall; 2–4, 10–13, 16: subsidiary halls; 7–9, 17, 18: priests'
quarters; 5, 6, 14, 15 storage rooms; 19–26: lower range of cells on east
side; 27–33 upper range of cells on east side. Late ninth–early tenth
century

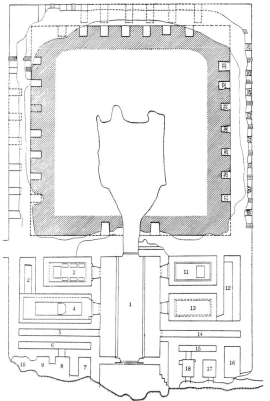

287. Plan of the Kōfukuji, Nara-ken, Japan. 1: middle main hall; 2, 3 east
and west main halls; 4: pagoda tower; 5: teaching hall; 6: inner main
gateway; 7: front main gateway; 8 sutra repository; 9: bell tower; 10 priests'
quarters; 11: refectory; 12: waiting hall. Rebuilt in A.D. 710

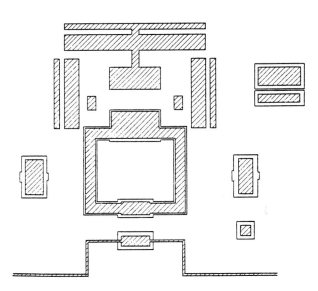

Hall (*kondō*) – near to the centre, the *kōdō* engaged in the back wall, and refectory and habitations arranged beyond in perfect syummetry. Excavation of the foundations of the Kudara-dera in the Osaka-fu revealed a somewhat similar plan, but the building engaged in the back wall of the inner precinct was the *kondō*, and the *kōdō* and the refectory in line beyond. At the Kōfukuji (rebuilt 710) the pagoda is removed from the inner precinct, standing in its own enclosure together with an image hall; the main precinct, after a Middle Gate, is an empty courtyard, with *kondō* in the back wall, while teaching hall, small twin buildings serving as gong-lodge and scripture repository are beyond, together with many utilitarian buildings set symmetrically [287]. The notable exception to the general axial plan is the Hōryūji (founded in 670), where the inner precinct contains the main image hall and the pagoda, i.e. quite dissimilar buildings, to right and left of the entrance. Although an explanation for this irregularity has been sought in the temple history, the *kondō* alone having survived from fire and somehow having determined the plan upon rebuilding in 708–715, there is now sufficient evidence in China for early asymmetry to allow that the Hōryūji may have followed a primitive scheme. It is possible – as is argued below for sculpture of the early eighth century – that the Chinese models for these temple plans were elaborated initially in the Zhejiang-Jiangsu region, passing thence directly to Japan.

THE TIMBER FRAME

The principle of the upward-curving bracket arm (*gong*), extending from wooden pillar head or masonry wall to carry the support of the eaves upwards and outwards, was already applied in building of the later Han period. The Han bracket carried two or three bearing-blocks (*dou*) intervening between the arm and the eaves beam it carried. A single projecting arm adding one further vertical thrust to the thrust of the pillar itself, a one-step system (*yitiao*, 'one jump', Jap. *degumi*, 'projecting complex'), was as far as Han architects had taken the idea, when in dwellings and lower buildings mere vertical out-leaning stays might serve [183, 185, 288]. A development of the bracket complex to provide two or three extra vertical supports seems not to have taken place before the mid-sixth century. Thereafter, through the Tang period, the eaves bracketing was expanded into two-step and three-step systems by the multiplication of *dougong*. These differed little from the earlier shapes, but increased the involvement of the inner roof timbers in the scheme. Extending the eaves meant also raising the support directly over the pillar heads, and this was achieved through piling *dougong* rather than lengthening the pillars themselves.[14] In the quest for height the number of eaves beams placed over the heads of the outer pillars might be increased. These beams were separated vertically either by brackets and bearing-blocks parallel to the pillar line or by curving struts approximating to Vs or inverted Vs, the 'camel's humps' or 'frog's thighs' of the Chinese and Japanese nomenclature (*tuofeng*, *kaerumata*). After the seventh century and until the adoption of merely decorative treatment in the Ming period, the bracket clusters were invariably set over the pillars, but

288. Stone engraving of a gate-house showing simple angular and oblique stay eaves support. From the subterranean tomb in Yinan-xian, shandong. Late second century A.D.

289. *Dougong* brackets and *ang* cantilever, at the middle gate of the Hōryūji, Nara, Japan. Seventh or eighth century

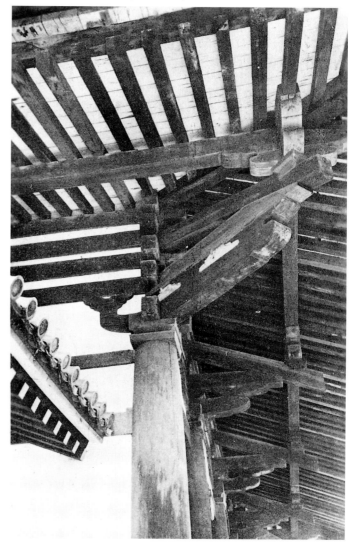

290. Hip-and-gable roofs shown in detail of a mural in Cave 285 at Dunhuang

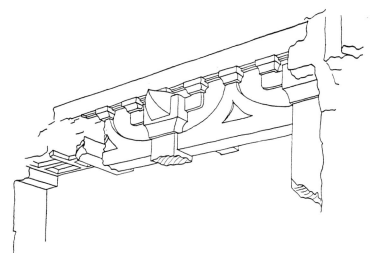

291. Façade of Cave 5 at Maijishan. Mid-sixth century

in some earlier structures *dougong* might also be placed over the intercolumnar spaces.[15] A most fruitful device, adopted probably in the sixth century and much developed in the Tang period, was a powerful slanting member, *ang* (Jap. *otaruki*), used in a three-step projection (*santiao, mitesaki*). It descends parallel to the rafters and is held by a *dou* on or near the pillar head, sometimes piercing the heart of a bracket cluster. On its end it carries *dougong* of its own to support the eaves still farther out. The *ang* at first ran simply from the head of an inner pillar to that of an outer one, but it was soon inserted as a cantilever, the inner end fixed to a purlin and exerting its independent thrust on the roof [289]. The Tang architect used these few elements – single and tripartite brackets with multiple bearing-blocks, inter-beam struts, repetitions of bracket clusters outwards and upwards, and intervention of the *ang* – to create all the outward and most of the inner effect of his largest designs. The exposed logic of the eaves structure entered powerfully into the architectural aesthetic. Being composed of many small independent parts, the bracket complexes were readily re-paired, and their nature tended to assure that subsequent renewal preserved the original shapes and functions even when the upper roof structure above was altered.

Murals in the Dunhuang caves depict buildings and gate-ways of late Northern Wei and Western Wei date. Some of these have hip-and-gable roofs, displaying a small triangular truss at the ridge, a device absent from later timber frames. The acroteria are strongly hooked [290]. No brackets, but only zig-zag struts without projection, appear beneath the eaves. It is doubtful whether this matches any metropolitan architecture. In pictures of wooden pavilions and towers of Northern Zhou, Sui and early Tang date, *dougong* and inverted-V struts alternate in the wall plane, without pro-jecting arms, the struts sited between the pillars. Versions of this wall-plane bracketing were imitated in stone, as seen in Cave 10 at Yungang; and since a projecting element would have been awkward in this case, the wall-plane arrangement is prolonged in stone-carved façades into the eighth century. Elegant examples are the ornament of a sarcophagus of 608,[16] façades of the mid-sixth century in Cave 5 at Maijishan in Gansu [291] and of the early eighth century in

Caves 4 and 16 at Tianlong-shan in Shanxi. A variant omits the Vs (Maijishan Cave 4) or places *dougong* also between the pillars.[17] As ornament on stone, wall-plane bracketing is found until the end of the Tang period, but from *ca* 600 bracketing with projecting arms becomes the rule in wooden buildings. In Sui buildings brackets with three bearing-blocks are in the wall-plane; in the seventh century beam ends may project a little way under the *dougong* to support timbers bridging an ambulatory roof, and at the corners of the eaves brackets may be contrived to project also on the diagonal.[18] By the beginning of the eighth century two-step bracketing with doubled eaves beams appears to be general, as seen in the city-wall pavilions painted in prince Yidé's tomb of 706.[19] This scheme is elaborated by the increase of bearing-blocks, as at the Nanchan-si of 782 in Shanxi,[20] and presently down-sloping projecting members are added at the corners of the eaves, doubled or tripled.[21] By 857, at the Foguang-si which survives on Tai Shan in Shanxi, a four-step system is created with double *ang* [292, 295].

292. The simplest form of the *ang* cantilever, as seen at the Hōryūji, Nara, Japan. Late eighth century. After Yang Hongxun

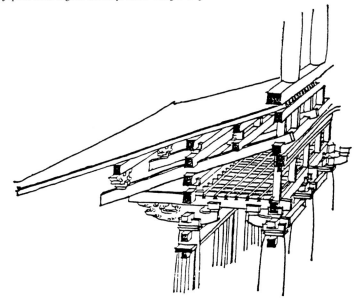

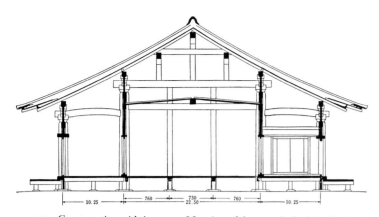

293. Cross-section with inner roof framing of the great hall of the Gankōji, Nara, Japan. Seventh century. The dimensions are in Tang feet.

Interior pillars, of diameter-to-height proportion similar to those of the façade or peristyle, i.e. 1:8 or 1:9, stand at points where lines joining the outer pillars intersect. Transverse and longitudinal beams are slotted into pillar heads or rest on bearing-blocks held by brackets. It is one of the graces of the early designs that these beams, especially those bridging the outer aisles, often curve a little downwards at the ends: the 'rainbow beams' (*hongliang*). In the earliest designs the others are set as a simple reactangular frame with horizontals separated by vertical posts. Nowhere is there resort to an immoveable triangular truss. The walls are screens of the lightest timber, often much decorated by openwork, placed between pillars. The ensuing complication flows logically from the measures adopted to increase the outward throw of the eaves: as the bracket clusters stepped outwards on the exterior, equivalent clusters balanced them on the inner side; given the nature of the framing it became essential to balance the weight of the roof about the line of the outer pillars, so that no outward thrust was placed on the latter; and simultaneously the insertion of *ang* affected both the general framing and the means used to ensure the underpinning of the roof. Similarly, as the quest for height led to the multiplication of brackets, the eaves must be turned upwards as much as possible – although this effect was exaggerated into mannerism only in post-Tang times. The development at this stage is seen by comparing the inner framing as deduced for the original forms of the earliest Japanese temples [341, 293].[22]

During the eighth century, in larger buildings, more attention is paid to the freeing of the interior from pillars to make room for the array of images. In the Great Hall of the Nanchan-si this is achieved without resort to *ang*. The outer brackets are two-step, simple brackets on transverse beams reaching to the ridge. In this small building the rectangle of four-pillar side is kept free without difficulty by the uninhibited use of transverse beams, a method hardly available when the images demanded still more room. More usually in the main temple buildings, as in the Tōshōdaiji *kondō*, width exceeds depth [294].[23] Here an eight-pillar façade and five-pillar side surround an inner clear area equivalent to two by five intercolumnar spaces, with consequent complication of the roof frame. Cantilevered timbers were sited under the rafters.[24]

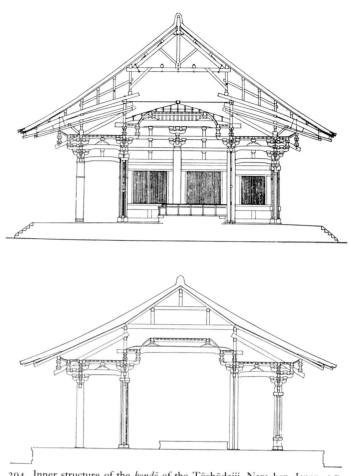

294. Inner structure of the *kondō* of the Tōshōdaiji. Nara-ken, Japan. A.D. 759.

The Foguang-si represents the state of the art in the mid-ninth century [295].[25] It is erected on a plan of seven bays by four, measuring 37.5 metres across the front and 21.5 metres in depth. The clarity and strength of its construction, like its dimensions and general style, place it in parallel with the *kondō* of the Tōshōdaiji, with which it is approximately contemporary. A slight break in the fall of the hipped roof at the first purlin below the ridge gives a mildly concave profile. Large dragon acroteria face each other along the roof ridge.[26] The four-step projection of the bracketing is of a visual perfection never bettered even in more elaborate later complexes. The top two steps are carried at the corners by a pair of *ang* set one above the other (the Tōshōdaiji has three steps and a single *ang*). The inner structure survives as the most authentic evidence for the final Tang solution to the problem of interior space: the central image platform stands in an area two bays deep and five wide, the overhead space enlarged by raising transverse beams on four-step bracket clusters, a most satisfactorily lucid decoration.[27]

While it takes us beyond the limit of this chapter, a glance at some tenth-century structures makes just conclusion of the Tang history. A temple hall erected in 938, of four by five bays, maintains the rigour of the seventh century, with two-step brackets, no *ang*, and only diagnostic *tuofeng* to give an immediate hint of the dating. These raise longitudinal beams from which kingposts rise to the ridge, the posts supported by sloping struts which make a kind of triangular

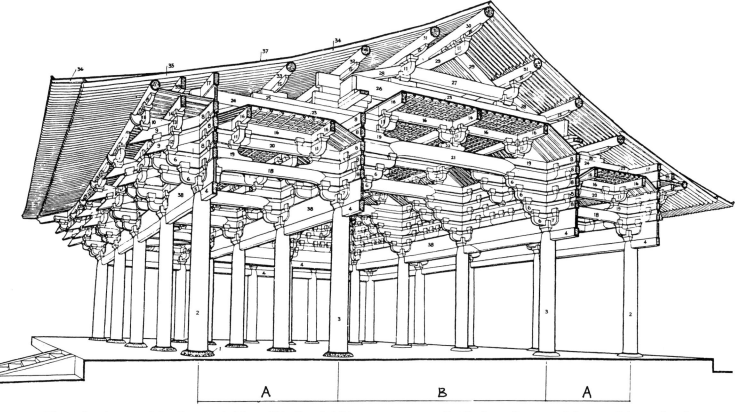

295. The timber framing of the Foguang-si, Mount Tai, Shanxi. Mid-ninth century. A.B. 夕槽 outer gulleys. C 内槽 inner gulley. 1. 柱础 pillar base. 2. 檐柱 eaves pillar. 3. 内槽柱 inner-gulley pillar. 4. 阑额 fixed railing. 5. 栌斗 impost block. 6. 华栱 flower bracket. 7. 泥道栱 plaster channel bracket. 8. 柱头方 pillar head square. 9. 下昂 lower ang cantilever. 10. 耍头 play head. 11. 令栱 command bracket. 12. 瓜子栱 melon seed bracket. 13. 慢栱 lazy bracket. 14. 罗汉方 arhat square. 15. 替木 substitute timber. 16 平基方 level base square. 17. 压槽方 pressure trough square. 18. 明乳栿 clear breast girder. 19. 平驼峰 half camel peak. 20. 素方 plain square. 21. 四椽明栿 four-rafter grass girder. 22. 驼峰 camel peak. 23. 平闇 level obscurer. 24. 草乳栿 grass breast girder. 25. 缴背 joining back. 26.四椽草栿 four-rafter grass girder. 27. 平梁 level beam. 28. 托脚 supporting foot. 29. 叉毛 folded hands. 30. 脊椽 ridge rafter. 31. 上平椽 upper purlin. 32. 中平椽 middle purlin. 33. 下平椽 lower purlin. 34. 椽 rafter. 35. 檐椽 eaves purlin. 36. 飞子 flier (reconstructed). 37. 望板 roof boarding. 38. 栱眼壁 bracket socket wall. 39. 牛脊方 ox spine square. For 'square', more appropriate may be 'piece', 'component'

truss in the roof (though hardly one immoveably anchored). The simple scheme suggests an architectural vacuum into which the ornamental devices favoured by Song were soon to be drawn.[28] The Dule-si (Temple of Exclusive Joy) in the Ji-xian of Hebei, dating from 984, with four- and three-step brackets, rises to three storeys. *Ang* are inserted only under the roof eaves (i.e. not under the skirting eaves of the ground storey) and a bracket-supported balustrade surrounds the top storey. Heavy transverse beams devoid of charm build under the roof to the ridge, separated by *tuofeng* of the most jobbing kind. The desire to furnish high space for a huge image has dictated an expansion which the structure hardly warrants, the survival of the hall being apparently owed to plain corner stilts like telegraph poles which have been added, regardless of appearance, at some later critical moment.[29] The Daxiongbao hall of the Fengguo-si in the Yi-xian of Liaoning arose still later in the tenth century. It is remarkable for preserving a bracket system comparable in its cunning to that of the Foguang-si itself.[30]

WOODEN TOWERS

No Tang-date example in wood of the tower which was indispensable to the temple complex is now extant in China.

There can however be no doubt that towers were framed in the manner of their contemporaries which survive in Japan. Stone, used in the earliest time for some memorial pagodas, as described below, was abandoned before the eighth century. Buddhist notables were curiously enamoured of brick as a material, the towers extant from Tang in this material certainly denoting special success in securing official and civic recognition. However skilled the craft of the wooden tower, brick could go higher.

In both wood and brick, towers were built for their appearance alone, evidently raised as a rule over a foundation deposit of real or imitated relics and small images, neglecting entry and habitation. The wooden tower was conceived as a succession of eaves, contracting in diameter only slightly towards the summit; and the spacing of the eaves is reduced upwards, regardless of the utility and convenient access of the storeys so defined. To build wholly in timber required bracketing of at least two-step projection and triple corner arms, and cantilevered support, and so towers of the classic form as it survives in Japan are not likely to have been known in China before the Sui period. The earliest towers extant in Japan are of five eaves storeys, with no accessible floors. That of the Hōryūji, as rebuilt at Nara in 708–714, had originally single *ang* at each

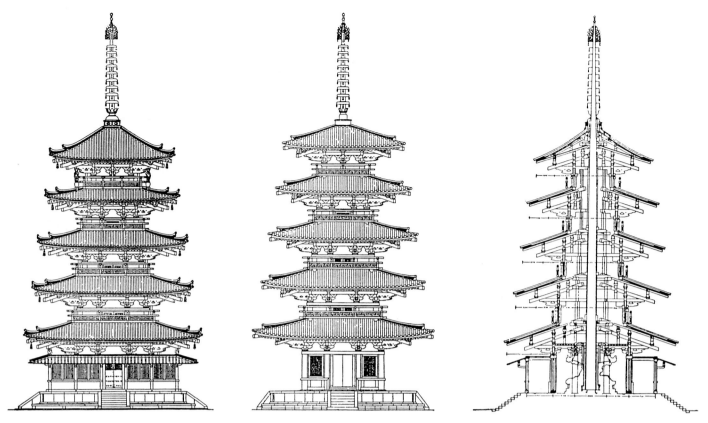

296. Tower of the Hōryūji, Nara, Japan. A.D. 708–714 A: as at present. B: restored to original form. C: the internal framing.

corner, later increased to a pair [296]. The load on the inner ends of the *ang* in each series is carried vertically to the top. Brackets are in one tier and give one-step support on a single arm at two intermediate positions, and at the corners work in three directions, the longer and massive diagonal arm (with 'cloud' undulation along the lower edge) holding the *ang* to furnish a wide second step. Under each series of eaves is a balustrade giving a false impression of an approachable balcony. Such is the coherence of the eaves structure that scarcely any load is transferred to the central mast. This is a single spar: where in some towers the foot of the mast has rotted away the structure still stands firm. The coeval tower of the Kōfukuji has triple tiers of brackets and corner *ang* providing a third step outwards. The Yakushiji tower of 710 alternates wider and narrower eaves in three pairs, dispensing with the false balcony between the members of each pair and so enriching the bracket display.

MEMORIAL PAGODAS

While they copy some superficial detail from wooden buildings, the masonry towers surviving in China are not otherwise influenced by timber-framed equivalents. A group of memorial pagodas of the sixth–eighth centuries are raised in stone on a square base, scarcely rank as *ta* and fulfil a purpose distinct from that of towers related to the temple plan. Their form suggests that they were scaled up from small metal reliquaries rather than inspired by any Indian design. They revert to a tradition present from the second century A.D. in adopting unreal architectural devices, in the

spirit of the elaborately worked funeral pillars placed in pairs before tombs in Sichuan [297]. The Simenta (Four-door Pagoda) attached to the Shentong-si[31] in the Tai mountains of Shandong is dated in a tablet preserved at the temple to the Eastern Wei year 544 [298].[32] Although this date may be questioned, origin in the earlier sixth century seems undeniable; the pagoda stands as the earliest stone building above ground now extant in China, only the Songyue-si brick tower of 523, noticed below, claiming seniority among the pagodas. The Simenta is built of ashlar sandstone one course thick, in shape close to a cube of 7.4-metre side. It is a study in proportions, the doors in round-headed recesses and the grooved lines below the eaves calculated to enhance the height. The eaves are corbelled out by five courses of masonry, and similar corbelling continues to the apex at a 300 slope only a little steeper than that of most wooden buildings. Inside the cell a stone pillar is carved on its four faces with a seated Buddha and flanking Bodhisattvas, and rises as support to the roof.[33] To some extent this pagoda proposes a model for others that were to follow, and its stone corbelling may have inspired rather than copied the brick version. The roof finial is a unique survival, exotic if not quite identifiably Indian, displaying the prescribed nine rings of the *xianglun*, the feature said to imitate an Indian ceremonial parasol. In stone technique nothing appears which is not to be anticipated from the vaulted stone tombs of Han, the tomb here being turned inside out; a surprising austerity has rejected the wood-derived detail which was multiplied in Yungang caves some eighty years earlier. The shape and dimensions of the Simenta were repeated in the Xiuding-si

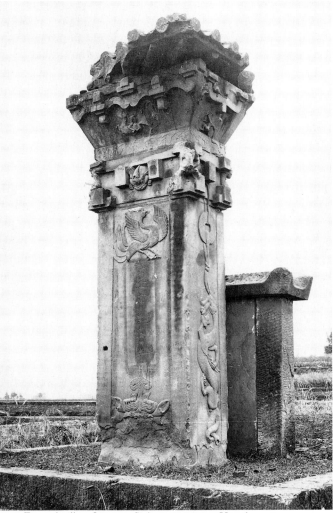

297. Funeral pillar, Qu-sian, Sichuan. A.D. 121. Ht 2.67 metres

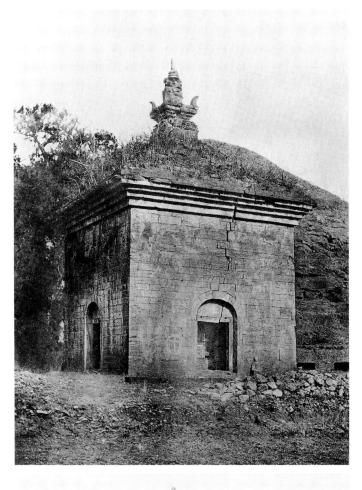

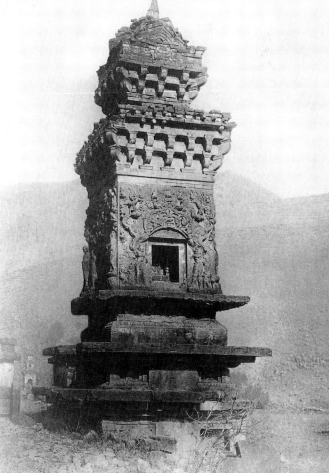

near Anyang in Henan. The shrine was founded in 590 and later given much elaborate ornament. According to some authorities the condition of the buiding as it now survives is owed to the emperor Tai Zong's campaign of Buddhist restoration, and is thus to be dated in the mid-Tang period. But rather it seems that the sculpture and other decoration belongs, if to Tang, then to the very last decades of that period, and more probably to the later tenth century. The sculpture and relief ornament cover the whole of the main façade of the round-headed entrance and of the slender engaged pillars at the corners the skill of the mason is at its finest, in a manner not recorded from other monuments.[34]

The sanctuary pagodas of ashlar masonry built in 711–727 at the Yunju-si (Fang-xian, Hebei) are more simply designed: a square-based cella under a varying number of eaves jutting horizontally. One roof has nine such eaves lines, evidently derived from the *xianglun*; another has seven, and another a single line imitating the edge of tiles. Most of the roofs are crowned by a symbolic stupa, at least one of which rests on eight lotus petals, the rectangular bases with

298. The Simenta, Tai Shan, Shandong. A.D. 544

299. The Longhuta, Licheng-xian, Shandong. Mid-fourth century

peaked corners resembling the like feature on the Simenta.[35] Resort to wooden forms reasserts itself at the so-called Longhuta (Dragon and Tiger Pagoda), an architectural fantasy in stone said to commemorate Lang Gong, founder of the nearby Shentong-si [299]. This monument dates however shortly after Tang, in part marking a transition from Tang to Song style, and evidently built under the influence of the architects of the tenth- and eleventh-century pagodas built in Liao. Its brackets copy no real type, but somewhat resemble those of the brick towers.[36] A polygonal form adopted for tombs and small chapels in the eighth century is represented by the burial pagoda of Jing Cang, seventh patriarch of the Chan sect.[37] Built in brick in 746 and now decaying, it stands at the precinct of the Huishan-si (Temple of Assembled Excellence) in the Song mountains of Henan. As well as the material, the octagonal plan and the blind doors and windows rank this sanctuary with the late-Tang towers. The cella might well form the ground floor of such a tower: an image niche with round head occupies one facet (its equivalent on the opposite side frames an inscribed tablet), the facets at right angles to this have imitations of wooden doors with large rivet heads, and the intermediate facets are decorated with rectangular windows recessed in moulded frames. The angles carry pilasters whose heads are joined by a beam supporting a second eaves beam by inverted-V struts. The circular roof, originally a sub-conical dome and now the most ruinous part, rises through two lines of eaves to a finial of spherical jewel on lotus petals, in all the closest to stupa shape of the surviving sanctuaries and towers.

BRICK TOWERS

The general design of the tower pagodas varies according to the base, square or polygonal, and to the choice of multiple eaves or accessible storeys. The earliest and most remarkable survival is that of the Songyue-si on the western slope of Songyue mountain in Dengfeng-xian, Henan [300].[38] A palace that had been completed here in 509 was replaced by a temple consecrated in 523, the successive works of the Northern Wei emperors Xiao Ming and Xuan Wu. The temple buildings are said to have comprised over a thousand bays. While it is uncertain just how soon after the temple consecration the pagoda was planned and completed, the Indian air of the whole and of some of the ornament, and points of comparison with late-Northern Wei cave-temples suggest that the work was at least well in hand by the fall of the dynasty in 535. Exotic features are the dodecahedral base and the great multiplication of eaves within a curve recalling the Indian *sikhara*. The triple division of the profile – podium, tower and apex – conforms tolerably to the classical *bada/gandi/mastaka* of later Indian temples, as does the contrast of the verticals in the base with the horizontals above. The round-headed recesses which abound at all levels, possibly at first intended to hold images, have an Indian look. Lions *passant* in relief occupying recessed panels between the pillars of diagonal bays are Indian symbols of royalty, absent from the walls of the cave-shrines, but not unrelated to the equally exotic dwarfs and monsters carved in the Gong-xian caves. Only corbelled brick courses

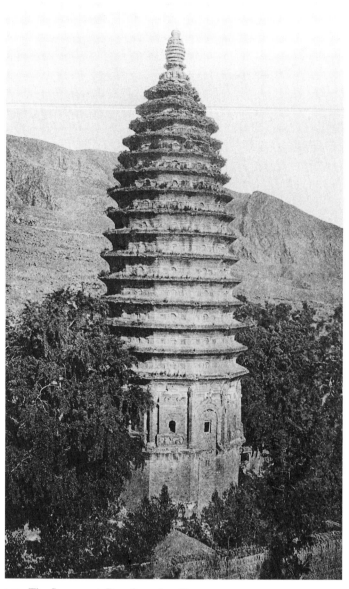

300. The Songyue-si, Dengfeng-xian, Henan. A.D. 523

support the sill at the base of the main floor (i.e. the accessible chamber under the eaves) and the fifteen garlands of eaves above. No imitation of wooden bracketing appears, either because it did not enter into brick architecture at this time or because it was rejected here as unsuited to an indianizing scheme. A similar ideosyncrazy is in the treatment of the tops of the engaged pillars, these passing the zone of simulated eaves beams to terminate in a rounded feature not now explicable. There is no reason to think that the Songyue-si tower was an isolated achievement of Northern Wei architects, although nothing similar now survives. Notions of Indian splendour were about. On returning from a journey in Indian in 519–526 the Buddhist pilgrim Song Yun spoke of king Kanishka's celebrated stupa as rising to a height of seven hundred feet, with thirteen storeys and thirteen gilded copper umbrellas in its *xianglun*.[39]

The next monument takes us to a square-based brick tower which better accords with ancient Chinese ideas of

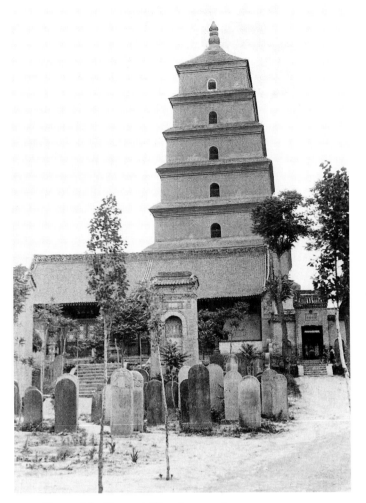

301. Tower of the Dayan-si, Chang'an. A.D. 652

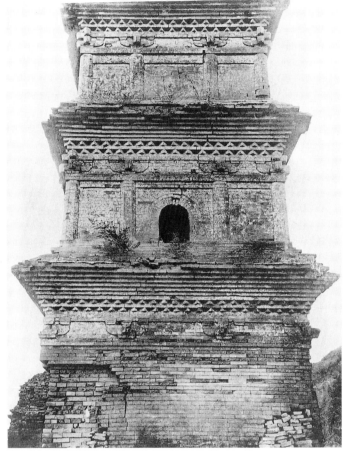

302. Tomb pagoda of Xuan Zang. Song Shan, Henan. Mid-eighth century

ceremonial architecture: the Dayan-si (Great Wild-goose Pagoda) belonging to the Cien-si (Temple of Mercy) at the centre of the newly replanned Tang capital of Chang'an [301].[40] A first tower built in 652 on the instance of the celebrated India-travelling monk Xuan Zang (who chose the name lightly on recalling a bird meat permitted to members of a south-Indian Hinayāna sect) rose through five storeys to 54 metres, on a base of 42-metre side. A refurbishment at the beginning of the 98th century altered these dimensions to 55 metres and 25.4 metres and added a sixth storey, to which was soon joined a seventh. The Dayan-si is a pagoda of accessible storeys, with eaves corbelled out by eighteen courses. The sides are divided into panels by shallow flat pilasters, these reducing from nine at the base to seven at the third storey and five from the fourth storey upwards. No wooden bracketing is imitated, and the panelling of the sides does not proclaim its origin in wooden architecture. The spirit of the tower inherits from the ancient *lingtai*. A single doorway look-out on the south face of each storey perilously lacks a balcony; a central square cavity extending unbroken through the whole height contains a staircase. Such an unadorned mass seems not to speak

for the elegance which poetic tradition confers on the Tang capital.

Xuan Zang's tomb pagoda had been built in 669 at the Xingjiao-si, and there can be little doubt that its shape was taken as a model for the Great Wild-goose Tower [302].[41] Xuan Zang's tower makes fuller use of wooden forms in brick imitation: above the panels of the sides are three 'eaves beams'; over the two pilasters on each side and at the corners are *dougong* with a short projecting arm and triple bearing-blocks, and in the profile a refinement of proportion such as eluded the builders of the larger tower. More typical of the *ta* built in the Xian-fu during the first two decades of the 8th century are the Small Wild-goose Pagoda (*Xiaoyanta*) of 710 at the Jianfu-si and the tower of the Xiangji-si of 712.[42] These have ten close-set storeys, accessible though hardly habitable, and present a profile curving a little in the upper half. The former places two courses of diagonally laid bricks under the corbelling which divides the storeys, but is otherwise plain, while the latter has panelled sides like those of the Great Wild-goose Tower. In storeys and profile these towers return to the design established in the Northern Wei period, while retaining the Xi'an square plan.[43]

The Buddhist Icon: Tang International Style

The title given to the fourth section of this book draws attention to the commerce of ideas westwards and eastwards which distinguished the Tang reigns. The western frontier was more open to trade than ever before, and Korean and Japanese rulers to the east avidly took up Chinese conceptions of art, religion and political thought.[1] Following upon the national unity achieved by the Sui, Chinese power expanded rapidly through the Târim basin, to the farthest points reached by Chinese diplomacy and arms in the Han period. Between 635 and 648 Chinese suzerainty was established over Yarkand, Khotan, Kucha, Kashgar, Karashahr and Turfan. Bukharan ambassadors came to the Tang court in 618 and 626 and continued to bring gifts later in the century. Farghana followed suit in the late 650s, bringing 'tribute' regularly thereafter. Tribute is recorded from Samarqand and Maimargh. So effective was the *pax Sinica* through Central Asia that the Persians appealed to China for help against the Arab invaders, help refused by the emperor Tai Zong (627–649). Pērōz, son of the Sasanian king Yazgard III, came to Chang'an, failed even when supported by a Chinese army to regain his father's throne, took refuge in Tukharistan and ended as a 'military officer of the left' at the Chinese capital.[2] The pretence at diplomatic exchange with the Persian royal house lasted through the opening decades of the eighth century. Meanwhile the Buddhist traffic of travelling priests and iconic models passing through Central Asia by way of the oasis cities was facilitated by the relative stability of the Uighur Turks and continued the propagation of the religion on its customary lines. The implantation of Zoroastrianism and Nestorian Christianity in some of the great Chinese cities was however a direct effect of the Islamic disruption. The latter events are to be associated with immigrants brought by commerce, the majority of whom were Sogdians: from Sogdiana rather than the central plateau of the Sasanian empire came most of the merchants, and thence also the main trade-goods were despatched to China. Sogdian was the lingua franca. The *Wei History* had spoken of the barbarians' trade as concentrated in Samarqand, and from the fifth century onwards Guzang in Gansu had been a main point of arrival. It seems that already by the end of the seventh century Sogdians and Arabs had pressed eastwards to create jointly the great foreign emporium on the Grand Canal at Yangzhou, where in 760 a thousand of the merchants were massacred in communal unrest. Accompanying these events is an Iranian contribution to the art of metropolitan China, further to the older influence present in the Dunhuang and Kizil murals. As before, the painting style and other decorative motifs travelled from Sogdiana and the Central Asian city-states, where Sasanian tradition was still alive after the Arab conquest. The fresh wave of iranianizing style, reaching its height in Tang China during the first half of the eighth century, is documented by a few objects excavated or otherwise preserved in East Asia, but more generally it appears in

Buddhist iconography, and to a less extent also in secular painting.

The Iranian element in Tang art runs counter to all that metropolitan native tradition had instituted in design and colour. In Buddhist painting its effect is threefold: a proliferation of small ornamental units, geometric or floral; a use of near-primary colours set together with little transition; and in figure-work a concentration on the static august image. The influence of the last of these, seen in the late-fifth-century creation of the cross-ankled Bodhisattva, now passed further into the growing Tang cult of Amitâbha, *Amituo*. An Iranian concept contributes to the character of this divinity: '...as lord of "boundless light" he suggests Ahura Mazda. As lord of "boundless life" he bears the same title as Ameretât, one of the six Mazdean Amesha Spentas...'[3] The Dunhuang murals of the Pure Lands (*jingtu*), presided over by Amitâbha or Maitreya, are a glorified version of a Persian royal audience. Light is interpreted in multiple colour as bright as the pigments allow. The added discipline of the Chinese brush produced the International Style of the Tang Buddhist icons, justly so called for its currency through Central Asia, north China, Korea and Japan. A starting point is a style aptly named jewelled from its characteristic diapered components.

TANG INTERNATIONAL STYLE: JEWELLED MOTIFS

Decoration consisting of regular repeats of small geometric figures, usually symmetrical about single or double axes and richly coloured, is applied generally in depicting Buddhist subjects. As they develop these motifs blend gradually into floral figures which retain a hard precision and are coloured in the same contrasting tones, generally of red and green. Even in flower-like versions the motifs of this medallion style, or jewelled style, remain distinct from the Tang floral style proper. Their origin in the Iranian tradition is made very clear by their large part in Sogdian painting of the sixth and seventh centuries.[4] They seem to reflect the currency, through the whole zone of Tang influence, of pattern-books antedating the emergence of the vegetable realism characteristic of the eighth century. Landmarks in the history of the jewelled style and its floral accompaniment can be taken from the painted ceilings of the Dunhuang cave-shrines, where three stages of the development are readily discerned. The lantern-roof raised by corbelled beams and the baldaquin roof, as imitated in paint on many of the Dunhuang cave-shrines, were a prime vehicle for the style (cf. Caves 123, 329, 372).[5] In Cave 257, dated about the middle of the fifth century, the units are strongly geometric, with rectangular panels and repeated stiff contours both in diapers of anonymous figures and in the scrolled plant border, the last a devolved version of the half-palmette used in continuous design at Yungang [303]. In the sixth century, while the

303. Dunhuang Cave 257. Detail of ceiling with jewelled ornament

304. Dunhuang Cave 251. Detail of ceiling with floral and jewelled ornament

Northern Wei spirit persists, an increasing proportion of pseudo-floral motifs is incorporated [304]. By 600 the jewelled motifs in their simplest form are confined to the outer frame; where florets are inserted these are still more akin to the Iranian or Northern Wei type than to the more elaborate jewelled florets that were to follow; but towards the end of the evolution, in the first half of the eighth century, the geometric figures are closer to an organic style of contemporary flower-painting, although colours remain sharply separated rather than blending at the junctions [306, 307]. It is at this point that the themes of the jewelled style are generously adopted into the figural subjects of mural and other icon painting, and are borrowed by metal-worker and potter. The state of the process is least clear in the mid-seventh century. One notes therefore with interest that the jewelled motifs in their primitive form were sufficiently familiar at this time for them to appear on a stoneware tazza from a tomb of 667; and in the Tang *floruit* (the Chinese *sheng-Tang*, 713–765) they feature still in minor ornament, especially on the buckles and pendants of saddlery.[6]

During the first half of the eighth century geometric and floral jewels were commonly used in the minor arts, and accordingly appear in this rôle in icon painting. On silk damask they might appear alone, often in five-colour weave in which beaded and lobed rondels alternate with florets placed at the centre of four symmetrical leaf-sprays of the stiffest sort [308].[7]

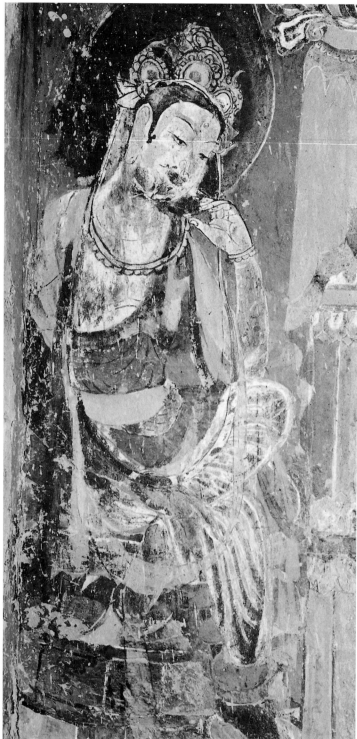

305. Dunhuang Cave 57. Bodhisattva's jewelled headdress. Early Tang.

306, 307. Details of the north wall of Dunhuang Cave 148, showing floral frames and obliquely drawn Bodhisattva headdresses. Middle Tang

308. Fragment of flowered damask from Dunhuang cave 17. Eighth to ninth century. British Museum. Width 8 cm.

Stages in the development of the jewelled style in iconic painting conjugate naturally with the draughtsmanship, as regards particularly the increase of perspective drawing that is to be followed in Dunhuang murals, diagnosed for example in the treatment of the jewelled head-dress of Bodhisattvas.

Jewelled halo:

Sui:	Beaded rondels	Cave 407
Early Tang:	More elaborate geometric divisions	Cave 57
Tang *floruit*:	Floral medallions, some of *ru-i* shape	Cave 103
Middle and late Tang:	The above continued, with added triangles, or replaced by formal lotus petals corresponding to those composing the throne [309].	Cave 184

Jewelled head-dress:

Sui:	Elaborate outlines lacking painted detail.	Caves 402, 407
Early Tang:	Numerous simple cabochons set with pearls, shown slightly oblique as necessary [305].	Caves 57, 123, 220
Tang *floruit*:	Elaborate jewels drawn in full detail, often in oblique view [307].	Caves 172, 445
Middle and late Tang:	As above with still freer perspective drawing [309]	Cave 158

A similar sequence may be constructed from the ornament of image dais and throne, railings and platforms, as they are represented in the *jingtu* compositions from the early Tang and later. In the floruit floral work tends increasingly to oust the geometric motifs, and wholly *organic* floral motifs are dominant in the Middle and late Tang.

TANG INTERNATIONAL STYLE: FLORAL MOTIFS, COLOUR

The best that secular painting could make of floral ornament of this formal kind is seen in such banal decoration as that in Cave 93 of mid-Tang, or in the pseudo-coffering of the vaulted approach to princess Yongtai's tomb of 706; and in the Shōsōin on scores of objects – lacquered trays, foot rules, scripture wrappers – which cannot be much later in date.[8] The fully fleshed floral scroll which escapes from the tyranny of the half-palmette appears rather suddenly, around the turn of the seventh century. A fine example of such a scroll, inhabited by lute-players, is seen in Cave 427 at Dunhuang. It is based upon the peony, which now usurps floral design as much as it invades the poetry of the time. More rarely a flower chain is painted with quite superior accuracy and charm, like the hibiscus in the margin of the Dunhuang silk icon of the Thousand-handed Guanyin preserved in the Delhi Museum, or in the floreate ornament of mandala painting which passed at this time from China to Japan [310].[9]

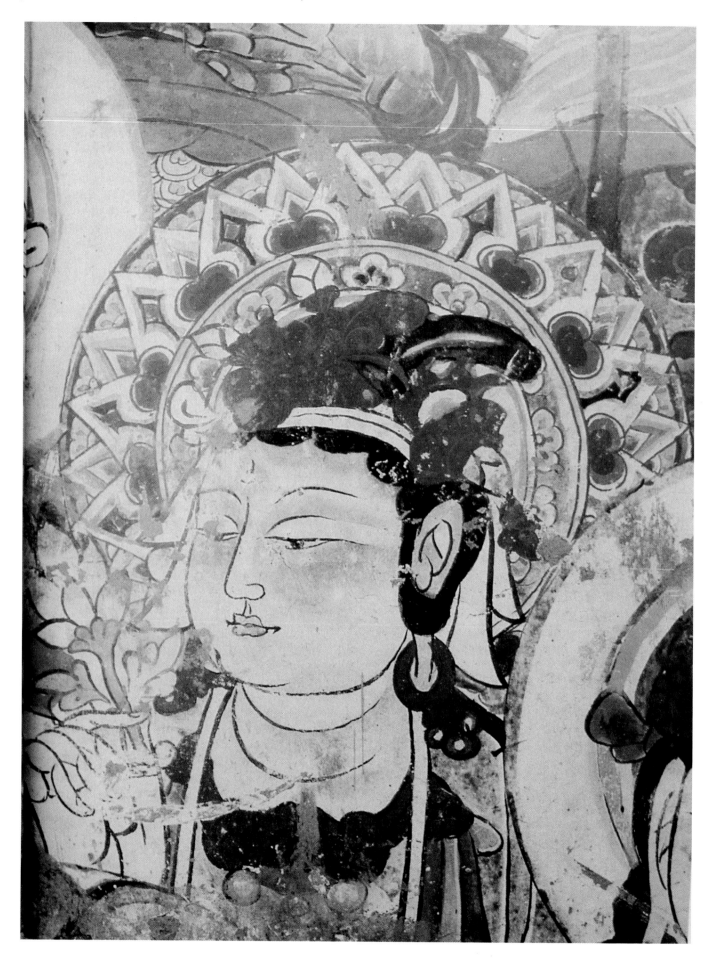

309. (*facing page*) Dunhuang Cave 36. Head of Bodhisattva. Early tenth century

310. Detail of the Taizōkai mandala showing the 'rainbow colours'. Kyōō Gokokuji, Kyoto, Japan. Early ninth century

311. Fragment of a painting on silk: part of the figure of a lokapāla, from Dunhuang Cave 17. Ninth century. British Museum. Height of the fragment 63 cm

Tang International Style in principle arranges the 'rainbow colours' blue, green, red, orange – in bands parallel to the contours of the design. In each band the intensity of the colour decreases from the same margin, left or right as the case may be, to give a precise darker edge and a lighter and softer one. An all but invariable characteristic is that the dark edges define curves, commonly convex to the motif but sometimes concave. When this method of breaking the light falling on a surface is transferred to the folds of garments in icons, only one colour is used, but the shading of the tone and its application against curving lines remain the same [311].

312. Dunhuang Cave 217. Dancer

313. Dunhuang Cave 112. Image array with linear draperies. Mid-Tang

TANG INTERNATIONAL STYLE:
LINEARITY, FIGURES, PERSPECTIVE

In the style of icon painting established in Buddhist ateliers from Turfan to Nara at the opening of the eighth century, a long, gently inflected line, natural to the retentive Chinese brush, is essential and characteristic. The influence of the Chinese brush is detectable from the late seventh century even so far west as the Qumtara Period III murals in the Kucha state. Its line readily diminishes or increases in breadth and its inflexion can suggest the depth of the relief it circumscribes. The effect contrasts with the less pliant line of Sogdian painting, where the renewal of pigment on a harder point denied the possibility of an unbroken line executed by one movement of the artist's arm and hand.[10] From the middle of the seventh century the Chinese line combines with Iranian colouring and ornamental detail to produce the iconic style of Dunhuang, in the cave murals and the contemporary paintings on silk. The flying scarves and draperies of the dancers in Cave 217 are an initial extravaganza in this idiom [312]. Image arrays of the seventh

century make comparatively sober use of it; by mid-Tang flowing lines are close-set to crowd the field, as in Caves 112 and 158, contributing to the illusion of third dimension by overlapping and interveaving [313]. In late Tang the linear pattern is heavier, the pose of figures more static, the treatment betraying fatigue (Caves 138, 196). From this phase the style was inherited by Song artists.[11]

The surface for mural painting was prepared with several layers of reinforced stucco topped by a mixture of kaolin and chalk, and the painting was executed *al secco*. Ultramarine was used in a white-lead matrix, with vermilion, a white pigment made of kaolin, carbon black and a vegetable red.[12] A first design in black line guided the application of colour, and the black line was then renewed over the colour and corrected or refined as necessary. In some work it seems likely that the final version was that of a superior hand, but not by way of *pentimento* as has been supposed. The method used in silk painting was in general the same, although in the best of these icons the discrepancy between the first and the final design is barely noticeable. A number of near-contemporary practice sketches which were among the manuscripts recovered at Dunhuang further clarify the brush technique. Curving lines made by a steady hand positioned on the concave side of the curve predominated in the smaller sub-

jects, larger sweeps required action of the arm, and nowhere appear the hard straight lines found in Sogdian painting. To suggest movement and relief, the line in these sketches varies in width and weight, but in the better silk paintings it is more uniform, an anticipation of the iron-wire line of later secular painters.[13] The subjects of the main icons produced on silk depart little from the mural equivalent, except in occasional refinement. The superior execution of some paintings on silk indicates an exceptional artist. In these colour is more delicately handled, graded tones modelling the form more fully. Examples of the best work in this manner are the Samantabhadra and Manjusrî of the British Museum, unfortunately much damaged,[14] and the Thousand-handed Guanyin of the Delhi Museum from which a detail of the floral frame was instanced above.

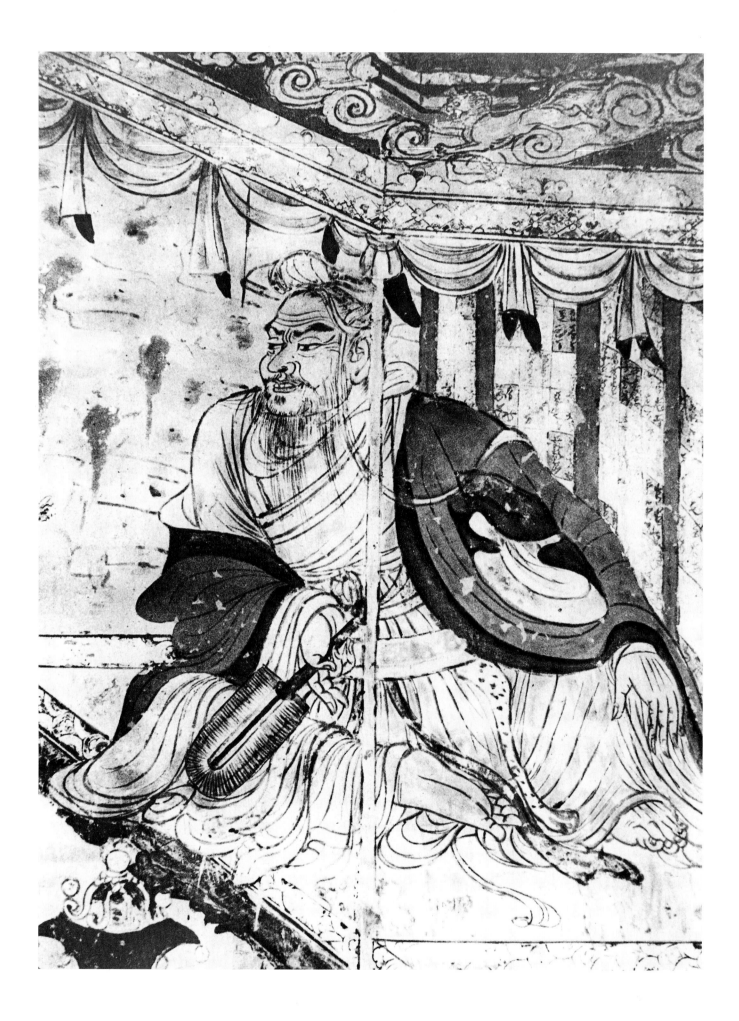

Tang Secular Painting, Figures and Landscape

THE THEORISTS

At this point the material for a history of painting performance seen in surviving monuments, as against theory preserved in literature, becomes perplexing. The detail of murals in the Dunhuang shrines gives a sufficiently vivid impression of one class of non-iconic landscape and figures, in styles one may expect to be related in some degree to metropolitan secular styles. Ninth-century writers on the other hand discuss at length a sophisticated tradition, of figures and landscape, which seems little connected with the Buddhist murals. To confound the matter further, the few paintings on paper and silk which survive as the work of Tang painters (i.e. bear their signatures and in the past have been attributed to them confidently or speculatively) do not fit well with either of these two divisions. The authorship and dating of these paintings have in every case been questioned in recent scholarship, although all of them answer in some measure to the art as Tang authors describe it. Apart from the Buddhist murals, information on Tang practice and theory that is primary and contemporary owes its recording to a reassessment made in the course of mid-ninth-century debate on issues which had faced painters in the previous century. The reassessment aimed at something more than the listing of artists' names and picture titles which had been customary in official records from the Han period onwards.[1] The records of artists and some theoretical writings of former times are included in the Tang texts, with inevitable bias towards the current debate. Contradictory points arise. The view that subjects depicted in earlier times, women and horses for example, now appeared different from reality because they really *were* different, as Zhang Yanyuan believed, hardly accords with the theory of the artist's creative rôle as Zhu Jingxuan would have it. Zhu's theory approaches that of his Northern Song successors: that modes of perception are supplied by the artist's mind, and have no objective existence apart from him. Subjective theory has not yet gone so far in Tang, but already the lasting polarities of Chinese criticism are envisaged, mental image and subjective transformation together with a restraining dose of simple realism.

Zhu Jingxuan and Zhang Yanyuan, both writing in the mid-ninth century, recorded their viewing and collecting of pictures, and compiled biographies. The former professes to speak only of paintings he has seen, and the latter anthologizes older texts to support his contentions. Neither makes an issue of sheer authenticity. Since the fourth century at least, accurate copying had been inculcated as a means of preserving paintings and maintaining artistic skill. There is no reason to doubt that this routine was followed through the Tang period as it was ever after. Many of the paintings now ascribed to Tang artists are likely to be palace work of the tenth century and the Northern Song, made for royal collections in official studios not unlike those which functioned later under the aegis of imperial academies. When a reasonable degree of fidelity is acceptable in copywork of this high order, the modern historian may hazard a wider account of Tang art than the exclusive evidence of irrefutably dated mural painting would allow.

In his *Tangchao minghualu* (Catalogue of Distinguished Painters of the Tang Dynasty), published in 835, Zhu Jingxuan proposes aesthetic values distinct from those of literature and calligraphy, to which his predecessors had mostly adhered.[2] He first keeps to an old theme, the difficulty of giving the illusion of life, but puts it in new terms. The 'slow brush' (*gongbi*, the 'working brush') is to be distinguished from the 'fast brush' (*subi*); meticulous delineation is contrasted with and rated under rapid work. There is here an echo of the Buddhist theory of instantaneous enlightenment. Rapid execution best reveals artistic personality and individual gift, guaranteeing spontaneity; and spontaneity, as a quality long put first in criticism of calligraphy, needs no justification.[3] The painter chosen to be the ideal exponent of the rapid brush is Wu Daozi (Daoyuan), active in the first half of the eighth century, favourite of the emperor Minghuang and subsequently regarded as the greatest of figure painters. He is said (since by convention no artist is allowed absolute originality) to have imitated the line of Lu Tanwei, a visually unreportable painter of the fifth century. The example of Wu Daozi is used by Zhu also to legitimize painting in ink without colour. He further challenges tradition by accepting ink-wash and ink-splash, methods followed apparently by contemporaries of Wu Daozi if not by that master himself.[4] Work in wash and splash is to be viewed from a distance, Zhu's concern being with the total vision of a scene, where fault might be found in realistic detail which disregards the natural capacity of the viewer's eye.

Zhang Yanyuan's *Lidai minghuaji* (Record of Noted Painters of All Dynasties) was finished in 847.[5] It includes an essay by Zong Bing (375–443) in which an aspect of Buddhist pantheism entertained by the poet Xie Lingyun (395–433) is combined with Confucian idealism in the exaltation of landscape painting: the contemplation of landscape is compared with the visionary experience of a meditant, the artist's task being to capture the divine reason (*shenli*) which is present in nature.[6] Other early texts quoted by Zhang better serve his more pictorial purpose, the chief among them the six maxims included in the *Guhua pinlu* (A Record of the Classification of Painters of Former Times) of Xie He (*fl. ca* 500). The maxims are each conveyed in four characters, and the question was debated whether the four should be taken to form a single compound expression, or should be read as a double-character expression followed by a gloss. The latter is undoubtedly correct.[7] Still more remarkable is the view taken by commentators ancient and

314. Dunhuang Cave 103. Vimalakīrti

modern that the six maxims all embody elusive aesthetic principles, when the latter four at least are so directly practical. It seems that Xie He was rewording some current precepts when he wrote:

i. Resonance of spirit, that is, giving the impulse of life.
ii. Bone structure, that is, using the brush.
iii. Fitting the object, that is, representing the shape.
iv. Suiting the type, that is, applying colour.
v. Building, that is, fixing positions.
vi. Transmitting, that is, copying.

Both the painter Gu Kaizhi (ca 344–406), writing his *Lun hua* (On Painting),[8] and Zhang Yanyuan himself seek psychological meaning in the first two maxims. 'Bone structure' (*gufa*), originally intended for horses or their representation, becomes a quality of drawing involving strength and conviction. Through the eighth-century advocacy of linear style it was inevitably identified with line. To Gu Kaizhi, concerned equally with portraiture and landscape, 'resonance of spirit' (*qiyun*) seems to mean no more than the illusion of life. By Zhang Yanyuan and his contemporaries this precept is joined to *li yi* ('establishing the idea'), a concept derived from the criticism of calligraphy, with a glance also at the 'transferring thought' (*qianxiang*) of Gu Kaizhi. In sum the artist, uniquely qualified to reveal the essence of existence – the 'truth' (*zhen*) of nature in Zhu Jingxuan's parlance – must identify himself constructively with the spiritual qualities inherent in his surroundings.

PORTRAITURE AND FIGURE PAINTING

Portraiture was a chief occupation of Tang artists, but apart from appraisal of Wu Daozi's line and speed, Tang comment on this branch of painting only repeats the three-centuries-old apophthegms of Gu Kaizhi.[9] The latter held portraiture to be the most difficult art, and criticized finished works for their lack of the 'spirit of life', and for not 'giving exhaustively the very best' even when they were beautiful. The representation of the eye was to be all-important, a portrait being begun 'from the neck up'; and in speaking of the importance of relative size and spacing in groups of figures Gu shows an awareness of spatial illusion which he does not explicitly address. There are to be adjuncts to the figure scene – bamboos, trees, rocks – which should be shown in lighter colours.

SINGLE FIGURES

The spontaneity and fluency of an eighth-century version of Vimalakīrti in Cave 103 at Dunhuang sets it apart from other contemporary work in the cave-shrines [314]. The keen-eyed debater listens intently and is about to speak; a mental attitude takes the place of the physical movement once deemed essential to the illusion of life. This linear performance bids fair to represent in essentials if not in refinement the secular portraiture of mid-Tang. Its style became a lasting department of Chinese painting. The stone engraving of 1025 showing *Confucius and his disciples* is in the same idiom.[10] To the latter, and to stone engravings of Guanyin, the name of Wu Daozi has traditionally been attached. The Guanyin type standing in three-quarter view initiated a convention, independent of the mural icons, which retains its force into the Song period: the multiple lines are lazily and unnecessarily inflected in direction and breadth, for sweetness above all, and there is no suggestion of Wu Daozi's swift brush. Nothing survives of the whirlwind performance of the Wu legend. The most that can be said is that a linear style, without colour, whose fortunes were great in the Northern Song, had its roots in the eighth century, when it was thought to derive from Wu Daozi and accorded with some theoretical axioms of that time. An outstanding handscroll fictitiously attributed to Wu Daozi is *The emperor at his son's departure* of the Osaka Museum: here the realism of the style could go no farther, the alert figures of each group are closely related in an intelligible space, the ground plane – not drawn – is conceived to slope little upwards and the view-point is raised [315].[11] The Abe collection's *Portrait of the scholar Fu Sheng*, bearing an improbable attribution to the poet-landscapist Wang Wei (699–759), has points of comparison with the Dunhuang Vimalakīrti and apart from the murals the strongest claim to Tang date of the surviving figure paintings, as it is certainly first in quality, a heartfelt portrayal of a legendary personality [316]. In the delicate brushwork mere linear rhythm is not prominent, the uniform ink line unobtrusive; a hint of archaistic exaggeration of mid-Tang perspective possibly indicates the ninth century. Its purplishbrowns and blues and tones of red set the standard for the coloured figural tradition which extends from the late Tang.

FIGURE GROUPS

Handscrolls portraying persons engaged in activity are attributed to Yan Liben (*fl.* 640–680) and Zhou Fang (*fl.* 780–810). The former was a contemporary of Weichi Yiseng, the Khotan painter who came to China from Central Asia in 627 at the bidding of the emperor Tai Zong and became famous for the illusory realism of his flower painting in coloured 'relief style'. Yan Liben, court artist to the same emperor, had general duties in painting, architecture and interior decoration. A century later Zhou Fang enjoyed the patronage of Dai Zong and succeeded Wu Daozi as painter of temples. The work of Yan Liben and Zhou Fang initiated the imperial custom of recording scenes of palace life, the former acquiring a particular reputation for portraying the foreign tribute-bearers who mark Chinese ascendancy.[12] The styles of these two masters, and that of their late-tenth-century imitator Zhou Wenju, are no longer distinguishable among surviving handscrolls, all of which are likely to have been produced or copied, at the earliest, in the tenth–eleventh centuries. The scrolls are painted on silk in strictly uniform and fine ink-line, mostly with light colour. The attached titles point their character as entertainment for long-waiting aspirants to imperial audience:

i. *Playing music.* Ladies grouped around the seated instrumentalist and some separate figures apparently dancing ('Weichi Yiseng', Villa I Tatti collection).
ii. *Ladies playing double sixes.* Two ladies play, two stand close to them and whisper together, two male

315. Detail of *The empreor at his son's departure*, a painting fictitiously attributed to Wu Daozi. Museum of Art, Osaka

316. *Portrait of the scholar Fu Sheng*. Museum of Art, Osaka. Ninth–tenth century

317. *Ladies playing double sixes.* Freer Gallery of Art, Washington. 30.7 by 48 cm

attendants stand at a respectful distance on one side and two joking and gesticulating girls on the other ('Zhou Fang', Freer Gallery) [317].

iii. *Women and infants playing.* Four women, seated and standing each with a child, placed irregularly in the field of the picture ('Zhou Fang', Metropolitan Museum).

iv. *King Liyu and his brothers playing weiqi.* The four members of the chess party relate very naturally together; the king (the last ruler of the Southern Tang dynasty) faces the viewer directly and the other three are shown from a viewpoint raised a little; the painted screen behind the group figures an old man seated with four women attending, these also in the Zhou Fang style ('Zhou Wenju', Freer Gallery) [318].

v. *Scholars of the Northern Qi dynasty collating classical texts.* The most elaborate of the compositions in this class. Four scholars, conversing or absorbed in text, sit on a wide bench, another sits apart, all attended by seven females and six males, three of the latter grooms holding two horses ('Yan Liben', Boston Museum) [319].

vi. *Portraits of the emperors.* Thirteen emperors (Han to Sui dynasties), some parading and some seated, respectively with two male or two female attendants, each a separate subject, the subordinate figures smaller. All the figures are in rigid three-quarter view, the emperors' features delicately drawn but very plainly stereotyped ('Yan Liben', Boston Museum).

vii. *A concert at court.* Ten seated and two standing women around a table with wine bowl, dipper and cups; four instrumentalists with lute, flute, *qin, sheng.* The perspective is such that the farthest of the women, towards whom the table expands, are level with the viewer's eye, the others below ('Zhou Wenju', National Palace Museum, Taipei).

viii. *Ladies preparing newly woven silk.* Three older women in garments meticulously painted, and two girls,

318. *King Liyu and his brother playing weiqi.* Freer Gallery of Art, Washington. 31.3 by 50 cm

319. *Scholars of the Northern Qi collating classical texts.* Museum of Fine Arts, Boston. 27.6 cm by 1.14 metres

along the length of silk which, held taut, determines their placing and stance; the colours unusually varied: light blue, pink, light purple and brown ('after Zhang Xuan', a copy credited to the emperor Huizong of the early twelfth century, Boston Museum). Cf. the similarly attributed *Emperor Ming Huang playing a flute, NPM 300 pl. 15).

ix. *Lady Guo and her sisters setting out on horseback.* Four women, one carrying a child, and one male attendant; notable are the shading and veining of the horses' bodies, and the detail of their embroidered saddle-cloths ('after Zhang Xuan', a copy credited to Li Gonglin, *ca* 1100) [320].

x. *Woman seated at an embroidery frame.* A single subject sitting idle and pensive before a large frame drawn in exact Tang perspective, i.e. from a raised view-point with retreating parallel edges shown slightly expanding ('Zhou Fang', but a Ming-date exercise in the manner. Freer Gallery).

xi. *Wanshan shinütu* (Round-fan painting of beautiful women). Two women and a girl seated at a large embroidery frame; to the left another seated woman turns her back and looks away ('Zhou Fang', Beijing Palace Museum).[13]

xii. *Zanhua shinütu* (Beautiful women with flowered hairpins). ('Zhou Fang', Shenyang Museum).[14]

xiii. *A musical party of the court ladies.* ('Zhang Xuan', The Fogg Art Museum).

So uniform is the convention observed in these works that no change in techique and no passage of time can be asserted among the first nine and the last four in the list, and the tenth is to be dated so much later on other grounds. The hard outlines and the colours confined within them follow a fixed rule. Pattern on textile is painted across the folds in the Dunhuang manner. Two areas of experiment appear: the disposition of the figures in space, and the attention the participants direct to each other, both tending to unify the scene. The scholars, and still more the chess players,

serve the second purpose [319, 320]. If progress in representing space is looked for, again it is the same two subjects that excel the others, but by so little that no conclusion on change in studio style seems possible. Detail of costume and toilette is of manifest importance – the antiquarian interest of the artists matches that of the modern viewer. The Confucian moral concern which had informed all figurative and narrative painting hitherto has quite vanished, a comment of a kind on the ambiance of the new patronage when this moved with the imperial court from Chang'an to Loyang and Nanjing.[15] While post-Tang dates are assigned by all authorities to these paintings, the origin of the linear figure style which they refine upon is readily traced archaeologically to the early eighth century. The male and female servants engraved in line on stone coffin slabs in the tomb of the princess Yongtai (*ob.* 706) represent the best of an artisan tradition in tomb embellishment – a tradition which one surmises to stand in some relation to the sophisticated art of the period [321].[16] The painted figures in prince Yide's tomb of 710, crowded monotonously as servants and soldiers,[17] inaugurate the patrician theme of subordinates

320. Detail of scroll of *Lady Guo and her sisters setting out on horseback.* National Palace Museum, Taipei. Width of the scroll 33.6 cm

321. Ink impression of a stone-engraved figure in the tomb of princess Yongtai. Early eighth century. About lifesize

322. Figures painted on a lacquered box. Early sixth century. Height of the panel about 80 cm

suitably employed, but the stylistic lineage is found in humbler murals such as those of the Lou Rui tomb of *ca* 570 described above. There is resort to similar figure schemes in decorating lacquer, perhaps at the lowest artisanal level, sometimes in action excluded by palace decorum – swinging along with the sedan chair, putting cushions for noble posteriors – in this case on a box of early-sixth-century date [322].[18] But for success in seizing lively action and keen facial expression, through rapid and economic painting, all of this is eclipsed by the lay figures incidental to mural compositions at Dunhuang. One need only glance at some minor scenes of walls dating from the early eighth to late ninth century (e.g. cattle in a rice field in Cave 148 [323], the groups in a miracle scene in Cave 12, riders and scattered bystanders [324], and a butcher in his shop in Cave 85, the mourners of the Buddha in Cave 158) to be convinced of the existence of a genre style which must have had wide currency. How such artisan painting related to the figure painting of contemporary sophisticates can only be guessed, but it bears the hint of something more expressive achieved by secular painters than is found in the post-Tang copywork in which the work of these artists is mirrored.

A contrast to the fashion of ornamental courtly figures is presented by the most celebrated work of Tang ancestry: the British Museum's handscroll painted in fine black line and light colour on silk, 'Admonitions of the instructress to the court ladies' (*Nüshizhen tuzhuan*). A hypothetical original has long been credited to Gu Kaizhi, modern scholars hesitating

323. (*facing page, above*) Dunhuang Cave 148. Cattle in the rice-field, a scene illustrating the Baoenjing (sūtra on requiting blessings).

324. (*facing page, below*) Dunhuang Cave 12. Bystanders at the scene of a miracle in Amitābha's Pure Land

325. The Admonitions scroll: man and woman in converse seated on a bed. British Museum. The entire scroll 19.5 cm by 3.47 metres

between the tenth and the earlier eleventh century in dating the copy. The Confucian motivation and the style which flows therefrom set this scroll emphatically apart from the Zhang Xuan/Zhou Fang school. Nine scenes illustrate an essay written by Zhang Hua (232–300) for the edification of the imperial harem. Quotations placed with each scene form the continuous text of the second half of the essay:[19]

i. An opening scene, which lacks its text, presents Lady Feng, concubine of Yuan Di of Han, interposing herself between the emperor and an escaped bear. The emperor sits on a stool and cries in alarm, two girls flee [327].

ii. The Han emperor Cheng Di sits in a litter guarded by 'strong men' (lishi); Lady Ban Jieyu, whom Zhao Feiyan has slandered, walks speaking as the emperor listens, but refuses to join him in the litter: 'should he not cherish her if (as emperor) he is responsible for small matters as well as great ones?' [326].

iii. A precipitous mountain; on the right a flying crow stands for the sun, on the left the moon is symbolized by a hare pounding simples; on the left an archer of disproportionate size kneels to shoot an arrow at the mountain: 'the Dao however mighty does not kill, the sun rises to the zenith then declines, the moon waxes then wanes, greatness is like a heap of dust, fortunes change like the snap of a cross-bow trigger' [328].

iv. A lady at a mirror paints eyebrows on her forehead, and a maid combs a lady's hair: 'people know how to trim their looks, but how much better to adorn their nature. Failing this, woe to society'.

v. Man and woman seated within a screened bed, 'his dictum is good for a thousand leagues, but if it is unjust, it will be questioned under the blanket' [325].

vi. A bearded man and numerous children; a lady offers a child a toy, a young man reads a scroll, a child's hair is combed; the text dwells on clear and modest speech, on vicissitude, and bids thought on multiplying progeny.

vii. Man and woman converse as the man turns away: 'do not welcome the importunate, do not cherish the self-centered . . . conceit of beauty, adornment of the person, detestable to the cultivated mind [junzi] are causes of kindness bound and broken'.

viii. A lady kneels humbly: 'restraint of one's pride, delicacy in one's thinking, this brings happiness'.

ix. A lady stands writing on a tablet, two others stand before her exchanging glances and emphasizing her words by hand gestures: 'thus has the instructress, charged with admonition, made bold to address the ladies of the harem'.

The high moral theme called for a style which, if not the

326. The Admonitions scroll: *Emperor Cheng Di and Lady Ban Jieyu*. British Museum

327. The Admonitions scroll: *Lady Feng and the bear*. British Museum

328. The Admonitions scroll: *Mountain and archer*. British Museum

班婕有辭割歡同輦夫豈不懷防微慮遠

班婕有辭割歡同輦夫豈不懷防微慮遠

道罔隆而不殺物無盛而不衰日中則昃月滿則微崇猶塵積替若駭機

329. Arhat. Imperial Household Collection, National Museum, Tokyo. Tenth–eleventh century

painting (*baimiao*), to which Tang work of the Admonitions class gave birth. In the use of extended scarves and ribbons there is a point of contact with a Buddhist style of dancers and flying genii adopted from *ca* 700.[20] The effect is to make more palpable the space in which the figures stand and move, although of perspective device there is very little. The slanting presentation of scene 5, a raised view-point falling on rectangular lines of recession enclosing an intimate scene, is typical of a method which can hardly have antedated Tang, one which passed to Japan with the general Chinese influence of the eighth century and was there revived in later Yamato school painting. The relations of persons in posture and line of sight is handled with great ease, and the lack of a painted floor line causes no hindrance. But the mutual relations of persons, other than the moral stance of scenes 2 and 8, are less well handled than is the case in some decorative painting, and the crowd of scene 6 is difficult to disentangle. The use of stereotypes is verified by the replication of the figure of Lady Feng in scene 1 as the figure of the Fairy of the River Luo appearing in the landscape subject discussed below. Symbol predominates in scene 3, with its spatially inexplicable archer and mountain. In a few garments and scarves there is a little shaded modelling, a detail which was seized upon and exaggerated by some later imitators of the Admonitions style. In all, these features vindicate the importance that has been given to the scroll as a compendium of Tang mannerism, whatever the earlier origin of each detail.

Paintings of Buddhist subjects conspicuously join the repertoire of professional lay painters from the early eighth century. A tradition to which this work gave rise remains apart from the iconic painting proper, although commissions for fashionable versions of the Guanyin, and for a new line in expressionist and even grotesque evocations of the arhat character, must have come from temple as much as laity. Some of these paintings rank with the decorative figure work, such as the Freer Gallery's *Avalokitesvara with kundika and willow branch*, attributed to Yan Liben; but the most productive convention was that credited to Guan Xiu (832–912), whose style is related in part to that of the Admonitions scroll. Attributions of these paintings are very loose, any old-style arhat picture seeming to qualify. Traditional attributions included an arhat in the Freer Gallery painted with latter-day fulness which avoids the grotesque; a red-ink rubbing from a stone engraving, in the Royal Ontario Museum, with an antic knarled face answering to the linearly knarled tree against which the arhat sits, must record an earlier acceptance of the style. The true Guan Xiu manner is however most likely to be that seen in silk paintings of the complete series of the sixteen arhats preserved in the Japanese imperial household [329]. The rocks on which the worthies sit somewhat resemble a landscape convention that was adopted in the eighth-century Buddhist murals; the treatment of robes and musculature of the breast appears to be a simplified version of the colour-banding of the International iconic style, a single colour being shaded off on the side of each ink line, with similar disregard of the direction of light and of detailed relief. These pictures have the best claim to a date in the tenth or eleventh century, and to represent a legacy of Tang professional painting.

invention of Gu Kaizhi himself, connects in its origin with the pre-Tang tradition of the early sixth-century coffin engravings. The slender females with elongated faces give the Admonitions scroll an archaic air which Tang connoisseurs must have perceived and encouraged. The taut line enclosing subordinate colour, and the resolute poses interpreting the moral point, create drama without resort to overt physical demonstration. The combination was never quite repeated in the long sequel of uncoloured black-line

LANDSCAPE

There are three categories of landscape painting to be distinguished under the Tang: a complex of Buddhist conventions; landscape framing narrative; a distant and lofty view of mountains. Only the last, the least well documented under Tang, connects directly with the classical high mountain established as a unique theme in the following Five Dynasties period (907–960). Most of the landscape detail included in the Dunhuang murals, shapes referable in part to east-China schemes that had evolved continuously from Han, constitute a Buddhist tradition governed by its own precepts.[21] The simplest formula, a regular row of sugar-loaf hills, is foreign to the Gandhāran and Iranian styles whose influence was felt at Dunhuang, but occurs in China on Szechuan tomb-tiles of the second century. Terrestrial and celestial versions of the early-sixth-century hunting scene employ this method, huntsmen and wild animals leaping through the serrated topography, as in Cave 249 at Dunhuang. Hills so configured surround the cave-niches of meditating Bodhisattvas in Cave 285, and in Cave 257 they form the background to the successive scenes of the Deer King *jātaka*. Placed obliquely, the line of hills betokens spatial recession. An undulating profile on one side, interior parallel contours, alternating colour and interior coloured bands, are further details which appear archaistic in other Chinese contexts. A Buddhist device appearing to run counter to contemporary secular notions of landscape is the patterned scheme of nature, a dense arrangement of rocks, trees or leaves, which accompanies such iconic themes as the Meditating Bodhisattva, the Buddha visiting Indra at the Indrasaila cave, and the meditants and 'spirit kings' as depicted at the base of the Trübner stele. Such compact masses of trees and rocks echo Indian, Gandharan, practice, for even in the most crowded scenes the Chinese artist preferred some spacing, whether or not this contributed to depth-perspective. The crowding of natural forms is allied to the adoption of conventional shapes for the components. In Indian lore a particular leaf might denote a sacred person, as when the Seven Buddhas of the Past are labelled each with his appropriate tree. Of the seven or eight leaf-forms distinguished in India, only three were copied in the east: *pipal* or Bodhi tree (*ficus religiosa*), under which Sâkyamuni achieved enlightenment; the *sāla*, under which he was born and died – this represented by unspecific fronds – and the dragon-flower tree, *nāgapushpa* (*longhua*), which was multiplied in the east as the emblem of Maitreya.[22] In the Dunhuang murals a cluster of bushy-topped trees might be compressed into a single plane and a single patch of pigment. It follows that two trends in the Buddhist landscape match similar tendencies in the secular draughtsmanship: the reduction of small elements to a fixed repeated shape, and the recognition that the effect of distance required small items to be blended together. But gradually, even in strict iconic subjects, the Chinese brush is manifested in the conventional detail of Buddhist mural painting, just as its character is asserted by linear figure design in the approach to the International Style. The stages in this process signify as much for secular as for Buddhist tradition:

i. By the beginning of the sixth century the *nāgapuspa* and *sāla* leaves join in clumps in landscape which lacks immediate cult reference, and the same shape might represent a mass of foliage or a cloud (cf. detail of the Sudāna *jātaka* mural in Dunhuang Cave 428: mid-sixth century; detail of mountain and clouds in Dunhuang Cave 285: mid-sixth century).

ii. In the late seventh and the eighth centuries this practice persists, but now the tree-branches are made clearer and filled with graded ink wash (cf. trees in landscape on the south wall of Dunhuang Cave 209, and distant trees on the Lute Landscape, Shōsōin).

iii. A tree of angular contour and calligraphic detail, reflecting the movement of the Chinese brush, stands at the head of tree forms which were to evolve through the history of classical landscape (cf. the landscape attributed to Gu Kaizhi; the Ingakyō scroll landscapes, Japan).

Landscape as the setting of the *jātaka* narrative indispensable to Buddhism naturally tended to the archaic. After the sixth century however no elaborate *jātaka* sequences seem to have been attempted, and long scrolls of sequential events were never to be frequent in secular painting. The development of the type, with its symbolic treatment of spatial design, ceased as the spatial devices of eighth-century secular painting came to be generally accepted. The change was towards a new realism of mountain and plain, made possible by the adoption of a regular and consistent linear system which made more explicit the illusion of spatial recession, and by a higher order of verisimilitude in rocks and plants.[23] Nearly the whole of the contemporary evidence for this change is furnished by glimpses of mural detail at Dunhuang. One such detail, in Cave 172 (mid-eighth century), occurs over the heads of Manjusrî and his companions: through a flat plain stretching to a distant horizon a zig-zag river diminishes in width until it disappears [330]. The bushy-topped trees and boxed triangular hills spread on the plain follow the old formula. Much more ambitious is the contemporary representation in Cave 217 of *The Gate of the Illusion City* as described in the Lotus Sūtra [331].[24] Here the boxed hills are more curvilinear and placed irregularly to suggest the varying routes taken by travellers moving

330. Dunhuang Cave 172. River landscape

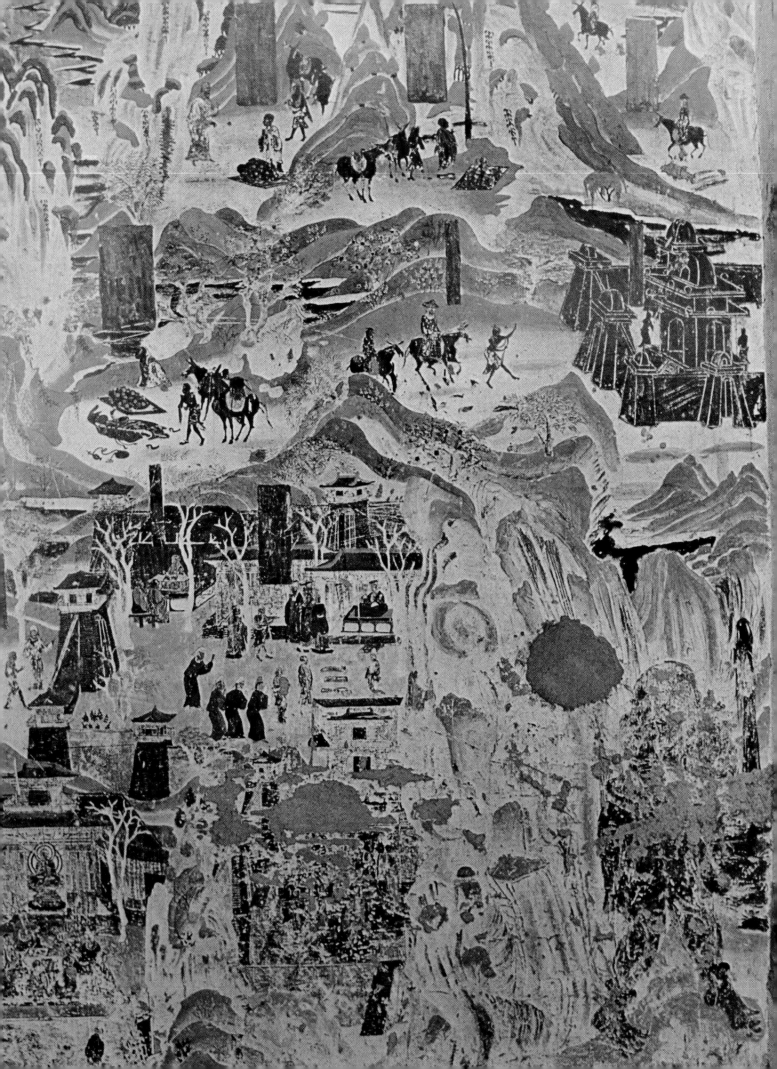

332. Reconstruction by Nakamura Shigeo of a landscape described by Gu Kaizhi

in the valleys; the view-point is high and perspective reduction is limited to the vanishing river on the left of the composition, people and horses remaining the same wherever they are placed. The lower half of the picture is filled with an aerial view of a fortified enclosure in which an official appears to sit in audience. The majesty of mountain and distance is not the subject of the composition.

There can be little doubt, despite the paucity of contemporary evidence of unassailable date, that landscape art devoted to impressions of towering crag and misty distance, with little of explicit narrative content, existed in the Tang period. Earlier literature, especially Gu Kaizhi's *Memoir on Painting Cloud Terrace Mountain* (*Hua Yuntaishan ji*), treats of persons acting in the natural scene, and not placed as bucolic addenda; nor, as in the parlance of later critics, does landscape in Gu's view qualify for *sheng dong*, a term absent from his essay [332]. But in the setting of an exploit by the Daoist adept Zhang Daoling (who threw himself over a cliff to be lifted magically to safety), there is much that is relevant to form and to psychology of perception as they combine in painted landscape in the decades immediately following Tang:

The mountain is to be shown with a broad face to the viewer and there is a darker space behind it. Clouds, issuing from the east, cross it in the west. A clear sky, and sky at the top and water at the bottom of the picture correspond, all being painted in light blue colour. If the sun is shown departing westward from the mountain, the mutual spacing of the elements of the picture can be shown with increasing detail from the east end of the composition. On the other hand, in a position somewhat below the middle of the picture, five or six passages of purple rock resembling solid clouds envelop the ridges and appear to mount them like dragons... while ridges are multiplied beneath. The beholder's eye soars upward and is held there... On the western face of the precipice are beetling crags... Generally the scale of the figures should show them about three-quarters of an inch when seated, painted in a miniaturist style in bright colour, for it is just this treatment that will make the mountain look high and the human figures distant. On the east side towards the middle is a sheer cliff, cinnabar red and

331. Dunhuang Cave 217. *The City of Illusion*

jutting, precipitous and black, with a single pine-tree on top. The Master [i.e. Zhang Daoling] looks towards a cliff that is turned into a ravine whose sides may be close, so that between its walls is created an atmosphere both mysterious and divine. Here is a place for immortal spirits [i.e. Zhang's disciples] to dwell; room should be made for them to stand together. The next peak can be made to resemble a pavilion rising in purple rock, like the left terminal tower of a great gateway, lofty and dark, connecting to the west with the Cloud Terrace and serving to indicate the path to it. The gate-tower peak on the left of the path rises from a crag below which is empty space.

Allowing that some aspects of composition here described are no more than is found in mural painting of the Northern Wei period, and that the absence of any reference to brushwork and linearity seems to preclude insertions of seventh- or eighth-century date, much of the contents of the essay astonishes both by its anticipation of tenth-century landscape style and by its failure to find confirmation in surviving pre-Tang work. It is therefore not surprising that the fifth-century authenticity of the text has been questioned, and that a conservative view of it should accept the possibility of minor addition and substitution that bring it so mysteriously into line with Tang thinking. Noticeable as latter-day considerations are the interest in tone and colour, and (in a passage following what is translated here) mention of streams disappearing into depths of distance. One is reminded of Zhu Jingxuan's 'rising to the utmost height', 'marvellous depth', 'clouds and rain, dark and shadow'; while the mystery which is to be invoked clings to landscape itself rather than to religious association in the manner of Buddhist quietism. It is curious that the description speaks of western and northern faces of the mountain, the viewer looking south, which might indicate some obliquity of the presentation, the division of the subject into three parts implying a frame greater in width than height.

The relevance of Gu Kaizhi's *Memoir* to Tang practice is demonstrated at a number of points in the fragments of eighth-century mural landscape already described. Fuller confirmation of this affinity is offered by comparison with unique documents: the scenes decorating a lute and a silver box preserved in the Shōsōin, memorial storehouse of the Japanese emperor Shōmu, objects of dates hardly much anterior to the emperor's death in 749.[25] One lute picture, executed in lacquer pigment in browns, red, green and black, shows large figures of 'barbarians' riding an elephant in the immediate foreground, backed by the view of a valley contained between vertical cliffs retreating to a far horizon [333]. The implied eye-line of the viewer varies: we are opposite the riders but high above the valley floor, seeing Zhang Yanyuan's 'level distance as far as the eye reaches'. Birds fly up the valley in a string diminishing in size; the indented sides of the cliffs are defined in line and shaded wash, forming many 'ridges'; disproportionately large tree-fronds of conventional shapes fill the middle ground, others crowning distant cliff-tops are smaller and blend together.

The conformity of this composition with Gu Kaizhi's receipt need not be stressed, nor the advance it marks on any other examples of Tang landscape which have been

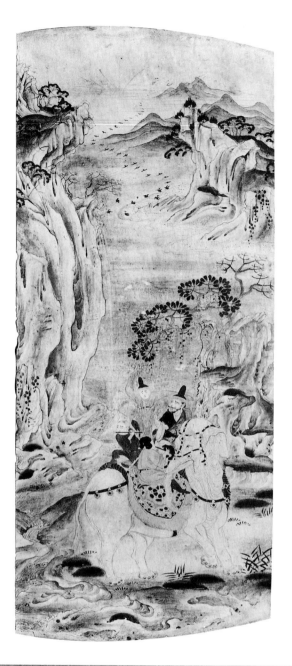

cited. The other picture on the belly of the lute is a hunting scene, structured on approximately the same principle, with a mighty beetling cliff, but giving conspicuous place to huntsmen, mounted and on foot, all of about the same size, occupying the foreground and the middle ground. Underlying the richly pigmented surface of these paintings is a firm linear structure not unlike that of the mountain in the third scene of the Admonitions scroll, where peaked crags lean against each other towards the summit, with transverse bands connecting them that are either ledge-paths or wisps of cloud, while fringes of small trees reinforce the main outlines. If the lute pictures may be taken to represent the faithful use made by craftsmen of a landscape style prevalent in the mid-eighth century, the scene painted on the silver box is ornamental fantasy of an individual kind: crags, very freely drawn in line with wash shading, bend their heads over branching valleys, cavorting around a space whose existence is confirmed by flights of birds, the viewer imagined high above all of this. Spiralled linear parcels of cloud are an archaic touch absent from the lute pictures.

A painting on silk in the National Palace Museum, Taipei, *Emperor Ming Huang's journey to Shu*, attributed to Li Zhaodao (630–730) and intended to demonstrate Tang landscape style at its grandest, is an archaistic exercise of a high order belonging probably to the eleventh century. It has been built with the *Yuntaishan* description in mind, reproducing the vertical peaks in tripartite division, the multiple ridges, oblique crags and unifying horizontal clouds of that essay; its trees however are more realistic than any of assured Tang date, and the horsemen wending their way through the ravines along many paths are a new feature. No distant view is attempted beyond the glimpse of rippled water, an unprecedented adjunct, in the slit of the main gorge.[26] *The Travellers in a mountain pass* wears a still more rigid air of archaism.[27] Li Zhaodao is reputed to have excelled in architecture with minute detail of figures, and is not credited in tradition with an individual landscape style.

333. Landscape painted on a lute, and landscape in gold and silver on a box of persimmon wood. Respectively height 40.5 cm, length about 45 cm. Eighth century. Shōsōin collection, National Museum, Nara.

334. Landscape attributed commemoratively to Li Sixun. British Museum

He is represented as faithful to the 'blue and green' style of his father, the court painter Li Sixun (distinguished as Big Li from his son, Little Li), who in later writing is posited as founder of a Northern School. Li Sixun himself is said to have applied a *working brush* in minutely observed detail, to have been outstanding for bright colour and a verisimilitude which caused the emperor Xuan Zong to exclaim 'In your painting one can hear the sound of water flowing through the dark'. Examples of latter-day attributions to Li Sixun are two 'blue and green landscapes' in the British Museum, and one quite similar in the Freer Gallery, all composed of numerous buildings nestled between crags and woods, a romantic formula frequent in Yuan and Ming painting [334]. The style of *Sailing boats and a riverside mansion* attributed to him in the collection of the National Palace Museum, with its buildings half hidden among cedars (*shan*), may better represent his time, for the trees closely resemble those of eighth-century murals at Dunhuang.[28]

Thus in landscape as in figure painting is manifest a division between style under court patronage and style to which the observations of the critics are directed. What is inferred of the great-mountain theme under Tang discloses in some detail the origins of the classical tradition which was to follow. In the case of landscape in the horizontal hand-scroll, depicting either human action or the unrolling of hill and dale for its own sake, the question of Tang origin is more obscure. Two models of such landscape received much attention, one associated with Gu Kaizhi, and the other with the statesman, poet and painter Wang Wei (698–759). In later writing the two types appear as landscape models of romantic poetry and of quietistic philosophy. A latter-day version of *The legend of the Luo river nymph* in the British Museum, to be dated probably in the fourteenth century, assembles most entertainingly all the elements which tradition attributes to the master, and in its depiction of figures,

mountain, regimented vegetation and dragons offers also a compendium of skills characteristic of the time of its fabrication [335]. A scroll on the same subject preserved in the Freer Gallery is a stricter exercise in archaic forms (except perhaps the ship), but is judged to be not earlier than the twelfth–thirteenth century.[29] In both paintings the narrative centres on the poet's first encounter with the nymph, his infatuation and failure to meet the invitation to follow her to her watery realm, the nymph's departure of injured dignity accompanied by all her sprites and dragons, and the poet's desolation at the end. The Freer version introduces only some crags to separate the scenes; the space in which the figures stand and move is not defined by ground line or other perspective device, and to this extent the composition follows one Tang fashion. In the London version, on the other hand, continuous landscape with high peaks and distant views backs a flat foreground. The triple perspective[30] adopted here is that so firmly established in post-Tang painting: one looks down on to the plain and river from low elevation, horizontally across to the base of the hills from a higher point, and upwards to the peaks. Only one contemporary source, the pure-land scenes of eighth-century murals at Dunhuang, confirms us in the belief that this scheme of perspective was currently adopted in the mid-Tang period. It appears in caves ranging in date from the mid-seventh to the late eighth century (Caves 217, 148, 12, 138). Exercised so readily in Buddhist painting, it cannot have been foreign to the contemporary secular landscape style as a method followed alongside the looser spatial arrangement of such work as the Admonitions scroll and the theme of the Lo river nymph.

The career of Wang Wei as a poet-painter appealed especially to the post-Song *literati* painters, and to them must be attributed some professing copies of Wang Wei's work made in comparatively recent times. After retiring to a country

335. *The legend of the Luo river nymph* (detail). Fourteenth century. British Museum

336. Detail of a landscape scroll supposedly in the manner of Wang Wei. British Museum. Scroll 41 cm by 5 metres

337. Detail of a snowscape scroll attributed to Wang Wei. Honolulu Academy of Arts

estate at Lantian south of Chang'an, Wang delighted in 'streams, woods and the lute', and the sentiment of his poetry enwraps familiar scenery. His fame as artist was said to rest on a scroll depicting the vicinity of Lantian and the hills and woods along the banks of the nearby Wang river, the celebrated *Wang chuan tu*. Typical of the copies is a scroll in the British Museum said to have been made by Zhao Mengfu (1254–1322) [336]. It shows a continuous line of low hills échelonned into the distance and backing an undulating plain varied by scattered rocks and clumps of trees.[31] Usually an enclosure like the one in this picture, or a small building, symbolizes the artist's residence in quiet ambiance: tranquillity rather than awe-inspiring scale and height is the key-note, and tones of ink and coloured wash soften the effect of the outlines.

At an early date, possibly even in the Tang period, Wang Wei's name became associated with handscrolls and hanging scrolls in which snow is used to bring out the contours and relief of landscape. The citable examples are now assigned to the tenth or eleventh century, and no comparable designs at all of irrefutable Tang date can be adduced. The magnificent handscroll in the Honolulu Academy of Arts makes delicate use of ink wash and blank white silk to create a snowscape of utter isolation and silence. Bare-branched deciduous trees and various conifers are sparingly inserted against this background – the former with a delicacy that may be thought to belie the accepted dating of this work – and as the land vanishes towards the left, birds resting and flying make palpable the empty space [337].[32] In the Taipei Museum a hanging scroll of vertically échelonned peaks was once assigned to Wang Wei by virtue of its snowy contours, although the blue and green that predominate in the picture would no doubt have given it to Li Sixun.[33] After the close of Tang however the most skilled use of toned ink washes and subdued colour was credited to Han Huang (723–787), exemplar apparently of Zhu Jingxuan's aphorisms regarding pigment. This view of Han Huang's work is attested by a considerable number of remarkable paintings, now judged to be of the eleventh or twelfth century, which belong to the aggregate of Northern Song style and belong decisively to the account of that period. Among them is the Ohara Museum's *Scroll of bulls*, notable for the command of the animals' physique as much as for the toning of the pigment; and the British Museum's *Water buffaloes*, a distillation of the late-twelfth-century manner.

Buddhist Sculpture under the Tang

Buddhist sculpture of the Tang period falls broadly into four classes distinguished by region, date and style. A continuing tradition, which prolongs north-China values in the form they had reached under the Sui, is best followed in the work of the later cave-shrines at Longmen, occupying the seventh century [338].[1] Also preserved in the stone sculpture of north-China caves and in images excavated in Sichuan is a full eighth-century rendering of the indianizing manner adumbrated under the Northern Qi and the Sui. In the stucco images of the Dunhuang shrines the work of the sculptor approaches most closely to that of the icon painter, from about the mid-sixth century setting a goal of unaffected realism which renounces significant handling of bodily mass but fits well with the decorative naturalism of the mid-Tang. Least well documented, for China, is the sculptural and painted representation of the Mahāyānist deities whose cult invaded China prominently from the beginning of the eighth century. Work of this class appears reflected in the contemporary Buddhist art of Japan, where it is surmised that the underlying Chinese influence passed from the Jiangsu-Zhejiang region.

An incipient columnar manner informs the build of seated and standing images of the Lianhua cave at Longmen, where work began in the 520s, rounded relief softening the analytic linearity both in the main bulk of the figures and in the detail, an anticipation of the Eastern Wei style. The pentad of a seated Buddha simply draped, flanked by plain-robed Ananda and Kāsyapa, and again by two decorated Bodhisattvas, now interpreted in columnar style, was due to persist with little change until the mid-Tang, as a Henan/Hebei tradition. A beginning of the late-sixth-century treatment with its more unified and softer relief may be placed at the Suiyu-si caves, begun from 570 in the Handan-xian of Hebei, where notably the seated Buddha has the classical form bequeathed to Tang [339]. The fag end of the tradition appears in stone statuary excavated at Yangzhou in Jiangsu, dated to 873, which includes the Eleven-headed Guanyin of the Mahāyānist selection of images.[2] In contrast, the sculpture of the Maijishan caves shows the life of a more purely analytic style from the early sixth century until the tenth–eleventh century, with only minor concession to the development seen farther east under the Sui, Tang and early Song.[3] An innovation in all the areas where varieties of this Continuing tradition were practised is the introduction of the twin 'world guardians' lokapāla (lishi), brawny tutelars with bare torso or fully armoured, who were set at the two extremes of the pentad array and at the entrances to cave-shrines. Such a subject invited an attention to limb and muscle which no Buddhist sculptor had previously given, and provided the occasion of histrionic posture which interested the Chinese artist in much figural art. The Longmen caves of the 670–680s, Wanfou-dong, Jinan-dong and especially the Fengxian-si, mark the apogee of the Continuing tradition. Decorated Bodhisattvas differ

338. Image in high relief of a *lishi* at the entrance to the Jinan Cave at Longmen. *Ca.* A.D. 700. Somewhat over lifesize

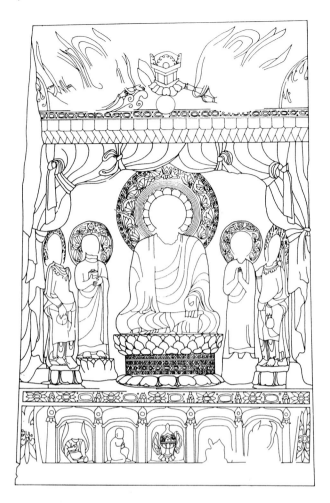

significantly, those of the Wanfou-dong stock-upright, those of the Jinan-dong having the slightly inflected waist which to a small degree anticipates the manner of the indianizing images of the eighth century.

The Fengxian-si of Longmen eclipses all its contemporaries in scale and splendour.[4] On a wide platform excavated from the cliff a group of images commissioned by the emperor Gao Zong was completed in 672–673. A seated Vairocana, 10.7 metres high, captures in the face an ideal of remoteness tempered by humanity; the robe, a series of strings, falls in the natural curves to which the analytic manner is now reduced, hanging like thin cloth [340, 341]. A corresponding robe is worn by the surviving disciple, on Vairocana's right. The Bodhisattvas maintain the Northern Qi–Sui fashion, the ornaments richer than ever. The body flexes slightly at the waist towards Vairocana: some influence of images designed in *tribhanga* pose is present here, as in many Bodhisattvas of the last decades of the seventh century, but the sculptural implication of the device is by no means realized. Remarkably well preserved on Vairocana's left, two guardians have the air of pose just assumed; Tuota Tian (later to be referred to the north) balances

339. Scheme of the pentad at the entrance to the western Cave of the Shuiyu-si, Handan-xian Gushan, Hebei. Late sixth century

340. The Fengxian-si, Longmen. A.D. 672–673

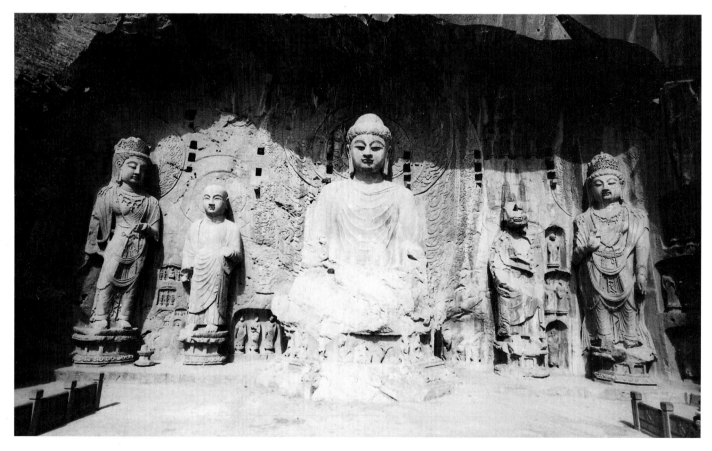

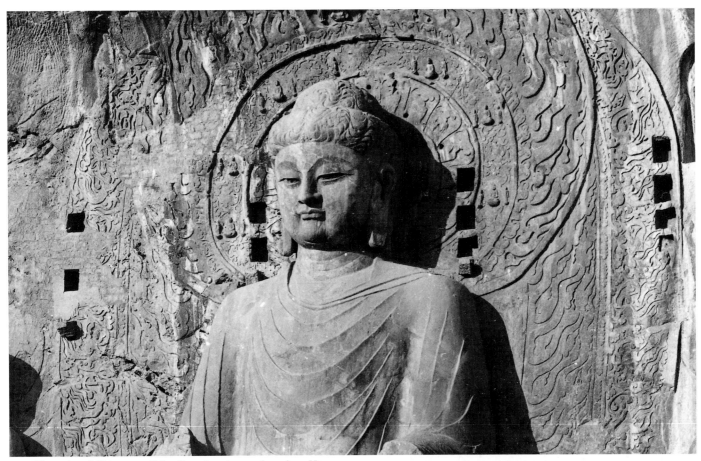

341. The colossal Vairocana of the Fengxian-si. A.D. 672–673. Ht 10.7 metres

342. *Lishi* at the Fengxian-si. A.D. 672–673

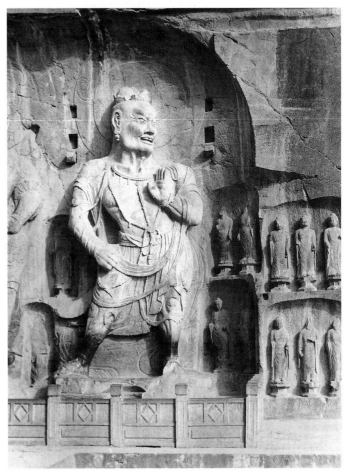

nicely, resting his right foot on a vanquished demon, while the *lishi* to his left has leapt into a minatory stance [342]. The compromise between caricatured energy and anatomical truth seen in these figures recurs frequently in work of about the same date, as with elaborate pseudo-musculature at the entrance of the Jinan-dong and the Wanfo-dong. Two smaller figures, in the University Museum of Philadelphia, are less studied in their swelling veins and muscles, marking probably a preceding stage of the type [343],[5] and still more tentative are the guardians at the entrance of the Yaofang-dong, dated to *ca* 570 and presumed the earliest of the series.[6]

All the statuary we have described is in high relief, virtually ronde-bosse, but still attached to the wall of cliff or cave. The *lishi* of the Fengxian-si however, with their sidewards look and stance, imply attention paid to free-standing subjects. Free-standing sculpture survives less well from the Tang period, but sufficiently to show that such work guided the cave sculpture, and that the style and detailed content known to us in stone were also repeated exactly in free-standing wooden images. The Eleven-headed Guanyin in wood, in the Cleveland and Berlin museums and in the Hōryūji (Nara, Japan), betray only a negligible trace of the *déhanchement*[7]; the crispness of the detail on such an image as the stone Guanyin of the Boston Museum (of the

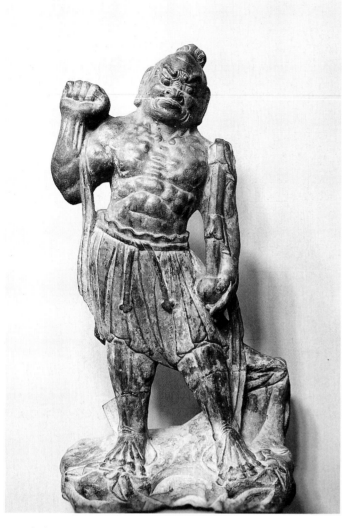

343. *Lishi*. University Museum, Philadelphia. Ht 54.5 cm

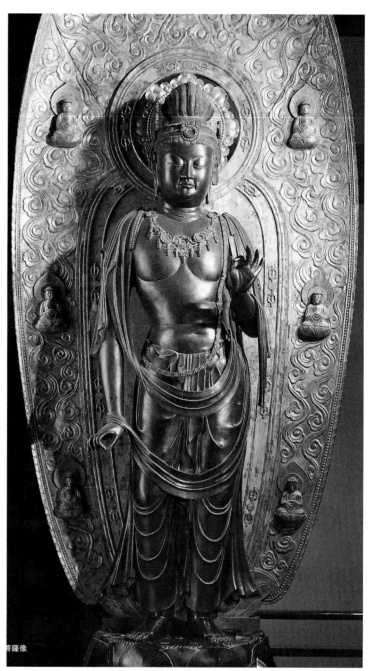

344. Standing image of Gekkō (Moon Radiance) placed at the right hand of Yakushi in the trinity of the Yakushiji, Nara, Japan. A.D. 697–728. Ht 3.12 metres

mid-sixth century rather than the Sui date that has been assigned to it) comes close to hypothesizing comparables cast in bronze.[8] No large-scale bronze figure survives from period in China, although the casting of large, even colossal, images is widely reported; it is however inconceivable that the unsurpassed Yaoshi (Bhaishajyaguru) trinity of the Yakushiji in Nara, Japan, should not resemble contemporary Chinese work, whatever degree of superior refinement in the casting be claimed for Japanese native craft [344].[9] The flanking Bodhisattvas in this trinity of 697–728 show a full understanding of the *tribhanga* pose, the hips flexed towards the Bhaishajyaguru Buddha seated in the centre, the body resting on the straight nearer leg, the knee of the outer leg slightly flexed – the *spielbein* of German writers. It may be argued that the changes seen in the later Tang Bodhisattvas of Continuing style owe their design in part to the indianizing style as described below: the rounding, in upright figures, of breast and hips about a constricted waist, occasionally an exaggerated unbalanced *déhanchement*, as seen in a statues of 820–824 excavated at the Dahai-si in the Yingyang-xian, Henan. This latter is a wholly intelligible declension from an earlier sensitivity visible in the torso of the Bodhisattva

standing on Vairocana's right at the Fengxian-si of Longmen [345]. The standing figures of the Tianlong-shan, of the middle of the eighth century, belong to the middle of this development.[10]

CONTINUING STYLE: 580–680

One may define stages of a continuous development leading from the mid-sixth to the mid-ninth century. The columnar style established in Shandong, Henan and south Shanxi by 560–570 (at Yunmen-shan, Tuo-shan, Cave 8 on Tianlong-

345. Bodhisattva images excavated on the site of the Dahai-si, Rongyang-xian, Henan. A.D. 820–824

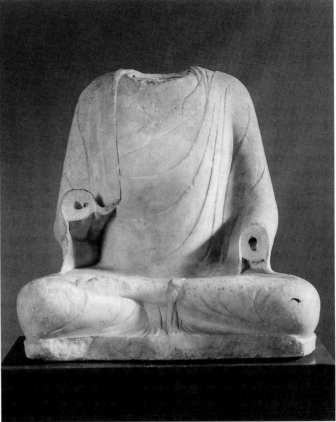

347. Stone seated Sākyamuni. *ca* A.D. 700. Museum of Far Eastern Antiquities, Stockholm. Ht 45 cm

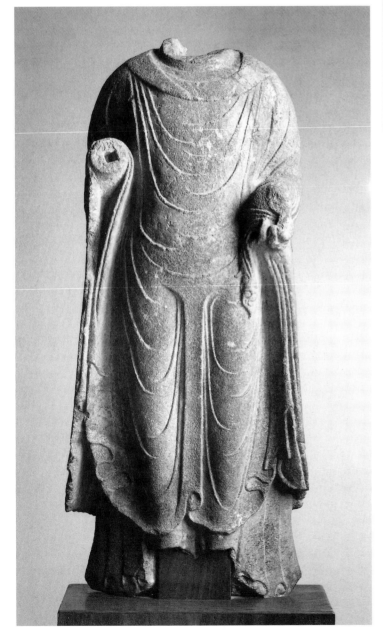

shan and at the Yaofang-dong of Longmen) is refined during the following century to a new explicit formula, such as is rendered most ambitiously at Longmen in the seated Sākyamuni of the Huijian-dong (worked 660–683). Here the legs are pendent ('in European fashion'); the cylindrical neck is triple-grooved in the manner now approved; the broad-plated robe set in artificial but unassertive loops combines in a pleasant rhythm; the half-closed eyes bespeak withdrawn meditation as it was now conceived. A coarser version of the same formula is set in a trinity on the Moya wall of Cave 6. The Buddha seated in the normal manner with raised legs, as seen at the Binyang North cave and the Zhaifu-dong, although hardly a decade earlier than the Huijian-dong image, falls short of the latter in design, finish and expression. A first transformation of style is thus to be dated around 640. The ideal columnar drapé, stiff and geometricized, is seen on the standing Sākyamuni in the Kansas Museum,[11] of *ca* 620 [346], on a seated Sākyamuni in the Stockholm Museum which can be little later [347], and on another dated to 639 in the Fujii Yūrinkan.[12] The post-660 robe more gently enfolds the figure in rhythmic curves which now define the portions of the body more realistically and join the throne cloth in almost continuous pattern, as exemplified in the Baoqing-si sculpture described below.

346. Stone standing image of Sākyamuni. *ca* A.D. 600–620. Nelson-Atkins Museum of Art, Kansas City. Ht 71.1 cm

CONTINUING STYLE: 680–720

The Baoqing-si sculpture marks the second transformation of Continuing style under the Tang. Although this sculpture does not belong with work of the indianizing style as defined below, one may surmise an allied exotic influence here also. The Eleven-headed Guanyin images, of which six survive, are portrayed with bare trunk and arms covered by narrow swaths of cloth so thin that the relief of the anatomy is not disguised.[13] From the waist downwards the legs are made equally apparent. The dismissal of drapé and the care bestowed on the surface of bare flesh, especially in the superior specimen of the Hosokawa collection, tempt one to invoke an Indian Gupta model, if only one conveyed to the east by a sculptor's paper draft [348].[14] Still, in the disposal of the narrow crease lines which alone represent the garment, Chinese linear rhythm is asserted, with a delicate illusion of verisimilitude that is unprecedented. The historical context of the Baoqing-si sculpture and the date of 703 inscribed on a trinity panel (this inferior to the Bodhisattva reliefs) support a date in the last decade of the seventh century for the majority of the work.[15] The trinity panel in the collection of Hosokawa Moritatsu represents, in miniature, the Chinese work from which the Yakushi trinity must derive [349].[16] A natural poise of the inclined head and the open arms of the seated Bodhisattva in the Hosokawa Moritatsu collection evokes a distant Indian influence no less than the Guanyin, and adds to this impression a new competence in the articulation of trunk and limbs.[17] The drapery is also of the 'wet' diaphanous kind used on the Guanyin, the three-tiered lotus throne a new exercise in the floral design of this component. Meanwhile such statues as the standing Guanyin of the Philadelphia University Museum and the high-throned seated Sākyamuni of the Tokyo Shodō Hakubutsukan, dated to 706 and 711, show harder lines and columnar design unaffected by the Baoqing innovation.

CONTINUING STYLE: 720–750

Apart from the images originating from the caves on the Tianlong Shan of Shanxi province, which belong to our category of Indianizing style, no stone sculpture reliably dated can be adduced for these decades. On the other hand, and rather inexplicably, many small images of gilded bronze must belong here, their treatment a prolongation of Continuing style. The majority of these pieces are of inferior workmanship. Lacking inscription and unearthed without record, their detailed chronology remains obscure, their abundance perhaps a sign of an increase in domestic piety at the expense of temple endowment. It appears that nearly all the surviving specimens fall in the first half of the eighth century, the heyday of Tang decorative art, the *sheng Tang*. Commonest are single figures of Sākyamuni/Maitreya, a miniature row of the Seven Buddhas of Past Ages, and a standing Guanyin type framed in flowing scarves which as ornamental addition chime well with the spirit of this time. The Guanyin of the San Francisco Museum is the fullest version of the type, the body flexed in the pose of Buddha's companions, although the image was no doubt intended to

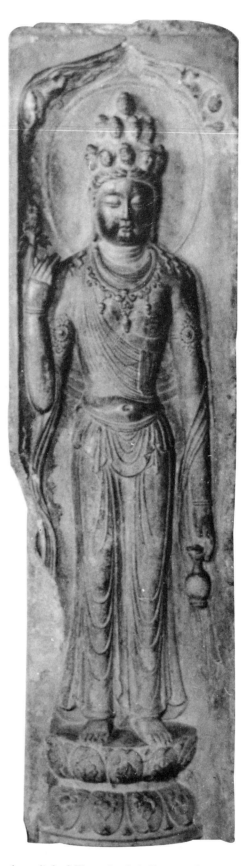

348. Stone bas-relief of Eleven-headed Guanyin, from the Baoqing-si, Chang'an, Shaanxi. *ca* A.D. 700. Hosokawa Moritatsu collection. Ht 1.12 metres

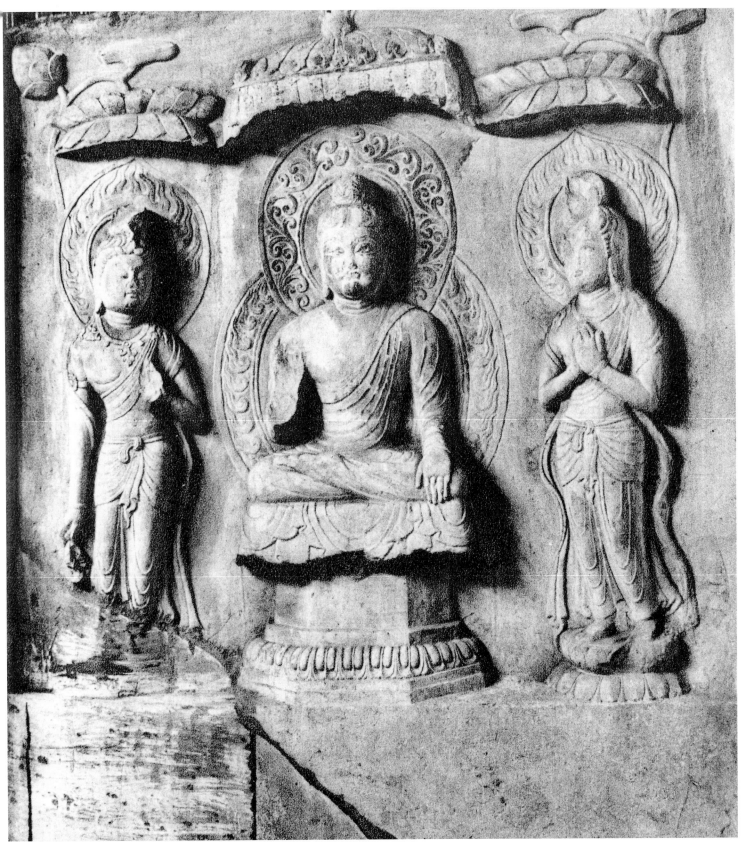

349. Stone Sākyamuni trinity from the Baoqing-si, Chang'an, Shaanxi.
Early eighth century. Hosokawa collection, Japan. Ht 1.04 metres

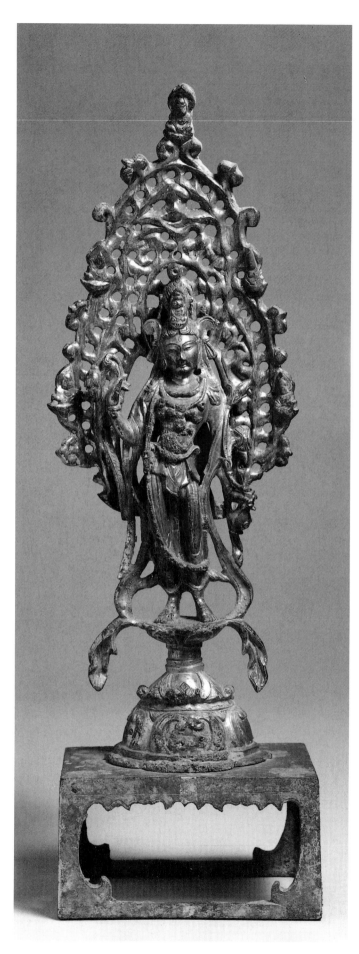

stand alone as recipient of the individual cult by now well established [350]. The *ajouré* mandorla is unusually elaborate, rimmed with cusps and buds and holding five small Buddhas; the head-dress rises high to wrap the Buddha image which denotes relation to Amitābha, knotted wings project from the sides, a lotus on a long stem seems to rise from the flask in the left hand. The simpler and more frequent rendering of this figure is seen in other Guanyin of the same museum and a comparable piece in the Cologne museum. The candelabra-like array of the Seven Buddhas is ideally represented by an example in Cologne.[18] The seated version of the Guanyin is rarer.[19] The altar group of gilded bronze images incorporating Guanyin of this order is well represented by two specimens in San Francisco. In one of these disciples, *lishi*, lions and the precious jewel are set with the Guanyin around the Buddha seated with pendent legs; in the other the Guanyin hold respectively moon and sun, on the Buddha's right and left sides, corresponding to the moon and sun designations of the Bodhisattvas in the Yakushiji trinity.[20] The central images are furnished with splendid floral mandorlas [351].

350. Gilded bronze image of Guanyin. Early eighth century. Asian Art Museum of San Francisco. Ht 29.9 cm. B60B334

351. Gilded bronze altar with seated Bhaishajyaguru and companions. Early eighth century. Asian Art Museum of San Francisco. Ht 26.3 cm. B60B1038

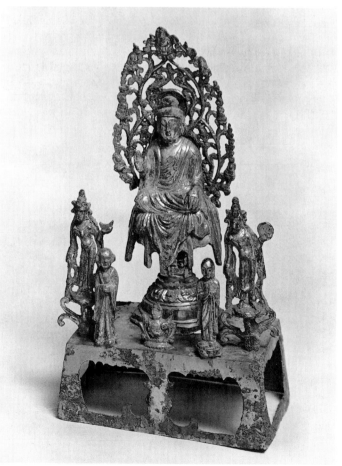

CONTINUING STYLE IN THE LATE EIGHTH
AND EARLY NINTH CENTURIES

Though the material is exiguous, and no specimen dated by
inscription, the change wrought in Continuing style in the
decades around 800 is probably to be judged from a minia-
ture triptych shrine carved in white sandalwood, brought
from China and preserved in the Kongōbu-ji on Kōya-san,
Japan.[21] The distinct treatment of detail seen here accom-
panies an unparalleled association of images. The central
seated Buddha raises a hand in *abhaya*, but is identified as
Amitābha by Mizuno, who acknowledges the eccentricity of
the iconography. In the outer wings of the triptych sit
Bodhisattvas in the meditating pose (a leg raised on the
outer knee) but now wearing a full-skirted robe which all but
hides the posture. All three images have the unslimmed bulk
of person and heavy facial expression which characterize this
phase.[22] Pairs of further Bodhisattvas, pairs of pratyeka
buddhas and a number of disciples accompany each main
image. Below are the customary medley of censers, lions,
demons and dwarfs. The popularity of miniature altars in
wood is demonstrated by the existence of an equivalent in
gilt bronze, whose strange iconography and crude modelling
sufficiently agree with the other work attributed to *ca* 800.[23]
More normal to the product of this phase is perhaps a
seated gilt bronze image of Sākyamuni in the Metropolitan
Museum. The manner is distinctive, if still within the
bounds of Continuing style, with fresh study of the face and
of hands delicately poised in the teaching gesture.[24] But
doubt attaches to the dating of all Buddhist sculpture of
the late Tang, and this piece may rather belong with the
seated Guanyin of the St Louis Museum which opinion has
assigned to the tenth or early eleventh century [352].[25] In
stone, for the ninth century, one may instance the high-
throned seated Buddha of the Los Angeles Museum, and a
standing Guanyin in the Metropolitan Museum which is said
to have come from Longmen, sympathizing perhaps with
Priest's comment on the latter, that, with elements of
majesty, it 'radiates a smug, provincial vacuity'.[26]

INDIANIZING STYLE

It was speculated in an earlier chapter how central- or
southern-Indian influence is likely to have reached China
(p. 128). Insofar as pieces among the sculpture recovered at
the site of the Wanfo-si near Chengdu in Sichuan warrant
assumption of Indian influence, this was probably mediated
by the Liang court and its successors in Jiangsu rather than
inspired by direct westward contact; and in Sichuan the
effect seems not to have spread far from the capital city.[27]
The indianizing style of Tang comprises the build of the
figure, both standing and seated, a facial type, the treatment
of bare flesh and diaphanous drapé, floral additions, and the
ornaments placed against the bare skin. These features are
realized mostly in Bodhisattva, for even at the Wanfo-si,
where they are most pronounced, the seated Buddha observes
the type we have attributed to Continuing style; while the
images of the Longxing-si, though wrapped in heavier, more
round-bulking robes than their eastern equivalent, do not

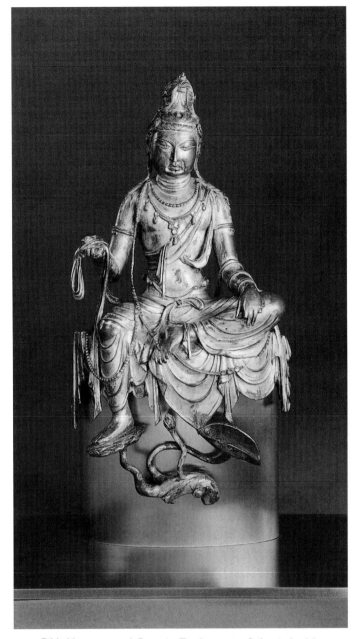

352. Gilded bronze seated Guanyin. Tenth century. St Louis Art Museum.
Ht 27.9 cm

depart far from Continuing norms.[28] A standing Guanyin at
the Wanfo-si presents an ideal combination of the indianizing
features, apart from the missing head [353]. The *déhanche-
ment* is interpreted with proper regard to the tension of the
legs, the shoulders poised naturally over a slimmed waist:
the body as a whole and not only its surface divisions is
taken as the goal of the work. Solidity and independence
beyond the previous east-China norm distinguish the jewelled
chains crossing over the stomach and the collar hung below
the neck. While confidence in realistic stance and moulding
of limbs is characteristic of earlier sculpture at the Wanfo-si
(cf. the Ashoka statue of 562–565, the Sākyamuni of 529
and its singledraped near-contemporary), the Guanyin must
mark the advent of a new canon, however distantly trans-
mitted, which places the work in the central-Indian tradition

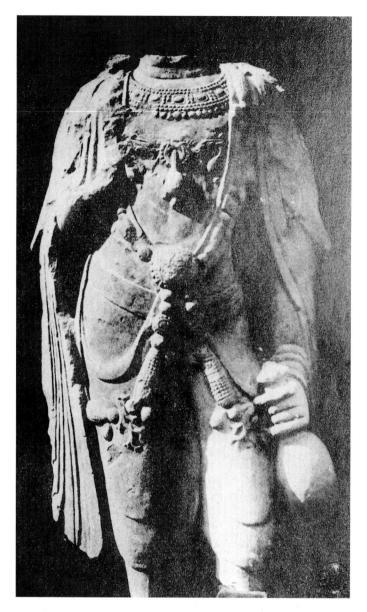

353. Stone standing torso of Guanyin, from the Wanfo-si, Chengdu, Sichuan. Eighth century. Near half lifesize

soft chiselling amd abrasion. Of the 21 major caves (i.e. omitting some small niches), Cave IX is of two storeys, Cave XIX faces west and the rest south.[31] Not all the caves are susceptible of dating in the scheme proposed by Vanderstappen and Rhie, and while some (notably Caves XIV, XVI, XVII, XVIII and XXXI) so uniformly present the new indianizing style that they seem to have been executed within a short time, the sculpture of others showing a variant of Continuing style analytic and columnar (Caves I, II, III) do not so clearly derive from a single commission [355]. In the caves where indianizing style predominates, as in Cave XIV, the Buddha image, now probably intended as Amitābha, is not necessarily affected by the new manner, but in Cave XVII it is adapted to it. Where no other sign of indianizing appears, the Bodhisattva head may conform to the new design or approximate to it (as is the case also in Sichuan at the Longxing-si).

The Tianlong Shan Bodhisattva interprets a new conception of this entity: one of great bodily ease and immediate human presence [356]. He is bare to the waist, displaying soft undulating flesh; a band of light cloth is thrown across

354. Stone Bodhisattva head, from the Wanfo-si, Chengdu, Sichuan. Eighth century. Lifesize

represented ideally by the so-called Sanchi torso. The latter is deemed to date from the ninth century at the earliest, while the Wanfo-si figure must belong to the decades around 700.[29] Other indianizing elements may be listed: the noble Bodhisattva head, common to the Wanfo-si and the Longxing-si, with its head-dress, recalls the Mathura tradition [354]; the elaboration of large floral items, the pot-bellied attendant on the base of a throne, the combination of clinging drapery overlaid by jewel-chains, and not least the magnificently swinging torso of a *lishi*, all breathe a fresh exotic.[30]

Some elements of the indianizing style appear diffused through the sculpture of central and east China from the Northern Qi onwards, as has been observed in regard to the stance and decoration of the Bodhisattva. Full expression of the exotic tradition beyond Sichuan is confined however to the statuary of the cave-shrines on the Tianlong Shan in Shanxi, where the light buff-grey sandstone lent itself to

the breast from waist to right shoulder and a narrower band lying over the left shoulder. The standing figure is gently flexed; the seated figure has one leg drawn up to the throne with head and upper trunk leaning towards it. The images were left attached to the cave wall, the natural pose still giving wholly the impression of sculpture in the round. Under covering the relief of limb and muscle is still respected, only puckered ridges in the cloth revealing its presence. The eyes are narrowed to a dreamy retirement, the hair artificially arranged in tight divisions on crown and top-knot, the latter a naturalistic version of the *ushnisha*. Against the *ushnisha* is usually imitated a floriated jewel of precious metal and stone; a similar necklace with pendants hangs low around the neck.

There are signs of stages in the accomplishment of the indianizing style at Tianlong Shan, and of inferior rendering of the ideal model. In Cave IV what appears to be tentative work, a seated Buddha with an exaggeratedly slimmed waist and Bodhisattvas clumsily rendered in the inflected body, may represent an early phase of the style. Possibly from the same cave and now in the Tokyo National Museum,

355. Sculpture in situ at the cave-shrines of the Tianlong Shan, Shanxi. Mid-eighth century

356. Torso of stone standing Bodhisattva, from the Tianlong Shan, Shanxi. Mid-eighth century. Rietberg Museum, Zürich. Ht 98 cm

357. Stone seated Sākyamuni, from the Tianlong Shan. Mid-eighth century. National Museum, Tokyo. Ht about 75 cm

358. Stone Sākyamuni, from Dingzhou, Hebei. Seventh century. Victoria and Albert Museum, London. Ht 1.45 metres

a similar Buddha seated with pendent legs suggests a settled version of an initial indianizing design [357]. Some Bodhisattva images displaying a pronounced awkward inflexion, while still within the range of Tianlong Shan sculpture, fall short of the ideal.[32] Somewhere within reach

of the same white limestone but not at the Tianlong Shan cave-shrines themselves were carved standing Bodhisattvas of distinct types in which the indianizing manner was further modified, or merged in part with columnar design [358, 359].

A teasing matter besides is the place to be assigned to the stucco sculpture of Dunhuang in relation to the contemporary indianizing styles of Sichuan and Shanxi. The suggestion made earlier in this chapter, that indianizing influence reached west China from the Jiangsu area, begged a large question: why should similar influence not arrive through Central Asia? Since Buddhist travellers to all parts of India in the Tang period passed through Central Asia, it is to be assumed that models and designs for images mostly came eastwards by the same way. It does not follow however that ideas for monumental sculpture were entirely dependent on this traffic. While items of design that entered into the sculpture of the Wanfo-si and the Tianlong Shan caves were present at Dunhuang, it is entirely credible that sculptural impulse reaching Sichuan and Shanxi from east China was the cause of their incorporating these items in the indianizing style we have described. One readily perceives features of Dunhuang work which are consonant with this view. The clay modelling of the Dunhuang artists and their close association with the icon painter led to a fastidious superficial realism of detail at the expense of sculptural expression in the total figure. In Cave 43, of the seventh century, nothing distinguishes the Sākyamuni pentad from Columnar statuary except the bareness of the upper torso of the Bodhisattvas. In the first half of the eighth century, for example in Caves 118, 194, 320 and 384, Bodhisattva images certainly approximate in shape to the indianizing figure, but their inferior sculptural quality, as seen today, would seem to disqualify them from any significant contribution to indianizing style.[33]

MAHĀYĀNA AND VAJRAYĀNA

Much that has been recounted of the Buddhist sculpture relates to changes in doctrine and iconography in central India and Bengal which are traced from the second century A.D. onwards. An early and passing allusion in China to Mahāyānist catholicity was the admission of Kumārakadeva, Mahesvara and Indra at Yungang. As Indian Buddhism sought accommodation with extraneous cults, new deities swarmed into the pantheon, particularly when in 747 Padmasambhava of Swat, at the invitation of king Khri-srong-lde-btsan, arrived in Tibet and 'introduced a system of magic and mysticism (saturated with Sivaism) which found its way into Mongolia and China'.[34] The impact of the multi-image Vajrayānist iconography (so called from the metaphor of the thunderbolt used to describe the cogency of the gods of its huge pantheon), which emerged as a complete system in north-east India in the seventh century, was not prominent in China before the Yuan period. Mahāyānist influence before that time, in sculpture and painting if not in doctrine, was sporadic and inconsistent, as if the Chinese iconist were faintly pursuing a distant process not fully apprehended. The Mahāyānist conception of the Buddha

359. Torso of stone standing Bodhisattva. Eighth century. Cleveland Museum of Art. Ht 1.58 metres

360. Stone bas-relief of Acala. Late eighth or ninth century. Field Museum of Natural History, Chicago. About half lifesize

Chinese. Avalokitesvara, Guanyin, represents for China a main aspect of Mahāyānist soteriology. The eleven-headed version of this image adopted into Tang sculpture finds a sixth-century predecessor in the Kenheri temple near Bombay. Of the Mahāyānist system of cosmic Buddhas there is little sign in Chinese sculpture beyond the majestic representation of Vairocana at Yungang and Longmen. The Amitābha cult established itself independently in conformity with the Chinese popular notion of salvation located somehow in the west. A deity fundamental to Vajrayānist iconography, Acala (the immoveable, *Budong*, Jap. *Fudō*), makes a brief appearance in Tang sculpture, while its fortune in Japan from the eighth century was very great.[35]

It appears that the deities of late Mahāyāna and of Vajrayāna made little appeal to Chinese sculptors in stone, possibly because of their complexity and demand in iconographic detail. The Acala was to hold a sword as exactly described in various texts, the hair should hang in a pigtail to the left, the protruding teeth are to point alternately up and down, and the expression is to be as fierce as possible. The stone version in the Field Museum of Chicago, in style unrelated to other contemporary sculpture, appears to mark the beginning of a type of which no successors survive in China [360].[36] In Japan, on the other hand, in painting and wooden statuary, the Fudō inspired some of the greatest work of the ninth and tenth centuries. For these icons there is no precedent in Japan itself, and the conclusion is to hand that they follow directly on the practice of a Chinese school

and Bodhisattva as timeless entities, such as governed Chinese sculpted icons from their beginning in the fourth century, detracted inevitably from the historical commemoration of the founder Sākyamuni upon which Hinayāna teaching was based. Manjusrī had a special attraction for the

361. Central panel of painting of the Liangjie (ryōkai) mandala. Early ninth century. Tōji, Kyoto, Japan

working in wood, probably in the Jiangsu region, whose home product has totally perished.

While trace of the new images in Tang painting is equally elusive in China, there can be no doubt that the accomplished and mature style of mandala pantheon-schemes reaching Japan in the early decades of the ninth century is to be credited to Buddhist artists on the mainland. Outstanding among the mandalas preserved in Japan is the *Ryōkai mandara* belonging to the Tōji in Kyoto, which is likely to have followed Kūkai on his return from a journey of enquiry to China in 804–806, if indeed it was not part of the many mandara and scriptures which he brought with him [361]. Evidence for late-Mahāyānist icons that is found among the paintings on silk recovered at Dunhuang belongs to the tenth century, a century after the Tibetan occupation of the Dunhuang region and the advent of Tibetan lamaist influence. These paintings include such novelties as a hooded Kshitigarbha (guardian of the earth, one of the eight Dhyāni Bodhisattvas) and a mandala painting demonstrating the universality of the Lotus Sūtra, presided by a Guanyin in the shape of a Sakti, the female consort of the Amitābha whose small image perches on a cloud at the summit of the picture [362].

362. Mandala of the Universality of the Lotus Sūtra, from Dunhuang. Eighth century. British Museum

Tang Non-Buddhist Sculpture and Decorated Objects

MONUMENTAL SCULPTURE

Secular sculpture of monumental size makes only brief appearances in the art record prior to the Tang period. The ceramic soldiers and horses of the Qin emperor's tomb, already described, afford a glimpse of highly formalized naturalism in the full-sized human figure for which no precedent survives, and which ceases without sequel in the ensuing Han period, despite the attention given at that time to small-scale modelling both naturalistic and schematic. Much-cited works in this connexion are the large stone animals placed around the tomb mound of the general Huo Qubing, who died *ca* 117 B.C. and was buried in central Shaanxi, near to the Mouling, tomb of the emperor Wu-di.[1] Huo's mound, rising to 12 metres on a base of 20 metres' diameter, was furnished in recent time with a brick-built entrance under an arched roof and a small crowning pavilion. The tomb is first mentioned early in the seventh century by the official and commentator Yan Shigu; when first examined archaeologically, by Victor Segalen in 1920, the mound had scattered around it figures of animals, some fragmentary, hewn from blocks of stone whose native shapes seem to have influenced the sculptured form. The original arrangement of the sculpture is not known: if the animals were placed in a row before the tomb entrance, as became the later practice, they seem not to have formed the symmetrical pairs placed along the approaches to imperial tombs in the manner demonstrable from the third century. The surviving intact pieces are a water buffalo and two horses. The former is crouched in a compact mass, as if a minimum of work was to be done on the boulder, but the head is alert and the folded legs are well conceived. A full-sized standing horse which remains at the site follows a pre-Han design, reflecting the old steppe race and resembling the bronze horses of the third century B.C. (e.g. a specimen from the celebrated tomb at Jincun, Henan) rather than the bronze versions of the second century B.C. from Wuwei in Gansu, for which the new breed recently introduced from Western Asia was the model.[2] The standing horse is presented in profile and apparently intended to be seen only from the side [363]. The stone filling the space beneath the belly portrays in relief a barbarian warrior, dwarfish and hirsute, holding a weapon in his left hand and evidently trampled. Some illogical grooves on the side and down the legs acknowledge the musculature, but without resemblance to the conventional muscle-marks of Inner Asian animal art, which in Shaanxi, and with the Xiongnu connexion, might have been expected. Another horse from the tomb, preserved in the Xi'an museum, is represented as leaping from a low posture over an enemy. The carving in this instance is like that of the water buffalo, broad surfaces devoid of detail suggesting the parent block of stone, and indeed appears to be unfinished. In all of this work is a powerful expression of life which places it in a high order of skill, despite its apparently negligent style. The sum of eccentricities displayed – the

animal subjects, the movement imposed on massive form, the overt allusion to enemies who had occupied the general in his lifetime – answers in a sense to the character of the man commemorated. Huo Qubing was ennobled as marquis following his three victories over the Xiongnu; an image he brought back from a distant campaign, the property of a Xiongnu chieftain, is likely to have been a representation of the Buddha. Huo is said to have been taciturn of disposition, a contemner of the normal military strategies of the Chinese.

Like the Qin clay statues, the Huo Qubing stones appear as the work of sculptors lacking further context, made possibly under the remote influence of the tradition in which the large 'stag stones' of Mongolia were produced, rather than in contact with any Chinese metropolitan practice. To a small degree however they introduce the pursuit by Han artists of the realism conveyed in smaller statuary and ornamental animals through sharp movement. Applied to unreal subjects of myth or superstition, in enduring material at least, such realism seems not to have achieved monumental size during the Han period. A tradition of stone sculpture which portrays unreal animals in monumental size

363. Stone horse at the tomb of Huo Qubing. Late second century B.C. Xingping-xian, Shaanxi. Ht 1.4 metres

appears to take its rise in Sichuan at the beginning of the second century A.D. A winged lion at the tomb of Gao Yi, situated some 140 km south-west of Chengdu, marks the beginning of a series whose surviving larger and perfected members are found in the fifth century far to the east, in the Song, Qi, Liang and Chen kingdoms of Zhejiang/Jiangsu.[3] At the Gao Yi tomb and at similar tombs in central Sichuan stand the memorial stone pillars composed of architectural elements which were cited in Chapter 19 above as architectural documents [297]. In these pillars is evidence of a school of monumental stone sculpture, rather than of practical architecture, and Gao Yi's winged lion is probably to be connected with it.

After Han the lineage of this non-Buddhist sculpture is still to be sought in Buddhist contexts, shown in the lions and demons associated with schemes of images in the Guyang cave at Longmen and the Gong-xian caves. A protome of a lion whose hinder part formed a pillar footing at the site of the Tongquetai palace in Linzhang-xian, Henan, dated to the Cao Wei dynasty (220–265), differs little from the lions in the Buddhist caves, and points the transition from the secular to the Buddhist usage of this motif.[4] In Shandong some crude pillar-like stone figures of large-headed servants and soldiers of comparable date were placed before great tombs, but these are not paralleled in Buddhist sculpture and had no sequel.

The Jiangsu sculptures, numbering thirty-one groups and all situated near to Nanjing, capital of the successive south-eastern dynasties, are placed before royal and noble mausolea. The largest item is a beast standing between two and a half and three metres to the head, and about three metres long: a winged lion-like monster with strongly curved breast, back and neck, gaping mouth and heavy tail, its set varying between a firm stance and a striding pose with parted legs [364]. As a winged lion, connexion with a corresponding animal of the Achaemenid west is naturally to be supposed, but the comparison cannot be further particularized. The Jiangsu lion recreates the winged lion of the Gao Yi tomb without further exotic influence, increasing its size, unifying the design into strongly curved masses, and adding surface decoration. This last is broadly archaistic, though not specifically so, recalling features of monsters made in bronze and jade in the centuries intervening after the Han. The curving and spiralling tufts on neck, breast and haunches echo the lines of the whole figure, this decoration declining in quality progressively through the life of the type as the energy of the total design reduces.

In a full array the lions were placed in pairs before tombs on the south side, together with a pair of columns, fluted and capped and carrying a rectangular panel intended for inscription, and a pair of stele slabs posed on tortoises which carried the main history of the buried person. This configuration is said to have descended from the eastern Han period, though no complete arrangement survives as antecedent to that of Jiangsu [365]. Small detail differentiates the lions. At imperial tombs they have been designated *tianlu* (heaven's fortune) and *qilin* (the unicorn monster of ancient lineage), the former bearing two stumpy horns and occupying the east, and the other with its single horn guarding the west. It appears that noble persons were entitled only to

364. Defensive lion (*tianlu*) at the tomb of Chen Qian, emperor of Chen, at Ganjiaxiang near Nanjing, Jiangsu. A.D. 566. Ht 3 metres

365. Stone memorial pillar with name and titles, at the tomb of Xiao Jing, marquis of Wuping, at Ganjiaxiang near Nanjing, Jiangsu. *ca* A.D. 523. Ht about 6.25 metres

hornless lions, but the sculptural heralding of their tombs in other respects resembled that of the emperors. Over the century and a half which saw the carving of the sculptures, from the set of Wu Di of Song (*d.* 422) to that of Wen Di of Chen (*d.* 566), changes in execution reflect only waning fidelity to a model rather than evolution of style. In lions the formula of feathered wings, curly tufts and the detail of the mask might be simplified or revived in full variety. Their perfected elaboration appears about 480, when a striking *passant* posture with well-spaced legs was adopted. In the early decades of the sixth century simpler decoration of the lion became acceptable and the striding stance lost some of its force (mausoleum of Wu Di of Liang). Very fat lions, even one with a cub, were carved for the tomb of Xiao Jing, marquis of Pingzhong. The nearest approach to sculpture occurring in contemporary work at the Gong-xian cave-shrines is seen in relief panels along the edges of a stele at the mausoleum of Xiao Hong, king of Jinghui, where are depicted the very fairy animals, raging demons and birds of good omen that were admitted to the lowest register of Buddhist schemes. The panels are positive evidence for what in principle is most probable, that artists from the same milieu were employed on both Buddhist and non-Buddhist sculpture, and were capable of employing the same pattern-book in both types of work.

TANG STONE SCULPTURE

What has been described embodies realism of the Han order. The sudden redirection which most intimately characterizes Tang sculpture occurs in the second quarter of the seventh century: the adoption for the first time of natural verisimilitude as the sculptor's goal. In tomb guardians and other genies, energetic realism of the traditional kind

366. Stone bas-relief of the imperial horse 'Blown-dew purple', from the Zhaoling, Tuquan-xian, Shaanxi. A.D. 636–645. Philadelphia University Museum. Ht 1.76 metres

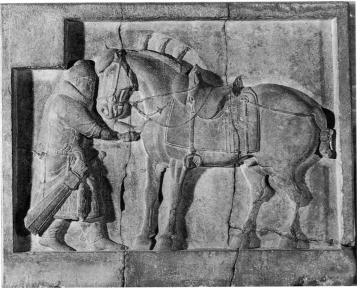

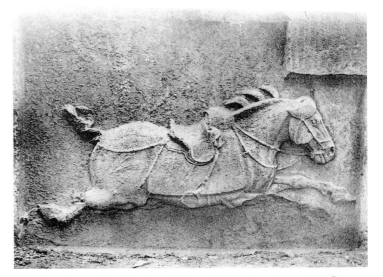

367. Stone bas-relief of the imperial horse 'Tight-rein yellow-white'. See ill. 365. After Chavannes. Ht about 1.7 metres.

continues and is further developed, but the greater invention is found in the naturalistic figures. Tang motivation towards large stone sculpture of non-Buddhist type[5] does not compare with the private and official patronage of Buddhist images. More popularly taste for naturalistic modelling manifests itself chiefly in the *mingqi*, clay figurines displayed at grand funerals and placed in tombs, which in principle continue the practice dating from Han, but from the last decade of the seventh century become a medium for a much-varied fashionable art. But the new naturalism is heralded in stone by outstanding work which appears suddenly, without traceable stylistic precedent, some time after 636: the relief panels depicting the six favourite war-horses of the emperor Taizong.[6] The emperor declared in 636 that the horses should be commemorated *accurately* in stone sculpture. Five years before his death in 650 the horse portraits in high relief were placed at his tomb mound beyond the north gate of the palace precinct, in groups of three in separate small pavilions. Each oblong relief is about 1.66 metres high and 2.23 metres wide (the dimensions of the Quanmaogua stone), having at a top corner a rectangle reserved for inscriptions which are no longer fully legible. The account of each horse is preserved in the Song transcriptions:

> *West pavilion:*
> i. Saluzi, 'Blown-dew purple' [366]
> ii. Quanmaogua, 'Shaggy-maned yellow'
> iii. Botiwu, 'White-hoofed raven'
> *East pavilion:*
> iv. Telepiao, 'Tight-rein yellow-white' [367]
> v. Qingzhui, 'Greenish chestnut'
> vi. Shidaichi, 'Dynasty-serving red'

The deep relief shows almost the whole depth of the subjects; the meticulous rendering of saddlery and the unprecedented reality of musculature set an example which not even the eighth-century ceramic horse models achieve, although these may have set the style. Nos. 2 and 3 are taken

at the trot, No. 1 stands quiet while an arrow is removed from its chest by a general who has relinquished his own steed to the emperor; and the others are shown at full gallop. The reality of the riderless charging steeds, with stirrups, sweat-cloth and tails swept back, should be compared with the fanciful treatment of the second-century 'flying horse' from Wuwei, careful though the attention paid to equine points in the latter.[7] While so unhappily isolated in the artistic record, the circumstances of the imperial commission which gave rise to the reliefs deserve notice as an indication of what must have occurred at other times, when a call was made upon the services of sculptors fully competent in the naturalistic style, allied to sculptors engaged earlier on the extraneous minor elements of the Buddhist cave schemes but much advanced beyond this performance. We may surmise that artists so equipped were to be found only in central or east China, Henan or Jiangsu, whence imperial command might summon them to tasks for which patronage was lacking in their original sphere. Here we may notice the monumental stone sculptures set along the road leading to the Qianling, the tomb of the succeeding emperor Gaozong (650–683). A nervous eye and a taut head are attempted in the winged horse, so beautifully and unnaturally scrolled on its shoulders, but the quality of Taizong's chargers is absent. As to the squads of stump-officials lining the last part of the approach, now all headless, for them no sculptural merit has ever been claimed.[8]

POTTERY FIGURINES

From the last decade of the seventh century Tang verisimilitude is manifest no less in pottery figurines, occurring therefore some two generations after the event signalled by Taizong's horses.[9] The manufacture of the figurines formed a specialized branch of potter's craft, but one apart from other ceramic production. It was limited in its materials to earthenware and lead-based glaze, confined to a small number of kilns serving the needs of a defined class of customers, and in its original and most significant form an activity of little more that half a century. The large numbers of surviving figurines is not to be wondered at in comparison with the extreme rarity of contemporary secular sculpture in stone: with the custom of furnishing rich tombs abundantly with figurines denoting wealth of servants, security by supernatural guardians, and privileged access to costly trade goods reaching China from the west, the figurine potter became at once indispensable in the vicinity of the Tang capital and in the aura of the Tang court. His pre-eminence effectively ceased with the rebellion and social upheaval of the 750s. There had been an element of social rivalry, for competition in funeral grandeur required the display of tomb figurines to be made along the route of the cortège. The subjects of the figurines reflect the dichotomy created by the fashion for natural portrayal: unreal beings were still to be fantastic and superhuman, while a kind of domestic fidelity was to be observed in rendering the familiars of the dead. Between the stone-carver and the model-maker there could be no shared technique, and all new subjects belonged to the potter, whose

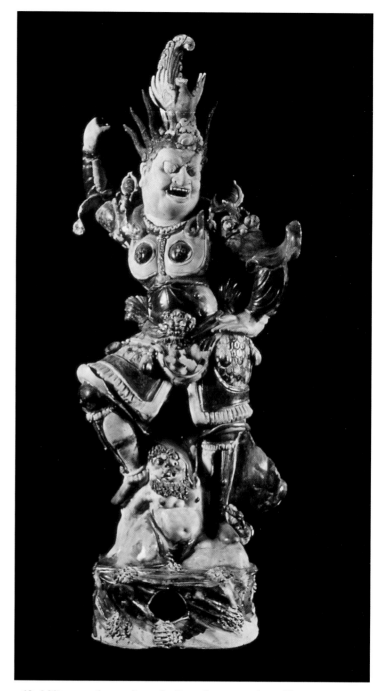

368. Military tomb guardian, *shenjiang*, from a tomb at Chongpu, near Si'an, Shaanxi. First half of the eighth century. Ht 65.5 cm.

mass production established naturalistic stereotypes at the start.

After the prosperity of figurines and models of Eastern Han there is much loss and little innovation to show in this line before the mid-sixth century. The Han figurines appear to have been produced mainly at kilns in Henan, in earthenware which might be covered with green or brown glaze. This technique is traced fitfully as late as 700; but by 537 servitors and animals are found in Hebei made of a white-firing clay which dispenses with glaze altogether, this possibly replaced by earth-colour painting which has not survived.[10] In a tomb of 595 in Henan are examples on which black-glazed detail imitates this painting. The clay body contains kaolin, the material of high-fired pottery, but is not fired beyond earthenware hardness. In the same tomb was a group of soldiers, officials and grave-guardians made of white-bodied stoneware on which detail is picked out in blackish brown.[11] Here then was the seed of a new technique, but the essay in high-fired modelling seems to have been still-born. The use of a clear lead glaze continued in east China, now over a white or cream-coloured earthenware body, classically in the briefly modelled or moulded and monotonously elegant figurines of the late seventh and early eighth centuries in the Sui-dynasty tombs of east China. But this region lacked the stimulus which ordered change in Shaanxi, a fashionable influence reaching Chang'an from Turfan, now established as a Chinese commandery and an early stop from Dunhuang along the northern route through Xinjiang. In the late seventh century, figurines were made here of painted wood, or of poorly fired clay finished with rich ornament in earth-colours, and during the second half of the seventh century this practice was imitated in pottery at Chang'an, using reds, greens, yellow, white and blue.[12] The history of the plain foot soldiers standing stiffly at attention which were common in the later sixth century is difficult to follow in the early seventh century, but by 700 it shows dramatic change: the military now appear enlarged into *shenjiang* (divine generals) and *tianwang* (celestial monarchs), usually made to stand at about half human size – no doubt the limit which the firing technique allowed [368]. Through the first half of the eighth century the control of tense posture improves, the threat of imminent movement reaching to near-dislocation of contorted limbs. In these respects the clay sculpture only gradually realizes qualities already present in the stone sculpture of the Fengxian-si in the eighties of the previous century, but in the best work the comparison is close. A group of 716 from Shaanxi has guardians modified from the Sui model followed in east China independently of Chang'an fashion; but in Shaanxi this type had already been immediately adapted to local demand, first with abundance of realistic detail in armour, dress and facial features, and then, towards the mid-century, with fantasy which brings honest generals into the realm of unreal apotropaeic spirits. A full grave group comprised six figures: two soldiers, two officials and two apotropaeic monsters. The accoutrement of the military may be compared with the painted versions found in a number of deep shaft-tombs of the early seventh century, particularly those of 706 in the tomb of the princess Yongtai, where on the soldier's *zhanpao* (battle dress) one sees more meticulously rendered

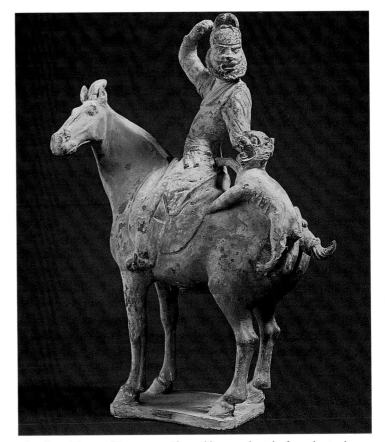

369. *Sancai* figure of huntsman with troublesome cheetah, from the tomb of princess Yongtai in Qian-xian, Shaanxi. A.D. 706. Ht 31.5 cm

the small floral details which potters were at pains to imitate.[13] It becomes clear that in the case of the military guardians, assimilated to the Buddhist *lokapāla* and taking the place of the *fangxiang* tomb-protectors of the Han, the potter was tributary to the sculptors and painters of major works both Buddhist and secular, and the question is posed whether he was equally beholden when he portrayed characters of lay life in smaller figurines. Apart from the face the majority of the larger military figures are decorated in three-colour lead glaze, the celebrated *sancai*. The reds, greens, white and various yellow-browns, with rarer blue, here also imitate the knot-dyed and stencilled textiles which influenced contemporary lead-glazed ceramics in general.

The large and small officials and courtiers, equally colourful in paint or glaze, show less sculptural manipulation, for they mostly stand gravely in waiting, but they introduce for the first time in Chinese art (if some inconspicuous sketchy work in the Dunhuang murals is excepted) a genre-type interest served by the naturalism now in vogue. It is characteristic that a huntsman is shown turning suddenly backwards on his mount as a cheetah tries to join him behind the saddle [369]. These figurines are in the main produced by moulds, like the larger types, but more scope is allowed to free modelling in the finish, and in instances such as the huntsman cited and the figure of a seated servitor feeding a bird,[14] the work appears to be wholly modelled in the clay. The careful

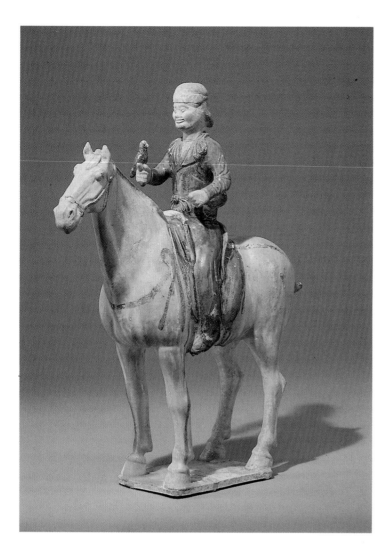

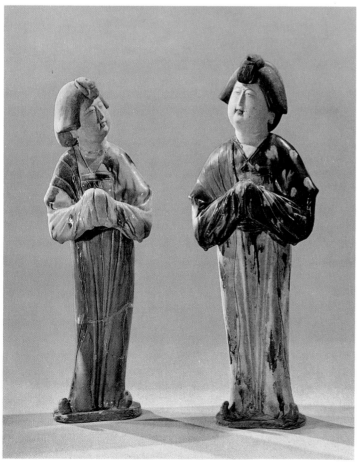

stance of a boy holding a hawk, the straight-backed dignity of a lady riding out, the effort of a horseman mounting, a mounted trumpeter blowing an instrument (this made originally of perishable material and now vanished), a mounted falconer perching his bird [370], are individual subjects portrayed with striking freshness. In the large category of handsome women, musicians, dancers and court officials, elegance of stance, a sinuous waist and often a face treated with exceptional delicacy are main concerns. The rule for court ladies is an attentive demeanour and a plump, pomaded and rouged face with repainted eyebrows and a *tache de beauté* – a ring of six black dots on the forehead [371]. The coiffure can be shown to follow fashion closely, in wing-like extensions and elaborate chignon, with exaggerated versions given to the dancers; the modish affectation of Turkish costume issuing from Turfan, close bodice and shorter skirt as befits the rider, contrasts with the long gown and stole of more normal Chang'an fashion. The riders are given natural proportions while the inclined heads of standing ladies are a little exaggerated.[15] The clay body of the figurines is pinkish or buff, over which a whitish wash is brushed to represent the pale skin desirable in women of distinction. Despite the realistic detail wrought on the tomb figurines there is no evidence that representation of a deceased person was intended, although this has been surmised from the individuality of an occasional figurine. Such is the unique model of a woman seated on a stool found in a tomb near to Xi'an.[16] Here the skirt is decorated with numerous white and red rosettes in relief, set in vertical stripes and suggesting embroidery rather than the usual knot-dying; but the low-cut opening of the neck and the raised right arm with pointing finger appear to indicate a dancer or actress. A woman with the dancer's padded shaped shoulders, pendent sleeves and extravagant head-dress is mounted on a capering horse, as if the movement of her mount replaced the sleeve-whirling dance so often praised in Tang writing and represented among the figurines [372].[17]

The capacity seen in these courtly figures to go beyond the limits of mould routine for the production of individual work is present equally in the figurines of servants, foreigners and grotesques whose *raison d'être* is the celebration of the Inner Asian connexion. During the first half of the eighth century Chinese military prestige and political control in Central Asia were at a maximum. The leading circle of Chang'an and its imitators in other provinces enjoyed as never before the luxury and social panache offered by exotic goods, a situation revealed nowhere more vividly than in the ceramics and fine metalware consigned to their tombs. From the mid-seventh century, nine tenths of the figurines placed in a tomb might represent servants of a lowly order, many of them identifiable as Central Asians from their eyes, beards, noses and dress. Grooms of horses and camels wearing baggy Turkish trousers belong to this facial class. For all the stereotyping there is an individual touch in the best work, and room for wit: the groom straining at a tether, impudently attitudinizing grooms wearing the 'Phrygian' cap of the Parthian or Sogdian citizen [373], a travel-worn bagman with his goods on his shoulders, curly-headed black grooms with quizzical expression, dwarf entertainers. The grasping Sogdian merchant was a figure of fun. Humour and genre

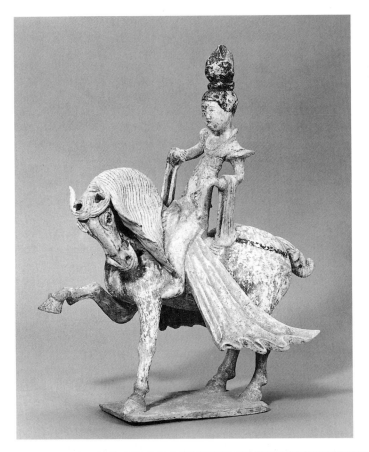

370. (*facing page*) *Sancai* figure of a falconer. First half of the eighth century. Denver Art Museum. Ht 42.9 cm

371. *Sancai* figures of courtiers, from Xi'an, Shaanxi. First half of the eighth century. Heights 42 and 45 cm

372. *Sancai* figure of a mounted dancer. Mid-eighth century. Idemitsu Museum of Art, Tokyo. Ht 45 cm

373. *Sancai* camel and groom. Early eighth century. Asian Art Museum of San Francisco. Heights 58.5 and 89 cm. B60P536, B60S95

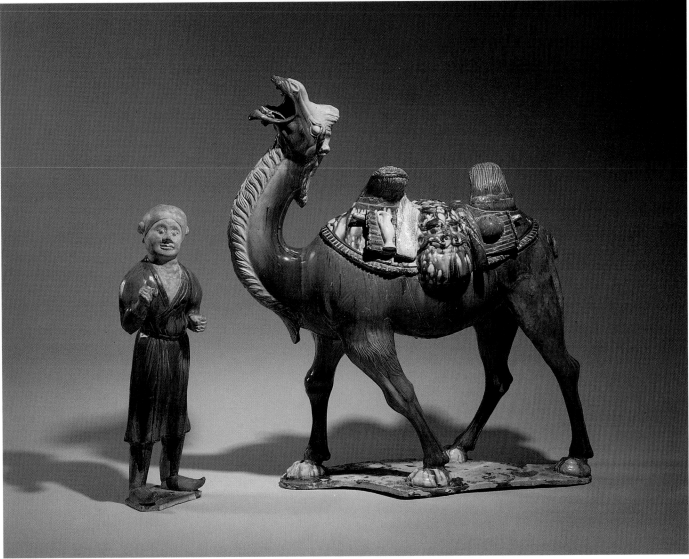

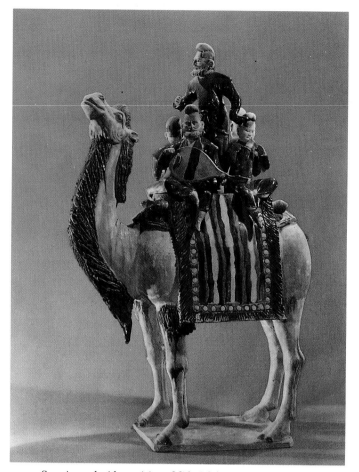

374. *Sancai* camel with musicians. Mid-eighth century. Ht 58.5 cm

Here the accuracy of detail can be more closely checked, and proves to match all that can be otherwise confirmed, in head-straps and saddlery, sweat-cloths and saddle cloths, appended medallion-like ornaments and the saddle and stirrups themselves. In the cover of lead glaze the challenge was greater, for plain and mottled coats of many kinds must be attempted, all under the critical eye of a Xi'an generation of unprecedented horse snobs. Small models were made, but the greatest care was expended on figures of half a metre or more in height [375]. The ideal comprehended exaggerations which may be presumed to reflect points sought by fanciers in the exceptional western breed which the figurines portray: small head and strong neck, prominent pastern-joint (the fetlock tuft not shown), high shoulder and low rump. The saddlery with its ornaments and the head-straps were in the best specimens moulded separately and applied, to be fired together with the whole figurine, or in exceptional figures were added in gilded bronze together with bridle-bit and stirrups. It is likely that various types commemorated particular horses, but the only contemporary comment on the delineation that is recorded appears to be the remark by the poet Tu Fu to the effect that horses painted by his contemporary Han Kan carried too much flesh (although here lack of *bone* is also a hint at painting style). The pottery horse of the seventh century, with light-green high-fired glaze over white slip, is shown lop-necked, while the eighth-century ideal is deer-necked or cock-throttled. Excavation has shown that the former is peculiar to Henan, occurring there both in the early plain glaze and later in full three-colour glaze.[19] But the more interesting variants – the bare-

motif are at a height in the loads devised for figurines of camels: a pilgrim bottle, twists of wool and rolls of cloth, grotesque human masks, vegetables, a monkey; or a jocular load of musicians with their various instruments – *sheng* hand-organ, pan-pipes, flute, lute and *qin* zithers. In their midst stands a female dancer, or the lute-player [374].[18] The camel itself, either dromedary or the Bactrian variety, is a sculpture second in quality only to the horse in the potter's repertoire. The series begins in the Sui period with camels of comparatively squat proportions, the classical type leading to the lead-glazed masterpieces of 720–730. In the final riderless stereotype the camel's mouth is open and the head held high while it takes a long step forward, the general colour white or light brown with detail of mane, saddle-cloth and load picked out in strong brown and green. Others stand still under the control of a separately modelled groom. The theme had been first adopted under the Northern Wei in central China, when it seems to have denoted trade passing northwards through Inner Mongolia, this camel distinct by a small head set on an exceptionally strong neck, lacking lead glaze and in no degree matching the verisimilitude of the version created for the Shaanxi tombs as symbol of the trans-Tarim trade.

The case of the horse model differed from that of the other figurines, for no subject can have been more closely studied or more critically viewed, its rendering outdoing even the lauded horse painting of the mid-Tang period.

375. *Sancai* figure of a horse. Cleveland Museum of Art. Mid-eighth century. Ht 76.8 cm

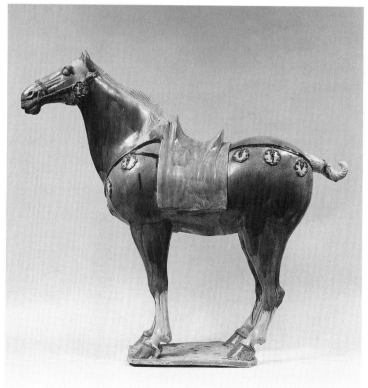

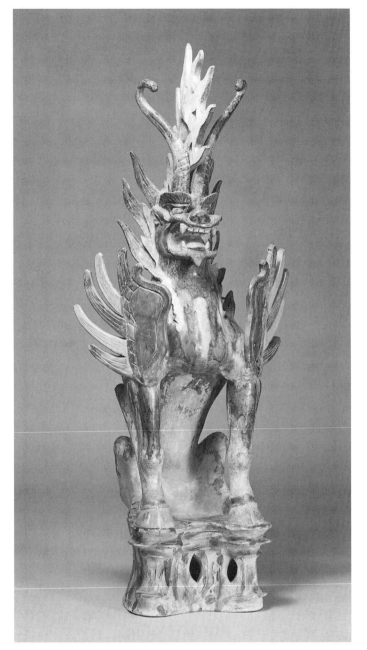

376. *Sancai* apotropaeic lion. First half of the eighth century. Asian Art Museum of San Francisco. Ht 96.5 cm. B60S52

bodied groom displaying his muscles on a neighing mount,[20] horses neighing with head raised or with lowered head inspecting a hoof – all found in Qian-xian, are the work of the Shaanxi potter, sometimes with *jeu d'esprit* in splashing dappled or viscous glaze that can represent the reality only by metaphor. The Henan camel of the eighth century resembles its Shaanxi contemporaries except in its freer glaze splash and the spread of shaggier mane over humps, shoulders and thighs.[21] These points of comparison bear upon the problem of the local origin of the pottery figurines to which we revert below.

Tang apotropaeic figurines work on the inveterate task of devising ever more terrifying monstrosities to ensure the seclusion of the dead. Improving on some earlier eastern types more summarily portrayed, the potters of the decades

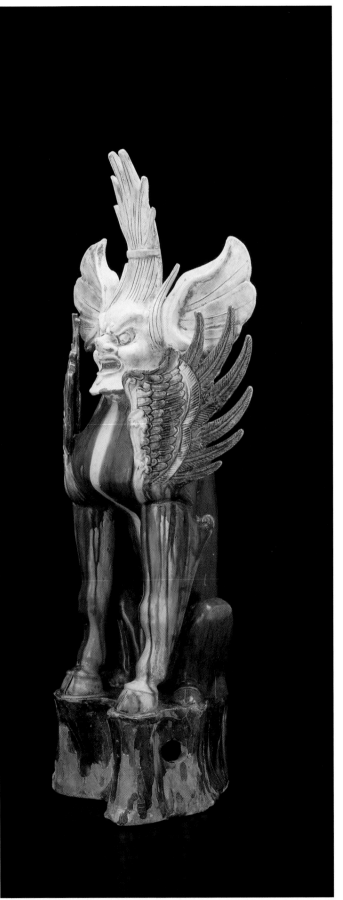

377. Man-lion tomb guardian. First half of the eighth century. Institute of Fine Arts, Chicago. Ht about 65 cm.

after 800 produced a lion and a man-lion of unprecedented repulsiveness. The former, at its most elaborate, is horned and winged, hoofed, crowned by flames, with jaws agape; the latter is similar in other respects but bears a scowling human head flanked by huge vegetable ears [376, 377]. Both have the air of particular invention, in which notions deriving from the tradition of *Shanhaijing* demons are combined with elements of Iranian and Buddhist iconography: the griffin, the raging flame-surrounded anthropomorph of the Mahāyānist pantheon and the pierced rock pedestal used with some Buddhist images to symbolize Himalayan remoteness. The yellow, green and brown of these figurines is applied as mere variegation. Combination, confusion and artistic transformation ever governed the design of these entities. Here the large ugly head of the *qitou* of Han iconographers is taken up.[22] One surmises that drawimgs or models of earlier versions were available to the Tang artists. The prototype of the Tang man-lion first appears made of stoneware in a Henan tomb of 595, a human-faced lion from whose head protrude a pair of horns and a pair of vertical spikes. Half a century later in Shaanxi the *qitou* has quit the previously pointed skull which distinguished him, substituted a top-knot of hair and acquired features of a Central Asian cast. From this to the three-colour versions made in Shaanxi after 700 was a small step in the design, but the figures are now transformed in the energy of their expression and in the unity achieved in combining their disparate parts, the fruit of Chang'an inspiration. The arbitrary choice allowed to the potter-sculptors is apparent in the figure of a bull fashioned with the realism this subject normally achieved, to which is attached a horned head related to the apotropaeic lion.[23] A couched lion, usually with stumpy horns, bent in a curve while it licks a hind paw, derives from the Buddhist throne-guarding lion as a mere ornament. A number of versions of bull or ox, standing quiet or with lowered head and stamping foot, are the most successful of the realistic animal portraits, denoting in their case only worldly wealth. Simpler glazed figurines of dog and pig appear to come chiefly from Henan, where they continue a tradition founded anciently in that region for the representation of domestic animals among the tomb figurines.

LEAD GLAZE AND METAL FORM

The matter of the origin of Chinese lead glaze and of the special uses to which it was put in the Tang period raises problems standing apart from the general history of Tang ceramics. East of Chang'an, only the kilns at Gong-Xi'an in Henan have produced evidence of the production of three-coloured glazed ware. Monochrome lead glaze, brown or green, had been used in Henan from *ca* 100 B.C., covering models and figurines but not vessels intended for food or drink, the motive from the start being the imitation of patinated bronze.[24] The celadon produced in the third and fourth centuries in the Zhejiang/Jiangsu region displaced earthenware and lead glaze as the medium for funeral vessels even when they imitated bronze. Thereafter, until the Tang expansion of the technique, the history of lead glazing on earthenware is tenuous, although through its employment on roof tiles it must still have been practised on an industrial

scale. Two purposes governed the Tang revival: the enlivening of ceramic for its own sake with colours that suddenly made a new appeal, and the imitation of exotic vessel shapes. Both purposes paid tribute to the influence which passed from the Sasanian capital at Ctesiphon, or from Sogdiana, through Kucha along the northern route through Central Asia. Silver, sometimes parcel-gilt, had reached the Northern Wei capital at Datong, Shanxi, early in the sixth century, as witnessed by a dish with relief of a hero in the boar hunt and a boar hunt found there in a tomb.[25] With the advent of Tang the terminus of the chief luxury trade was switched to Chang'an. The kind of decorated pottery ewer made in Shaanxi after 700 was anticipated in high-fired ware farther east. The Lou Rui tomb of the Sui period provides an epitome of the later Shaanxi subjects: in celadon, jar and ewer with ornament of lion masks, petalled rondels and leaf sprays applied in high relief; in earthenware the camel, lion, bull and standing and mounted servitors which a century later were to be essayed in Shaanxi three-colour lead-glazed pottery, with the characteristic transformation of sculptural style.[26] Silver vessels appear in Shaanxi tombs after 700, when their equivalents in lead-glazed pottery at once become a staple of the funeral trade.[27] Although three-colour lead glaze is thus far reported only from the Gong-xian kilns, this manufacture may have been located at other places in Henan and Hebei. Earthenware tiles, at least some of them lead-glazed, must have been made close by in raising any major building, the tile-kiln itself leaving little trace, and with the materials thus available other earthenware goods could readily have been produced. The quality of the figurines made in Shaanxi in the first half of the eighth century is not anticipated in either Shaanxi itself or Henan, tombs of this date in both of these regions showing the style known farther east and south in the Sui period and through the seventh century.[28] Figurines dated to the Tang *floruit* in central China are comparable to the Shaanxi specimens in horses, inferior in human figures and *qitou*, the total impression they make suggesting local manufacture to the Shaanxi pattern rather than importation from that province.[29]

The iranianizing work in three-colour earthenware is confined to the contents of tombs in Shaanxi, most of them in Qian-xian. In designing ewers, the most impressive of the funeral vessels, the Chinese potter freely altered and combined elements supplied by his native tradition and those transmitted from the Iranian west. In pottery, silverware and textiles the artists of the first half of the eighth century initiated a new but comparatively short-lived phase during which ornament departed from the perennial resort to archaistic design. This *floruit* of Tang culture ended in 755 when the rebellion led by An Lushan obliged the emperor to abandon Chang'an. In addition to selection from models currently arriving from the west, the eighth-century repertoire assembled vegetable and jewelled items previously found mainly in the carved decoration of the Buddhist cave-shrines. A stoneware ewer of the early seventh century from Henan is a version of a Sasanian shape, and an epitome of the iranianizing repertoire as it existed before the west-China enhancement of that inspiration a century later. The Henan ewer is overladen with the exotic ornament:[30] a cabochon

378. *Sancai* ewer. Early eighth century. Hakkaku Art Museum, Kobe. Ht 35.6 cm

379. *Sancai* dragon-handle bottle. Early eighth century. Idemitsu Museum of Art, Tokyo. Ht 33.4 cm

jewel combined with a palmette and surrounded by symmetrical petals and small curling fronds; beaded zones and beaded rondels, the latter containing relief of an indecipherable figural subject of Hellenistic type; a sorry-looking hawk's head as lid and an extenuated feline stretched as handle over the whole height of the ewer. A stoneware bowl of 667, excavated in Shaanxi but certainly introduced from a Jiangsu kiln, copies a west-Iranian wooden vessel studded with square petalled jewels and oval cabochons, these surrounded by fine beading, and petalled rosettes.[31] Both of these vessels have broad lotus petals around the base, a contribution from the pervasive habit introduced by Buddhists. Even more telling as representatives of iranianizing taste are a number of so-called lotus-petal bottles in stoneware, whose sides are crowded with petal lobes, florets hanging from medallion-chains, jewels set in palmettes etc., all in deep relief and certainly imitating repoussé silver. The lotus-petal bottles were made in the north-east, probably at a Zibo kiln in north-east Shandong. Similar ornament is found on jars of the mid-sixth century originating also in the north-east, in some instances in a naïve arrangement of widely spaced motifs. Taken together these vessels record an early phase of iranianizing style which is distinct from that adopted after 700 by Shaanxi potters and their Henan imitators.[32]

Ewers in three-colour earthenware were adapted from western examples available in Shaanxi, the relief ornament which is usual on them deriving from the cast or repoussé relief of the models. But immediately were introduced dragon-handles, a more traditional kind of bird-head, and scrolling akin to that already made familiar in the Buddhist cave-shrines and in the detail of funeral monuments, with some archaistic touches which include fragments of the old Han cloud-scroll. One type bears a parrot-like head holding a pearl, the sides of the vessel adorned with floral medallion, strutting phoenix or a Sasanian subject such as a mounted bowman aiming at an animal (or a fleeing warrior delivering his Parthian shot[33]), these motifs framed usually with separate florets or wisps of cloud. The handle may be developed into vegetable nodes and cusps, and the body may be covered entirely with medallions and floreated jewels [378]. The dragon-handle ewer and the dragon-handle bottle take a further step into traditional Chinese form, the lineage of the dragon-head ascending as far as the pre-Han period [379]. On these vessels the different colours of the lead glaze may be applied approximately, or the colours may be freely splashed and dripped across the ornament. The viscosity or fluidity of the glaze largely governed the freer effects, yet beyond this technicality must be recognized an appreciation of the haphazard pattern of polychrome glaze for its own sake. On many pieces where applied decorative items are few or absent, the beauty of surface depends on the glaze

alone. That this should be so presents a distinct phase in Chinese aesthetics: the acceptance in formal ornament of imprecise pattern formed by chance dispersal of colour. Nothing of this kind had been current before, and after Tang it appears rarely; and then, much later, only in terms of kiln transformations of glaze on high-fired ceramics, when the artist's control of the result was even less decisive. In determining the position of defined passages of colour, or the approximate flow of glaze, the eighth-century potter might employ glazes of such viscosity that the vessel could be simply painted with pattern that fired in fairly regular figures; the detail might be contained within grooves impressed on the clay; or areas of pattern might be reserved by the use of gum, wax or rice-paste, in the manner of the knot-dying of textile, so that colour made more exact shapes [380–382].[34] The result is not unlike the decoration of some textiles reaching Shaanxi with the westward trade, which themselves probably legitimated the new and, for China, quite uncharacteristic imprecision in ornamental design. Three-colour lead glazing joined in the cult of the exotic prevailing in the first half of the eighth century. On jars, tripod dishes and bowls its variety is unending. Both shape and ornament may copy Sasanian vessels more or less allusively, the three-colour pattern alluding to ornament cast and repoussé in silver. On the so-called pilgrim flasks the dancing figures imitate the equivalent on Sasanian silver vases, and the ductus of animal design may resemble the heraldic motifs of the Iranian repertoire.[35]

SILVER, PORCELAIN, GOLD

Under western influence arose in Shaanxi a silver craft in small table pieces which mediated between metal and ceramic form to more lasting effect than the earthenware imitation of larger vessels. In three-colour earthenware ring-handled cups, bowls with sharply carinated profile and cups on a pedestal-foot imitated some well-established metal types, but in local silver and the hard-fired stoneware and porcelain which copied it other shapes were added. An early stage of Tang silverware is seen from a Chang'an tomb of 608, plain bowls and pedestal cups, where the decoration that marks the post-700 revival is totally lacking.[36] Some of the silver of the eighth-century *floruit* has been recovered from hoards thought to have been buried during the trouble of the Lu Shan rebellion in the middle of the eighth century, most notably the groups of vessels found at Hejiacun and Shapocun in the southern suburb of Chang'an.[37] Judging from these hoards and from a set of vessels in the Hakkaku museum,[38] a service of gold and silver might hold:

pedestal cups with lobed or carinated sides [383];
ring-handle cups with lobed or segmented sides;
plain pedestal cups;
round bowls carinated, lobed or petal-sided [384];
low oval bowls with lobed sides;
platters with single animals in relief;
bucket with swinging handle [385];
asymmetrical pilgrim bottle [386];
spouted ewer.

380. *Sancai* long-necked bottle. Early eighth century. National Museum, Tokyo. Ht 25 cm

Among the ornamental schemes those using single animals in comparatively high relief (repoussé) are the rarer: boar, bear, horse, phoenix, tortoise, always parcel-gilt [386]. The remainder of these vessels is left plain. On cups and bowls the ornament is chased with a blunt-nosed burin, and punched and raised against a mastic cushion: a scatter of flying birds among florets and cloud wisps is most usual on cups and bowls, all on a ground seeded with small, close-set punched circles.[39] This technique abbreviates the habit of Sasanian silversmiths, whose detail, even the seeding of the ground, is raised in low relief. The mounted huntsmen of

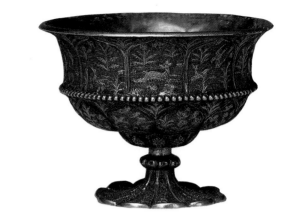

383. Silver pedestal cup. Mid-eighth century. Hakkaku Art Museum. Diam. 5.4 cm

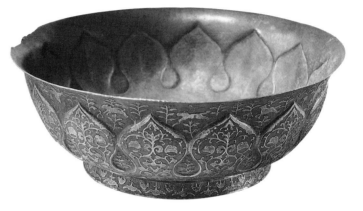

381. Tripod *sancai* jar from Xi'an, Shaanxi. First half of the eighth century. Ht 22 cm

385. (*below right*) Silver bucket with parcel-gilt ornament of birds and flowers, excavated at Xi'an, Shaanxi. Mid-eighth century. Ht 24.2 cm

384. Silver petal-sided bowl. Mid-eighth century. British Museum. Diam. 18 cm

382. *Sancai* tripod dish. First half of the eighth century. National Museum, Tokyo. Diam. 29.3 cm

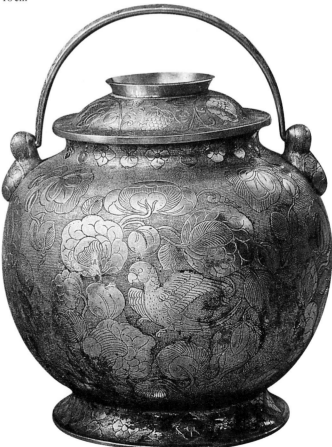

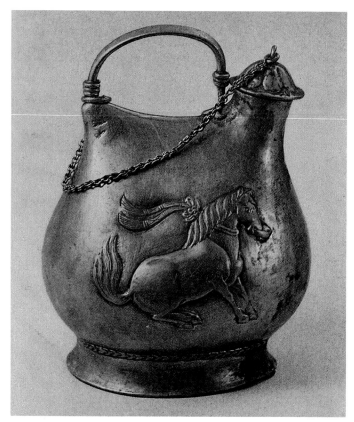

386. Silver flask with gilded relief of horse, excavated at Xi'an. Mid-eighth century. Ht 18.5 cm

the Sasanian platters are introduced into the Tang schemes on a small scale among birds, florets and animals, so that they approximate to the hunting scene familiar in earlier Chinese ornament. On one of the several silver bowls preserved in the Shōsōin and inscribed in Japan with the date 766 the hunter's landscape includes mountains drawn in the style of the archer scene in the Admonitions scroll (p. 202). The vegetable motifs take a hint from the Iranians, but inevitably assume Chinese shaping and ductus, in leafy branching scrolls, isolated nosegays and a scrolled vine, all executed in lighter symmetry than appears on Sasanian models.[40] The *hamsa* goose, and human standing figures raised in relief in a scrolled frame are rarer motifs. The uniformity of much of the ornament on gold and silver argues a close-knit silver-working tradition alive in the first half of the eighth century, but there are variants suggestive of separate workshop practice or distinct pattern-books. Thus gold filigree is applied to the sides of a ring-handled cup, and two further types of composition differ from what has been described. The set of silver vessels preserved in the Hakkaku museum may stand for a more delicate handling of the vegetable motifs than appears in the vessels of the two hoards cited above: plants are double-lined and together with the figures of the hunt are parcel-gilt; a bowl consists wholly of gilded silver. Among the Hejiacun pieces the ornament of the bucket is dissimilar, consisting of parrots placed in a circle of large blooms, all parcel-gilt, the detail in each unit chased within the outline; and corresponding ornament occurs on bowls [385].[41] This broader design is

related to ornament used on silver platters found in Liaoning and Hebei. Besides the vessels made wholly of silver a few surviving objects show the metal combined with other materials. A bowl, itself of silver, is covered with textile as a base for mastic on which is secured a pattern of separate lotus blooms cut from silver foil; and on a pair of iron shears on which intricate scrolling is cast or hammered, the ground is filled with silver.[42]

The distribution of finds of silver east of Shaanxi raises the question whether these are to be accounted as export from the Shaanxi workshops or as the work of local silversmiths copying Shaanxi style more or less successfully. The broader manner attested at Hejiacun anticipates a style which survives into the second half of the eighth century. It is seen developed most individually in parcel-gilt silver platters excavated at Harqin Qi in Liaoning from the tomb of the high official Liu Zan who died in 796.[43] Their decoration consists of symmetrical groups of leaves and petals filled with shaping strokes, surrounding paired dragon-fish, couched deer or lion (the last stretching its muzzle to a rear paw in the manner of the lions made in Shaanxi three-colour pottery). Besides the floral design, the animals and a fish-shaped vase (a type known also in three-colour ware) point to Shaanxi origin. In the Kuancheng-xian of north-east Hebei the find of a similar deer-platter encourages the hypothesis of a particular market for silver of this region of China and raises the possibility of production at some centre nearer than Shaanxi.[44] Meanwhile a gold ewer from Xi'an-yang in Shaanxi belonging also to the late eighth or the early ninth century shows a weakly designed agglomeration of the silver motifs of the *floruit*, in which large blooms are incorporated.[45] A transition is to be observed in silver recovered at Xingyuancun, Yanshi-xian, Henan, where in a tomb of 738 were included boxes (one shell-shaped) and a ladle covered with an altered version of the Shaanxi leafy scroll, as if here were the work of Henan silversmiths imitating the Shaanxi standard.[46] On the other hand a tomb at the same place dated to 814 contained none of this work, but only an eccentric brazier of gilded bronze bearing compact ornament of wide petals, and a silver box with doves and leaves in the broad style, the accompanying bowl, jar and spittoon being of white stoneware. In this change lies the key to the commercial event which displaced silver from funeral gifts in central and east China: the advent of white stoneware and porcelain of high quality. The western influence ceasing, silverware rather copies than dictates to the potter. This is true of plain lobed bowls and a lobed pedestal cup of the ninth century from Zhejiang, where the only decorated silver is a small hemispherical bowl chased with the pattern of a string bag.[47] In Jiangsu in 846 gilded silver was moulded in repoussé with barely decipherable animal shapes for the back of a comb, to the accompaniment of white stoneware vessels. The repoussé of the comb crowds together to produce a knobby surface. Similar relief nearly entirely obscures any flat ground on a silver platter excavated on the West Outer Grounds of the Daming Palace at Chang'an.[48] There is therefore no reason to doubt an origin in Shaanxi for the Jiangsu comb-back, with a date probably in the ninth century. Design of tightly packed leaf and petal excluding any plain ground marks a step away from the

iranianizing schemes of the *floruit* and to some extent a return to a decorative habit of the early seventh century, well represented by a gilt-bronze box of 603.[49] But the last chapter in this silver history is, surprisingly, a notable revival of the *floruit* manner, signalled by a large hoard found at Dingmao-qiao, Dantu-xian, Jiangsu. This is estimated to date from the last decades of the Tang period, and, as suggested by an identical mark engraved on the majority of the pieces, is confirmed as the product of a single workshop.[50] The cups, cup-stands, bowls and ewers of this group are in plain silver, while a number of pedestal boxes, a bottle and some small trays and dishes, and particularly a parcel-gilt model of a tortoise represent new techniques and subjects. The floral ornament, more closely set than in the classical precedent of the early eighth century, is raised in a new style of relief, with dragon-fish, boys playing, pairs of doves; new shapes are a lid like a lotus leaf, oblong lobed dishes, a box with sides conforming to a blossom-spray lid. The tortoise carries on its back a cylinder imitating a sutra-case, the dragon-fish and flowers of its ornament and the scrolled tendrils on the seeded ground are compressed in miniaturist style which ignores the rhythms of the classical model.[51] The fag end of the silver tradition springing from the Shaanxi enterprise of the *floruit* may be traced to the Liao territory of north-east China in the century following Tang. The silver ewers found at Aohan Qi in Liaoning are plain but for a human head applied incongruously to one handle end, while the strange tiger at the centre of a pedestal platter has lost all touch with Tang realism.[52]

STONEWARE AND PORCELAIN

In central and east China the alternation in funeral potteries between green-glazed and white-glazed stoneware broadly reflects the rivalry of the celadon kilns of Jiangsu/Zhejiang and kilns in Henan/Hebei which made a fine white ware their aim in high-quality product.[53] The white surface was ensured either by the use of a pure kaolin or by covering the clay with a white wash, in either case finishing with a colourless transparent glaze. At the Qiaocun kiln in the vicinity of Anyang in north Henan fine-bodied white and green ware was produced shortly before 600, and experiment in both types of stoneware was proceeding contemporaneously at Gong-xian farther to the east in Henan. Since the gradual increase achieved in the body density largely determines the change from stoneware to porcellaneous ware and then to porcelain, no exact division between these categories is drawn. Until the mid-eighth century porcellaneous ware of low translucency was manufactured together with stoneware of varying quality, and not until *ca* 700 was a white clay of sufficient plasticity in use for light potting; in this line commendable elegance eluded the potter before the middle of the ninth century. White slip or an opaque white glaze hiding a greyish body were employed indiscriminately at Henan/Hebei kilns through nearly the whole of the Tang period, but by the end of the dynasty the highest quality and the most refined shapes are found in a white-bodied ware, bearing transparent colourless glaze, which ranks as porcelain by its thinness and translucency.

387. Dish-mouth bottle of white stoneware, with three dragon-head handles. Late seventh or early eighth century. Ashmolean Museum, Oxford. Ht 37.5 cm

The broad technical division which is thus traced between Jiangsu/Zhejiang and Henan/Hebei corresponds also to a general division of aesthetic aims related to a main theme of this chapter: the class of ceramic shapes in which metal form is imitated at a high level of skill. The rivalry of the producers naturally determined that fashionable demand should influence both regions. In the south-east however a tradition calling for vessel shapes based on post-Han bronze lingered more tenaciously than in central China. When celadon was imitated in Henan there appear the four-lug jars, dish-mouth bottles, pedestal dishes, candleholders, tea

bowls[54] etc. of the metropolitan tradition of the south-east, but also the phoenix-head ewer and dragon-handle bottle which reflect the western and ultimately iranianizing influence. A dragon-handle bottle – with three handles – in white stoneware with a clear glaze bears at the base of the handles floral jewels resembling the like motif on Shaanxi three-colour pottery [387]. Another specimen doubles the body in a fantasy akin to the westernizing styles.[55] The imitation of shapes established in silver is associated with the rise, towards the end of the Tang period, of white-ware kilns located in south Hebei, when the primacy of Henan kilns in this line was challenged.[56] The famed white-ware long attributed to kilns at 'Xingzhou' compares most closely with the silverware whose history is traced above. The location of this site, after long dispute, is agreed to lie in south Hebei and probably in the Xingtai-xian, and now is perhaps to be wholly identified with kilns at Neiqiu a short distance to the north of Xingtai city.[57] From the late ninth century shapes copying silver types known in the first half of the eighth century were made at these kilns, in a white porcelain scarcely bettered in the subsequent development of Chinese ceramics. Plain cups or cups on a small pedestal, ring-handled cups, bowls and shallow dishes with lobed sides, and dishes with inscribed peony scroll are among the pieces which chiefly recall the early silver. The later phase of silverware, comprising plain-surfaced vessels with allegiance to the central and eastern regions and dating from the ninth century, appears to inspire unprecedentedly thin and translucent porcelain distinguished by its foliated outlines. One dish has its lip divided into five ogee lobes and its centre impressed with the design of a peony flower; another takes the shape of a five-petalled althea flower whose petals are divided and lightly scored with radiating lines [388]. Before the end of the ninth century this excelling ware reached Zhejiang, where the tomb of Qian Kuan, dated to 900, contained sets of floreate bowls and lobed cups, the latter including an example of the oval pedestal-cup of the classical early-eighth-century shape.[58] In white stoneware/porcelain also were made models of metal objects which in Shaanxi were subjects of a kind for imitation in lead-glazed earthenware: censers of various shapes,[59] a pacing caparisoned lion of the Buddhist imagery [389] and a lion protome forming a rhyton of a western type [390]. Meanwhile the flower of Zhejiang celadon looked to its own more traditional ornament, the vegetable motif freely incised (i.e. not impressed) and the dragon pair carved no less freely amid their clouds.[60] The style of silverware was rarely followed.

Our incomplete knowledge of the decorative metalwork of the Tang period, other than silverware, is due to the almost exclusive part given to ceramics in funeral furniture. Something can be said of the design of mirrors, and regretfully little of the goldcraft and jewellery whose superlative standard can be shown from a few outstanding pieces. Like the silver, the decoration on the back of bronze mirrors in part prompts comparison with motifs occurring also on textile, qualified by the necessity of the circular field and extended by the inclusion of inherited items, while some schemes of striking originality find no parallels in other departments of craft. After the turn of the second and third centuries mirrors virtually disappear from tomb gifts until the Sui period. The

388. Foliate dish of white porcelain. Ninth century. Asian Art Museum of San Francisco. Diam. 13.6 cm. B60P1392

compact schemes adopted at that time are in tune with other contemporary systems of extended decoration: six contiguous rondels holding phoenix and hunting dog, or a pattern of stiff florets repeated in six equal segments of the circles; in the outer zone an inscription, or a succession of panels with stiff linear sprays resembling those of the interior. Similar schemes persist for a decade or two after 600, rectilinear frames replacing the rondels or processing animals with reminiscence of the Han TLV scheme.[61] But no design could be more inimical to the canons of the *floruit* ornament, and after 700 no further archaism of this order appears. Two types predominate in the first half of the eighth century. The more individual, as presenting ornament absent from other departments of decorative art, is the scheme known as *qinshou putao jing*, the mirror decorated with birds and animals on grape vine [391]. The comparative uniformity of the design and its close dating within a few decades suggest discrete invention and production at a single workshop. In appearance varying between squirrel, rat and monkey, the animals cavort in very high relief through a net of vine tendrils bearing a few leaves and many bunches of grapes. Three or four parakeets usually occupy the outer zone of the circle, at whose centre is a larger indeterminate beast, the whole contained within a band of simple scrolling. Variants of the scheme introduce peacocks, add a wide outer zone with more animals and vine, or frame the whole in a line of rosettes. Never before had the mirror ornament been so animated in delicate relief. Although the items are many times repeated, symmetric arrangement is sedulously avoided. The mirrors stand at the very apex of their craft. When unaffected by corrosion their surface has a dull silvery sheen which is characteristic of Tang mirror-making, and prompts retrospect on the technique of the art as it was

389. Pacing caparisoned lion of white stoneware, serving as stand for a Buddhist image. Late seventh or eighth century. British Museum. Ht 19.5 cm

391. Bronze mirror back with repoussé birds and animals in grape scrollery. Early eighth century. Formerly Vannotti collection. Diam. 9.9 cm

practised from the late Han period.[62] The composition of the bronze alloy is found to be fairly uniform from the Period of the Warring States to the Tang period, the aim being constant: to produce a hard surface capable of taking sufficient polish for reflection and to resist the internal strain on cooling which is caused by the varying thickness of mirror plate and its relief ornament. Tin accounts for a quarter of

390. Rhyton of white stoneware, shaped as a lion protome. Late seventh or eighth century. British Museum. Ht 12.7 cm

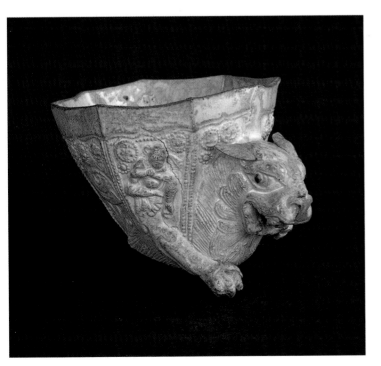

the alloy in most cases, rising to a third in the silver-bright Tang mirrors.[63] As against the greenish or black colour of Han mirrors, those of the eighth century are often silver bright; but the collector's persistent notion that silver was involved in the production receives no support from analysis. Nevertheless special treatment seems likely in their case, possibly an induced tin-enrichment of the surface in the course of casting, but the nature of the process awaits elucidation. At the beginning of the eighth century the art of the mirror involved silversmith and goldsmith as well as the bronze-caster. The meticulous building of the mould model in wax as still followed by the majority of the Tang mirrors could be transferred to repoussé in precious metal, making a circular plate to be fitted on to the bronze bed. Then the animals of the *qinshou putao* rise to virtual ronde-bosse, on a ground seeded with the usual small circles, or scrolls are tweaked up to give a breaking-wave effect. Exceptionally, in specimens where the applied back is of gold, the design takes the animals-and-vine as its start but enlarges detail of birds and vegetable and floral items into an individual scheme [392].[64]

The second mirror design of the *floruit* recalls more closely the range of ornament found on the contemporary silver vessels: arrangements in moderate relief of scrolled leafy tendrils interspersed with birds, running animals, even the mounted huntsmen of the iranianizing repertoire. The design has symmetrical or revolving repeats, with about one half of the ground left plain. Often the outline is formed into eight ogival lobes separated by a prominent ridge from the interior ornament, each lobe with its own floret. Phoenixes confronted among floating flowers and plants are among the most graceful of these inventions [396]. At this point occurs a rapprochement of mirror ornament with that of textile, the

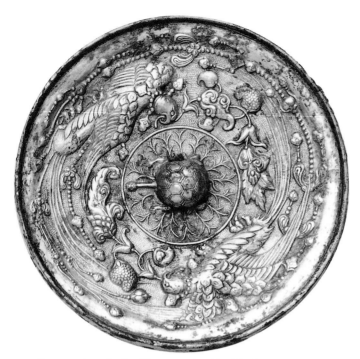

392. Bronze mirror back with repoussé gold of birds and grapes. Early eighth century. Formerly Vannotti collection. Diam. 9.4 cm

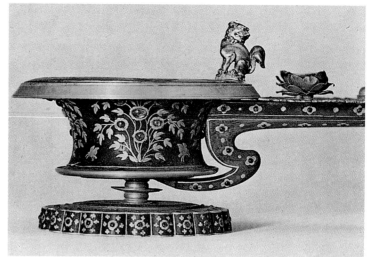

393. Detail of a bronze censer, preserved in the Shōsōin, Nara, Japan. Mid-eighth century

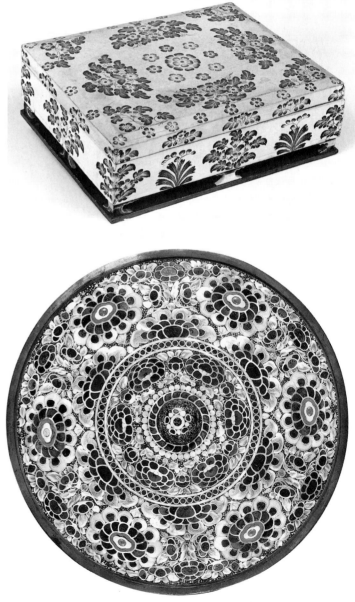

latter clearly the origin of the motifs. The jewelled motifs, the flying birds and scattered flowers and plants, the paired phoenixes and careering horsemen, all are found wax-dyed on gauzes and other silk weaves of the eighth century.[65] A distinct class of the mirrors, probably to be dated towards the middle of the eighth century, relies on reproducing the circular blooms, more or less elaborate, which figure on wax-dyed silk and on brocades woven on the draw-loom with multiple warps.[66] No material surviving in China illustrates the ornament of the mid-eighth century so well as the possessions of the Japanese emperor Shōmu. In 756 they were dedicated by his widow to the Buddha of the Tōdaiji; stored in the Shōsōin treasure-house, they have remained in perfect condition until the present day. The floral themes are to be seen dyed and woven on fabrics, worked into carpets, painted on silk and wood, as inlay of mother-of-pearl and ivory [393–5]. All arise from the elaboration of the more or less formal multiple rosette whose origin and development can be studied in the roof ornament of the Dunhuang cave-shrines, and in the jewelled motifs of the Tang International Style. Mirrors bearing ornament paralleling silver or textile motifs, more rarely the *qinshou putao* type, have been excavated from tombs of the earlier eighth century in central China, in Henan and Hunan. In the late eighth and the ninth centuries the influence of *floruit* style declines, and the chief place is taken by less strictly ordered and more crowded floral schemes, and dragons in cloud. In the final Tang decades, briefly drawn coursing animals lose classical quality altogether.[67] A new departure of the mid-ninth century in Sichuan is a figural design which anticipates the pictorial ornament of Song-dynasty mirrors.[68] Two persons, men or women, are shown below a leafy tree, apparently engaged in farm pursuits, a theme echoing a

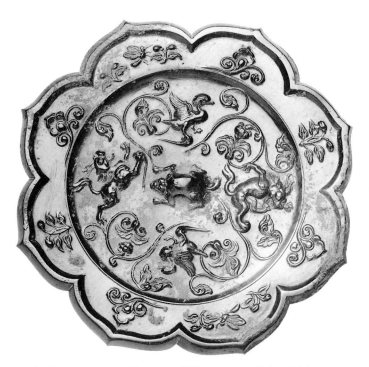

396. Bronze mirror with cast relief ornament. Early eighth century. Formerly Vannotti collection. Diam. 22 cm

bucolic interest of Sichuan art already manifest in the later Han period.

While much of the craftwork described above has employed gold as applied foil or gilding, nothing is said of work wholly executed in the metal. Comparatively little in solid gold survives from the Tang period, or is made available in publication. Some boxes show the metal treated in the same manner as the silver, but the design is surprisingly jejune.[69] A bowl with a pouring lip and beading around the rim may be typical of vessels which relied for effect on the more or less plain metal.[70] Some sporadic excavated fragments of the sixth century and pieces attributed to Tang show continued mastery of the granulation and filigree first practised in the Han period but, with a few exceptions, they are of minor interest as specimens of the craft. A compact and intricate buckle worked chiefly in granulation, found at Bogedaqin in Xinjiang, so closely resembles another from the Chinese station at Pyongyang in North Korea that it would appear to be of the same Eastern Han date. The source of this advanced work has not been located, and the post-Han history of the craft, if indeed it continued, remains obscure.[71] The finest intact piece of jewellery thus far discovered in China, excavated on the site of a residence within the Xi'an precinct, is believed to have been imported from north India before the end of the sixth century. We may judge here the variety and quality of jeweller's work which challenged the skill of Tang goldsmiths: twenty-eight pierced decahedrons made of gold with granulation, about one centimetre in diameter and each encrusted with ten pearls, are the links of a necklace measuring 66 cm in length; at the juncture, and pendent below, are semi-precious stones in granulated frames, the central lower stone of amber colour and the others of various hues of lapis-lazuli.[72]

394. Painted wooden box, preserved in the Shōsōin, Nara, Japan. Mid-eighth century

395. Bronze mirror backed with ornament in mother-of-pearl, preserved in the Shōsōin, Nara, Japan. Mid-eighth century

List of Bibliographical Abbreviations

ACB Watson, W., *Ancient Chinese Bronzes*. London 1962, 1977.

ADC Watson, W., *Art of Dynastic China*. Paris 1979 (*L'art de l'ancienne Chine*), Freiburg 1980 (*China, Kunst und Kultur*), New York and London 1981.

BH1 Binyon, L., ed., *Catalogue of the International Exhibition of Chinese Art 1935–6*. Royal Academy of Arts, London, 1935.

BH2 Watson, W., *The Genius of China: An Exhibition of Archaeological Finds in the People's Republic of China*. Royal Academy of Arts, London, 1973.

BMFEA *Bulletin of the Museum of Far Eastern Antiquities, Stockholm*.

CFS Watson, W., *Cultural Frontiers in Ancient East Asia*. Edinburgh, 1971.

FCB Pope, Gettens, Cahill, Barnard, *The Freer Chinese Bronzes*. 2 vols. Freer Gallery of Art, Washington DC, 1967.

GBAC Fong Wen, ed., *The Great Bronze Age of China. An exhibition from the People's Republic of China*. Metropolitan Museum of Art, New York, 1980.

JW Jenyns, R. S., Watson, W., *Chinese Art: The Minor Arts*. 2 vols. Fribourg, 1963, Tokyo, 1964 (Japanese).

KG *Kaogu*. 考古

KGXB *Kaogu. Xuebao*. 考古学报

PTC Watson, W., *Pre-Tang Ceramics of China*. London, 1991.

NPM 300 Three hundred masterpieces of Chinese painty in the National Palace Museum, Taichung 1959.

TLC Watson, W., *Tang and Liao Ceramics*.

WW *Wenwu* (including the early *Wenwu cankao ziliao*).

XKF Xia Nai, ed. 新中国的考古发现和研究 Beijing, 1984.

Note that 'Institute of Archaeology' alone refers to the Beijing institute first under the Academy of Science, later incorporated in the Academy of Social Science.

Notes

CHAPTER 1 NEOLITHIC ART

1. For early history in the light of archaeology, see in the *History* section of the General Bibliography: Creel 1937, Granet 1934 and 1957, Kaizuka 1946, Maspero 1965, Maspero and Balazs 1967, Chang Kuang-chih 1980, Keightley ed. 1983, Elisseeff 1979, and the early chapters of *The Cambridge History of China* (Twitchett and Loewe ed.); for mythology, see in the General Bibliography *Mythology and religion*: Granet 1951 and 1959, Maspero 1971, Wen Yiduo 1948, Morimi 1944, Yuan Kê 1957, Allan 1991.

2. On the regional divisions of early potteries see *PTC*.

3. Detail on this and later ceramic groups in *XKF* and *PTC*. The first manifestation of Henan tradition is referred to a Peiligang culture, and it is debated whether this phase should not be regarded as the inception of Yangshao.

4. Dahecun culture, said to be some 1500 or 2000 years later than Peiligang, and apart from the pottery not closely connected with the earlier culture.

5. e.g. at Liuzizhen on the Wei river.

6. Institute of Archaeology 1963.

7. ibid. pp. 166–8, 176–7.

8. cf. Zhang Xuecheng's map in Watson 1971a (Bib. Ch. 7) p. 31.

9. *XKF* pp. 68 f.; *PTC* pp. 50 f.

10. At the Zou-xian site itself the deposits cease before the appearance of Longshan types, but at other places the Dawenkou series is shown to pass into Longshan in the upper layers. 'Dawenkou culture' is classified separately from Longshan, although the two traditions are intimately connected, only the latest phase, the classical Longshan, making its appearance in Henan.

11. In the south-east the pillar beakers betoken the Liangzhu culture. *PTC* p. 178.

12. cf. *BH2* nos. 40, 41.

13. Academia Sinica 1934 (also Starr 1956); Liang Siyong 1954.

14. *XKF* pp. 105 f.; *PTC* pp. 79 f. reviews the problems of the north-western painted ceramics as they stood in 1990, noting the current bibliography. For extension of the painted-pottery culture into Qinghai see Qinghai Province Archaeological Team 1984. Other aspects in Andersson 1923, 1947; Palmgren 1934; Watson 1960.

15. *XKF* pp. 118 f.

CHAPTER 2 SHANG ART

1. The initial, pre-war, excavations on Shang-date sites in Henan were published by Academia Sinica in Beijing up to 1936 and after 1949 in Taipei. Summaries of these, and of post-war excavations in Henan and beyond, are found in Cheng Te-k'un 1959 (Gen. Bib. *Survey*); Chang K. C. ed. 1986, Creel 1937 (Gen. Bib. *History*), Guo Baojun 1933a, b, Li Chi 1977, Ma Dezhi *et al.* 1955, Umehara 1939, 1959, Zou Heng 1956, Rawson 1980 (Gen. Bib. *Survey*), Watson 1962a (Gen. Bib. *History*), 1977 (Gen. Bib. *Archaic bronze*). Of the volumes of illustration listed, the catalogue by Pope, Gettens *et al.* (ibid.) is notable for its technical information, *GBAC* for its introductory fulness and large-scale photography, and Sugimura 1966 for enlarged illustration of detail.

2. It must be said that nearly the whole of the antiquarian literature is concerned with the inscriptions cast on ritual bronze vessels, illustrations where they exist helping artistic analysis but little.

3. See Kane 1974, Bagley 1980c.

4. The three divisions as usually named by western writers are:

1. Erlitou phase
2. Zhengzhou phase
3. Anyang period

Chinese authorities prefer:

1. Erlitou culture period
2. Erligang period
3. Yinxu period

The latter scheme avoids identifying the strata excavated on the site near to Anyang with the presence of a seat of government, or a central ritual site, at the same place, although this identity seems most probable and is generally assumed. The 'Erlitou culture period' is regarded as corresponding either to the Xia dynasty of history (twenty-first–sixteenth century B.C., traditionally 2205–1760 B.C.), or to an early phase of the Shang dynasty, the former view prevailing among Chinese scholars.

5. In the opinion of most Chinese scholars, who ever question diversity of origin, the 'Erlitou culture' is made to account for all contemporary developments in north and central China, thus extending supposed political dominance from Henan to the south-east and in other directions.

6. Hubei Provincial Museum 1976b; Henan Provincial Museum 1975. The finds made at Panlongcheng and other sites in the Yangtze basin fuel the argument about the Anyang origin of Shang styles and the existence of independent traditions in regions located far to west, south and east. While regional variation may be adduced in support of a wide territorial base for the developed bronze age and its arts, strong aspects of similarity in vessel shapes and ornament must indicate a manner of diffusion, to be interpreted as political dominance from a centre, ostensibly Henan.

7. Institute of Archaeology 1965b. *GBAC* nos. 31–40. Bagley 1980d.

8. See Karlgren 1935, 1937, 1944, 1946, 1951.

9. *ACB* pl. 36a.

10. Bachhofer 1944 pp. 107–16.

11. Loehr 1953: Loehr's five styles are compared on p. 13 with four styles defined by Li Chi and Wan Jiabao, both systems basing the sequence on a supposed succession of technical method.

12. *KGXB* 1955 9 25. Watson 1960 (Bib. Ch. 12) p. 22, pls. 45–52.

13. Shanxi Cultural Office 1958; Gao Zhixi 1960; *BH2* nos. 79, 81.

14. cf. Watson 1973b pp. 1–13.

15. cf. *ACB* pl. 81a, (correctly) of the tenth or ninth century B.C.

CHAPTER 3 BRONZE IN THE XIZHOU PERIOD

1. A Zhou potentate was described as *bo*, 'earl' of the west, in oracle period I = Wu Ding; at the end of Shang the term was *Zhou hou*, 'marquis' of the west. The historical tradition that Wen Wang of Zhou unified all the west against Shang is probably a later invention.

2. cf. a *pou* in the Nezu Institute of Fine Arts 1978 p. 202, no. 651.

3. cf. Watson 1970a (Bib. Ch. 2) pp. 171–86. For the *gui*, see *ACB* pl. 45b.

4. Tang Jinyu *et al.* 1980.

5. These affiliations are the basis of the analysis in Karlgren 1937 (Bib. Ch. 2).

6. As at Zhuangbai, Fufeng-xian, Shaanxi. See Shaanxi Zhouyuan Team 1978.

7. Lintong-xian Museum 1977; Zhang Zhenglang 1978.

8. Ch'en Mengjia 1954 (Bib. Ch. 2) p. 29 pls. 40–1.

9. Sichuan Provincial Museum 1981; Institute of Archaeology 1984.

10. Suizhou City Museum 1982; Cheng Changxin 1983.

11. Shi Xingbang 1954, p. 121.

12. Lodge *et al.* 1946 (Gen. Bib. *Archaic bronze*) pls. 29, 28; Pope *et al.* 1967 no. 50, pl. 50; no. 66, pl. 66.

13. Gê Jin 1972; see *GBAC* nos. 49–51.

14. *ACB* 39a.

15. Some *guang* incorporate *taotie*, *leiwen* and other motifs known in late-Shang, and have been accordingly attributed to the Shang period; but the generalization made here as to the proliferation of zoomorphic vessels in the first Zhou decades applies to *guang* as to other shapes. Some specimens (e.g. Shanghai Museum 1964 (Gen. Bib. *Archaic bronze*) no. 15) display the large bird motif, attesting a Shaanxi affinity and probably a post-Shang date.

16. Institute of Archaeology 1986.

17. It may be added that the elongated bird is further associated with features apparently alien to Yinxu, e.g. the ruminant-head handles, the *gui* on a foot-rim with plain sides or rhomboid reticulation and bosses.

18. Pope *et al.* 1967 no. 58.

19. Shanxi Antiquities Committee 1986.

20. *ACB* 32, 44a.

21. *ACB* 43a.

22. Shaanxi Zhouyuan Team 1979a. One may speculate whether the bird in the large version represents the red-bird emblem of the Zhou rulers or the yellow-bird emblem of the Yellow Emperor. The design can only be derived from the peacock, which reappears unmistakably in Han iconography but can hardly be traced in the interim. On the *guang* of *ca* 1000 B.C. excavated in the Fufeng district of Shaanxi a broad tail with 'eyes' suggests the peacock, although only small birds appear in other ornament. cf. *BH2* no. 90.

23. *ACB* 16.

24. For examples of the 'double-G' motif in process of evolution, on documented pieces, see Xinyang District Committee 1980a, b.

25. For examples see Shaanxi Zhouyuan Team 1979b and 1986; Inner Mongolian Archaeological Institute 1987.

26. *BH2* no. 95.1r.

27. Sun Jingming *et al.* 1983, cf. pl. I/5 with pl. II/1.

28. For the Western Zhou period we cannot broach the question of the location of bronze foundries and the centres whence the various styles were disseminated, beyond an inference that the earliest Zhou work belonged to the *heimat* in Shaanxi and that vessels were cast at the cities of the chief feudatories in central China, or under their instructions. The existence of bronze casting at more or less remote places is borne out by groups of vessels decorated in styles differing from those that have been described and showing distinct provincialism, e.g. the *kui*-derived band on a *ding* excavated in Jiangsu (Liu Xing, Wu Dalin 1976), the deformed animal triple band on vessels from the vicinity of Beijing (Cheng Changxin 1983). The presence of the humped *kui* on one piece of the latter group indicates early-Zhou date.

CHAPTER 4 BRONZE IN THE CHUNQIU AND ZHANGUO PERIODS

1. Shandong Archaeological Institute 1984.

2. Henan Provincial Museum 1981; Shandong Provincial Museum 1978.

3. Huaining Cultural Office 1983.

4. Zhenjiang Museum 1987.

5. Sui-xian Museum 1980; Hubei Provincial Museum 1980.

6. Baoji City Museum 1980; Nanjing Museum 1985.

7. cf. *ACB* 56b. All the stages of the processes we describe are represented on bronze vessels excavated in Henan: cf. Institute of Archaeology 1959c. The Shanbiaozhen site appears to be dated too low by the excavators ('300–240') unless an unparalleled reburial of older bronzes is assumed. Among the Liulige bronzes are examples of all styles from Chunqiu to the varieties of late-Zhou inlay.

8. Arguments for the dating of the Cai tomb are reviewed in Soper 1964 pp. 3–7. The earliest date inferred is 517 and the latest (Guo Moruo) 457. In the light of subsequent excavation the latter appears too low.

9. Luoyang Museum 1981; Xinyang District Committee 1984.

10. cf. *BH2* no. 101.

11. Ma Chengyuan 1960.

12. Salles 1934 pp. 146 ff.; Shanxi Archaeological Institute 1989.

13. ACB 65b; Institute of Archaeology 1956b.

14. Karlgren called these motifs 'teeming hooks and spirals', and the less geometricized variant has been termed 'feather-and-curl', the two not being kept strictly apart. It seems well to make a systematic distinction, for each type had its sequel; and 'spiral-and-triangle' will serve better for the first, since the angularity of the triangle is a persistent feature.

15. See *BH2* no. 135. Correspondence of the terminology adopted in *ACB* with that of the present account is as follows, the earlier term preceding:

Shanxi style:	the two Houma/Liyu styles;
First Huai style:	the style of the Cai Hou bronzes, now better seen as a provincial version of Liyu style;
Second Huai style:	the Henan picturesque style;
Third Huai style:	the three subdivisions of Henan geometric style.

The changes are made necessary by the now obligatory abandonment of Karlgren's 'Huai style', which was adopted for nearly all Warring States styles in recognition of a supposed primacy of Anhui province, as represented by the contents of richly furnished tombs situated in the Huai river valley, especially near the town of Shouzhou.

16. The so-called Stoclet bell and the *Huangchi hu* of the former Cull collection: W. P. Yetts 1939 no. 12; Watson 1965.

17. *JW* no. 8.

18. e.g. on the *bianhu*, *ACB* no. 67b.

19. Note especially Hunan Yiyang District 1985.

20. Drawn wire was not known in China at this time. The fine spiralled lines of precious metal were cut from foil and sometimes can be seen to be continuous with the wider panels of inlay.

21. Some examples are: chariot-pole mount, Watson, 1963 (Gen. Bib. *Survey*) pl. 39, and *BH2* 127; Wenwu Chubanshe 1976 (*Xuan*) no. 63; *hu* in the Art Institute of Chicago and the Metropolitan, Loehr 1968b (Gen. Bib. *Archaic bronze*) nos. 72, 73; inlay in iron, *BH2* 131; Pope *et al.* 1967 (ibid.) no. 99; Lett 1959 (Gen. Bib. *Survey*) nos. 25, 30.

22. Examples are: Tokyo National Museum 1981 no. 38; *ACB* col. pl. G left, 80a, 80c; Hubei Yichang Museum 1988 (Bib. Ch. 5); *ACB* 80a, 80c; Sichuan Antiquities Committee 1956.

23. Watson 1963 (Gen. Bib. *Survey*) pl. 19.

24. ibid. pl. 18. cf. *JW* no. 40. Further examples are: *ACB* 76b; *Xuan* no. 64; *GBAC* nos. 75, 76, 77–90.

25. *FCB* nos. 100, 101, pls 94, 95.

26. *Xuan* no. 65.

27. Loehr 1968b no. 70, in the Minneapolis Institute of Art.

28. See Hubei Cultural Office 1966; Watson 1972.

29. Wu Shunqing *et al.* 1988 pl. III/3.

30. *FCB* no. 104.

31. Guangdong Provincial Museum 1974.

32. cf. *JW* no. 39, a *hu* so exceptional that it was at the time of writing thought to be an archaizing work of the Song period.

33. cf. *JW* no. 23.

34. *ACB* 89c.

35. Institute of Archaeology 1959b p. 105, pl. 69; *JW* 23; *WW* 84 1 10 pl. 2, p. 17; Watson 1967; *ACB* 89c.

36. Lion-Goldschmidt 1960 nos. 44, 45.

37. *ACB* 85a, c, d; 86a.

38. *ACB* col. pl. G right, 86b; Watson 1963 pl. 26.

39. Henan Antiquities Team 1979.

40. For examples excavated in Sichuan see Wang Youpeng 1987.

41. Shanghai Museum 1964, no. 71; *GBAC* no. 70.

42. *GBAC* no. 70; Watson 1960, no. 86; Hubei Provincial Museum 1980 no. 47; Eskenazi 1989 no. 5; d'Argencé 1977a no. XLIV; Gushihou Gudui Group 1981 pl. 2/2; Zhejiang Antiquities Committee 1984 pl. 2/1.

43. Lett 1959 no. 24; *FCB* no. 98; *ACB* 62a; d'Argencé 1977a no. XLIII; cf. Song Zhaolin 1981.

44. See *GBAC* no. 91; Sichuan Provincial Museum 1976; Han Wei *et al.* 1981 (pl. 5/3); Zhenjiang Museum 1987; Ye Xiaoyan 1983; Shanxi Provincial Museum 1957.

45. Tokyo National Museum 1981 no. 4; Henan Antiquities Team 1979; Liu Laicheng, Li Xiaodong 1979; Li Xueqin, Li Ling 1979; Huang Shengzhang 1979.

46. Hubei Provincial Museum 1980 pl. 54.

CHAPTER 5 JADE

1. Berthold Laufer's magistral volume launched the western study of the subject in 1912. Jade ceremonial and antiquarian lore as it appears in the Chinese classics (*Shujing, Zhouli, Yili*) and collectors' writings is summarized in Jenyns 1951 (we may now correct the impression given in his chapter 'Difficulties of chronology from lack of archaeological evidence'). Salmony 1938 and 1952 furnish a most valuable corpus of the early types. Latter-day theories are criticized in the light of archaeology by Xia Nai 1983. Hansford 1968 devotes a long chapter to the material and its sources. The archaeological evidence for the Siberian connexion is discussed in Watson 1971a (Bib. Ch. 7).

2. cf. Liu Dunyuan 1988.

3. Penannular rings of the Siberian type in nephrite and agate have been found at the Yinyangying neolithic site near Nanjing (Jiangsu). See Nanjing Museum 1958 pl. XVII.

4. See Changshou City Antiquities Committee 1984; Wang Zunguo 1984; Shanghai Conservancy Committee 1986; An Zhimin 1988; Zhang Minghua 1989.

5. In the classics and in antiquarian literature the *bi* and *zong* are designated symbols of heaven and earth, and sovereign emblems. August meanings are attributed to the different jade colours – green, black, white. A medieval antiquarian believed the *zong* to be 'part of a chariot wheel nave', cf. Jenyns 1951. The Ming period saw the antiquarian production of myriads of close copies or fanciful variants of *zong* and *bi*.

6. cf. radiological dates of 3050, 2850, 2790, 2250 B.C. See Wang Zunguo 1984.

7. cf. Institute of Archaeology 1975, 1976a, 1986b. On the *jibi* (*xuanji*) see Cullen and Farrer.

8. Henan Cultural Office 1957 pl. IV, nos. 2, 3; Institute of Archaeology 1959a (Bib. Ch. 2) pl. XXX.

9. On technique see *KG* 1976 4 229.

10. Willetts 1958, Chapter 2, compares the shapes of neolithic and later jade artifacts, summarizes knowledge of the method of manufacture, proposing utilitarian origins of the shapes, and recounts latter-day symbolism.

11. Institute of Archaeology 1982a, 1977.

12. Sickman and Soper 1956 pls. 1, 2.

13. Guo Baojun 1936, Umehara 1959 (Bib. Ch. 2).

14. An unusually sophisticated type of the *jue* has terminals at the radial gap shaped to suggest the head and tail of a dragon; the perimeter may be notched in the manner of the 'astronomical' *bi*, and the inner rim flanged in accordance with

one class of *bi* made in the late neolithic of the south-east and in the Shang period.

15. See review of *jue* in You Rende 1981.

16. Institute of Archaeology 1979, 1987b.

17. Shanxi Archaeological Institute 1986. The deer, so important in the later art of the Inner Asian steppes, is comparatively rare in early Chinese art. A deer mask occupies the principal place in the decoration of one of the two large rectangular *ding* from the royal tomb at Xibeigang, of the early Yinxun period; in jade the pieces cited appear to be the only excavated specimens. One may question the date or the authenticity of the British Museum's two plaques of complete antlered deer, often attributed to the Western Zhou (Jenyns 1951 pl. XXVII G, H).

18. Sites are Hebei Liulihê, Shaanxi Fufeng, Haojing, Fengxi (Institute of Archaeology 1984 (Bib. Ch. 3); Shaanxi Zhouyuan Team 1986; Shanxi Antiquities Committee 1986; Institute of Archaeology 1962a (Bib. Ch. 3).

19. Henan Provincial Museum 1981.

20. Xinyang District Committee 1984.

21. Zhang Changshou 1987.

22. Institute of Archaeology 1987a.

23. Henan Provincial Museum 1981; Hunan Provincial Museum 1984a; Jin Xueshan 1957; Institute of Archaeology 1957 (Bib. Ch. 4) pl. 45.

24. Shanxi Archaeological Institute 1984.

25. Zhejiang Antiquities Committee 1984.

26. Hubei Jingzhou Museum 1982; Hubei Yichang Museum 1988.

27. On the *chi*: You Rende 1986.

28. Institute of Archaeology 1959c (Bib. Ch. 4) pls. 110 ff.

29. Tokyo National Museum 1981, pls. 44 ff.

30. cf. Henan Antiquities Office 1979 (Bib. Ch. 4).

31. Shandong Archaeological Institute 1982 pls. 94 ff; Institute of Archaeology 1956a (Bib. Ch. 11) fig. 99, pl. 53/2.

CHAPTER 6 LACQUER ART

1. cf. Wang Shixiang 1983 p. 20 f.

2. cf. Institute of Archaeology 1983a. The fragment of a lacquer vessel is illustrated on p. 203, fig. 9, no. 9.

3. Hebei Provincial Museum 1974.

4. The convenient record of Shang-dated wood is Umehara 1959. No doubt some comparatively large flat structures were fixed on walls. Slight evidence for mural painting of Shang date is cited from an Anyang excavation in the form of a fragment of greyish-white 'wall surface' on which is part of a design in red bands punctuated with black rondels at the angles. cf. Institute of Archaeology 1976b.

5. *KG* 1984 5 405, pl. 2.

6. Institute of Archaeology 1959b (Bib. Ch. 4) pl. XLI/2; Xinyang District Committee 1984 fig. 30.

7. Knowledge of the lacquerware and other wood craft of south-central China came with a rush in the mid-1950s, when material excavated in Hubei was assigned to the Warring States as the product of Chu patronage. See Beijing Historical Museum 1954; Shang Chengzuo 1957 (revised ed.); Hubei Jingzhou Museum 1985. cf. Watson 1989a pp. 71–86.

8. Hunan Provincial Museum 1972 (Bib. Ch. 8) pl. IV/3.

9. Hubei Jingzhou Museum 1980.

10. cf. Hubei Provincial Museum 1973a fig. 8.

11. Xiangyang District Museum 1982 fig. 4/3; Hubei Antiquities Committee 1957; Yangzhou City Museum 1980.

12. cf. cranes and snakes from Changsha, in the Cleveland Museum (*JW* no. 127); drumstand of cranes on tigers excavated in Jiangling-xian, Hubei Jingzhou Museum 1982 fig. 21; antlered human head with protruding tongue in Watson 1962 (Gen. Bib. *History*).

13. Hubei Yichang Museum 1988, pl. 6/7; Hubei Provincial Museum 1973b.

14. Henan Cultural Office 1959. See also Watson 1972 (Bib. Ch. 4) pl. 72.

15. Henan Cultural Office 1959, pls. 39 ff., 56–7.

16. Shandong Provincial Museum 1977 fig. 13.

17. Hubei Antiquities Committee 1957; Shandong Provincial Museum 1977.

18. See Wu Shunqing *et al.* 1988; Hubei Provincial Museum 1980 (Bib. Ch. 4) pl. 88.

CHAPTER 7 INNER ASIA AND THE CHINESE BORDERS

1. Synthesizing works on the subject of this chapter are by Borovka, Jettmar, Minns, Porada, Rudenko, Watson. For gather-all illustration see Bunker, Chatwin and Farkas 1970.

2. Rudenko 1962a, b; Artamonov 1969 summarizes and well illustrates the material, with a history of excavation.

3. The rôle of Greek colonists vis-à-vis their south-Russian neighbours is the subject of the magistral Minns 1913.

4. The possibility has been entertained that the gold plaques were manufactured under some Chinese sponsorship for the express purpose of export to Mongolia and Central Asia. Proof is increasingly claimed for this connexion. See Bunker 1992a.

5. We avoid the formal use of 'Animal Style' and 'Steppe Art' which have been so widely applied. As definitive terms both have erroneous implications, useful though they are in a general account.

6. Rudenko 1958 pp. 101 ff.

7. The limiting dates of the Luristan *floruit* have been much disputed, but opinion settles to those given in the text.

8. The summary given here owes much, for Western Asia, to Frankfort 1959 and, for the Iranian plateau, to Culican 1965.

9. Barnett 1957.

10. The geographical distribution of the 'stag-stones' was studied by Soviet-Hungarian expeditions in the late 1960s and early 1970s. From Mongolia the stones extend west of the Baikalye. Some were associated with grave mounds; a minority include human figures and heads in the ornament. The disc placed at the top of some stones has suggested to theorists a connexion with a sun cult.

11. Watson 1971a pls. 80–3.

12. ibid. pp. 54 ff.

13. ibid. pls. 69–74.

14. ibid. pl. 37b.

15. cf. note 32 below.

16. See Beijing Antiquities Institute 1989 pl. 4, a find made near Beijing.

17. Lodge *et al.* 1946 (Gen. Bib. *Archaic bronze*) pls. 26, 27.

18. See the account in Prušek 1971 Chapter XVI.

19. Herodotus states that Cyrus wished to marry Tomyris, the ruling queen of the Massagetae, and that it was in a campaign against this people that he lost his life.

20. Watson 1971a Chapter 4.

21. See Barnett 1956 pp. 111–16; Ghirshman 1950.

22. Watson 1971a pls. 81, 83.

23. Rudenko 1953, 1960.

24. Rudenko 1953 pls. CI–CIII.

25. ibid. pls. CXV–CXVI.

26. Objects from the Seven Brothers kurgan (late fifth and early fourth century B.C.) are particularly relevant to comparisons with material from the East Asian steppes. See Artamonov 1969 pls. 107–37.

27. There is unfortunately no means of distinguishing the ancestry of these Turkic rulers from the mass of northern barbarians variously named by the Chinese after their main regions of habitation.

28. See Watson op. cit. *passim.*

29. The deer motif may be a contribution to the art of the Mongolian plateau made by the Sakas of the Ili valley of east Turkestan. Localized examples in bronze, of a routine plainness, are illustrated in Inner Mongolian Antiquities Team 1963 (Gen. Bib. *Survey*) pls. 80, 82, 83.

30. Rudenko 1962a, b.

31. cf. Hebei sites (Zhangjiakou City Antiquities Office 1987; Beijing Antiquities Institute 1989) which demonstrate the proximity of a more exclusive nomad culture with another in which animal-style bronzes occur with bronze vessels of metropolitan type. Plaques of ring-footed tigers and horses were found at both places, and both sites are dated to the later fifth or the early fourth century B.C. For fighting horses and pacific quadrupeds see Ningxia Archaeological Institute 1988 fig. 9.

32. cf. Xiongnu graves of fourth–third-century date at Xigoupan in Inner Mongolia contained bronze deer and ibex adapted as pole-tops, and many examples of animal design repoussé on gold foil (Yikezhaomeng Station 1980; Tian Guangjin, Guo Suxin 1980). The latter include attack by tiger on pig, couched deer, horses, eagle-head monster alone and in fight with tiger.

33. cf. Institute of Archaeology 1962a (Bib. Ch. 3) p. 139, fig. 93; Ningxia Archaeological Institute 1988 fig. 10/6.

CHAPTER 8 CULTURAL UNITY. THE HAN EMPIRE

1. The question of schematic style vis-à-vis realistic style under Han is discussed in Watson 1974 (Gen. Bib. *Survey*) and 1975. (Bib. Ch 10)

2. Henan Cultural Office 1959 (Bib. Ch. 6).

3. Watson 1975 (Gen. Bib. *Survey*) pl. 75. A brush was used for writing in the Shang period, and some Shang ornament may suggest the use of the brush in the original design, but no paintings survive earlier than those cited.

4. An Zhimin 1973; Sun Zuoyun 1973; Hunan Provincial Museum 1972; Archaeology 1975b; Gu Tiefu 1978; Xi Zezong 1978.

5. Nan Bo 1975 fig. 4.

6. Henan Antiquities Team 1964a (Bib. Ch. 9).

7. cf. Hubei Provincial Museum 1986; Li Zhengguang, Peng Qingye 1957 fig. 13a; Suizhou City Museum 1982 p. 150; Anhui Antiquities Team 1978 p. 16.

8. Li Zhengguang, Peng Qingye 1957 fig. 13/4.

9. Anhui Antiquities Team 1978; Yangzhou City Museum 1980.

10. Institute of Archaeology 1980b pls. 194–5.

11. Hunan Provincial Museum et al. 1972 pl. III/1.

12. Xianyang Cultural Committee 1982 fig. 3.

13. ibid. fig. 7.

14. Xianyang Cultural Committee 1979 fig. 11.

15. BH2 no. 165.

16. Xianyang Cultural Committee 1982.

17. ibid. fig. 11.

18. cf. Zhou Dao 1975; Yangzhou City Museum 1980.

19. Anhui Antiquities Team 1979; Nanjing Museum 1979 pp. 418–19; Guangzhou Antiquities Committee 1957 pl. 5; Jenyns and Watson 1963 (Gen. Bib. Decorative art) no. 131; Yangzhou City Museum 1988 pp. 23, 25, 29.

20. Watson 1974 (Gen. Bib. Survey) figs. 32, 33; Hubei Xiaogan District Team 1976 p. 55, fig. 7/1; Li Zhengguang, Peng Qingye 1957 fig. 13/1, 5.

21. Wu Shunqing et al. 1988 (Bib. Ch. 4).

22. Umehara 1943 collects the inscribed lacquers known at that date and still furnishes a basis for the study in the late Western and early Eastern Han periods.

23. Watson 1957 (Bib. Ch. 6) pp. 49 ff.

24. Well illustrated in Fontein and Hempel 1968, col. pl. XX (Gen. Bib. Survey).

25. Shi Huang Ling Team 1978, 1979. At some entrance chapels of the precinct were placed pottery images of servants, models of submission and patience, whose qualities, if less vivid, resemble those of the soldiers. See BH2 1973a no. 136; Beijing Locomotive Factory 1975.

26. Yunnan Provincial Museum 1956; Wang Ningsheng 1979; Yi Xuezhong 1987.

CHAPTER 9 ICONOGRAPHY UNDER THE WESTERN HAN

1. Descriptions began in the west with the work of Laufer and Waterbury. Hentze wrote of the motif he called Wanderung der Tiere, discussed bird symbolism, the rôle of the antlered shaman, and lunar cults. Bulling dealt with Totenspiele; Loewe examined the official side of Han religion and ritual. Finsterbusch has provided an exhaustive catalogue of motifs painted and carved on the walls of Han tombs, a work complementary to her examination of the Shanhaijing (the earliest Chinese pseudo-bestiary) in its relation to visual art. Eastern scholars have chiefly combed ancient literature: notably, in China, Wen Yiduo and Yuan Kê; in Japan, Izushi Yoshihiko, the most helpful Morimi Kisaburo, and Hoshikawa Kiyotaka, author of a thorough edition of the Chuci.

2. cf. papers by Barnard 1972, Hayashi 1972, Bunker 1972.

3. Institute of Archaeology 1980b vol. I (Bib. Ch. 8) p. 256, figs. 170–1.

4. The first mention of xuanwu is in the Chuci. Hawkes 1959 dates this anthology to the beginning of the first century B.C. Others date earlier, and the contents must in any case record earlier tradition.

5. As does Hoshikawa.

6. cf. BH2 no. 90.

7. By Morimi.

8. According to one theory the division of the sky into tianzuo, each denoted by a prominent constellation, was evolved gradually from the middle Shang period. In oracle inscriptions of the time of the emperor Wu Ding (1339–1281 B.C.) there is mention among others of the Bird Star, niao xing. Later this name is applied to the 25th of the 28 xiu (mansions) along the ecliptic; or to the southern group of seven mansions taken together, the 'palace' of the Red Bird. It is doubtful whether the system of tianzuo and xiu was completed and systematized before the Han period.

9. See Finsterbusch 1952. The Shanhaijing is known to the historian Sima Qian and by this token is taken to consist of pre-Han texts, although it was probably not put in its present form until the beginning of Han.

10. Henan Antiquities Team 1964a.

11. According to the comparison of pottery with that of the Shaogou tombs in Henan.

CHAPTER 10 DRAUGHTSMANSHIP AND PAINTING UNDER THE EASTERN HAN

1. Tiles and bricks with impressed ornament of this early stage are little illustrated in comprehensive works. See Zhou Dao et al. 1986 pls. I–XXX; and Finsterbusch 1966 (Bib. Ch. 9) nos. 997–1006.

2. Sickman and Soper 1968 pl. 26.

3. See Finsterbusch 1966 (Bib. Ch. 9) nos. 274–8.

4. cf. Nagahiro 1965 pp. 21 ff.

5. These items are illustrated together in Shimonaka 1952 (Gen. Bib. Survey) pls. 79–81. Bird-shoot, mensuration, horse-and-cart are placed as three scenes top to bottom on a single panel; damaged and unidentifiable scene, kitchen, horse-and-cart similarly on another panel; both panels in a Japanese collection.

6. Zhucheng-xian Museum 1987; Nanjing Museum 1984b.

7. Originally by Nagahiro 1965 pp. 13 ff.

8. At Luanzhen-cun in Feicheng-xian.

9. Suide-xian Museum 1986 (fig. 5 for the cosmic pillar); Wu Lan, Xue Yong 1987; Nagahiro 1965 p. 39; Shaanxi Provincial Museum 1959; Finsterbusch 1966 (Bib. Ch. 9) nos. 380–501.

10. Jiang Yingju 1983; Luo Chenglie, Zhu Xilu 1979; Jiaxiang-xian Cultural Office 1986; Jining District Group 1982.

11. The classic western publication of the chapels is in Chavannes 1909 vol. I (Gen. Bib. Sculpture), where the inscribed titles of the scenes are translated. Chavannes' proposed reconstruction of the several chambers of the shrine is less clear than that of Nagahiro 1965 pp. 45–8, which follows an account of the other funeral chapels of the period. An elaborate slab-built tomb excavated in Anqiu-xian in east Shandong, not included in Nagahiro's survey, is the best guide to reconstruction. It consists of three chambers in line from a south entrance, each greater in width than depth. The engraved stone ornament here is not in the 'silhouette' manner described in our text from the Wu shrines, but more resembles the low relief of the first century, mainly with dragons, phoenix, tiger, bull. One scene however of the magic tree with archer Yi and the unharnessed horse, is a close earlier version of this motif as portrayed on a Wu stone. The Anqiu tomb belongs to the earlier 2nd century. See Shandong Provincial Museum 1964. For general description see ADC pp. 539–40.

12. Henan Antiquities Team 1964a; Shandong Provincial Museum 1964.

13. Chavannes 1909 vol. I pls. XLIV, LIII and passim.

14. ibid. e.g. pls. XLV, LI, LX, LXV.

15. ibid. passim in pls. XLIV–LXV, LIII.

16. ibid. e.g. pls. LI, LXV, LXVI–LXVIII. Watson 1974 (Gen. Bib. Survey) pl. 48.

17. Chavannes 1909 vol. I, e.g. LI.

18. ibid. pl. XLIV, top register.

19. Cf. a study of the various lists in Naitō 1953 (Gen. Bib. History) pp. 8 ff.

20. Chavannes 1909 vol. I, pl. LXIV.

21. ibid. pl. LX. Watson 1974 (Gen. Bib. Survey) pl. 47. ADC pl. 331.

22. Chavannes 1909 vol. I pl. LIX.

23. ibid. pl. XLIV, at the right end of the second register; Nagahiro 1965 p. 74.

24. Chavannes 1909 vol. I pl. XLVI; Nagahiro 1965 p. 80.

25. Chavannes 1909 vol. I pl. XLV; Nagahiro 1965 p. 93.

26. Chavannes 1909 vol. I pl. XLIV; Nagahiro 1965 p. 75.

27. Nagahiro 1965 p. 76.

28. Chavannes 1909 vol. I pl. XLI.

29. ibid. pl. XLIV.

30. Zeng Zhaoyu et al. 1956.

31. The suggestion is Nagahiro's.

32. Institute of Archaeology 1985; Xu Diankui, Cao Guojian 1987.

33. You Zhenyao 1986.

34. Haining-xian Museum 1983; Yue Fengxia, Liu Xingzhen 1984.

35. Zhang Pengchuan 1978.

36. ADC pl. 330.

37. cf. Rudolph and Wen Yu 1951; Finsterbusch 1966 (Bib. Ch. 9) nos. 199–223. For illustrations of the Sichuan bricks see Chongqing City Museum 1957; also: Chang Renxia 1955; Liu Zhiyuan 1958. For the two last items in the list of subjects see Chengdu Antiquities Office 1981; Li Hongfu 1983.

38. The Xinjin figures are best illustrated (realized from the stones) in Nagahiro 1965 pp. 148–9.

39. See Bulling 1960 (Bib. Ch. 9); ACB pls. 92b, 93b–104, with bibliography. Examples of mirror ornament as found in recent excavation yielding approximate dating:

Four-dragon band (the earlier specimens with some interlace, the later with dragons in remote linear transformation), mid-second century B.C. to mid-second century A.D.: Hubei Provincial Museum 1976; Pingshuo Archaeological Team 1987; Yangzhou Museum 1988.

Inscription alone or with star etc. (late second century B.C. to early second century A.D.): Zhejiang Antiquities Committee 1957; Hubei Provincial Museum 1976; Hunan Provincial Museum 1984b; Yangzhou Museum 1987; Yangzhou Museum 1988; Zhucheng-xian Museum 1987.

TLV design, early and fully developed (second quarter first century B.C. to first decade first century A.D.): Zhejiang Antiquities Committee 1957; Hunan Provincial Museum 1984b; Yangzhou Museum 1988; Zhou Zheng 1987.

Caoye ('grass and leaves') *design* (last quarter of first century B.C. to mid-first century A.D.): Yanfen District Office 1987; Jiangxi Provincial Museum 1976; Hunan Provincial Museum 1984b.

Shenshou ('gods and monsters') *mirrors* in review: Qin Shizhi 1986; Wang Zhongshu 1988.

40. The fullest account of the game is given in Fu Juyou 1986. The four or eight nipples usually included in the TLV scheme probably also denote planets or stars, and the rarer twelve nipples the mansions of the celestial horizon. The four nipples appear with stylized dragons, symbols of heaven, already on mirrors of the first century B.C. See *ACB* pp. 97 ff for an account of the mirrors of the later group and the theories of the interpretation of TLV mirrors as game-board, sundial etc. The date given there for the fully decorated TLV type is to be revised from late first century B.C. to mid–late first century A.D.

41. A typical inscription: 'When the sages make a mirror they draw essences from the Five elements. It is born in the serenity of the Dao. It is adorned with designs and its brilliance is like that of the sun and moon. Its substance is pure and hard, so that it resembles jade. It removes baleful influences. May the Central kingdom be at peace. May our descendants multiply and prosper. The Yellow Skirt and the Primordial Blessing are fast established'. cf. *ACB* p. 101.

42. See also Zhou Zheng 1987; Hunan Provincial Museum 1984b.

43. *ACB* pl. 100b.

44. ibid. pls. 101a, 100a.

45. Quoted from Cammann 1948 pp. 159 f.

46. cf. *ACB* pls. 99a, 101b.

47. cf. Watson 1954. These mirrors have been frequent in graves in the Shaoxing district of Zhejiang, some with the reign-titles of the Wu dynasts who ruled this territory from 221 to 280.

CHAPTER 11 ARCHITECTURE IN RETROSPECT FROM THE SECOND CENTURY A.D.

1. Institute of Archaeology 1963 (Bib. Ch. 1); *ADC* p. 583.

2. Yang Hongxun 1988.

3. Institute of Archaeology 1983c.

4. Yang Hongxun 1976.

5. Henan Antiquities Institute 1983a.

6. As note 4.

7. A bronze concavo-convex disc 18 cm across was the only example recovered of metal footings used on foundations where no boulders remained. See Shi Zhangru 1947.

8. *ADC* pp. 554–5.

9. Institute of Archaeology 1976.

10. Institute of Archaeology 1982b fig. 5.

11. Shaanxi Zhouyuan Team 1979c; Fu Xinian 1981a, b; Yang Hongxun 1981.

12. Shaanxi Zhouyuan Team 1981; Yang Hongxun 1981.

13. Fu Xinian 1981a fig. 5.

14. But the tiered shrine on terreplein was adopted in other parts of China: cf. the foundation so interpreted at Yangzishan (Sichuan), Sichuan Antiquities Committee 1957.

15. High tomb mounds were first adopted by the Zhou rulers, the earliest those of Wen Wang and Wu Wang. Unexcavated, they show no external signs of shaping in the manner of the Warring States tombs.

16. Hebei Antiquities Team 1965 pl. I-1; Huang Zhanyue 1981.

17. Institute of Archaeology 1965a p. 116 fig. 138;

18. Fu Xinian offers various interpretations of the gallery structure, one of which proposes small pavilions alongside the main hall on the top level. This feature is suggested by ground-plans established elsewhere from excavation but not warranted by the Hui-xian bronze design.

19. Hebei Antiquities Office 1979 pl. VIII, no. 3; Fu Xinian 1980.

20. cf. Yu Weichao 1985 pp. 117 ff. The security of the grave-gifts was much in mind, and in some instances – the Mancheng and Zhongshan tombs – has furnished the modern excavator with large intact collections of decorative objects.

21. The employment of hollow bricks hardly enters the history of architecture. They are occasionally found flooring tombs in the Period of the Warring States and replaced wood entirely in many tombs from *ca* 100 B.C. They fell out of use early in Eastern Han, being replaced by the small solid bricks.

22. Hunan Provincial Museum 1984 tomb M204, p. 65.

23. cf. Luoyang Antiquities Team 1983.

24. cf. ibid. 1987 fig. 1.

25. Beijing Historical Museum 1955 (Bib. Ch. 10); *ADC* p. 531; Henan Antiquities Team 1964c; see ibid. 1983c for a similar tomb in Li-xian, Hebei.

26. Gansu Provincial Museum 1974.

27. Henan Antiquities Team 1963b.

28. Zeng Zhaoyu *et al.* 1956 (Bib. Ch. 10); *ADC* p. 543; Watson 1960 (Gen. Bib. *Survey*) pls. 110–14.

29. Detail is best shown in Yashiro *et al.* ed. 1963 (Gen. Bib. *Survey*) vol. 8, pl. 76; cf. also *GBAC* fig. 107; and Fu Xinian 1980 fig. 3.

30. The suggestion is Fu Xinian's, op. cit.; his term is *mojiaogong* ('angle skirting bracket').

31. cf. Finsterbusch 1966 (bib. chap. 9) pls. 536–43.

32. e.g. Shandong Cultural Office 1959 pl. 171; *ADC* pp. 570, 571; Gansu Museum 1974 pl. xiv, no. 1; Guo Qinghua 1985 fig. 6; Institute of Archaeology 1962c pl. 88.

33. e.g. Boyd 1962 (Gen. Bib. *Architecture*) p. 89; *ADC* pl. 120; Art Gallery, Chinese University of Hong Kong 1984 pls. 101, 103, 321, 233, 238.

34. Chongqing City Museum 1957 (Bib. Ch. 10) pl. 7.

35. A poetic description of his palace is the subject of a *fu* included in the *Wenxuan* of Liang Zhaoming.

36. Huang Zhanyue 1989.

37. Tang Jinyu 1959; Wang Zhongshu 1982 (Bib. Ch. 8) figs. 30–2; *ADC* pp. 590–2.

38. Tao Fu 1976. See *ADC* pp. 595–6.

39. Institute of Archaeology 1989 fig. 1.

CHAPTER 12 THE PERIOD OF THE SIX DYNASTIES

1. For information on the introduction and development of Chinese Buddhism, on literary evidence, see Ch'en 1964 (Gen. Bib. *Religion*), Soper 1959, Tsukamoto 1944, Waley 1931 (Bib. Ch. 20), Zürcher 1959.

2. *Bodhisattva*, a being who possesses the seed of Buddhahood and the prospect of absorption into Nirvāna, potentiality which the later theology describes in eminent cases as voluntarily abandoned for better capacity to aid mankind.

CHAPTER 13 THE AGE OF DIVISION: SCULPTURE OF THE NORTHERN WEI FIRST PHASE

1. Shang sculpture presents an extension to stone of the ornament used on bronze and other materials. With the exception of the standing Sākyamuni of A.D. 477 described below in the text, no early work of any size survives in bronze. The small sculptures of the Zhou and Han periods do not qualify as monumental and are noticed in retrospect below in treating of Tang pottery figurines.

2. General accounts of sculpture: Chavannes 1909; Sirén 1925; Mizuno 1950 (Gen. Bib. *Sculpture*); Matsubara 1961 (ibid.); Tsukamoto 1942 (Bib. Ch. 12); Hallade 1950; Snellgrove ed. 1978; Tokiwa and Sekino 1926 (Gen. Bib. *Architecture*); Pelliot 1914 (Bib. Ch. 18); Priest 1944 (Bib. Ch. 15); d'Argencé ed. 1974 (Gen. Bib. *Sculpture*); Munsterberg 1967 (Bib. Ch. 20); Rowland 1963 (Bib. Ch. 22); W. Willetts 1958 Chapter 5 (Gen. Bib. *Survey*); Sickman and Soper 1956 (Gen. Bib. *Survey*) Chapters 8–10, 14; Seckel 1964 (Gen. Bib. *Mythology and Religion*); *ADC* pp. 131–218.

3. The varying historicity of the accounts of these first contacts with Indian Buddhism, preserved chiefly in the *Hou Han shu* of the fifth century and the *Gao seng zhuan* of the sixth century, is examined in Ch'en 1964 (Gen. Bib. *Mythology and Religion*) (with large reasoned bibliography) and Soper 1959 (Bib. Ch. 12). The first reliable record of scriptures brought to China is for A.D. 148, when An Shigao arrived to translate a number of *hinayāna* sutras. Sutras of this 'historical' class were still being translated at a time when *mahāyāna* wisdom scriptures (*Prajñāpāramitā, Amitāyus, Vimalakīrti, Lotus*) had already been translated. The sorting out of the doctrinal and iconographic confusion which ensued was a chief task of Kumārajīva when he arrived in Chang'an as translator and instructor in 401. The literary evidence shows a patrician interest in Buddhism increasing from the time of the emperor Ming Di, who after his vision of a 'golden man' in a dream of A.D. 64 sent emissaries to the west. In one account the emissary Cai Yin is said to have returned with a painted icon made in north-west India for king Udyāna (for whom had been carved the supposed prototype of all sculpted images), and with two Indian missionaries accompanied by a scripture.

4. cf. Caves 268 and 275.

5. See Rowland 1947 (Bib. Ch. 19) for more faithful Indian-type images.

6. An Iranian iconographic influence is to be seen in the Bodhisattva seated with legs crossed at the ankles, the head decorated with ribbons and the body often swathed in broad crossing bands of textile. When Maitreya is intended (as is shown by his naming in the dedicatory inscription of a few images) he is to be imagined seated in his paradise, Sukhāvatī, located in the Tushita heaven, awaiting the arrival of the faithful and his own destiny as Buddha of a future *kalpa*. The cross-legged posture occurs in Gandharan sculpture, but is more probably of Iranian than Indian origin. It resembles, with a slight change of perspective, the crossed ankles of portraits of deities and feasting nobles in Pyandjikent frescoes of later date. cf. Yakubovski 1954b pls. *passim*.

7. cf. Wang Zhongshu 1985. Small images were also made in stoneware of the third century in Zhejiang, as separate pieces or mounted on the sides of vessels. The banality of the roughly grooved garment and erratically moulded face leaves them unrelated to known bronzes. See Mizuno 1950 (Gen. Bib. *Sculpture*) figs. 37, 38.

8. In this early period the individual cult of Maitreya was specially popular in the Far East, and the iconographical distinction from Śākyamuni poorly observed, images of the latter being named Maitreya (*Mile*) in some dedicatory inscriptions.

9. See Munsterberg 1967 (Bib. Ch. 20) pl. 39.

10. The example illustrated from Nelson-Atkins Museum of Art, Kansas City, is matched by many others, some with inscribed dates falling between the twenties and the fifties of the fifth century, e.g. the image dated to 429 illustrated at Matsubara 1961 (Gen. Bib. *Sculpture*) p. 4, and another dated to 450 which was excavated at Boxing in Shandong, as illustrated at Ding Mingyi 1984 fig. 1. The subject of the early images in bronze and stone is reviewed in some detail in Capon 1973.

11. For the glories backing the images the Chinese distinguish *head-light* and *body-light*. It is convenient here to call both of these *mandorla*, although this word refers to the almond shape of the body-light only.

12. A seated Buddha in the same style in the Freer Gallery of Art is dated to 451. Here the flames are inscribed on a smooth-edged mandorla, which carries also a lotus-petal aureole and three small Buddhas of the past.

13. In the Fogg Museum of Art, Cambridge, U.S.A.

14. See Matsubara 1961 (Gen. Bib. *Sculpture*) pls. 10, 11.

15. See *ADC* col. pl. 73.

16. The sculpture is in the Fujii Yūrinkan, Kyoto. See Matsubara 1961 (Gen. Bib. *Sculpture*) pl. 14a.

17. Matsubara 1961 (Gen. Bib. *Sculpture*) pls. 9a, 9b.

18. Shirakawa collection, Japan. Sirén 1925 pls. 116, 117.

19. In the Okura Museum of Chinese Antiquities, Tokyo. See Matsubara 1961 (Gen. Bib. *Sculpture*) pls. 20, 21.

CHAPTER 14 YUNGANG CAVE-SHRINES: NORTHERN WEI SECOND PHASE

1. The definitive description of the Yungang cave-shrines is the vast work by Mizuno and Nagahiro 1952. This includes a full review of chronology, and Leon Hurvitz's now standard translation of Wei Shou's treatise on Buddhism and Daoism (mid-sixth century). Chavannes 1909 pls. 200–77 usefully show the caves as they were before they received the attention of conservationists and tourists. Su Bo 1978 discusses periodization; the new numeration of the caves is given by the Institute for Preservation of Yungang Antiquities 1988. The caves now stand open; wooden façades were built when they were first hollowed out, and some façades were renewed later.

2. The conclusions of Mizuno/Nagahiro and Soper on dating, commemoration and patronage are incorporated in the table.

3. *Arhat* (Ch. *Luohan*): the perfect man of the *hinayāna*, still short of Buddhahood and *nirvāna*. *Apsaras*: female celestial spirit attendant on Buddhas etc.

4. The *abhaya mudrā*, the right hand raised with palm outwards, is the most frequent gesture in all the early images. It is said to intend reassurance that the cycle of rebirths is not eternal, and *nirvāna* finally attainable.

5. The pretext for the erotes must be the pure souls reborn in the lily pond of the Western Paradise, this feature belonging to the iconography of Amitābha, *Mituofo*, whose cult is featured in art more explicitly after Northern Wei.

6. The historical evidence for the Wei involvement with the southern Liu Song state and the consequent effect of intrusive patronage on sculptural style is adduced in Soper 1960a (Bib. Ch. 12).

7. *Jātaka*: properly stories about a Buddha's previous terrestrial lives, used also for the events of Śākyamuni's experiences prior to the Enlightenment.

8. The rôle of the Lotus Sūtra (*Saddharmapundarīkasūtra*), the sermon on the Eagle Peak, in the decoration of the paired caves, giving authority for massed deities and infinite ornamental adjuncts, is examined in Davidson 1954. See also Ch'en 1964 (Gen. Bib. *Mythology and Religion*) pp. 378 ff.

9. This deity, called Suddhāvāsa in Indian iconography, must be a deliberate choice. He rules the five heavens into which arhats eventually enter. The many arhats introduced unobtrusively into Yungang sculpture seem already interpreted in their enhanced Mahāyāna status. The Kumārakadeva, a form of Brahmā, presides over the three divisions of the *dhyāna* (meditation) heaven filled with occupants undistracted by taste or smell. The casual adoption of such images underlines the remoteness of Chinese Buddhism of this time from recent Indian doctrine.

10. The small *dhyāna* Buddha in the crown of the first of these two images (but not in the crown of the second) becomes later the regular sign of Avalokiteśvara, *Guanshiyin*, as companion of Amitābha, but this concept is not yet clearly expressed in any Yungang cave.

11. See Inner Mongolian Antiquities Team 1984.

12. A comparable specimen is found in the Auriti collection of the Museo d'Arte Orientale in Rome. See Soper 1966b no. 20.

CHAPTER 15 NORTHERN WEI THIRD PHASE: A.D. 495–535

1. That is, sculpture of the Mathura rather than the Gandhara tradition. The same central-Indian practice may also have inspired some of the variants of jewelled head-dress portrayed on Bodhisattvas and apsarases of the second- and third-phase sculpture. For the general literature see note 2 to Chapter 13.

2. Finds of coin prove commercial contact at this time with Sasanian Iran.

3. See Li Shaonan 1984: bronzes excavated in Boxing-xian, Shandong, inscribed with dates from 477 to 587 and illustrating successive period styles, date the Padmapāni from the 470s. cf. one of the best-wrought images of this type in the Seattle Art Museum, *ADC* pl. 258.

4. *ADC* pls. 348–9, 351, 356.

5. A point to consider is also that these images were made at a time when the technique of 'Meditation on the Buddha' as yielding a vision was influential in pictorial art. cf. Waley 1931 (Bib. Ch. 20) pp. xii ff.; and Liu Huida 1978.

6. See Chavannes 1909 (Gen. Bib. *Sculpture*) pls. 278–398; Mizuno and Nagahiro 1941; Longmen Conservancy 1961.

7. The main Longmen caves and the beginning of work in them:

Guyang-dong	from 493
Binyang-dong	from 505
Lianhua-dong	from 520s
Weizi-dong	from 522
Shiku-si	from 520s
Weizi-dong	from 520s
Shisiku	from 520s
Yaofang-dong	from 570
Zhaifu-dong	from ?636
Huijian-dong	from 650s
Fahua-dong	from 650s
Fengxian-si	from 672 (the central image)
Wanfo-si	from 670–680s
Jinan-dong	from 684
Ganjing-si	from 684
Leigutai-dong	from 684 (the middle cave)

For the inscriptions on which this chronology is based see the appendix to Li Yukun 1980.

8. i.e. this sūtra, *Fahua-jing*, its importance already stressed since the time of Kumārajīva, provides the iconography even more completely than before. The sūtra proposes a conspectus of all Buddhism, recounts miracles, notably the meeting of Śākyamuni and Prabhūtaratna, and instances of aid given by Guanyin and Samantabhadra, and endlessly praises the Buddha's compassionate nature. The chief study of the Longmen iconography is Tsukamoto 1944 (Bib. Ch. 12) pp. 355 ff.

9. The reference is to Greek archaic sculpture, a comparison made by Japanese writers. This formation of the lips is seen as early as 477 on the bronze Śākyamuni of the Metropolitan Museum. Unhappily nearly all the faces or heads of the niche images at Longmen have been knocked off and dispersed by trade. Many survive undocumented in museums and private collections.

10. At Longmen inscriptions of dedication to Amitābha (*Mituofo* or – before the Tang period – *Wuliangshou*) begin from 519, although there is no indication in the sculpture of the Pure Land (*jingtu, sukhāvatī*) of Amitābha which was to be so prominent in the cult.

11. The relief with procession of courtiers headed by the emperor was removed from the Binyang-dong to the Nelson-Atkins Museum of Art, Kansas City.

12. The progressive introduction of new themes from 493 to 530 is summarized from the three oldest caves as follows (I = Guyang-dong; II = Binyang-dong; III = Lianhua-dong):

Framing of niches:

I: curtain swags along lintels are rare, the beam lintel terminates in double bends, and rows of small niches with images may fill the 'beam' area; but commoner are flat 'arches' with ogival top line. The filling of these last may be images, or crossing chains imitating flower garlands of the Indian kind, suspended from lotus-heads or carried by small human figures. Over one niche are extremely serpentine dragons supported on lateral columns decorated with floral meander and rising to lotus capitals.

II: Flames or multiple small Bodhisattvas (half the body showing) cover the wall behind images and replace the niche frame.

III: Flames, apsarases, the Seven Buddhas of the Past and a new version of the grape-scroll fill the ogival arches.

The head halo:
I: Lotus petals, or Buddhas and apsarases, encircle the head, once with a Buddha trinity as the innermost ring.
II: Petals, and a new scroll derived from the Yungang type.
III: A circle of large petals.

Jewels:
II: Jewelled chains are added to Bodhisattvas, hanging in crossed loops down the front of the garment and doubling the similarly crossed loops of scarves. The chains resemble blossom garlands.

Ceilings:
I: Flying apsarases almost exclusively.
II: Apsarases flying around a large central lotus bloom; sometimes the tasselled fringes of a baldaquin.
III: A large lotus bloom on a ceiling otherwise plain, but probably painted in the original state.

Minor figural themes:
I: Line-engraved heads of arhats haloed in three-quarters filling wall spaces; praying donors. In sculpture, lions beside the image thrones, dwarfs and monsters supporting at the lowest level. Low on the south wall is a cross-legged Bodhisattva with lions of an unreal Chinese kind, small praying donors, and in separate niches at the sides two grotesque humanoids worthy of the *Shanhaijing*, representing vanquished demons. The scene of the citizen Vimalakīrti and the Bodhisattva Manjusrī separately housed and engaged in debate (symbolizing reconciled *mahāyāna* and *hinayāna* doctrine) now appears, as well as scenic allusions to the Sudāna and Mahāsattva *jātakas*.
III: Vimalakīrti and Manjusrī are included as small items over a niche arch; here and there a dragon from whose mouth issues a lotus-bud. The scenes in secular style include the Meditating Bodhisattva receiving gifts while fine-robed and umbrella'd courtiers attend.

13. Ministry of Culture 1954; Sullivan *et al.* 1969. There are a few sandstone statues said to have been brought to the site.

14. The Maijishan complex is one of a number of Buddhist centres first established by Juqu Mengsun, the Hunnish ruler of the Liang state, the remotest of them being the cave-shrines of Dunhuang at the western end of the province. The excavation of further caves and the modelling of new images continued at Maijishan until the Ming period, with notable sculpture of Tang and Song date.

15. See Ministry of Culture 1954 figs. 2, 8. The lack in the caves of the central pillars which at Yungang and Dunhuang hold Buddhas facing in each of the cardinal directions may indicate less preoccupation with Mahāyāna doctrine at Maijishan. The Meditating Bodhisattva does not appear in any of the Maijishan arrays. As elsewhere, the Bodhisattva with high jewelled head-dress is probably intended as Maitreya.

16. Another instance of retardation vis-à-vis the metropolitan caves is the cave-shrine called Wangmuguan in Jingchuan, Gansu. A Yungang style appears to have survived there into the sixth century. The same is true of the Nanshiku in the same district which was begun in 510. cf. Gansu Provincial Museum 1984.

17. The repeated restoration of the statuary, continued until the Ming period, makes stylistic assessment hazardous even for the images originated in Northern Wei, and particularly so thereafter. The carved stelae and the mural painting of Maijishanj are noticed below together with the corresponding monuments.

18. Henan Antiquities Team 1963a.

19. Caves 1 and 2 were begun by the emperor Xuanwu in 517, the former completed in 523, and the latter left unfinished. The emperor Xiaozhuang supervised the excavation of the twin Caves 3 and 4 from *ca* 520 to their completion in 528. Cave 5 was worked at intermittently until 539, and lacks a central pillar, the ceiling apparently contemporary with those of 1 and 3. Cave 1 has four niches on each of the three inner walls, with only zones of courtiers' procession on the returns of wall at the entrance; of the others only 5 has major niches on the walls, one on each.

20. The origin and symbolism of the *shenwang* are obscure. They are found only in the company of Buddhist subjects, although there appears to be no place for them in scriptural lore. Some minor Daoist items in Longmen sculpture, notably Xiwangmu and Dongwanggong, are illustrated by Wen Yucheng 1988.

CHAPTER 16 MONUMENTAL SCULPTURE
OF THE MID-SIXTH CENTURY

1. For the general literature see note 2 to Chapter 13.

2. Many pieces from the work of this school survive in museum collections. The documented series was excavated on the site of the ancient temple. See Yang Boda 1960; Cheng Jizhong 1980.

3. *ADC* pls. 375, 377 (the latter in the St Louis Art Museum) and d'Argencé ed. 1974 no. 32. The latter two are dated respectively to 505 and 533.

4. Liu and Liu 1958 (Bib. Ch. 22). The Wanfo-si was situated a short distance outside the west gate of Chengu, near a bridge which still bears its name. Its foundation is attributed in local tradition to the mid-second century, but the first written record of its existence refers to the year 529 of the Liang state. In the Tang period called the Jingzhong-si ('temple of the pure assembly'), it is said to have been abolished in the persecution of 845, but it was re-established a few years later and eventually restored in the Ming period. In 1882 villagers unearthed fragments of sculpture 'as big as houses and as small as the knobs on the end of a scroll'. More fragments were recovered in 1937 and 1945–6, and more than 200 were found during building work in 1953. This last group is preserved with other specimens in Chengdu. No systematic excavation has taken place on the site.

5. Liu and Liu 1958 (Bib. Ch. 22) pl. 13.

6. An exception to this generalization is the group image of the Rietberg Museum, Zürich, in which six figures are arranged around a seated Buddha in analytic style (see Brinker and Fischer 1980 no. 50). The inscription dated to 536 places this piece in Eastern Wei, although the markedly provincial character of the sculpture indicates rather the Western Wei territory. Other examples of the group composition made under Northern Qi are attributed to Shanxi: see Shanxi Provincial Museum XXX pls. 26, 33; and one dated to 551 but closely imitating the 522 version from the Wanfo-si is illustrated from a Japanese collection by Matsubara 1961 (Gen. Bib. *Sculpture*) pl. 102.

7. cf. *BH2* no. 243; Museum of Fine Arts, Boston, 1982 no. 85; d'Argencé ed. 1974 (Gen. Bib. *Sculpture*) no. 56 (the latter two present a Meditating Bodhisattva). See Cheng Jizhong 1980 for comparable small-scale items excavated at Gaocheng Hebei dated to 562 and 570, evidently the product of the Quyang centre.

8. See e.g. Matsubara 1961 (Gen. Bib. *Sculpture*) pls. 89b, 91a, 91c, 101a, 110b; the Sackler seated trinity in the Metropolitan Museum; Mizuno 1950 (Gen. Bib. *Sculpture*) pl. 44 (this piece hailing from Xi'an) and Shanxi Provincial Museum pl. 29; d'Argencé ed. 1974 no. 45.

9. This image type, derived from a detail of Gandhara sculpture depicting the palace scene of Sākyamuni's history, was adopted for an individual cult in China already in the pre-Yungang period of Northern Wei. In the Yungang caves the theme is quite subordinate, but from Eastern Wei onwards as an independent image the Meditating Bodhisattva, with right ankle placed on the left knee, the head inclined and the right hand raised to the cheek, responds to the successive phases of sculptural style. The examples illustrated in Matsubara 1961 (Gen. Bib. *Sculpture*) pls. 97B and 133 show Eastern Wei and Northern Qi style at their best, the latter with freely spreading drapery in the 'aerial' manner. The Meditating Bodhisattva is frequently portrayed in linear engraving or low relief on the back of the mandorlas from the late Northern Wei onwards. His cult was peculiar to north China and particularly to the north-eastern region, passing thence to Korea and Japan.

10. Museum of Fine Arts, Boston, 1982 no. 87 p. 101. This statue is said to have been excavated in 1903 in the middle precinct of the White-horse temple (*Paima-si*) in Loyang. See the annotation to plate 98 in Fontein and Hempel 1968 (Gen. Bib. *Survey*). Despite the identification as Maitreya (cf. the right hand raised in the *abhaya* gesture) the impression given by the statue is that of the misericordious Guanyin.

11. The head-dress also displays the jewel, surrounded by flames, the head-dress image of a seated Buddha which later denotes the Bodhisattva as appendage to Amitābha being not yet adopted.

12. See Shimonaka ed. 1952 (Gen. Bib. *Survey*) pl. 119 and annotation.

13. Liu and Liu 1958 (Bib. Ch. 22) pls. 8, 11.

14. ibid. pl. 9.

15. ibid. pl. 17.

16. Tathāgata, *Rulai*, and not Buddha is now the correct term. For an account of the Amitābha cult in its western connexions see Soper 1940a (Bib. Ch. 12) section III; Watson 1983.

17. The *lishi* flanking the door to the Yaofang-dong are similar but more awkwardly composed, so that the introduction of the type in north China is likely to have been not earlier than the 570s. Most picturesque and elaborate relief carving of guardian figures is found at the doorway of the Lingquan-si in the Anyang-xian of Henan: see Henan Province Architectural Conservancy 1988. The main images are of the 560s or 570s and are in columnar style, while the guardians and the small reliefs of spirit kings (*shenwang*) have generous curving forms and three-quarter poses which resemble corresponding items of the Wanfo-si school of Sichuan and the Northern Zhou sculptors.

18. *ADC* pl. 394.

19. The finest work of the Japanese sculptor is found in the series of seated images deriving ultimately from the Chinese type and extending from the eighth to the eleventh century.

20. See Saitō 1950 (Gen. Bib. *Survey*) figs. 41–3.

21. Two groups of caves were excavated on the Xiangtang mountains, seven on the south mountain (Nan-Xiangtang-shan) and three on the north end of the

mountain (Bei-Xiangtang-shan), all completed under the Northern Qi, whose art they represent at its best. In one of the northern caves are three large seated Buddha images, one of them with one leg pendent – an innovation at this time in the design of a main image. The build of the images is that of the columnar manner of the mid-sixth century. The drapé makes a regular pattern of shallow folds, something short of the harder lines of the Sui canon. The impersonality of the Wei face gives way to a more benign expression.

22. cf. d'Argencé ed. 1974 nos. 74, 75; Sirén 1925 (Gen. Bib. *Sculpture*) pl. 186 (Wannieck collection) and pls. 300, 305. The last, a Guanyin dated to 581, shows the type surviving into the Sui. The Guanyin of the Cernuschi museum, 1.2 metres high, is one of the most successful examples, the form convincingly balanced and dignified despite its columnarity. This piece may well have come from the Xiangtang-shan cave-shrine on the Henan–Hebei border, where the Northern Qi style received its fullest expression.

23. Liu and Liu 1958 (Bib. Ch. 22) pl. 17; and Sirén 1925 (Gen. Bib. *Sculpture*) pls. 313, 325 (the former of these recorded as from Sian, Shaanxi).

24. cf. examples in the Metropolitan Museum: Priest 1944 (Bib. Ch. 15) nos. 26, 27, pls. LVII, LVIII; *ADC* pl. 392; Asian Art Museum, San Francisco (d'Argencé ed. 1974 no. 77); Musée du Louvre (Sirén 1925 (Gen. Bib. *Sculpture*) pl. 268B); Stoclet collection (Sirén ibid. pl. 322A). The last two are of small size, respectively stone and gilt-bronze.

25. See Li Shaonan 1984 (Bib. Ch. 15). Small images carved on the sides of 'pagoda pillars' at the site of the Changle-si in the Handan-xian of Hebei are probably of Northern Qi date and on their scale show a relaxation of the drapé lines beyond what is seen in the contemporary monumental sculpture. See Handan City Conservancy 1982.

CHAPTER 17 DRAUGHTSMANSHIP AND PAINTING OF THE SIX DYNASTIES IN HENAN, HEBEI AND JIANGSU

1. The tombs situated in the Danyang-xian of Jiangsu, at the villages of Wujiacun and Jinjiacun, are thought to have served members of the Xiaoqi line of local rulers who were in office from 427 to 502. See Nanjing Museum 1960, 1974 and 1980. The best illustrations and fullest discussion are in Nagahiro 1969 pp. 43–53, pls. 1–8.

2. A mountain scene with the Four Noble Recluses of Shang Mountain (*Shang-shan sihao-tu*) is impressed on a brick found in Deng-xian on the southern border of Henan. The patterned style resembles that of the Danyang-xian bricks, with the addition of outlined hills. The Jiangsu fifth-century style is not otherwise known to have penetrated so far north. Nagahiro 1969 p. 52, fig. 4; and Yonezawa ed. 1963 p. 122, pl. 35.

3. Shanxi Archaeological Institute 1983a.

4. The Binyang relief is in the Nelson-Atkins Museum of Art, Kansas City. Those of Gong-xian are in Caves 1 and 3.

5. Earlier however, under the Northern Wei, demonic figures joined displays on the occasion of feasts and the like, as in 403 when they were depicted at the instance of the state Board of Music, apparently in revival or continuance of a Han practice. Nagahiro suggests that the painter Gu Kaizhi (to whom is ascribed the original of the 'Admonitions of the Instructress' scroll in the British Museum) may have contributed to the graphic models of the demons.

6. Luoyang Museum 1980.

7. See Zhao Wanli 1956.

8. Nagahiro 1969 p. 118.

9. ibid. pls. 17–28 the demonic subjects, and pls. 43–4 and 45–56 the scenes of filial piety, taken from two sets of rubbings, in the Kansas City museum and in Kyoto University. See note 14 below. To be compared are the engraved designs on a stone lintel and door jambs in the Metropolitan Museum, consisting of dragons *passant* placed symmetrically about a horned monster mask. See Priest 1944 (Bib. Ch. 15) no. 24, pl. LIII.

10. See d'Argencé ed. 1974 (Gen. Bib. *Sculpture*) no. 44, p. 108.

11. The twenty-four were listed by Guo Juye of the Yuan dynasty, some of Han date or earlier, others as late as the Song dynasty. See W. F. Mayers, *Chinese Reader's Manual*, p. 355. Guo's list does not however include all the exemplars illustrated on the funeral stones of the Six Dynasties.

12. Nagahiro 1969 pls. 19–34.

13. ibid. pls. 35–6.

14. The work is probably of *ca* 530. Trees, mountains, people, buildings, carriages, horses, are engraved in a continuous frieze of still further compaction and confusion on stones formerly in the possession of C. T. Loo, now untraced. An inscription dates this work to 520, but, as Nagahiro opines (Nagahiro 1969 p. 183, pls. 39–42), a rather later date is likely.

15. The Kansas stones consist of two slabs each with three framed subjects: Guo Ju; Yuan Gu, the pious grandson; Laolaizi; Cai Shun; Shen Ming, minister of Chu; the noble widow of Liang. The further two slabs of which rubbings are preserved in Kyoto University add: an unidentified scene; Dong Yong in two

scenes; piety at the parents' tomb; the impious Wang Ji; filial nourishing of the mother. See Nagahiro 1969 pp. 187 ff.

16. ibid. pls. 37–8. The subjects are: Yuan Gu; Guo Ju; Shun called to the throne from ploughing; Dong Yong; Cai Shun; an unidentified scene labelled *wei* ('officer').

17. See Liu and Liu 1958 (Bib. Ch. 22) pls. 31, 2, 5, 29.

18. cf. Matsubara 1961, fig. 77; and the stele base in the University Museum, Philadelphia: *ADC* pls. 380–1.

19. In the Museum für Ostasiatische Kunst, Cologne: *ADC* pl. 383.

20. These stelae are respectively in the Boston and Kansas museums.

21. These two stelae are respectively in the Rietberg Museum, Zürich, and the University Museum, Philadelphia. On a Western Wei stele of 551 in the Cernuschi museum two scenes in archaic style representing the death of Śākyamuni and his entombment in a Chinese type of sarcophagus (!) are crowned by a stiff row of trees in the secular style, these set along the front of a low wall. Bells are hung on the trees, and on the wall are placed vessels of the 'pure bottle' (*jingping*) or 'princely bottle' (*wangziping*) which was associated with Buddhist rite. Over the wall appear three semi-circular shapes which may stand for stupas.

22. The later date assumes an error in a cyclical year which 'is not an unusual one in Chinese documentation' according to Priest, whose description of the stele's content is followed here. See Priest 1944 (Bib. Ch. 15) no. 23, pls. XLIII–LII; on the style see Bunker 1965.

23. The priests are named in adjoining inscriptions: *The priest Huixun when making an offering to the Buddha*; and *The metropolitan priest Huigang when making an offering to the Buddha*.

24. To quote Priest: 'The lovely lady... carrying what might be a bowl of flowers, must be the apsaras who entered into a discussion of sex with the monk, lightly changing him into an apsaras and herself into him until he was convinced that there was no sex at all'.

25. Cited previously for their sculptural import. See note 20 to Chapter 15. See Bunker 1964.

CHAPTER 18 PRE-TANG MURAL PAINTING IN WEST CHINA

1. See the account of a Jilin tomb in Jilin Archaeological Team 1984.

2. Dunhuang at the extreme western end of Gansu province was created a *jun* administrative district under Wu Di at the end of the second century B.C., and at once became important as the Chinese terminus of the northern route passing through the Tarim basin to the far west, this road beginning at the Jade Gate (*Yumen*), a short distance to the south-west of the town. A south-facing ridge of the Mingsha ('singing sand') mountain, across desert about thirty kilometres to the south-east of the town, became the site of many cave-temples, under the name Mogao-ku. The earliest historical record of them dates to A.D. 366. Priests and artists were attracted to the growing Buddhist settlement from metropolitan China and from the oasis cities of Central Asia. Gray and Vincent 1959 is valuable for the history of the place and of persons named in inscriptions at the caves it illustrates, and for its bibliography. The first western illustration is Pelliot 1914. For iconographical description of the paintings on silk and paper acquired by the British Museum, with transcription of their inscriptions, see Waley 1931 (Bib. Ch. 20). The paintings are described and many illustrated in colour in Whitfield and Farrer 1990 (Bib. Ch. 20). For the shapes of the caves see e.g. *ADC* pp. 582–3. The caves are catalogued and their sculpture and painting briefly described in Dunhuang Institute 1982. The pictorial (coloured) record and every aspect of description and exegesis are best in the definitive Xia Nai, Nagahiro *et al.* 1980, whose indispensable assistance to our narrative is most gratefully acknowledged. Briefer illustration is in Chang Shuhong 1959. Wall inscriptions and many dimensions are added in the catalogue (pictures negligible) by Xie Zhiliu 1957 (note that the cave numbers differ here, with a concordance to those of the Dunhuang Institute).

3. The chronological divisions proposed in Xia Nai, Nagahiro *et al.* 1980 are followed here. The chief caves are assigned as follows:

Period I: Rule of Bei Liang, A.D. 421–*ca* 439. Caves 268, 272, 275.
Period II: Rule of Northern Wei during its middle period, 465–500. Caves 251, 254, 257, 259, 260, 263, 265, 487.
Period III: Control by the house of Yuan Rong, a member of the Northern Wei ruling clan, A.D. 525–545. Caves 246, 247, 248, 249, 285, 286, 288, 431, 435, 437.
Period IV: Rule by Western Wei and Northern Zhou, A.D. 545–580. Caves 290, 294, 296, 287, 299, 301, 428, 430, 432, 438, 439, 440, 441, 442, 461.
Period V: Rule by Sui, A.D. 584–585. Caves 303, 305.
Period VI: Rule by Sui, A.D. 589–613. Caves 244, 277, 278, 280, 292, 285, 302, 305, 311, 312, 393, 394, 398, 399, 393, all numbers from 400.

Period VII: End Sui and beginning Tang, early seventh century. Caves 244, 282, 390.

4. On the southern route through the Tarim no Chinese traits in painting are visible at Khotan (active mid-sixth to mid-seventh century), while traces of sculpture relate to Periods III to V at Dunhuang; the Gandharan style at Miran extends approximately from late third to mid-fourth century, antedating the earliest surviving work at Dunhuang. Along the northern route Chinese influence appears at Kutcha only in the third phase, late in the seventh century; at Kizil a little to the west of Kutcha the well-preserved murals relate chiefly to Period I at Dunhuang. At Turfan, a short distance to the north-west of Dunhuang, Chinese influence is apparent from the first phase of the developed settlement, in the late seventh century, when artistic and political links with Tang China are close.

5. If pigment is lost the underlying draft may be prominent. It is possible that the murals of the Period I caves have suffered some loss of surface, leaving the broad circles and curves of the cartoon unintentionally prominent. The oxidization of the white lead so liberally used has now darkened some of the original pigments.

6. The deer, living near the Ganges, once rescued a man from drowning, enjoining on him to speak no word of this. But when, to please his consort, the king offered vast reward for knowledge of the fabled animal, the rescued man betrayed his promise – his body being immediately covered with disease – and led the hunting party to the deer's haunts. Before an arrow flew the deer came to the king, knelt before him and recounted the story of the rescue. The king reviled the man and decreed perpetual protection for the deer and its kind.

7. For an analysis of all the motifs of Dunhuang ceiling ornament, see Ho Chuimei 1980 (Bib. Ch. 17), lodged in the University of London.

8. One recalls the communication between Sichuan and central China which was effected by the Northern Zhou conquest of the western provinces.

CHAPTER 19 ARCHITECTURE FROM HAN TO TANG

1. The audience hall of the Changle palace built by the first Han emperor at Loyang measured about 400 by 100 (English) feet. It was joined to the Weiyang palace of his successor, reported a little larger still, by a covered passage leading over the city wall. *Fu* poems by Zhang Heng (A.D. 78–139) with rhapsodic praise of Chang'an and Loyang set a convention of allusive description of soaring halls brilliantly coloured and alive with painting and sculpture. The *Xijing zaji* ('Miscellany of the Western Capital'), an early anthology of minor matters of the Western Han, variously attributed and later much drawn upon, describes a noble residence as having a vermilion courtyard, 'overhead vermilion lacquer, paving all of bronze often gold-plated, white jade steps...' The historian Si-ma Qian ascribes to the Jianzhang palace of Wu-di 'a thousand gateways and a myriad of interior doors'. He gives the nearby Phoenix towered gateway, *Fengque*, a height of some 160 feet, and the Well-fence Pavilion, *Jinglanlou*, fifty *zhang*, about 400 feet (*Shiji VIII*). In Loyang the Cloud Tower, *Yuntai*, a high-platformed building or tower destroyed by fire 'from above' in A.D. 185, was evidently of some age, having been built by the Zhou court. It was used to store 'maps, books, administrative documents, art objects and rarities' (*Hou Han shu* 24). See Soper 1940b. Zhang Heng's *fu* are translated by E. von Zach in *Asia Major III* (1926) and *Monumenta Serica IV* (1940).

2. *Pagoda*, a word of uncertain derivation, denotes strictly any sacred building raised over a holy relic. In China and Japan the majority of such buildings are high towers, or miniature imitations of these, and are termed *tower* or *pagoda tower* indifferently, *ta* and *tō* respectively in Chinese and Japanese. The temple is *si* in Chinese and *ji* or *tera* (*dera*) in Japanese.

3. cf. *Luoyang qielanji* ('Record of the temple precincts of Luoyang') by Yang Xuanzhi, excerpted in Soper 1940a (Bib. Ch. 12) fully translated in Wang Yit'ung 1984 (ibid.). It was composed in praise of the new capital built *ca* A.D. 500 at Loyang, motivated by its destruction in the rebellion of 532–534. Foundation and patronage are its theme and disappointingly little is to be gleaned from it on architecture.

4. The fullest record of the subject is Tokiwa and Sekino 1926 (Gen. Bib. *Architecture*). The towers are ideally described and illustrated in Boerschmann 1931 (ibid.). Considering the extent of subsequent neglect and destruction, the early dates of these surveys, with the opportunity for photography and measurement they enjoyed, give them exceptional value. Further see Sekino 1938.

5. We quote from the translation of Wei Shou's treatise by Leon Hurvitz in Mizuno and Nagahiro 1952 (Bib. Ch. 14) vol. XVI.

6. The term used in this and similarly early texts is *Fotu*, a rendering of some Indian version of 'Buddha stupa'. It seems to be applied indifferently to temple and pagoda.

7. For the Yongning-si see Institute of Archaeology Luoyang group 1973 and 1981. The lore of the *mingtang*, so much speculated on in Chinese ritual antiquarianism, is well summarized by Soper in Sickman and Soper 1956/1968 (Gen. Bib. *Survey*) pp. 212–14 and *passim*. The foundation of a circular building

of Tang date, interpreted as a revival of the *mingtang*, was excavated at Loyang: Institute of Archaeology Luoyang group 1988.

8. cf. Chen Congzhou 1956.

9. As given in the *Luoyang qielan-ji*.

10. The connexion between Indian stupa and Chinese pagoda tower, an unproductive topic, need only be what is implied at the Yongning-si, the structural resemblance no more than *lang* functioning as *pradakshina-patha*, the tower itself prolonging ancient Chinese custom. The multiple-umbrella finials (*xianglun*) preserved on early towers in Japan imitate an Indian feature which may have been present also at the Yongning-si. For the stupa in India and beyond see Rowland 1953 pp. 51 ff. and *passim*.

11. See Longmen Conservancy 1986.

12. Handan City Cultural Office 1982.

13. In Kirinsar-xian. Institute of Archaeology 1983a.

14. A lack of surviving evidence may account for the apparent sudden advance in the sixth century. The difficulty of obtaining long timber for pillars must certainly be another reason for the elaboration of bracketing. The murals of the Dunhuang caves depict small buildings with Chinese roofs without eaves brackets, an omission perhaps owed to ignorance or to economy of the artist's effort. See Dunhuang Institute Archaeological group 1976.

15. cf. Yang Hongxun 1984; Qi Yingtao 1965; Qi Yingtao 1983.

16. Institute of Archaeology 1980a (Bib. Ch. 23) pls. I, II.

17. See also illustrations in the review of early evidence for architecture in Qi Yingtao 1983.

18. These features are to be found on buildings of the Hōryūji, i.e. in use well into the seventh century, but in this instance may be deliberately archaic and represent a practice of the Sui period.

19. cf. Wang Renbo 1973 on these murals.

20. Qi Yingtao and Chai Zejun 1980. This temple is said to be the only one that survives from the time before the persecution of 841–859, when all the temples in cities were destroyed.

21. cf. a building depicted on the wall of Cave 172 at Dunhuang.

22. Relevant surveys of Japanese architecture: Asano 1969; Ōoka 1966; Tazawa and Ōoka 1957; Sekino 1949; Itō *et al.* 1977.

23. Qi and Chai 1980.

24. It is characteristic that the later heightening of the roof which has produced the present state of the *kondō* makes abundant use of cantilevered timbers.

25. First described by Liang Sicheng in 1934. The account is abstracted by Soper in Sickman and Soper 1968 pp. 243 ff. See also *ADC* p. 578.

26. These may be a later addition or replacement, since they more resemble tenth-century types. See Qi Yingtao 1978 on roof-ridge ornaments.

27. With the Foguang-si has been compared an engraving of a Buddha hall on a lintel of the Dayanta at Xi'an. But the analogy is false: the simpler two-step brackets and the wall-plane camel's humps and vertical struts of the engraving suggest a design taken from a pattern-book, old-fashioned when the Dayanta was built and nearer to a Sui model. Illustration in Sickman and Soper 1956/1968 (Gen. Bib. *Survey*) p. 244.

28. The Dayun-si (Temple of the Great Cloud); Yang Lie 1962.

29. *ADC* p. 528 for further description and an illustration.

30. *ADC* p. 534.

31. Little of the temple itself remains despite renovation in 1486–95.

32. *ADC* p. 342.

33. The much-restored sculpture is of Eastern Wei origin.

34. See Henan Provincial Museum 1979; Henan Antiquiities Team 1983b. The conclusion in the latter survey (well illustrated) is that the building with 'the greater part' of its exterior decoration in carved brick was completed by the Xiantong period, 860–873, whereas the pair of four-armed guardians placed either side of the entrance, also in brick, are of Song date.

35. *ADC* p. 526. Many miniature memorial shrines were built in stone in north Henan on the lines of the Yunju-si pagodas. See Yang Huancheng 1983.

36. Further in *ADC* p. 540; Sickman and Soper 1956/1968 (Gen. Bib. *Survey*) pp. 242, 259.

37. *ADC* p. 557; Sickman and Soper ibid. p. 242.

38. The temple to which the tower belonged was built by the emperor Xiao Ming of the Northern Wei dynasty on the site of a summer palace that had been the resort of his predecessor, Xuan Wu. He is said to have exhausted the finances of the state on the temple halls and the fifteen-storey pagoda. See Sickman and Soper ibid. p. 230; *ADC* p. 557.

39. There is a comparison to be made between the Songyue-si pagoda and the five-storey octagonal pagoda of the Fogong-si in Ying-xian, Shanxi. The latter is the only wooden tower to survive from its time. Built however in 1056, according to an affixed stone inscription, it belongs to the history of Liao architecture. See *ADC* p. 579.

40. City plans determined the spaces available for palace domain and temple precinct, the run of walls and the form of gateways. Excavation on the foundations of palaces and gateways has revealed too little to contribute to the history

of architecture more than the most speculative of reconstructions. For Chang'an see Shaanxi Cultural Office 1958, and the report of excavation on the site of the vast Daming palace: Institute of Archaeology 1959. Paintings by court artists of Song and later time purporting to show Tang palace architecture at its most flourishing were particularly pleasing to emperors. See Fu Xinian 1983 on the paintings attributed to the school of the Tang painter Li Sixun. On the Dayanta see Sickman and Soper ibid. p. 241; *ADC* p. 593.

41. *ADC* p. 594, Sickman and Soper ibid. p. 141.

42. See Yuan Wanli, Xiao Shan 1980; Sickman and Soper ibid. p. 241; *ADC* p. 594.

43. Small stone pagodas carved in the Tang period belong to the realm of sculpture. For two examples see Henan Province Architectural Conservancy 1986.

CHAPTER 20 THE BUDDHIST ICON: TANG INTERNATIONAL STYLE

1. For commerce and its routes between China and the Iranian west, and the admission of foreign religions to China, see the summary and bibliography in Watson 1983 (Bib. Ch. 16) pp. 537–58.

2. Thus according to the *Tang History*. The *New Tang History* makes another Persian the subject of the latter part of this story, leaving Pērōz in Chang'an from the start.

3. Quoted from Soper 1940a (Bib. Ch. 12) p. 141.

4. See Azarpay 1981 pls. 14, 28 and *passim*.

5. It is argued that the lantern-roof, known at Bāmian in Afghanistan, was inspired from Iran. See Soper 1947.

6. *BH2* no. 289; and Watson 1983 (Bib. Ch. 16) pl. 46.

7. Weiwuer District Museum 1972 (Bib. Ch. 23) pl. 39.

8. Watson 1976 pl. Id.; cf. Kunaichō Shoryōbu 1952 nos. 35, 361. The Shōsōin, in the precinct of the Tōdaiji, Nara, Japan, a store for the personal belongings of the emperor Shōmu who died in 749, was sealed in 756. The contents have remained perfectly preserved and virtually intact ever since.

9. Watson 1976 pl. IIa.

10. Compare the line e.g. in the *Rustam Cycle* and the *Amazon Cycle* of the Panjikent (Samarqand) murals of the late seventh century. See Azarpay 1981 pls. 4 ff. and 14 ff.

11. Whereas the first contacts with western religious painting had been through Khotan, after the Arab invasion more direct contact was made with India. Xuan Zang and Wang Xuance returned from their journeys there in 649 and 663. Although a few paintings in Indian style were preserved in Dunhuang, seventh-century Indian influence upon Chinese style and iconography is not perceptible there, but is to be sought as transmitted to Japan in the opening decades of the eighth century.

12. The colours as identified at the British Museum and quoted in Gray and Vincent 1959 (Bib. Ch. 18) p. 35.

13. Watson 1976 pls. V, VI.

14. Whitfield and Farrar 1990 nos. 17, 18.

CHAPTER 21 TANG SECULAR PAINTING, FIGURES AND LANDSCAPE

1. The following are listed in the Gen. Bib. *Painting*. Recent solid works on the historical record are Yu Jianhua 1954 and Zhongguo Shuhua Yanjiuhui 1970. Western histories, Sirén 1956–1958 and Cahill 1960, are based more exclusively on surviving work and accepted copies. Literary comment and historical contexts are summarized in Cohn 1951, Waley 1923, Sullivan 1962. Indispensable tools are Suzuki Kei ed. 1982 and Laing 1969. Lawton 1973 reviews figure painting in the context of the Freer Gallery collection.

2. For discussion of this text see Nakamura Shigeo 1965 (Gen. Bib. *Painting*) pp. 251 ff. We acknowledge gratefully the assistance afforded by this book.

3. Here and subsequently, with some exceptions, we omit the anecdotes which are the vehicle for the greater part of Chinese writing on the performance of artists. The meticulous Wang Tzai took ten days to paint a pine tree. Wu Daozi's dragon, rendered in seconds, took flight from the wall as soon as it was completed. R. S. Jenyns 1935 deals discursively with this matter.

4. Wu Daozi, apparently an independent professional painter, accepted imperial commissions, as when for the emperor Xuan Zong he represented three hundred *li* of the Jialing river in a single day (his contemporary Li Sixun took many months on the same task). Wu is said to have executed three hundred mural paintings in Chang'an and Loyang. His case furnishes an example of the poor survival of the work of an acknowledged master, the extent of subsequent attribution to him and, as suspected, the creation of work in the style for imperial collections. The *Xuanhe huapu*, catalogue of the collection formed by the emperor Hui Zong (1101–25), lists ninety-three paintings by Wu Daozi, but among Hui Zong's leading contemporaries the painter Mi Fei knew of only four, and the author aesthete Su Shi of only one. Cf. Cohn 1951 (Gen. Bib. *Painting*) p. 70.

5. Discussed in Nakamura Shigeo 1965 (Gen. Bib. *Painting*) pp. 269 ff.; text with full annotation in Yu Jianhua 1954 (Gen. Bib. *Painting*). See also Acker 1954.

6. Nakamura Shigeo 1965 (Gen. Bib. *Painting*) pp. 39 ff. On the Buddhist concern with landscape see Mather 1958 pp. 67–9; also *ADC* pp. 261 f.

7. cf. Nakamura Shigeo 1965 (Gen. Bib. *Painting*) pp. 163 ff.

8. Text of the *Lun-hua* in Nakamura Shigeo 1965 (ibid.) pp. 28 ff.

9. History speaks of Gu Kaizhi as engaged in both secular painting, landscape and portraiture, and Buddhist subjects. Other professional painters of Buddhist themes, who appear much in textual tradition but whose contemporary work has also vanished, are Lu Tanwei (*ca* 440–500) and Zhang Sengyu (*fl.* 500–520). The former is said to have initiated a 'calligraphic' line; the latter, greatest painter under the Liang dynasty, was ever celebrated for his *The brushing of the elephant*, and *The drunken priest*. Lawton 1973 (Gen. Bib. *Painting*) gives a commendably full account of the subsequent histories of subjects treated in the early figure scrolls.

10. Cohn 1948 (Gen. Bib. *Painting*) fig. 12.

11. Examples of the aberrant attribution of superior paintings to this artist are the Freer Gallery's *Liu Hai and his toad*, and the Kōgakuji's beautiful *Guanyin*, both wearing a Southern Song or Yuan air. The Freer Gallery's *Lohan* attributed to Wu Daozi is painted with a brush line resembling that of the Guanyin described in our text.

12. Paintings of this class which are fathered upon Yan Liben, while outstanding of their kind, are late: e.g. the handscrolls *Uighur bringing tribute* (Nezu Institute), *Admonishing in chains* (Freer Gallery), *Foreign envoy with tribute bearers* (*NPM* pls. 1, 2), all of which are likely to be of Song or Yuan date. This tradition, subject and manner, lingered on provincially until the Ming and later. See Grube and Sims 1985 (Gen. Bib. *Painting*), papers by Steinhardt and Watson.

13. Xu Shucheng 1980 pl. IX.

14. As above.

15. For illustration see Sirén, Cohn, Cahill *et al.* (Gen. Bib. *Painting*)

16. See Shaanxi Antiquities Committee 1964; Jin Weinuo 1962; also tomb of Li Hui and Yan Wan, Hubei Provincial Museum 1987.

17. See Wang Renbo 1973.

18. See Datong City Museum 1972 pls. 12, 13.

19. Translated by Chavannes ed. in *Toung Pao* X no. 1. There is a commentary on the text by Li Shan in the *Wen xuan*. The text is quoted in Zhongguo Shuhua Yanjiuhui 1970 (Gen. Bib. *Painting*) I pp. 23 f.

20. See Dong Xijiu 1982.

21. Points made here summarize Watson 1980.

22. Sullivan 1962 pp. 139 ff. is very full in the discussion of hills, trees and leaves.

23. Western writers have inclined to attach a notion of meritorious *progress* to successive stages in the creation of spatial illusion. cf. A. C. Soper 1941 pp. 147 ff.; and Sullivan 1962, where the thesis draws on the widest possible choice of decorative motifs.

24. *Huacheng*, symbolizing the incomplete nirvāna which according to the Mahāyānists was all that Hinayāna could offer.

25. *Shōsōin tana betsumokuroku* (Kunai shoryōbu 1951: Bib. Ch. 20) pls. 43, 57. The lute paintings are well illustrated and discussed in Yonezawa Yoshiho 1962 (Bib. Ch. 22).

26. See Sickman and Soper 1956/1968 (Gen. Bib. *Survey*) pl. 74, where the painting is given a putative eighth-century date.

27. *NPM* 300 pl. 4.

28. *NPM* 300 pl. 3.

29. In Lawton 1973, an exhaustive account of the Freer painting and all the circumstances of the *fu* by Cao Zhi (192–232) which it illustrates. The *Lidai minghuaji* mentions a work by Gu Kaizhi illustrating a poem (*shi*, not *fu*) by Cao Zhi but gives no sign the Luo Shen was the subject. Not until the Song was the name of Gu Kaizhi attached to paintings of this subject. Note that the caption to pl. 134 *ADC* (part of the the British Museum's painting) gives 'eleventh century' as the date of the copy; but it is clear that the leaf forms, which resemble those of the *wenjen* painters, and some other detail make a Yuan or early Ming date more probable. An album-leaf in the National Palace Museum, Taipei, evidently cut from a scroll, shows the Luo Shen in a dragon chariot closely resembling that of the British Museum's painting. If the seal *Mi Fei* on this album-leaf is accepted as genuine a date in the late eleventh century is indicated; but such a seal is ubiquitous on paintings of the Qing imperial collection. See *NPM* 300 I pl. 33.

30. Since there is not here (or in any other Chinese compositions before the frank imitation of western method) any question of *vanishing-point* perspective, objection may be taken to the term 'triple perspective'; but any closer descriptive term for the spatial structure of Chinese landscape would be exceedingly cumbersome.

31. For an illustration see Cohn 1948 (Gen. Bib. *Painting*) p. 51.

32. See illustration and discussion in Yonezawa Yoshiho 1962 (Bib. Ch. 22).

33. *NPM* 300 I pl. 31; Cohn 1948 (*ut sup.*) p. 50.

CHAPTER 22 BUDDHIST SCULPTURE UNDER THE TANG

1. For the dating of Longmen caves see note 7 to Chapter 15.

2. Handan City Conservancy 1987, figs. 10, 11; Li Fangcai 1980.

3. See Dong Yuxiang 1983.

4. See Longmen Conservancy 1961 (Bib. Ch. 15) pls. 114, 115; and *ADC* p. 565, pls. 65, 66.

5. *Philadelphia University Museum Bulletin*, vol. 9 (1941), nos. 2–3, p. 59.

6. Longmen Conservancy 1961 (Bib. Ch. 15) pls. 128, 129. The *lishi* in the Rietberg Museum is said to have come from the cave-shrine on the Xiangtang Shan in Henan, and so would be contemporary with those of the Yaofang-dong (see *ADC* pl. 75).

7. Mayuyama 1976 vol. 2, pl. 154; Museum für Ostasiatische Kunst Berlin 1970 no. 18.

8. *ADC* pl. 79.

9. Watson 1959 pls. 23a–23e. The bronze trinity, it appears, was dedicated at an 'eye-opening ceremony' (consecration of an image) in 697, conforming to a vow made in 680 by the emperor Temmu in a prayer for his wife's recovery from an eye disease. When the original temple at Okamoto was moved in 728 to its present site in Nara it is recorded that 'new statues were cast', but stylistic comparison with China supports the earlier date for the trinity.

10. Zhengzhou City Museum 1980. The head of the Fengxian-si Bodhisattva fits awkwardly however, reflecting nothing of the indianizing style.

11. *ADC* pl. 419.

12. *ADC* pl. 421, where the dating should be corrected to 'mid-seventh century'; Matsubara 1961 (Gen. Bib. *Sculpture*) pl. 155.

13. For three of the Guanyin images remaining in Japan see Saitō 1950 (Gen. Bib. *Survey*) pls. 20, 21 (the ideal Hosokawa specimen), and Matsubara 1961 (Gen. Bib. *Sculpture*) pls. 164a, b.

14. cf. Soper 1964 (Bib. Ch. 20) on sculpture drafts from Dunhuang.

15. The history of the Baoqing-si sculptures makes interesting reading as a unique record of a fate which might befall Chinese Buddhist sculpture. When the Guangzhai-si was founded in the Guangzhai suburb of the capital Chang'an in 677 the empress Wu financed the erection of a building in the precinct called the Qibaotai 'Platform of the Seven Treasures', i.e. the variously listed seven precious stones, metals etc. of Buddhism. Over thirty carved stones were placed as a dado around the platform. When the Guangzhai-si fell into ruin the stones were moved to the Baoqing-si near to the south gate of Chang'an, some inserted into the brick tower and others placed between two other buildings of the precinct, the Fodian and the Houdian. The latter portion of the stones, it seems, was inserted into the inner brick wall of the Fodian in the course of a nineteenth-century refurbishment. Inscriptions found on the stones were sporadically discussed by epigraphers from the Kangxi period onwards, but their artistic importance was first perceived by Mr Okakura Tenshin in 1893. In the winter of 1906, when the stones 'escaped' (i.e. were purloined) from the Fodian, Mr Hayayama Kōkichi, who had accompanied Mr Okakura in 1893, purchased 'most of the stones' and brought them to Japan. Nineteen of them found their way into the collection of the Hosokawa household. Of the Eleven-headed Guanyin images two reside in the Hosokawa collection, two went to the Freer Gallery, one to the Boston Museum of Fine Arts, one to the Yokohama Hara household. (This follows the account given by Fukuyama Toshio in Saitō 1950 (Gen. Bib. *Survey*) p. 269.)

16. Saitō 1950 ibid. pl. 22.

17. ibid. pl. 27

18. D'Argencé ed. 1974 (Gen. Bib. *Survey*), respectively nos. 98, 81, 97; Gabbert ed. 1972, nos. 91, 98; also Matsubara 1961 (Gen. Bib. *Sculpture*) pls. 169a, b.

19. cf. Matsubara 1961 (ibid.) pl. 161b.

20. D'Argencé op. cit. nos. 92, 93.

21. See Mizuno Seiichi's note to pl. 29 Saitō 1950 (Gen. Bib. *Survey*), and cautious dating to *ca* 800. The temple tradition records that it was brought from China by Kōbō Daishi (774–835).

22. The central panel of a wooden triptych preserved in the Metropolitan Museum displays a Guanyin seated in a cave, also an iconographic oddity, in style not unlike the Kongōbu-ji triptych, but much inferior in quality. See Priest 1944 (Bib. Ch. 15) pl. 79.

23. D'Argencé op. cit. no. 115.

24. *ADC* pl. 415.

25. *ADC* pl. 413; but note that Matsubara, op. cit. (Gen. Bib. *Sculpture*) pl. 161, assigns Tang date to a similar though more simply adorned image.

26. *ADC* pl. 80; Priest 1944 (Bib. Ch. 15) pl. LXXXVII.

27. The Tang-date sculpture excavated on the site of the Longxing-si, in the vicinity of the Dafo-si in Qionlai-xian some 70 kilometres south-west of Chengdu, displays the indianizing style distinctly only in the noble heads of its Bodhisattvas. See Feng Guoding *et al.* 1958. An example of direct contact with India through Southeast Asia is a Guanyin type peculiar to Yunnan, but this dates to the twelfth century. See *ADC* pl. 450.

28. cf. Liu and Liu 1958 pl. 18. For excavation on the site of the Wanfo-si see footnote 4 to Chapter 16.

29. For the Sanchi torso see Rowland 1953 (Bib. Ch. 19) pl. 95. The dating of the Wanfo-si figure to *ca* 700 fits well with the bronze Bodhisattvas of the Yakushiji.

30. The Wanfo-si items cited are seen in Liu and Liu 1958 pls. 18–21, 24–5, 35.

31. Vanderstappen and Rhie 1964 pp. 189–220. This valuable paper summarizes information provided by S. Tanaka, O. Sirén, T. Sekino and D. Tokiwa, supplementing it from observation made during an inspection of the site. All the pieces of quality were lamentably removed in 1923, after nearly every head was broken off, and dispersed commercially to museums in America, Europe and Japan. It is uncertain whether any complete figures at all now remain in the caves.

32. cf. Brinker and Fischer 1980 (Gen. Bib. *Survey*) no. 52 and *ADC* 420; Seattle Art Museum 1951 (Bib. Ch. 22) p. 57; notably also the outstanding if somewhat over-bent Bodhisattva in the Rockefeller collection: *BH1* no. 2498, pl. 63.

33. The distortion owed to repeated, even recent, restoration at Dunhuang is an unquantifiable factor. In some cases histrionic gesture applied to figures *soi-disant* of the Sheng Tang (e.g. Cave 384) speak loudly of the Song manner.

34. Quoted from Soothill and Hodous 1937 (Gen. Bib. *Various*). For an outline see Watson 1971b.

35. Sawa 1960 pp. 46 ff., pl. 3.

36. A more sophisticated Chinese version is illustrated in Watson 1971b pl. 1b.

CHAPTER 23 TANG NON-BUDDHIST SCULPTURE AND DECORATED OBJECTS

1. See descriptions in Fu Tianqiu 1964; Ma Yuyun 1964. They are illustrated in Segalen *et al.* 1923–4 (Gen. Bib. *Survey*).

2. See White 1956; *BH2* nos. 211–22.

3. For the Gao Yi lion see *ADC* p. 599, fig. 999. The Jiangsu monuments were first described and illustrated in Segalen *et al.* (ibid.). They are well illustrated in Yao Qian and Gu Bing 1981 (Bib. Ch. 15) and Segalen 1978 (Bib. Ch. 12).

4. Now in the Okura Museum, Tokyo. See Shimonaka 1952 (Gen. Bib. *Survey*) pl. 82. This piece is said to have come from the Tongquetai, a terreplein in the north-west corner of Ye in Linzhang-xian, Henan, the site of the Wei capital.

5. A number of seated images approximating to the Buddhist type and of inferior manufacture are explained as representing Daoist worthies or divinities. They are characteristically of Western Wei date and region. See Sirén 1925 (Gen. Bib. *Sculpture*) pls. 123–30.

6. Chavannes 1909 (Gen. Bib. *Sculpture*) pls. CCLXXXVII–CCXXC, showing the unrepaired panels in situ behind the Xuanwumen, the north gate of the Daminggong palace situated beyond the north-east boundary of the Tang precinct of Chang'an. The panels of the Quanmaogua and the Saluzi now reside in the Philadelphia University Museum (cf. Jayne 1941 pp. 47–9). The remaining four panels are preserved in the Beilin in Xi'an. See Harada Yoshito 1941 p. 385, where is cited the story of Taizong's resolve, as told in Chapter 42 of the *Cefu yuangui* (*diwangbu: renci*) offered to the throne by Wang Qinruo *et al.* in 1005. The panels are recorded in the *Junshilu* of Zhao Mingcheng which was published by his wife Li Qingzhao some time in the Shaoxing period (1131–62).

7. See Hu Pingsheng 1989.

8. cf. Hê Zicheng *et al.* 1982.

9. In general on the yield of tomb excavation around Chang'an, Institute of Archaeology 1980a. On the figurines: *TLC* Chapter IV; Fernald 1950; Mahler 1959 (Bib. Ch. 19); Satō Masahiko 1965 (Bib. Ch. 9).

10. Hebei Conservancy 1979.

11. *PTC* pl. XXX.

12. cf. tombs of Zheng Rentai (664) and Li Zhen (shortly after 700), in Shaanxi Provincial Museum 1972, Zhaoling Antiquities Office 1977.

13. Shaanxi Antiquities Committee 1964 pl. VI f.

14. *TLC* p. 187, fig. 206.

15. The mounted *meiren* is found as early as 664 in the tomb of Zheng Rentai (Shaanxi Provincial Museum 1972), made of painted earthenware, showing a high-crowned and wide-brimmed hat held by a scarf tied below the chin – a bold exposure compared with the *weimao*, which was a combination of hat and ample head shawl. On costume, hats and coiffure see Sun Ji 1984.

16. See Museum Collections Conservancy 1955, colour plate.

17. Idemitsu Museum of Arts 1978 (Gen. Bib. *Survey*) pl. 184.

18. On musicians and dancers portrayed in pottery and stone see Zhou Weizhou 1978.

19. Antiquities Exhibition Team 1972 p. 96.

20. *BH2* no. 274.

21. Both the dromedary and the Bactrian camel were known in China from early times. The artist appears to be less successful with the humps. When these are not obscured by the load they look unconvincing.

22. For a summary of the rôles of *Qitou, Fangxiang, Tianlu* and *Pixie* see *TLC* p. 205.

23. *TLC* p. 209 pl. 230.

24. The first appearance of lead glaze in China may be just prior to Han, but this has not been confirmed by excavation. Lead glazing is known also in Western Asia in the second century B.C., but a link thence to China, though suspected, has not been demonstrated. On technical aspects see relevant passages in *TLC* and *PTC*.

25. Datong City Museum 1983 pl. I/1. Vessels of actual Sasanian origin have rarely survived in China, though from this time onwards a relative abundance of Sasanian coins bears witness to trade. A parcel-gilt silver ewer of Northern Zhou date, found in a brick-built shaft-tomb at Guyuan in the southern tip of Ningxia province, 100 kilometres from the Shaanxi border, is in pure Iranian-Hellenistic style, with reliefs of fully-fashioned standing figures of men and women in three couples around the sides, one of whom appears to be a naked Hermes. See Ningxia Muslim Museum 1985 figs. 23, 24 and col. pl.

26. Shanxi Archaeological Institute 1983 pls. V–VII.

27. On the Tang silverware see a list of excavated sites in Rawson 1986; on ornament applied to gold and silver, and its imitation in pottery, see Rawson 1982, Watson 1986. There is valuable illustration in Gyllensvärd 1953; the subject is broadly sketched in Jenyns and Watson 1963 (Gen. Bib. *Decorative art*).

28. cf. for Shanxi, Changzhi City Museum 1989, a tomb of 691; for Hunan, Xiong Chuanxin 1981 and Hunan Provincial Museum 1980, tombs of the early seventh century; for Hubei, Hubei Xiaogan District Museum 1985, a tomb of the mid-seventh century.

29. For these comparisons cf. for Henan, Luoyang Antiquities Team 1983, Institute of Archaeology 1986c, Yichuan-xian Museum 1985, Datong City Museum 1972; for Zhejiang, Quzhou City Museum 1985. The last of these reported excavations is the first thus far in Zhejiang to produce three-colour figurines, where otherwise the producers of celadon dominated the funeral market with their vessels. In unglazed earthenware, horses and grooms approximating to the Shaanxi eighth-century canon, and women, camels, *qitou*, and guardian markedly distinct from this, were found in a Henan tomb dated to 685. See Institute of Archaeology 1984b.

30. *TLC* p. 16, pl. 6. Sasanian silver has been recovered from tombs in China as early as the first decade of the 6th century (cf. Xia Nai on a tomb dated to 504 containing a dish with scene of huntsman and boar, Datong City Museum 1983 fig. 4, pl. 1). The provincial look of this piece corroborates the argument from ewer shapes that the bronze and silver product of Sogdiana rather than that of the Iranian plateau supplied models to China. See the analysis of shapes in Marshak 1971 and the remark in *TLC* p. 104.

31. *BH2* no. 289.

32. *PTC* pp. 61 f., pls. 22, 23, 36; Tregear 1976 (Gen. Bib. *Ceramics*) pl. 109; Saitō 1950 (Gen. Bib. *Survey*) pl. 49.

33. cf. a bird-head ewer in the Shanghai Museum, d'Argencé ed. 1984 pl. 70.

34. The coloured glaze was painted on fired earthenware and fixed in a second firing.

35. In Grabar 1967 compare the reticulated arrangement of florets of the bowl and dish, pls. 33, 35, with the glaze pattern of the jars *TLC* pls. 45, 50, and the treatment of the winged lion of the plate in pl. 26 with the pacing phoenix of *TLC* pl. 11.

36. See first item in note 9, pp. 3–28, pl. XI.

37. Respectively Xia Nai 1972; Xi'an Antiquities Committee 1964. The Hejia hoard had been buried at the residence of one Li Shouli (*d.* 741), a cousin of the emperor Xuan Zong. The Shapocun silver was found on the site of the Xingqing palace within the Chang'an precinct.

38. See the select catalogue ed. Shirakawa Shizuka 1978.

39. There are rarer examples of ornament similar to what is described here, but with scrolling and floral items etc. raised higher and briefly moulded in repoussé. See Gyllensvärd 1957 figs. 8e, 11e, 24j.

40. For the comparison with Sasanian design see Grabar 1967 pls. 40 and 41, an oval lobed cup with vine-scroll and animal rondels in the Seattle Art Museum, and a parcel-gilt dish with dog, hare and birds set in a widely spaced vine-scroll in the Detroit Institute of Arts.

41. *Chasing*, line impressed without cutting the metal, is the appropriate term for much the greater part of the surviving silverware. A few pieces are traced with a cutting tool which leaves a slightly raised edge along the line. See Jenyns and Watson 1963 (Gen. Bib. *Decorative art*) pl. 26.

42. Watson 1970c.

43. Harqin Banner Museum 1977.

44. Kuancheng-xian Conservancy 1985. A related platter with relief of a deer is preserved in the Shōsōin treasure-house in Nara, Japan, in this case implying a date before the closure in 756.

45. Li Yufang 1982; Foreign Languages Press 1972 pl. 159.

46. Institute of Archaeology 1986c. The silver mirror-backs included in the tomb of 738 have also a provincial character vis-à-vis Shaanxi.

47. Zhejiang Provincial Museum 1984 pl. IV.

48. Tokyo National Museum 1973 pl. 141.

49. As above, pl. Collateral 75.

50. Dantu-xian Education Office 1982. The silversmith's mark *lishi*, 'strong man' guardian of the Buddhist arrays, is not known elsewhere.

51. The group of silverware preserved in the British Museum, illustrated in Jenyns and Watson 1963 (Gen. Bib. *Decorative art*) pls. 31–3, is related by style to the Dingmao-qiao pieces. It is said to have been found at Beihuangshan, Shaanxi. One piece is inscribed as made to an order of 877.

52. Auhan Banner Museum 1978.

53. See *TLC* pp. 58 ff. and 62 ff., with detail under the heads of the vessel shapes, and bibliography down to 1984; *PTC*, chapters on the Central, Northeast and Southeast Zones.

54. The *wan* bowl used in drinking tea increases its share of the product as the tea habit gathered force from the beginning of the eighth century.

55. *TLC* p. 101, pl. 68.

56. On the still obscure question of the exact location of these Hebei kilns and their individual contribution to white-ware product, see *TLC* pp. 59–60.

57. Neiqiu-xian Conservancy 1987.

58. Zhejiang Provincial Museum 1979.

59. cf. examples of the censers in the Boston Museum of Fine Arts and the Honolulu Academy of Arts. See *TLC* p. 135, pl. 114, and p. 216, pl. 264.

60. *TLC* p. 129, pl. 105, and p. 133, pl. 109.

61. cf. the mirror from a princely tomb in the Qian-xian of Shaanxi, in Zhu Jieyuan 1983.

62. What follows is partly extracted from Watson 1989b.

63. The *kaogongji* chapter of the pre-Han ritual text *Zhouli* speaks of the alloy as 'copper-tin half', which is taken to mean that the content of tin *plus* lead amounts to one half of the copper. The lead content of the mirrors was fairly constant at 5–6 per cent, and facilitated casting and subsequent polishing.

64. cf. lobed mirrors with applied repoussé gold in Jenyns and Watson 1963 (Gen. Bib. *Decorative art*) pls. 16, 17.

65. cf. colour plates in Weiwuer District Museum 1972. On the earliest evidence of weaving, of Shang date, see Chen Juanjuan in 1979; on twill, other warp-patterned weaves and multi-warp brocade weave identified from excavation in Xinjiang see Xia Nai 1963; on Xinjiang finds of brocades, knot-dyed and wax-dyed silks, Weiwuer District Museum 1972; Wang Binghua 1973. The last of these reports includes fragments of indubitable Persian origin. The question of importation from Iran or local manufacture of brocades, illustrated in the first-named book above, is still debated. There the compound weave of pl. 46 assimilates Persian metropolitan style, to a barely credible degree in view of the Chinese character *gui* ('noble') included in the design and thought to indicate a Shaanxi product. The brocade of pl. 36, with birds confronted in beaded rings, more plausibly represents Chinese adaptation. The brocade of pl. 45 shows the same mixture of birds, florets and blooms as supplies mirror ornament. Gauzes (knotted warps) are analysed in Shanghai Textile Institute 1978 and Wu Wenhuan 1979.

66. cf. Zhou Xin, Zhou Changyuan 1979; Liu Lianyin 1986; Li Zhengxin 1986; Xu Yongxiang 1986 fig. 6, a mirror dated to 757.

67. cf. the periodization of Sui and Tang styles in Henan by Xu Diankui 1989.

68. Luo Jiarong 1984.

69. Gyllensvärd 1957 no. 39. (Gen Bib. *Decorative Art*)

70. See Eskenazi and Co. (Gen. Bib. *Decorative Art*) pl. 61. The decoration of phoenixes is weakly drawn, and the inscription naming a goldsmith in 'western Zhejiang' appears dubious.

71. cf. Gyllensvärd 1957 nos. 37, 38; openwork filigree in gold was found in a Shanxi tomb which must date shortly after 571 (Shanxi Archaeological Institute 1983). The Xinjiang granulated buckle is published in Li Yuchun 1982.

72. Xiong Cunrui 1987; Institute of Archaeology 1980a, col. pl. I.

Bibliography

Items are listed first as *General Bibliography* regarding the whole book, subdivided by subjects ordered alphabetically, then as *Bibliography by Chapters* attached more closely to the chapters of the book. Where necessary a cross-reference is included in the citation given in the Notes. Consistency and acceptable brevity in naming institutions in translation made a difficulty, but the original wording is readily found on following the reference.

GENERAL BIBLIOGRAPHY: WORKS OF INTEREST
TO MORE THAN ONE CHAPTER

This section is divided as follows:

Survey and Catalogues

ARDENNE DE TIZAC, J. H. D'. *L'art chinois classique*. Paris, 1926.
ART GALLERY, CHINESE UNIVERSITY OF HONG KONG. 广东出土先秦文物. Hong Kong, 1984.
ASHTON, L. R. B., GRAY, B. *Chinese Art*. London, 1947.
BACHHOFER, L. *A Short History of Chinese Art*. New York, 1946.
BRINKER, H., FISCHER, E. *Treasures from the Rietberg Museum*. New York, 1980.
BRITISH MUSEUM. *Chinese Art from the Collection of H.M. King Gustav VI Adolf of Sweden*. London, 1972.
BUHOT, J. *Arts de la Chine*. Paris, 1951.
CHENG, TE-K'UN. *Archaeological Sites in Szechwan*. Cambridge, 1957.
CHENG, TÊ-K'UN. *Archaeology in China*. 3 vols. Cambridge, 1959–63.
CHENG, TÊ-K'UN. *Studies in Chinese Archaeology (collected papers)*. Institute of Chinese Studies of the Chinese University of Hong Kong. Hong Kong, 1982.
CHENG, TÊ-K'UN. *Studies in Chinese Art (collected papers)*. Institute of Chinese Studies of the Chinese University of Hong Kong. Hong Kong, 1983.
CHRISTIE, MANSON AND WOODS LTD. *The Frederick M. Mayer Collection of Chinese art* (sale catalogue). London, 1974.
D'ARGENCÉ, R.-Y. L. *The Hans Popper Collection of Oriental art*. San Francisco, 1973.
D'ARGENCÉ, R.-Y. L. ed. *Treasures from the Shanghai Museum. 6000 years of Chinese art*. San Francisco, 1977b.
DAWSON, R. ed. *The Legacy of China*. Oxford, 1964.
ESKENAZI AND CO. *Chinese and Korean Art from the collections of Dr Franco Vannotti, Hans Popper, and others* (sale catalogue). London, 1989.
FITZGERALD, C. P. *China: A Short Cultural History*. 4th ed. London, 1976.
FONTEIN, J., HEMPEL, R. *China, Korea, Japan*. Berlin, 1968.
GÖPPER, R. ed. *Meisterwerke aus China, Korea und Japan*. Museum für Ostasiatische Kunst der Stadt Köln. Cologne, 1977.
GYLLENSVÄRD, B., POPE, J. A. *Chinese Art from the collection of H.M. Gustav VI Adolf of Sweden*. New York, 1966.
HÁJEK, L., KENSNER, L. *Nejstarší čínské umení ve sbírkách Národní Galerie v Praze*. Prague, 1990.
HAKKAKU MUSEUM OF ART. 白鶴吉金撰集. Kōbe, 1951.
HEIBONSHA KABUSHIKI KAISHA. 世界美術全集 vols. 7, 8 (China I, II). Tokyo, 1950–2.
IDEMITSU MUSEUM OF ARTS. 中国古代美术. Tokyo, 1978.
INNER MONGOLIAN ANTIQUITIES TEAM. 内蒙古出土文物选集. Beijing, 1963.
KAWADE SHOBŌ KABUSHIKI KAISHA. 世界陶瓷全集 vols. 8–9. Tokyo, 1955–6.

LETT, A. *Kinesisk Kunst i Kunstindustrimuseet*. Copenhagen, 1959.
LION-GOLDSCHMIDT, D., MOREAU-GOBARD, J.-C. *Arts de la Chine*. London, 1960.
MAYUYAMA AND CO. *Mayuyama, Seventy years* (vol. I ceramics; vol. II sculpture, painting, bronze). Tokyo, 1976.
MIZUNO, SEIICHI 水野清, 中国佛教美术. Tokyo, 1968.
NATIONAL PALACE MUSEUM. *Chinese Art Treasures* (catalogue of exhibition by the Government of the Republic of China). Taipei, 1961.
NATIONAL PALACE MUSEUM. *Chinese Cultural Art Treasures. National Palace Museum Illustrated Handbook*. Taipei, 1966.
NATIONAL PALACE MUSEUM. *Selection of Masterworks in the Collection of the National Palace Museum*. 10th ed. Taipei, 1974.
NATIONAL PALACE MUSEUM. *Chinese Cultural Art Treasures*. 10th ed. Taipei, 1975a.
NEZU INSTITUTE OF FINE ARTS. 根津美术馆名品目录. Tokyo, 1978.
PAINE, R. T. *The Charles B. Hoyt Collection. A memorial exhibition*. Boston, 1952.
PAUL-DAVID, M. *Arts et styles de la Chine*. Paris, 1953.
PIRAZZOLI-T'SERSTEVENS, M. *L'art chinois*. Paris, 1962.
RAGUÉ B. VON. *Ausgewählte Werke ostasiatischer Kunst* (Staatliche Museen, Preussischer Kulturbesitz. Museum für Ostasiatische Kunst). Berlin, 1970.
RAWSON, J. *Ancient China, Art and Archaeology*. British Museum, London, 1980.
ROYAL ACADEMY OF ARTS. *Catalogue of the International Exhibition of Chinese Art 1935–6*, ed. L. Binyon. London, 1935.
ROYAL ACADEMY OF ARTS. *The Chinese Exhibition. A commemorative catalogue of the International Exhibition of Chinese art*. London, 1936.
SAITŌ MICHITARŌ 齐藤道太郎. ed. 平凡社世界美术全集. vol. 8, China II (Sui, Tang). Tokyo, 1950.
SCOTT, R. E., HUTT, G. ed. *Style in the East Asian tradition. Percival David Foundation of Chinese Art Colloquies on Art and Archaeology in Asia No. 14* (1987).
SEGALEN, V., VOISINS, G. DE, LARTIGUE, J. *Mission archéologique en Chine*. 3 vols. Paris, 1923–4.
SHIMONAKA, MISABURŌ 下中弥三郎. ed. 平凡社世界美术全集. vol. 7, China I (Qin to Nanbeichao). Tokyo, 1952.
SICKMAN, L. C. S., SOPER, A. C. *The Art and Architecture of China*. Harmondsworth, 1956/1968.
SIRÉN, O. *A History of Early Chinese Art*. 4 vols. London, 1929–30.
SIRÉN, O. *Kinas konst under tre Årtusenden*. Stockholm, 1942.
SULLIVAN, M. *Chinese Ceramics, Bronzes and Jades in the collection of Sir Alan and Lady Barlow*. London, 1963.
TREGEAR, M. *Chinese Art*. London, 1980.
WATSON, W. *Archaeology in China*. London, 1960.
WATSON, W. *China before the Han Dynasty*. London, 1961.
WATSON, W. *Handbook to the Collections of Early Chinese Antiquities*. British Museum, London, 1963.
WATSON, W. *The Genius of China: An Exhibition of Archaeological Finds in the People's Republic of China*. London, 1973a.
WATSON, W. *Style in the Arts of China*. Harmondsworth, 1974.
WATSON, W. *Realistic Style in the Art of Han and T'ang* (Ferens Lecture in the University of Hull). Hull, 1975.
WATSON, W. *Art of Dynastic China*. New York, London, 1979a.
WATSON, W. *Studies in Chinese Archaeology and Art* (Collected Papers) London 1995.
WATT, J. C. Y. ed. *Asiatic Art in the Museum of Fine Arts Boston*. Boston, 1982.
WILLETTS, W. *Chinese Art*. 2 vols. Harmondsworth, 1958.
XIA NAI 夏鼐. 新中国的考古发现和研究.
YASHIRO YUKIO et al. ed. 讲谈社版世界美术史大系. vols. 8, 9 (China I, II). Tokyo, 1965.
YETTS, W. P. *The George Eumorfopoulos Collection: Catalogue of the Chinese and Korean Bronzes, Sculpture, Jade, Jewellery and Misc. Objects*. 3 vols. London, 1929–32.

Archaic Bronze

D'ARGENCÉ, R.-Y. L. *Bronze Vessels of Ancient China in the Avery Brundage Collection*. San Francisco, 1977a.
DEXEL, T. *Chinesische Bronzen*. Brunswick, 1958.
ECKE, G. *Sammlung Lochow: Chinesische Bronzen*. Beijing, 1943–4.

ELISSEEFF, V. *Bronzes archaïques chinois au Musée Cernuschi.* Paris, 1977.
ESKENAZI AND CO. *Ancient Chinese Bronzes from the Stoclet and Wessén Collections* (sale catalogue). London, 1975.
ESKENAZI AND CO. *Inlaid Bronze and Related Material from Pre-Tang China* (sale catalogue). London, 1991.
HUANG TI 黄逖 ed. 云南青铜器. Beijing, 1981.
KARLGREN, B. *Chinese Bronzes: The Natanael Wessén Collection.* Museum of Far Eastern Antiquities. Monograph series vol. I. Stockholm, 1969.
KELLEY, C. F., CH'EN MENG-JIA. *Chinese Bronzes from the Buckingham Collection.* Chicago, 1946.
LODGE, J. E., WENLEY, A. G., POPE, J. A. *A Descriptive and Illustrated Catalogue of Chinese Bronzes acquired during the administration of John Ellerton Lodge.* Washington DC, 1946.
LOEHR, M. *Chinese Bronze Age Weapons.* Ann Arbor, 1956.
LOEHR, M. *Ritual Vessels of Bronze Age China.* New York, 1968b.
POPE, J. A., GETTENS, R. J., CAHILL, J., BARNARD, N. *The Freer Chinese Bronzes.* 2 vols. Washington DC, 1967-9.
RAWSON, J. *Chinese Bronzes. Art and Ritual.* London, 1987.
RONG, GENG 容庚. 商周彝器通考. Beijing, 1941.
SHANGHAI MUSEUM. 上海博物馆藏青铜器. Shanghai, 1964.
SUMITOMO, KICHIZAEMON 住友吉左卫门. 泉屋清赏. Kyoto, 1934.
SUMITOMO MUSEUM. 泉屋清赏新集绘. Kyoto, 1962.
UMEHARA, SUEJI 梅原末治. 欧米蒐储支那古铜精华. 7 vols. Osaka, 1933.
WATSON, W. *Ancient Chinese Bronzes.* 2nd ed. London, 1977.
WENWU CHUBANSHE 文物出版社. 中国古青铜器选. Beijing, 1976.

Architecture

BLASER, W. *Chinese Pavilion Architecture* (tr. D. K. Stephenson). New York, 1974.
BOERSCHMANN, E. *Die Baukunst und religiöse Kultur der Chinesen.* 2 vols. Berlin, Leipzig, 1911-31.
BOERSCHMANN, E. *Chinesische Architektur.* 2 vols. Berlin, 1925.
BOERSCHMANN, E. *Chinesische Baukeramik.* Berlin, 1927.
BOERSCHMANN, E. *Chinesische Pagoden.* Berlin, 1931.
BOYD, A. C. C. *Chinese Architecture and Town Planning, 1500 B.C.-A.D. 1911.* London, 1962.
BUSSAGLI, M. ed. *Oriental Architecture.* New York, 1974.
CHEN, MINGDA 陈明达. 营造法式大木作研究. Beijing, 1981.
LI, CHI. *The Beginnings of Chinese Civilisation.* Seattle, 1957.
LIU DUNZHEN 刘敦桢. 中国古代建筑史. 1984.
MURATA, J. JIRŌ 村田治郎. 满州史迹. Tokyo, 1944.
PRIP-MÖLLER, J. *Chinese Buddhist Monasteries.* Copenhagen, London, 1937.
SEKINO, TADASHI 关野贞. 支那の建筑芸术. Tokyo, 1938.
SEKINO, TADASHI 关野贞. 日本の建筑芸术. Tokyo, 1949.
SICKMAN, L. C. S., SOPER, A. C. *The Art and Architecture of China.* Harmondsworth, 1968.
SIRÉN, O. *Chinese Architecture* (*Encyclopedia Britannica*, 14th ed.).
TOKIWA DAIJŌ, SEKINO TADASHI 常盘大定, 关野贞. 支那佛教史迹. 11 vols. Tokyo, 1926-38.
YETTS, W. P. *The George Eumorfopoulos Collection: Catalogue of the Chinese and Korean Bronzes, Sculpture, Jade, Jewellery and Misc. Objects.* 3 vols. London, 1929-32.
ZHONG YUANZHAO, CHEN YANGZHENG ed. *History and Development of Ancient Chinese Architecture.* Beijing, 1986.

Ceramics

AYERS, J. *The Seligman Collection of Oriental Art. Vol. II. Chinese and Korean pottery and porcelain.* London, 1964.
AYERS, J. *The Baur Collection, Geneva: Chinese Ceramics.* 3 vols. Geneva, 1968.
CHEN, WANLI 陈万里. 陶瓷考古文集. Hong Kong, 1989.
CHINA SILICA INSTITUTE. 中国古陶瓷论文集. Beijing, 1982.
D'ARGENCÉ, R.-Y. L. ed. *Chinese Ceramics from the Avery Brundage Collection.* San Francisco, 1967.
FENG, XIANMING 冯先铭. 中国陶瓷史. Beijing, 1982.
FUNG PING SHAN MUSEUM. *Exhibition of Ceramic Finds from Ancient Kilns in China.* Hong Kong, 1981.
GOTŌ, SHIGEKI 后藤茂树. 世界陶瓷全集, vols. 8-10. Kawade Shobō, Tokyo, 1955.
GRAY, B. *Early Chinese Pottery and Porcelain.* London, 1953.
HEMPEL, R. *Tausend Jahre Chinesische Keramik aus Privatbesitz.* Hamburg, 1974.
HOBSON, R. L. *Handbook of the Pottery and Porcelain of the Far East in the Department of Oriental Antiquities.* British Museum, London, 1948.
HONEY, W. B. *The Ceramic Art of China and other Countries of the Far East.* London, 1945.

LION-GOLDSCHMIDT, D. *Les poteries et porcelaines chinoises.* Paris, 1957.
MAYUYAMA, JUNKICHI. *Chinese Ceramics in the West.* Tokyo, 1960.
MEDLEY, M. *The Chinese Potter.* Oxford, 1976.
MUSEUM OF ORIENTAL CERAMICS, OSAKA. 东洋陶瓷 展会. Osaka, 1982.
ORIENTAL CERAMIC SOCIETY. *The Ceramic Art of China* (*Jubilee Exhibition by the Oriental Ceramic Society*). Transactions O.C.S. 38 (1969-71). London, 1972.
SAITŌ SEI 齐藤正 *et al.* 东京国立博物馆 横河. Tokyo, 1982.
SCOTT, R. E. *Percival David Foundation of Chinese Art. A guide to the collection.* London, 1989.
TREGEAR, M. *Catalogue of Chinese Greenware in the Ashmolean Museum.* Oxford, 1976.
WATSON, W. *Tang and Liao Ceramics.* Fribourg, 1984.
WATSON, W. *Pre-Tang Ceramics of China.* London, 1991.

Decorative art

ESKENAZI AND CO. *Tang* (sale catalogue, esp. Tang gold and silver, Buddhist images). London, 1987.
ESKENAZI AND CO. *Early Chinese Art from Tombs and Temples* (sale catalogue, esp. sculpture, silver, Zhanguo bronze). London, 1993.
FEDDERSEN, M. *Chinese Decorative Art* (tr. Arthur Lane). New York, 1961.
JENYNS, R. S., WATSON, W. *Chinese Art: The Minor Arts.* 2 vols. Fribourg, 1963-5.
KAO, M. ed. *Chinese Ivories from the Kwan Collection.* Hong Kong, 1990.
LOEHR, M. 'The fate of the ornament in Chinese art', *Archives of Asian Art* 21 (1967-8). 1967-8.
RAWSON, J. *Chinese Ornament: the Lotus and the Dragon.* British Museum, London, 1984.
SHANGRAW, C. F. 'Chinese lacquers in the Asian Art Museum of San Francisco', *Orientations* vol. 17 no. 4, 1986.
SPEISER, W., GOEPPER, R., FRIBOURG, J. *Chinese Art: Painting, Calligraphy, Stone-rubbing, Wood Engraving* (tr. Diana Imber). Zürich, 1964.
STRANGE, E. F. *Catalogue of Chinese Lacquer in the Victoria and Albert Museum.* London, 1925.
STRANGE, E. F. *Chinese Lacquer.* London, 1926.
WATSON, W. 'On some categories of archaism in Chinese bronzes', *Ars Orientalis* IX. 1973b.

History

ASHTON, L. R. B. *Aspects de la Chine.* Paris, 1955.
CHANG, KUANG-CHIH. *Shang Civilization.* New Haven, 1980.
CHEUNG, KWONG-YUE. 'Recent archaeological evidence relating to the origin of Chinese characters', D. N. Keightley, ed., *The Origins of Chinese Civilization.* Berkeley, Los Angeles, 1983.
CREEL, H. G. *The Birth of China.* New York, 1937.
EBERHARD, W. *A History of China.* London, 1950.
ELISSEEFF, D., ELISSEEFF, V. *La civilisation de la Chine classique.* Paris, 1979.
FITZ GERALD, C. P. *China: a short cultural history.* London, 1935.
FRANKE, O. *Geschichte des chinesischen Reiches.* 5 vols. Berlin, 1930-52.
GERNET, J. *Ancient China from the Beginnings to the Empire* (tr. R. Rudorff). Berkeley, Los Angeles, 1968.
GOODRICH, L. C. *A Short History of the Chinese People.* London, 1948.
GRANET, M. *La pensée chinoise.* Paris, 1934.
GRANET, M. *Chinese Civilization* (tr. Innes and Brailsford). New York, 1957.
GROUSSET, R. *L'empire des steppes.* Paris, 1939.
GROUSSET, R. *De la Chine au Japon.* Monaco, 1951.
KAIZUKA, SHIGEKI 贝塚茂树. 中国古代史学 发展. Tokyo, 1946.
KEIGHTLEY, D. N. ed. *The Origins of Chinese Civilization.* Berkeley, 1983.
LI, XUEQIN. *Eastern Zhou and Qin Civilizations* (tr. K. C. Chang). New Haven, London, 1985.
LOEWE, M. *Imperial China: the historical background to the modern age.* London, 1966.
MASPERO, H. *La Chine antique.* Paris, 1965.
MASPERO, H., BALAZS, E. *Histoire et institutions de la Chine antique.* Paris, 1967.
MCALEAVY, H. *The Modern History of China.* London, 1967.
NAITŌ, TORAJIRŌ 内藤虎次郎. 支那上古史. Tokyo, 1944.
NEEDHAM, J. *Science and Civilisation in China.* 7 vols. Cambridge, 1954-.
SAID, E. W. *Orientalism.* London, 1978.
TWITCHETT, D., LOEWE, M. ed. *The Cambridge History of China.* Cambridge, 1979.
WATSON, W. *China before the Han Dynasty.* London, 1962a.
XIA, NAI 夏鼐 ed. 新中国的考古发现和研究. Beijing, 1984.
YANG KUAN 杨宽. 战国史. Shanghai, 1955.

Mythology and Religion

ALLAN, S. *The Shape of the Turtle: myth, art, and cosmos in early China*. New York, 1991.

BIRRELL, A. *Chinese Mythology. An introduction with translations of narratives*. 1994.

CH'EN, K. K. S. *Buddhism in China*. Princeton, 1964.

COHN, W. *Buddha in der Kunst des Ostens*. 2 vols. Leipzig, 1925.

CONZE, E. *Buddhism*. Oxford, 1930.

CONZE, E. *Buddhism: Its Essence and Development*. 3rd ed. New York, 1959.

CONZE, E. *Buddhist Scriptures*. Harmondsworth, 1959.

EBERHARD, W. *The Local Cultures of South and East China*. Leiden, 1968.

FOUCHER, A. *La vie du Bouddha, d'après les textes et les monuments de l'Inde*. Paris, 1949.

GRANET, M. *La religion des Chinois*. 2nd ed. Paris, 1951.

GRANET, M. *Danses et légendes de la Chine ancienne*. Paris, 1959.

MASPERO, H. *Le Taoïsme et les religions chinoises*. Paris, 1971.

MORIMI, KISABURŌ 森三樹三郎. 支那古代神話. Kyoto, 1944.

PETRUCCI, R. *La philosophie de la nature dans l'art d'Extrême-Orient*. Paris, 1910.

SAWA TAKAAKI 佐和隆研. 仏像国典 Tokyo 1962.

SECKEL, D. *The Art of Buddhism* (tr. Ann E. Keep). New York, 1964.

WEN, YIDOU 闻一多. 全集, vol. I. Shanghai, 1948.

WIEGER, L. *Histoire des croyances religieuses et des opinions philosophiques en Chine*. Re-edited. Paris, 1953.

YUAN, KÊ 袁珂. 中国古代神话. Shanghai, 1957.

ZÜRCHER, E. *The Buddhist Conquest of China. The spread and adaptation of Buddhism in early medieval China*. Leiden, 1959.

Painting

CAHILL, J. *Chinese Painting*. Skira, Switzerland, 1960.

COHN, W. *Chinese Painting*. 2nd ed. London, 1948.

CONTAG, V., WANG, C. C. *Seals of Chinese Painters and Collectors of the Ming and Ch'ing Periods*. Rev. ed. with supp. Hong Kong, 1966.

FARRER, A. *The Brush Dances and the Ink Sings: Chinese paintings and calligraphy from the British Museum*. British Museum, London, 1990.

FONG, W. *Beyond Representation. Chinese painting and calligraphy 8th–14th century*. New York, 1958.

GRUBE, E. J., SIMS, E. M. *Between China and Iran. Percival David Foundation of Chinese Art Colloquies on Art and Archaeology No. 10. 1980*. London, 1985.

GULIK, R. H. VAN. *Chinese Pictorial Art as viewed by the Connoisseur*. Rome, 1958.

JENYNS, R. S. *A Background to Chinese Painting*. London, 1935.

LAING, E. M. J. *Chinese Paintings in Chinese Publications*. Ann Arbor, 1969.

LAWTON, T. *Chinese Figure Painting*. Washington DC, 1973.

LEE, S. E. *The Colors of Ink. Chinese paintings and related ceramics from the Cleveland Museum of Art*. New York, 1974.

LI, C. T. *A Thousand Peaks and Myriad Ravines: Chinese painting in the Charles A. Drenowatz Collection*. 2 vols. Ascona, 1974.

LOEHR, M. 'Chinese paintings with Sung dated inscriptions', *Ars Orientalis* IV (1961). Baltimore, 1961.

LOVELL, H. C. *An Annotated Bibliography of Chinese Painting Catalogues and Related Texts*. Michigan Papers in Chinese Studies No. 16. Ann Arbor, 1973.

MARCH, B. 'Linear perspective in Chinese painting', *Eastern Art* III (1931).

NAKAMURA SHIGEO 中村茂夫. 中国画论の展开. Kyoto, 1965.

NATIONAL PALACE MUSEUM. *Descriptive and Illustrated Catalogue of the Paintings in the National Palace Museum*. Taipei, 1968.

NATIONAL PALACE MUSEUM. *The Proceedings of the International Symposium on Chinese Painting*. Taipei, 1970.

NATIONAL PALACE MUSEUM 山水画墨法特展图录 (catalogue of special exhibition on the ink method of landscape painting). Taipei, 1987.

NATIONAL PALACE MUSEUM. 渊明逸致特展图录 (catalogue of special exhibition on the theme of Yuan Taoming's retreat). 10th ed. Taipei, 1988.

NATIONAL PALACE MUSEUM. 冬景山水特展图录 (catalogue of special exhibition of snow landscape). 10th ed. Taipei, 1989.

OSAKA MUSEUM OF FINE ARTS. *Osaka Exchange Exhibition: paintings from the Abe collection and other masterpieces of Chinese art (at San Francisco)*. Tokyo, 1970.

SIRÉN, O. *Chinese Painting: Leading Masters and Principles*. 7 vols. London, 1956–8.

SUZUKI, KEI. *Comprehensive Illustrated Catalog of Chinese paintings*. Tokyo, 1982.

TOMITA, K. *Portfolio of Chinese Paintings in the Boston Museum (Han to Sung periods)*. Boston, 1933.

TSENG, YÜ 曾堉. 中国画学书目表. Taipei, 1980.

VANCOUVER ART GALLERY. *The Single Brushstroke: 600 years of Chinese painting from the Ching Yuan Chai collection (i.e. the J. Cahill collection)*. Vancouver, 1985.

WALEY, A. *An Introduction to the Study of Chinese Painting*. London, 1923.

YU, JIANHUA 俞剑华. 中国绘画史. Shanghai, 1954.

ZHANG, SHUBO 张树柏. 故宫藏画精选 (paintings of the Palace Museum, Beijing). Hong Kong, 1981.

ZHONGGUO SHUHUA YANJIUHUI 中国书画研究会. 中国名画家丛书. Hong Kong, 1970.

Philosophy

FUNG, YU-LAN. *The Spirit of Chinese Philosophy* (tr. E. R. Hughes). London, 1947.

FUNG, YU-LAN. A. *History of Chinese Philosophy* (tr. D. Bodde). Princeton, 1953.

HUGHES, E. R. ed. and tr. *Chinese Philosophy in Classical Times* (translated texts). London, 1950.

KALTENMARK, M. *Lao-tseu et le taoïsme*. Paris, 1965.

KALTENMARK, M. *La philosophie chinoise*. Paris, 1972.

WRIGHT, A. F. *The Confucian Persuasion*. Stanford, 1963.

WRIGHT, A. F., TWITCHETT, D. *Confucian Personalities*. Stanford, 1962.

Sculpture

CHAVANNES, E. *Mission archéologique dans la Chine septentrionale*. 3 vols. Paris, 1909–15.

D'ARGENCÉ, R.-Y. L., TURNER, D. ed. *Chinese, Korean and Japanese Sculpture in the Avery Brundage Collection*. San Francisco, 1974.

ESKENAZI AND CO. *Ancient Chinese Sculpture* (sale catalogue). London, 1978.

MATSUBARA, SABURÔ 松原三郎. 中国佛教雕刻史研究. Tokyo, 1961–6.

MIZUNO, SEIICHI 中国の雕刻. Tokyo, 1950.

OSAKA MUNICIPAL ART MUSEUM. 石佛. Kyoto, 1953.

SIRÉN, O. *Chinese Sculpture from the Fifth to the Fourteenth Century*. 4 vols. London, 1925.

SIRÉN, O. *Kineska och japanska skulpturer och målingar i Nationalmuseet*. 3 vols. Malmö, 1946.

SIRÉN, O. *Chinesische Skulpturen der Sammlung Eduard von der Heydt*. Zürich, 1959.

SOPER, A. C. 'Chinese sculpture in the Avery Brundage collection', *Apollo* LXXXIV No. 54 (1966). 1966c.

Writing

CHANG, L.L., MILLER, P. *Four Thousand Years of Chinese Calligraphy*. Chicago, London, 1990.

CH'EN, CHIH-MAI. *Chinese Calligraphers and their Art*. London, New York, 1966.

CHEUNG, KWONG-YUE. 'Recent archaeological evidence relating to the origin of Chinese characters', D. N. Keightley, ed., *The Origins of Chinese Civilization*. Berkeley, Los Angeles, 1983.

CHIANG, YEE. *Chinese Calligraphy*. 2nd ed. Cambridge, Mass., 1954.

Various

HANSFORD, S. H. *A Glossary of Chinese Art and Archaeology*. London, 1972.

HERRMANN, A. *A Historical and Commercial Atlas of China*. New York, 1962.

LOEHR, M. *Chinese Art: Symbols and Images*. Wellesley, Mass., 1967.

MAYERS, W. F. *The Chinese Reader's Manual*. Shanghai, 1924.

SCHAFER, E. H. *The Golden Peaches of Samarkand. A study of T'ang exotics*. Berkeley, 1963.

SCHAFER, E. *The Vermilion Bird. T'ang images of the south*. Berkeley, 1967.

SCHAFER, E. H. *Pacing the Wind. T'ang approaches to the stars*. Berkeley, 1977.

SOOTHILL, W. E., HODOUS, L. *A Dictionary of Chinese Buddhist Terms*. London, 1937.

TREGEAR, T. R. *A Geography of China*. London, 1966.

WERNER, E. T. C. *A Dictionary of Chinese Mythology*. New York, 1961.

WILLIAMS, C. A. S. *Outlines of Chinese Symbolism*. Shanghai, 1941.

BIBLIOGRAPHY BY CHAPTERS

CHAPTER I *Neolithic Art*

ACADEMIA SINICA. *Ch'eng tzü yai* (tr. K. Starr, q.v.). Beijing, 1934.

ANDERSSON, J. G. 'An early Chinese culture', *Geological Survey of China*. Beijing, 1923.

ANDERSSON, J. G. 'Symbolism in the prehistoric painted ceramics of China', *BMFEA* I (1929).

ANDERSSON, J. G. 'Prehistoric sites in Honan', *BMFEA* 19 (1947).

BYLIN-ALTHIN, M. 'The site of Ch'i-chia-ping, Hsi-ning-hsien, Gansu', *BMFEA* 18 (1946).

INSTITUTE OF ARCHAEOLOGY. 西安半坡. *Special Archaeological Series IV No. 14*. Beijing, 1963.

INSTITUTE OF ARCHAEOLOGY. 新中国出土文物. Peking, 1972.

LIANG SIYONG 梁思永. 龙山文化：中国文明的前期之一, *KGXB* 1954 (7). 55.

PALMGREN, N. *Kansu Mortuary Urns of the Pan Shan and Ma Chang Groups.* Peking, 1934.

QINGHAI PROVINCE ARCHAEOLOGICAL TEAM. 青海柳湾. 2 vols. Beijing, 1984.

SHANDONG CULTURAL OFFICE. 大汶口. Beijing, 1974.

STARR, K. (tr.). *Ch'eng tzü yai. Yale University Publications in Anthropology No. 52*. New Haven, 1956.

WATSON, W. *Archaeology in China.* London, 1960.

CHAPTER 2 *Shang Art*

BACHHOFER, L. 'The evolution of Shang and Early Chou Bronzes', *Bulletin of Art* 1944 26.

BAGLEY, R. W. 'P'an-lung-ch'eng: a Shang city in Hupei', *Artibus Asiae* 39 (1977).

BAGLEY, R. W. 'The beginning of the bronze age: the Erlitou culture period', Fong, Wen, ed., *The Great Bronze Age of China*. New York, 1980a.

BAGLEY, R. W. 'The Zhengzhou phase (the Erligang period)', ibid. 1980b.

BAGLEY, R. W. 'The appearance and growth of regional bronze-using cultures', ibid. 1980c.

BAGLEY, R. W. 'The high Yinxu phase (Anyang period)', ibid. 1980d.

BAGLEY, R. W. 'The rise of the Western Zhou dynasty', ibid. 1980e.

BAGLEY, R. W. 'Transformation of the bronze art in later Western Zhou', ibid. 1980f.

BAGLEY, R. W. 'A Shang city in Sichuan', *Orientations* vol. 21, no. 11 (1990).

CHANG, K. C. *The Archaeology of ancient China.* New Haven, London, 1963.

CHANG, K. C. ed. *Studies of Shang Archaeology.* New Haven, London, 1986.

CHANG, TSUNG TUNG. *Der Kult der Shang-Dynastie im Spiegel der Orakels-chriften.* Wiesbaden, 1970.

CH'EN, MENGJIA 陈梦家. 殷代铜器. *KGXB* 7 (1954).

FONG, WEN ed. *The Great Bronze Age of China.* New York, 1980.

FREER GALLERY OF ART. *A Descriptive and Illustrative Catalogue of Chinese bronzes.* Washington DC, 1946.

GAO, Z. S. 高至喜. 商代人面方鼎, *WW* 1960 10 57.

GARNER, H. M. 'The composition of Chinese bronzes', *Oriental Art* VI/44 (1960). 6/44.

GUO, BAOJUN 郭宝钧. B-区发掘纪之一. 安阳发掘报告 4 1993a.

GUO, BAOJUN 郭宝钧. B-区发掘纪之二. 安阳发掘报告 4 1933b.

HENAN PROVINCIAL MUSEUM. 郑州新出土的商代前期大铜鼎, *WW* 1975 6 64.

HENAN PROVINCE CULTURAL INSTITUTE. 藁城台西商代遗址. Beijing, 1985.

HU, HOUYI 胡厚宜. 殷墟发掘. Shanghai, 1955.

HUBEI PROVINCIAL MUSEUM. 盘龙城1974年度田野考古纪要, *WW* 1976 2 5. 1976a.

HUBEI PROVINCIAL MUSEUM. 盘龙城商代二里冈期的青铜器, *WW* 1976 2 26. 1976b.

INSTITUTE OF ARCHAEOLOGY. 郑州二里冈. *Special Archaeological Series D no. 7*. 1959a.

INSTITUTE OF ARCHAEOLOGY. *Special Archaeological Series D no. 23*. 1965b.

KANE, V. C. 'The independent bronze industries in the south of China contemporary with the Shang and Western Zhou Dynasties', *Archives of Asian Art* 28 (1974–5).

KARLBECK, O. 'Anyang marble sculptures', *BMFEA* 7 (1935).

KARLGREN, B. 'Yin and Chou in Chinese Bronzes', *BMFEA* 8 (1935).

KARLGREN, B. 'New Studies on Chinese Bronzes', *BMFEA* 9 (1937).

KARLGREN, B. 'Some early Chinese bronze masters', *BMFEA* 16 (1944).

KARLGREN, B. 'Once again the A and B styles in Yin ornamentation', *BMFEA* 18 (1946).

KARLGREN, B. 'Notes on the grammar of early bronze décor', *BMFEA* 23 (1951).

KIDDER, J. E., JONATHAN, E. *Early Chinese Bronzes in the City Art Museum of St Louis.* St Louis, 1956.

LI CHI. *Anyang.* Seattle, 1977.

LOEHR, M. 'The Bronze Styles of the Anyang Period', *Archives of the Chinese Art Society of America* 7 (1953).

MA DEZHI, ZHOU YONGZHEN, ZHANG YUNPENG 马待志, 周永珍, 张云鹏. 一九五三年安阳大司空发掘报告, *KGXB* 9 (1955).

SHANXI CULTURAL OFFICE. 山西石楼县二郎坡出土商周铜器, *WW* 1958 1 36.

SOPER, A. C. 'Early, middle, and late Shang: a note', *Artibus Asiae* 28 (1966).

SUGIMURA, YUZÔ 杉村勇造. 中国古铜器. Tokyo, 1966.

UMEHARA, SUEJI 梅原末治. 河南安阳出土白色土器再论, *Shinagaku* 9/4 (1939).

UMEHARA, SUEJI 梅原末治. 河南安阳发现木器印影图录. Kyoto, 1959.

WATSON, W. 'The individuality of the Henan tradition in the Shang period', *Proceedings of the conference on Sinology.* Taipei, 1970a.

WATSON, W. 'On some categories of archaism in Chinese bronzes', *Ars Orientalis* IX (1973). 1973b.

ZHANG, TUNSHENG 张囤生 ed. 殷墟妇好墓. *Institute of Archaeology Special Archaeological Report D no. 23.* Beijing, 1980.

ZOU, HENG 邹衡. 试论郑州发现的殷商文化遗址, *KGXB* 1956 3 77.

ZOU, HENG 邹衡. 夏商周考古学论文集. Beijing, 1980.

CHAPTER 3 *Bronze in the Xizhou Period*

CHEN, FANG-MEI. 'The stylistic development of Shang and Zhou bells', *Style in the East Asian tradition. Percival David Foundation of Chinese Art Colloquies on Art and Archaeology in Asia No. 14.* London, 1987.

CHENG, CHANGXIN 程长新. 北京市顺义县牛栏山出土一组周初带铭青铜器, *WW* 1983 11 64.

GE, JIN 葛今. 湿阳高家堡早周墓发掘报记, *WW* 1972 7 5.

GUO, BAOJUN. 商周铜器总和研究. Beijing, 1981.

INNER MONGOLIAN ARCHAEOLOGICAL INSTITUTE. 内蒙古黑城考古发掘纪要. *WW* 1987 7 2.

INSTITUTE OF ARCHAEOLOGY. 沣西发掘报告. *Special Archaeological Series D no. 12.* 1962a.

INSTITUTE OF ARCHAEOLOGY. 洛阳中州路西工段. *Special Archaeological Series D no. 4.* 1962b.

INSTITUTE OF ARCHAEOLOGY. 长安张家坡西周铜器群. *Special Archaeological Series B no. 15.* 1965a.

INSTITUTE OF ARCHAEOLOGY. 1981–1983 年琉璃河西周燕国墓地, *KG* 1984 5 405. 1984a.

INSTITUTE OF ARCHAEOLOGY. 长安张家坡西周井叔墓发掘简报, *KG* 1986 1 22. 1986a.

LINTONG-XIAN MUSEUM. 陕西临潼发现武王征商簋, *WW* 1977 8 1.

LIU XING, WU DALIN 刘兴, 吴大林. 江苏漂水发现西周墓, *KG* 1976 4 274.

LU LIANCHENG, HU ZHISHENG 卢连成, 胡智生. 宝鸡弭国墓地. Beijing, 1988.

RAWSON, J. 'Eccentric Bronzes of the Early Western Zhou', *Transactions of the Oriental Ceramic Society* 47 (1982–3).

RAWSON, J. *Western Zhou Ritual Bronzes from the Arthur M. Sackler Collections.* Cambridge Mass., 1990.

SHAANXI ZHOUYUAN TEAM. 陕西扶风百一号西周青铜器窖藏发掘简报, *WW* 1978 3 1.

SHAANXI ZHOUYUAN TEAM. 陕西扶风齐家十九号西周墓, *WW* 1979 11 1. 1979a.

SHAANXI ZHOUYUAN TEAM. 陕西岐山凤雏村西周青铜器窖藏简报, *WW* 1979 11 12. 1979b.

SHAANXI ZHOUYUAN TEAM. 扶风黄堆西周墓地钻探清理简报, *WW* 1986 8 56.

SHANXI ANTIQUITIES COMMITTEE. 西周镐京附近部分墓葬发掘简报, *WW* 1986 1 1.

SHI, XINGBANG 石兴邦. 长沙普渡村西周墓葬发掘记, *KGXB* 8 (1954).

SICHUAN PROVINCIAL MUSEUM. 四川彭县西周窖藏铜器, *KG* 1981 6 496.

SUIZHOU CITY MUSEUM. 湖北随县新发现古代铜器, *KG* 1982 2 139.

SUN JINGMING 孙敬明 *et al.* 山东临朐新出铜器铭文考释友有关问题, *WW* 1983 12 13.

TANG JINYU 唐金裕 *et al.* 陕西省城古县出土殷商铜器整理简报, *KG* 1980 3 211.

WATSON, W. 'The city in ancient China', Moorey, P. R. S., ed., *The Origins of Civilization*, Wolfson College Lectures 1978. Oxford, 1979b.

WU, BOLUN 武伯纶. 扶风齐家村青铜器群. Beijing, 1963.

XINYANG DISTRICT COMMITTEE. 河南信阳发现两批春秋铜器, *WW* 1980 1 42. 1980a.

XINYANG DISTRICT COMMITTEE. 河南罗山县发现春秋早期铜器, *WW* 1980 1 51. 1980b.

ZHANG, ZHENGLANG 张政烺.「利簋」释文. *KG* 1978 1 58.

CHAPTER 4 *Bronze in the Chunqiu and Zhanguo Periods*

BAOJI CITY MUSEUM. *WW* 1980 9 1.

BARNARD, N. ed. *Early Chinese Art and Its Possible Influences in the Pacific Basin.* New York, 1972.

BARNARD, N. 'The twelve gods of the Chan-kuo period silk manuscript excavated at Chang-sha', ibid.

CHEN, PEIFEN 陈佩芬. 上海博物馆藏青铜镜. Shanghai, 1987.

CHENG, TE-K'UN. 'The slate tomb culture of Li-fan', *Harvard Journal of Asiatic Studies* 9–12 (1946).

DOHRENWEND, D. 'The early Chinese mirror', *Artibus Asiae* XXVII (1964).

ERDBERG, E. VON. 'A hu with pictorial decoration', *Archives of the Chinese Art Society of America* 6 (1952).

GALERIES NATIONALES AU GRAND PALAIS. *Zhongshan: Tombes des rois oubliés* (exhibition catalogue). Paris, 1985.

GUANGDONG PROVINCIAL MUSEUM. 广东肇庆市北岭松山古墓发掘简报, *WW* 1974 11 69.

GUSHIHOU GUDUI GROUP. 河南固始侯古堆一号墓发掘简报, *WW* 1981 1 1.

HAN WEI, CAO MINGTAN 韩伟,曹明檀.陕西凤翔高王寺战国铜器窖藏, *WW* 1981 1 15.

HENAN ANTIQUITIES TEAM. 河南省平山县战国时期中山国墓葬发, *WW* 1979 1 1.

HENAN PROVINCIAL MUSEUM. 河南信阳市平桥县春秋墓发掘简报, *WW* 1981 1 9.

HUAINING CULTURAL OFFICE. 安徽怀宁县出土春秋青铜器, *WW* 1983 11 68.

HUANG, SHENGZHANG 黄盛璋.关于战国中山国墓葬遗物若干问题办正, *WW* 1979 5 43.

HUBEI CULTURAL OFFICE.湖北江陵三座楚墓出土大批重要文物, *WW* 1966 5 33.

HUBEI PROVINCIAL MUSEUM. 随县曾侯乙墓. Beijing, 1980.

HUBEI YICHANG DISTRICT MUSEUM. 湖北枝江县姚家港楚墓发掘报告, *KG* 1988 2 166.

HUBEI PROVINCIAL MUSEUM.当阳金家山九号春秋楚墓, *WW* 1982 4 41.

HUNAN YIYANG DISTRICT.益阳楚墓, *KGXB* 1985 1 89.

INSTITUTE OF ARCHAEOLOGY. 寿县蔡侯出土遗物, *Special Archaeological Series B no. 5* (1956). 1956b.

INSTITUTE OF ARCHAEOLOGY. 长沙发掘报告. *Special Archaeological Series D no. 2* (1957).

INSTITUTE OF ARCHAEOLOGY. 上村岭虢墓地. *Special Archaeological Series D no. 10* (1959). 1959b.

INSTITUTE OF ARCHAEOLOGY.山彪镇与琉璃阁. *Special Archaeological Series B no. 11* (1959). 1959c.

INSTITUTE OF ARCHAEOLOGY. 澧西发掘报告. *Special Archaeological Series D no. 12* (1962). 1962a.

INSTITUTE OF ARCHAEOLOGY. 洛阳中州路. *Special Archaeological Series D no. 4* (1959). 1962b.

INSTITUTE OF ARCHAEOLOGY. 辉县出土器物图案. Beijing, 1964.

KARLGREN, B. 'Huai and Han', A and B styles in Yin ornamentation'. *BMFEA* 13 (1941).

KARLGREN, B. 'Some pre-Han mirrors', *BMFEA* 35 (1963).

KOMAI, KAZUCHIKA 驹井和爱.中国古镜 研究. Tokyo, 1953.

LAWTON, T. *Chinese Art of the Warring States Period. Change and continuity, 480–222 B.C.* Washington DC, 1982.

LI XUEQIN, LI LING 李学勤,李零.平山三器与中山国史的若干问题, *KGXB* 1979 2 147.

LIU LAICHENG, LI XIAODONG 刘来成,李晓东.试谈战国时期中山国历史上的几个问题, *WW* 1979 1 33.

LUBO-LESNICHENKO, YE. *Drevnie Kitaiskie sholkovye tkani i vyshivki...v sobranii Gosudarstvennogo Ermitazha.* Leningrad, 1961.

LUOYANG MUSEUM. 河南洛阳春秋墓, *KG* 1981 1 24.

MA, CHENGYUAN 马承源.鸟兽龙纹壶, *WW* 1960 4 79.

MACKENZIE, C. 'The Chu tradition of wood carving', *Style in the East Asian Tradition. Percival David Foundation of Chinese Art Colloquies on Art and Archaeology in Asia No. 14* (1987).

NANJING MUSEUM. 江苏丹徒磨盘墩周墓发掘简报, *KG* 1985 11 985. 1984a.

RAWSON, J. 'Western Zhou sources of interlaced motifs', *Style in the East Asian Tradition. Percival David Foundation of Chinese Art Colloquies on Art and Archaeology in Asia No. 14* (1987).

SALLES, G. 'Les bronzes de Li-yu', *Revue des arts asiatiques.* 8 no. 3 (1934).

SHANDONG ARCHAEOLOGICAL INSTITUTE. 山东沂水刘家店子春秋墓发掘简报, *WW* 1984 9 1.

SHANDONG ARCHAEOLOGICAL INSTITUTE. 曲阜鲁国故城. Jinan, 1982.

SHANDONG PROVINCIAL MUSEUM. 莒南大店春秋时期莒国殉人墓, *KGXB* 1978 3 317.

SHANXI ARCHAEOLOGICAL INSTITUTE. 太原金胜村251号春秋大墓及车马坑发掘简报, *WW* 1989 9 59.

SHANXI PROVINCIAL MUSEUM.山西长治市分水岭古墓的清理, *KGXB* 1957 1 103.

SICHUAN ANTIQUITIES COMMITTEE. 成都羊子山第172号墓发掘报告, *KGXB* 1956 4 1.

SICHUAN PROVINCIAL MUSEUM. 成都百花潭中学十号墓发掘记, *WW* 1976 3 40.

SO, J. F. 'Hu vessels from Xinzheng: towards a definition of Chu style', G.

Kuwayama, ed. *The Great Bronze Age of China, a symposium.* Los Angeles, 1983.

SONG, ZHAOLIN 宋兆麟.战国弋射图及弋射溯源, *WW* 1981 6 75.

SOPER, A. C. 'The tomb of the marquis of Ts'ai', *Oriental Art* X, no. 3 (1964).

SUI-XIAN MUSEUM. 湖北随县城郊发现春秋墓葬和铜器, *WW* 1980 1 34.

SUN, HAIBO 孙海波.新郑彝器. Beijing, 1937.

SWALLOW, R. W. *Ancient Chinese Bronze Mirrors.* Peking, 1937.

TOKYO NATIONAL MUSEUM. 中山王国文物展. Tokyo, 1981.

UMEHARA, SUEJI 梅原末治. 战国时期铜器 研究. Kyoto, 1933.

VAINKER, S. 'A southwest Chinese bronze in the Burrell collection', *Style in the East Asian tradition. Percival David Foundation of Chinese Art Colloquies on Art and Archaeology in Asia No 14* (1987).

WANG, YOUPENG 王有鹏.四川绵竹县船棺墓, *WW* 1987 10 22.

WATSON, W. 'A Chinese bell of the fifth century B.C.', *British Museum Quarterly* XXX (1965).

WATSON, W. 'A Chinese bronze figure of the fourth century B.C.', *British Museum Quarterly* XXXI (1967).

WATSON, W. 'Traditions of material culture in the territory of Ch'u', N. Barnard, ed., *Early Chinese Art and Its Possible Influences in the Pacific Basin.* New York, 1972.

WEBER, C. D. *Chinese Pictorial Bronze Vessels of the Later Zhou Period.* Ascona, 1968.

WEBER, G. W. *The Ornaments of Late Chou Bronzes.* New Brunswick, 1973.

WENWU CHUBANSHE 文物出版社.中国古青铜器选. Beijing, 1976.

WHITE, W. C. *Tombs of Old Loyang.* Shanghai, 1934.

WHITE, W. C. *The Bronze Culture of Ancient China.* Toronto, 1956.

WU SHUNQING 吴顺青 *et al.* 荆门包山2号墓... 清理与复原, *WW* 1988 5 15.

XINYANG DISTRICT COMMITTEE. 春秋早期黄君孟夫妇墓发掘报告, *KG* 1984 4 302.

YE XIAOYAN 叶小燕. 东周刻纹铜器, *KG* 1983 2 158.

YETTS, W. P. *The Cull Chinese Bronzes.* London, 1939.

ZHEJIANG ANTIQUITIES COMMITTEE. 绍兴306号战国墓发掘简报 , *WW* 1984 1 10.

ZHENJIANG MUSEUM. 江苏镇江谏壁王家山东周墓, *WW* 1987 12 24.

CHAPTER 5 *Jade*

AN, ZHIMIN 安志敏.关于良渚文化的若干问题, *KG* 1988 3 236.

AYERS, J. *A Jade Menagerie. The Worrell Collection.* London, 1993.

BEIJING JADE TECHNIQUE GROUP. 对商代琢玉工艺的一些初步看法, *KG* 1976 4 229.

BLUETT AND SONS. *Chinese Jades from the Mu-Fei Collection.* London, 1990.

CHANGSHOU CITY ANTIQUITIES COMMITTEE. 江苏常熟良渚文化遗址, *WW* 1984 2 12.

CULLEN, C., FARRER, A. S. 'On the term *Hsüan chi* and the flanged trilobate discs', *Bulletin of the School of Oriental and African Studies, University of London,* vol. XLVI, pt 1 (1983).

D'ARGENCÉ, R. -Y. L. *Chinese Jades in the Avery Brundage Collection.* San Francisco, 1972b.

DOHRENWEND, D. *Chinese Jades in the Royal Ontario Museum.* Toronto, 1971.

GUO, BAOJUN 郭宝钧.浚阳辛村古残墓之清理, *KGXB* 1936 1 167.

GURE, D. 'Selected examples from the jade exhibition at Stockholm 1963: a comparative study', *BMFEA* 36 (1964).

HANSFORD, S. H. *Chinese Carved Jades.* London, 1968.

HARTMENN, J. M. *Ancient Chinese Jades from the Buffalo Museum of Science.* New York, 1975.

HAYASHI MINAO. 'On the Chinese neolithic jade tsung/cong' (adapted in English by A. C. Soper), *Artibus Asiae* vol. L 1/2 (1990).

HEBEI ANTIQUITIES OFFICE. 河北平山县战国时期中山墓葬简报, *WW* 1979 1 1.

HENAN CULTURAL OFFICE. 郑州商代遗址发掘, *KGXB* 1957 1 53.

HENAN PROVINCIAL MUSEUM. 河南淅川县下寺一号墓发掘简报, *KG* 1981 2 119.

HUBEI JINGZHOU MUSEUM. 江陵天星观1号楚墓, *KGXB* 1982 1 71.

HUBEI YICHANG MUSEUM. 湖北枝江县姚家港楚墓发掘报告, *KG* 1988 2 157.

HUNAN PROVINCIAL MUSEUM. 长沙树木岭战国墓阿弥岭西汉墓, *KG* 1984 9 790. 1984a.

INSTITUTE OF ARCHAEOLOGY.河南偃师二里头遗址三,八区发掘简报, *KG* 1975 5 302. 1975a.

INSTITUTE OF ARCHAEOLOGY.偃师二里头遗址的铜器和玉器, *KG* 1976 4 259. 1976A.

INSTITUTE OF ARCHAEOLOGY.安阳殷墟五号墓的发掘, *KGXB* 1977 2 57.

INSTITUTE OF ARCHAEOLOGY. 1964-1977 年殷墟西区墓葬墓发掘报告. 1979 1 27.

INSTITUTE OF ARCHAEOLOGY. 殷墟玉器. *Special Archaeological Series B no. 20* (1982). 1982a.

INSTITUTE OF ARCHAEOLOGY. 1984年秋河南偃师二里头遗址发现的, *KG* 1986 4 318. 1986b.

INSTITUTE OF ARCHAEOLOGY. 1984–85 年澧西西周遗址墓葬发掘报告, 1987 1 15. 1987a.

INSTITUTE OF ARCHAEOLOGY. 1976 年安阳小屯西北地发掘简报, *KG* 1987 4 295. 1987b.

JENYNS, R. S. *Chinese Archaic Jades in the British Museum*. London, 1951.

JIN, XUESHAN 金学山. 西安半坡战国墓葬, *KGXB* 1957 3 63.

LAUFER, B. *Jade, a study in Chinese archaeology and religion. Field Museum of Natural History Publication 154. Anthr. Series 10*. Chicago, 1912.

LIU, DUNYUAN 刘敦愿. 有关日照两城镇玉坑玉器的资料, *KG* 1988 2 121.

LOEHR, M. *Ancient Chinese Jades from the Grenville L. Winthrop Collection in the Fogg Art Museum, Harvard University*. Cambridge Mass., 1975.

MIZUNO, SEIICHI. 水野清一. 殷周青铜器と玉. Tokyo, 1959.

NA, CHIHLIANG. 玉璧, *The National Palace Museum Monthly of Chinese Art*, vol. 1 no. 1 (1983).

NANJING MUSEUM. 南京市北阴阳营第一, 二次的发掘, *KGXB* 1958 1 7.

PALMER, J. P. *Jade*. London, 1967.

PELLIOT, P. *Jades archaïques de Chine appartenant à M. C. T. Loo*. Paris and Brussels, 1925.

POPE-HENNESSY, U. *Early Chinese Jades*. London, 1923.

RAWSON, J., AYERS, J. *Chinese Jade Throughout the Ages* (exhibition catalogue). London, 1975.

SALMONY, A. *Carved Jades of Ancient China*. Berkeley, 1938.

SALMONY, A. *Archaic Jades from the Sonnenschein Collection*. Chicago, 1952.

SALMONY, A. *Chinese Jade through the Wei dynasty*. New York, 1963.

SHAANXI ZHOUYUAN TEAM. 扶风黄堆西周墓地钻清理简报, *WW* 1986 8 56.

SHANDONG ARCHAEOLOGICAL INSTITUTE. Jinan, 1982.

SHANGHAI CONSERVANCY COMMITTEE. 上海青浦福泉山良渚文化墓地, *WW* 1986 10 1.

SHANXI ANTIQUITIES COMMITTEE. 西周镐京附近部分墓葬发掘简报, *WW* 1986 1 1.

SHANXI ARCHAEOLOGICAL INSTITUTE. 山西长子县东周墓, *KGXB* 1984 4 503.

SHANXI ARCHAEOLOGICAL INSTITUTE. 山西灵石旌介村商墓, *WW* 1986 11 1.

SHEN, BAICHANG. 殷墟玉器. Beijing, 1982.

TOKYO NATIONAL MUSEUM. 中山王国文物展. 1981.

WANG, ZUNGUO. 汪遵国. 良渚文化「玉敛葬述略」, 1984 2 13.

WATT, J. Y. C. *Chinese Jades from Han to Qing*. New York, 1980.

XIA, NAI 夏鼐. 1983. 商代玉器的分类定名和用途, *KG* 1983 5 455.

XINYANG DISTRICT COMMITTEE. 春秋早期黄君孟夫妇墓发掘报告, *KG* 1984 4 302.

YANG, JIANFANG. 中国古玉书目, Hong Kong, 1982.

YOU, RENDE. 尤仁德. 商代玉雕龙纹的造型与纹饰研究, *WW* 1981 8 56.

YOU, RENDE. 尤仁德. 战国汉代玉雕螭纹的造型与纹饰研究, *WW* 1986 9 69.

YU WEICHAO, XIN LIXIANG. 俞伟超, 信立祥. 孔望山摩崖造像的年代考察, *WW* 1981 7 12.

ZHANG, CHANGSHOU 张长寿. 记澧西新发现的兽面的玉饰, *KG* 1987 5 470.

ZHANG, MINGHUA 张明华. 良渚玉戚研究, *KG* 1989 7 626.

ZHEJIANG ANTIQUITIES COMMITTEE. 绍兴306号战国墓发掘简报, *WW* 1984 1 10.

CHAPTER 6 *Lacquer Art*

BEIJING HISTORICAL MUSEUM. 楚文物展览. 1954.

GARNER, H. M. 'Technical studies of oriental lacquer', *Studies in Conservation* 8 no. 3. London, 1963.

HEBEI PROVINCIAL MUSEUM. 河北槁城县台西村商代遗址1973年的重要的发现, *WW* 1974 8 42.

HENAN CULTURAL OFFICE. 河南信阳楚墓出土文物图录. Zhengzhou, 1959.

HUBEI ANTIQUITIES COMMITTEE. 长沙出土的三座大型木椁墓, *KGXB* 1957 1 93.

HUBEI JINGZHOU MUSEUM. 江陵雨台山楚墓, 马山一号楚墓. Beijing, 1985.

HUBEI JINGZHOU MUSEUM. 江陵雨台山楚墓发掘简报, *KG* 1980 5 391.

HUBEI JINGZHOU MUSEUM. 江陵天星观1号楚墓, *KGXB* 1982 1 71.

HUBEI PROVINCIAL MUSEUM. 湖北江陵太晖观楚墓清理简报, *KG* 1973 6 337. 1973a.

HUBEI PROVINCIAL MUSEUM. 湖北江陵拍马山楚墓发掘简报, *KG* 1973 3 151. 1973b.

HUBEI YICHANG MUSEUM. 湖北枝江县姚家港楚墓发掘报告, *KG* 1988 2 157.

INSTITUTE OF ARCHAEOLOGY. 1975年安阳殷墟新发现, *KG* 1976 4 264. 1976b.

INSTITUTE OF ARCHAEOLOGY. 1980 年秋河南偃师二里头遗址发掘简报, 1983 3 199. 1983a.

INSTITUTE OF ARCHAEOLOGY. *KG* 1983 3 199. 1983b.

JENYNS, R. S. 'Chinese lacquer'. *Transactions of the Oriental Ceramic Society* 17 (1939–40). 2nd ed.

KOREAN ANTIQUITIES SOCIETY. 乐浪彩箧冢. Tokyo, 1934.

KOREAN ANTIQUITIES SOCIETY. 乐浪王光墓. Tokyo, 1935.

SCOTT, R. E. 'The earliest Chinese lacquer', *Lacquerwork in Asia and Beyond. Percival David Foundation of Chinese Art Colloquies on Art and Archaeology in Asia No. 11* (1932).

SHANDONG PROVINCIAL MUSEUM. 临淄郎家庄一号东周殉人墓, *KGXB* 1977 1 73.

SHANG, CHENGZUO 商承祚. 长沙出土漆器图录. Beijing, 1955 and 1957.

UMEHARA, SUEJI 梅原末治. 河南安阳发现木器印影图录. Kyoto, 1959.

WANG, SHIXIANG 王世襄. 髹饰录解说. Beijing, 1983.

WATSON, W. 'Chinese lacquered wine-cups', *British Museum Quarterly* XXXI (1957).

WATSON, W. 'The sources and development of style in pre-Han and Han lacquer ornament', *Proceedings of the Second International Conference on Sinology*. Taipei, 1989a.

WU'SHUNQING 吴顺青 *et al*. 荆门包山2号墓 ... 清理与复原, *WW* 1988 5 15.

XIANGYANG DISTRICT MUSEUM. 湖北襄阳擂鼓台一号墓发掘简报, *KG* 1982 2 147.

XINYANG DISTRICT COMMITTEE. 春秋早期黄君孟夫妇墓发掘报告, *KG* 1984 4 302.

YANGZHOU CITY MUSEUM. 扬州西汉「姜莫书」木椁墓, 1980 12 1.

CHAPTER 7 *Inner Asia and the Chinese Borders*

ARTAMONOV, M. I. *Treasures from the Scythian Tombs in the Hermitage Museum*. London, 1969.

BARNETT, R. D. 'The treasure of Ziwiye', *Iraq* XVIII (1956).

BARNETT, R. D. *A Catalogue of the Nimrud Ivories*. London, 1957.

BEIJING ANTIQUITIES INSTITUTE. 北京延庆军都山东周山戎部落墓地发掘纪略, *WW* 1989 8 17.

BOROVKA, G. I. *Scythian Art*. London, 1928.

BUNKER, E. C. 'Ancient ordos bronzes with tin-enriched surfaces', *Orientations* vol. 21 no. 1 (1990).

BUNKER, E. C. 'Gold belt plaques in the Siberian treasure of Peter the Great: dates, origins and iconography', G. Seaman, ed., *Foundations of Empire: Archaeology and Art of the Siberian Steppes*. Los Angeles, 1992a.

BUNKER, E. C. 'Significant changes in iconography and technology among ancient China's north-western pastoral neighbours from the fourth to the first century B.C.', *Bulletin of the Asia Institute* New Series, vol. 6 (1992). 1992b.

BUNKER E. C., CHATWIN, C. B., FARKAS, A. R. *Animal Style Art from East to West*. New York, 1970.

CULICAN, W. *The Medes and Persians*. London, 1965.

DAI YINGXIN, SUN JIAXIANG 戴应新, 孙嘉祥. 陕西神木县出土匈奴文物, *WW* 1983 12 23.

DITTRICH, E. *Das Motiv des Tierkampfes in der altchinesischen Kunst*. Wiesbaden, 1963.

FRANKFORT, H. *The Art and Architecture of the Ancient Orient*. Harmondsworth, 1959.

GAI, SHANLIN 盖山林. 内蒙古自治区准格尔旗速机沟出土一批铜器, 1965 2 44.

GHIRSHMAN, R. 'Le trésor de Sakkez', *Artibus Asiae* XIII (1950).

JETTMAR, K. 'The Karasuk culture and its south-eastern affinities', *BMFEA* 22 (1950).

JETTMAR, K. *The Art of the Steppes* (tr. A. E. Keep). London, 1964.

KERR, R. 'The tiger motif: cultural transference in the steppes', *Percival David Foundation of Chinese Art Colloquies on Art and Archaeology No. 7* (1977).

KISELEV, S. V. *Drevniaya istoriya yuzhnoi Sibiri*. 2nd ed. Moscow, 1951.

LATTIMORE, O. *Inner Asian Frontiers of China*. New York, 1940.

LIN, YÜN. 'A reexamination of the relationship between bronzes of the Shang culture and of the Northern Zone', K. C. Chang, ed., *Studies of Shang Archaeo-logy, selected papers of a conference*. New Haven, 1986.

MAMORU, MASAO 护雅夫. 汉. Tokyo, 1980.

MINNS, E. H. *Scythians and Greeks*. Cambridge, 1913.

NINGXIA ARCHAEOLOGICAL INSTITUTE. 宁夏同心倒墩匈奴墓地, *KGXB* 1988 3 333.

OSAKA MUNICIPAL ART MUSEUM. 古代北方美术. Osaka, 1954.

PORADA, E. *Ancient Iran. The art of pre-Islamic times*. London, 1965.

PRUŠEK, J. *Chinese Statelets and the Northern Barbarians 11400–300 B.C.* Dordrecht, 1971.

RAWSON, J. 'The transformation and abstraction of animal art motifs on bronzes from Inner Mongolia and Northern China', *Percival David Foundation of Chinese Art Colloquies on Art and Archaeology No. 7* (1977).

ROSTOVTSEV, M. *The Animal Style in South Russia and China*. Princeton, 1929.

RUDENKO, S. I. *Kul'tura naseleniya gornogo Altaya v skifskoe vremya*. Leningrad, 1953.

RUDENKO, S. I. 'The mythological eagle, the graphon, the winged lion and the wolf in the art of the northern nomads', *Artibus Asiae* XXI no. 2 (1958).

RUDENKO, S. I. *Kul'tura naseleniya tsentral'nogo Altaya v skifskoe vremya*. Leningrad, 1960.

RUDENKO, S. I. *Sibirskaya kollektsia Petra Pervogo*. Moscow, 1962a.

RUDENKO, S. I. *Kul'tura Khunnov i Noinulinskie Kurgany* (translations by Pollems 1969 and Thompson 1970) Moscow, 1962b.

RUDENKO, S. I. *Die Kultur der Hsiung-nu und die Hügelgräber von Noin Ula* (tr. H. Pollems). Bonn, 1969.

TIAN GUANGJIN, GUO SUXIN 田广金，郭素新．西沟畔匈奴墓反英的诸问题，*WW* 1980 7 13.

TIAN GUANGJIN, GUO SUXIN 田广金，郭素新·鄂尔多斯式青铜器．Beijing, 1986.

TREVER, C. *Excavations in Northern Mongolia*. Leningrad, 1932.

WATSON, W. *Cultural Frontiers in Ancient East Asia*. Edinburgh, 1971a.

YIKEZHAOMENG STATION. 西沟畔匈奴墓，*WW* 1980 7 1.

ZHANGJIAKOU CITY ANTIQUITIES OFFICE. 河北宣化县小白阳墓地发掘报告，*WW* 1987 5 41.

CHAPTER 8 *Cultural Unity. The Han Empire*

AN, ZHIMIN 安志敏·长沙新发现的西汉帛画试探，*KG* 1973 1 43.

ANHUI ANTIQUITIES TEAM. 阜阳双古堆西汉汝阳侯墓发掘简报，*WW* 1978 8 12.

ANHUI ANTIQUITIES TEAM. 安徽天长县汉墓发掘，*KG* 1979 4 320.

BEIJING LOCOMOTIVE FACTORY. 略论秦始皇时代的艺术成就，*KG* 1975 6 334.

BODDE, D. *Festivals in Classical China. New Year and other annual observances during the Han dynasty, 206 B.C.–A.D. 220*. Princeton, 1975.

GU, TIEFU 顾铁符．驻堆帛书「天文气象杂占」内容简述，1978 2 1.

GUANGZHOU ANTIQUITIES COMMITTEE. 广州市龙生冈43号东汉木椁墓，*KGXB* 1957 1 141.

HUBEI PROVINCIAL MUSEUM. 1978云梦秦汉墓发掘报告，*KGXB* 1986 4 479.

HUBEI XIAOGAN DISTRICT TEAM. 湖北云梦睡虎地十一座秦汉发掘简报，*WW* 1976 9 51.

HUNAN PROVINCIAL MUSEUM *et al.* 长沙马王堆一号墓发掘简报．Beijing, 1972.

INSTITUTE OF ARCHAEOLOGY. 马王堆二，三号汉墓发掘的至要收获 *KG* 1975 1 47. 1975b.

INSTITUTE OF ARCHAEOLOGY. 满城汉墓发掘报告. 2 vols. Beijing, 1980b.

LI ZHENGGUANG, PENG QINGYE 李正光，彭青野·长沙沙湖桥一带古墓发掘报告，*KGXB* 1957 4 33.

LOEWE, M. *Everyday Life in Early Imperial China*. London, 1968.

LOEWE, M. *Crisis and Conflict in Han China*. London, 1974.

LUOYANG MUSEUM. 洛阳中州路战国车马坑，*KG* 1974 3 171.

NAN, BO 南波·江苏连云港市海州西汉侍其繇墓，*KG* 1975 3 169.

NANJING MUSEUM. 江苏盱眙东阳汉墓，*KG* 1979 5 412.

PIRAZZOLI-T'SERSTEVENS, M. *The Han Civilization of China*. Oxford, 1982.

RAWSON, J. 'Chou influence on the development of Han bronze vessels', *Arts Asiatiques* XLIV (1989).

SEGALEN, V., VOISINS, G. DE, LARTIGUE, J. *L'art funéraire à l'époque des Han*. 3 vols. Paris, 1935–24.

SHIHUANGLING TEAM. 秦始皇陵东侧第二号兵马俑坑钻探试掘简报，*WW* 1978 5 1.

SHIHUANGLING TEAM. 秦始皇陵东侧第三号兵马俑坑钻探试掘简报，*WW* 1979 12 1.

SUIZHOU MUSEUM. 湖北随县刘家崖发现古代青铜器，*KG* 1982 2 142.

SUN, ZUOYUN 孙作云·马王堆一号汉墓漆棺画考释，*KG* 1973 4 247.

TRUBNER, H. *Arts of the Han Dynasty (exhibition by Chinese Art Society of America)*. New York, 1961.

UMEHARA, SUEJI 梅原末治·支那汉代纪年漆器图说·Kyoto, 1943.

WANG, NINGSHENG 王宁生·晋宁石·寨山青铜器图象所见古代民族考，*KGXB* 1979 4 423.

WANG, ZHONGSHU. *Han Civilization* (tr. K. C. Chang *et al.*). New Haven, London, 1982.

XI, ZEZONG 席泽宗·马王汉墓帛书中慧星图，*WW* 1978 2 5.

XIANYANG CITY MUSEUM. 陕西咸阳马泉西汉墓，*KG* 1979 2 125.

XIANYANG CULTURAL COMMITTEE. 咸阳市空心砖汉墓清理简报，*KG* 3 225.

YANGZHOU CITY MUSEUM. 杨州东风砖瓦厂八，九号汉墓清理简报，*KG* 1982 3 236.

YANGZHOU CITY MUSEUM. 杨州邗江区胡场汉墓，*WW* 1980 3 1.

YANGZHOU CITY MUSEUM. 江苏邗江姚庄101号西汉墓，*WW* 1988 2 19.

YI, XUEZHONG 易学钟·晋宁石寨山12号墓贮贝器上人物雕像考释，*KGXB* 1987 4 413.

YUNNAN PROVINCIAL MUSEUM. 云南晋宁石寨山古遗址及墓葬*KGXB* 1956 43.

YUNNAN PROVINCIAL MUSEUM. 云南晋宁石寨山古墓群发掘报告．Beijing, 1959.

ZHOU, DAO 周到·南阳汉画象石中的几幅天象图，*KG* 1975 1 58.

CHAPTER 9 *Iconography under the Western Han*

BARNARD, N. 'The Ch'u silk manuscript and other archaeological documents of ancient China', N. Barnard, ed., *Early Chinese Art and Its Possible Influences in the Pacific Basin*. New York, 1972.

BULLING, A. *The decoration of mirrors of the Han Period*. Artibus Asiae Supplementum XX (1960).

BULLING, A. 'A landscape representation of the Western Han period', *Artibus Asiae* XXV 4 (1962).

BUNKER, E. C. 'The Tien culture and some aspects of its relationship to the Dong-Son culture', N. Barnard, ed., *Early Chinese Art and Its Possible Influences in the Pacific Basin*. New York, 1972.

DENG, SHUBIN. 'From severance to linkage: communicating with heaven in prehistoric China', *National Palace Museum Bulletin* XXVI 1/2 (1991).

DUBS, H. H. 'Han "hill censers"', *Studia Serica B. Karlgren dedicata*. Copenhagen, 1964.

FINSTERBUSCH, K. *Das Verhältnis des Shan-hai-djing zur bildenden Kunst*. Berlin, 1952.

FINSTERBUSCH, K. *Verzeichnis und Motivindex der Han-Darstellungen*. 2 vols. Wiesbaden, 1966 1971.

FISCHER, O. *Die Chinesische Malerei der Han-Dynastie*. 3rd ed. Berlin, 1931.

HAWKES, D. *Ch'u Tz'u. The songs of the south*. Oxford, 1959.

HAYASHI, M. 'The twelve gods of the Chan-Kuo period silk manuscript excavated at Ch'ng-sha', N. Barnard, ed., *Early Chinese Art and Its Possible Influences in the Pacific Basin*. New York, 1972.

HENAN ANTIQUITIES TEAM. 洛阳西汉壁画墓发掘报告，*KGXB* 1964 2 107.

HENTZE, C. *Chinese Tomb Figures*. London, 1928.

HENTZE, C. *Mythes et symboles lunaires*. Antwerp, 1932.

HENTZE, C.. *Objets rituels, croyances et dieux de la Chine antique et de l'Amérique*. Antwerp, 1936.

HENTZE, C. *Frühchinesische Bronzen und Kulturdarstellungen*. Antwerp, 1937.

HOSHIKAWA, KIYOTAKA 星川清孝·楚辞研究·Nara, 1961.

HUMAN PROVINCIAL MUSEUM. 长沙马王堆一号汉墓发掘简报·Beijing, 1972.

INSTITUTE OF ARCHAEOLOGY. 长沙发掘报告．*Special Archaeological Series D no. 2*. Beijing, 1957.

INSTITUTE OF ARCHAEOLOGY. 洛阳烧沟汉墓．*Special Archaeological Series D no. 6*. Beijing, 1959d.

IZUSHI, YOSHIHIKO 出石诚彦·支那神话传说研究·Tokyo, 1943.

KOBAYASHI, TAIICHIRO 小林太市郎·汉唐古俗　明器土偶·Kyoto, 1947.

KOMAI, KAZUCHIKA 驹井和爱·中国古镜研究·Tokyo, 1953.

LAUFER, B. *Chinese Clay Figures*. Chicago, 1914.

PIRAZZOLI-T'SERSTEVENS, M. MICHÈLE. *La civilisation du royaume de Dian à l'époque Han, d'après le matériel exhumé a Shizai shan (Yünnan)*. Paris, 1974.

SATÔ, MASAHIKO 佐藤雅彦·中国土偶·Tokyo, 1965.

VON DEWALL, M. 'Decorative concepts and stylistic principles in the bronze art of Tien', N. Barnard, ed., *Early Chinese Art and Its Possible Influences in the Pacific Basin*. New York, 1972.

WANG, NINGSHENG 王宁生·云南考古·Kunming, 1980.

WATERBURY, F. *Early Chinese Symbols and Literature: vestiges and speculations*. New York. 1942.

WATSON, W. 'The kingdom of Tien and the Dongson culture', *Readings in Asian Topics: papers read at the inaugural symposium of the Scandinavian Institute of Asian Studies*. Copenhagen, 1968.

CHAPTER 10 *Draughtsmanship and Painting under the Eastern Han*

BEIJING HISTORICAL MUSEUM. 望都汉墓壁画．Beijing, 1955.

BULLING, A. 'Three popular motives in the art of the Eastern Han period', *Archives of Asian Art* XX (1066–67).

BULLING, A. 'Historical plays in the art of the Han period', *Archives of the Chinese Art Society of America* XXI (1967–8).

CAMMANN, S. 'The TLV pattern on cosmic mirrors of the Han dynasty', *Journal of the American Oriental Society* 68 (1948).

CHANG, RENXIA 常任侠. 汉代绘画选集. Beijing, 1955.

CHAVANNES, E. *La sculpture en pierre en Chine au temps des deux dynasties Han.* Paris, 1893.

CHAVES, J. 'A Han painted tomb at Loyang', *Artibus Asiae* XXX/1 (1968).

CHENGDU ANTIQUITIES OFFICE. 四川成都曾家包东汉画像砖石墓, *WW* 1981 10 25.

CHONGQING CITY MUSEUM. 四川汉画像砖选集. Beijing, 1957.

FAIRBANK, W. 'The offering shrines of Wu Liang Tz'u', *Harvard Journal of Asiatic Studies* VI (1941).

FAIRBANK, W. 'A structural key to Han mural art', *Harvard Journal of Asiatic Studies* VII (1942).

FAIRBANK, W. *Adventures in retrieval: Han murals and Shang bronze moulds.* Harvard-Yenching Institute Studies XXVIII (1972).

FISCHER, O. *Die Chinesische Malerei der Han-Dynastie.* 3rd ed. Beilin, 1931.

FU, JUYOU 傅举有. 论秦汉时期的博具, 博戏兼及博局纹镜, *KGXB* 1986 1 21.

HAINING-XIAN MUSEUM. 浙江海宁东汉画像石墓发掘简报, *WW* 1983 5 1.

HENAN ANTIQUITIES TEAM. 河南南阳官寺汉画像石墓发掘报告, *KGXB* 1963 1 111. 1963b.

HENAN ANTIQUITIES TEAM. 洛阳西汉壁画墓发掘报告, *KGXB* 1964 2 107. 1964a.

HUBEI PROVINCIAL MUSEUM. 光化五座西汉墓, *KGXB* 1976 2 149.

HUNAN PROVINCIAL MUSEUM. 湖南资兴东汉墓, *KGXB* 1984 1 53. 1984b.

INSTITUTE OF ARCHAEOLOGY. 长沙发掘报告. *Special Archaeological Series D no. 2.* Beijing, 1957.

INSTITUTE OF ARCHAEOLOGY. 洛阳烧沟汉墓. *Special Archaeological Series D No. 6.* Beijing 1959d.

INSTITUTE OF ARCHAEOLOGY. 河南偃师杏园村东汉壁画墓, *KG* 1985 1 18.

JANSE, O. *Briques et objets funéraires de l'époque des Han, appartenant à C. T. Loo et Cie.* Paris, 1935.

JIANG, YINGJU 蒋英炬. 汉代的小祠堂, *KG* 1983 8 741.

JIANGXI PROVINCIAL MUSEUM. 南昌东郊西汉墓, *KGXB* 1976 2 171.

JIAXIANG-XIAN CULTURAL OFFICE. 山东嘉祥南武山汉画像石, *WW* 1986 4 87.

JINING DISTRICT GROUP. 山东嘉祥宋山1980年出土的汉画像石, *WW* 1982 5 60.

LI, HONGFU 李洪甫. 连云港市锦屏山汉画象石墓, *KG* 1983 10 894.

LIU, ZHIYUAN 刘志远. 四川汉代 '画像砖艺术'. Beijing, 1958.

LUO CHENGLIE, ZHU XILU 骆承烈, 朱锡禄. 嘉祥武氏墓群石刻, *WW* 1979 7 90.

NAGAHIRO, TOSHIO 长广敏雄. 汉代画像 研究. Tokyo, 1965.

NANJING MUSEUM. 东汉彭城相缪宇墓, *WW* 1984 8 22. 1984b.

PINGSHUO ARCHAEOLOGICAL TEAM. 山西朔县秦汉墓发掘简报, *WW* 1987 6 1.

QIN SHIZHI 秦士芝. 盱眙县出土东汉神兽镜, *WW* 1986 4 93.

REN YUEXIN 仁日新. 山东诸城汉墓画象石, *WW* 1981 10 14.

RUDOLF, R. C. *Han Tomb Art of West China. A collection of first and second century reliefs.* Berkeley, 1951.

RUDOLPH, R., WEN YU. *Han tomb Art of West China.* Berkeley, 1951.

SHAANXI PROVINCIAL MUSEUM. 陕北东汉画像石刻选集. Beijing, 1959.

SHANDONG PROVINCIAL MUSEUM. 山东安丘汉画象石墓发掘简报, *WW* 1964 4 30.

SUIDE-XIAN MUSEUM. 陕西绥德汉画象石墓, *KG* 1986 1 82.

WANG, ZHONGSHU 王仲殊. 建安纪年铭神兽镜综论, *KG* 1988 4 348.

WATSON, W. 'A bronze mirror from Shao Hsing, Chekiang province', *British Museum Quarterly* XIX (1954).

WATSON, W. *Realistic style in the art of Han and T'ang* (Ferens Lecture in the University of Hull). Hull, 1975.

WHITE, W. C. *Tomb Tile Pictures of Ancient China.* Toronto, 1939.

WU LAN, XUE YONG 陕西米脂宫庄东汉画像石墓, *KG* 1987 11 997.

XU DIANKUI, CAO GUOJIAN 徐殿魁, 曹国鉴. 偃师杏园东汉壁画墓的清理与临摹札记, *KG* 1987 10 945.

YANFEN DISTRICT OFFICE. 晋南区沃苏村汉墓, *WW* 1987 6 61.

YANGZHOU MUSEUM. 江苏仪征胥浦101号西汉墓, *WW* 1987 6 1.

YANGZHOU MUSEUM. 江苏邗江姚庄101号西汉墓, *WW* 1988 2 19.

YOU, ZHENYAO 尤振尧. 江苏泗洪曹庙东汉画像石, *WW* 1986 4 40.

YUE FENGXIA, LIU XINGZHEN 岳凤霞, 刘兴珍. 浙江海宁长安镇画像石, *WW* 1984 3 47.

ZENG ZHAOYU, JIANG BAOGENG, LI ZHONGYI. 曾昭燏, 蒋宝庚, 黎忠义. 沂南古画像石墓发掘报告. Nanjing, 1956.

ZHANG PENGCHUAN 张朋川. 河西出土的汉晋绘画简述, *WW* 1978 6 59.

ZHEJIANG ANTIQUITIES COMMITTEE. 绍兴漓渚的汉墓, *KGXB* 1957 1 133.

ZHOU, ZHENG 周铮. 「规矩镜」应改称「博局镜」, 1987 12 1116.

ZHOU DAO, LÜ PIN, TANG WENXING 周到, 吕品, 汤文兴. 河南汉代画像砖. Taipei 1986.

ZHUCHENG-XIAN MUSEUM. 山东诸城县西汉木韓墓, *KG* 1987 9 778.

CHAPTER 11 *Architecture in Retrospect from the Second Century a.d.*

ART GALLERY, CHINESE UNIVERSITY OF HONG KONG. *Archaeological Finds from Han tombs at Guangzhou and Hong Kong.* Hong Kong, 1983b.

ART GALLERY, CHINESE UNIVERSITY OF HONG KONG. 广东出土先秦文物. Hong Kong 1984.

FU, XINIAN 傅熹年. 1980. 战国中山王畕墓出土的北域图, *KGXB* 1980 1 97.

FU, XINIAN. 傅熹年. 陕西岐山凤雏西周建筑遗址初探, *WW* 1981 1 65. 1981a.

FU, XINIAN 傅熹年. 陕西扶风召陈西周建筑遗址初探, *WW* 1981 3 34. 1981b.

GANSU PROVINCIAL MUSEUM. 武威雷台汉墓, *KGXB* 1974 2 87.

GUO, QINGHUA 郭清华. 陕西勉县老道寺汉墓, *KG* 1985 5 429.

HEBEI ANTIQUITIES OFFICE. 河北平山县战国时期中山国墓葬发掘简报, *WW* 1979 1 1.

HEBEI ANTIQUITIES TEAM. 河北易县燕下都第十六号墓发掘, *KGXB* 1965 2 79.

HENAN ANTIQUITIES INSTITUTE. 郑州商代城内宫殿遗址第一次发掘报告, *WW* 1983 4 1. 1983a.

HENAN ANTIQUITIES INSTITUTE. 蠡县汉墓发掘记要, *WW* 1983 6 45. 1983c.

HENAN ANTIQUITIES TEAM. 河南南杨官寺汉画象石墓发掘报告, *KGXB* 1963 1 111. 1963b.

HENAN ANTIQUITIES TEAM. 河南襄城茨沟汉画象石墓, *KGXB* 1964 1 111. 1964c.

HUANG, ZHANYUE 黄展岳. 说坟, *WW* 1981 2 89.

HUANG, ZHANYUE 黄展岳. 关于王莽九庙的问题, *KG* 1989 3 261.

HUNAN PROVINCIAL MUSEUM. 湖南资兴东汉墓, *KGXB* 1984 1 53.

INSTITUTE OF ARCHAEOLOGY. 唐长安大明宫. *Special Archaeological Series D No. 11.* Beijing, 1955.

INSTITUTE OF ARCHAEOLOGY. 辉县发掘报告. Beijing, 1965a.

INSTITUTE OF ARCHAEOLOGY. 新中国的考古收获. *Special Archaeological Series A No. 6.* 1962c.

INSTITUTE OF ARCHAEOLOGY. 1975年安阳殷墟的新发现, *KG* 1976 4 264.

INSTITUTE OF ARCHAEOLOGY. 河南柘城孟庄商代遗址, *KGXB* 1982 1 49. 1982b.

INSTITUTE OF ARCHAEOLOGY. 河南偃师二里头二号宫殿遗址发掘简报, *KG* 1983 3 206. 1983c.

INSTITUTE OF ARCHAEOLOGY. 汉长安城未央宫第一号建筑遗址发掘简报, *KG* 1989 1 33.

KOMAI, KAZUCHIKA 马井和爱. 曲阜鲁城 遗迹. Tokyo, 1951.

LUOYANG ANTIQUITIES TEAM. 洛阳烧沟西14号汉墓发掘报, *WW* 1983 4 29.

LUOYANG ANTIQUITIES TEAM. 河南洛阳宁东汉墓清理简报, *WW* 1987 1 37.

SHAANXI ZHOUYUAN TEAM. 陕西岐山凤雏西周建筑基址发掘简报, *WW* 1979 10 27. 1979c.

SHAANXI ZHOUYUAN TEAM. 扶风召陈西周建筑群基址发掘简报, *WW* 1981 3 10.

SHANDONG CULTURAL OFFICE. 山东文选选集普查部分. Beijing, 1959.

SHI, ZHANGRU 石璋如. 殷墟最近之重要发现, *KGXB* 2 (1947) 1.

SHI, ZHANGRU 石璋如. 殷代地上建筑复原的第一例. (... 第二 , 第三例 *Annals Academia Sinica* 1 1954, 1970, 1976).

SHI, ZHANGRU 石璋如. 殷墟建筑遗存. Taipei, 1959.

SICHUAN ANTIQUITIES COMMITTEE. 成都羊子山土台遗址清理报告, *KGXB* 1957 4 17.

TANG, JINYU 唐金裕. 西安西郊汉代建筑遗址发掘报告, *KGXB* 1959 2 45.

TAO, FU 陶复. 秦咸阳第二号遗址复原问题, *WW* 1976 11 31.

TŌA KŌKO GAKKAI 东亚考古学会. 邯郸. Tokyo, 1954.

YANG, HONGXUN 杨鸿勋. 从盘龙城商代宫殿遗址..., *WW* 1976 2 16.

YANG, HONGXUN 杨鸿勋. 西周岐邑建筑遗址初步考察, *WW* 1981 3 23.

YANG, HONGXUN 杨鸿勋. 妇好墓上「母辛宗」建筑复原, *WW* 1988 6 62.

YU, WEICHAO 俞伟超. 先秦两汉考古学论集. Beijing, 1985.

CHAPTER 12 *The Period of the Six Dynasties*

NAGAHIRO, TOSHIO 长广敏雄. 六朝时代美术 研究. Tokyo, 1969.

SEGALEN, V. *The Great Statuary of China.* Chicago, 1978.

SOPER, A. C. 1940a. 'Literary evidence for early Buddhist art in China, I. Foreign images and artists', *Oriental Art* II 1 (1940).

SOPER, A. C. 'Literary evidence for early Buddhist art in China, II. Pseudo-foreign images', *Artibus Asiae* XVI 1 2 (1953).

SOPER, A. C. *Literary Evidence for Early Buddhist Art in China.* Ascona, 1959.

SOPER, A. C. 'South Chinese influence on the Buddhist art of the Six Dynasties period', *BMFEA* 32 (1960). 1960a.

SOPER, A. C. 'Imperial cave-chapels of the Northern Dynasties. Donors, beneficiaries, dates', *Artibus Asiae* XXVIII (1966). 1966e.

TSUKAMOTO, ZENRYŪ 冢本善隆. 支那佛教史研究. Tokyo, 1944.

WANG YI-TÚNG (tr.). *A Record of the Buddhist monasteries in Loyang* (translation of Yang Xuanzhi's *Loyang qielan ji*). Princeton, 1984.

ZÜRCHER, E. *The Buddhist Conquest of China. The spread and adaptation of Buddhism in early medieval China.* Leiden, 1959.

CHAPTER 13 *The Age of Division: Sculpture of the Northern Wei First Phase*

ASHTON, L. R. B. *Introduction to the Study of Chinese Sculpture.* New York, 1924.

CAPON, E. *The Interdependence between Chinese Buddhist sculpture in bronze and stone from A.D. 386 to A.D. 581* (University of London M. Phil. thesis). 1973.

CHAVANNES, E. 'Six monuments de la sculpture chinoise', *Ars Asiatica* II. Paris and Brussels, 1914.

DING, MINGYI 丁明夷. 谈山东博兴的铜佛造像, *WW* 1984 5 32.

HALLADE, M. *L'art du Gandhara et de l'Asie Centrale.* Paris, 1950.

MIZUNO, SEIICHI 水野清一. 中国の佛教美术. Tokyo, 1968.

SNELLGROVE, D. L. *The Image of the Buddha.* UNESCO, 1978.

WANG, ZHONGSHU 王仲殊.论吴晋时期的佛像夔凤镜, *KG* 1985 7 63b.

WANG ZHONGSHU 王仲殊. 吴镜师陈世所作神兽镜论考, *KG* 1986 11 1020.

WATSON, W. 'A dated Buddhist image of the Northern Wei period', *British Museum Quarterly* XXII Nos. 3/4 (1958).

YAKUBOVSKI, A. YU., DYAKONOV, M. M. *Zhivopis' drevnego Pyandzhikenta.* Moscow, 1954a.

CHAPTER 14 *Yungang Cave-shrines: Northern Wei Second Phase*

DAVIDSON, J. L. *The Lotus Sutra in Chinese art.* New Haven and Oxford, 1954

YAKUBOVSKI, A. YU. *Voprosy izucheniya Pyandzhikentskoi zhivopisi.*

HURWITZ, L. *Wei Shou: Treatise on Buddhism and Taoism* (translation, with Chinese text and annotation by Tsukamoto Zenryū), included in Mizuno and Nagahiro 1956 vol. 16. ed Kyoto, 1956.

INNER MONGOLIAN ANTIQUITIES TEAM. 内蒙古白灵淖城圐圙北魏古城遗址调查与试掘, *KG* 1984 2 145.

INSTITUTE FOR PRESERVATION OF YUNGANG ANTIQUITIES. *The Yungang Caves.* Beijing, 1973.

INSTITUTE FOR PRESERVATION OF YUNGANG ANTIQUITIES. 新纶云冈石窟窟号的说明, *WW* 1988 4 30.

MIZUNO, S., NAGAHIRO, T. 云冈石窟, Unkō sekkutsu, *The Buddhist cave-temples of the fifth century A.D. in north China.* 20 vols. 1952–1956.

ROWLAND, B. 'Notes on the dated statutes of the Northern Wei dynasty and the beginnings of sculpture in China', *The Art Bulletin* XIX 1 (1937).

SOPER, A. C. *Chinese Korean and Japanese bronzes* (catalogue of the Auriti collection). Rome, 1966b.

SU, BO 宿白. 云冈石窟分期试论, *KGXB* 1978 1 25.

CHAPTER 15 *Northern Wei Third Phase: A.D. 495–535*

GANSU PROVINCIAL MUSEUM. 甘肃湿川王母宫石窟调查报告, *KG* 1984 7 622.

HENAN ANTIQUITIES TEAM 巩县石窟寺. Beijing, 1963a.

LI, SHAONAN 李少南. 山东博兴出土百馀件北魏至隋代铜造像, *WW* 1984 5 21.

LI, YUKUN 李玉昆. 龙门杂考, *WW* 1980 1 25.

LIU, HUIDA 刘慧达. 北魏石窟与禅, *KGXB* 1978 3 337.

LONGMEN CONSERVANCY 龙门石窟. Beijing, 1961.

MINISTRY OF CULTURE 麦积石窟. Beijing, 1954.

MIZUNO, S., NAGAHIRO, T. 水野清一, 长广敏雄. 龙门石窟の研究. Tokyo, 1941.

PRIEST, A. *Chinese Sculpture in the Metropolitan Museum of Art.* New York, 1944.

SULLIVAN, M., DARBOIS, D., DE SILVA, A. *The Cave Temples of Maichishan.* London, 1969.

WEN YUCHENG 温玉成.龙门石窟造像的新发现, *WW* 1988 4 21.

WENLEY, A. G. *The Grand Empress Dowager Wen Ming and the Northern Wei Necropolis at Fang Shan. Freer Gallery Occasional Paper* I/1. Washington DC, 1947.

XIAO, CANKUN 萧灿坤. 龙门石窟. Hong Kong, 1979.

YAO QIAN, GU BING 姚迁, 古兵. 南朝陵墓石刻. Beijing, 1981.

YU XINING, LUO SHUZI 于希宁, 罗菽子. 北魏石窟浮雕拓片选. Beijing, 1958.

CHAPTER 16 *Monumental Sculpture of the Mid-sixth Century*

CHENG, JIZHONG 程纪中. 河北槀城县发现一批北齐石造像, *KG* 1980 3 242.

HANDAN CITY CONSERVANCY. 河北邯郸鼓山常乐寺遗址清理简报, *WW* 1982 10 26.

HENAN PROVINCE ARCHITECTURAL CONSERVANCY. 河南安阳灵泉寺石窟及小南海石窟, *WW* 1988 4 1.

MUSEUM OF FINE ARTS, BOSTON. *Asiatic Art in the Museum of Fine Arts.* Boston, 1982.

SHANXI PROVINCIAL MUSEUM. 山西石雕艺术.

WATSON, W. 'Iran and China', Yarshater, E., ed. *The Cambridge History of Iran*, vol. 3(1) p. 537. Cambridge, 1983.

YANG, BODA 杨伯达. 曲阳修德寺出土纪年造像的艺术风格与特征, *Bowuyuan yuankan* 2 1960.

CHAPTER 17 *Draughtsmanship and Painting of the Six Dynasties in Henan, Hebei and Jiangsu*

BUNKER, E. C. 'The Spirit Kings in sixth century Chinese Buddhist sculpture', *Archives of the Chinese Art Society of America* XVII (1964).

BUNKER, E. C. 'The style of the Trübner stele', *Archives of the Chinese Art Society of America* (1965).

HO, CHUIMEI. *Ceiling painting in the Mogao cave-temples* (University of London M.Phil. dissertation). 1980.

LUOYANG MUSEUM. 洛阳北魏画像石棺, *KG* 1980 3 229.

NAGAHIRO, TOSHIO 长广敏雄. 六朝时代美术. Tokyo, 1969.

NANJING MUSEUM. 南京西善桥南朝墓及其砖刻壁画, *WW* 1960 8/9 37.

NANJING MUSEUM. 江苏丹阳胡桥南朝大墓及砖刻壁画, *WW* 1974 2 44.

NANJING MUSEUM. 江苏丹阳县胡桥, 建山两座南朝墓葬, *WW* 1980 2 1.

SHANXI ARCHAEOLOGICAL INSTITUTE.太原市北齐娄睿墓发掘简报, *WW* 1983 10 1. 1983a.

SOPER, A. C. 'Life-motion and the sense of space in early Chinese representational art', *Art Bulletin* XXX (1948).

SOPER, A.C. *Textual Evidence for the Secular Arts of China in the Period from Liu Sung through Sui* (A.D. 420–618). Ascona, 1967.

YONEZAWA, YOSHIHO 米沢嘉圃 ed. 讲谈社版世界美术大系 8 China I. Tokyo, 1963.

ZHAO WANLI 赵万里. 汉魏南北朝墓志集释. Beijing 1956.

CHAPTER 18 *Pre-Tang Mural Painting in West China*

CHANG, SHUHONG 常书鸿. 敦煌壁画. Beijing, 1959.

DUNHUANG INSTITUTE. 敦煌莫高窟内容总录. Beijing, 1982.

GRAY, B., VINCENT, J. E. *Buddhist Cave Paintings at Dun-Huang.* London, 1959.

HURWITZ, L. *Wei Shou: Treatise on Buddhism and Taoism* (translation, with Chinese text and annotation by Tsukamoto Zenryū), included in Mizuno and Nagahiro 1956 vol. 16. ed. Kyoto, 1956.

JILIN ARCHAEOLOGICAL TEAM. 吉林集安吾盔坟四号墓, *KGXB* 1984 1 121.

PELLIOT, P. *Mission Pelliot en Asie Centrale. Les Grottes de Touen-Houang.* 6 vols. Paris, 1914–24.

SILVA, A. DE. *The Art of Chinese Landscape Painting.* New York, 1967.

STEIN, A. *The Thousand Buddhas: Ancient Buddhist paintings from the cave-temples of Tun-huang on the western frontier of China.* London, 1921.

XIA NAI, NAGAHIRO, CHANG HONGSHU, OKAZAKI 夏鼐, 长广, 常鸿书, 冈崎 *et al.* ed. 中国石窟 5 vols. Tokyo, 1980.

XIA NAI, SU BO, NAGAHIRO 夏鼐, 宿白, 长广 *et al.* ed. 中国石窟 石窟·Tokyo, 1983.

XIE, ZHILIU 谢稚柳. 敦煌艺术叙录. Shanghai, 1957.

CHAPTER 19 *Architecture from Han to Tang*

ASANO, KIYOSHI 浅野清. 奈良时代建筑研究. Tokyo, 1969.

CHEN, CONGZHOU 陈从周. 柱础述要, *Kaogu Tongxun* 1956 3 91.

DUNHUANG INSTITUTE ARCHAEOLOGICAL GROUP. 敦煌莫高窟北朝壁画中的建筑, *KG* 1976 2 109.

FU, XINIAN 傅熹年.论几幅传为李思训画派金碧山水的绘制时代, *WW* 1983 11 76.

GROUSSET, R. *In the Footsteps of the Buddha.* London, 1932.

HANDAN CITY CULTURAL OFFICE.河北邯郸鼓山常乐寺遗址清理简报, *WW* 1982 10 26.

HENAN ANTIQUITIES TEAM. 安阳修定寺塔. Beijing, 1983b.

HENAN PROVINCE ARCHITECTURAL CONSERVANCY. 河南安阳灵泉寺代双石塔, *WW* 1986 3 70.

HENAN PROVINCIAL MUSEUM. 河南安阳修定寺唐塔, *WW* 1979 9 7.

INSTITUTE OF ARCHAEOLOGY. 唐长安大明宫. 1959.

INSTITUTE OF ARCHAEOLOGY.新疆吉木萨尔高昌回鹘佛寺遗址, *KG* 1983 7 618. 1983a.

INSTITUTE OF ARCHAEOLOGY LUOYANG GROUP. 汉魏洛阳城初步勘查, *KG* 1973 4 198.

INSTITUTE OF ARCHAEOLOGY LUOYANG GROUP. 北魏永宁寺塔基发掘简报, *KG* 1981 3 223.

INSTITUTE OF ARCHAEOLOGY LUOYANG GROUP. 唐东都武则天明堂遗址发掘简报, *KG* 1988 3 227.

ITÔ NOBUO 伊藤延男 et al. 日本建筑 (文化财讲座). Tokyo, 1977.

LONGMEN CONSERVANCY.洛阳龙门香山寺遗址的调查与试掘, KG 1986 1 40.

MAHLER, J. G. The Westerners among the Figurines of the T'ang Dynasty. Rome, 1959.

ŌOKA, MINORU 大冈实. 南都七大寺研究 . Tokyo, 1966.

QI, YINGTAO 祁英浅. 中国古代建筑年代的鉴定, WW 1965 4 14.

QI, YINGTAO 祁英浅. 中国古代建筑的脊饰, WW 1978 3 62.

QI, YINGTAO 祁英浅. 中国早期木结构建筑的时代特征, WW 1983 4 60.

QI YINGTAO, CHAI ZEJUN 祁英浅, 柴泽俊. 南禅寺大殿修复, WW 1980 11 61.

ROWLAND, B. 'Chinese sculpture of the pilgrimage road', Bulletin of the Fogg Art Museum IV 2 (1935).

ROWLAND, B. 'Indian images in Chinese sculpture', Artibus Asiae X (1947).

ROWLAND, B. The Art and Architecture of India. Harmondsworth, 1953.

SEKINO, TADASHI 关野贞. 支那建筑艺术 . Tokyo, 1938.

SEKINO, TADASHI 关野贞. 日本建筑艺术 . Tokyo, 1949.

SHAANXI CULTURAL OFFICE.唐长安城地基初步探测, KGXB 1958 3 79.

SOPER, A. C. 'Janpanese evidence for the history of the architecture and iconography of Chinese Buddhism', Monumenta Serica IV 2 (1940), pp. 641 ff. 1940b.

TAZAWA YASUSHI, ŌOKA MINORU 田泽坦, 大冈实 . 图说日本美术史 . Tokyo, 1957.

WANG, RENBO.唐懿德太子墓壁画题材的分析, KG 1973 6 381.

YANG, HONGXUN 杨鸿勋.唐长安青龙寺密宗殿堂 (遗址4)复原研究, KGXB 1984 3 383.

YANG, HUANCHENG 杨焕成.豫北石苔纪略, WW 1983 5 70.

YANG, LIE 杨烈.山西平顺县古建筑勘察记, WW 1962 2 40.

YUAN WANLI, XIAO SHAN 袁万里, 笑山.西安香积寺与善导塔, WW 1980 7 77.

CHAPTER 20 *The Buddhist Icon: Tang International Style*

AZARPAY, G. Sogdian Painting. The pictorial epic in Oriental art. Berkeley, 1981.

BANERJEE, P. 'Hindu trinity from Central Asia', National Museum Bulletin (New Delhi) No. 2.

BANERJEE, P. 'A Siva icon from Piandjikent', Artibus Asiae XXXI (1969).

BUNKER, E. C. 'Early Chinese representations of Vimalakīrti', Artibus Asiae XXXI/I (1968).

KUNAICHŌ SHONYŌBU 宫内厅书陵部.正仓院棚别目录. Kyoto, 1951.

MUNSTERBERG, H. Chinese Buddhist Bronzes. Rutland, 1967.

PELLIOT, P. Mission Pelliot en Asie Centrale. Les Grottes de Touen-Houang. 6 vols. Paris, 1914–24.

SAWA, TAKAAKI 佐和隆研. 佛像图典. Tokyo, 1963.

SOPER, A. C. 'The "dome of heaven" in Asia', Art Bulletin 29 (1947).

SOPER, A. C. 'Representations of famous images at Tun-Huang', Artibus Asiae XXVII/4 (1964–5).

WALEY, A. A Catalogue of Paintings recovered from Tun-Huang by Sir Aurel Stein, K.C.I.E. British Museum, London, 1931.

WATSON, W. 'Divisions of T'ang decorative style', Percival David Formdation of Chinese Art, Colloquies as Art and Archaeology No. 5 (1976).

WHITFIELD, R., FARRER, A. Caves of the Thousand Buddhas. Chinese Art from the Silk Route. British Museum, London, 1990.

YAKUBOVSKI, A. YU. Voprosy izucheniya Pyandzhikentskoi zhivopisi. Moscow, 1954.

YAKUBOVSKI, A. YU., DYAKONOV, M. M. Zhivopis' drevnego Pyandzhikenta. Moscow, 1954.

CHAPTER 21 *Tang Secular Painting, Figures and Landscape*

ACKER, W. R. B. Some T'ang and pre-T'ang Texts on Chinese Painting. Leiden, 1954.

BISCHOFF, F. A. La forêt des pinceaux: étude sur l'Académie du Han-lin sous la dynastie des T'ang et tradution du Han-lin-tche. Paris, 1963.

DATONG CITY MUSEUM.山西大同石家塞北魏司马金龙墓, WW 1972 3 20.

DONG XIJIU 董锡玖.敦煌壁画和唐代舞蹈, WW 1982 12 58.

HUBEI PROVINCIAL MUSEUM.湖北郧县唐李徽阎婉墓发掘简报, WW 1987 8 30.

JIN, WEINUO 金维诺.「步辇图」与「凌烟阁功臣图」, WW 1962 10 13.

MUNAKATA, KIYOHIKO. Ching Hao's Pi-fa-chi: a note on the art of the brush. Ascona, 1974.

SHAANXI ANTIQUITIES COMMITTEE.唐永泰公主墓发掘简报, WW 1964 1 7.

SHAANXI PROVINCIAL MUSEUM.唐李贤墓壁画. Beijing, 1974a.

SHAANXI PROVINCIAL MUSEUM.唐李重润墓壁画 (English text: Murals of the tomb of Li Chung-jun of the Tang dynasty). Beijing. 1974b.

SOPER, A. C. 'Early Chinese landscape painting', Art Bulletin XXIII (1941).

SOPER, A. C. 'The first two laws of Hsieh Ho', Far Eastern Quarterly VIII 4 (1949).

SOPER, A. C. (tr.). 'The famous painters of the T'ang dynasty' (translation of the Zhu Jingxuan's Tang chao ming hua lu), Archives of the Chinese Art Society of America IV (1950).

SULLIVAN, M. The Birth of Landscape Painting in China. Berkeley, 1962.

WANG RENBO 王仁波.唐懿德太子墓壁画题材的分析. WW 1973 3 20.

WATSON, W. Realistic Style in the Art of Han and T'ang (Ferens Lecture in the University of Hull). Hull, 1975.

WATSON, W. 'Landscape elements in the early Buddhist art of China', Percival David Foundation of Chinese Art Colloquies on Art and Archaeology No. 8 (1979). London, 1980.

XU SHUCHENG 从「纨扇女仕图」「簪花仕女图」略谈唐人仕女图, WW 1980 7 71.

ZHANG YANYUAN, YU JIANHUA 张彦远, 俞剑华 ed. 历代明画记. Hong Kong, 1973.

CHAPTER 22 *Buddhist Sculpture under the Tang*

BRINKER, H., LUTZ, A. Der Goldschatz der drei Pagoden. Rietberg Museum, Zürich, 1991.

COX, J. H. Chinese Buddhist Bronzes (exhibition catalogue). Ann Arbor, 1950.

DAYAKONOVA, N. V., SOROKIN, S. S. Khotanskie drevnosti. Leningrad, 1960.

DONG, YUXIANG 董玉祥. 麦积山石窟, WW 1983 6 18.

DUNHUANG INSTITUTE. 敦煌彩塑. Beijing, 1978.

FENG, GUODING 冯国定 et al.四川邛崃唐代龙兴寺石刻. Beijing, 1958.

GABBERT, G. ed. Buddhistische Plastik aus China und Japan. Wiesbaden. 1972.

GRAY, B. 'A great Sui dynasty Amitâbha', British Museum Quarterly XX 3 (1951).

HANDAN CITY CONSERVANCY.邯郸鼓山水浴寺石窟调查报告, WW 1987 4 1.

LI, FANGCAI 李方才.扬州出土的唐代石造像, WW 1980 4 65.

LIU ZHIYUAN, LIU TINGBI 刘志远, 刘延璧.成都万佛寺石刻艺术. Shanghai, 1958.

MAYUYAMA AND CO. Mayuyama, Seventy years (vol. I, ceramics; vol. II, sculpture, painting, bronze). Tokyo, 1976.

MIZUNO, S., NAGAHIRO, T. The Buddhist Cave Temples of Hsiang-t'ang-ssu (English summary). Kyoto, 1937.

MUSEUM FÜR OSTASIATISCHE KUNST BERLIN. Ausgewählte Werke Ostasiatischer Kunst. Berlin, 1970.

ROWLAND, B. 'Indian Images in Chinese Sculpture'. Artibus Asiae (1947) 10.

ROWLAND, B. The Evolution of the Buddha Image. New York, 1963.

SAWA, TAKAAKI 佐和隆研. 密教美术论. Tokyo, 1960.

SAWA TAKAAKI 佐和隆研. 1961. 日本密教美术 . Tokyo, 1961.

SEATTLE ART MUSEUM. Handbook. Seattle, 1951.

SIRÉN, O. 'Chinese marble sculpture of the Transition period', BMFEA 12 (1940). 7 vols.

SULLIVAN, M., DARBOIS, D. The Cave Temples of Maichishan. London, 1969.

VANDERSTAPPEN, H., RHIE, M. 'The Sculpture of T'ien Lung Shan', Artibus Asiae XXVII (1964).

WATSON, W. Sculpture of Japan. London. 1959.

WATSON, W. 'Styles of Mahāyānist iconography in China', Percival David Foundation of Chinese Art Colloquies on Art and Archaeology No. 2 (1971). 1971b.

YONEZAWA, YOSHIHO 米泽嘉圃. 中国绘画史研究. Tokyo, 1962.

ZHENG ZHENDUO 郑振铎. 麦积山石窟. Beijing, 1954.

ZHENGZHOU CITY MUSEUM. 河南荥阳大海寺出土的石刻造像, WW 1980 3 56.

CHAPTER 23 *Tang Non-Buddhist Sculpture and Decorated Objects*

ANTIQUITIES EXHIBITION TEAM 山土文物展览工作组. 文物大革命期间出土文物. Beijing, 1972.

AUHAN BANNER MUSEUM. 敖汉旗营子出土的金银器, KG 1978 2 117.

BAO, QUAN 保全. 西安市文管会收藏的几件唐代金银器, Kaogu yu wenwu 1982 1 54.

CHANGZHI CITY MUSEUM.山西长治市唐代冯廓墓, WW 1989 6 51.

CHEN, JUANJUAN 陈娟娟.两件有丝织品花印痕的商代文物, WW 1979 12 70.

CHEN, PEIFEN 陈佩芬.上海博物馆藏青铜镜. Shanghai, 1987.

DANTU-XIAN EDUCATION OFFICE. 江苏丹徒丁卯桥出土唐代银器窖藏, WW 1982 11 15.

D'ARGENCÉ, R.-Y. L. ed. Treasures from the Shanghai Museum of Art. San Francisco, 1984.

DATONG CITY MUSEUM. 山西大同石家塞北魏司马金龙墓, WW 1972 3 20.

DATONG CITY MUSEUM. 大同市小站村花圪塔台北魏墓清理简报, WW 1983 8 1.

EXCAVATED MATERIAL EXHIBITION GROUP. 文化大革命期间出土文物. Beijing, 1972.

FERNALD, F. E. *Chinese Pottery Figurines.* Toronto, 1950.

FONG, WEN, FU, MARILYN. *Sung and Yuan paintings* (paintings acquired from the C. C. Wang collection). New York, 1973.

FOREIGN LANGUAGES PRESS. *Historical Relics unearthed in new China.* Beijing, 1972.

FU, TIANQIU 傅天仇. 陕西兴平县霍去病墓前的西汉石雕艺术, *WW* 1964 1 40.

GRABAR, O. 'An introduction to the art of Sasanian Silver', *Sasanian Silver, Late Antique and Mediaeval Arts of Luxury from Iran.* Ann Arbor, 1967.

GYLLENSVÄRD, B. *Chinese Grold and Silver in the Carl Kempe Collection.* Stockholm, 1953.

GYLLENSVÄRD, B. 'Tang gold and silver', *BMFEA* 29 (1957).

GYLLENSVÄRD, B. *Chinese Ceramics in the Carl Kempe Collection.* Stockholm 1964.

HAN, WEI 韩伟. 唐长安城内发现的袖珍银熏球, *Kaogu yu wenwu* 1982 1 59.

HARADA, YOSHITO 原田淑人. 东亚古文化研究. Tokyo, 1941.

HARQIN BANNER MUSEUM. 辽宁昭盟「喀喇沁」旗发现唐代鎏金银器, *KG* 1977 5 327.

HÊ, ZICHENG, WANG RENBO 贺梓城、王仁波. 乾陵, *WW* 1982 3 86.

HEBEI CONSERVANCY. 河北景县北魏高氏墓发掘简报, *WW* 1979 3 17.

HU, PINGSHENG 胡平生「马踏飞鸟」是相马法式, *WW* 1989 6 75.

HUBEI XIAOGAN DISTRICT MUSEUM. 安陆王子山唐吴王妃杨氏墓 *WW* 1985 2 83.

HUNAN PROVINCIAL MUSEUM. 湖南长沙咸嘉湖唐墓发掘简报, *KG* 1980 6 506.

INSTITUTE OF ARCHAEOLOGY. 唐长安城郊隋唐墓. *Special Archaeological Series D no. 22.* Beijing, 1980a.

INSTITUTE OF ARCHAEOLOGY. 河南偃师杏园的两座唐墓, *KG* 1984 10 904. 1984b.

INSTITUTE OF ARCHAEOLOGY. 河南偃师杏园的六座纪年唐墓, *KG* 1986 5 429. 1986c.

JAYNE, H. H. F. *Chinese Collections of the Philadelphia University Museum.* Philadelphia, 1941.

KOBAYSHI, TAIICHIRO 小林太市郎. 汉唐古俗上明器土偶. Kyoto, 1947.

KUANCHENG-XIAN CONSERVANCY. 河北宽城出土两件唐代银器, *KG* 1985 9 857.

LI, YUFANG 李毓芳. 咸阳市出土一件唐代金壶, *Kaogu yu wenwu* 1982 1 53.

LI, YUCHUN 李遇春 新疆三仙洞的开窟时代和壁画内容初探, *WW* 1982 4 13.

LI, ZHENGXIN 李正鑫. 唐代花枝铜镜, *WW* 1986 9 41.

LIU, LIANYIN 李廉银. 常德地区收集的孙吴和唐代铜镜, *WW* 1986 4 90.

LUO, JIARONG 罗家容. 从唐代和元年铜镜谈傅出「喂牛镜」, *WW* 1984 7 70.

LUOYANG ANTIQUITIES TEAM. 河南洛阳涧西谷水唐墓清理简报, *KG* 1983 5 442.

MA, YUYUN 马孑云. 西汉霍去病墓石刻记, *WW* 1964 1 45.

MARSHAK, B. I. *Sogdiyskoe serebro.* Moscow, 1971.

MIZUNO, SEIICHI 水野清一. 唐三彩 (陶器全集 25 (1965)). Tokyo, 1986.

MUSEUM COLLECTIONS CONSERVANCY. 西安东郊王家坟清理了一座唐墓, *WW* 1955 9 152.

NEIQIU-XIAN CONSERVANCY. 河北省内丘县邢窑调查简报, *WW* 1987 9 1.

NINGXIA MUSLIM MUSEUM. 宁夏固原北周李贤夫妇墓发掘简报, *WW* 1985 11 1.

QUZHOU CITY MUSEUM. 浙江衢州市隋唐墓清理简报, *KG* 1985 5 450.

RAWSON, J. 'The ornament of Chinese silver of the Tang dynasty', *British Museum Occasional Paper No. 40.* London, 1982.

RAWSON, J. 'Tombs or hoards: the survival of Chinese silver of the Tang and Song periods, seventh to thirteenth century A. D.', Michael Vickers, ed., *Pots and Pans. Oxford Studies in Islamic Art III.* Oxford, 1986.

SHAANXI ANTIQUITIES COMMITTEE. 唐永泰公主墓发掘简报, *WW* 1964 1 7.

SHAANXI PROVINCIAL MUSEUM. 唐郑仁泰墓发掘简报, *WW* 1972 7 33. 1972a.

SHAANXI PROVINCIAL MUSEUM. 西安南郊何家发现唐代窖藏文物, *WW* 1972 1 30. 1972b.

SHANGHAI TEXTILE INSTITUTE. 西夏陵区一〇八号墓出土的丝织品, *WW* 1978 8 77.

SHANXI ARCHAEOLOGICAL INSTITUTE. 太原市北齐娄睿墓发掘简报, *WW* 1983 10 1.

SHEN CONGWEN 沈从文. 唐宋铜镜. Beijing, 1985.

SHIRAKAWA, SHIZUKA 白川静. 白鹤荣华. ed. Kyoto, 1978.

SUN, JI 孙机. 唐代妇女的服装与化妆, *WW* 1984 4 57.

TOKYO NATIONAL MUSEUM. *Archaeological Treasures Excavated in the People's Republic of China.* Tokyo, 1973.

TOKYO NATIONAL MUSEUM *et al.* 中华人民共和国 :古代青铜器展. TOKYO, 1976.

TRUBNER, H. *The Arts of the tang Dynasty* (exhibition catalogue). Los Angeles, 1952.

WANG, BINGHUA 王炳华. 盐湖古墓, *WW* 1973 10 28.

WATSON, W. 'Overlay and p'ing-t'o in Tang silverwork', *Journal of the Royal Asiatic Society. Studies in honour of Sir Mortimer Wheeler.* London, 1970c.

WATSON, W. 'Precious metal: its influence on Tang earthenware', Michael Vickers, ed., *Pots and Pans. Oxford Studies in Islamic Art III.* Oxford, 1986.

WATSON, W. 'Technique in bronze and precious metal', *Chinese and Korean art from the collections of Dr Franco Vannotti* etc. Eskenazi, London, 1989b.

WEIWUER DISTRICT MUSEUM. 吐鲁番县阿斯塔那：哈垃和卓古墓群清理简报, *WW* 1972 1 8.

WHITE, W. C. *The Bronze Culture of Ancient China.* Toronto, 1956

WU, WENHUAN 吴文寰. 从瑞光寺塔发现的丝织品看古代链成罗, *WW* 1979 11 40.

XIA, NAI 夏鼐. 新疆新发现的古代丝织品：绮、锦和刺绣, *KGXB* 1963 1 45.

XIA, NAI 夏鼐. 无产阶级文化大革中的考古新发现, *KG* 1972 1 29.

XI'AN ANTIQUITIES COMMITTEE. 西安东南郊沙坡村出土一批唐代银器, *WW* 1964 3 30.

XIONG, CHUANXIN 熊传新. 湖南湘阴县隋大业六年墓, *WW* 1981 4 89.

XIONG, CUNRUI 熊存瑞. 隋李静训墓出土金项链金手镯的产地问题, *WW* 1987 10 77.

XU, YONGXIANG 许勇翔. 唐代玉雕中的云龙纹装饰研究, *WW* 1986 9 58.

XU, DIANKUI 徐殿魁. 洛阳地区隋唐墓的分期, *KGXB* 1989 3 275.

YAO QIAN, GU BING 姚迁,古兵, 南朝陵墓石刻, Beijing, 1981.

YICHUAN-XIAN MUSEUM. 河南伊川发现一座唐墓, *KG* 1985 5 459.

XHAOLING ANTIQUITIES OFFICE. 唐越王李贞墓发掘简报, *WW* 1977 10 41.

ZHEJIANG PROVINCIAL MUSEUM. 浙江临安晚唐钱宽墓出土天文图及官字款白瓷, *WW* 1979 12 18.

ZHEJIANG PROVINCIAL MUSEUM. 浙江淳安县朱塔发现唐代窖藏银器, *KG* 1984 11 979.

ZHOU, WEIZHOU. 西安地区部分出土文物中所见的唐代乐舞形象, *WW* 1978 4 74.

ZHOU XIN, ZHOU CHANGYUAN 周欣,周长源. 扬州出土的唐代铜镜, *WW* 1979 7 53.

ZHU, JIEYUAN 朱捷元. 唐李贤墓出土的鸟兽纹铜镜, *WW* 1983 7 37.

Glossary

The glossary includes place names only exceptionally. Other place names will be found in the Chinese entries of the bibliographies.

Amituo	阿弥陀
ang	昂
Asukadera	飞鸟寺
baimiao	白描
Banpo	半坡
Banshan	半山
Baoqing-si	宝庆寺
Baoxiang-si	宝相寺
bi	璧
bianhu	扁壶
Bilengjieli	毗楞竭梨
bing	柄
Bingling-si	炳灵寺
Binyang-dong	賓阳洞
Bogedaqin	博格达沁
boju	博局
boshanlu	博山炉
Botiwu	白蹄乌
Budong	不动
Cai hou	蔡侯
Cai Shun	蔡顺
Caoye	草叶
Cefu yuangui	册府元龟
chan	禅
Changle-si	长乐寺
Changzi	长子
Cheng wang	成王
Chenggu	城古
Chengziyai	城子崖
chi	螭
Chiyou	蚩尤
Chongxiu bogutulu	重修博古图录
Chunqiu	春秋
Cien-si	慈恩寺
Dahai-si	大海寺
Dahecun	大河村
Dai hou	軑侯
Dai Kuei	戴逵
Daminggong	大明宫
Dashizhi	大势至
Daxiong (constellation)	大能
Daxiongbaodian	大雄宝殿
Dayan-si	大雁寺
Dayun-si	大云寺
degumi	出组
Dengfeng-xian	登封县
Di (tribe)	狄
Dian	滇
ding	鼎
Dongwanggong	东王公
Dongyong	董永
dou	豆
Dou Wan	窦绾
dougong	斗拱
dui	敦
Dule-si	独乐寺
Dunhuang	敦煌
erbei	耳杯
Erligang	二里冈
Erlitou	二里头
Fahua-dong	法华洞
fang ding	方鼎
fangxiang	方相
feng	凤
Fengguo-si	奉国寺

fengque	凤阙
Fengxian-si	奉先寺
fotu	浮屠
Fogong-si	佛宫寺
Fu Hao	妇好
Fudō	不动
Fujii Yūrinkan	藤井有麟馆
Fuxi	伏羲
Gao Yi	高纬
Gaocheng-xian	嵩城县
Gaojiabao	高家堡
gê	戈
gong (bracket)	拱
gongbi	工笔
Gongdao	宫道
Gong-xian	巩县
gu (vessel)	觚
Gu Kaizhi	顾恺之
Guhuapinlu	古画品录
Guanxiu	贯休
guang	觥
Guanghan-xian	广汉县
Guangshan-xian	光山县
Guanshiyin	观世音
gufa	骨法
gui (vessel)	簋
gui (jade)	珪
Guo Ju	郭巨
Guweicun	固围村
guwen	縠纹
Guyang-dong	古阳洞
Han Huang	韩滉
Han Gan	韩干
hangtu	夯土
hê	盉
Hejiacun	何家村
hongliang	虹梁
hōryūji	法隆寺
Houma	侯马
hu (vessel)	壶
huang (jade)	璜
Huangchi	黄池
Huayin-xian	华阴县
Huayuancun	花园村
Huijian-dong	惠简洞
Huilang	回廊
Huishan-si	汇善寺
hun	魂
Huo Qubing	霍去病
jia	斝
jian	鉴
Jianfu-si	荐福寺
Jiangling-xian	江陵县
jiangtang	讲堂
Jiankang	建康
Jiaxiang-xian	嘉祥县
jibi	玑璧
Jinan-dong	极南洞
Jing Cang	净藏
Jinghui	靖惠
jinglanlou	井栏楼
Jingmen	荆门
jingping	净瓶
jingtu	净土
Jinshilu	金石录

Jinjiacun	金家村
Jin	晋
Jiumiao	九庙
Ji-xian	汲县
jue (vessel)	爵
jue (jade)	玦
junzi	君子
kaerumata	蛙股
kaiming	开明
Kang wang	康王
Kanjing-dong	看经洞
Kaogutu	考古图
Keshengzhuang	客省庄
kōdō	讲堂
kondō	金堂
Kongōbu-ji	金刚峰寺
Kōyasan	高野山
kui	夔
Kūkai	空海
lang	廊
Lao Laizi	老莱子
lei	叠
Leigutai-dong	擂鼓台
leiwen	雷纹
li	鬲
Li Gonglin	李公麟
Li Sixun	李思训
li yi	立意
Li Zhaodao	李昭道
Liangzhu-xian	良渚县
Lianhua-dong	莲花洞
Lidai minghua ji	历代明画记
lingtai	灵台
Lingyan-si	灵岩寺
Linzi-xian	临菑
lishi	力士
Liu Chang	刘昶
liubo	六博
Liujiadian	刘家店
Liulige	流漓阁
Liulihe	流漓河
liurui	六瑞
Liyu-xian	李峪县
Longhuta	龙虎塔
Longmen	龙门
Longshan	龙山
Longxing-si	龙兴寺
Lu Tanwei	陆探微
Lunheng	论衡
Lun hua	论画
Luohan	罗汉
Luoyang qielanji	洛阳伽蓝记
machangyao	马厂窑
Maijishan	麦积山
majiayao	马家窑
Mancheng-xian	满城县
Maoling	茂陵
Mashan-xian	马山县
Mawangdui	马王堆
Mi Fei	米芾
Mianzhu-xian	绵竹县
Miaodigou	庙底沟
Miaofa lianhuajing	妙法莲花经
Min Sun	阂损
mingqi	明器
mingtang	明堂
mitesaki	三手先
Mituofo	弥陀佛
Mizhi-xian	米脂县
Mogaoku	莫高窟
Mouling	茂陵
moya	摩崖
Nanchan-si	南禅寺
Ningxiang-si	宁乡寺
Nüshizhen tujuan	女士箴图卷
Nüwa	女娲

otaruki	尾椽
Panjiagou	潘家沟
Panlongcheng	盘龙城
Pingcheng-xian	平城县
Pingzhong-xian	平忠县
pixie	辟邪
piyong	擗踊
po	魄
pou	瓿
Puducun	普渡村
pushou	铺首
Qianling	乾陵
qianxiang	迁想
Qiaocun	桥村
qilin	麒麟
qin	琴
Qingzhui	青骓
qinshou putao	禽兽薄萄
qitou	魌头
qiyun	气韵
Quanmaogua	拳毛䯄
Qufu-xian	曲阜县
ruyi	如意
ryōkai mandara	两界曼陀罗
Saluzi	飒露紫
sancai	三彩
sanhualou	散花楼
sanlongjing	三龙镜
santiao	三跳
sê	瑟
Shanbiaozhen	山彪镇
Shang	商
Shangcunling	上村岭
Shang fang	尚方
Shangshan sihaotu	商山四皓图
Shanhaijing	山海经
Shanshi taizi	善事太子
Shapocun	沙坡村
Shen Ming	申明
sheng dong	生动
sheng	笙
sheng-Tang	盛唐
shenjiang	神将
shenshou	神兽
Shentong-si	神通寺
Shenwang	神王
Shidaichi	侍代赤
Shiku-si	石窟寺
shisiku	十四窟
Shiri wang	尸毗王
Shōmu	圣武
Shōsōin	著仓院
Shou-xian	寿县
Shuiyu-xian	水浴县
Simenta	四门塔
sitang	祠堂
Song Yun	宋云
Songyue-si	嵩岳寺
subi	速笔
ta	塔
Taixicun	台西村
taixie	台榭
Tangchao minghualu	唐朝名画录
Tangshan	唐山
taotie	饕餮
Telepiao	特勒骠
Tianlongshan	天龙山
tianlu	天禄
Tianwang	天王
tianzuo	天座
Tōdai-ji	东大寺
Tōji	东寺
Tongquetai	铜雀台
Tōshōdaiji	东招提寺
tuofeng	驼峰
Tuotatian	托塔天

wadang	瓦当
Wanfo-si	万佛寺
Wang Chong	王充
Wang Ji	王寄
Wang Qinruo	王钦若
Wang Wei	王维
Wang Xuance	王玄策
Wangmugong Shiku	王母宫石窟
wangziping	王子瓶
Wang Xi	王廙
Wei Shou	魏收
weishou	畏兽
Weichi Yiseng	尉迟乙僧
Weiyanggong	未央宫
Weizidong	魏字洞
wenren	文人
Wu wang	武王
Wu Daozi	吴道子
Wu Ding	武丁
Wu Huo	乌获
Wu Liang	武梁
Wuliangshou	无量寿
Wuguancun	武官村
Wuhuan-xian	乌桓县
Wuhuo	乌获
Wujiacun	吴家村
Wutaishan	五台山
wuxing	五行
Xia	夏
xian	仙
xiang	祥
Xiangji-si	香积寺
xianglun	相轮
Xiangtangshan	响堂山
Xianyang-xian	咸阳县
Xiao Hong	肖宏
Xiao Jing	肖景
Xiaoyan-si	小雁寺
Xiaoyanta	小雁塔
Xibeigang	西北冈
Xie He	谢赫
Xijingzaji	西京杂记
Xindian	辛店
xingfajia	形法家
Xingjiao-si	兴教寺
Xingqinggong	兴庆宫
Xingzhou	邢州
Xinjin-xian	新津县
Xinyang-xian	信阳县
Xiongnu	匈奴
Xiude-si	修德寺
Xiuding-si	修定寺
Xiwangmu	西王母
Xizhou	西周
Xuan Zang	玄奘
Xuanhe huapu	宣和画谱
xuanji	璇玑

Xuanwu	玄武
Yakushiji	药师寺
Yan	燕
Yan Liben	阎立本
Yan Shigu	颜师古
Yangguang-si	杨官寺
Yangshao	仰韶
Yangzishan	羊子山
Yanshi-xian	偃师县
Yaofangdong	药方洞
Yaoshi	药师
yi	匜
Yi the archer	羿
Yi-xian	义县
Yide	懿德
Ying-xian	应县
Yinxu	殷墟
yitiao	一跳
Yongning-si	永宁寺
Yongtai	永泰
you	卣
Yu Rang	豫让
Yuan shi	元氏
Yuangu	原谷
yubei	羽杯
yulianzang	玉敛葬
Yungang	云冈
Yunju-si	云居寺
Yunmeng-xian	云梦县
Yuntaishan	云台山
yuren	羽人
Yutaishan	雨台山
Zeng hou	曾侯
Zengzi	曾子
Zhaifu-dong	齐祓洞
zhang	璋
Zhang Daoling	张道陵
Zhang Xuan	张萱
Zhang Hua	张华
Zhang Sengyu	张僧繇
Zhang Yanyuan	张彦远
Zhangjiapo	张家坡
zhanpao	战袍
Zhao Feiyan	赵飞燕
Zhao Mengfu	赵孟俯
Zhao Mingcheng	赵明诚
Zhao wang	昭王
zhi (vessel)	觯
zhinü	织女
Zhongshan	中山
Zhou Fang	周方
Zhou hou	周候
Zhou Wenju	周文矩
Zhu Jingxuan	朱景玄
zong	瑄
Zong Bing	宗炳
zun	尊

Index

Pages are noted in roman, illustration numbers in italics. Museums etc are mostly entered by location, the full titles being with the references. The Yungang caves are denoted as usual by Roman numbers, those at Dunhuang by the Arabic numbers of the Dunhuang Institute. A concordance of the various Dunhuang numerations is included in Xie Zhiliu 1957 (bib: chap. 18).

Picture Acknowledgements

The Art Institute of Chicago: 85 Samuel M Nickerson Fund, 1932.45, 377 Gift of Charlotte Bordeaux, Pauline Wood Egan, Gordon P O'Neil, John O'Neil III, Sandra O'Neil, Potter Palmer, Oakleigh B Thorne, Honore Wamsler and Arthur M. Wood, 1991.826 photograph © 1993, All Rights Reserved; Art Museum, Princeton University: 44 Gift of J. Lionberger Davis, Museum purchase from Arthur M Sackler Foundation, 56 Museum purchase from C. D. Carter Collection, gift of the Arthur M Sackler Foundation, Carl Otto von Kienbusch Jr., Memorial Collection, 58 Museum purchase, Carl Otto von Kienbusch Jr., Memorial Collection; Ashmolean Museum, Oxford: 41, 387 (inv. 1957 1072); Asian Art Museum of San Francisco, The Avery Brundage Collection: 14 (inv. B60 P1110), 59 (inv. B60B954), 174 (inv. B60B1064), 192 (inv. B60 1034), 215 (inv. B60 643), 216 (inv. B60B1035), 350 (inv. B60B334), 351 (inv. B60B1038), 373 (inv. B60P536 AND B60S95), 376 (inv. NO. B60S51), 388 (inv. B60 P1392); British Museum: 16 (acc. 1929 6–14 1), 30 (acc. 1957 10–23.1), 81 (acc. 1956.6–12.1), 82 (acc. 1937 4–16 218), 88 (acc. 1945 10–17 201, 198, 1936.11–189.250, 1947.7–12.360, 100, (acc. 1945.10–17.157), 109 (acc. 1947.7–12.515), 110, 111, 130 (acc. 1932 10–8 51), 311 (acc. 1919.1–1.169), 325–28, 139 (acc. 1916 8–3 1,2), 140 (acc. 1947 7–12 365, 1916.8–3 1,2) 306 (acc. MA 912), 325 (acc. 1903.0408.07), 327 (acc. 1903.0408.01), 328 (acc. 1903.0408.01), 334, 335 (acc. 1930.10–15.02), 336 (acc. 1889.11–11.01), 103, 104, 137 (acc. 1950.11–16.5), 362, 389 (acc. 1936.10–12.61), 390 (acc. 1968.4–22.21); China News Agency: 152; Cleveland Museum of Art: 122 and 123 Purchase from the J H Wade Fund, 38.9, 236 GIFT OF THE JOHN HUNTINGTON ART POLYTECHNIC TRUST, 14.567, 250 The Fanny Tewksbury King Collection, 57.360, 359 Purchase from the J H Wade Fund 29.981, 375 Anonymous Gift 55. 295; Cultural Relics Publishing House, Beijing: 23, 31, 50, 61, 64, 66, 77, 79, 88, 91, 92, 96, 102, 107, 125, 145, 149, 156, 209, 220, 222, 228, 229, 232, 237, 240–42, 340–42, 353–54, 381, 385–86; Danish National Museum, Ethnological Collection: 134; Denver Art Museum: 13 (acc. 1948.2), 370 (acc. 1954.38); Field Museum of Natural History, Chicago: 360 neg. A85594; Courtesy of the Freer Gallery of Art, Smithsonian Institution, Washington D.C.: 157 & 158 (3500), 159 (51.5), 234, 317 (39.37), 318 (17.411); Fujii Yūrinkan, Kyoto: 193, 239; Hakkaku Museum, Kobe: 39, 46, 63, 378, 383; The Harvard University Art Museums, bequest of Grenville L. Winthrop: 32; Heibonsha, Tokyo: 190, 262–83, 303–5, 307–8, 312–13, 323–24, 330–31; Honolulu Academy of Arts, gift of Mr Robert Lehman, 1960: 337; Idemitsu Museum of Art, Tokyo: 372, 379; Courtesy of the Imperial Household Agency's Museum, Tokyo: 329; Institute of Archaeology, Beijing: 11, 68, 371, 374; Messrs Christie: 35, 95; Messrs Eskennazi: 84, 155, 391–92, 396; Courtesy Messrs Faber & Faber: 5, 10; Metropolitan Museum of Art: 51 Munsey Bequest, 1924 (24.72.1–14), 136 Rogers Fund, 1918 (18.43.11), 141, 196 Kennedy Fund, 1926 (26.123), 259–61 Rogers Fund 1929 (29.72); Minneapolis Institute of Arts, Bequest of Alfred F Pillsbury: 21 (inv. 50.46.123), 57 (inv. 50.46.119), 86 (inv. 50.46.112), 98 (inv. 50.46.392), 253 (inv. 46.23.1–6); Musée Cernuschi, Paris: 48, 132; Musée Guimet, Paris: 172; Museum für Kunst und Gewerbe, Hamburg (photo Kiemer & Kiemer): 34; Museum Für Kunsthandwerk, Frankfurt-am-Main: 224; Museum für Ostasiatische Kunst, Berlin: 138 (inv. 1965–23b); Museum of Decorative Art, Copenhagen, (photo Ole Woldbye), 94; Museum of Far Eastern Antiquities, Stockholm: 12 (inv. K5155), 36, 45 (inv. 372/74), 83, 99 (inv. 1105), 101 (inv. 1541), 108 (inv. 829), 173 (inv. 1506), 347 (inv. NMOK 14); Museum of Fine Arts, Boston: 181 John Wheelock Elliot Fund, 238 Gift of Denman W. Ross in memory of Okakura Kakuzo, 244 Gift of Mrs W. Scott Fitz, 246 Francis Bartlett Fund (acc. 15.254), 319 Denman Waldo Ross Collection; National Museum, Tokyo: 357, 361, 380, 382; National Museum of Chinese History, Beijing: 69; The Nelson-Atkins Museum of Art, Kansas City, Missouri: 65 (Nelson Fund 41–33), 193 (Nelson Fund 51–25), 226 (Nelson Fund 40–38), 252 & 256 (Nelson Fund 33–1543/2a), 254 & 255 (Purchase Nelson Trust), 346 (Nelson Fund 33–91); National Palace Museum, Taipei, Taiwan: 74, 320; Nezu Institute of Fine Arts: 29, 47; Okura Shukokan, Tokyo: 197; Osaka Municipal Museum of Art: 315, 316; Réunion des Musées Nationaux, Paris: 127, 217, 235; Rheinisches Bildarchiv: 15; Rietberg Museum, Zurich (Wettstein & Kauf): 87, 223, 356; Royal Ontario Museum of Archaeology: 54; Seattle Art Museum: 218 Thomas D Stimson Memorial Collection: Service de Documentation Photographique, Cliché Segalen: 363; Shanghai Museum: 27, 33, 40, 42, 72, 93; St Louis Art Museum: 234, 352; University Museum, University of Pennsylvania, Philadelphia: 219 (neg. S8–1152), 245 (neg. S4–134143), 257 (neg. S8–62862–3). 343 (neg. G8–1305), 366 (neg. S8 62844); Courtesy of the Office of the Shōsōin Treasure House: 333, 393–95; Sumitomo Museum, Kyoto: 49, 171; Courtesy of the Victoria and Albert Museum: 358; Yunnan Provincial Museum: 153, 154 after (*Cf. Bibliography*) Artibus Asiae: 97; Asano Kiyoshi, 1969: 293, 294; A Brankston Photograph: 179; Chang Shuhong 1959: 314; Chavannes: 205, 206, 208, 367; Finsterbusch: 187, 288; Heibonsha *Sekai bijutsu zenshû*: 207, 211, 212, 214; Henan Antiquities Team, 1963: 230, 231, 249; *Kaogu Xuebao*: 161; Kaogu: 105; Liu Duzhen, 1984: 295; Longmen Conservancy, 1961: 338; *Maijishan Shiku*, Beijing 1954: 209, 227; Mizuno and Nagahiro 1952: 25, 198; Shang Chengzuo: 118, 119; Sickman and Soper 1958: 151, 204, 221, 289, 294, 299–302; Tazawa and Ooka 1957: 286, 296; *Historical Relics* Beijing 1972: 2, 3, 6, 9; *Wenwu*: 20, 55, 62, 71, 106, 113–15, 120, 148, 163, 248, 251, 321, 339, 345; Yammanaka photograph: 200; Yao Qian, Gu Bing, 1981: 364–65; Yashuhiro Ishimoto Mandala: 310; Zeng Zhaoyu *et al.* 1956: 167, 168, 183

The Arts of China to AD 900

William Watson

This handsome book is the first in a major three-volume series that will survey China's immense wealth of art, architecture, and artefacts from prehistoric times to the twentieth century. *The Arts of China to AD 900* investigates the beginnings of the traditions on which much of the art rests, moving from Neolithic and Bronze Age China to the era of the Tang Dynasty around AD 900.

William Watson discusses in lively detail a wide range of art forms and techniques: porcelain and pottery, lacquer art, religious and secular painting and sculpture, mural painting, monumental sculpture and architecture. He explains the materials and techniques of bronze casting, jade carving, pottery manufacture, and other arts, and he describes the most important sites, the artefacts that were produced at each one, and the historical interactions between different areas. He discusses the iconography, the technique and the function of every art form.

Written by one of the most distinguished scholars in the field of Chinese art and archaeology, this lavishly illustrated book will be a valuable resource for both experts and beginners in the field.

William Watson is emeritus professor of Chinese art and archaeology at the University of London. He was formerly director of The Percival David Foundation, London, and has written a number of other books on Chinese art and architecture.